1992

The Age of the Marvelous

THE AGE OF
THE MARVELOUS

Edited by Joy Kenseth

HANOVER · NEW HAMPSHIRE

Hood Museum of Art · Dartmouth College

MCMXCI

Hood Museum of Art, Dartmouth College, Hanover, NH 03755

Distributed by the University of Chicago Press
5801 South Ellis Avenue, Chicago, IL 60637

ISBN 0−944722−09−1 (hardcover) ISBN 0−944722−10−5 (softcover)

This book has been published in conjunction with an exhibition entitled
The Age of the Marvelous organized by the Hood Museum of Art.

Exhibition schedule:

Hood Museum of Art, Dartmouth College
September 21 − November 24, 1991

North Carolina Museum of Art, Raleigh
January 25 − March 22, 1992

The Museum of Fine Arts, Houston
May 24 − August 25, 1992

High Museum of Art, Atlanta
October 6, 1992 − January 3, 1993

Editor: Debra Edelstein

Printed in Lunenburg, Vermont, U.S.A., by The Stinehour Press.

This project has been supported in part by grants from
the National Endowment for the Humanities and
the National Endowment for the Arts, federal agencies,
and a generous gift from the Bernstein Development Foundation.

COVER ILLUSTRATION:
Jan Davidsz. de Heem, Dutch, 1606−ca. 1684, *Still Life with Parrots* (detail), late 1640s, oil on canvas.
The John and Mable Ringling Museum of Art, Sarasota, Florida. Acc. no. SN 289 (cat. no. 11).

CONTENTS

For

SYDNEY J. FREEDBERG

with admiration and affection

IN 1554 MATTEO BANDELLO remarked that "if there ever was an age when one sees varied and wondrous things I believe that ours is one, for it is an age in which, more than any other, things happen that are worthy of astonishment, compassion, and reproach." The mid-sixteenth century was indeed such an age, and so is the late twentieth century. The rapid production of new and quite astonishing consumer goods should be evidence enough of the wondrous age in which we live. But the extraordinary increase in new scientific knowledge is more meaningful. A measure of this is the publication of scientific journals. According to a recent report, there were only 100 such journals in 1800. By 1850, however, there were 1,000, and by 1900, 10,000. Currently there are close to 100,000, and since 1665, when they first appeared, their number has doubled every fifteen years. Indeed, the growth in scientific knowledge is such that it is said that 80 to 90 percent of all scientists who have ever been are alive today!

Such an extraordinary and rapid increase in the production of new knowledge at once forces and frustrates our attempts at classifying it. This distinguishes our age from that of the sixteenth century. Five hundred years ago, in his *Gesta grayorum*, Francis Bacon listed with confidence the essential apparatus of the learned gentleman: a most perfect and general library; a spacious and wonderful garden replete with rare birds, beasts, and fish of all kinds; a still-house of mills, instruments, furnaces, and vessels; and a huge cabinet, "wherein whatsover the hand of man by exquisite art or engine has made rare in stuff, form or motion; whatsoever singularity, chance, and the shuffle of things hath produced; whatsoever Nature has wrought in things that want life and may be kept; shall be sorted and included." In brief, a collection of all things required to form a full and perfect model of the universe.

One cannot imagine such a model today: the universe is simply too large. Indeed, the ambition of many of our leading educators is not to form a model of all known knowledge but to select only that which they hold to be essential to the transmission of the noblest of human virtues. This, in our time, is an ambition fraught with political posturing. One person's noble virtues are another's elitist ideology. There is, simply put, no consensus on what constitutes, as a former president of Harvard University once said, "the common knowledge and the common values on which a free society depends." The recent controversy on American college and university campuses over how to define, or even the *validity* of, a core curriculum is but one manifestation of how Western society is seeking to address the rapid increase in the production of complex and often contradictory knowledge.

It is within this context—an ever-expanding body of knowledge and a crisis of confidence over our ability to order it—that we present this exhibition. It is a thorough and scholarly presentation of a phenomenon central to the era's fascination with its own expanding universe and to its confidence in forming a perfect model of it in all its sublime greatness. The marvelous was at once a category of knowledge and, in Descartes's words, "the first of all the passions." It was marked by an intense fascination with all things rare, exotic, or extraordinary, as evidenced by Bacon's description of his learned apparatus. And it had a special place in the celebrated cabinets of the day. The *Wunderkammer*, or wonder room, housed the most marvelous things, such as a nautilus shell or a "unicorn's horn," as well as scientific apparatus, examples of exotic animals and flora from the New World, and graphic, pictorial, sculptural, and especially *trompe-l'oeil* representations of all kinds of *meraviglie*. This would sometimes be distinct from the *Kunstkammer*, or cabinet of fine arts, and sometimes confused with it. But it would always be part of the same effort to collect and classify representative examples of the most wondrous natural and man-made objects that were thought to comprise a microcosm of universal knowledge.

While the subject of the marvelous has been considered in previous art-historical literature, and examples of it included in other exhibitions, *The Age of the Marvelous* is the first exhibition to address it as central to an understanding of European culture of the Renaissance and baroque periods. For this, we are grateful to our guest curator, Joy Kenseth, Associate Professor of Art History at Dartmouth College. Professor Kenseth has been a model faculty curator at the Hood Museum of Art and evidence of the museum's commitment to serve the college as a catalyst for advanced scholarship and instruction. Her presence in the museum has been a vital part of our programs, and we look forward to further cooperative ventures with her and her faculty colleagues.

The organization of an exhibition of this complexity requires the selfless participation of numerous individuals. At the museum Associate Director Timothy Rub guided us through every aspect of its execution from beginning to end with characteristic thoroughness. Evelyn Marcus, Curator of Exhibitions, and her staff, James Watkinson, Louise Glass, and Nick Nobili, performed heroically in executing the plans of our guest designer, ElRoy Quenroe of Quenroe Associates, Inc. Kellen Haak, Registrar, and his staff, Kathleen O'Malley, Kimberly King Zea, Deborah Haynes, and Karin Rothwell managed the tour of the exhibition with the highest degree of professionalism. Robert Eliason gathered important information on the natural specimens exhibited in the wonder room, Victoria Bedi provided key assistance in gathering and checking the catalogue bibliography, and Jeff Nintzel did a superb job in photographing works in the Hood collection as well as from the Dartmouth College Libraries. Susan Sager-Barry, Administrative Assistant in the department, was invaluable to the preparation of the catalogue manuscript. Debra Edelstein, editor of the catalogue, was critical to its accuracy and verbal elegance, while graphic designer Christopher Kuntze gave the book its visual grace. Elisabeth Gordon, with the assistance of Dartmouth senior Gail McGuire, and Nancy McLain, respectively,

handled all public relations and financial matters with care and precision. Barbara J. MacAdam, Mary McKenna, Theresa Delamarre, and Julia Gómez helped in numerous and essential ways at key moments in the project. Lesley Wellman, with the assistance of Constance Skewes, conceived and coordinated all of its educational programming. Dartmouth students Lisa Anderson and Bophal Mompho cheerfully provided much-needed assistance in the production of the catalogue. But no one was more important to the success of the exhibition than Katherine Hart, Curator of Academic Programming, and Ann Trautman, Curatorial Assistant. They worked long and tirelessly in preparing the catalogue manuscript for publication and in developing related curricular programming. Successful relations between the museum and the college depend on the quality of our academic programs, and Kathy and Ann, together with Professor Kenseth, were central to their planning and implementation.

Presentation of the exhibition at our sister institutions was greatly assisted by Anthony Janson, Chief Curator of the North Carolina Museum of Art; George T. M. Shackelford, Curator of European Painting and Sculpture at the Museum of Fine Arts, Houston; Paula Hancock, Curator of Research, and Marjorie Harvey, Coordinator of Exhibitions, at the High Museum of Art. We are grateful for their advice and assistance in the preparation of the exhibition. Equally, we acknowledge the generosity of our many lenders, public and private. The nature of *meraviglie* is such that they are often quite delicate, fragile, and rare. Our lenders' belief in the importance of the exhibition and their trust in our stewardship made possible the exhibition, and we remain in their debt.

The support of the National Endowment for the Humanities was critical throughout the project and testament to the high quality of the exhibition's many and broad contributions to the advancement of scholarship in the humanities and public education. The National Endowment for the Arts also provided funding essential to the implementation and presentation of the exhibition and its educational programs. For their role in preparing the grant applications to the endowments, we again acknowledge Timothy Rub, Joy Kenseth, Evelyn Marcus, and Elisabeth Gordon. In addition, Raphael Bernstein, Overseer of Dartmouth's Hood Museum of Art and Hopkins Center for the Performing Arts and President of the Bernstein Development Foundation, provided timely and critical support for the exhibition and related curricular programming at the college.

On behalf of the Hood Museum of Art, Dartmouth College, and my colleagues, Richard S. Schneiderman, Director of the North Carolina Museum of Art; Peter Marzio, Director of the Museum of Fine Arts, Houston; and Gudmund Vigtel, Director of the High Museum of Art, I acknowledge the many contributions of all agencies and individuals who have contributed to the presentation of *The Age of the Marvelous*.

James Cuno
DIRECTOR, HOOD MUSEUM OF ART

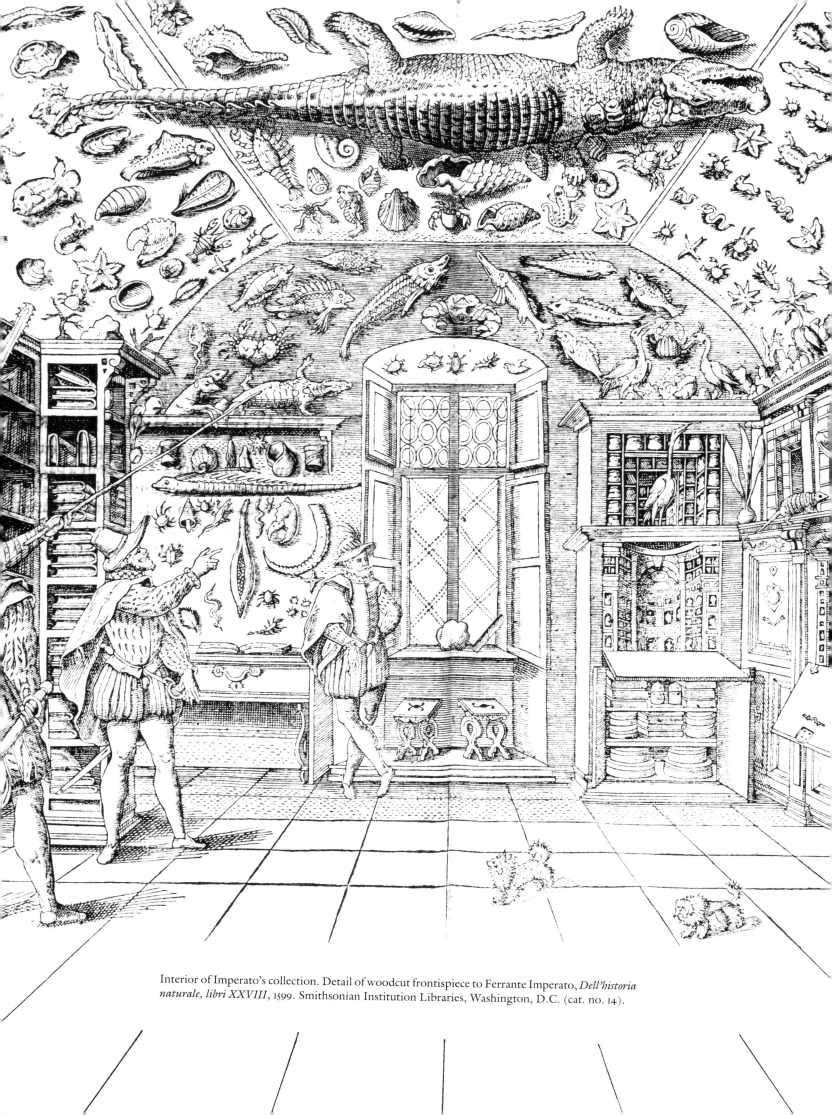

Interior of Imperato's collection. Detail of woodcut frontispiece to Ferrante Imperato, *Dell'historia naturale, libri XXVIII*, 1599. Smithsonian Institution Libraries, Washington, D.C. (cat. no. 14).

PREFACE

THROUGHOUT HISTORY people have been interested in objects or phenomena that have the power to excite wonder or astonishment. This was especially true of Europeans during the late-Renaissance and baroque periods, as their fascination with the marvelous developed as a major cultural force, embracing most fields of human endeavor. This exhibition is designed to show the depth and breadth of European interest in the marvelous during the sixteenth and seventeenth centuries. Comprised of works of art, cartographic materials, illustrated texts, natural specimens, and scientific apparatus, it aims to illustrate the varied and multidisciplinary nature of this phenomenon.

The exhibition is organized into five sections, each of which addresses fundamental issues pertaining to the vogue for the marvelous. The first section considers the most important historical antecedents of this phenomenon and major events that led to its development. Additionally, the works of art and illustrated texts displayed here introduce several themes that receive concentrated attention in other parts of the exhibition. The second section is devoted to the most characteristic expression of the period's fascination with the unusual and extraordinary—the *Kunst- und Wunderkammer* or cabinet of curiosities. Meant to evoke the appearance of early museums, it brings together a wide variety of natural and artificial objects that were regarded as marvels by sixteenth- and seventeenth-century collectors. In the next three sections, the exhibition focuses on the major categories of marvels: the natural, the artificial, and the supernatural. "Nature's Wonders and the Wonders of New Worlds" emphasizes the efforts of cartographers, natural scientists, and artists to represent and document celestial and geographical discoveries, anthropological and zoological wonders, and extraordinary and unusual specimens from the botanical world. "Marvels of Art" takes up the subject of man-made works having the power to provoke wonder, specifically "miraculous" constructions for gardens, festivals, and the stage, and surprising painted illusions and visual deceptions. Finally, "The Christian Marvelous" considers the supernatural phenomena of Christian belief. Here the exhibition draws attention not only to the central mysteries of the faith, but also to the Catholic community's efforts to legitimize the religious marvels of the post-biblical period. In a general way, the sequence reflects the chronology of events that contributed to the heightened interest in the marvelous: the great geographical discoveries; the growth of the printing industry; the successes of trade with distant worlds; developments in technology, engineering, and optics; the impact of the Counter-Reformation; and the increased reports of miracles in the late sixteenth and seventeenth centuries.

Visitors to the exhibition will notice that illustrated books comprise a large proportion of the objects on display. While many of these publications can be considered marvels in their own right, their strong representation is intended to show the significance of the print medium in disseminating information about wondrous objects and phenomena.

The nine essays in this catalogue elaborate the exhibition's main themes and are arranged in a manner that closely reflects its format. My opening essay offers a broad overview of the marvelous, paying particular attention to the contemporary events that led to a heightened interest in wondrous things and to the categories and criteria of the marvelous. James V. Mirollo then examines the marvelous as an aesthetic goal, especially as it was promoted by literary theorists of the time. "A World of Wonders in One Closet Shut" discusses the principles behind curiosity cabinets and the types of marvels that were exhibited in them. The next three essays correspond to the section of the exhibition titled "Nature's Wonders and the Wonders of New Worlds." James A. Welu focuses on the efforts of cartographers to record the latest geographical discoveries. William B. Ashworth, Jr., shows how traditional views of anthropological and zoological wonders were revised once New World Indians and animals were found and after minute forms of life were viewed through the lens of the microscope. Elisabeth B. MacDougall then looks at botanical marvels—the fantastic florae of legend, exotic imports, and remarkable home-grown specimens. The next two essays are devoted to marvels of art. In the first of these, Mark S. Weil offers an account of the curious and ingenious designs made for gardens and festivals and of the spectacular effects achieved in theatrical performances. In the second, Arthur K. Wheelock, Jr., explores the issue of deceptive and illusionistic imagery, especially with regard to *trompe-l'oeil* pictures made by seventeenth-century Dutch artists. Finally, Zirka Zaremba Filipczak deals with the subject of Christian miracles, especially those that were disputed by Protestants but accepted as true by Catholics. As she observes, the age of the marvelous was a period in which miraculous visions were reported with remarkable frequency.

As comprehensive as *The Age of the Marvelous* is, however, it does not offer the definitive account of the phenomenon. Neither the exhibition nor the accompanying catalogue discusses music or architecture, for example, though both contribute to an aesthetic of the wondrous. Additionally, more remains to be said about the ancient and medieval sources of the marvelous and about the connections that existed between natural magic and the arts. It is my hope, and that of all who contributed to *The Age of the Marvelous*, that the exhibition and catalogue offer glimpses of a wondrous world and prompt further explorations of this rich and fascinating material.

Joy Kenseth
HANOVER, NEW HAMPSHIRE
MARCH 1991

14

ACKNOWLEDGMENTS

IN JANUARY 1985, I first discussed the possibility of this exhibition with the then director of the Hood Museum of Art, Jacquelynn Baas. With her enthusiastic support, I began research on the project and explored some of its chief themes in a series of seminars with my students at Dartmouth College. It is difficult to believe that a project which began rather modestly has now become a major undertaking. A project of this size and complexity requires the cooperation of many people. Numerous individuals and institutions have kindly lent objects to the exhibition and to them I owe a special debt of gratitude. Roger Arvid Anderson, Ruth Blumka, Michael Hall, Arthur and Charlotte Vershbow, Barry MacLean, and Walter Paine, have been exceptionally generous and had it not been for their support the exhibition surely would have suffered in significant ways. Crucial loans to the exhibition have also been made by Alfred Balch, Peter and Kit Bedford, Arthur Holzheimer, Julius Held, Robert Tobin, Mr. and Mrs. John Walsh, Kevin Weremeychik, Dian and Andrea Woodner, Professors Jay Pasachoff and Gary Johnson, and other private collectors who wished to remain anonymous. To all of these individuals, I wish to extend my sincerest thanks.

The staffs of the lending institutions were particularly helpful in securing loans for *The Age of the Marvelous*. Kind assistance was received from William Chiego at the Allen Memorial Art Museum, Oberlin College, Suzanne Foley of the Bayly Art Museum, University of Virginia, and Terrell Hillebrand of the Sarah Campbell Blaffer Foundation. At the Museum of Fine Arts, Boston, Clifford Ackley, Peter Sutton, Anne Poulet, Jeffrey Munger, and Shelley Langdale, provided much assistance. I am most indebted to Sue Welsh Reed of that institution. She has supported my efforts in this project from the beginning and has extended me many courtesies for which I am especially grateful. David Brooke and Martha Asher at the Sterling and Francine Clark Institute of Art greatly facilitated the loan of their important painting by Murillo while Evan Turner, Jane Glaubinger, Henry Hawley, and Bruce Robertson of the Cleveland Museum of Art went to considerable lengths to see that important works from their institution would be included in the exhibition. Much needed assistance also was received from Gail Davidson, Deborah Shinn, and Margaret Smith at the Cooper-Hewitt Museum; Lewis Story, David Curry, Timothy Standring, and Julie Smith from the Denver Art Museum; Jan van der Marck and J. Patrice Marandel, Iva Lisikewycz, and Nancy Coley of the The Detroit Insitute of Arts; Russell Panczenko and Patricia Junker of the Elvehjem Museum of Art of the Uni-

15

versity of Wisconsin-Madison; John Hallmark Neff and George Snyder at the First National Bank of Chicago; Ross McGuire, Elisa Kamimoto, and Richard Ambrose from the Fresno Metropolitan Museum; John Walsh, George Goldner, Dawson Carr, Peter Fusco, and Jill Finsten of The J. Paul Getty Museum; Cynthia Burlingham of the Grunwald Center of the Graphic Arts, UCLA; and Walter Seamans, John Arrison, Kurt Hasselbach, and Donna Weber of the MIT Museum. Additional thanks go to Konrad Oberhuber and Fritz Koreny of the Graphische Sammlung Albertina; Marjorie Cohn and Emmy Norris of the Harvard University Art Museums; Jeanne Newlin, Brian Benoit, and Catherine Johnson of the Harvard Theater Collection; John F. Stevens and Walter J. Karcheski, Jr., from the Higgins Armory Museum; Edmund Pillsbury and William Jordan at the Kimbell Art Museum; Linda Hardberger at the Marion Koogler McNay Art Museum; Susan E. Davidson at the Menil Collection; James Draper, Suzanne Boorsch, Charles Little, Colta Ives, Andrea Bayre, Tom Rassieur, Clare Vincent, Marceline McKee, and Marci Jo Karp at The Metropolitan Museum of Art, New York; and Evan Maurer, Michael Conforti, and Peggy Tolbert at The Minneapolis Institute of Arts.

Staff members of the National Gallery of Art have helped in many ways: in addition to Arthur Wheelock, whose contributions to our project have been considerable, I want to thank in particular J. Carter Brown, Andrew Robison, and Diane DeGrazia. I also benefited very much from the assistance and helpful advice of David Brown, Douglas Lewis, and Neal Turtell of that institution. Marc Wilson and Roger Ward at the Nelson Atkins Museum offered me much support, as did E. John Bullard and Valerie Olsen at the New Orleans Museum of Art. I owe a special debt to Anthony Janson and David Steel at the North Carolina Museum for their confidence in this project and to Laurence Ruggiero at the John and Mable Ringling Museum for so generously lending a key work to the exhibtion, Jan Davidsz. de Heem's *Still Life with Parrots*. The staff at the Royal Ontario Museum has been exceptionally helpful in realizing *The Age of the Marvelous* and thanks go in particular to Peter Kaellgren, Howard Creel Collinson, June Rilett, and Cara McEachern. Other individuals who have contributed significantly to the realization of the exhibition include: Michael Shapiro and Marie Nordmann at The Saint Louis Art Museum; Steven Turner, Smithsonian Institution, Museum of American History; Dean Porter and Stephen Spiro of The Snite Museum of Art, University of Notre Dame; Andrea Norris, John Wilson, and Patricia Fidler of the Spencer Museum of Art, University of Kansas, Lawrence; Susan Donahue Kuretsky and Rebecca Lawton of the Vassar College Art Gallery; Patrick McCaughey, Linda Ayres, and Linda Roth at the Wadsworth Atheneum; and Kristen Zaremba of the Ian Woodner Family Collection. While he was at the Walters Art Galley, Eric M. Zafran offered me considerable support; more recently Robert P. Bergman and Joaneth Spicer of that institution have given me their kind assistance. I am obliged additionally to the staff of the Worcester Art Museum, especially James E. Welu and Sally Freitag; and to Richard S. Field, Lisa Hodermarsky, and Anthony Hirschel of the Yale University Art Gallery.

16

ACKNOWLEDGMENTS

Among the personnel of those museums from whom we are borrowing scientific and natural history items primarily, I would like to extend my thanks to the following: Mary LaCroy and Richard Sloss of the American Museum of Natural History; Barry and Judith Dressel and Tim Flanagan of the Berkshire Museum, as well as the former director Gary Berger; William Kochanczyk of the Museum of Science, Boston; Howard Reed of the Fairbanks Museum and Planetarium; David Goudy, Linny Levin, and Joan Waltermire of the Montshire Museum; and Adrianne Noë, Douglas Landry, and Donna Quist of the National Museum of Health and Medicine; and Charles Remington of the Peabody Museum of Natural History, Yale University.

A significant number of libraries have lent to this exhibition and as with the museums of art and science, their staffs have extended many kindnesses to us. Among those to whom I am most indebted are: Carol Spawn of the Library at the Academy of Natural Science of Philadelphia; Marcus McCorison and Georgia Barnhill, the American Antiquarian Society; Peter Harrington, the Anne S. K. Military Library, Brown University; Judy Warnmen and Jean Boise, the Arnold Arboretum; Janet Parks, Herbert Mitchell, and Angela Giral from Avery Library, Columbia University; Robert Babcock, Vincent Giroud, and Paul Allen of the the Beinecke Rare Book and Manuscript Library, Yale University; Robert Volz of the Chapin Rare Book Library, Williams College; Ellen Wells at the Dibner Library, Smithsonian Institution Libraries; John Dixon Hunt of Dumbarton Oaks; Judith Gardner-Flint of the Milton S. Eisenhower Library, Johns Hopkins University; Stephen Ferguson and Charles Greene at the Firestone Library, Princeton University; Frank Halpern at the Free Library of Philadelphia; Linda Stanley and Thomas Kemp from the Historical Society of Pennsylvania; Jennifer Lee and John Stanley of the John Hay Library, Brown University; James Green at the Library Company of Philadelphia; Carol Pulin and John Wolter of the Library of Congress; Bruce Bradley and William Ashworth at Linda Hall Library, University of Missouri; Richard Baker, book conservator, St. Louis; William M. Voelkle, Cara Denison, and Hope Mayo at The Pierpont Morgan Library; Roberta Waddell, Barbara Woytowicz, Margaret Glover, and Louisa Wood of the New York Public Library; Mary Wyley, Robert Karrow, and Cynthia Wall of the Newberry Library; Michael J. Durken, Ann Blackburn, and Edward Fuller from the Swarthmore College Library; Connell B. Gallagher of the Bailey/Howe Library, University of Vermont; Barbara McCorkle of the Yale University Library; and Ferenc Gyorgyey and Janis Braun of the Harvey Cushing/John Hay Whitney Medical Library, Yale University.

The greatest number of rare books in the exhibition have been lent by the Dartmouth College Libraries. I am profoundly thankful for their generosity and for their willingness to entrust us with so many rare volumes for the duration of the exhibition. At the Baker Library Special Collections, Philip Cronenwett and Stanley Brown offered me extraordinary assistance, while Ken Cramer helped me with particularly difficult problems of research. I am grateful as well to John Berthelsen, the head of the Map Division of Baker

ACKNOWLEDGMENTS

Library, who helped me in my research on the maps in the exhibition and to Shirley Grainger-Inselburg and Constance Rinaldo at the Dana Biomedical Library, who gave me free access to the rare book room, allowing me to conduct research there in blissful solitude. Indeed, the many hours I spent in both these libraries were among my happiest in the course of this long project.

Other departments at the college have also lent objects to the exhibition, and they too have extended me many courtesies. Richard Birnie, Gary Johnson, and Bobby Bammel of Earth Sciences have been especially supportive and enthusiastic, while Ken Korey from Anthropology and Stanley Carpenter of the Anatomy Department did much to help me in my endeavors.

Apart from the lenders to the exhibition I want to express my appreciation to my colleagues in the Department of Art History. They provided me with moral support, tolerated my long absences, and on more than one occasion relieved me from departmental duties so that I could devote my time to the exhibition. In the last two years, when the pressures of the project became most intense, Elisabeth O'Donnell, Tracey Adkins, and Jan Smarsik, all from the department's slide library, extended me innumerable favors and to them, as well as to Felicia Grayson, I am deeply grateful. I owe as much if not more to the staff of Sherman Art Library. Barbara Reed, Mary Guerin, Marjorie Whyte, and Claudia Yatsevitch went to extraordinary lengths to help me in my research; they cheerfully and patiently attended to my needs and extended me exceptional liberties in the borrowing of books.

During all the phases of this project, I have had the good fortune to collaborate with a remarkable group of consultants: William Ashworth, Zirka Zaremba Filipczak, Elisabeth MacDougall, James Mirollo, Mark Weil, James Welu, and Arthur K. Wheelock, Jr. I have benefited enormously from their counsel, and their scholarly insights, and am indebted to them not only for the wonderful contributions they have made to the exhibition catalogue but also for the encouragement and unflagging support they have given to me over these many years. Personnel from the museums to which the exhibition will travel have also offered me much enthusiastic encouragement, especially my former student George Shackelford at the Museum of Fine Arts, Houston, Paula Hancock and Marjorie Harvey of the High Museum, and Anthony Janson at the North Carolina Museum of Art.

Numerous other people have assisted me in a variety of ways. Arthur R. Blumenthal, Robert Dance, Samuel Y. Edgerton, Frank Manasek, Peter Tillou, Richard D. Whiting, MD, Ron Kilpatrick, and Walter Denny answered many of my queries and in some instances were instrumental in helping me locate objects for the show. Sarah Blake McHam and Paul Barolsky have given me unstinting support throughout the life of this project, buoying up my spirits when they needed it and offering me valuable constructive criticism. Their encouragement and that of Susan Donahue Kuretsky has sustained me most of all. I also want to extend a special word of thanks to Jane and Raphael Bernstein

18

who had faith in this project early on and whose generosity assured that it would reach completion.

The preparation of this catalogue has been a most arduous task. A team effort in the purest sense, it has involved the dedicated efforts, insights, and patience of many people. I am grateful also for the advice and guidance of Roderick Stinehour during all phases of the production of the catalogue, as well as to Christopher Kuntze, who as designer is also responsible for its elegant appearance and was especially patient with the long and drawn out process of production. In addition to the consultants, I want to offer my thanks especially to those who wrote the catalogue entries—Anne Trautman, Hilliard Goldfarb, Walter Karcheski, Liz Guenther, and Katherine Hart. Debra Edelstein's editorial work has enhanced the text immeasurably, while Barbara MacAdam kindly consented to help with proofreading. James Tatum, Robert Rabel, Jerry Rutter, and Cheryl Brown of the Classics Department and Werner Hoffmeister of the German Department kindly helped with translations of primary texts. The bibliography was painstakingly researched by Victoria Bedi of the Dartmouth College Libraries. Our student assistants, Sarah McDaniel, Pam Gordon, Lisa Anderson, Bophal Mompho, and Carrie Heinonen cheerfully took on tasks related to the catalogue's production as well as to the project in general. Particularly noteworthy has been the contribution of Susan Barry. She has been a kind and efficient associate in the project, typing the manuscript, and overseeing myriad details relating to loans and other related aspects of the exhibition.

The sumptuous and magnificent exhibition design is due to the many talents of ElRoy Quenroe of Quenroe Associates, and its interpretation and implementation to the more than heroic efforts of Evelyn Marcus and her staff, Jim Watkinson, Nick Nobili, and Federico Rodriguez.

My most heartfelt thanks go to all my friends at the Hood Museum of Art. They have treated me with exceptional kindness and patience over the last years, making me feel at home on another side of Dartmouth's campus, and offering me support every step of the way. The museum's most recent directors, James Cuno and Timothy Rub, have patiently and enthusiastically guided me through the bewildering thicket of tasks related to a loan exhibition and Timothy, in particular, played a major role in our successful attempt to gain major funding from the National Endowment for the Humanities. Hilliard Goldfarb, Barbara MacAdam, and Tamara Northern have given generously of their time as have the other members of the staff, Kellen Haak, Kathleen O'Malley, Kim King Zea, Debbie Haynes, Karin Rothwell, Julie Edwards of the Registrar's Office, Lesley Wellman of the Education department, Evelyn Marcus and her staff in the Exhibitions department, as well as Nancy McLain, Elisabeth Gordon, Adrienne Hand, Mary McKenna, Theresa Delemarre, and Jeff Nintzel. Very special thanks also go to Robert Eliason, who arranged for the loans of all the natural history objects in the exhibition and intrepidly looked not only in museums, but in field, stream, and by roadside for some of the wonder room items. Had it not been for their warm friendship and their professional demeanor, I doubt

that I would have had the courage to see the project through to its end. Of all those who have been engaged in *The Age of the Marvelous*, however, I owe the most to Anne Trautman, Curatorial Assistant for this project, and Katherine Hart, Curator of Academic Programming. They have shown extraordinary dedication and fortitude and have assumed a tremendous number of responsibilities—finding objects, writing catalogue entries, research, proofreading—that would have defeated less stouthearted souls. Their professionalism, intelligence, and unfailing good humor have been exemplary, and I have benefited in profound ways through my association with them. Indeed, I doubt that I will ever be able to repay them fully for the many contributions they have made to this project.

Although my interest in the marvelous has been most intense in recent years, I was first stimulated to think about this subject while I was a graduate student in the Fine Arts Department at Harvard. At that time I had the good fortune to take a series of seminars from Sydney J. Freedberg in which the art of *maniera*, sixteenth-century painting in Venice, and the aesthetic of the marvelous were considered in detail. I vividly remember Sydney's inspired lectures and over the years they have prompted me to think about a wide range of subjects from painting to sculpture, poetry, and cultural history in general. While I was studying at the Fogg and in the years since, Sydney has given me extraordinary support (no doubt more than I deserved), the benefit of his wise counsel, and many hours of kind attention. No one has influenced me more; there is no one to whom I am more deeply indebted. With my very great appreciation and affection, therefore, I happily dedicate this catalogue to him.

Joy Kenseth

Library, Academy of Natural Science of Philadelphia, Pennsylvania

Allen Memorial Art Museum, Oberlin College, Oberlin, Ohio

American Antiquarian Society, Worcester, Massachusetts

American Museum of Natural History, New York, New York

Anatomy Department, Dartmouth College, Hanover, New Hampshire

Roger Arvid Anderson

Anne S.K. Brown Military Library, Brown University, Providence, Rhode Island

Library, Arnold Arboretum, Harvard University, Cambridge, Massachusetts

Avery Architectural and Fine Arts Library, Columbia University, New York

Bailey/Howe Library, University of Vermont, Burlington, Vermont

Alfred Balch, Lyme, New Hampshire

Bayly Art Museum of the University of Virginia, Charlottesville, Virginia

The Clay P. Bedford Collection, Lafayette, California

Beinecke Rare Book and Manuscript Library, Yale University, New Haven, Connecticut

The Berkshire Museum, Pittsfield, Massachusetts

Blumka Gallery, New York

Ruth Blumka, New York

Chapin Library of Rare Books, Williams College, Williamstown, Massachusetts

The Cleveland Museum of Art, Cleveland, Ohio

Cooper-Hewitt Museum, The Smithsonian Institution's National Museum of Design, New York

Dana Biomedical Library, Dartmouth-Hitchcock Medical Center, Hanover, New Hampshire

Dartmouth College Library, Hanover, New Hampshire

Marilyn Denny, Amherst, Massachusetts

The Denver Art Museum, Denver, Colorado

The Detroit Institute of Arts, Michigan

Dumbarton Oaks, Trustees for Harvard University, Washington, D.C.

Earth Sciences Department, Dartmouth College, Hanover, New Hampshire

Elvehjem Museum of Art, University of Wisconsin-Madison, Madison, Wisconsin

Fairbanks Museum and Planetarium, St. Johnsbury, Vermont
First National Bank of Chicago, Chicago, Illinois
Fresno Metropolitan Museum, Fresno, California
J. Paul Getty Museum, Malibu, California
Graphische Sammlung, Albertina, Vienna, Austria
Grunwald Center for the Graphic Arts, University of California, Los Angeles
Michael Hall, Esquire, New York
Hart Nautical Collections, The MIT Museum, Cambridge, Massachusetts
Harvard Theater Collection, Harvard University, Cambridge, Massachusetts
Harvard University Art Museums, Harvard University, Cambridge, Massachussetts
Harvey Cushing/John Hay Whitney Medical Library, Yale University, New Haven, Connecticut
John Hay Library, Brown University, Providence, Rhode Island
Julius S. Held
Higgins Armory Museum, Worcester, Massachusetts
Arthur Holzheimer, Highland Park, Illinois
Hood Museum of Art, Dartmouth College, Hanover, New Hampshire
John and Mable Ringling Museum of Art, Sarasota, Florida
Gary Johnson, Hanover, New Hampshire
Kimbell Art Museum, Fort Worth, Texas
John K. Lee
Library Company of Philadelphia, Philadelphia, Pennsylvania
Linda Hall Library, Kansas City, Missouri
Barry L. MacLean
McNay Art Museum, San Antonio, Texas
Mr. and Mrs. Fred Marcus
The Menil Collection, Houston, Texas
The Metropolitan Museum of Art, New York
Milton S. Eisenhower Library, Johns Hopkins University, Baltimore, Maryland
The Minneapolis Institute of Arts, Minnesota
The Montshire Museum of Science, Norwich, Vermont
Museum of Fine Arts, Boston, Massachusetts
Museum of Science, Boston
National Gallery of Art, Washington, D.C.
National Museum of Health and Medicine, Armed Forces Institute of Pathology, Washington, D.C.
The Nelson-Atkins Museum of Art, Kansas City, Missouri
The Newberry Library, Chicago, Illinois
New Orleans Museum of Art, New Orleans, Louisiana
New York Public Library, New York

North Carolina Museum of Art, Raleigh, North Carolina

Walter C. Paine

Professor Jay M. Pasachoff, Hopkins Observatory, Williams College, Williamstown, Massachusetts

Peabody Museum of Natural History, Yale University

S.J. Phillips, London

The Pierpont Morgan Library, New York

Princeton University Libraries, Princeton, New Jersey

Various Private Collections

Private Collection, Hanover, New Hampshire

Private Collection, New York

Private Collection, Washington, D.C.

Private Collection, Worcester, Massachusetts

Royal Ontario Museum, Toronto, Ontario

The Saint Louis Art Museum, St. Louis, Missouri

Sarah Campbell Blaffer Foundation, Houston, Texas

Smithsonian Institution Libraries, Washington, D.C.

Smithsonian Institution, Museum of American History, Washington, D.C.

The Snite Museum of Art, Notre Dame University, South Bend, Indiana

Spencer Museum of Art, The University of Kansas, Lawrence

Sterling and Francine Clark Art Institute, Williamstown, Massachusetts

Swarthmore College, Swarthmore, Pennsylvania

Mrs. A. Alfred Taubman

Robert L. Tobin Collection

Vassar College Art Gallery, Poughkeepsie, New York

Arthur and Charlotte Vershbow, Boston, Massachusetts

Wadsworth Atheneum, Hartford, Connecticut

Mr. and Mrs. John Walsh, Los Angeles

The Walters Art Gallery, Baltimore, Maryland

K. Weremeychik

Dian and Andrea Woodner, New York

Worcester Art Museum, Worcester, Massachusetts

Yale University Library, Yale University, New Haven, Connecticut

Yale University Art Gallery, Yale University, New Haven, Connecticut

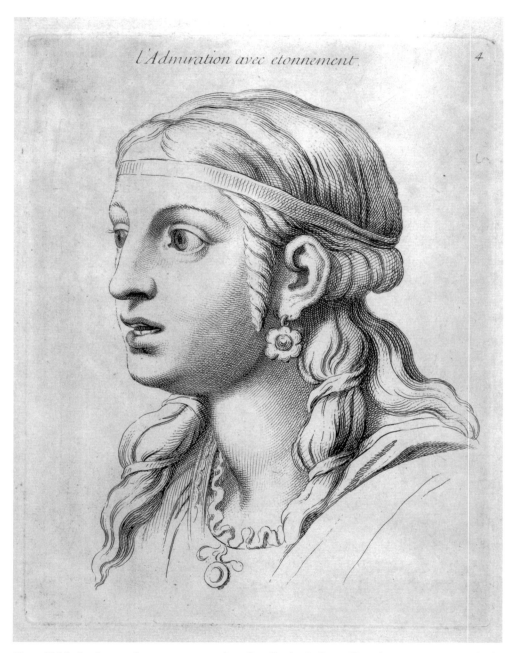

Fig. 1 *L'Admiration avec étonnement*, engraving after Charles Le Brun (French, 1619–90). From Charles Le Brun, *Expressions des Passions de l'Ame*, Paris, 1727. Dartmouth College Library, Hanover, New Hampshire

The Age of the Marvelous: An Introduction

Joy Kenseth

> When our first encounter with some object surprises us and we find it novel, or very different from what we formerly knew or from what we supposed it ought to be, this causes us to wonder and to be astonished at it. Since all this may happen before we know whether or not the object is beneficial to us, I regard wonder as the first of all the passions. It has no opposite, for, if the object before us has no characteristics that surprise us, we are not moved by it at all and we consider it without passion.
>
> RENE DESCARTES, *The Passions of the Soul*, 1649[1]

D URING THE SIXTEENTH AND SEVENTEENTH CENTURIES European culture was marked by an intense fascination with the marvelous, with those things or events that were unusual, unexpected, exotic, extraordinary, or rare. The word marvel (*meraviglia* in Italian, *merveille* in French, *Wunder* in German) was widely applied to anything that lay outside the ordinary, especially when it had the capacity to excite the particular emotional responses of wonder, surprise, astonishment, or admiration. Commonly, the word referred to such responses themselves; and when Descartes designated wonder as the first of all passions, he made it clear that human reaction to surprising, unusual, or marvelous things was in itself a subject of considerable importance (*fig. 1*).

The vogue for the marvelous was both long-lived and remarkably widespread. A phenomenon chiefly of the late-Renaissance and baroque periods, that is, the century and a half that extended from ca. 1550 to ca. 1700, it cut across almost all national boundaries in Europe and was a common thread in a great many areas of human endeavor—the literary as well as the visual arts, music and drama, religion, the natural sciences, and philosophy. In the century preceding Descartes's famous treatise on the passions, Europeans spoke often of marvels and their power to engender wonder in the beholder. Literary critics analyzed and debated the subject with particular frequency and thoroughness, and for many of those who evaluated the visual arts it became a matter of special concern. In his

25

famous account of the lives of the artists, for instance, the painter and biographer Giorgio Vasari repeatedly employs the closely related terms *meraviglia*, *mirabile*, *miracolo*, and *stupendo* when he wishes to express his high regard for some artistic achievement. Significantly these terms are applied most often when he considers the art of his own age, the sixteenth century. Indeed, in the first biography of the third part, that of Leonardo da Vinci, he immediately launches into a story that informs the reader of the value of the marvelous in art. Having been given a wooden buckler by his uncle Piero da Vinci, Leonardo, as Vasari tells us, decided to paint on it something that would "terrify anyone who saw it and produce the same effect as the head of Medusa." To accomplish this Leonardo brought into his room "a number of green and other kinds of lizards, crickets, serpents, butterflies, locusts, bats, and various strange creatures of this nature." He assembled "a fearsome and horrible monster" from various parts of these animals and then "depicted the creature . . . belching forth venom from its open throat, fire from its eyes and smoke from its nostrils in so macabre a fashion that the effect was altogether monstrous and horrible." After the painting was finished, Leonardo invited Piero to his room, which he had taken care to darken but for a light that shone on the buckler. When Piero saw the picture, he "was completely taken by surprise and gave a sudden start, not realizing that he was looking at the buckler and that the form he saw was, in fact, painted on it. As Piero backed away, Leonardo checked him and said: 'This work certainly serves its purpose. It has produced the right reaction, so now you can take it away.'" Piero, so Vasari states, "thought the painting was indescribably marvelous and he was loud in his praise of Leonardo's ingenuity."[2]

This amusing story is no doubt apocryphal, but it draws attention to the significance that Vasari attached to the marvelous as both object and subjective response, as both cause and effect. Not only is the painting in itself worthy of praise, but the effect it produces is also desirable. Throughout the story of Leonardo's monster, Vasari enlightens his readers about qualities or characteristics that determine artistic wondrousness: the subject matter was unusual, as were the measures taken to produce it; the painting was an illusionistic tour de force that had the capacity to deceive the unsuspecting viewer; the "staged" presentation of the picture heightened its dramatic appearance, thereby assuring the "right reaction" of wonder or astonishment. Born of Leonardo's remarkable imagination (his ingenuity) and proof of his exceptional artistic skills, the painting was a virtuoso performance, a marvel that resulted in an act of marveling. Vasari was the most widely read and influential of writers on art who saw wonder as a desired goal and who made evaluations of artistic creations on the basis of *meraviglia*. From the time of the publication of the first edition of *The Lives of the Artists* in 1550 until the late seventeenth century, professional critics as well as amateurs again and again voiced their appreciation for the marvelous, for the unexpected and the extraordinary, for the stunning and astonishing effects that could be achieved by art.

Although the subject of the marvelous has been taken up frequently in the literature

of art history, it usually has been regarded as but one facet of artistic style, mannerism notably, or as an aspect of artistic genres like the elaborate decorations, or *apparati*, that were designed for festivals. Often it is seen as a regional phenomenon, as a characteristic of the art produced in Italy or in the courts of the Habsburgs especially.[3] But European interest in an art that had the capacity to arouse wonder transcended regional boundaries and was manifested in most, if not all, of the various styles practiced in the sixteenth and seventeenth centuries.[4] A remarkably pervasive phenomenon, the taste, indeed a quest, for the marvelous can be discerned in all areas of artistic production—painting and sculpture, architecture, the decorative arts, printmaking and book illustration, garden design, theatrical and festival productions. This exhibition provides an opportunity to examine Europe's undeniable fascination with the marvelous in the sixteenth and seventeenth centuries and to address, in particular, several fundamental questions that have never been explored or that have been insufficiently considered in the past: What were the sources for the marvelous? What were the criteria by which something was judged to be a marvel? Why did an interest in objects that provoked wonderment and surprise develop? Why, eventually, did such an interest fade? The focus of *The Age of the Marvelous* is primarily art historical, yet the issues it investigates have vast cross-disciplinary ramifications. As we shall see, the history of the art of the marvelous was inextricably bound to the history of science and exploration and to the histories of religion and the literary arts.

The Rise of Interest in the Marvelous

The European vogue for the marvelous was shaped in part by beliefs in the miraculous and fantastic that had survived from the medieval world. Fabulous creatures of folklore, supernatural phenomena with apocalyptic associations, and the miraculous powers of holy relics or religious images all continued to be regarded as wonders in the sixteenth and seventeenth centuries. With the arrival of the Renaissance an interest in the marvelous, especially as it embraced phenomena both observable and concrete, peaked. The age of the marvelous grew out of an intellectual and cultural climate marked by a revival of learning, by an expansion of philosophical and scientific horizons, and by an emphasis on the study of man, his activities, and the world around him. In their endeavors to observe and describe all aspects of the physical world, Renaissance Europeans discovered marvels no less, and often more, exciting than those of fiction. Equally important, as Renaissance humanists sought to recover the artifacts, the art, and the texts of antiquity, evidence came to light that the classical civilization they revered had dealt at length with the subject of the marvelous. The ancient attitudes on this subject became the foundation for a greatly expanded view of the marvelous. At the same time that Renaissance scholars adopted these attitudes, they also revised them to accord with their own new outlook on the world. Their discovery and translation of and revived interest in certain ancient texts had particular significance in this regard.

Pliny the Elder's *Natural History* (cat. no. 2), Ovid's *Metamorphoses* (cat. no. 3), and the so-called popular criticism of Callistratus and other writers provided numerous descriptions of natural, supernatural, and man-made wonders and at the same time offered abundant information about why some things, but not others, were perceived as marvels.[5]

While Ovid's *Metamorphoses* told of the wondrous transformations of the gods and other supernatural phenomena, Pliny's *Natural History* was of prime importance for its encyclopedic account of natural wonders and for its reports of such artistic marvels as the famous Seven Wonders of the World and the remarkable achievements in painting by Apelles, Parrhasius, and Zeuxis. No less striking were the descriptions of artistic wonders found in ancient rhetorical treatises such as Callistratus's *Descriptiones*. Stressing the miraculous or "magical" nature of works of art, the authors of these texts, like Pliny later, spoke of statues that feigned an exhibition of emotions and of paintings that were amazingly lifelike. Such a way of seeing and evaluating works of art was echoed in the sixteenth and seventeenth centuries and determined to a considerable degree how modern critics assessed the artistic achievements of their own age.

Equally influential were Aristotle's *Rhetoric* (cat. no. 1a) and *Poetics* (cat. no. 1b). The *Rhetoric* had long been familiar to Europeans, but the *Poetics* was practically unknown until the 1530s and 1540s. One of the major discoveries of the time, it became, as did the *Rhetoric*, a chief source for most proponents of the marvelous in the sixteenth and seventeenth centuries. What became apparent to Europeans in their study of these two treatises was the emphasis that Aristotle placed on the desirability of unexpected or surprising effects and on the need to put in to poetry or tragedy something astonishing, something, in other words, that was extraordinary and rose above the commonplace. Aristotle's views were central to the development of literary criticism in the sixteenth century, but the impact of his authoritative voice extended beyond the arena of the literary arts. In the *Poetics* and the *Rhetoric*, as Rensselaer Lee notes, artists and poets alike "found justification for the fantastic and marvelous."[6]

Just as new-found and newly regarded texts of ancient writers contributed significantly to the taste for the marvelous, so the discovery and exploration of hitherto unknown worlds fostered its development. Although from very early times reports of exotic, strange, and fabulous creatures had reached Europe, interest in wonders of other worlds was heightened considerably after the voyages of Marco Polo. He had many strange tales to tell, most of which, unlike the accounts that had survived from the days of Alexander the Great, had a factual basis and were eyewitness reports.[7] In the fourteenth century Sir John Mandeville reported seeing a great many marvels while traveling in Africa and the Orient. As it turned out, he never journeyed to these foreign lands, but his detailed descriptions of fabulous human races and other wonders, all of them derived from earlier sources, had wide popular appeal from the Middle Ages until late in the Renaissance.[8] The most important factor contributing to the vogue for the marvelous, however, was the discovery of the New World and other distant lands in the late fifteenth

and early sixteenth centuries. Following the voyages of Columbus, Magellan, Vespucci, and the other great navigators, trade with these new worlds accelerated rapidly, which resulted in a tremendous influx to Europe of exotic objects, both natural and man-made. These marvels were not the subjects of sailors' exaggerated reports but observable facts, and from the early sixteenth century they were documented, described, and represented in paintings, prints, atlases, travel accounts, and illustrated natural histories.

The exploration of the Americas can be seen as the major catalyst for an interest in the marvelous, but expeditions to the Orient, the Middle East, and, to a lesser extent, Africa from the second half of the sixteenth century onward served to intensify and broaden it significantly. Portuguese contacts with Japan as well as East Africa and the commercial ventures of the Dutch East India Company and other enterprises in China, Turkey, India, and Persia resulted in a greatly increased volume of exotic imports to Europe. These exotica, especially the man-made objects, were avidly sought by European collectors and, like the items from America, were proudly displayed in their museums and cabinets of curiosities.

As in the case of exploratory and commercial ventures, great advances in science and technology significantly contributed to the burgeoning taste for the marvelous. The most important were the inventions of the telescope and microscope. These two instruments, often considered marvels in themselves, opened up vast new worlds to Europeans: while Galileo's telescope revealed the satellites of Jupiter and the richly textured surface of the moon, the microscope brought into view the most infinitesimal details of the natural world. Other optical devices held great fascination for Europeans: concave, convex, and double convex lenses as well as vexing mirrors offered surprisingly distorted views of the world, while the camera obscura, the forerunner of our modern cameras, astonished viewers with "magical" images, strange apparitions, and wondrous views "of nature's passing show."[9] In the area of technology there were several advances that had an impact on the making of an art of the marvelous. As a consequence of new as well as technically improved stage machinery, for example, designers were able to contrive more elaborate and surprising illusionistic effects for theatrical performances. Hydraulic engineering, especially as it was undertaken by the Florentine artist Bernardo Buontalenti, became much more sophisticated and complex, thereby permitting the production of spectacular automata and fountain displays in gardens. Finally, important refinements in the construction of the lathe allowed artisans to execute tiny and impressively intricate turned items in ivory, wood, and other natural materials.

The vogue for the marvelous coincided with and to a large extent was stimulated by the great religious upheavals of the sixteenth century — the Protestant Reformation and the Counter-Reform movement of the Catholic church. As Katherine Park and Lorraine Daston have shown, certain types of marvels, namely monsters, became a matter of particular interest when Luther used them as polemical tools against the Church of Rome (cat. no. 6).[10] While Luther himself did not see monsters and prodigious phenomena as

portents of disaster or as signs of political upheaval (rather, he said, "I incline towards a particular interpretation which pertains to the monks"), his challenges to Catholicism set off a new wave of concern about the meaning of prodigies and extraordinary natural occurrences.[11] To the popular mind floods, earthquakes, monstrous births, comets, and other celestial apparitions were signs of a worldwide reformation, apocalyptical in its nature. Of greater consequence for the history of art, however, was the Protestant denial of miracles regarded as true by Catholics (that is, miracles which occurred after the early Christian period) and its condemnation of religious imagery. In the years following the Council of Trent (1545–63), and especially in the seventeenth century, the reformed Catholic church sponsored the production of images that vividly illustrated the central mysteries of the faith: it encouraged the search for holy relics, and it promoted a new iconography that stressed the lives of the saints, especially their visions, ecstasies, and mystical raptures. An unprecedented number of paintings showing these orthodox marvels were produced in the course of the seventeenth century. The task of the artist was to use all the resources of illusionism to make them appear believable. As Rudolf Wittkower remarks, in the baroque period "nothing was left undone to draw the beholder into the orbit of the work of art. Miracles, wondrous events, supra-natural phenomena are given the air of verisimilitude; the improbable and unlikely is rendered plausible, indeed convincing."[12]

Finally, it should be emphasized that the growth of interest in the marvelous was directly linked to the spread of printing. By means of a variety of printed materials, information about miracles, prodigious events, natural and artificial wonders was transmitted to a wide, and increasingly literate, public. Besides the key texts by classical authors, which were published in numerous editions, the late-Renaissance and baroque periods saw a proliferation of books by contemporary writers who debated the value of the marvelous as it pertained to the literary arts. The discourses and commentaries of Francesco Robortelli, Torquato Tasso, Sir Philip Sidney, Emmanuele Tesauro, and numerous other critics offered readers exhaustive, not to mention complex, analyses of *meraviglia* both as an aesthetic device and as the desired end of the writer's craft. In the field of the visual arts, widely diverse publications spoke frequently of the marvelous: guidebooks and travelogues enumerated the *meraviglie* found in urban centers, private collections, and gardens; festival books documented the wondrous inventions made for parades and theatrical productions; biographies, notably those by Vasari, Carlo Ridolfi, Carel van Mander, and Filippo Baldinucci, told of the rare and exceptional achievements of painters, architects, and sculptors. Catalogues of collections published at this time described the wealth of artificial and natural marvels that were on display in the early museums, *Kunst- und Wunderkammern*, and cabinets of curiosities. The flourishing genre of wonder books dealt exclusively with extraordinary phenomena, human and animal anomalies, and other curiosities.[13] Pierre Boiastuau, Thomas Lupton, and Nathaniel Wanley, for instance, printed lengthy catalogues of all the known, recorded, and

supposed wonders (cat. nos. 6, 7). Natural histories published during this period, such as those by Konrad Gesner and Ulisse Aldrovandi, gave detailed accounts of actual *animalia* but also devoted considerable space to a discussion of monsters and fabulous creatures (cat. nos. 104, 108).

Europeans read of exotic wonders, especially those from the New World, in a broad range of published materials. Travel accounts, botanies, and geographical histories documented the strange and rare forms of life to be found in the Americas and usually, as in the case of André Thevet's *Les Singularitez de la france antarctique* and Willem Piso and Georg Marggraf's *Historia naturalis Brasiliae* they contained informative, if not always reliable, illustrations of the native flora and fauna (cat. nos. 113, 118). Between 1590 and 1614 Theodor de Bry and his son Johann published in thirteen volumes their comprehensive account of the voyages of exploration: an ambitious and influential publication, it provided detailed information about the appearance, the customs, and the life of the American Indians (cat. no. 117). In the course of the sixteenth and seventeenth centuries a vast number of geographies and atlases went into publication. The most famous of these, the 1662 *Atlas Maior* by Joan Blaeu, contained all the latest information about the physical world and was richly embellished with images of animal life, the human races, and various architectural wonders. One of the great glories of seventeenth-century cartography, this opus was in itself a marvel of the age (cat. nos. 87–90).

Categories of Marvels in the Sixteenth and Seventeenth Centuries

Printed materials provide the greatest body of evidence of the extraordinary hold that wonders and marvels of every sort had on the European imagination. They attest to the wide-ranging, cross-disciplinary character of this phenomenon and at the same time give detailed information about what Europeans regarded as marvelous. The objects and/or phenomena that were identified as having the power to excite wonder, surprise, and astonishment fall into three major categories: the supernatural, the natural, and the artificial.

THE SUPERNATURAL

In 1588 the poet Giovambattista Strozzi the Younger delivered a paper to the Florentine Academy titled "Is It a Good Idea to Make Use of the Fables of the Ancients?" Taking issue with earlier writers who opposed such a practice on religious grounds, Strozzi argued that while the supernatural beings of Christianity and pagan myth should not be mixed, mythological material was desirable in poetry because it delighted and caused men to marvel.[14] Strozzi was not alone in his appreciation of the pagan miracles, especially insofar as they had the capacity to arouse wonder and hence give pleasure. The fabulous events described by Homer (the story of Circe turning men into swine, for example, or the transformation of Odysseus's ship into stone), and the remarkable metamorphoses

related by Ovid (the many stories of Jupiter's miraculous transformations, for instance) had wide appeal in this era and became the subjects of countless poems and works of art (cat. nos. 3, 46, 47).

But for Christians the most important marvels were the sublime workings of God. Acts of divine intervention, or the miraculous encounters between man and God, were the "modern" counterparts of the pagan supernatural and, in contrast to them, were held as absolute truth. The miracles of Christ and the visions and mystical raptures of the saints were not "fantastic fictions but pure and simple belief in what exists."[15] The church encouraged the making of images showing these orthodox marvels, and throughout the seventeenth century they were produced in large numbers. Visions, miraculous healings, and the like were reported with great frequency; and holy relics, including the head of Saint Martina and the miraculously intact body of the early Christian martyr Saint Cecilia, were found as well (*fig. 2*; cat. no. 214). Numerous artists and poets of the time took such relics as their subject matter. Two relics—the veil of Saint Veronica (frequently represented by painters) and the shroud of Turin (a central image in the poet Marino's *Dicerie sacre*)—were especially favored because they bore the supernaturally imprinted image of Christ (cat. nos. 212, 213). As travelogues and inventories of collections reveal,

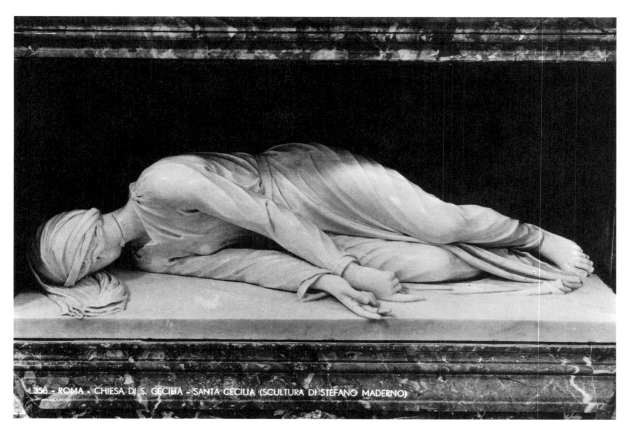

Fig. 2 Stefano Maderno, *Saint Cecilia*, 1600. Marble. Santa Cecilia in Trastevere, Rome.

holy relics were especially prized items in many of the early museums. When relics were not available, images of them or of other Christian miracles were displayed in their stead. In either case they offered a comparison with natural and artificial wonders, demonstrating unequivocally that God's appearance on earth was the most exalted marvel of all.

THE NATURAL (*Naturalia*)

Europeans most often considered natural wonders as examples of God's ingenuity; less frequently they described them as cases of "nature erring." A great many animal, botanical, and geological specimens were regarded as marvels, but normally the term was applied when the object was unusually large or small, extremely rare, exotic, abnormally or grotesquely shaped, or spectacularly beautiful. Plants or parts of animals believed to have special or "magical" curative powers were regarded as wonders, as were animals that displayed unusual behavior. The range of items that were seen as wonders extended as well to phenomenal natural events such as rainbows, earthquakes, and volcanic eruptions. No less fascinating to the European mind were the human prodigies: dwarfs, freaks, and other human anomalies often became the subject of art and poetry and were discussed at great length in natural histories. Although sometimes viewed as nature's "mistakes," they were most often regarded, like geniuses, as God's marvelous work and the products of his divine wisdom.

Many texts from the period offer very strange mixtures of natural wonders or of what were believed to be natural wonders. Johann Zahn, for instance, in his study of natural wonders, devotes a section to "*Flores et fructus producendi mirabiles*" (Marvelous flowers and fruits to be grown) (cat. no. 139). Among these marvels we find a monstrous anthropomorphic turnip, an image of a crucified man in a cabbage stem, the fabled plant called the Scythian lamb, a monstrous hand-shaped carrot, and a botanical import from America, the passionflower. Books on natural magic, a popular field of study at this time, offer a bewildering variety of natural, as well as artificial, wonders. Giovanni Battista della Porta's *Magiae naturalis* is a case in point: he describes such diverse phenomena as "earthy creatures generated of putrefaction," "wonderful force of imagination, and how to produce party-coloured births," "plants changed, one degenerating into the form of another," "eggs hatched without a hen," "the changing of metals," "counterfeiting precious stones," "the wonders of the lodestone," "artificial fires," "invisible writing," "burning glasses and the wonderful lights by them," and "beautifying women."[16]

Throughout the sixteenth century and far into the seventeenth, the botanical and animal fantasies of ancient and medieval lore continued to be counted among the natural wonders. Unicorns, the fabled lamia that ate crying children, and the man-eating mantichora, for instance, appeared in Gesner's natural history and in Aldrovandi's encyclopedia, while fabulous flora such as the Scythian lamb were included in John Parkinson's *Paradisi in sole paradisus terrestris* (cat. nos. 104, 108, 152). Interestingly, many of the

New World wonders were given the fantastic appearance of the creatures of fable. In Arnoldus Montanus's *De Nieuwe en Onbekende Weereld*, for example, we cannot be sure of the identity of some of the animals represented. A baboon (*papio*) is the central figure in one of these images (cat. no. 119A), while a type of sloth has been given the appearance of the mythical mantichora. The fantastic appearance of New World flora and fauna can be explained in part by the illustrator's or natural scientist's reliance on verbal reports; but it was a consequence also of dealing with fragments rather than the entire animal. Many of the New World specimens never reached Europe alive. They expired from natural causes or, as often happened apparently, were eaten by hungry sailors on the return voyage to Europe. Left with carapaces, bones, and other such fragments, scientists made imaginative reconstructions of the creatures, usually by attempting to match the remains with contemporary descriptions of exotic animals.[17]

The natural wonders discovered in America and other distant lands excited tremendous interest. A bird like the Brazilian toucan was a marvel because of its great beak (see Ashworth essay, *fig. 20*), while the bird of paradise, from New Guinea (cat. no. 122), was deemed marvelous because of its fabulous plumage and because for a long time it was believed to have no feet. The dodo, on the other hand, attracted attention both as a flightless bird and as a creature of very odd appearance. An unusually tame animal that

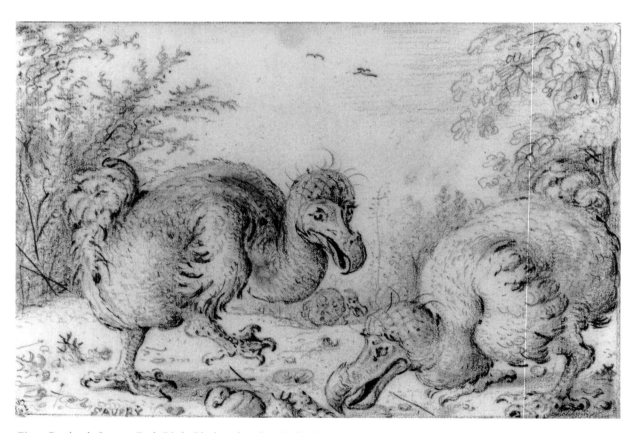

Fig. 3 Roelandt Savery, *Dodo Birds*. Black and umber chalk. Crocker Art Museum, Sacramento, California.

also, alas, was very tasty, it became extinct about seventy years after its discovery in 1598 on the island of Mauritius in the Indian Ocean (*fig. 3*). The plant life, so unlike that at home, was remarkable for its diversity. Corn, tomatoes, pineapple, bananas, potatoes, and pumpkins were found there along with a great many other unusual specimens. The plants were imported to Europe and celebrated in paintings by artists such as Albert Eckhout, who saw them firsthand on a trip to the New World (Brazil), and by Jacopo Ligozzi, who studied the specimens in the botanical collections of the Medici (*figs. 4, 5*). The New World flora often amazed because of their great size, or because of the oddness and complexity of their shapes. When John Gerard, for example, describes the melon or hedgehog thistle (cat. no. 147), he is effusive in his praise: "Who can but marvel at the rare and singular workemanship which the Lord God almighty hath shewed in this Thistle . . . This knobby or bunchy masse or lump is strangely compact and context together containing in it sundry shapes, and formes, . . . [and it is] as bigge as a mans body from the belly upward." Gerard is even more impressed by the torch thistle or thorny Euphorbium: "There is not among the strange and admirable plants of the world

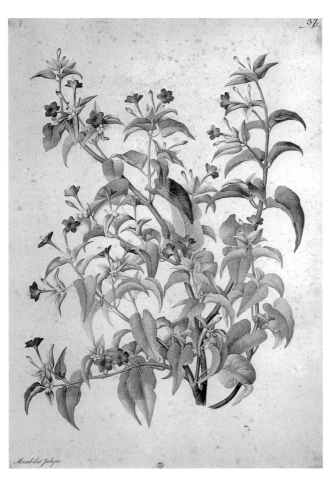

Fig. 4 Jacopo Ligozzi, *Marvel of Peru*, ca. 1580.
Watercolor. Gabinetto Disegni e Stampe, Uffizi, Florence.

35

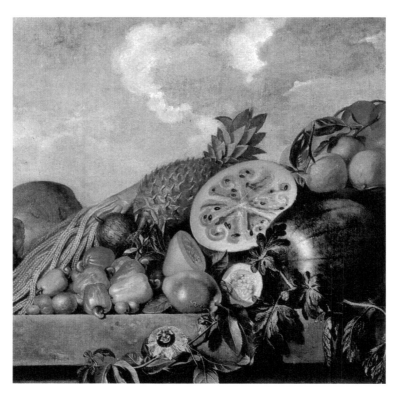

Fig. 5 Albert van der Eckhout, *Still Life with Brazilian Fruits*, 1644.
Oil on canvas. The National Museum of Denmark, Copenhagen.

anyone that gives more cause to marvell, or more moveth the minde to honor and laud
the Creator, than this plant. . . . [It] riseth up to the height of a speare twenty foot long,
. . . it hath diverse bunches and vallies. . . . [and upon it] doe stand small star-like Thistles,
sharpe as needles. . . . the trunke or body is of the bignesse of a mans arme."[18]

Of all the wonders to be found in the New World, however, the native inhabitants
aroused the greatest curiosity. At first the early discoverers thought they had stumbled
upon Eden, which they believed had escaped the great deluge of Noah's time. This notion
was quickly put to rest, however, when they came upon the Caribs and other cannibalis-
tic natives. Nonetheless, the discovery of the Indians amazed the Europeans. From the
earliest published reports of their discovery to the end of the seventeenth century, Eu-
ropeans documented and described their appearance, their rituals, their ingenuity in
hunting animals, their methods of making beer, and their strange habit of "drinking
smoke" (cat. nos. 113, 117).

The discovery of the New World partly accounted for the intensified interest and
search for marvels at home. Much attention was paid to human anomalies like Siamese
twins and to marvels like Pedro Gonzalez of the Canary Islands, whose body was com-
pletely covered with hair. Gonzalez and his family (his children inherited his condition)
became very well known in Europe and were represented in Aldrovandi's book on mon-

sters, in an exceptionally delicate portrait by Lavinia Fontana, and in Joris Hoefnagel's celebrated manuscript albums of *naturalia* (cat. nos. 108, 111; Wheelock essay *fig. 4*).

It was characteristic of the period that other extremes of nature should arouse interest as well. For instance, longevity rarely failed to arouse attention. Natural histories and prodigy books regularly included reports of people who had lived exceptionally long lives. In 1698, for example, the credulous Edward Doughtie published his book *Wonder of Wonders*, in which he states he is giving "an exact relation of Francis Mason, of Mile-End Green near London, who hath lived in reign of nine kings and queens, being a hundred threescore and twelve years of age."[19] A fascination for the opposite phenomenon also developed: Jan Swammerdam in 1681 published an essay called *Ephemera Vita or the natural history of the Ephemeron: a fly that lives but five hours.*

Surely among the greatest discoveries that Europeans made at home was the world as seen through the microscope. The famous microscopist Robert Hooke pronounced the miniature world he found as worthy of admiration as nature's grander forms. Although, as he noted, "many other natural philosophers . . . are now everywhere busie about greater things," it was his hope and belief that his "little objects are to be compared to the greater and more beautiful works of nature, a flea, a mite, a gnat, to an Horse, an elephant, or a Lyon."[20] The spectacular engravings in Hooke's *Micrographia* (1665), based on his own finely executed drawings, testify to the wondrousness of the tiny forms he saw through the lens of his microscope (*fig. 6*; cat. no. 129). The microscope, he observes

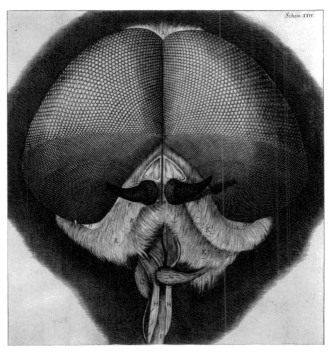

Fig. 6 Robert Hooke, Eyes and head of a grey drone-fly. Engraving from *Micrographa*, London, 1665. Dartmouth College Library, Hanover, New Hampshire (cat. no. 129).

THE AGE OF THE MARVELOUS

is useful in "surveying the already visible world, and for the discovery of many others hitherto unknown." Like the telescope, the microscope is helpful in "producing new Worlds and Terra-Incognitas to our view."[21]

When, nearly two decades later, Nehemiah Grew looked at cross sections of plants through the microscope, he expressed his views in much the same way. In the dedicatory epistle to King Charles II from his *The Anatomy of Plants* (1682) he wrote, "Your Majesty will here see, that there are those things within a plant, little less admirable than within an animal" (cat. no. 161). The various parts of the plant are "as punctually set together, as all the lines of a flower or face . . . the staple of the stuff is so fine, that no silk-worm is able to draw anything near so small a thread. So that one who walks about with the meanest stick, holds a piece of Nature's Handicraft, which far surpasses the most elaborate Woof or Needle-work in the World." In sum, he says, "Your Majesty will find, that we are come ashore a new world, whereof we see no end."[22]

Nature's handicraft, as it was revealed through the microscope, was ultimately seen as further proof of the infinite complexity and beauty of God's design. "In the most minute and disdained of creatures," Constantijn Huygens exclaimed when looking through Cornelius Drebbel's microscope, we "meet with the same careful labor of the great architect, everywhere an equally indescribable majesty."[23] A similar sentiment, no less eloquently expressed, appears in Swammerdam's study of the louse: "I present . . . herewith the Almighty Finger of God in the anatomy of the louse, in which you will find wonder upon wonder and God's wisdom clearly exposed in one minute particle. The lines of Apelles bring all the world to admiration, but here you will see in a fragment of a line the entire structure of the most ingeniously created animals in the whole universe."[24]

THE ARTIFICIAL (*Artificialia*)

While for Europeans God's ingenuity was apparent in all the natural wonders, the ingenuity of man was revealed in artificial wonders. Just as God, through his divine handiwork, had the power to create the most extraordinary things, so the artist or the artist/engineer had the capacity, by means of his technical skills and his imaginative powers, to rival God's work on earth in the fashioning of exceptional, unusual, and surprising objects. The idea of the artist as God's rival was not new in the sixteenth and seventeenth centuries, but it assumed a degree of importance unparalleled in earlier times. The artist's godlike power, as critics of literature and art so often emphasized, is lodged in his *ingegno*—his wit, genius, ingenuity, or talent. A human faculty that is inborn and not acquired through experience, it is an imaginative capacity, an ability to invent or to fashion the new. *Ingegno*, according to the critic Emmanuele Tesauro, is analogous to God's creative power, for just as God can make something out of nothing, so man, by means of his God-given *ingegno*, can produce being from nonbeing.[25]

But it is not enough, according to the champions of the marvelous, for an artist to

38

of the Turks, the Chinese, American Indians, and so forth. As the importation of foreign items into Europe increased, the taste for a "foreign air" in paintings and other works of art became more prevalent. Paintings and prints showed the exotic creatures kept in menageries, while numerous pictures, especially those by Dutch and Flemish artists, celebrated the abundance of *artificialia* and *naturalia* that originated in foreign worlds (cat. nos. II, 124, 125).

The remarkable proliferation of imagery characterized by foreign, strange, and bizarre elements was stimulated, however, by more than an enthusiasm for exotic imports. Artists, like the poets of the time, found justification for the use of strange subject matter (and for strange effects) in ancient literature, especially in the *Rhetoric* of Aristotle. "People do not feel towards strangers as they do towards their own countrymen, and the same thing is true of their feeling for language." Because of this, Aristotle says, it is advisable "to give to everyday speech an unfamiliar air: people like what strikes them and are struck by what is out of the way."[44] Indeed, use of the unfamiliar is a means of achieving the marvelous. Vasari acknowledged this on many occasions. Filippino Lippi's paintings were marvels to behold, he says, because of their strange caprices, their novelty, and the variety of their bizarre elements.[45] He praises a "marine monster" made by Piero di Cosimo because of its deformity and because it is so extravagant, bizarre, and fantastic.[46] Michelangelo's vestibule for the Library of San Lorenzo, he reports, astonished everyone because the artist had made such strange breaks in the design of the steps and had departed so widely from common practice.[47] The paintings of the *ingegnosissimo pittor fantastico* Giuseppe Arcimboldo, perhaps the most celebrated painter of *bizzarrie* in the late sixteenth century, elicited the admiring approval of many writers. His "composite portraits," wherein the likeness of a man is assembled out of vegetables, flowers, marine animals, or kitchen utensils, are a "wonder to behold," according to Giovanni Paolo Lomazzo.[48] The strangeness of these creations are so ingenious, says Gregorio Comanini, that the wonder of the beholder "is forced to turn to downright astonishment"[49] (cat. nos. 25, 26). In Fra José de Sigüenza's appraisal of the paintings of Hieronymous Bosch, we find a similar enthusiastic regard for the strange and fantastic elements of art. "It is amazing," he says, "that a single head can imagine so many things."[50] But he knew well that Bosch's fantasies were not absurd imaginings but "great books of wisdom" that imparted fundamental religious truths. In fact, many of the artistic fantasies and *bizzarrie* of this period carried some underlying political, religious, or moral significance. Such marvels aroused delight but their *raison d'être* was not entertainment alone. They also provided a new way of seeing familiar subjects, and the new insights gained were in themselves a reason for marveling.

VARIETY

By the middle of the sixteenth century an appreciation for variety as a source of the marvelous already was evident in the culture of Europe. As John Shearman has shown, it came to be a characteristic not only of the visual arts, but of madrigals and poetry as well. The literary prototype for this kind of *meraviglia*, he points out, probably was the shield of Achilles described by Homer.[51] A remarkable object, it had embossed on its surface the entire history of the world and mankind. Its wondrousness derived from the cumulative effect of diverse subjects and details and from bringing together in one space apparently dissimilar things.

In 1600 Paolo Beni argued that a play is much better if it contains events "full of variety and inconstancy, crowded with strange and unexpected accidents, in which therefore enter the marvelous."[52] Late-sixteenth- and seventeenth-century *commedie* and operas rarely failed to realize this goal. A spectator at a theatrical performance held in Florence in 1628, for instance, described as "mirabilissimo" an intermezzo in which a great variety of mythological figures were represented and in which numerous special effects were achieved.[53] Almost ten years later, when Grand Duke Ferdinand II of Florence commissioned the score for the performance of *Le nozze degli dei*, he specifically requested that it have a "varietà di stile" (a stylistic variety). He got what he asked for, not only in the scoring of the musical, but also in the elaborate choreography and stage sets that were conceived for it (cat. no. 170).[54] One of the most famous performances of the time, it was considered *maraviglioso* by the members of the audience, a spectacle they would have preferred not to see end.

In painting there was a corresponding predilection for variety and for the remarkable effects that an accumulation of motifs and contrasting shapes or textures could achieve. Mannerist images—such as those by Giulio Romano, Arcimboldo, Savery, and Coninxloo—are most often seen as typifying this love for variety, but later, baroque works also demonstrate a fascination for a wealth of detail and a piling up of widely diverse objects. Dutch and Flemish still-life paintings, the so-called *pronkstilleven* (the showy or ostentatious still-life pictures) especially, are celebrations of variety: exotic birds and shells are set next to intricately wrought cups; exquisite China bowls are placed on Turkish carpets; rare and delicious fruits are displayed near finely blown vessels of glass (cat. no. 193). The variety of such pictures demonstrates, ultimately, an effort by the artist to be encyclopedic; this is not unlike the aspirations of collectors who, in their cabinets of curiosities and in their wonder rooms, brought together in one place a wide and rich assortment of the world's natural and artificial marvels.

THE UNUSUALLY LARGE AND THE UNUSUALLY SMALL

In the ancient world the works of art most commonly regarded as *mirabilia* were either impressively large or extremely small.[55] The most famous example of the former type was

the colossal statue of Helios at Rhodes, one of the Seven Wonders of the World. According to Pliny, the gigantic sculpture originally stood 70 cubits (105 feet) tall and even though it had been toppled by an earthquake, it still excited wonder and admiration. "Few men can clasp the thumb in their arms," he said, and "where the limbs are broken assunder, vast caverns are seen yawning in the interior."[56] Of the colossal statues that survived from ancient times, the marble *Farnese Hercules*, which had been found in the Baths of Caracalla sometime before 1556, aroused particular admiration. When the Dutch artist Hendrick Goltzius made his splendid engraving of it ca. 1592–93, he left no doubt that the figure impressed on account of its gigantic scale (cat. no. 27).

Extant *colossi* as well as the descriptions of enormous statues in ancient texts had stimulated the interest of artists long before the 1590s, however. In the fifteenth century the sculptor Donatello was to have executed a series of gigantic figures for the buttresses of the cathedral of Florence. The project, just scarcely begun in Donatello's lifetime, was not resumed until the beginning of the sixteenth century, when Michelangelo "miraculously resuscitated" a roughly carved block of marble that "had been left for dead" in the cathedral's precinct. As Vasari later wrote, the great figure that resulted, the *David*, "put in the shade every other statue, ancient or modern, Greek or Roman."[57] A work that rivaled the achievements of ancient sculptors, it was the first of many *colossi* executed in the sixteenth century that excited wonder in Europeans. For the gardens of the Medici Villa at Pratolino, for example, the sculptor Giovanni da Bologna carved the enormous *Allegory of the Apennines* that seemed "like a monster" towering above the fish pond (cat. no. 179). And for his own garden at Bomarzo, Count Vicino Orsini had carved from the natural rock a series of fantastically oversize figures or, as he had inscribed on an accompanying stone tablet, "meraviglie" (see Weil essay, *fig. 8*). A fascination for the colossal or the unusually large in art had analogues in poetry (the device of hyperbole, for example) and in the natural sciences (giants, whales, and other great beasts were frequently the focus of attention). As the inventories of sixteenth- and seventeenth-century collections reveal, Europeans were especially fond of exceptionally large natural specimens, be they animal, vegetable, or mineral.

As we have already seen, seventeenth-century microscopists found miniature forms of life a cause for marveling. Tiny specimens of nature were collected and described by scientists and were celebrated also by poets and artists, just as they had been in the ancient world. The poet Artale, for instance, addressed one of his sonnets to a flea, and artists such as Jan van Kessel became specialists in the representation of insects (cat. no. 126). Equally intriguing were miniature works of art, especially micro-sculptures rendered out of walnuts, cherry stones, and other similar natural materials (cat. no. 44). These *meraviglie* were often found in the collections of the time and invariably provoked wide-eyed amazement.

Vasari writes about such tiny marvels in his life of Madonna Properzia de' Rossi. She earned her fame by making miniscule carvings in peach stones and nuts. One of these,

representing the Passion of Christ, included an infinite number of figures besides the crucified figure and all the apostles. "It was certainly a marvel to see [such a thing represented] upon a nut so small," he says.[58] Like Properzia, who was regarded as a great wonder, the artist Il Raggio also created extraordinary micro-sculpture. According to Vasari, he carved a relief on a conch shell that showed the whole of Dante's Inferno, complete with all the circles and *bolgi* and all the figures that the poet had described in his epic poem.[59] One wonders whether Vasari had actually seen the work of Il Raggio and Properzia, but his exaggerated claims of the "infinite" number of figures they described in miniature scale serve their purpose, namely that extraordinary technical skill (and in these instances, astounding patience as well) is a marvel and thus worthy of our greatest admiration. Indeed, as when he speaks of artists who have the phenomenal ability to represent things on a grand scale, what impresses him most is the demonstration of virtuosity and the achievement of what seems to be the impossible.

DEMONSTRATIONS OF SUPREME TECHNICAL SKILL OR VIRTUOSITY; THE TRIUMPH OVER DIFFICULT PROBLEMS AND THE ACHIEVEMENT OF THE SEEMINGLY IMPOSSIBLE

In his treatise *De' veri precetti della pittura* (1586), Giovanni Battista Armenini tells "how laudable it is to finish one's works well and how displeasing [it is] to do the opposite." Although, for Armenini, it is not a good thing to carry technical refinement to excess, the execution of a work of art "without defects" arouses delight and is also a cause, he implies, of marveling. As an example of technical perfection, Armenini cites a series of drawings that he had seen by Leonardo da Vinci: "They were finished in a manner so extraordinary . . . that the more I considered them, the more it seemed to me impossible to imitate them, or for them to have been made by the hand of another. In truth, moreover, in many endeavors diligence is no less necessary than genius."[60] Like Armenini, most Europeans of the Renaissance and baroque periods had the highest esteem for those artists who rendered their works flawlessly, who demonstrated, in other words, supreme technical skill and a complete mastery of their art. Dutch seventeenth-century pictures, in particular, were acclaimed for their fineness of execution and for the proof they gave of technical accomplishment. The highest value was placed on the artist's ability to record with "a faithful hand" the objects that came into his view.[61] Pictures such as those by Jan Davidsz. de Heem and Willem Kalf are marked by a sensitivity to the rendering of detail, a precision of execution, and a high finish that gives them a nearly magical quality (cat. nos. 11, 193). And in their own time, as now, such works were praised as supreme demonstrations of the artist's virtuoso skills.

During this era there was a great demand for decorative objects and sculptures that demonstrated superior technical skill and the artist's triumph over difficult natural materials. In the great courts of Europe artisans were expected to realize their creations to perfection. Intricate and exquisitely wrought items, particularly those fashioned from

46

gold and silver, and objects made from ivory, hard stone, and rock crystal were prized especially. Artists such as Cornelius Bellekin, Jeremias Ritter, and David Bessman created exemplary works in precious metals, and often they ingeniously incorporated natural materials like nautilus shell in their designs (cat. nos. 29, 30, 58). Of the Italian artists who fashioned virtuoso objects, none is better known perhaps than Benvenuto Cellini. In his autobiography the goldsmith and sculptor tells how one of his most famous works, the saltcellar for King Francis I, was received by its patron. Upon seeing the completed object, Francis is reported to have said, "God be praised that here in our own day there be yet man born who can turn out so much more beautiful things than the ancients." [62] This favorable comparison was especially welcome to Cellini, for he had long considered that his superbly crafted objects rivaled those of the classical world. Cellini's pride was fully justified: the saltcellar was a splendid and ingeniously conceived object, a virtuoso performance that showed in all its aspects "the most marvelous craftsmanship." [63]

Sixteenth- and seventeenth-century writers often describe as wondrous the ability of an artist to overcome difficulty and to do what seems the impossible. Vasari says that by means of his great skill, Michelangelo "was able to solve incredibly difficult problems." The figure of *Jonah* from the Sistine Ceiling, for example, was an amazement because Michelangelo had conquered the problem presented by the curvature of the vault: through the force of his art Michelangelo had made the figure appear straight (or normal). [64] Baldinucci praises Bernini's remarkable design for the Vatican staircase (the Scala Regia). It was, he says, the most difficult work Bernini ever executed, and the solution he devised for it was marvelous. [65] The original staircase had a disconcerting telescoping effect. Dark and narrow, it was located on a site that did not permit a continuous wide passage. By an ingenious placement of columns, however, Bernini created the illusion that the stairs were wider where they were narrow, and narrower where they were wide. By making openings at strategic points, furthermore, he created a staircase that was well lighted and safe.

Critics were always impressed by an artist's ability to carry out tremendous work in an unbelievably short time or to accomplish great feats, especially in old age. Baldinucci marveled at the oversize figures that Bernini executed for the Ponte Sant'Angelo. When the artist was well on in years, he notes, he carved three of these figures "in the space of two years: a thing that to those most competent in art seemed to be an impossibility." [66] The Dutch biographer Carel van Mander, when speaking of the art of Goltzius, praises him for his virtuosity and for his "heroic strength as a draughtsman." (Goltzius had a permanently crippled right hand owing to a childhood accident.) He was especially impressed by a set of prints in which Goltzius convincingly imitated a great many different styles. "And what is particularly astonishing," van Mander remarks "is that he accomplished this within a very short time." [67] Finally, we might mention here another very different, not to say highly unusual, instance of artistic virtuosity. As recounted by van Mander, the painter Cornelis Ketel decided to put away his brushes and to paint instead

with his fingers, feet, and thumbs. The biographer marveled at Ketel's unique practice, noting that what he admired most was the neatness with which his painted figures had been done.[68]

VIVIDNESS AND VERISIMILITUDE

Ancient authors such as Pliny and Callistratus considered the best works of art to be those that simulated reality with an uncanny exactitude. A sure demonstration of technical mastery, such realism often was seen by them to have magical or miraculous qualities: a statue or a painting, for instance, did not just give the appearance of life, but was alive.[69] The rhetorical concept of *energeia* (the ability to make something seem vividly present) became a matter of particular concern to literary critics in the sixteenth and seventeenth centuries; and when, as Speroni claimed, the poet made his subjects appear vivid, marvelousness was the result.[70] Like the critics of poetry, Vasari saw the effect of lifelikeness or verisimilitude as a source for the marvelous. "Leonardo may be said to have painted figures that lived and breathed," he says. "If one looked closely at the *Mona Lisa*," a picture, by the way, that Vasari never saw, "one would swear that the pulses were beating." Indeed, "all those who saw it were amazed to find that it was as alive as the original."[71] This way of viewing and praising works of art, so obviously dependent upon the rhetorical language of the ancients, has numerous analogues in the seventeenth century. Bernini, we are told, made his marble blocks "live and breathe."[72] His famous statue *Apollo and Daphne* astonished because of its verism, and in its own time it was called a miracle of art (*fig. 8*). There is also the famous story of Bernini's portrait bust of Monsignor Montoya. According to Baldinucci, the marble bust was so lifelike that when the Monsignor went to see it, his friend Cardinal Maffeo Barberini introduced Montoya to the portrait, then in turn introduced the portrait to Montoya.[73]

Caravaggio was both condemned and praised for the highly realistic effects of his paintings. While disdaining the "vulgar" aspects of his images, his biographers nonetheless recognized his exceptional mimetic abilities. His *Boy Bitten by a Lizard* is so effectively done that the boy, according to Giovanni Baglione, "seems truly to cry out." The *Head of Medusa* is an illusionistic tour de force that had as powerful an impact as Leonardo's "monster" and that Baglione found "terrifying." Marino, not surprisingly, admired the picture greatly and made it the subject of one of his poems. For Joachim von Sandrart, Caravaggio's *Incredulity of Saint Thomas* was especially praiseworthy for its naturalism, and "in comparison all other pictures seemed to be colored paper." But Caravaggio's *Amor Victorious* impressed him most. "It yields very little to life itself," he declaimed, " . . . not without reason may this painting be called 'the eclipse of all painting'."[74]

Spanish and Dutch critics were no less enthusiastic in their regard for the artist's ability to achieve an effect of the lifelike and the true. Antonio Palomino, for instance, tells of a picture by Zurbarán in which he had "painted a dog so lifelike that anyone looking at it fears its momentary attack."[75] But to him the greatest achievement was the

48

Fig. 8 Gian Lorenzo Bernini, *Apollo and Daphne*, ca. 1622–25.
Marble. Villa Borghese, Rome.

large portrait *Las Meninas* by Velázquez, which proved the artist's genius: "The figure painting is superior, the conception new, and in short it is impossible to overrate this painting because it is truth, not painting."[76] Cornelis de Bie praises Rembrandt in a similar way. "Nature is abashed" by his art, he says, and "the very soul of life" dwells within his works.[77] De Bie draws attention repeatedly to the mimetic skills of artists and to the effects of verisimilitude that they can achieve thereby: a portrait is praiseworthy when it is true to life; a still life is a wonder when it deceives the beholder into thinking that it is nature herself.[78] Like many others of his time, de Bie is fascinated by the artist's capacity to create an illusion of reality. *Trompe-l'oeil* pictures and other painted deceptions are seen as the products of the artist's cunning—his sleight of hand—and often they work a kind of magic on the beholder (cat. nos. 194–198).[79]

The accomplishments of these seventeenth-century painters was the culmination of a long tradition of illusionistic painting that went back as far as Giotto. The imitation of nature (the recreation of the third dimension on a flat plane, the simulation of textures, etc.) was an integral part of the Renaissance movement back to the classics and a reflection

of the humanistic interest in the natural world and man's place in it. Seventeenth-century illusionistic paintings similarly reflected worldly concerns: they seemed to bring objects of the material world within the spectator's reach, and they served also to make the mysteries of faith appear as concrete and palpably present phenomena.

THE TRANSCENDENT AND THE SUBLIME

As poets and literary critics of the sixteenth and seventeenth centuries so often noted, effects of the marvelous could be achieved by "raising the lifelike to its highest degree of perfection." [80] In contrast to the achievement of verisimilitude, the creation of a perfected world, either in poetry or in the visual arts, was seen as an emulation of God's creative powers, and the artist or poet who was able to accomplish such exalted works did so because he was divinely inspired. The representation of a world that in its beauty and its grandeur transcended the ordinary and that, above all, gave an exalted view of an exalted subject was singled out especially as the noblest end of art. This was the view expressed by the Spaniard Francesco Pacheco in his *El arte de la pintura* (1649). If the aim of painting is "to approximate what it intends to imitate," he says,

> then let us now add that when it is practised as a Christian work, it acquires another more noble form and by this means advances to the highest order of virtue. This privilege is born of the greatness of God's law, by means of which all actions . . . committed with thoughtfulness and directed to the final goal, become greater and are adorned with the rewards of virtue. But do not think that art is destroyed or denied by this; rather it is elevated and ennobled and receives new perfection. Thus . . . we can say that painting, which before had imitation as its sole aim, now, as an act of virtue, takes on new and rich trappings; and, in addition to imitation, elevates itself to a supreme end—the contemplation of eternal glory. [81]

Pacheco, the ardent defender of art in the service of Catholicism, was speaking mainly of what the painters of his own time should aspire to. But long before Pacheco critics had determined that images presenting an elevated subject in an elevated way were the noblest creations and the most worthy of admiration. Vasari was especially vocal on this point. Raphael and Leonardo da Vinci, both of whom he considered divinely inspired, had given an extraordinary beauty and grace to the holy figures in their paintings. Leonardo had achieved these qualities in his *Saint Anne* cartoon, for example, while Raphael had done the same in his *Entombment of Christ*. Both works, he says, aroused amazement in those who saw them and everyone regarded them as marvelous. [82]

For Vasari, though, it was the "divine" Michelangelo who had attained the sublime, who had with his art reached the pinnacle of perfection. When describing Michelangelo's *Pietà*, he exclaims "that it staggers belief that the hand of an artist could have executed this inspired and admirable work so perfectly." "It is certainly a miracle," he adds, "that a formless block of stone could have been reduced to a perfection that nature is scarcely able to create in the flesh." Indeed, the beauty of the figures and the loveliness of their expression are, as Vasari implied, wholly commensurate with the divine nature of the

50

subject matter.[83] Vasari's appreciation for Michelangelo's creative powers reached its peak, however, when he set about to describe the gigantic fresco of the *Last Judgment*. "The awesomeness and grandeur of this painting . . . are so overwhelming that it defies description; for in it may be seen marvelously portrayed all the emotions that mankind can experience . . . [It has] an amazing diversity of figures . . . [and] all these details bear witness to the sublime power of Michelangelo's art, in which skill was combined with a natural inborn grace." The *Last Judgment*, according to Vasari, "must be recognized as the great exemplar of the grand manner of painting, directly inspired by God and enabling mankind to see the fateful results when an artist of sublime intellect infused with divine grace and knowledge appears on earth. . . . How fortunate they are . . . who have seen this truly stupendous marvel of our times!" Indeed, when the fresco was opened to view for the first time in 1541, Vasari reports that it aroused the wonder and astonishment of the whole of Rome. And when at last Vasari himself gazed upon Michelangelo's imagined view of the final day of mankind, he was, he said, stupified by what he saw.[84]

THE SURPRISING AND UNEXPECTED

According to Aristotle, the inclusion of surprising and unexpected elements in a play or poem was desirable because it heightened the effect of the marvelous.[85] Such elements were valued by poets and literary critics of the Renaissance and baroque periods, just as they were by artists and the writers who commented on art. Any of the qualities or characteristics previously described can be seen as elements or subsets of surprise, especially when first experienced by the beholder. The marvelous *artificialia* that were most often cited for their surprising and unexpected effects, however, were the spectacles, the theatrical performances, and the set pieces or waterworks devised for gardens. Sudden changes of stage scenery that seemed to happen as if by magic, water jokes and trick fountains that ambushed unwary visitors to gardens, and parade barges that unexpectedly metamorphosed before the eyes of the beholder were designed specifically to surprise, to astonish, and ultimately to give pleasure. Those who attended the spectacular *commedie* in Florence frequently reported how sudden changes on the stage "surpassed everyone's expectation."[86] And from such travelers as John Evelyn and Richard Lassels we learn how first encounters with large-scale automata or *giocchi d'acqua* provoked wonder because they were unanticipated. The marvelous power of unforeseen events was well understood by Bernini. On the occasion of Pope Innocent X's visit to the Fountain of the Four Rivers, the artist arranged for the surprise opening of the water ducts. Overcome by this sight, the pope was reported to have said to Bernini, "In giving us this unexpected joy . . . , you have added ten years to our life." As Baldinucci recounts, "Bernini knew that the more unexpected it was, the more pleasing it would be to the pope."[87]

As in the case of fountain designs and stage scenery, most of the wondrous *artificialia* of this time were marked by a fascination with metamorphosis, with the transformation of one form into another. Indeed, it was an essential and underlying characteristic of the

age, evident not only in the visual arts, but also in the natural sciences and the literary arts. Yet, simultaneously, and in some measure as a consequence of it, there was a corresponding need to make a permanent record of these ephemeral *meraviglie*. The changeable theater sets and the "magical" transformations of parade barges and fireworks were set down for posterity in festival books and prints. Fragile and short-lived insects were recorded in visual form partly in an effort "to preserve their memory." The mystical raptures and visions of the saints were affirmed in the concrete form of paintings, sculptures, and other works of art. The documenting of *meraviglie* can be seen not only in the many printed books of the time, but also in works of art that carry accompanying text. An inscription next to Stefano Maderno's famous statue of Saint Cecilia informs us that Cardinal Sfondrato had seen the miraculously intact body of the virgin martyr (*fig. 2*). The text in a painting by José de Ribera identifies the subject as fifty-two-year-old Magdalena Ventura, a human wonder who began to grow a beard at the age of thirty-seven (*fig. 9*). A *cartello* in a painting of a radish tells us that the remarkable vegetable

Fig. 9 José de Ribera, *Magdalena Ventura with Her Husband and Son*, 1631.
Oil on canvas. Museo Fundación Duque de Lerma, Hospital de Tavera, Toledo.

52

was grown in Fredrichstatt and weighed over seven and a half *ponds* (approximately eight and a quarter pounds) (*fig. 10*). And in a painting by Bartolomé Murillo a lengthy text gives the details of Fray Julián's vision of the ascension of the soul of Philip II to heaven (cat. no. 220). In all of these works the truth or the reality of the marvel is asserted. Even though, as we have seen, sixteenth- and seventeenth-century Europeans were fascinated by the fabulous creatures of myth, the overwhelming number of their marvels were visible, tangible, and documentable phenomena. The marvelous, as they saw it, made an immediate impact: it was present either to the beholder's sight or to his touch; it was also, as in the case of the Christian mysteries, a direct and authentic human experience.

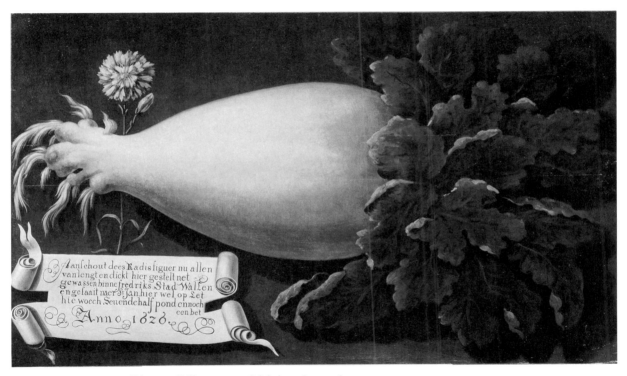

Fig. 10 Anonymous, *Radish*, 1626. Rijksmuseum-Stichting, Amsterdam.

The Waning of the Marvelous

By the year 1700 the taste for the marvelous had diminished in most of Western Europe. Although the fashion persisted well into the eighteenth century, notably in the art of the rococo and in the curiosity cabinets of the Nordic countries and Russia, it no longer existed as a major cultural force. There were several reasons for its waning, many of which emerged while the vogue for the marvelous was at its height.

The Catholic church, by the mid-seventeenth century, had won back many of its former adherents in Europe and, through the activity of its missionaries abroad, had

converted great numbers of foreigners to the faith. Consequently, there was no longer a need for an art that had the power to persuade by means of an insistent realism or by effects that made the religious subject matter dramatically immediate to the beholder. The decrease in imagery that described miracles as physically present phenomena and the significant decline in reports of miraculous events can be attributed most of all, however, to a new climate of skepticism engendered by developments in philosophy and science. The existence of many miraculous healings, visions, and resurrections was called into doubt, while the central mysteries of faith were represented as remote occurrences.

With the rise of the new science and its objective and rational approach to the study of nature, much of the wonder went out of the observation of the physical world. Indeed, this was poignantly described by Emmanuele Tesauro in his *Il cannocchiale Aristotelico*: the telescope, he noted with regret, had helped to diminish that sense of mystery that mankind had previously enjoyed in viewing the heavens.[88] As Galileo's revolutionary ideas took hold, scientists sought to explain natural phenomena in mathematical terms, not as integral parts of a larger whole in which man occupied a place of central importance. By doing away with the old hierarchy of being, they focused their attention on the *how* of events rather than on questions of ultimate causes. Where before aberrations and anomalies such as monsters were explained in terms of divine will and ingenuity, they now became the subjects of medical pathology.

One of the interesting ironies in the history of the marvelous was that as cabinets of curiosities and *Wunderkammern* proliferated all over Europe, the *naturalia* and the *artificialia* in them lost their capacity to excite wonder. As Baxter Hathaway has observed, "the concept of the marvelous presupposed a contrast to what is experienced in everyday life."[89] But when exotic and wonderful objects came into the possession of a great many collectors and when their specific types were displayed in large numbers, they no longer could be regarded as marvels. Indeed they became commonplaces and a familiar part of human experience. A similar situation occurred in the history of those gardens which had as their main components spectacular fountains and automata, impressive large-scale statuary, and surprising water tricks. After the mid-seventeenth century, especially in Italy, they fell out of fashion in large part because they were so familiar and thus had lost their power to excite wonder, surprise, and astonishment.

As the marvels lost their magic, the voices of disapproval were more clearly heard. As noted at the beginning of this essay, René Descartes considered wonder the first of all passions. At the same time, however, he concluded that wonder was useful only insofar as it caused man to learn. An excess of wonder, he said, "can never be other than bad," for "it may prevent or pervert the use of reason." Excessive wonder, he observed,

makes us fix our attention solely on the first image of the objects before us without acquiring any further knowledge about them [and] it leaves behind a habit which makes the soul disposed to dwell in the same way on every other object coming before it which appears at all novel. This is what prolongs the troubles of those afflicted with blind curiosity, i.e., those who seek out rarities simply in order to

wonder at them and not in order to know them, for gradually they become so full of wonder that things of no importance are no less apt to arrest their attention than those whose investigation is more useful.[90]

The objections raised in literary criticism, and in theories of art as well as in philosophical discourses, centered on the old debate of instruction versus delight. Artists and poets, they argued, should aim not only to give pleasure but also to educate their audience. They saw the excesses, the oddities, the demonstrations of virtuosity in poetry and art as frivolities, as meaningless exercises that ultimately had no edifying purpose. Echoing the words of Horace, they advised poets and artists to stress the morally uplifting, and to do this they should avoid the fantastic and other deviations from the norm. Though the marvelous was widely appreciated up to the end of the seventeenth century, it was the defenders of the norm and the morally uplifting, as Rudolf Wittkower once observed, who finally "won the day."[91] Yet, when we survey our own culture and consider its fascination with things both large and small (skyscrapers and microchips), with spectacular human accomplishment (the landing on the moon or the prodigious talent of a child violinist), with the discoveries made by the space probe *Voyager*, with the special effects of movies, and with fireworks, parades, and extraordinary technological inventions, then it seems that a love for the marvelous has not been extinguished but is, rather, still very much with us.

NOTES

1. John Cottingham, Robert Stoothoff, and Dugald Murdoch, trans. *The Philosophical Writings of Descartes* (Cambridge: Cambridge University Press, 1985), vol. 1, p. 350.

2. Giorgio Vasari, *Le vite de' più eccelenti pittori, scultori, ed architettori*, ed. Gaetano Milanesi (Florence: G. C. Sansoni, 1981), vol. 4, pp. 23–24 (hereafter cited as Vasari-Milanesi). The translation given here is by George Bull, *Giorgio Vasari: The Lives of the Artists* (London: Penguin Books, 1965), pp. 258–59.

3. See for instance, John Shearman, *Mannerism* (Harmondsworth: Penguin Books, Ltd., 1967); Eugenio Battisti, *Rinascimento e barocco* (Turin: Einaudi, 1960); Maurizio Fagiolo dell'Arco and Silvio Carandini, *L'Effimero Barocco: Strutture della festa nella Roma del '600* (Rome: Bulzoni Editore, 1977). *Meraviglia* as a baroque aesthetic was discussed by Laura Giles of the Art Institute of Chicago in a paper delivered at the College Art Association annual conference in New York City, February 1990. Literature pertaining to the *meraviglie* found in the Habsburg collections and in sixteenth- and seventeenth-century

Kunst- und Wunderkammern is cited below in my essay "A World of Wonders in One Closet Shut."

4. It should be emphasized here that while mannerism and many forms of the baroque style embraced the marvelous, high-Renaissance classicism and the ideal or classical style of the baroque rejected the marvelous and shunned deviations from the norm. Additionally, there were specific categories of art (everyday or low-life scenes, for example) in which the marvelous clearly was not an aesthetic goal. But even within these different currents, there were instances when works of art were praised in terms of the wondrous. As shall be pointed out later, there were special works (especially high-Renaissance classical works) that were perceived as marvels or as having particular qualities of the marvelous about them.

5. For a discussion of the discovery, translation, and revived interest in the ancient authors, especially Aristotle, see Baxter Hathaway, *Marvels and Commonplaces: Renaissance Literary Criticism* (New York: Random House, 1968), pp. 9–19. The "popular criticism" of the ancient writers is described in J. J. Pollitt,

The Ancient View of Greek Art: Criticism, History, and Terminology (New Haven: Yale University Press, 1974), pp. 63–66.

6. Rensselaer Lee, "Ut Pictura Poesis: The Humanistic Theory of Painting," *Art Bulletin* 22 (1940): 230.

7. Rudolf Wittkower, *Allegory and the Migration of Symbols* (Boulder, Col.: Westview Press, 1977), p. 76.

8. Ibid., pp. 76, 85.

9. Svetlana Alpers, *The Art of Describing: Dutch Art in the Seventeenth Century* (Chicago: University of Chicago Press, 1983), p. 13. A more detailed discussion of the camera obscura and other "magical" devices appears in Martin Kemp, *The Science of Art: Optical Themes in Western Art from Brunelleschi to Seurat* (New Haven: Yale University Press, 1990), chap. 4, "Machines and Marvels."

10. Katherine Park and Lorraine J. Daston, "Unnatural Conceptions: the study of monsters in sixteenth- and seventeenth-century France and England," *Past and Present* 92 (1981): 27–28.

11. Luther stated his position on this subject in a letter to Wenzelaus Link, January 16, 1523. Cited in Park and Daston, p. 26, n. 16.

12. Rudolf Wittkower, *Art and Architecture in Italy, 1600–1750* (Harmondsworth: Penguin Books, 1958), p. 92.

13. Park and Daston, "Unnatural Conceptions," pp. 35–43, discuss some of the most popular and influential of the wonder and prodigy books that appeared at this time.

14. Giovambattista Strozzi the Younger, "Se sia bene il servirsi delle favole delli antichi," lecture delivered to the Accademia Fiorentina, 1588. See Bernard Weinberg, *A History of Literary Criticism in the Italian Renaissance* (Chicago: University of Chicago Press, 1961), vol. 1, p. 330.

15. Hathaway, *Marvels and Commonplaces*, p. 141. Hathaway here refers to the opinion expressed by the poet Bellisario Bulgarini in his 1585 publication *Repliche alle risposte del Sig. Orazio Capponi*.

16. The first edition of della Porta's book on natural magic appeared under the title *Magiae naturalis sive de miraculis rerum naturaliam libri iiii* (Naples, 1558). This was followed by other editions of 1559 and 1561 and a greatly expanded version of the original book in 1589. The late sixteenth and seventeenth centuries saw many other editions of della Porta's famous work, including the English version cited here, *Natural Magick* (London, 1658). The diverse topics of his study are enumerated in the book's table of contents.

17. Oliver Impey and Arthur MacGregor, eds., *The Origins of Museums: The Cabinet of Curiosities in Sixteenth- and Seventeenth-Century Europe* (Oxford: Clarendon Press, 1985). See in particular the essay by Wilma George, "Alive or Dead: Zoological Collections in the Seventeenth Century," p. 184.

18. John Gerarde, *The Herball; or, General Historie of Plantes* (London, 1636), title page.

19. Edward Doughtie, *The Wonder of Wonders* (London, 1698), pp. 1177, 1179.

20. Robert Hooke, *Micrographia; or, Some Physiological Descriptions of Minute Bodies Made by Magnifying Glasses* (London, 1665), preface.

21. Ibid.

22. Nehemiah Grew, *The Anatomy of Plants: With an Idea of a Philosophical History of Plants* (London, 1682), dedicatory epistle.

23. From Huygens's "Autobiography," written between 1629 and 1631. The Latin text (cited and translated by Alpers, *Art of Describing*, p. 9) reads: "... in minimis quibusque ac despectissimis eandem opificis industriam, parem ubique et ineffabilem maiestatem offendamus." The manuscript was first published by J. A. Worp, "Fragment eener Autobiographie van Constantijn Huygens," in *Bijdragen en Mededeelingen van het historische Genootschap* (Utrecht) 18 (1897): 1–122.

24. Swammerdam's dedicatory epistle, written in April 1678, appears in the posthumous publication of his *Biblia naturae* I (Leiden, 1737), p. 67. The translation of the passage cited here appears in Th. H. Lunsingh Scheurlur, "Early Dutch Cabinets of Curiosities," in Impey and MacGregor, *The Origins of Museums*, p. 120.

25. Emmanuele Tesauro, *Il cannocchiale Aristotelico* (Turin, 1670); August Buck facsimile edition (Berlin: Verlag Gehlen, 1968), pp. 82–83. Tesauro here states that "L'ingegno naturale, è una maravigliosa forza dell'Intelletto . . . non senza qualche ragione gli Huomini ingegnosi fur chiamati *Divini*. Peroche, sicome Iddio di quel che non è, produce quel che è: così l'ingegno, di *non Ente*, fà *Ente*." A little later he says: "Onde fra gli antiqui Filosofi, alcuni chiamarono l'Ingegno, *Particella della Mente Divina*: & altri un regalo mandato da Iddio à suoi più cari." Modern commentaries on Tesauro's view of *ingegno*, especially as it pertains to literature, appear in Eugenio Donato, "Tesauro's Poetics: Through the Looking Glass," *Modern Language Notes* (*MLN*) 78 (1963): 27, and in Joseph Anthony Mazzeo, *Renaissance and Seventeenth-Century Studies* (New York: Columbia University Press, 1964), pp. 30–48, 53.

26. Antonio Minturno, *L'Arte poetica* (Venice, 1564), p. 41. The English rendering of this passage is from Hathaway, *Marvels and Commonplaces*, p. 156.

27. Carel van Mander, *Het Leben der Doorluchtighe Nederlandische en Hooghduytsche Schilders* (Haarlem, 1604), fols. 216v–17. (Contained in the facsimile edi-

tion of van Mander's *Het Schilder-Boeck* [Haarlem, 1604; Utrecht: Davaco Publishers, 1969].) The life of Bosch is translated in part by Wolfgang Stechow, *Sources and Documents: Northern Renaissance Art, 1400–1600* (Englewood Cliffs, N. J.: Prentice-Hall, 1966), p. 21.

28. Lázaro Diaz del Valle's high praise for the work of Alonso Cano is recorded in his *Epilogo y nomenclatura de algunos artifices* (1656–59). The full Spanish text is published in F. J. Sanchez Canton, *Fuentes literarias para la historia del arte espanol* (Madrid, 1933), vol. 1, pp. 387–90. Part of this text is given in English translation in Robert Enggass and Jonathan Brown, *Sources and Documents: Italy and Spain, 1600–1750* (Englewood Cliffs, N.J.: Prentice-Hall, 1970), pp. 175–78. Contemporary appreciation of Torelli and his achievements in the theater are cited at length in Per Bjürstrom *Giacomo Torelli and Baroque Stage Design*. Stockholm: Nationalmuseum, 1962. For van Mander's assessment of Lucas van Leyden, see his *Het Leben*, fol. 212.

29. *Vocabulario degli Accademici della Crusca* (Venice, 1516; Florence: Licosa Reprints, 1976).

30. Celio Rodigino [Lodovico Ricchieri], *Lectionum antiquarum libri xxx* (Venice, 1516); quoted in Weinberg, *History of Literary Criticism*, vol. 1, p. 258.

31. Giovan Battista Pigna, *I romanzi* (Venice, 1554), p. 17.

32. Francesco Patrizi, *La deca ammirabile* (1587). The unpublished manuscript (MS Pal. 408) in the Biblioteca Palatina, Parma, is summarized in Weinberg, *History of Literary Criticism*, vol. 2, pp. 772–74. According to Patrizi, the twelve sources for the marvelous in poetry are ignorance, fable, novelty, paradox, augmentation, change from what is usual, the extranatural, the divine, great utility, the very exact, the unexpected, and the sudden.

33. Vasari-Milanesi, part 4, p. 136.

34. "Con novello stupore traheva à se gli occhi di tutti con l'ammiratione." Carlo Ridolfi, *Le Maraviglie dell' arte* (1648); reprint ed. Detlev von Hadeln (Rome: Società multigrafica editrice SOMU, 1965), part 1, p. 151.

35. Marco Boschini, *Ricche minere della pittura Veneziana* (Venice, 1674). The translation is from Enggass and Brown, *Italy and Spain*, pp. 54–55.

36. Filippo Baldinucci, *Notizie dei professori del disegno da Cimabue in qua* (Florence, 1682); reprint of the V. Batelli edition (Florence: Studio per edizione scelte, 1974–75), part 2, pp. 509–15.

37. Ibid., part 5, p. 644, 595. The English translation is by Catherine Enggass, *The Life of Bernini* (University Park: Pennsylvania State University Press, 1966), p. 16.

38. The assessments of Caravaggio's art by his seventeenth-century biographers can be found in Walter Friedlaender, *Caravaggio Studies* (New York: Schocken Books, 1969). A good summary of the critical opinions about this artist is Richard E. Spear, "The Critical Fortune of a Realist Painter," in *The Age of Caravaggio* (New York: The Metropolitan Museum of Art, 1985), pp. 22–27. Marino praised Caravaggio in two poems for his "La Galleria." See, Giuseppe Guido Ferrero, ed., *Marino e i Marinisti* (Milan and Naples: Riccardo Ricciardi editore, n.d.), pp. 577, 596.

39. Francesco Stelluti, *Trattato del legno fossile minerale* (Rome, 1637), p. 5. Cited in Impey and MacGregor, *The Origins of Museums*, p. 170.

40. Vasari-Milanesi, part 4, p. 354, and part 5, p. 551.

41. For a summary discussion of the objects in the Habsburg collections, see the essays by Elisabeth Scheicher (chap. 4) and Rudolf Distelberger (chap. 5) in Impey and MacGregor, *The Origins of Museums*. Many of the rarities collected by Rudolf II are discussed in the exhibition catalogue *Prag um 1600: Kunst und Kultur am Hofe Rudolfs II* (Essen, June 6–October 30, 1988). On the rarities in some of the Italian museums, see Dario Franchini, et al., *La Scienza a Corte: Collezionismo eclettico e immagine a Mantova fra Rinascimento e Manierismo* (Rome: Bulzoni, 1979).

42. Dürer's diary entry of August 27, 1520, is quoted in Erwin Panofsky, *The Art and Life of Albrecht Dürer* (Princeton: Princeton University Press, 1971), p. 209.

43. To gain some idea of the exotica collected by Europeans, see Impey and MacGregor, *The Origins of Museums* (chaps. 27–33) as well as Monika Kopplin, "'was frembd und seltsam ist': Exotica in Kunst- und Wunderkammern," in *Exotische Welten Europäische Phantasien* (Stuttgart: Institut für Auslandsbeziehungern, Württembergischer Kunstverein, 1987), pp. 296–317. A more specialized study, having to do with a single collector's taste for the exotic, is Valerio Rivosecchi, *Esotismo in Roma Barocca: Studi sul Padre Kircher* (Rome: Bulzoni Editore, 1982).

44. Aristotle, *Rhetoric*, book 3, chap. 1, 14046b:9–14. I have used the translation of Friedrich Solmsen, *The Rhetoric and the Poetics of Aristotle* (New York: Random House, 1954), p. 167.

45. Vasari-Milanesi, part 3, p. 461.

46. Ibid., part 4, p. 138.

47. Ibid., part 7, pp. 193–94.

48. Gianpaolo Lomazzo, *Rime* (Milan, 1587). Cited by Piero Falchetta, "Anthology of Sixteenth-Century Texts," in *The Arcimboldo Effect: Transformations of the Face from the Sixteenth to the Twentieth Century*, ed. Pontus Hulten (New York: Abbeville Press, 1987), pp. 179–81.

49. D. Gregorio Comanini, *Il Figino, overo del fine della pittura* (Mantua, 1591). Cited by Falchetta, "Anthology," pp. 189–90.

50. José de Sigüenza, *Historia de la Orden de San Jeronimo* (1603). See Stechow, *Northern Renaissance Art*, pp. 22–24.

51. Shearman, *Mannerism*, pp. 141–51.

52. Paolo Beni, *Risposta alle considerazioni o dubbi dell'Ecc. mo Sig. Dottor Malacreta* (Padova, 1600), p. 89. The Latin text and English transcription appear in Weinberg, *History of Literary Criticism*, vol. 2, p. 1098.

53. As described in a letter of Luigi Inghirami. Cited in A. M. Nagler, *Theatre Festivals of the Medici, 1539–1637* trans. George Hickenlooper (New Haven: Yale University Press, 1964), p. 148.

54. See Nagler, *Theatre Festivals*, pp. 162–73.

55. For a discussion of the ancient world's interest in the large and small, see John Onians, *Art and Thought in the Hellenistic Age, the Greek World View 350–50 B.C.* (London: Thames and Hudson, 1979). See especially chap. 4, "Measure and Scale."

56. Pliny, *Natural History*, trans. J. Bostock and H. T. Riley (London: H.G. Bohn, 1855–57), book 34, chap. 18. An interesting study of this statue can be found in Herbert Maryon, "The Colossus of Rhodes," *The Journal of Hellenic Studies* 76 (1956): 68–86.

57. Vasari-Milanesi, part 7, p. 154, 156.

58. Ibid., part 5, p. 75. Examples of Properzi de' Rossi's tiny sculptures in nuts are illustrated in Adalgisa Lugli, *Naturalia et mirabilia: Il collezionismo enciclopedico nelle Wunderkammern d'Europa* (Milan: Gabriele Mazzotta editore, 1983), tav. iv, illus. 72.

59. Ibid., part 3, p. 463. Il Raggio is discussed in the life of Filippino Lippi.

60. Giovanni Battista Armenini, *De' veri precetti della pittura* (1586). The translation consulted here is by Edward J. Olszewski (New York: Burt Franklin and Co., 1977), pp. 196–98.

61. See Alpers, *Art of Describing*, chap. 3, for a discussion of the Dutch emphasis on technical virtuosity.

62. Benvenuto Cellini, *Autobiography*, trans. George Bull (Baltimore: Penguin Books, 1956), p. 291.

63. Vasari's account of Cellini appears in Vasari-Milanesi, part 7. Although he never saw the saltcellar, he speaks of Cellini's other finely crafted objects as "maravigliosi" or as having "un artifizio maravigliosissimo." See especially pp. 621, 622.

64. Vasari-Milanesi, part 7, pp. 150, 186.

65. Baldinucci, *Notizie*, part 5, p. 624.

66. Ibid., part 5, p. 646.

67. Van Mander, *Het Leben*, fol. 284v.: "de heldhaftigheid der Teeken-kunst"; " . . . en, dat zeer te verwonderen is, zulks binnen zeer korten tijd gedaan" See Stechow, *Northern Renaissance Art*, pp. 53–55, for the English rendering of this passage.

68. See van Mander, *Het Leben*, fols. 278–79v. An English translation of Ketel's life appears in Carel van Mander, *Dutch and Flemish Painters*, trans. Constant Van de Wall (New York: McFarlane, Warde, McFarlane, 1936), pp. 341–47.

69. On the ancient view of vividness and likeness and on the popular view of the "magical" properties of art, see Pollitt, *Ancient View of Greek Art*, pp. 63–64, 78, 134, 184, 196.

70. For a discussion of Speroni's views on this subject, particularly as they were expressed in his *Discorsi* and in his essay *Della poesie*, see Hathaway, *Marvels and Commonplaces*, p. 155. Speroni sees the marvelous arising out of the use of particulars, but he also argues that this can be achieved by the elaboration or the amplification of scenes, through digressions, novelties of words, and so forth.

71. Vasari-Milanesi, part 4, p. 40. It should be pointed out here that Vasari praised many earlier artists such as Giotto, Masaccio, and Donatello for the effects of lifelikeness they had achieved in their works. Indeed, for Vasari, lifelikeness was a primary quality that rescued art from the crude Byzantine style and restored it to its former glory.

72. Baldinucci, *Notizie*, part, 5, p. 584.

73. Ibid., part 5, pp. 591–92, 589.

74 Giovanni Baglione, "La vita di Michelagnolo da Caravaggio, Pittore," in *Vite de pittori scultori ed architetti* (1642), cited in Friedlaender, *Caravaggio Studies*, p. 234; Joachim von Sandrart, "Michael Angelo Marigi von Caravaggio, Mahler," in *Teutsche Academie* (1675), cited in Friedlaender, *Caravaggio Studies*, pp. 264–65. Caravaggio was familiar with Vasari's account of Leonardo. His *Head of Medusa*, in fact, recollects Vasari's descriptions of two works by Leonardo—the "monster" and a painting of Medusa. Marino's poem on the *Medusa*, "La Testa di Medusa in Una Rotella," can be found in Ferraro, *Marino e i Marinisti*, p. 577.

75. From Antonio Palomino, *El museo pictórico y escala optica*, part 3. Cited in Enggass and Brown, *Italy and Spain*, p. 197.

76. Ibid.

77. Cornelis de Bie, *Het Gulden Cabinet van de Edel vry Schilderconst* (1622), ed. G. Lemmens (Soest: Davaco Publishers, 1971), p. 290.

78. See, for example, de Bie's account of the painter de Heem, ibid., pp. 217–19.

79. See, in particular, John Moxon's definition of handicraft in his *Mechanical Exercises* of 1672, cited by Alpers, *Art of Describing,* p. 105.

80. Hathaway, *Marvels and Commonplaces*, p. 55 ff., gives many examples of poets and critics who dwelt on this issue.

81. Francesco Pacheco, *Arte de la pintura, su antigvedad, y grandezas* (Seville, 1649), cited in Enggass and Brown, *Italy and Spain*, p. 163.

82. Vasari-Milanesi, part, 4, pp. 327–28 and part 4, p. 38. It should be stated here that the creation of a perfect or ideal beauty did not in itself guarantee that a work of art would be seen in terms of the marvelous. Indeed, many idealized images of the sixteenth and seventeenth centuries were not so characterized; however, when critics such as Vasari or Baldinucci employ the term, they do so in order to demonstrate that the perfection achieved is exceptional.

83. Ibid., part 7, p. 151.

84. Ibid., part 7, pp. 212–15.

85. For the importance this had for poets and literary critics, see Hathaway, *Marvels and Commonplaces*, pp. 161–65.

86. See, for example, the reaction of those who attended the performance of *Le nozze degli dei* in Florence, cited in Nagler, *Theatre Festivals*, p. 169.

87. Baldinucci, *Notizie*, part 5, p. 620.

88. Tesauro, *Il cannocchiale*, pp. 89–90.

89. Hathaway, *Marvels and Commonplaces*, p. 160.

90. Cottingham, et al., *The Philosophical Writings of Descartes*, vol. 1, pp. 354–56.

91. Wittkower, *Art and Architecture*, p. 172.

Fig. 1 Tiziano Vecellio, called Titian, *The Penitent Magdalen*, 1530–35. Oil on panel. Pitti Palace, Florence.

The Aesthetics of the Marvelous: The Wondrous Work of Art in a Wondrous World

James V. Mirollo

IN THE FIRST DECADE OF THE SEVENTEENTH CENTURY, THE POET Giambattista Marino (1569–1625) was well on his way to establishing a reputation that would make him the most representative and widely influential poetic voice of his day. In the midst of a ferocious feud with a rival poet, and reflecting on a century of literary production and theorizing that had just passed, he uttered the following, much quoted tercet as a brief manifesto of his own artistic credo and what he had come to conclude was the goal of literary art generally: "The end of the poet is to arouse wonder (I speak of the excellent, not the foolish): Let him who does not know how to astonish go work in the stables!"[1] That this connoisseur and collector of paintings envisioned the same goal for the visual arts was made clear when he published his *Galeria* (1619), a collection of some six hundred lyrics that interpret and praise lavishly an equal number of real and imaginary paintings and statues. One of these, Titian's version of the penitent Magdalen now in the Pitti Palace, Florence (*fig. 1*), is minutely described and glossed, then hailed in a final ecstatic flourish:

> Oh celestial semblance, oh masterly craftsman,
> For in his work he outdoes himself;
> Eternal ornament of cloth and paper,
> Marvel of the world, honor of art![2]

Marino's praise affirms that works of verbal and visual art are marvels of the world that astonish their audience with the representational power of their themes and their technical bravura.

This essay focuses on the aesthetics of the marvelous in relation to the theory and practice of works of art, as Marino conveniently proposes them. But his reference to the world also reminds the reader that wonders of art compete with other perceived wonders,

61

hence it is essential to set the artistic marvelous within a larger view of the marvelous. That view encompasses the wonders of the physical world, of man himself as a microcosm of that world, and of those inventions that mediate between the two through man's utilization of natural materials and resources to explore, explain, mimic, and tame nature.

In addition, for the late-Renaissance and seventeenth-century sensibility, the response to wonders is likely to be at least partly filtered through its awareness of a tradition, going back to classical antiquity, that noted, catalogued, and speculated upon marvels. Hence a history of the idea of the marvelous must be taken into account along with the surviving artistic and material records of the later "age of the marvelous." Before considering that tradition, however, it will be helpful to clarify what might seem wondrous in late-Renaissance culture as revealed by some primarily literary sources, which will in turn enable understanding of how that culture incorporates or departs from the classical mode.

Quite obviously, the sheer quantity, variety, and power of nature's creatures, elements, and forces, as catalogued and described by a natural history that accepted pure fantasy along with more-or-less accurate depictions, was immensely appealing. The collection of *histoires prodigieuses* in many illustrated volumes was a genre of the period, stemming as will be seen from Pliny's *Natural History*. One of the most popular of these books of wonders was Father Etienne Binet's *Essay des merveilles de nature et des plus nobles artifices* (1621). By its title alone Binet's work indicates that *artifices* or inventions of an ingenious kind elicit wonder as much as do nature's marvels. The modern philosopher Georges Poulet quotes Binet's remark that "the mind of man gives itself the air of a little God and prides itself on making worlds of crystal, and counterfeits the miracles of the universe," and then comments:

Astrolabes, terrestrial globes, planispheres, and clocks are abridged universes, orbs in which the cosmos is drawn back to the miniscule. If there is an immoderate movement by which the mind stretches to the limit of things, there is the inverse movement by which these limits are shortened and coincide with the natural limits of the human mind.[3]

Poulet acknowledges here the well-known fascination of artists and thinkers of the seventeenth century with the vast and the tiny, not only their resemblance but also their convertibility, so that one can construct portable and manageable universes. But what authorizes this period to be labeled an "age of the marvelous" is that its culture was permeated by *a hitherto unprecedented coexistence of many kinds of wonders that assaulted, delighted, and jarred the sensibility*, including the existence of a New World and the perception of a new order in the heavens. Also, recent inventions like the printing press and artillery, which revolutionized such paradoxically disparate human activities as literacy and warfare, were bound to both astound and puzzle. The telescopic and microscopic views of reality now available, which were reflected as noted above in *artifices*, also manifested themselves in literary and visual conceits (amorous fleas and heavenly ceilings), profoundly altering previous notions of what constituted size, scale, height, depth, extent, and point of view.

While arguably still at the center of a knowable world, the human observer would have to feel that the circumferences or horizons of knowledge and expectation had giddily expanded.

Similarly, there was a taste for the metamorphic in both form and duration, with one form giving way to another in an instant.[4] Metamorphosis also meant the fluidity of and boundaries between various worlds of experience and their elements, hence the possibility of convertibility and transcendence, real or symbolic and emblematic. Analogies and relationships of large and small, light and dark and their convertibility could be seen in mystical terms, but also as a technical problem to be resolved by an invention such as the camera obscura.

Most wondrous of all, however, would be those familiar images and dogmas of the Christian marvelous newly refurbished or reinforced. For both Catholics and Protestants there were fresh miracles of faith, new exemplars of heroic sanctity and martyrdom, and novel reformulations of articles of belief to absorb. Nevertheless it must be recognized that there is a marvelous *in malo* as well as a marvelous *in bono*. If the marvelous or wondrous exhilarates because of its size or scope, its rarity, its novelty, its ingenuity, its paradoxicalness, it may also depress because of the fearful destructiveness that religion, nature, and human events may display or promise. Thus John Donne (1572–1631) gloomily complains that "new Philosophy calls all in doubt," but in a different mood joyously addresses his mistress's private part as "O my America! my new-found-land!" He rejoices in microcosmic man, Vesalian rather than Vitruvian, "I am a little world made cunningly/ Of Elements, and an angelic spright," but also moans that "black sinne hath betraid to endlesse night/My worlds both parts, and, oh, both parts must die." The antidote to despairing Christian reminders of death is, of course, the hope of the marvelous Christian paradox: "One short sleepe past, we wake eternally/And death shall be no more; death, thou shalt die."[5]

In the preface to story 72 of the third part of his *Novelle*, dating from 1554, Matteo Bandello (1485–1561) makes the following comment: "And if there ever was an age when one sees varied and wondrous things I believe that ours is one, for it is an age in which, more than any other, things happen that are worthy of astonishment, compassion, and reproach."[6] Bandello goes on to list among the wondrous and terrible events of his time the division of Christendom, the success of the invading Turks, the wars of the Christian princes in Italy, and the Sack of Rome. Shortly before, in his celebrated poem *Orlando Furioso* (1532), Ludovico Ariosto (1474–1533) had inserted an exuberant prophecy of the discovery of "nuove terre e nuovo mondo" (new lands and a new world); but in that same work he also denounced bitterly the invention of firearms, the "màcchina infernal," as a "scelerata e brutta invenzion" (infernal machine, wicked and ugly invention) because it ended honorable and chivalrous warfare.[7]

In addition to a marvelous *in bono* and *in malo*, the complexity of response to the wonders of one's world might include the idea of a marvelous in the eye of the individual

beholder, not noticed by the beholding culture at large. Montaigne (1533–92) inserts into his famous essay "On Experience" the following remark: "For in my opinion, the most ordinary things, the most common and familiar, if we could see them in their true light, would turn out to be the grandest miracles of nature and the most marvelous examples, especially as regards the subject of the actions of men."[8] Montaigne's elevation of the mundane to the marvelous is wholly secular, typical of his habit of drawing attention to a benign nature's unnoticed and unappreciated gifts, as when he experiences a surprising and delicious respite from the pain of his kidney stone. From a Christian perspective, the ordinary may also have marvelous spiritual resonances or reveal graceful intimations of the sacred, whether in a painting or a poem. Thus George Herbert (1593–1633) can have a pulley turn out to symbolize God's determination to bestow on his creatures all gifts except one, rest, so that "If goodnesse leads him not, yet wearinesse / May tosse him to my breast." Or he can invoke a simple flower to suggest that "These are thy wonders, Lord of Love, / To make us see that we are but flowers that glide" in search of the paradisal garden ready for us.[9]

The possibility of change, transformation, and convertibility in the world, whether it produces meaning and insight of a specifically Christian or of a secular kind, promises the type of marvelous associated with the phenomenon of metamorphosis, one of the key experiences cherished by the "age of the marvelous." For instance, Andrew Marvell (1621–78) revels in the transformations that occur before his eyes as he wanders about his patron's country house and grounds in "Upon Appleton House." Invoking baroque theater machinery, he observes that "No scene that turns with engines strange / Does oftener than these meadows change," each change revealing another emblem of his panegyric theme.[10] In a similar vein, the poet Góngora (1561–1627) sees through the persona of his *Soledades* (The Solitudes, 1613) that a twilight horizon confusingly makes "montes de agua y pielagos de montes" (unequal mountains into water and oceans into mountains).[11]

The metamorphic and symbolic capacities of nature may be found in her tiny forms as well as in her vast landscapes. The poet Thomas Carew (ca. 1595–ca. 1639) explored this motif in several of his poems, especially the two entitled "A Fly that Flew into My Mistress Her Eye" and "Upon a Mole in Celia's Bosom."[12] In the first, Carew says the fly, sucking incense and spice from Celia's breath, cheek, and lip, grew into a bird of paradise (ll. 8–11). Then, flying into Celia's eye,

> There scorch'd in flames and drown'd in dew
> Like Phaëton from the sun's sphere,
> She fell, and with her dropp'd a tear,
> Of which a pearl was straight compos'd,
> Wherein her ashes lie enclos'd.
> Thus she receiv'd from Celia's eye
> Funeral, flame, tomb, obsequy. (ll. 14–20)

In the second, Carew asserts that the mole in Celia's bosom was once a bee that fed on and drank from her breasts ("ambrosial meat" and "balmy sweat") until she drowned:

> Yet still her shadow there remains
> Confin'd to those Elysian plains,
> With this strict law, that who shall lay
> His bold lips on that milky way,
> The sweet and smart from thence shall bring
> Of the bee's honey and her sting. (ll. 15–20)

These same creatures could also be wittily converted into images of the sacred, *a lo divino*, as in the poems of Sor Juana de la Cruz (1651–95), and in particular her "Das las más fragrante rosa." Here the bee is born of the limpid dew of "the most fragrant rose," but "no sooner is it born than in the same coin it begins to pay in pearls what it had received in pearls." Playing on the precious "pearliness and reciprocality of dew and nectar," Sor Juana goes on to argue that rose and bee, mother and son, are interdependent and self-sufficient through mutual fertilizing and feeding. But what need, then, of the weeping dawn, that is, dew or tears of the sun (Christ)? Answers the poet, "Let Jesus weep, well and good, for that which He expends in dew He will recover later in nectar," alluding to the value of the Crucifixion.[13]

German and French poets, also in this sacred vein, frequently focused on the symbolic convertibility and metamorphic capacity of natural phenomena such as light and dark, or fire. The nativity poem "Uber die Geburt Jesu" of Andreas Gryphius (1616–64) opens with a fervid proclamation of a paradox:

> Night, more than light night! Night lighter than
> the day! Night brighter than the sun! In which
> the Light was born. . . .[14]

Pierre Le Moyne (1602–71) also explored and exploited the Christian marvelous in his long poem "Les merveilles de l'amour divin en Dieu, en la Nature, et dans les Amours inférieurs" (The marvels of divine love in God, Nature, and inferior Loves). Here is part of his meditation upon the element of fire as holy spirit:

> Far from the sun and moon, above the highest spirits,
> the fires of the Father and the Son are
> your common source. There your light is made from
> theirs; your flames are the continual expression
> of their heats; the vision of both of them
> complete themselves in you; and between them you
> make the eternal meeting of a fertile model and a fertile painting.[15]

The Idea of the Marvelous: The Tradition

The response to the wonders of the "age of the marvelous" was often filtered through classical precedent; hence it is essential to consider next the history of the idea of the marvelous and in particular concepts of wonder that survived antiquity to become pervasively influential.

The concept of the marvelous as initiated and developed by classical authors from Aristotle to Quintilian emphasized that the marvelous or wondrous was an event or creation as well as an effect. The occurrence in nature and human works of the unexpected, the awesome, or the inexplicable drew attention to and had an intellectual, emotional, and aesthetic impact on the observer.

For the wonders of nature the key text is Pliny's *Natural History*, which its editor characterizes as "an encyclopedia of astronomy, meteorology, geography, zoology and botany" that also includes "human inventions and institutions."[16] That "his selection is colored by his love of the marvelous" (p.lx), makes it less scientifically accurate and useful, but from the point of view of this essay accounts for its appeal to later times. It is ironic indeed that Pliny's thirst for the marvelous led him to seek a close-up view of the eruption of Vesuvius in 79 C.E., which caused his death at Stabiae from poisonous fumes. But then he himself had acknowledged the dual nature of the marvelous in his second book:

For let earthquakes not be mentioned, and every case where at least the tombs of cities survive, and at the same time let us tell of the marvels of the earth rather than the crimes of nature. . . . In these matters what other explanation could any mortal man adduce save that they are caused by the divine power of that nature which is diffused throughout the universe, repeatedly bursting out in different ways? (pp. 336–39)

In his seventh book Pliny asserts that nature seems to have created everything else for man's sake, "though she asks a cruel price for all her generous gifts," and so it is hard to tell whether she is a "kind parent" or a "harsh stepmother" (p. 507). Her ingenuity, however, is echoed by man, who produces with her materials works that mimic her, as when Pompey the Great placed in his theater "images of celebrated marvels, made with special elaboration for the purpose by the talent of eminent artists" (p. 529). And as is well known, Pliny was to take up among such *miracula* and *mirabiles* the celebrated works of painting and sculpture of antiquity, as there will be occasion to note below.

The collaboration of man and nature is appropriately enough illustrated in a letter written by Pliny's nephew in which he describes his Laurentian house and gardens.[17] With great relish Pliny the Younger recounts the variety of land and sea views, the manipulation of light, shade, and sound, and the integration of house and gardens. This important and influential description sets a precedent for later arrangements of nature in gardens that are manicured, revealing inherent geometric forms, or that artfully mimic nature's external appearance of wildness. In either type there will be carefully inserted

66

surprises, whether of sculpture or prospect or mechanics, that reveal an insatiable appetite for improving upon nature by making it more *mirabile*.

For the role of wonder as an educational, psychological, and aesthetic force, one must turn to crucial texts by Aristotle, his *Metaphysics*, *Rhetoric*, and *Poetics*. Aristotle's comments on wonder exerted an incalculable influence on Renaissance theorists, especially after the *Poetics* became available again by the second half of the sixteenth century.[18]

In the first book of his *Metaphysics* Aristotle argues that wonder motivates learning since a state of ignorance or puzzlement causes man to begin to philosophize.[19] In his *Rhetoric* he also notes that "learning, too, and wonder, are pleasant; for wonder implies the desire to learn, so that the wonderful is something desired." And further, "since learning and wonder are pleasant, such things as artistic imitation must be pleasant; for example, painting, sculpture, and poetry." Later, in discussing style, he argues that deviations from ordinary usage make for impressive style and that effective metaphor involves surprise, the novelty of unexpected learning, and a pleasant deception. These remarks were destined to become the authority for the marvelous style as a literary goal.[20] Finally, and equally influential, are his assertions in the *Poetics* of the impact of tragic plot on the audience. From his basic premise that representations produce pleasure, he goes on to argue that amazement is aroused when events occur contrary to expectations and are random but appear to have happened on purpose. Still later, comparing epic and tragic plots, he says that tragedy should arouse amazement or make men marvel, but that epic has greater scope for the inexplicable, at which men marvel most, because its audience does not see the action.[21] In sum, if Aristotle does not flatly proclaim that wonder is *the* end of poetry, he does enunciate a poetic and, by implication, an aesthetic of the marvelous, as his Renaissance readers will grasp.

Having established now the two strands of the tradition of the marvelous, this essay can focus on some of the rhetoricians and critics who discuss poems and paintings rather than earthquakes and strip mining. For Longinus, writing his treatise *On the Sublime* in the first century B.C., human aspirations soar "beyond the boundaries by which we are circumscribed" and men "always reserve their admiration for what is out of the ordinary." In literary terms, the grand style excites admiration because "in statues we look for the likeness of a man, whereas in literature we look for something transcending the human." Furthermore, "it is right that art should everywhere be employed as a supplement to nature, for in cooperation the two may bring about perfection."[22] In an essay entitled "Zeuxis or Antiochus" the second-century rhetorician Lucian of Samosata relates that a lecture he gave aroused in his audience great praise for its novelty, marvelous paradoxes, inventiveness, and strangeness of thought. He pretends to be disturbed by this preoccupation with novelty and cites the example of Zeuxis, who in a painting aimed at novelty of theme but, upon discovering that it rather than his technique drew applause, ordered the work covered up.[23] As J. J. Pollitt has shown, there was what he calls a "popular criticism" that emphasized "the marvelous and magical qualities of art."[24] These echoed

even in writings like chapters 33–36 in Pliny's *Natural History*, which purported to deal primarily with works of art made of metals and minerals. What dazzles the spectator is a realism that makes the work seem alive, a miraculous assumption of life, a display of technical bravura, or the costliness and value of materials and finished product.[25]

As Pliny's remark about referring to Pompey's theater of marvels indicates, the talent or *ingenium* of the artist is also celebrated and becomes legendary. Some examples of this "popular criticism" are Pliny's comment on the painter Nicomachus, who executed a commission in a few days "with a speed and an artistic skill that were both remarkable," and of course the contest between Zeuxis and Parrhasius in which the former's realistically depicted grapes fooled birds but the latter's rendering of a curtain deceived his fellow artist.[26] The sophist Philostratus the Elder, in his third-century *Imagines*, has a description of a painting of Cupids gathering apples that he calls "a beautiful riddle."[27] Furthermore, he asks his listener whether he has caught anything of "the fragrance hovering over the garden" and promises that his description will make the fragrance of the apples come to him (p. 21). His follower Callistratus says of a statue of Eros by Praxiteles that "you might have seen the bronze losing its hardness and becoming marvelously delicate in the direction of plumpness" (p. 385) and of a Dionysus that "it wholly passed the bounds of wonder in that the material gave out evidence of joy and the bronze feigned to represent the emotions" (p. 405). Finally, he tells us about a statue of Memnon in Ethiopia that had the power of speech and that saluted the rising day and moaned and shed tears at its departure (p. 407).

There was some continuity in the tradition of the marvelous during the Middle Ages, since wonder is an effect of miracles, which are central to the Christian marvelous.[28] After the recovery of Aristotle's texts in the twelfth and thirteenth centuries, such scholastics as Albert the Great and Thomas Aquinas continued the Aristotelian discussion of wonder in learning and as an effect of poetry.[29] But the unavailability of or lack of interest in the *Poetics* assured that there would be little if any attention to the effects of the tragic plot, which in any event had come to be regarded as a narrative rather than a dramatic structure. Thus when Averroes (1126–98) wrote his commentary on the *Poetics*, he made little of the marvelous in his source beyond perfunctorily giving his sense of what his author means: "Sometimes extrinsic devices are mixed with poetic images. If this happens by chance and without being planned, it is a marvel, since that which occurs because of chance is marvelous by its very nature."[30]

The wonders of the Christian marvelous as recorded in the New Testament and in the literature of the Middle Ages, and the Aristotelian discourse of wonder among the scholastics, should be supplemented by the continuity of observing and collecting works of art and what Umberto Eco calls "absurd oddities."[31] As he points out, the duc de Berry had a collection that included "the horn of a unicorn, St. Joseph's engagement ring, coconuts, whales' teeth, and shells from the seven seas" (p. 14), a truly strange mix of relics and exotics. Of Suger's attraction to the beauties of his church and its furnishings,

68

which ultimately transport him to a higher world, Eco comments that medieval taste discerned "in the concrete object an ontological reflection of, and participation in, the being and power of God" (p. 15).

Literary Criticism of the Marvelous

In the late Renaissance and well into the seventeenth century the concepts of both natural wonders and artistic wondrousness become powerful cultural forces. As the quotation from Descartes that prefaces the introduction to this catalogue demonstrates, the Aristotelian philosophical and psychological discourse of wonder retains its influence, here asserted as the first passion of the soul. At the same time, the availability in print of the *Poetics* and its commentators, along with a renewed interest in the *Rhetoric*, spurred an outbreak of literary theorizing that has caused the second half of the sixteenth century to be labeled "an age of criticism."[32] From approximately 1550 to 1650 one can discern several stages in this theorizing, conveniently simplified as follows: first, concern with the marvelous in tragic and epic plots; second, affirmation of the marvelous style; third, the declaration of the marvelous as the end of literary art, with analysis of the mental faculty of wit or ingenuity as its source and of witty products as its result; fourth, the inevitable reaction of late-seventeenth- and early-eighteenth-century neoclassicism.

Discussing the *ammirabile* (wondrous) in epic and tragedy in his *Poetica* of 1549, G. G. Trissino says that "all those who narrate or who allude to anything always add something of their own in order to arouse more wonder in those who listen."[33] Writing in 1557, G. B. Giraldi asserts that *il maraviglioso* can be found only in "those things that are outside of common experience and outside natural limits."[34] Bernardo Tasso, in *Ragionamento della poesia* of 1562, says the poet must imitate "the things that delight the people and arouse wonder in them."[35] In a *discorso* of 1574 Giulio del Bene claims that "a most beautiful ingredient of poetry is the wondrous, which occurs when something unexpected comes about for the audience, for men marvel and take delight in things that are new and beyond their knowledge."[36] In a *discorso* of 1586 Giason Denores, arguing that "every poem by its nature is based on the marvelous,"[37] shows how the marvelous is aroused by reversal and recognition in the plots of not only tragedy and epic but also comedy and the novella. He also emphasizes the *ingegno* of the poet and "la maraviglia delle parole" (the marvelous in words; p. 410), which he attributes to elevated style. These will be important themes of late-sixteenth- and early-seventeenth-century theorizing.

In 1597 Giovanni Talentoni delivered a lecture before the Milanese academy on the "Inquieti, Discorso sopra la maraviglia," which acknowledged the topicality of the marvelous and inquired into its bases. He takes up admiration or wonder as a passion of the soul, then goes on to discuss how it is produced by conjunctions of the animate and inanimate, the rational and nonrational, either through chance or intent. Finally, he takes up its effects, physiological as well as psychological and pleasureful.[38] If this *discorso*

69

suggests that *la meraviglia* was both a serious and an all-embracing concept, there were voices of opposition. For example, in a 1589 *discorso* on comedy, Nicolò Rossi protested against the introduction of "the marvels of the intermezzi" in order to "delight the torpid ears of the modern audience."[39] And in his essay of 1591 dedicated to the *Svegliati* of Naples, Giulio Cortese protested against those who "think that with badly expounded caprices they can offer to the souls of the erudite conceited marvels, and instead they offer nonsense."[40] "Concetti" were now in the air of course, for just a few years later, in 1598, Camillo Pelligrino the elder would write his *Del concetto poetico*, in which Marino is an interlocutor and an exponent of the new conceited or marvelous style.[41]

The key figure in these developments was undoubtedly Torquato Tasso (1544–95), whose *discorsi* on the heroic poem appeared in 1594. In justification of his own *Gerusalemme liberata*, Tasso tried to theorize a long narrative poem that would be both verisimilar and marvelous.[42] Based on historical event and incorporating a Christian framework of belief, it would aim at epic grandeur through its theme, structure, and style; but it would not eschew the delights of the marvelous. Here Tasso was admittedly contending with the popularity of the *Furioso*, whose romance, variety, and marvels far outweighed its nominal Christian subject. Thus Tasso allows for erotic episodes and supernatural interventions, the latter prescribed as follows:

Let the poet attribute certain actions that far exceed human power to God, his angels, to demons, or to those granted power by God or by demons, such as saints, magicians, and fairies. These actions, if considered in themselves, will seem marvelous—indeed they are even called miracles in common parlance. But if these same actions are regarded from the viewpoint of the efficacy and power of He who brought them about, they will be judged verisimilar.[43]

In his discussion of diction and metaphor, and in particular the question of the "strange and marvelous," Tasso comments that "the marvelous always brings with it delight, for the delightful is marvelous."[44] Later, in comparing the way lyric and heroic poets use *concetti*—the idea or content rather than the form of words—Tasso allows the lyric a range of matter if not subjects, then concludes that lyric poetry does not take its form from rhythm, meter, diction, or metaphor but rather from "the pleasingness, from the grace and from the beauty of the conceits."[45] While not authorizing the conceit understood as witty metaphor, Tasso here makes his contribution to a budding emphasis upon the marvelous as an effect of style as well as plot, and not only epic or tragic but lyric style.

For Tasso's seventeenth-century European successors among literary theorists, there is a shift to a new set of privileged notions and terms. The marvelous is now associated with the mental faculty or capacity of *ingenium* or the wit, which links the creature with the Creator, seen as the Supreme Wit who made the world cunningly. Human wit or *ingegno* or acuity is able to explore and exploit the creation to come up with startling, surprising, and novel insights and images expressed in appropriate imagery and language.

70

Rightly seen, or wittily seen, the world is full of marvels, among them, thanks to their *concetti*, works of art.

The ultimate source of theorizing on wit was the rhetorical tradition and in particular the comments of Aristotle, Cicero, and Quintilian on diction and metaphor as arousing wonder or surprising insight, whether in poetry or prose. These also included treatments of humorous or serious wit aimed at audiences in court or assembly.[46] Much of this tradition is recapitulated and expanded to embrace a larger arena of human witty creativity in the *Il cannocchiale Aristotelico* (1654) of Emmanuele Tesauro (1592–1675). Here is Tesauro's comment on *argutezze divine*:

At times even the great God enjoyed being the poet and witty speaker, verbalizing to men and angels with various heroic devices and figurative symbols his lofty conceits. And for good reason. First, so that the divine ingenuity does not concede anything to the human, nor does it grow sterile, for it fecundates other minds with conceits. For whatever is ingenious in the world is God or is from God. Then too because the style of the divine majesty does not partake at all of the trivial, but instead uplifts itself with noble imagery in such guise that its sublimity generates the marvelous and the marvelous veneration.[47]

It is Tesauro's formulations of the meaning of wit that have seemed to many modern readers to be particularly apt. For example, he refers to the variety and wonders of the world as "witticisms of Nature"; he refers to the two mirrors of the telescope as glass wings that allow us to soar where birds cannot fly; and he asserts that the marvelous is born when the mind of the auditor, "overcome by novelty, grasps the acuity of the representing wit and the unexpected image of the object represented."[48] A pun on one word, he says, can reveal "a full theater of marvels," and he adds that "the perfect acuities and witty conceits are none other than urbanely fallacious arguments."[49]

Tesauro's treatise is only one of several important essays on wit produced in Italy and Spain. The best known are the *Delle acutezze* (1639) of Matteo Peregrini (1595–1652) and the treatise on style (1662) by Sforza Pallavicino (1607–67), which offers a famously condensed definition of a conceit as "a marvelous observation gathered within a brief saying."[50] Also significant is the *Agudeza y arte de ingenio* (1648) of Baltasar Gracián (1601–58), which contains another definition of the conceit as "an act of the understanding that expresses the correspondence which exists between objects."[51] Gracián also argues for variety and the multiplying of "nobles perfecciones" (p. 17) and defends both difficulty and obscurity (p. 50), thereby affirming key elements of baroque poetics.

The inevitable reaction to the baroque and its supporting theory of the marvelous occurred primarily in France and England. Typical is the example of Jean Chapelain (1595–1674), who as a young writer out to make a reputation wrote an approving preface for Marino's *Adone* (1623) full of modish terms such as *la merveille* and *les conceptions*, but later repudiated his effort.[52] The more powerful Nicolas Boileau-Despréaux (1636–1711) summed up his view of the marvelous in four memorable lines from his *L'Art poétique* (1674):

Don't ever offer the spectator anything incredible:
The truth can sometimes not be verisimilar.
An absurd marvel has no appeal for me:
The mind is not moved by what it does not believe.[53]

Many years later, writing his *Life* of the poet Abraham Cowley, Samuel Johnson (1697–1772) summed up a century of reaction to the poetics of the marvelous by dissecting the weaknesses of its English practitioners, the so-called Metaphysical poets. According to Johnson, who regarded Marino as the culprit, the Metaphysicals "were wholly employed on something unexpected and surprising," and their wit was concerned to combine "dissimilar images" or "discover occult resemblances." Continuing his amazingly accurate though negative characterization of the marvelous style, Johnson says they "lay on the watch for novelty" and "endeavored to supply by hyperbole" what they lacked of the sublime. In their flights "they left not only reason but fancy behind them; and produced combinations of confused magnificence, that not only could not be credited, but could not be imagined." Yet, he concedes, "if they frequently threw away their wit on false conceits . . . they likewise sometimes struck out [i.e., came up with] unexpected truth."[54]

Art Criticism of the Marvelous

As Rensselaer W. Lee pointed out some years ago, late-Renaissance art theorists and critics, lacking a tradition to which they might turn for themes and terms, had to borrow from the literary sources and commentaries we have treated above.[55] Departing from the few but precious interart analogies found in Aristotle and Horace, they felt justified in appropriating the basic notions of wonder or marvel as educative and pleasureful, and of the marvelous as a goal of mimetic art. Literary structure and style could have their equivalents in such visual features as *disegno*, color, and chiaroscuro, and both the verbal and visual arts could share not only mimetic vividness but also psychological expressiveness and rhetorical persuasiveness, not to mention bravura technique. Thus the first of the critics, Giorgio Vasari (1511–74), may be said to use criteria based on a combining of Pliny and Aristotle. And from the first edition of his *Lives* in 1550 until the 1648 publication of Carlo Ridolfi's *Le meraviglie dell'arte*, there is a continuing application of an aesthetic of the marvelous in judging visual works. Ridolfi's book serves as a convenient terminus because by that time, and certainly afterward, the prevailing artistic language, especially in Italy, was baroque but the critical wind of art theory, especially in France, was blowing toward the neoclassical.[56]

Since much of this theorizing, as in the case of the literary critics treated above, tends to obligatory repetition and recycling of some familiar ideas, it can be conveniently sampled here, starting with Vasari's *Lives*. In the proem to the entire work he says that

"spiriti egregii" (noble spirits) strive to win glory by bringing their works to that perfection "which will make them astonishing and marvelous to the whole world."[57] Speaking of Giotto's painting at Assisi, he refers to a drinking figure rendered "with great and truly marvelous appeal, so much so that it seems like a living person drinking."[58] Later he says of a Leonardo cartoon that "it made all the artists marvel" and that people flocked to see "the marvels of Leonardo, which astonished all of those people."[59] In the hyperbolic vein he adopts for Michelangelo, he says of the *Pietà* that "in truth astonishment marvels that the hand of an artist could make in so short a time a thing so wondrous."[60] Clearly there is more Pliny here than Aristotle, but Vasari's late-sixteenth-century successors, in part influenced by the new interest in the decorum of sacred art promoted by the Council of Trent and the Counter-Reformation, will strive for more subtlety and rigor. Even Vasari himself, writing about that same *Mary Magdalene* of Titian that Marino was to gloss, says "although it is most beautiful, it does not move one to lasciviousness but to commiseration."[61]

Both Giovanni Andrea Gilio and Cardinal Gabriele Paleotti exhibit this contemporary concern with the "errori" of painters, which range from theological mistakes to Mannerist refinements and subtleties of form and meaning. Gilio, in his 1564 treatise *Degli errori e degli abusi de' pittori*, when discussing the appropriate rules for historical paintings, remarks that "that artist who does not take care to observe them will make his works more worthy of laughter than marvel."[62] In treating Michelangelo's Sistine ceiling, the interlocutors of Gilio's dialogue are torn between the desire to praise its marvelousness and the need to consider its errors, as in the anachronisms of the depiction of the Flood (pp. 94–95). In his *Discorso intorno alle imagini sacre e profane* of 1582, Paleotti acknowledges that images "above all are marvelously beneficial to the needs and edification of our fellow creatures."[63] While affirming the "meravigliose operazioni" of images, he also warns against *novità*, though without wishing to restrain the "invenzione ingegnosa" of painters (pp. 400–1), thereby indicating both the value and the dangers of the marvelous.

Writing in 1571 about the statue of Saint George by Donatello, Francesco Bocchi concludes with the formulaic, affirming that the statue has "that complete and rare beauty that, among human achievements, is so nearly incredible that it generates within our souls astonishment and wonder."[64] In his 1585 treatise *Della nobilità della pittura*, Romano Alberti attributes the nobility of painting to, among other qualities, not only its power to arouse wonder, but also to reproduce quickly and in brief a world of creatures, which is most pleasing, "as Aristotle says."[65] Gregorio Comanini, in his *Il figino onero del fine della pittura* (1591), also uses the terminology of *stupore* and *meraviglia*, insisting upon the equivalence of painting and poetry in imitating, with the painter using a "credibile mara-aviglioso" to delight just as poets do.[66]

With the treatises of Giovanni Paolo Lomazzo, Giovan Battista Armenini, and Federico Zuccari, more subtle arguments and distinctions are introduced into late-Renaissance theorizing. For example, in his 1584 treatise on the art of painting Lomazzo notes

that grotesques are an expression of *concetti* and ingenious *capricci*.[67] And in further assimilating poetry and painting, he argues that a painter must have "a certain poetic spirit" so that many painters write verses after completing a work![68] Moved by a similar *furor*, poets and painters make "stupendous representations that enrapture and transform us."[69] In his 1586 treatise *De' veri precetti della pittura* Giovan Battista Armenini asks, who does not know and understand that works that are *mirabili*, *stupende*, and of *alta meraviglia* have appeared thanks to the *virtù* and *giudizio* of those expert in them? And, he adds, thanks to the authority and *virtù* of those who, dominating others with prudence, have become connoisseurs and have dominance over their production, the fate of the marvelous is in the hands of knowing and supportive patrons![70] Another refinement can be found in Federico Zuccari's *Idea de' pittori, scultori et architetti* of 1607, where a distinction is made between painting's power to cause wonder in and to deceive human beings with its rendering of external nature and its power to render as well invisible things seen only by the internal sense or intellect. And in contrast to poetry, which strikes only the ears of the *dotti*, painting strikes the eyes of the *dotti* and the *semplici*, and so is even more *maravigliosa*.[71]

The tendency toward neoclassicism in the seventeenth century involved a diminution of emphasis on the marvelous and greater focus on rules, ideal beauty, and the expression of the general human passions. It is no accident that, for instance, Pierre Le Moyne's *Peintures morales* of 1640–43 purports to present a Marinesque gallery of visual and verbal elements, but instead of the *meraviglie* of art, the subject here is the virtues and the passions.[72] In his *Vite* of 1672 Giovanni Pietro Bellori, trying to steer a course between Caravaggian naturalism and mannerist subtleties, argues that the artist should copy the idea of nature in his mind, drawn from experience, rather than reproduce nature in as exact a mimetic fashion as possible—thereby depriving the marvelous of one of its key appeals.[73] Yet in his 1681 life of Bernini, Filippo Baldinucci could praise the *David* as expressing marvelously the anger of the Israelite through the portrayal of the artist's own features, which is naturalism par excellence![74]

French critics tend to be less ambivalent. Thus Nicolas Poussin puts clear restrictions on novelty and insists that the purpose of a painting is to "arouse the soul of the spectator to various passions."[75] Those passions will of course be analyzed by Le Brun in the wake of Descartes, who had described *admiration* or *wonder*, for example, in both physiological and psychological terms as a paralyzing surprise.[76] In this same vein, Anthony Ashley Cooper, Earl of Shaftesbury, in a 1714 essay, castigates "that false Relish which is govern'd rather by what immediately strikes the Sense, than by what consequently and by reflection pleases the Mind, and satisfies the Thought and Reason."[77] And when his countryman Colen Campbell, in his 1717 *Vitruvius Britannicus*, inveighs against the "affected" and "licentious" Bernini and the "wildly extravagant" Borromini, we know the fate of the marvelous has become entwined with that of the baroque.[78] Before the end of the century

74

Francesco Milizia will have given his famous definition of the baroque as "the superlative of the bizarre, the excess of the ridiculous."[79]

The last word should be reserved, however, for two more powerful critics. In his *Laocoön* of 1766 Gotthold Ephraim Lessing (1729–81) argued that "admiration is only a cold sentiment whose barren wonderment excludes not only every warmer passion but every other clear conception as well."[80] He refers to "the barren pleasure that comes from looking at a perfect resemblance, or from consideration of his skill as a craftsman" (p. 12). Further, with regard to Aristotle's pleasure arising from knowledge, Lessing says it is momentary and merely incidental (p. 127). But far more important, his separation of poetry and painting from each other as sister arts undermined the marvelous insofar as the tradition had joined them from the start. In a similar vein is Sir Joshua Reynolds's comments in his various *Discourses on Art*, and in particular his Discourse XIII, where he warns against "that mean conception of our art which confines it to mere imitation."[81] Later he says:

If we suppose a view of nature represented with all the truth of the *camera obscura*, and the same scene represented by a great artist, how little and mean will the one appear in comparison of the other, where no superiority is supposed from the choice of the subject. The scene shall be presented to the eye. With what additional superiority then will the same Artist appear when he has the power of selecting his materials, as well as elevating his style? (p. 237)

Epilogue

A modern critic of the marvelous has said, "The domain of the marvelous is immense. To explore it in a limited time one would have to be oneself a magician."[82] Because there are many kinds of marvelous, or at least many different ways in which it manifests itself, it cannot be said that the marvelous as a cultural force expired in the eighteenth century thanks to the ascendency of neoclassicism or the Enlightenment. It is true that the former established new rules of taste and that the latter preferred not to see the world as full of marvels and mysteries, wondrous to contemplate, but as a site of social, political, and economic problems to be solved, forces to be tamed, including what it regarded as religious superstition and absolutist tyranny.

The idea of the Sublime, however, proves that the marvelous cannot easily be quenched. Despite its emphasis on the awesome and the terrifying, its ingredients of aesthetic appeal and natural mystery show that the Sublime is in its way a resurfacing of the notion of a wondrous world. In surrealism and other currents of modern art, too, the surprising and the astonishing as well as the mysterious have again come to the fore, even if these effects have had to compete with the awesome impact of amazing scientific feats and inventions, cosmic explorations, and easy access to varied and far-flung cultures. The marvelous is therefore not a transient moment, an aberration of the baroque, but a

continuing quest to explore and express the essential joy and pain of existence in a still mysterious world. If this current age, with all its marvels, has not been an age of the marvelous in the same way as the earlier period was, it may be that instead of embodying a creative tension between the joy and pain this has been an age when the marvelous *in malo* has *seemed* to overwhelm the marvelous *in bono*. But the final accounting, it is hoped, is not yet done.

NOTES

1. "E del poeta il fin la meraviglia (Parlo de l'eccellente e non del goffo): Chi non sa stupir, vada alla striglia!" See my *The Poet of the Marvelous: Giambattista Marino* (New York: Columbia University Press, 1963), pp. 24–25. See also Jean Rousset, *La Littérature de l'âge baroque en France: Circé et le Paon* (Paris: Libraire José Corti, 1954), pp. 75–78.

2. "Oh celeste sembianza, oh magistero. /Ove ne l'opra sua se stesso ei vinse; /Fregio eterno de'lini e de le carte. /Meraviglia del mondo, onor de l'arte!" Mirollo, *The Poet of the Marvelous*, 292–93.

3. Georges Poulet, *The Metamorphoses of the Circle*, trans. Carley Dawson and Elliott Coleman (Baltimore: Johns Hopkins University Press, 1966), pp. 16–19. Poulet cites the 1636 edition of Binet, the ninth of twenty to 1657. See also Pierre Boaistuau, *Histoires prodigieuses* (1560; rpt. Paris: Club du Livre, 1961).

4. Rousset, *La Littérature de l'âge baroque*, pp. 13–31.

5. *The Complete Poetry and Selected Prose of John Donne*, ed. Charles M. Coffin (New York: The Modern Library, 1952), pp. 191, 83, 248, 251.

6. "E se mai fu età ove si vedessero di mirabili e differenti cose, credo io che la nostra età sia di quelle ne la quale, molto più che in nessun altra, cose degne di stupore, di compassione, e di biasmo accadano." *Tutte le opere di Matteo Bandello*, ed. Francesco Flora (Milan: Arnaldo Mondadori, 1952), vol. 2, pp. 567–69.

7. Ludovico Ariosto, *Orlando Furioso*, ed. Lanfranco Caretti (Milan-Naples: Riccardo Ricciardi, 1963), pp. 330, 231.

8. "D'autant qu'à mon avis, des plus ordinaires choses et plus communes et cogneuës, si nous sçavions trouver leur jour, se peuvent former les plus grands miracles de nature et les plus merveilleux exemples, notament sur le suject des actions humaines." Michel Eyquem de Montaigne, *Oeuvres complètes*, ed. Albert Thibaudet and Maurice Rat (Paris: Editions Gallimard, 1962), p. 1059.

9. *The English Poems of George Herbert*, ed. C. A. Patrides (London: Dent, 1974), pp. 166–67, 171–73.

10. *Andrew Marvell: The Complete Poems*, ed. Elizabeth Story Donno (Harmondsworth: Penguin Books, 1972), p. 87.

11. Luis de Góngora y Argote, *Obras Completas*, ed. Juan Millé y Giménez and Isabel Millé y Giménez (Madrid: Aguilar, 1956), p. 635.

12. The poems of Carew and those of Sor Juana, Gryphius, and Le Moyne quoted in the remainder of this section are conveniently gathered in *Baroque Poetry*, ed. J. P. Hill and E. Caracciolo-Trejo (London: Dent, 1975). The Carew poems are on pp. 103–4.

13. Ibid, pp. 266–67: "y a penas nace, / cuando en la misma moneda, / lo que en perlas recibío, / empieza a pagar en perlas" (ll. 5–8); "llore Jesús, norabuena, / que lo que expende en rocío / cobrará después en néctar" (ll. 46–48).

14. Ibid., p. 243: "Nacht, mehr denn lichte Nacht! Nacht, lichter / als der tag! Nacht, heller als die Sonn! In der / das licht geboren, "

15. Ibid., pp. 252–55:
Loin du soleil et de la lune,
Au dessus des plus hauts esprits,
Les feux du Père et ceux du Fils
Te sont une source commune.
Là tes éclairs se font des leurs;
Tes flammes sont de leurs chaleurs
L'expression continuelle;
De tous les deux en toy le regard est complet;
Et tu fais au milieu la rencontre eternelle
D'un modelle fecond, et d'un fecond portrait.
(ll. 31–40)

16. Pliny the Elder, *Natural History*, 10 vols., trans. H. Rackham (Cambridge, Mass.: Harvard University Press, 1979), vol. 1, pp. viii–ix.

17. Pliny the Younger, *Letters and Panegyricus*, 2 vols., trans. Betty Radice (Cambridge, Mass.: Harvard University Press, 1972), vol. 1, pp. 133–41; it is the seventeenth letter of the second book.

18. See J. V. Cunningham, "Woe or Wonder: The Emotional Effect of Shakespearean Tragedy," in *The Collected Essays* (Chicago: The Swallow Press, 1976), pp. 53–96. See also the unpublished dissertation by James P. Biester, "Strange and Admirable: Style and Wonder in the Seventeenth Century," Columbia University, 1989, for an updated discussion of the subject and a rich bibliography.

19. Aristotle, *Metaphysics*, trans. Richard Hope (Ann Arbor: The University of Michigan Press, 1960), p. 7.

20. *The Rhetoric of Aristotle*, trans. Lane Cooper (New York: Appleton-Century Crofts, 1960), pp. 64, 65, 185, 212–13.

21. Aristotle, *Poetics*, trans. Richard Janko (Indianapolis: Hackett Publishing Company, 1987), pp. 4, 13, 35.

22. Longinus, *On the Sublime*, in *Classical Literary Criticism*, trans. T. S. Dorsh (Harmondsworth: Penguin Books, 1977), pp. 146, 148.

23. Lucian, *Works*, 8 vols., trans. K. Kilburn (Cambridge, Mass.: Harvard University Press, 1968), vol. 6, pp. 155, 163.

24. J. J. Pollitt, *The Ancient View of Greek Art* (New Haven: Yale University Press, 1974), p. 63.

25. Ibid., pp. 63–64.

26. Pliny the Elder, *Natural History*, vol. 35, pp. 343, 309–11.

27. Philostratus the Elder, *Imagines*, and Callistratus, *Descriptions*, trans. Arthur Fairbanks (Cambridge, Mass.: Harvard University Press, 1979), p. 25.

28. Cunningham, "Woe or Wonder," p. 68.

29. Ibid., pp. 70–74.

30. Averroes, "The Middle Commentary on the *Poetics* of Aristotle," in *Classical and Medieval Literary Criticism*, translations and interpretations by Alex Preminger, O. B. Hardison, Jr., Kevin Kerrane (New York: Frederick Ungar, 1974), p. 359.

31. Umberto Eco, *Art and Beauty in the Middle Ages*, trans. Hugh Bredin (New Haven: Yale University Press, 1986), p. 14.

32. Baxter Hathaway, *The Age of Criticism: The Late Renaissance in Italy* (Ithaca: Cornell University Press, 1962). See also his *Marvels and Commonplaces: Renaissance Literary Criticism* (New York: Random House, 1968).

33. *Trattati di poetica e retorica del '500*, ed. Bernard Weinberg, 4 vols. (Bari: Laterza, 1970–74), vol. 2, p. 48: "tutti quelli che narrano o che riferiscono alcuna cosa sempre vi aggiungano del suo per fare più meraviglia a chi lo ascolta."

34. Ibid., vol. 2, p. 464: "cose che siano fuori dell'ordine commune e fuori de' termini naturali."

35. Ibid., vol. 2, p. 575: "le cose che il popolo dilettano e muovano a maraviglia."

36. Ibid., vol. 3, p. 196: "Bellissima parte è della poesia lo ammirabile quando qualcosa fuori della espettazione di chi l'ascolta adviene, perche gli uomini dellé cose nuove e fuori della loro opinione si maravigliano e ne pigliano dilletto."

37. Ibid., vol. 3, p. 390: "ogni poema per sua natura é fondato nella maraviglia."

38. See the discussion of Talentoni in Bernard Weinberg, *A History of Literary Criticism in the Italian Renaissance* (Chicago: The University of Chicago Press, 1961), vol. 1, pp. 238–39.

39. Weinberg, ed., *Trattati*, vol. 4, p. 40: "le meraviglie degli intramezzi"; "dilettare le svogliate orecchie dei moderni uditori."

40. Ibid., vol. 4, p. 181: "si pensano coi chiribizzi male spiegati porgere all'anime degli eruditi maraviglie di concetti et in vece di quelli vi pongano sciocchezze."

41. On Pellegrino's dialogue, see my *The Poet of the Marvelous*, pp. 11–12, 172–74.

42. Torquato Tasso, *Discorsi del poema Eroico*, in *Prose*, ed. Ettore Mazzali (Milan-Naples: Riccardo Ricciardi, 1959), pp. 487–729. There is an English translation: *Discourses on the Heroic Poem*, trans. Mariella Cavalchini and Irene Samuel (Oxford: Clarendon Press, 1973).

43. Ibid., p. 538: "Attribuisca il poeta alcune operazioni che di gran lunga eccedono il potere de gli uomini a Dio, a gli angioli suoi, a' demoni, o a coloro a'quali da Dio o da' demoni è conceduta potestà, quali soni i santi, i magi e le fate. Queste opere, se per se stesse saranno considerate, maravigliose parranno: anzi miracoli sono chiamati nel comune uso del parlare. Queste medesime, se si averà riguardo a la virtù ed a la potenza di chi l'ha operate, verisimili saranno giudicate."

44. Ibid., pp. 642–43: "la meraviglia sempre apporta seco diletto, perche il dilettevole è meravigliso."

45. Ibid., p. 687: "la piacevolezza, da la grazia e da la beltà dei concetti."

46. In addition to Aristotle's *Rhetoric*, cited above, n. 20, see Cicero, *De Oratore* 2 vols., trans. E. W. Sutton and H. Rackham (Cambridge, Mass.: Harvard University Press, 1959), vol. 1, pp. 357–418; Quintilian, *The Institutio Oratoria*, 4 vols., trans. H. E. Butler (Cambridge, Mass.: Harvard University Press, 1979–80), vol. 2, pp. 431–501.

47. Emmanuele Tesauro, "Il Cannocchiale Aristotelico," in *Trattatisti e narratori del seicento*, ed. Ezio Raimondi (Milan-Naples: Riccardo Ricciardi, 1960), p. 24: "Ancora il grande Iddio godé talora di fare il

poeta e l'arguto favellatore, mottegiando agli uomini e agli angeli con varie imprese eroiche e simboli figurati gli altisisimi suoi concetti. E a giusto ragioni. Primieramente, acciò che l'ingegno divino non ceda punto a l'umano, ne quella mente insterilisca, la qual feconda di concetti le altri menti. Però che quanto ha il mondo di ingegnoso, o è Iddio o è da Dio; Dipoi, acciò che lo stile della divina maestà non senta punto del triviale, ma da nobili figure si sollievi in guisa che la sublimità generi maraviglia, e la maraviglia venerazione."

48. Ibid., p. 26: "argutezzi della Nature"; p. 34; p. 74: "dalla novità soprafatto, considera l'acutezza dell'ingegno rappresentante e la inaspettata imagine dell'obietto rappresentato."

49. Ibid., p. 74: "unpien teatro di meraviglie"; p. 94: "le perfette argutezze e gli'ngenosi concetti non esser altro che argomenti urbanamente fallaci."

50. The essays by Peregrini and Pallavicino are edited along with Tesauro in *Trattatisti e narratori*, pp. 113–90 and 197–217; p. 198 "osservazione maravigliosa raccolta in un detto breve."

51. Baltasar Gracián, *Agudeza y arte de Ingenio*, 2nd ed. (Buenos Aires-México: Espasa-Argentina, S. A., 1944), p. 17: "un acto del entendimiento que esprime la correspondencia que se halla entre los objectos."

52. See Mirollo, *The Poet of the Marvelous*, pp. 73–74, 229–30.

53. Nicolas Boileau-Despréaux, *L'Art poétique*, in *The Continental Model*, ed. Scott Elledge and Donald Schier (Ithaca: Cornell University Press), 1960, p. 234:
Jamais au spectateur n'offrez rien d'incroyable:
Le vrai peut quelquefois n'être pas vraisemblable.
Une merveille absurde est pour moi sans appas:
L'esprit n'est point ému de ce qu'il ne croit pas.

54. *Samuel Johnson's Literary Criticism*, ed. R. D. Stock (Lincoln: University of Nebraska Press, 1974), pp. 208–10.

55. Rensselaer W. Lee, *Ut Pictura Poesis: The Humanistic Theory of Painting* (New York: W. W. Norton & Company, 1967), pp. 3–9 *et passim*.

56. See Dennis Mahon, *Studies in Seicento Art and Theory* (London: The Warburg Institute, 1947), p. 3.

57. Giorgio Vasari, *Le vite dei più eccellenti pittori, scultori e architetti*, 4 vols., ed. Licia and Carlo L. Ragghianti (Milan: Rizzoli, 1971–78), vol. 1, p. 85: "che le rendesse stupende e maravigliose a tutto il mondo."

58. Ibid., vol. 1, p. 564: "con grandissimo e veramente maraviglioso affetto, in tanto che par quasi una persona viva che bea."

59. Ibid., vol. 2, p. 612: "fece maravigliare tutti gl'artefici"; "le meraviglie di Lionardo, che fece stupire tutto quel popolo."

60. Ibid., vol. 4, p. 322: "invero si maraviglia lo stupore che mano d'artefice far in pocchissimo tempo cosa sì mirabile."

61. Ibid., vol. 4, p. 527: "ancora che sia bellissima non muove a lascivia, ma a comiserazione."

62. Giovanni Andrea Gilio, *Degli errori e degli abusi de'pittori*, in *Trattati d'arte del Cinquecento*, 3 vols., ed. Paola Barocchi (Bari: Laterza, 1960–62), vol. 2, p. 29: "quello artefice che di osservarlo non si curerà, farà le sue opere più tosto degne di riso che di maraviglia."

63. Gabriele Paleotti, *Discorso intorno alle imagini sacre e profane*, in Barocchi, *Trattati*, vol. 2, p. 213: "sopra tutto giovano meravigliosamente. . . . alla utilità et edificazione del prossimo."

64. Francesco Bocchi, *Eccellenza del San Giorgio di Donatello*, in Barocchi, *Trattati*, vol. 3, p. 194: "quella compiuta e rara bellezza che, nelle umane opere essendo quasi incredibile, genera negli animi nostri stupore e maraviglia."

65. Romano Alberti, *Trattato della nobilità della pittura*, in Barocchi, *Trattati*, vol. 3, p. 215.

66. Gregorio Comanini, *Il figino onero del fine della pittura*, in Barocchi, *Trattati*, vol. 3, p. 354.

67. Giovan Paolo Lomazzo, *Trattato dell'arte della pittura, scoltura et architettura*, in *Scritti d'arte del Cinquecento*, 3 vols., ed. Paola Barocchi (Milan-Naples: Riccardo Ricciardi Editore, 1971–77), vol. 3, pp. 2692–93.

68. Ibid., vol. 1, p. 354: "qualche spirito di poesia."

69. Ibid., vol. 1, p. 358: "stupende rappresentazioni . . . ci rapiscono e ci trasformano."

70. Giovan Battista Armenini, *De' veri precetti della pittura*, in Barocchi, *Scritti*, vol. 2, p. 2002.

71. Federico Zuccari, *Idea de' pittori, scultori et architetti*, in Barocchi, *Scritti*, vol. 1, pp. 1036, 1047.

72. On Le Moyne see Jean H. Hagstrum, *The Sister Arts* (Chicago: University of Chicago Press, 1958), pp. 106–7.

73. Giovan Pietro Bellori, *Vite de' pittori, scultori et architetti moderni*, excerpted in *A Documentary History of Art*, ed. Elizabeth Gilmore Holt (Princeton: Princeton University Press, 1982), vol. 2, pp. 94–106.

74. Filippo Baldinucci, *Life of Cavaliere Giovanni Lorenzo Bernini*, in Holt, vol. 2, p. 112.

75. Nicolas Poussin, Letter of November 24, 1647, to Paul de Fréart, Sieur de Chantelau, in Holt, vol. 2, p. 155.

76. Charles Le Brun, "Concerning Expression in General and in Particular," in Holt, vol. 2, p. 162.

77. Anthony Ashley Cooper, Third Earl of

Shaftsbury, "Notion of the Historical Draught or Tablature of the Judgment of Hercules," in Holt, vol. 2, p. 259.

78. Colen Campbell, "Introduction to Vitruvius Britannicus," in Holt, vol. 2, p. 290.

79. Francesco Milizia, *Dizionario delle belle arti del disegno*, 2 vols. (Bologna: Stamperia Cardinali e Frulli, 1827), vol. 1, p. 131: "il superlativo del bizzarro, l'eccesso del ridicolo."

80. Gotthold Ephraim Lessing, *Laocoön: An Essay on the Limits of Painting and Poetry*, trans. Edward Allen McCormick (Indianapolis: The Bobbs-Merrill Company, 1962), p. 11.

81. Sir Joshua Reynolds, *Discourses on Art*, ed. Robert R. Wark (New Haven: Yale University Press, 1975), p. 231.

82. Pierre-Maxime Schuhl, *L'Imagination et le merveilleux* (Paris: Flammarion, 1969), p. 35: "Le domaine du merveilleux est un domaine immense. Pour l'explorer en un temps limité, il faudrait être soi-même un magicien."

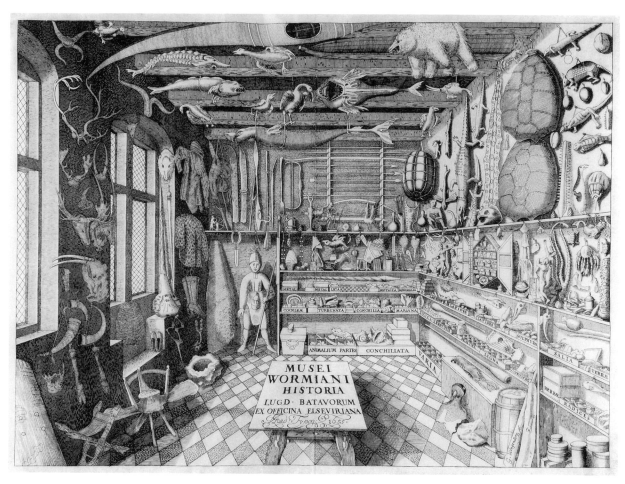

Fig. 1 Interior of Olé Worm's museum.
Engraved frontispiece to Olé Worm, *Museum Wormianum seu historia rerum rariorum*, Leiden, 1655.
Smithsonian Institution Libraries, Washington, D.C. (cat. no. 17).

"A World of Wonders in One Closet Shut"

Joy Kenseth

IN 1654 A VISITOR TO THE MUSEUM OF THE DANISH NATURAL-
ist Olé Worm reported that in this place "is found and can be examined with wonder,
odd and curious rarities and things among which a large part has not been seen
before, and many royal persons and envoys visiting Copenhagen ask to see the museum
on account of its great fame and what it relates from foreign lands, and they wonder and
marvel at what they see."[1] Worm's guests had every reason to be astonished, for the
museum's contents were a bewildering mixture of remarkable naturalia and man-made
objects. An illustration of the museum's interior (cat. no. 17; *fig. 1*) shows huge tortoise
shells, an armadillo, the spiral tusk of the narwhal, a saw of a sawfish, a penguin, oddly
shaped antlers and horns, the skin of a polar bear, and a host of other exotic animals or an-
imal fragments that the professor had acquired or received as gifts in a period of thirty
or so years. Displayed together with Worm's natural specimens was his vast collection of
ethnographic artifacts — man-made objects that came from the Americas, China, Turkey,
and other distant lands. A kayak was suspended from the ceiling of his museum, while
spears, bows and arrows, articles of clothing, and musical instruments were arranged on
the walls and shelves. On one shelf containing bone fragments, the preserved remains of
a squid, a crab, and small fish, two statuettes were displayed — one of a male nude and
the other a replica in miniature of Giovanni da Bologna's *Rape of the Sabine Woman*. On
the opposite side of the room, beneath the windows, was a large geode and in front of
this two stools, one with legs in the form of serpents and the other fashioned from the ver-
tebra of a whale.

When compared to the museums of today, Worm's collection seems an extraordinarily
odd and illogical assemblage: natural and man-made things were freely intermixed, and
the items, overwhelmingly, were exotic, unusual, and curious in their character. But in
the sixteenth and seventeenth centuries collections of this general type were common.

81

Not all of them had the character of Worm's, as many were comprised chiefly of paintings, sculptures, or antiquities, while others displayed works of nature and of art in about equal proportions. The differences between the collections often were more striking than their similarities.

The rarities that Worm installed in his museum contrasted noticeably, for instance, with those found in the gallery of the Medici grand dukes in Florence. Its rooms "were heaped up [with] rare exquisite things," according to one visitor.[2] Antique busts and statues lined the corridors; gold and silver plate, scientific instruments, and wonderfully turned items in ivory were installed in adjoining rooms. The most splendid room of the gallery, the Tribuna, was loaded with treasures, including precious gems and medals, finely made bronze statuettes, and masterpieces by Raphael, Michelangelo, Titian, and Dürer. The display of wealth and the prominence of works of art clearly set the gallery apart from Worm's museum. But the two collections nonetheless had some notable points in common. Both had many curious, indeed very strange, things on view, and the artificial and natural items were displayed in baffling juxtaposition. In the Medici collection prized works of art were exhibited with such things as a pearl the size of a hazelnut, a "unicorn's horn," a branch of coral that "still grew," and a famous iron nail, half of which, according to reports, had been turned to gold by the art of alchemy. Here, along with parade armor, pistols, and swords, one found Caravaggio's painting *Medusa*, American Indian cloaks composed of parrot feathers, an exceptionally powerful magnet, and "the skin of a horse pasted upon a wooden horse."[3] In the Medici gallery and in Worm's museum the oddity of nature vied for attention with some rare thing fashioned by human hands. And in both the beholder was confronted with a truly stunning diversity of objects.

Diversity, abundance, a love for the singular, the odd, and the uncommon—these were the traits of a majority of sixteenth- and seventeenth-century museums, or, as many of them were also called, cabinets of curiosities or *Kunst- und Wunderkammern* (rooms of art and marvels).[4] Though collections of rarities and other heterogenous items had been formed in earlier periods—medieval church treasuries and the treasury rooms of feudal lords are notable examples—it was not until the sixteenth century that they became widespread.[5] Established not just by monarchs and princes but also by natural scientists and by members of such professions as medicine, the law, and education, they were to be found all over Europe. No one has yet attempted to make a tally of these early museums, but by some estimates they numbered in the thousands.[6]

The proliferation of such museums, indeed the tremendous expansion of collecting in general, was a distinctly Renaissance phenomenon, a manifestation of the period's inquisitiveness, its preoccupation with understanding all aspects of the physical world, and its emphasis on individual human achievement. What lay behind the creation of the early museums especially was the humanist aspiration for comprehensive knowledge, a belief that in the course of his lifetime a man could know everything. And, indeed, as hu-

manist ideas spread across Europe, there was a corresponding increase in all-embracing, encyclopedic collections.

The Encyclopedic Museum and the Quest for Universal Knowledge

In his famous *Oration on the Dignity of Man*, first published in 1496, the humanist Giovanni Pico della Mirandola gave eloquent expression to the belief in man's privileged status in the world and his capacity to acquire comprehensive knowledge. After having created the celestial regions and the world teeming with animal life, he says, the Divine Architect "longed for a creature which might comprehend the meaning of so vast an achievement, which might be moved with love at its beauty and smitten with awe at its grandeur." God placed man at the center of the world, he declares, because from that vantage point he could more easily survey all that the world contains. But, according to Pico, man's comprehension and appreciation of God's work is not obtained automatically. Rather, by the exercise of his God-given free will he could descend into forms of life that were brutish or he could aspire to that which is divine. Man had been given extraordinary spiritual and intellectual powers and by means of these powers he should search out the causes of things, the ways of nature and the plan of the universe, and the mysteries of the heaven and earth. Pico argues vehemently against narrowness of mind, saying that one should range through all the masters of philosophy, "for by the confrontation of many schools and the discussion of many philosophical systems that 'effulgence of truth' of which Plato writes in his letters might illuminate our minds more clearly."[7]

In the 1530s François Rabelais voiced similar opinions. He provided one of the best-known tributes to the attainment of universal knowledge in his account of the life and deeds of Pantagruel. In a letter from his father Gargantua, Pantagruel is told that "no one has any business going out in public or being seen in company, unless he has been well polished in the workshop of Minerva." He therefore outlines an encyclopedic education for his son, admonishing him to devote himself to the study of a great range of subjects: he should learn all the languages, acquaint himself with every bit of history, and keep up with the liberal arts and music. He should endeavor to master all the laws of astronomy, know the best texts of civil law by heart and compare them with philosophy, and attain a perfect knowledge of man by reading the Old and New Testaments. As for the study of nature, he says, "let nothing be unknown to you."[8]

These writings articulate the confident belief that a universal knowledge was possible and that a human being had the means by which to achieve it. Such an outlook made a notable break with the past, for whereas in the Middle Ages the mysteries of nature and the world were matters best left to God, they now became the focus of human scrutiny. God had made the world for man's contemplation and man therefore should study and investigate it. In this age of the "decompartmentalization" of knowledge, as Erwin Panofsky has called it, totality or universality became the goal.[9] Following the example

of Pliny the Elder, whose *Natural History* increasingly became an important source of inspiration, men such as Konrad Gesner and Ulisse Aldrovandi produced vast compendia in which they attempted to inventory and describe all forms of life known to them. In a similar vein, Giorgio Vasari produced his vast account of the lives of the artists from the time of the renewal of the arts that began with Cimabue up until the artists of his own day. The desire for universality was evident in gardens, with their great diversity of botanical specimens, their abundant animals contained in menageries and aviaries, and their many antiquities, statues, and diverse hydraulic marvels. The subject matter of paintings was also often encyclopedic: ideal assemblages of animals were set in a Garden of Eden atmosphere; flowers of all seasons were gathered together in still-life pictures; and paintings from every category—religious, historical, mythological, portraits, still lifes, landscapes, and genre—were represented in pictures of collections. But it was in the museums of the time, in the cabinets of curiosities and the *Kunst- und Wunderkam-mern*, where the desire, indeed the quest, for comprehensiveness or encyclopedism was most prominent and most vigorously pursued.

<p style="text-align:center">✳ ✳ ✳</p>

In his 1565 publication *Inscriptiones vel tituli theatri amplissimi*, the Flemish doctor and artistic advisor Samuel Quiccheberg offers detailed guidelines for properly organizing collections. He argues for the creation of all-embracing museums in which it would be possible to learn about the whole world. Recalling the concept of the *theatrum mundi* as described earlier in the century by Giulio Camillo, Quiccheberg calls his ideal museum a *"universo theatro"* or theater of the universe. Such a museum, according to his plan, would in microcosmic form reflect the order of the macrocosm. The collection would be arranged according to the four cardinal points of the compass, the four seasons, the four elements, and the four ages of man. Religious imagery of all types would be represented and all known types of *naturalia* and *artificialia* would be arranged according to materials and in a logical sequence. At certain points, portraits and genealogies and other materials pertaining to the museum's founder would be installed. According to Quiccheberg, the exhibits of the ideal museum would allow one to gain knowledge of the universe and of God: they would reveal the creative ingenuity of man and his maker and, furthermore, would reflect the personality of the one who had brought the museum into being. Although Quiccheberg's elaborate scheme was never realized in any museum, his manual often determined the kinds of objects collectors purchased and, more significantly, served as a model for museum catalogues. His view of a comprehensive museum, one in which the *naturalia* and *artificialia* together would give insight into God's universe, was shared by many at the time and continued to be a guiding principle for numerous collectors in the seventeenth century.

Quiccheberg stated that he had devised his plans for the ideal museum after having

visited many libraries and museums, notably the collections of Duke Albrecht V (1528–79) in Bavaria.[10] Albrecht's Munich *Kunstkammer* was notable for its encyclopedic breadth, and among its vast holdings were objects—historical works, "miraculous things," paintings, sculptures, exceptional examples of craftsmanship—that became the basis for the classifications in Quiccheberg's manual. In the Munich *Kunstkammer*, moreover, objects were generally arranged according to materials, a method of organization that is advised by Quiccheberg and that ultimately derives from Pliny's *Natural History*. The arrangement of objects with respect to the unity of materials was also evident in the collection of Archduke Ferdinand II at Schloss Ambras (1570s), as well as in numerous other collections of the period.[11]

While the collection of Albrecht V was one of the most impressive of its time (it consisted of nearly 3,500 items), the most spectacular collection in Northern Europe during the late sixteenth century was that assembled by the Habsburg emperor Rudolf II. Established at the Hradschin Palace in Prague, its thousands of items included paintings, sculptures, exquisitely wrought decorative arts, ethnographic objects, instruments of astrology, alchemy, and magic, and every conceivable type of natural curiosity. The encyclopedic program of Rudolf's *Kunst- und Wunderkammer* embraced all the human arts, all the branches of human knowledge, and all the different realms of nature.[12] A museum shaped by the emperor himself and reflective of his varied interests and personal tastes, it was, according to Thomas DaCosta Kaufmann, "a form of *representatio*," whereby "Rudolf's possession of the world in microcosm . . . [was] . . . an expression of his symbolic mastery of the greater world."[13] Other princely collections carried a similar cosmological meaning. The Tribuna of the Medici grand dukes, for example, was designed in such a way that the power of the ruler was seen as an integral part of God's universal order.[14] The universality of such collections and their lavish displays of wealth served to glorify the owner, asserting his preeminence in the world of men as well as his favored position within a larger cosmological scheme. Although, after the publications of Copernicus and Galileo, man no longer stood at the center of the universe, the collector was able to place himself in the middle of a world of his own making, one that reflected the macrocosm in miniature and in which he could experience firsthand the manifold forms of nature and a variety of wondrous objects fashioned by man.

The collections formed by those in less powerful positions were not overlaid with elaborate political or cosmological symbolism, but they often served as status symbols and sometimes were a means to climb the social ladder. When a private citizen created a cabinet or museum of wide-ranging items, it gave evidence of his catholic tastes and the breadth of his learning. In short, it identified him as a gentleman. As Gargantua had said to Pantagruel, no one should go out into society "unless he has been well polished in the workshop of Minerva." The encyclopedic collection was, in fact, such a workshop. Monarchs and princes often saw the museum or the *Kunst- und Wunderkammer* as a place of study or as a laboratory, but it was the scholar-collector especially who regarded it as

a locus for intellectual pursuits. Indeed, the rise of collections coincided with the elevation of the status of the scholar, who no longer was a passive observer of the world but an active and engaged participant, investigating, questioning, and describing its myriad parts.[15] In the case of scientists such as Ulisse Aldrovandi, the encyclopedic collection functioned most of all as an instrument of learning (cat. no. 19). A professor of natural history at the University of Bologna, Aldrovandi conceived his museum of natural and ethnographic objects as a place where one could investigate, comprehend, and document the full extent of the natural world. Worm's museum was also meant as a place for study. He had created his museum chiefly for his students at the University of Copenhagen, so while it delighted and astounded princes and other dignitaries, it had a serious purpose, to enlighten young minds about the discipline of natural history.[16]

For many, the museums had a purpose beyond the pursuit of knowledge for its own sake. The quest for universal knowledge was linked to the celebration of God's creation. As Quiccheberg noted, the first great collections were those described in the Old Testament—the treasure house of King Hezeki'ah and the temple of Solomon—and built in the name of the Lord. These are the models for the Christian collector, for in making a "theater of the universe" he can represent and praise God's omnipotence and his wonderful acts.[17] A similar sentiment was expressed in the next century by a physician and collector from Kiel, Johann Daniel Major (1636–93). In a short treatise concerned with *Kunst- und Naturalienkammern*, Major speaks of the Fall of man and his redemption through Christ. Man strives for goodness and at the same time has an innate desire to acquire knowledge. In order to regain what had been lost at the time of Adam, his efforts should be directed to the praise of God. A collection therefore should not only satisfy man's desire to know, it should have a higher purpose—the recognition and honor of God's sublime work.[18]

Marvels in the Museums

Inscribed over the entrance to the cabinet assembled by the French doctor Pierre Borel were the words, "Stop at this place (curious one), for here you behold a world in the home, indeed in a Museum, it is a microcosm or Compendium of all rare things."[19] It was the exceptional, not the commonplace, item that interested him and that he felt was most worthy of display. A preference for the extraordinary and unusual could be found in a majority of the encyclopedic collections. When, for example, the Swiss Thomas Platter visited the collection of Walter Cope (d. 1614) in England at the end of the sixteenth century, he saw a remarkable accumulation of diverse and strange items. It was "an apartment stuffed with queer foreign objects in every corner," he said, and a most superior collection on account of the strange objects Cope had acquired on an "Indian voyage."[20] Lorenz Hoffman (d. 1630), a doctor of medicine in Halle, Germany, had an impressive collection of art, antiquities, and curiosities. He was able to show, for example,

an armband made of elk's hoofs, American Indian capes made of parrot feathers, rings fashioned from rhinoceros horn, and art objects such as "a hen made out of real feathers." Among his possessions were paintings by Dürer and Cranach, pictures of Martin Luther as a corpse and as a monk, two dozen miniature spoons hidden in a cherry stone, a plait of hair from an old German woman, a dragon in a box, and a skeleton of a four-week-old child.[21] The collection put together by the Veronese Lodovico Moscardo in the second half of the seventeenth century also was known for an abundance of *meraviglie*. In addition to mummies, exotic *naturalia*, and rare musical instruments, it had on display such curiosities as "giants' teeth," magical stones, and shells that produced ducks.[22] The museum of Manfredo Settala (1600–80) in Milan was packed with novelties and had very little in it that could be regarded as ordinary (*fig. 2*; cat. no. 18). Among its treasures were mummies; "rare and curious musical instruments;" burning glasses, perpetual motion machines, a crocodile and odd fish, "cunning locks and these not often to be seen"; books and maps made of leaves and the bark of trees; fossils and figured stones; pictures by Bronzino, Bassano, and Raphael; and a painting of "a woman of tall stature with her face hairy all over, every hair as long as one's hand, an egregious work of Paini."[23] Ferdinando Cospi's museum in Bologna, which was publicized as having "peculiar manufactures of Art" and "curious works of Nature," strongly emphasized the bizarre, the strange, and the monstrous.[24]

Another remarkable collection was that founded in 1638 by the Englishman John Tradescant at his home in Lambeth. A museum that reflected the owner's particular fondness for the strange and the unusual, The Ark, as it was called, became internationally famous within the first five years of its existence. Appropriately described as "a world of

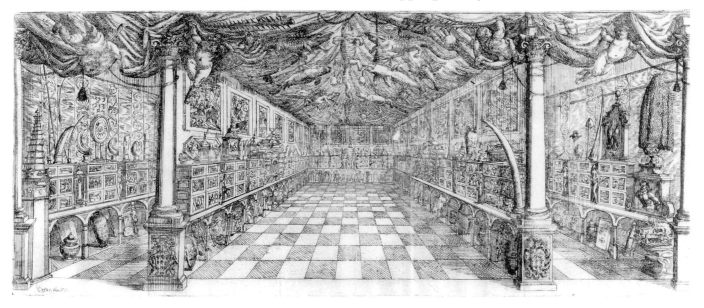

Fig. 2 Interior of Manfredo Settala's collection.
Engraved frontispiece from Paolo Maria Terzago, *Museum Septalianum*, Tortona, 1664.
Smithsonian Institution Libraries, Washington, D.C. (cat. no. 18).

wonders in one closet shut," it contained a wealth of natural and artificial rarities that included, among other things, "a goose which has grown in Scotland on a tree," "the hand of a mermaid, and the hand of a mummy," "bright colored birds from India," "Turkish and other foreign shoes and boots," "an elk's hoof with three claws," coins, all sorts of shells, two agate cups, "the Passion of Christ carved very daintily on a plumstone," "pipes from the East and West Indies," anamorphic pictures of Henry IV and Louis XIII of France, and a stuffed dodo.[25] The great variety of objects in The Ark, as one of Tradescant's contemporaries observed, made it the best place "for the full improvement of children in their education." And, indeed, the collection was frequented not only by children, but also by scholars and scientists who saw it as a valuable research tool.[26] But The Ark's fame rested less on its value for scholarly study than on its power to inspire wonder. According to its creator's own design, it was a repository of unusual, rare, and marvelous things; as Tradescant himself wrote, he "wanted the Bigest that can be gotten . . . Any thing that is strang[e]."[27]

Collectors like Tradescant assembled a great range of *meraviglie* because, it was believed, they best represented the creative forces at work in the world. If one wanted to comprehend and fully appreciate the creative capacities and ingenuity of human beings, then it stood to reason that the exceptional, rather than the ordinary, object should be collected. Similarly, nature's rarities were to be preferred to her commonplaces. By studying the unusual performances of nature or her "errors," one could gain insight into her variability and ultimately discover her hidden truths.[28] The curiosity cabinets and *Kunst- und Wunderkammern* were therefore often filled to the brim with specimens from the three kingdoms of nature, with wide-ranging examples of human industry and art, and with *miracula* or objects representing God's creative power. Objects usually fell into one of a museum's two major divisions, *naturalia* and *artificialia*, but often they seemed to defy classification and straddled the line between these two realms. In other instances, the line between the natural and supernatural was blurred, and many of the *meraviglie* were collected because of the air of mystery that surrounded them.

Typically, one found in the cabinets of curiosities items that had medico-magical properties; that is, objects whose value as wonders depended mostly on superstitious belief or derived from the authority of earlier, especially ancient, writers. *Coco-de-mer* (coconuts), rhinoceros horn, and "adders' tongues" (fossilized sharks' teeth) were collected, for example, because it was thought they were effective antidotes to poison (cat. nos. 32, 33). Dried herbs that strengthened memory, restored lost speech, or preserved youthfulness were kept, as were those that warded off apoplexy and pestilential vapors. Corals of every type were seen to have apotropaic qualities against the evil eye (cat. nos. 38, 39), while such things as musk pouches and bezoars (stones produced in the stomachs of ruminant animals) were valued either as aphrodisiacs or for their supposed prophylactic properties. Most collections of the time had fossils or what were called figured stones. Robert Plot, for example, scoured the English countryside for such *mirabilia*, while the

Jesuit polymath Athanasius Kircher, who found all sorts of miraculous images in fossil and mineral specimens, collected them in huge numbers (*figs. 3, 4*; cat. nos. 101, 184). Many items that wound up in museums exhibited nature's capacity to produce the weird and the grotesque: hairballs found in the stomachs of beasts, for example, or such things as kidney stones, double eggs, and malformed antlers or horns. Animals or animal fragments that were believed to have marvelous powers were commonly exhibited, and even after the spiral tusk of the unicorn was discovered to come from the narwhal rather than from an animal that sensed the purity of maidens, it continued to be a favorite item in *Wunderkammern*.

Most collectors boasted about having examples of extremely small and exceptionally

Fig. 3 Figured stones. Engraving. From Robert Plot, *The Natural History of Oxford-shire*, London, 1705. Dartmouth College Library, Dartmouth College, Hanover, New Hampshire (cat. no. 184B).

Fig. 4 Figured stones. Engraving. From Athanasius Kircher, *Mundus Subterraneus*, Amsterdam, 1665. Harvey Cushing/John Hay Whitney Medical Library, Yale University, New Haven, Connecticut (cat. no. 101A).

large animal specimens in their museums: thus, in addition to insects and tiny jewel hummingbirds, they proudly displayed such wonders as elephant tusks, the ribs of whales, and huge teeth (the remains of mastodons). Kircher's museum included "observations of small things seen through a microscope"; the Surgeons' Guild at Delft, on the other hand, had in its possession the stuffed body of the great *renoster*, or rhinoceros. In many *Wunderkammern*, moreover, one could find "giants' bones" (dinosaur fragments). While some collectors recognized these as the remains of exceptionally large animals, others believed them to be confirmations of the gigantic races described in the Old Testament.

The *animalia* that came from recently explored lands, especially from the New World, offered abundant proof of nature's exceptional performances. Exotic specimens constituted a significant part of a museum's holdings, and of these armadillo skins, Indo-Pacific shells, trunkfish and puffers, crocodiles, cassowaries, toucans, and the bird of paradise were often the preferred specimens.

The most startling items in the early collections, however, were the human and animal anomalies. These peculiarities of nature, or exceptional works of God, appeared not only in the collections associated with medical institutions, as one would expect, but also in the cabinets of private citizens and monarchs. The Borrilly collection in Aix claimed to have an "embalmed cyclops"; a two-headed calf was owned by the Royal Society; and in a surprising number of collections one saw the preserved remains of infant Siamese twins.[29] There were cases also of collectors keeping human anomalies as "live exhibits"; in the illustration of Lorenzo Legati's 1677 catalogue of the Museo Cospiano, for example, there appears the little dwarf who served both as guide and as study piece (*fig. 5*; cat. no. 19).[30] The fascination for such "exhibits" took an extraordinary turn with Peter I of Russia. At least four human prodigies were kept in the czar's household, including Foma, a man who had only two digits on each of his limbs. Foma was the prized wonder, apparently, for when he died Peter had him stuffed and installed with all the other *meraviglie* in his *Kunst- und Wunderkammer*.[31]

Collectible *artificialia* were as diverse as that of natural wonders. Besides paintings, sculptures, and decorative arts, man-made marvels included ethnographic items, mechanical devices, manuscripts and books, armor and weaponry, and mathematical as well as astronomical equipment. A rare painting by Albrecht Dürer was a cause for marveling, but so was a simple utilitarian object from a distant culture. Items representing deviations from the norm, such as playing cards for giants and dwarfs, found their way into the *Kunstkammer* of Schloss Ambras along with spectacular works of ivory and gold, cleverly designed tableclocks, and masterpieces in bronze. And among the curiosities kept at the University of Leiden *Anatomiekammer* one could see not only Egyptian surgical instruments, but also "a pair of stilts or skates with which the Norwegians, Laplanders and Finlanders run down high snowy mountains, with almost an incredible swift pace."[32]

The *artificialia* of a *Kunst- und Wunderkammer*, like many of the *naturalia*, could bring the collector into contact with worlds separated from him either by time or geo-

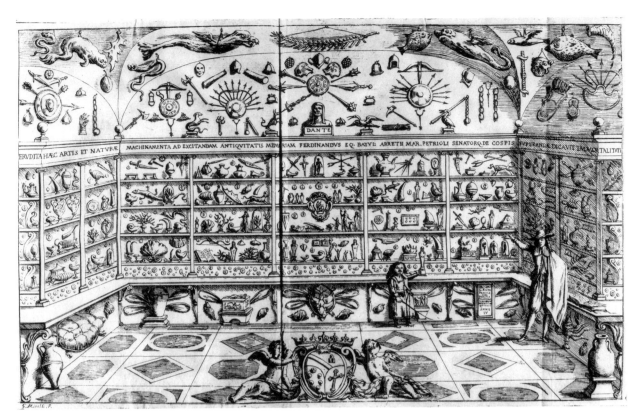

Fig. 5 Interior of Ferdinando Cospi's collection.
Detail of woodcut frontispiece to Lorenzo Legati, *Museo Cospiano annesso a quello del famoso Ulisse Aldrovandi*. Bolgona, 1677.
Smithsonian Institution Libraries, Washington D.C. (cat. no. 19).

graphical distance. The exotic or historical piece was a means of access to the invisible, ultimately serving the collector's quest to gain a complete view of the universe.[33] Humble utilitarian objects of foreign or ancient origin fulfilled this purpose, but more effective by far were the wonder-provoking items: spectacular or ingeniously created things, and curious or strange artifacts that had no resemblance to European productions. In the case of New World objects, anything associated with Indian rituals or customs aroused interest. Nine stone idols from America were listed among the *rariora* of Antonio Giganti's (1535–98) museum; Amazonian war axes and "flutes made of legs which have been eaten by the cannibals" were in the possession of Bernhard Paludanus (1550–1633); and in Kircher's museum in Rome, Brazilian necklaces, birch-bark ladles, and "masks of the inhabitants of Canada" were put on display.[34] Even more impressive were the feather-works—headdresses, capes, ceremonial fans, and shields—that originated from the tropical and subtropical regions of the American continent (*fig. 6*). Giganti described a Florida headdress in his collection as being made of "small, fine, yellow, cunningly wrought" feathers, and in the catalogue to Settala's museum we read of "ingeniously woven" curiosities made from the feathers of Indian birds.[35]

The collecting of exotica included not only the works of art and *ethnographica* of

91

Fig. 6 Feathered cape, Tupinamba culture, Brazil, 17th century. Nationalmuseet, Copenhagen. Recorded as being part of the Royal Danish *Kunstkammer* in 1689.

foreign cultures, but also samples of strange languages. Nehemiah Grew's inventory of the Royal Society (cat. no. 22) lists examples of Arabic letters, of the "Malabarine letters and language," and "of the China language in a considerable variety of Characters."[36] Samples of foreign languages were featured items in Giganti's museum and in Cospi's. Exotic books, parchment documents, and inscriptions on palmetto leaves were collected both for what they might have to say and for the curious aspect of their lettering. Many of the exotic languages collected could be translated, but others—Egyptian and New World hieroglyphs, for example—could not. But this made them all the more intriguing and more wondrous, especially for Athanasius Kircher, who spent a considerable amount of time trying to penetrate their mysteries.[37]

Kircher was an enthusiastic collector of Egyptian artifacts, and as evidence of an exotic culture of the distant past they were also of great fascination to Otto van Heurn

92

(1577–1652), a professor of medicine in Leiden. Van Heurn was ever eager to have more material for the Leiden *Anatomiekammer*, and in begging letters to David Le Leu de Wilhelm he specifically asked for gifts "from the soil of Egypt"—idols with animal heads, mummies, hieroglyphic inscriptions—for, as he said, Egypt was the "mother of all learning in the past and today a refulgence which lights up antiquity for all scholars."[38]

Van Heurn's way of regarding Egyptian antiquities was typical: they were of interest primarily for the historical information they divulged. Greek and Roman antiquities were collected for the same reason. There were many collectors, to be sure, who were sensitive to the aesthetic qualities of such works, but most owners of encyclopedic collections valued the ancient object—portrait bust, statue, cameo, or coin—for who or what it represented. It was a thrilling sensation to stand face to face with the "great worthies" of the past; it was marvelous to behold the famous events of distant times.[39] The subject matter of the work and the historical associations it triggered in the mind of the beholder were key, and for these reasons plaster copies of antiquities were easily accepted into a great many museums. Copies, or miniature replicas, also served as substitutes for celebrated antiquities that could not be purchased at any price. In this way the collector was able to have in his possession what were regarded as supreme achievements of ancient art. It was the fame associated with the object, not its authenticity, that mattered most.[40]

The paintings in encyclopedic collections were appreciated for similar reasons. It was the subject matter of the work or its fame or the fame of the artist that aroused interest. The intrinsic aesthetic qualities of paintings were not taken into consideration except by the most discriminating collectors, usually those who did not aim for encyclopedism in their museums. The universal program of the encyclopedic collections was reflected in the subject matter of the pictures: they represented the four seasons, the four elements, the ages of man, the senses, and so on. Additionally, paintings drew attention to famous historical events, great personages, fabulous mythologies, and to the exalted subjects of the Old and New Testaments. Works by the acknowledged masters—Raphael, Dürer, Titian, Giovanni da Bologna—assumed particular importance, and when a collector could not purchase an original by a great artist, a copy of it was a perfectly acceptable alternative.

Very often the works of art in collections were admired because of their monetary worth or because of the costliness of the materials from which they were made. Lassels and others who visited the Medici gallery, for example, were tremendously impressed by the sums many of the works there could fetch. Indeed, to them "it seemed that the fabulous richness and magnificence of the Medici collection could only be given adequate and succinct expression in terms of pounds sterling."[41]

Almost all *Wunderkammern* of the time contained historical curiosities. In the cabinet of the Reynst brothers, for instance, there was an ancient funerary chest said to contain the ashes of Aristotle.[42] Such things as a "set of cutlery bent out of true, a souvenir of a hunting accident" was on display in the Brandenburg *Kunstkammer*, while at Munich objects belonging to famous people or celebrities—"the huge boots 'belonging to the

Fig. 7 Carved rhinoceros horn cup, German, Augsburg, mid-17th century. Rhinoceros horn and ivory with silver gilt and gold mounts, amethysts, and turquoise. Ruth Blumka Collection, New York (cat. no. 33).

deformed Duke Johann Friedrich II of Sachsen-Coburg'," for instance—were put on display.[43] Objects of religious-historic interest, especially precious relics or objects having to do with miracles, were the most prized of these items. Collections preserved pieces of the True Cross, the holy remains (usually bone fragments) of saints, and such items of interest as stones from Mount Sinai. The Vienna treasury had among its *mirabilia* "a bowl from Solomon's temple" and "a horn which belonged to the Magi."[44] "A piece of cord used by Judas in his suicide" was housed at Schloss Ambras, "a crucifix bespattered with the blood of San Pedro Bautista and the 26 blessed Franciscans who suffered martyrdom with him in Japan in 1597" was in the palace of Condé de Benavente, while in the house of Principe de Esuilach there was "a Miraculous Christ that spoke to Saint Francis Borgia."[45]

In the greatest collections of the period—that of Rudolf II, for example—and in the smaller museums as well, one could expect to find numerous examples of mechanical and optical equipment, astronomical apparatus, and such things as burning glasses, glass lenses, and automata. Aldrovandi had a collection of clocks and distorting mirrors, while Cospi, who made scientific equipment, valued such things as telescopes and microscopes, not so much for their usefulness as for their beauty. The most remarkable of the mechan-

Fig. 8 Saracchi workshop, Ewer and cover, ca. 1600. Rock crystal, enamelled gold, jewelled in the form of a dragon. The Toledo Museum of Art, Gift of Florence Scott Libbey.

ical devices, however, were the automata, such as those that were made for and collected by Rudolf II. Devices that moved by clockwork mechanisms, they were prized for the ingenuity of their design and their extraordinary craftsmanship (cat. nos. 59, 60).

At Schloss Ambras and in other collections bronze castings made from nature constituted a significant part of the artificial *meraviglie*. While some of these objects served as inkpots or containers for sand, they usually were displayed as demonstrations of the artist's ingenuity and his ability to triumph over nature (cat. nos. 50–55). But among the examples of artistic virtuosity none were more splendid perhaps than the objects that were fashioned from nautilus shells, rhinoceros horns (*fig. 7*), ostrich eggs, coconuts, rock-crystals (*fig. 8*), ivory, and hard stones. Usually set in elaborately worked gold or silver mounts, the wondrous natural forms were made more wondrous by the hand of the artist (cat. nos. 29–34). Often, these objects were displayed next to examples of the raw materials themselves; in this way the ingenuity of nature and of man could be compared, making it clear indeed that man could not only emulate but also surpass nature in her designs. In other instances, such as paintings on alabaster or on polished stratified rock, the artist helped nature along in her artistry.[46]

Finally, we might consider an object that is a microcosm of artificial and natural marvels, the *Kunstschrank* designed by Philipp Hainhofer for Gustavus Adolphus of

95

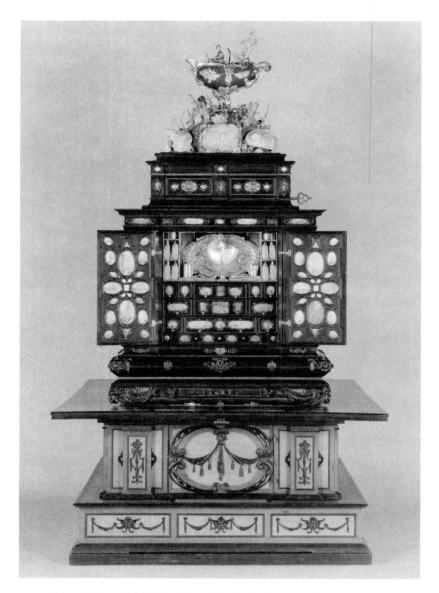

Fig. 9 Philipp Hainhofer, *Kunstschrank* of Gustavus Adolphus, 1625–31.
University of Uppsala, Sweden.

Sweden (*fig. 9*). In this remarkable demonstration of artistic ingenuity, a miniature *Kunstkammer* has been created. Within its little cabinets and drawers are contained precious stones, animal and plant specimens, objects that have magical properties, and miniature tools, writing utensils, and surgical instruments. It contains a musical instrument, a virginal, which because of its special clockwork mechanism can play several compositions automatically. Vexing mirrors and vexing lenses are part of its composition, as are artificial eggs and illusionistic insects. The crowning piece of the cabinet is a huge mineral mountain composed of coral, rock crystal, and a Seychelles coconut (*fig. 10*). Here art vies with nature, and ultimately triumphs, as it does in fact in the cabinet as a whole. A construction in which the theme of metamorphosis is pervasive, it has numerous

96

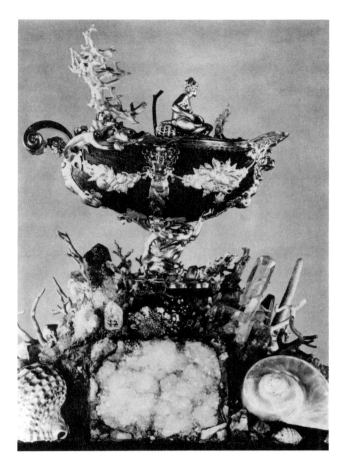

Fig. 10 Philipp Hainhofer. *Kunstschrank* of Gustavus Adolphus, 1625–31, detail showing the ewer of *coco-de-mer*. University of Uppsala, Sweden.

movable parts and images that have to do with transformation. In the end, the *Kunstschrank* presents, as do the larger *Kunst- und Wunderkammern*, the world in miniature, a microcosm, a *theatrum mundi* in which the wonders of nature and of man can be seen. According to Hainhofer, there were many who held "it to be the eighth wonder of the world." Indeed, their high praise was not without justification.[47]

The Declining Interest in Cabinets of Curiosities

The contents of *Wunderkammern*, curiosity cabinets, and encyclopedic museums shaped a world in which the collector could contemplate everything and ask any question. The *meraviglie* enabled him to make associations and to grasp the infinitely multifarious aspects of the universe. But around the middle of the seventeenth century interest in marvels and in encyclopedic collections began to decline, the result, in large part, of the scientific revolution. Since nature was now seen to be governed by general laws, it was not necessary to accumulate rare and remarkable things to gain a total view. The common or familiar object would suffice for the purposes of study. Encyclopedic collections increasingly came to be seen as inappropriate and inefficient instruments of learning. For some, like Nehemiah Grew, they were an irritation. They might be good for wonder and gazing,

he said, but they did not encourage serious and diligent study.[48] The idea of creating a microcosm, a theater that allowed one to observe the variety of God's creation, seemed preposterous. As Catherine II of Russia, later declared, it was silly "to enclose Nature in a cabinet—even a huge palace could not hold her."[49]

With the rise of the new science, and its objective and rational approach to the study of nature, collections of *naturalia* gradually were separated from those of *artificialia*, a process that was greatly hastened by the rise of academies devoted to specialized branches of knowledge. Science was seen as independent from art, and the fine arts (painting and sculpture), for example, were distinguished from the minor arts. With the rise of connoisseurship in the eighteenth century, additionally, works of art were considered from both more critical and more subjective points of view. The aesthetic merits of a work and questions of style and authenticity now were of major concern. The beauty of a work of art and its particular qualities of style, not only its subject matter or its fame, became the focus of attention.[50]

By the end of the seventeenth century cabinets of curiosities and *Kunst- und Wunderkammern* had lost much of their attractiveness, but they never fell out of favor completely. They continued far into the eighteenth century, especially in the Nordic countries and Russia, and had a revival as places of study in the early college and university museums of America. Today, however, the encyclopedic museum is a rarity, a relic of the past reflecting a world view and an approach to learning that no longer exist. But this is not to say that the collecting of *meraviglie* therefore has vanished. People the world over still collect exceptional things. They marvel at these possessions, learn from them, and like the collectors of the past, display them with pride.

NOTES

1. This source, not identified, is cited by Bente Dam-Mikkelsen and Torben Lundaek, *Ethnographic Objects in the Royal Danish Kunstkammer: 1650–1800* (Copenhagen: Nationalmuseet, 1980), pp. xix–xx.

2. This is the observation of Richard Lassels, who visited the gallery in 1650. From the unpublished journal of Richard Lassels, cited in Jane S. Whitehead, "'The Noblest Collection of Curiositys': British Visitors to the Uffizi, 1650–1789," in *Gli Uffizi: quattro secoli di una galleria*, ed. Paola Barocchi and Giovanna Ragionieri (Florence: Leo S. Olschki Editore, 1983), p. 290. Lassels described the contents of the gallery in detail in *The Voyage to Italy, or A Compleat Journey through Italy* (Paris: Vincent du Moutier, 1670), part 1, pp. 160–75.

3. These and other objects in the Medici gallery are enumerated in Lassels, *The Voyage to Italy*, pp. 160–75, and in a 1644 entry in *The Diary of John Evelyn*, ed. E. S. de Beer (Oxford: Clarendon Press, 1955), vol. 1, pp. 118–19.

4. The terms used to describe the early collections were numerous and varied from region to region. In Italy they generally went by the name *museo* or, less frequently, *studiolo*. *Galleria* (gallery) most often described collections containing only works of art (especially paintings), but there were instances, such as the Medici *galleria* and the "*museo ò galeria*" of Manfredo Settala, when it was applied to collections that contained curiosities as well. North of the Alps, the museums were named *Wunderkammer, Kunst-*

und Wunderkammer, Kuriositäten-Kabinett or *Kammer*, and *Raritäten-Kabinett* or *Kammer*. Museum or *Musaeum* was also used by many collectors. *Wunderkammer* (room of marvels) usually referred to the section of the *Kunst- und Wunderkammer* that housed *naturalia*. However, when the term was apparently first used (in the 1564–66 *Zimmerische Chronik* by Count Froben Christoph of Zimmern), it designated a collection comprised not only of natural curiosities, but also of religious objects, antiquities, and a library. In England and France the early collections also went by many names: museum (*musée*), cabinets of curiosities or rarities (cabinets or *chambres des curiosités* or *raretés*), and so on. The variations on the most familiar terms were considerable. Barbara Jeanne Balsiger ("The *Kunst- und Wunderkammern:* A Catalogue Raisonné of Collecting in Germany, France, and England, 1565–1750," Ph.D. dissertation, University of Pittsburgh, 1970, pp. 740–66) provides a helpful glossary of these terms and other words related to the early history of collecting. Also valuable is Paula Findlen's excellent essay "The Museum: Its Classical Etymology and Renaissance Genealogy," *The Journal of the History of Collections* 1:1 (1989):59–78. She considers, among other issues, the original definition of *musaeum* (including its most frequent usage as a place consecrated to the muses) and the concept of *musaeum* as a metaphor of late-Renaissance encyclopedism.

5. For a good survey of the history of collecting, and of collecting in the ancient and medieval periods, see Germain Bazin, *The Museum Age*, trans. Jane van Nuis Cahill (New York: Universe Books Inc., 1967). Another general history is David Murray *Museums: Their History and Their Use* (Glasgow: James Mac-Lehose and Sons, 1904). The treasury assembled by Jean de France, Duke of Berry (1340–1416) is frequently cited as an important forerunner of Renaissance princely collections. It was notable not only for precious works of art and antiquities, but also for curiosities such as ostrich eggs, polar bear hides, whale's teeth, and a tiny piece of paper upon which the entire Gospel according to Saint John had been inscribed. See Francis Henry Taylor, *The Taste of Angels: A History of Art Collecting from Ramses to Napolean* (Boston: Little, Brown and Company, 1948), pp. 50–55.

The literature on the museums of the sixteenth and seventeenth centuries is vast. Julius von Schlosser's *Die Kunst- und Wunderkammern der Spätrenaissance: Ein Beitrag zur Geschichte des Sammelwesens* (Leipzig, 1908) was the first modern study of the phenomenon of European cabinets of curiosities. The most important recent scholarship in this area includes the pre-viously cited study by Balsiger; Adalgisa Lugli, *Naturalia et Mirabilia* (Milan: Gabriele Mazzotta editore, 1983); Oliver Impey and Arthur MacGregor, eds., *The Origins of Museums: The Cabinet of Curiosities in Sixteenth- and Seventeenth-Century Europe* (Oxford: Clarendon Press, 1985); and Krzysztof Pomian, *Collectionneurs, amateurs et curieux. Paris, Venise: XVIe–XVIIIe siècle* (Bibliothèque des Histoires; Mayennes: Editions Gallimard, 1987). Another interesting essay on this subject is Giuseppe Olmi, "Dal 'Teatro del Mondo' ai mondi inventariati. Aspetti e forme del collezionismo nell'età moderna," in *Gli Uffizi: quattre secoli di una galleria*, ed. Barocchi and Ragionieri, pp. 243–44. Additionally, numerous scholarly studies of Renaissance and baroque museums have appeared in the serial publication begun in 1989, *The Journal of the History of Collections*.

6. Pomian, *Collectionneurs*, p. 64.

7. Giovanni Pico della Mirandola, *Oration on the Dignity of Man*, trans. A. Robert Caponigri (South Bend, Ind.: Regnery/Gateway, Inc., 1956). The relevant passages from this essay appear on pp. 5–8, 34, 43–44.

8. Samuel Putnam, ed. and trans., *The Portable Rabelais* (New York: The Viking Press, 1967), pp. 264–66.

9. Erwin Panofsky, "Artist, Scientist, Genius: Notes on the 'Renaissance-Dämmerung'," in The Metropolitan Museum of Art, *The Renaissance: Six Essays* (New York: Harper and Row, 1962), p. 128.

10. Balsiger, "Catalogue Raisonné," pp. 544–51. A detailed account of Quiccheberg's *Inscriptiones*, its sources, and its organization can be found here.

11. See Elisabeth Scheicher, "The Collection of Archduke Ferdinand II at Schloss Ambras: Its Purpose, Composition and Evolution," in Impey and MacGregor, *The Origins of Museums*, p. 31.

12. Arthur MacGregor, ed., *Tradescant's Rarities: Essays on the Foundation of the Ashmolean Museum* (Oxford: Clarendon Press, 1983), p. 74. Full discussions on Duke Albrecht's collections can be found in: H. Thoma and H. Brunner, *Schatzkammer der Residenz Munchen. Katalog*, 3rd ed. (Munich, 1970); C. Scherer, *Die Braunschweiger Elfenbeinsammlung* (Leipzig, 1931); and Lorenz Seelig, "The Munich Kunstkammer, 1565–1807," in Impey and MacGregor, *The Origins of Museums*, pp. 76–89. As to Rudolf's collections, see Erwin Neumann, "Das Inventar der rudolfinischen Kunstkammer von 1607–11", in *Queen Christina of Sweden: Documents and Studies* (Stockholm, 1966), p. 264; and Eliska Fucíková, "The Collection of Rudolf II at Prague: Cabinet of Curiosities or Scientific Museum?," in Impey and MacGregor,

The Origins of Museums, pp. 47–53. The 1607–11 inventory of Rudolf's *Kunstkammer* was published by R. Bauer and H. Haupt in "Das Kunstkammerinventar Kaiser Rudolfs II, 1607–11," *Jahrbuch der Kunsthistorischen Sammlungen in Wien* 72 (1976).

13. Thomas DaCosta Kaufmann, "Remarks on the Collections of Rudolf II: The *Kunstkammer* as a Form of *Representatio*," *Art Journal* 38 (1978):27.

14. For a discussion of the Tribuna and its iconographic program, see Detlef Heikamp, "La Tribuna degli Uffizi come era nel cinquecento," *Antichità Viva* 3 (May 1964):11–30.

15. See Eva Schulz, "Notes on the History of Collecting and of Museums," *Journal of the History of Collections* 2:2 (1990):205, and Findlen, "The Museum: Its Classical Etymology and Renaissance Genealogy," p. 64, and passim.

16. For information regarding Worm's collection, see, in addition to Dam-Mikkelsen and Lundaek, *Ethnographic Objects*, the essay by H. D. Schepelern, "Natural Philosophers and Princely Collectors: Worm, Paludanus and the Gottorp and Copenhagen Collections," in Impey and MacGregor, *The Origins of Museums*, pp. 121–27.

17. A discussion of Quiccheberg's citation of the biblical models can be found in Schulz, "Notes on the History of Collecting," pp. 208–9.

18. Ibid, pp. 209–11. Major's treatise is considered at some length here.

19. Pierre Borel, *Catalogue des choses rares qui sont dans le Cabinet de Maistre Pierre Borel, Médecin de Castres au haut Languedoc*, published in A. Colomiez, *Les Antiquitez, raretez, plantes, mineraux et autres choses considerables de la ville et du comté de Castres . . .* (Castres, 1649), p. 132. The inscription as well as the index to Borel's catalogue are cited in Balsiger, "Catalogue Raisonné," pp. 99, 796. Borel's collection is discussed at some length by Pomian, *Collectionneurs*, pp. 61–65.

20. See Arthur MacGregor "The Cabinet of Curiosities in Seventeenth-Century Britain," in Impey and MacGregor, *The Origins of Museums*, p. 148.

21. Balsiger, "Catalogue Raisonné," p. 261.

22. See Giuseppe Olmi, "Science-Honour-Metaphor: Italian Cabinets of the Sixteenth and Seventeenth Centuries," in Impey and MacGregor, *The Origins of Museums*, p. 14.

23. Paulo Maria Terzago, *Museo ò Galerie Adunata . . . Manfredo Settala* (Dertonae, 1664). The list of the collection from Giacomo Barri's *The Painters Voyage of Italy*, trans. W. L. of Lincolus-Iume (London, 1679), and a translation of the index to the Latin edi-

tion of the Terzago catalogue appear in Balsiger, "Catalogue Raisonné," pp. 387–92, 446–51. Additional information about Settala may be found in Giuseppe Olmi "Science-Honour-Metaphor," p. 12. Olmi does not share the opinion of other recent scholars who see Settala's museum as a center of scientific research. Curiosity was the focal point of the museum, he notes, and this certainly seems to be born out by the information in Lorenzo Legati's catalogue *Museo Cospiano Annesso a quello del famoso Ulisse Aldrovandi* (Bologna, 1677). For the opposing view, see Antonio Aimi, et al., "Collecting in Milan in the Late Renaissance and Baroque Periods," in Impey and MacGregor, *The Origins of Museums*, pp. 26–27; Silvio Bedini, "The Evolution of Science Museum" *Technology and Culture* 6 (1965):1–29; and G. Tavernari, "Manfredo Settala, Collezionista e Scienziato Milanese del '600," *Annali dell' Istituto e Museo di Storia della Scienza di Firenze* 1 (1976):43–61.

24. Legati, *Museo Cospiano*, preface. See cat. no. 19.

25. MacGregor, *Tradescant's Rarities*, pp. 20–21.

26. Ibid., pp. 22–23.

27. MacGregor, "The Cabinet of Curiosities in Seventeenth-Century Britain," p. 150.

28. This is the view expressed by Francis Bacon, *The Two Books of Francis Bacon of the Proficience and Advancement of Learning, Divine and Humane* (London, 1605) book 2, fol. 7v–9r. For a fuller discussion of this issue and of anthropological and zoological wonders particularly, see William B. Ashworth's essay in the present catalogue.

29. See the index to Boniface Borrilly's collection in Balsiger, "Catalogue Raisonné," p. 600. The Royal Society also had a skeleton and the preserved remains of aborted fetuses. The anatomist Frederick Ruysch was famous for his compositions of human skulls, monstrosities, and the preserved parts and bits of human beings. His collection was eventually purchased by Peter I of Russia. See Oleg Nemerov, "'His Majesty's Cabinet' and Peter I's Kunstkammer," in Impey and MacGregor, *The Origins of Museums*, p. 60.

30. Balsiger assigns this role to the dwarf in her "Catalogue Raisonné," p. 574.

31. O. Beljaev, "Kabinett Petra Velikogo," *Otdelenie* (St. Petersburg, 1800), vol. 1, p. 192. Cited in Nemerov, "'His Majesty's Cabinet'" p. 60.

32. H. J. Witkam, *Catalogues of all the Chiefest Rarities in the Publick Anatomie Hall of the University of Leyden* (Leiden, 1980), p. 38. See also William Schupbach's discussion of the contents of the *Anatomiekammer* in "Cabinets of Curiosities in

Academic Institutions," in Impey and MacGregor, *The Origins of Museums*, pp. 170–72.

33. See Pomian, *Collectionneurs*, pp. 16–59.

34. The contents of Giganti's museum are discussed by Laura Laurencich-Minelli in "Museography and Ethnographical Collections in Bologna during the Sixteenth and Seventeenth Centuries," in Impey and MacGregor, *The Origins of Museums*, p. 18. For information on the collection of Paludanus, see Dam-Mikkelsen and Lundbaek, *Ethnographic Objects*, p. 25. The contents of Kircher's collection were catalogued by Filippo Buonanni, *Museum Kircherianum; sive, Musaeum P. Athanasio Kircherio in Collegio Romano Societatis Jesu* (Rome, 1709). See catalogue no. 23.

35. On the featherwork in Giganti's museum, see Laurencich-Minelli, "Museography and Ethnological Collections," p. 20. Settala's collection of featherwork and other artifacts from America are listed in Terzago, *Museo ò Galeria Adunata*.

36. Nehemiah Grew, *Musaeum Regalis Societatis* (London: W. Rawlins, 1681), pp. 377–78. See cat. no. 22.

37. Kircher gave his scholarly attention to the interpretation of Egyptian hieroglyphs especially, and although his research did not solve their meaning (they were not deciphered until 1822), he published several volumes on the subject. See, for example, cat. no. 25.

38. Cited by Schupbach, "Cabinets of Curiosities in Academic Institutions," p. 171.

39. Lassels, *The Voyage to Italy*, p. 164.

40. For a discussion of the flourishing business of making copies, see Francis Haskell and Nicholas Penny, *Taste and the Antique: The Lure of Classical Sculpture 1500–1900* (New Haven: Yale University Press, 1981), chaps. 3, 5.

41. Whitehead, "British Visitors to the Uffizi," p. 292. For the admiration provoked by costliness of materials, see also Francis Haskill, *Patrons and Paint-*

ers: Art and Society in Baroque Italy (New York: Harper and Row, 1971), pp. 47, 49.

42. Anne-Marie S. Logan, *The 'Cabinet' of the Brothers Gerard and Jan Reynst* (Amsterdam: North Holland Publishing Company, 1979), p. 65.

43. See Christian Theuerkauff, "The Brandenberg *Kunstkammer* in Berlin," in Impey and MacGregor, *The Origins of Museums*, p. 12; Seelig, "The Munich *Kunstkammer*, 1565–1807," p. 84.

44. Rudolf Distelberger, "The Habsburg Collections in Vienna during the Seventeenth Century," in Impey and MacGregor, *The Origins of Museums*, p. 43.

45. See Scheicher, "The Collection of Archduke Ferdinand II," p. 35; Ronald Lightbrown, "Some Notes on Spanish Baroque Collectors," in Impey and MacGregor, *The Origins of Museums*, p. 137.

46. One of the most remarkable works of this kind, from the collection of Rudolf II, is a painting on alabaster showing on one side *The Fall of Phaeton* and on the other *The Triumph of Cupid and Bacchus*. Here the artist has made clever use of the colored patterns of the natural material. This transformation of the alabaster gains an added dimension of marvelousness on account of the subjects depicted–wondrous transformations drawn from the *Metamorphoses* of Ovid. For a discussion of these and other similar works, see Thomas DaCosta Kaufmann, *The School of Prague: Painting at the Court of Rudolf II* (Chicago: University of Chicago Press, 1985), p. 140.

47. This object is discussed in detail by Hans-Olof Boström, "Phillipp Hainhofer and Gustavus Adolphus's *Kunstschrank* in Uppsala," in Impey and MacGregor, *The Origins of Musuems*, pp. 90–101.

48. See Michael Hunter, "The Royal Society's 'Repository' and Its Background," in Impey and MacGregor, *The Origins of Museums*, p. 164.

49. Catherine's remarks are cited by Neverov, "'His Majesty Cabinet'," p. 60.

50. For a much more detailed account of the factors leading to the decline of encyclopedic collections, see Olmi, "Dal 'Teatro del Mondo'," pp. 248ff.

101

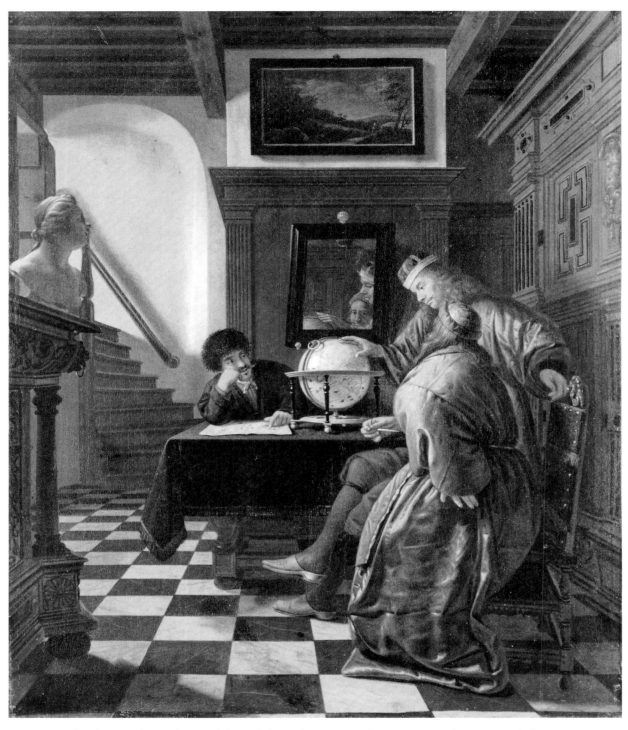

Fig. 1 Cornelius de Man, *Geographers at Their Work*, late 17th century. Oil on canvas. Hamburger Kunsthalle, Germany.

Strange New Worlds: Mapping the Heavens and Earth's Great Extent

James A. Welu

I T SHOULD COME AS NO SURPRISE THAT EUROPE'S OBSESSION
with the marvelous closely paralleled the great age of exploration. Beginning in the
late fifteenth century European explorers went far beyond all traditional boundaries,
which then resulted in an unprecedented growth in the knowledge of the earth and
heavens during the following two centuries. The concerted effort to document these new
findings produced a wealth of cartographic material that became a major factor in the
"age of the marvelous" (*fig. 1*).

The great discoveries of Columbus and Magellan can already be seen on early-six-
teenth-century maps. Like the early narrative accounts, these maps were essential to the
development of geographical thought and for grasping the new picture of the world.
Maps of this period presented the opportunity to trace the routes of important voyages
and to share some of the wonders encountered by the explorers themselves. It was
especially the maps that gave a sense of the vastness of the world and enabled exploring
nations, whether large or small, to comprehend the extent of their power. While many
of the early maps were intended for navigational purposes, some of the more decorative
examples were designed specifically for collectors, who took great delight in the artisti-
cally embellished geography. Particularly attractive were the manuscript maps, which
were often richly colored.

Most of the map making at the beginning of the sixteenth century was still based on
Ptolemy's *Cosmographia*, the major achievement of ancient Greek geography, which was
rediscovered in the fifteenth century (see cat. no. 75). But the picture of the world was
changing rapidly, and the extent to which contemporary man had surpassed the ancients
in geographical knowledge was proving to be one of the great wonders of the age. The
constant revising of Ptolemy's work helped to measure the amazing progress. Some of
the advances can be seen in Martin Waldseemüller's *Carta marina* (*fig. 2*) from 1516, in

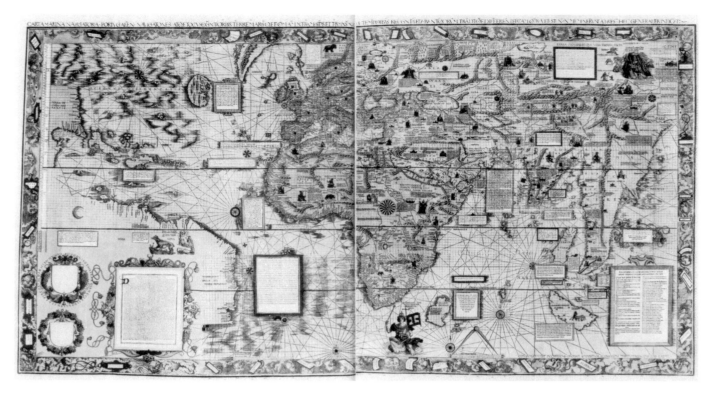

Fig. 2 Martin Waldseemüller, *Carta marina*, 1516.

which the German map maker relied primarily on the narratives and voyages of Italian and Portuguese explorers. On this large woodcut map even parts of Europe were taken from contemporary maritime charts, rather than from Ptolemy. By the mid-sixteenth century it was clear that much of the geography of antiquity was no longer valid and that modern exploration had resulted in a new and more accurate concept of the world, a world that seemed to offer endless surprise.

The early explorers were eager to record and in many cases brought back with them the specimens that fascinated them most, including plants, animals, and even natives. News of the findings spread rapidly, as witnessed by a comment in Sebastian Brandt's *Das Narrenschiff*, published only two years after Columbus set foot in the New World: "And in the meantime the Portuguese and the Spanish have discovered gold islands, and naked people, about which nothing had been known before."[1] Such curiosities were soon represented on maps. Particularly popular were those that were guaranteed to astonish, such as the cannibals encountered in Brazil and Java. The explicit depictions of humans preparing to devour other humans were so fascinating that they were repeated over and over until they became a veritable symbol for those parts of the world. Such images were dependent on the interests and biases of the explorers and the artists who accompanied them. In many of the early depictions of the American Indian the exaggerated representations of savage practices often suggest little more than half-human creatures. These

representations, which reflect the superior self-image of the European, were eventually countered by images of the noble savage, as seen in the engravings in Theodor de Bry's books on America, which were published at the end of the sixteenth century (cat. no. 117). De Bry's idealized figures were taken from drawings by the artist-cartographers Jacques Le Moyne, who accompanied an expedition to Florida, and John White, who accompanied an expedition to Virginia.[2] Reproduced by de Bry, these images were the inspiration for innumerable vignettes on maps published well into the following century (cat no. 81).

Including depictions of flora and fauna never before seen was another way of identifying newly discovered lands and adding further interest to the early-sixteenth-century maps. During this period it was the maps and not always the bestiaries that provided some of the first illustrations of foreign animals as well as, often, the most accurate record of their actual locations.[3] The first known image of the opossum, for example, appears on Waldseemüller's world map. The same map includes one of the earliest depictions of a rhinoceros in Africa and a reindeer in Tartary. The mythical and legendary creatures that had accompanied maps since medieval times were giving way to specimens that, although often as unusual, were actually observed. What was considered marvelous was now more a matter of documentation than of speculation.

While this early cartographic imagery stirred the imagination, it also helped to make the unknown seem familiar, especially when foreign territories were portrayed in European terms. On these maps the terrain and architecture in remote countries often look more like that of Europe. Such details reflect an underlying effort to not only document but also to control these distant lands. As Brian Harley has recently noted, "maps became a universal metaphor for the European hegemony in the New World."[4]

By the second half of the sixteenth century printing had spread throughout Europe, helping to further disseminate the new discoveries. The majority of maps were printed from engraved copper plates and were frequently embellished through hand coloring. The abundance of cartographic material in printed form enabled a broader audience to explore vicariously beyond their homeland and to contemplate wondrous phenomena both past and present. As a result cartographic material was collected for a variety of reasons, as John Dee noted in 1570:

Some to beautify their Halls, Parlors, Chambers, Galleries, Studies, or Libraries with; some other, for things past, as battles fought, earthquakes, heavenly firings, and such occurrences, in histories mentioned; thereby lively as it were to view the place, the region adjoining the distance from us, and such other circumstances; some other, presently to view the large dominion of the Turk: the wide Empire of the Muscovite: and the little morsel of ground where the Christiandom (by profession) is certainly known, little I say in respect of the rest, etc.: some other for their own journeys directing into far lands, or to understand other men's travels . . . liketh, loveth, getteth, and useth, Maps, Charts, and Geographical Globes.[5]

During the sixteenth century the collecting of maps grew dramatically. Some collectors

focused on historical geography, but the majority collected more recent maps both for their decorative value and to keep abreast of the dramatic changes in the picture of the world. In Italy some collectors chose to have maps of similar size bound together to form a book, a practice that had its greatest flowering in the Netherlands. This format, later known as the atlas, proved to be a very practical and effective way of disseminating the new appreciation of world geography. Like the curiosity cabinets or the exotic botanic gardens of the day, the atlas was a way of collecting the "entire world" in a manageable format. The first systematic compendium of current geographical information was the *Theatrum orbis terrarum* published at Antwerp in 1570 by Abraham Ortelius (see cat. no. 77). His great accomplishment was bringing together maps from numerous sources along with descriptive texts for a more comprehensive look at the world. Published in seven languages, the *Theatrum* had a long life—over forty editions by the time of its final printing in 1612.[6]

The mania for collecting geographical information prompted publishers to enlarge their atlases. Until his death in 1598, Ortelius regularly updated his *Theatrum* by producing supplements that included additional maps from a variety of sources. Among the maps he added was one of Iceland dated 1585 (see cat. no. 79). Taken from Olaus Magnus's large map of the Northern Region, which appeared almost a half century earlier, the Ortelius map and accompanying text document in graphic terms the "many wonders and strange works of God in this island," from "huge and marvelous great heaps of ice" to "so many sundrie sorts of fish." In addition to the rather realistic mountains, glaciers, and volcano, the Iceland map includes one of the most fantastic collections of sea monsters, which, judging from Ortelius's descriptions of each one, were still accepted as fact. Such maps, which were also available as separate sheets, were one of the major ways of recording, disseminating, and thereby keeping alive man's earliest reactions to some of nature's greatest wonders, no matter how exaggerated the original descriptions may have been.

Another kind of atlas produced in the Netherlands was Georg Braun and Frans Hogenberg's *Civitates orbis terrarum* (1572–1618), the first uniform collection of plans and views of cities from around the world (*fig. 3*). The six volumes included over five hundred maps and views along with descriptive texts. Seen as a complement to the work of Ortelius, the *Civitates* attempted to give as much information as possible so that the reader could make discoveries on his own. "What could be more agreeable," wrote Braun, "than in one's own home far from danger, to gaze in these books at the universal form of the earth . . . adorned with the splendour of cities and fortresses, and, by looking at the pictures and reading the texts accompanying them, to acquire knowledge which could scarcely be had but by long and difficult journeys?"[7]

The third type of systematically ordered collection of maps was the sea atlas, the majority of which were produced in Holland during the great expansion of its marine and mercantile empire. The first major work to bring maritime cartography to the atten-

Fig. 3 Paris. From Georg Braun and Frans Hogenberg, *Civitates orbis terrarum*, 1572–1618.

tion of the general public was Lucas Jansz. Waghenaer's two-volume *Spieghel der Zeevaerdt*, which appeared in 1584 and was soon published in many languages (*fig. 4*). Although quite technical, these volumes of charts and sailing directions succeeded in capturing the imagination of many by bringing the reader close to the actual voyages that resulted in so much wonderment. Again, it was documentation that sparked and helped to continue the interest in the marvelous. Often beautifully embellished, sea charts were also collected for their decorative qualities. According to one seventeenth-century catalogue, certain sea charts, which were "made according to very exact drawing," were also "very useful for framing and hanging up."[8]

By the seventeenth century the cartographic industry had moved from Antwerp to Amsterdam, where the great rivalry among major publishing houses resulted in the most complete and up-to-date maps available. It was Willem Jansz. Blaeu who originated the idea of producing an atlas showing in detail all the "known parts of the World." Following Blaeu's death, his son, Joan Blaeu, continued the project as part of an even grander scheme to describe in a multivolume publication the entire universe of earth, heavens, and sea. Only the first part of the program, which consisted of twelve volumes, was ever

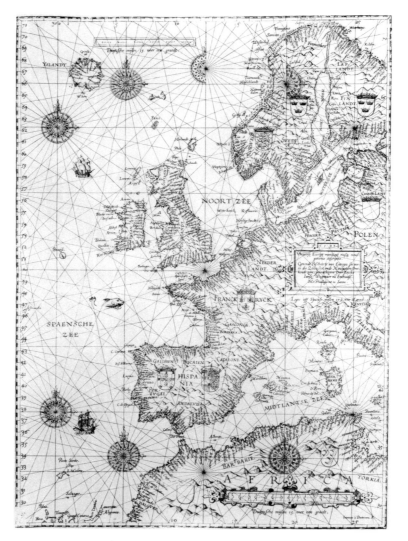

Fig. 4 Chart of the European coastline.
From Lucas Jansz. Waghenaer, *Spieghel de Zeevaerdt*, 1584.

completed (cat. nos. 87–90).[9] These volumes provided accounts of all the great voyages of discovery and detailed descriptions of their findings. The Blaeu atlas was sought after not only as the most extensive and current description of the world, but also as a work of art. The quality of its paper, engraving, coloring, and binding contributed to its popularity. At least one set of the atlas, now at the University Library of Amsterdam, was even given a specially designed wooden display case with elaborate carving.

In introducing his *Atlas Maior* Blaeu wrote, "Maps enable us to contemplate at home and right before our eyes things that are farthest away." This ability to travel the world on paper proved to be a great marvel in itself, as the English scholar Robert Burton also noted in 1621:

Methinks it would please any man to look upon a geographical map, on account of the incredible variety and pleasantness of the subject, and would excite to further steps in knowledge; Chorograph-

ical, Topographical Delineations, to behold, as it were, all the remote Provinces, Towns, Cities of the World, and never to go forth of the limits of his study, to measure by the scale and compass their extent, distance, examine their site.[10]

In addition to mapping the earth, cartographers also charted the heavens. At the beginning of the sixteenth century celestial maps, like terrestrial maps, were a compilation of knowledge gathered since antiquity. By 1532 Johannes Hunter produced two woodcut maps of the northern and southern skies that were the first to show the star positions as seen from the earth. Hunter's maps were, however, still derived from the Ptolemaic system. It was not until later in the century that celestial charts began showing some of the major new observations of the heavens. Willem Jansz. Blaeu, who studied with the great astronomical observer Tycho Brahe in the early 1590s, was particularly well prepared to disseminate new celestial discoveries and often incorporated celestial charts into his atlases. The telescope, invented in 1609, led to more accurate recordings of the heavens and the discovery of many new celestial bodies. The result was detailed maps of the moon and elaborate astronomical diagrams that offered a glimpse of a world far beyond man's reach.

The exploration of the heavens also brought about an increased production of celestial globes, particularly from 1600 on. The majority of commercially made globes consisted of engraved paper gores that were glued to a sphere made of plaster and paper. Once applied to the sphere, the gores were often hand colored and then varnished (*fig. 5*). Celestial and terrestrial globes were usually produced in pairs. Judging from catalogues of the period, globes were rather costly items. By the mid-seventeenth century a pair of hand-colored Blaeu globes, thirty-four centimeters in diameter, sold for thirty-two guilders,[11] approximately the equivalent of a month's wage for a skilled worker. Globes ranged greatly in size, from an inch to several feet in diameter, and of all the cartographic materials were the most effective in demonstrating the map maker's ability to reduce the entire world or universe to a small, manageable size. The power and wonder of these cartographic objects was well summarized by Samuel van Hoogstraten: "How valuable is a good map wherein one views the world as from another world, thanks to the art of drawing."[12] Globes, planispheres, armillary spheres, and a number of other scientific devices from this period were also admired for their craftsmanship and decorative qualities. As a result, these objects were popular in the *Kunst- und Wunderkammern* of the day.

The cartographic form that perhaps best exemplifies man's efforts to capture in a single work the marvels of an expanded world is the wall map. These maps were produced in relatively great number throughout the sixteenth and seventeenth centuries, though few originals survive due to their generally large size and constant exposure to light. Like atlases, wall maps were intended to give an in-depth look at the world and, because of their size, were capable of providing a wealth of information amidst an abundance of ornamentation. During the sixteenth century the decoration on wall maps was rather

Fig. 5 Willem Jansz. Blaeu, Terrestrial globe, 1602. Nederlands Scheepvaart Museum, Amsterdam.

stylized, but by the seventeenth century there was more emphasis on naturalistic imagery. At the same time the borders were greatly expanded to include additional illustrations and often extensive texts. Encyclopedic in nature, the wall map featured information both current and historical, and by the seventeenth century could be found in all kinds of domestic interiors. Often beautifully hand colored and measuring as much as eight feet across, these maps were, and still are, a marvelous sight to behold.

One of the most ornate wall maps ever produced is Pieter van den Keere's large world map of 1611, of which only a single example remains (*fig. 6*).[13] The elaborate ornamentation both enhances the map aesthetically and provides a colorful account of man's knowledge of the world at the beginning of the seventeenth century. Scattered across the two hemispheres are cartouches and vignettes consisting of plants, animals, and sailing vessels from around the world as well as mythological, historical, and contemporary figures, including many famous explorers and geographers. The spaces immediately framing the two hemispheres are crammed with imagery representing the Four Parts of

110

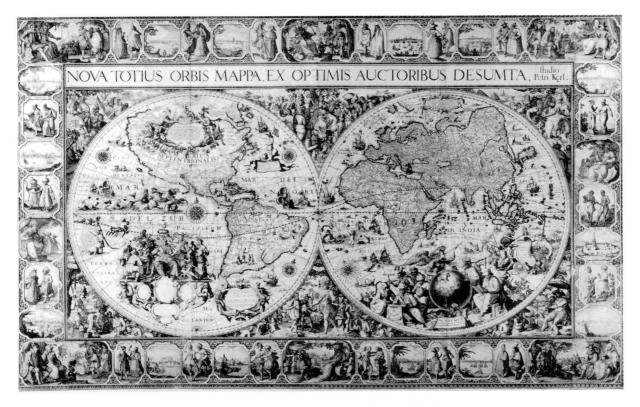

Fig. 6 Pieter van den Keere, World map, 1611. Sutro Library, San Francisco, California.

the World, from the Seven Wonders of the Ancient World to the many marvels of the New World. The outside border is equally ornate, displaying numerous vignettes that, like windows onto the world, give the viewer a closer look at cities, costumed figures, and national rulers from both near and far.

As we have seen, ornamentation played a major role in map making throughout the sixteenth and seventeenth centuries. During this period it was the artistic presentation of the geographical contents that resulted in the intense fascination with maps. Never before or since has cartographic material been so richly embellished. These objects, beautifully designed and exquisitely crafted, were more than a means to the marvelous; they were in themselves one of the great marvels of the age.

NOTES

1. Sebastian Brandt, *Das Narrenschiff* (Basel, 1494): "Auch hat man sydt in Portegal / Und in Hyspanien überal / Golt-inseln funden, und nacket lüt / Von den man forwust sagen nüt."

2. See Hugh Honour, *The New Golden Land: European Images of America from the Discoveries to the Present Times* (New York: Pantheon, 1975), pp. 68–78.

3. Wilma George, *Animals and Maps* (London: Secker and Warburg, 1969), pp. 61ff.

4. J. B. Harley, *Maps and the Columbian Encounter* (Milwaukee: University of Wisconsin Press, 1990), p. 99.

5. John Dee, preface to *Elements of Geometrie of the Most Ancient Philospher Euclide* (1570), trans. H. Billingsley, p. 570.

6. The *Theatrum* was produced in twenty-one Latin editions, two Dutch, five German, six French, four Spanish, two Italian, and one English.

7. Georg Braun and Frans Hogenberg, *Civitates orbis terrarum* (1572–1618), preface to book 3 (1581).

8. Cornelis à Beughem, *Bibliographia mathematica et artificiosa novissima* (Amsterdam: Van Waesbergen, 1688), p. 410.

9. The Latin edition (in eleven volumes) was followed by a Dutch and German edition, each nine volumes; a French edition of twelve volumes; and a Spanish edition of ten volumes.

10. Robert Burton, *The Anatomy of Melancholy* (1621), pt. 2, sec. 1, memb. 4.

11. See Joan Blaeu, *Catalogue des atlas, théâtre des citez globes, spheres, & cartes géographique & marinez* (Amsterdam, n.d.). Published in facsimile: *A Catalogue by Joan Blaeu. A facsimile with an accompanying text by Cornelis Koeman* (Amsterdam: Nico Israel, 1967).

12. Samuel van Hoogstraten, *Inleyding tot de Hooge Schoole der Schilderkonst: anders de Zichtbaere Werelt* (Rotterdam, 1678), p. 7: "Hoe heerlijk een goede kaert is, daer in men de werelt als uit een andere werelt bezeit, zy heeft het de Teykenkonst te danken."

13. It is in the Sutro Library, San Francisco. See Günter Schilder and James Welu, *The World Map of 1611 by Pieter van den Keere* (Amsterdam: Nico Israel, 1980).

112

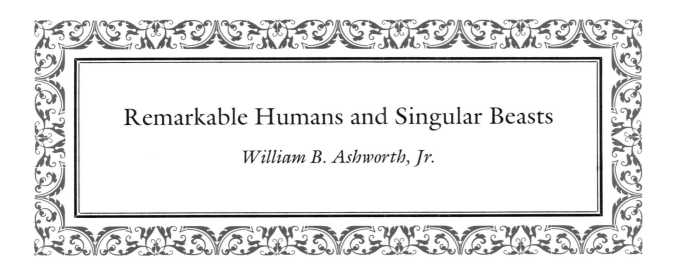

Remarkable Humans and Singular Beasts

William B. Ashworth, Jr.

W HEN A TWENTIETH-CENTURY VISITOR IS CONFRONTED with a seventeenth-century wonder room, whether in reconstruction or by historical illustration, the encounter is likely to be more bewildering and mystifying than awe-inspiring and full of wonder (see cat. no. 17; *fig. 1*). At least with respect to zoological specimens, any resemblance between a wonder room and a museum of natural history is hard to find. In the wonder room crocodiles, iguanas, and puffer fish may hang from the ceiling, alongside snowshoes and kayaks; toucan beaks and babirusa skulls may share crammed shelves with bowls sculpted from bezoars and goblets fashioned from ostrich eggs; narwhal tusks and Eskimo harpoons may stand in the corner, next to stools made of whale vertebrae and cuspidors hewn from rhinoceros horn. If a pattern lies behind such a mélange, it is difficult to perceive. If nature is being represented here, it is not the nature we are accustomed to viewing. So what exactly was a cabinet of curiosities trying to do? Was the wonder room just the result of virtuoso collecting fever run amok? Well, as is so often the case in the baroque era, appearances are deceiving. Behind the seeming chaos of the wonder room, there was a consistent ethos. Almost all of the natural objects were there because they fit one criterion: they showed nature wandering, jesting, stretching the limits of her domain, rather than nature in her normal course of action. How did it become established that a natural history collection should focus on objects from nature's extremities? In this essay I will try to answer the question, probe its consequences, and examine why such an ethos began to disappear in the late seventeenth century.

Zoological Practice in the Mid-Sixteenth Century

To understand the zoological program of wonder rooms, it is first necessary to comprehend the changes that zoology went through in the century between 1550 and 1650.

113

Fig. 1 Interior view of Olé Worm's museum. Engraved frontispiece to Olé Worm, *Museum Wormianum seu historia rerum rariorum*, Leiden, 1655. Smithsonian Institution Libraries, Washington, D.C. (cat. no. 17).

Zoology in 1550 was a reasonably pat science and had been so for a long time. The Greek biologist Aristotle had laid the foundation for the descriptive and anatomical part of the discipline, and the Roman encyclopedist Pliny the Elder had added the ethological overlay; little had changed in the ensuing millennium and a half. A glimpse into this late-Renaissance zoological world is best provided by Konrad Gesner's monumental *Historiae animalium* (1551–58; cat. no. 104).[1] This massive encyclopedia is primarily a description of animals that had been known to the Western world since antiquity, and much of the text is drawn from ancient authority, with modern descriptions included as appropriate. The principal innovation in Gesner's compendium is the addition of illustrations, in some cases drawn from life, and indeed this need to *see* the animal in question is a portent of the wonder room to come.

But there are passages with even greater portent in Gesner. These are the few articles on animals that were unknown to antiquity. In his first volume Gesner has a brief note on a strange beast he calls the simivulpa, an animal that we recognize as an opossum. In the second volume, on birds, we encounter the bird of paradise, known in Europe only

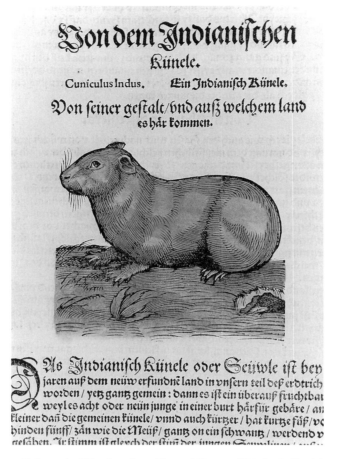

Fig. 2 Guinea pig. Woodcut from Konrad Gesner, *Thierbuch*, Zurich, 1563.

since the return of Magellan's crew from the East Indies. In later supplements, and in the German edition of 1563, Gesner adds other singular beasts: the arctopithecus or sloth, the armadillo, the guinea pig (*fig. 2*), the marmoset, and a handful of other animals that were recent arrivals on the European scene.[2]

The presence of these animals on Gesner's pages was to present some difficulties to natural historians, although Gesner did not realize it at the time. One problem was that the newly known creatures threatened the humanistic basis of zoology, with its reliance on Aristotle and Pliny and other classical authorities. An animal such as the opossum, which is not mentioned by ancient authors, must be approached quite differently from an elephant or a hyena. It comes without pedigree. Its description and attributes must be built up from scratch, with no help from authority. Zoologists were not quite used to doing natural history this way.

A second difficulty is that most of these new animals were singular in the true sense of the word: nothing like them was known in Europe; they were marvels, oddities, almost sports of nature. Who could have imagined an animal that carried its young in a pouch

115

on its belly, or a bird with a rhinoceros-like horn on top of its beak? The freakish nature of these new discoveries created a problem for the zoologist. The problem was whether or not marvels should be incorporated into mainstream natural history.

Marvels and Monsters

Marvels were traditionally a subset of what we call monster or prodigy literature. This genre constituted an entirely separate branch of natural philosophy. Indeed, monster lore might even be considered a part of moral philosophy, since throughout most of the sixteenth century a monster was viewed as a portent, as a direct act of God *against* nature and a sign of divine displeasure.[3] The existence of *natural* monsters was acknowledged, as, for example, the product of cross-breeding between different animal species or between humans and animals. But descriptions of such beasts were usually found in the monster literature, not in the literature on natural history.

One influential book on prodigies was printed while Gesner was completing his publishing enterprise—Konrad Lycosthenes's *Prodigiorum ac ostentorum chronicon* (1557). This folio rivals one of Gesner's tomes in its impressive appearance, but the subject matter within is quite different. Lycosthenes's volume is filled with satyrs, frog-headed babies, wild men, and three-legged fowls. But there is one small area of overlap with Gesner. We find in the Lycosthenes book woodcuts of several new marvels: an opossum (in fact, two

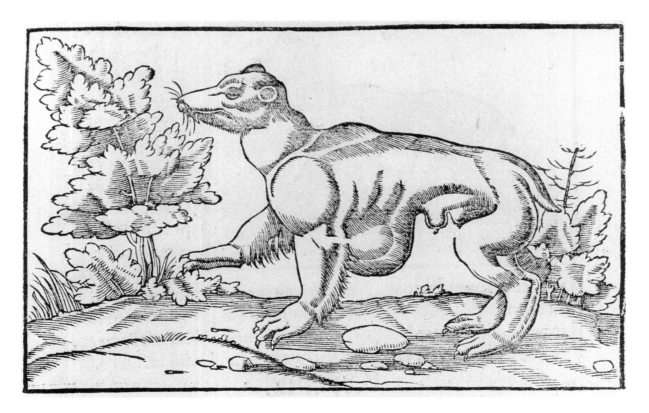

Fig. 3 Panther. Woodcut from Konrad Lycosthenes [Wolffhart], *Prodigiorum ac ostentorum chronicon*, Basel, 1557.

116

of them, with the second called a panther; *fig. 3*) and a cercopithecus, or tailed ape.[4] This overlap suggests that there was some uncertainty about what to make of the recent discoveries and to which branch of natural philosophy they belonged. The opossum seemed to qualify as a monster because it appeared to be half ape/half fox, hence the name simivulpa. The sloth seemed similarly qualified, since its name, arctopithecus, means bear ape, and so did the armadillo (a pig with a turtle's shell), the cercopithecus (a man ape), and any other animal that seemed to combine characteristics from several species. However, monstrous though they appeared to be, the new animals were also clearly part of the regular order of nature in the New World and therefore would seem to fall well within the purview of natural history. So what was to be done with the new singular beasts?

The crisis over the proper niche for newly discovered singular animals was resolved, perhaps unwittingly, by the French surgeon Ambroise Paré in his treatise *Des Monstres et prodiges* (1573; see cat. no. 109).[5] The title itself is illuminating, reflecting a definite change from the more typical "prodigies and portents." What Paré did was to bifurcate the monster domain, splitting off the marvels into a separate class. The lengthy initial section on monsters includes the usual three-headed lambs and pigs with human faces. Many of these are considered to be portents (although, surprisingly, many are attributed to natural causes). But in the last part of the book Paré introduces his marvels, and he assembles a truly international zoo, with entries and images of the ostrich (*fig. 4*), rhinoceros, sloth, nautilus, giraffe, bird of paradise, even the traditional elephant. What

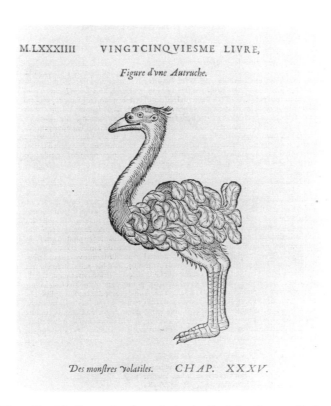

Fig. 4 Ostrich. Engraving from Ambroise Paré, *Les Oeuvres*, Paris, 1585.

is most interesting about his assemblage is that, marvelous though these animals may be, they are treated as eminently natural. They are not portents, not prodigies; it is nature who speaks through such creations, not God. In effect, Paré booted the marvels right into the arms of natural history. And in doing so he made the cabinet of zoological curiosities possible.

Sourcebooks of Singularities

One of the more curious features of the wonder rooms is that they generally contained only those items that the zoological authors had established as marvelous. In other words, the cabinets tended to follow rather than lead the literature. There were a relatively small number of zoological compendia that functioned as sourcebooks on exotica from the New World and the East Indies, and they became in effect guides to building a collection. It will be helpful to identify these at the outset.

We have already mentioned Gesner's *Historiae animalium*, with its few isolated accounts of New World fauna scattered among descriptions of more familiar animals. A contemporary, Pierre Belon, was perhaps more significant, in that singularities were his obsession and several of his books contain nothing but oddities. Belon spent three years traveling in Egypt and the Middle East, making firsthand observations of the flora and fauna there. He also seems to have had access to some of the zoological material that was trickling in from the New World and the East Indies. In 1551 Belon began publishing the results of his observations, often illustrated with his own sketches. His *L'Histoire naturelle des estranges poissons marins* (1551) contained illustrations of such curiosities as the hippopotamus, the argonaut or paper nautilus, and the even more exotic pearly nautilus, while his travel book *Les observations de plusieurs singularitez et choses memorables* (1553) presented the first accurate illustrations of the chameleon, the genet, and the ichneumon or Egyptian mongoose.[6] And Belon's *L'Histoire de la nature des oyseaux* (1555) contained the first illustration of the cock of the Indies or the native American turkey (*fig. 5*).[7]

Even more exotic was André Thevet's *Les Singularitez de la france antarctique* (1557; cat. no. 113).[8] Thevet, although a Franciscan, had joined the Huguenot expedition to Brazil in 1555; in his narrative the European reader was introduced to the toucan, the sloth, the bison, and the amazing (and still elusive) su (*fig. 6*). Thevet also provided riveting descriptions of the Tupinamba cannibals who inhabited the region. He later published a *Cosmographie universelle* (1575) that incorporated many illustrations and descriptions from his travel books; it was from it that Paré and many others gleaned their information about New World marvels.[9]

Certainly the greatest zoological compendium of the early seventeenth century was Ulisse Aldrovandi's *Natural History*, which appeared in twelve volumes from 1599 to 1648 (see cat. no. 108).[10] Aldrovandi's massive tomes attempted to encompass all of the natural world, and so the singular had to compete for page space with the normative. Neverthe-

DES OYSEAVX, PAR P. BELON.

femblable au Coc d'Inde,finon que l'vne porte la crefte, & les barbillons roug
qui au Coc d'Inde font de couleur de ciel . Il eft tout arrefté que touts authe
parlants du Coc d'Inde , que maintenós eftre *Meleagris*, ont dit quils font tach
de diuerfes madrures. Ces Cocs d'Inde ont vn toffet de poils durs, gros , & no
en la poiétrine , refemblants à ceux de la queuë d'vn Cheual, defquels ce feroi

Meleagris en Grec,Gibber en Latin,Coc d'Inde en Francoys.

ce et la couurent de fueilles verdes , tellemēt qu'en co
rant,fans fe doubter de l'embufche, la pauure befte tō
be en cefte foffe auec ces petits . Et fe voyant ainfi prife
elle(comme enragée) mutile *et* tue fes petits : *et* fai

Fig. 5 Turkey. Woodcut from Pierre Belon,
L'Histoire de la nature des oyseaux, Paris, 1555.

Fig. 6 Su. Woodcut from André Thevet,
Les Singularitez de la france antarctique, Paris, 1557.

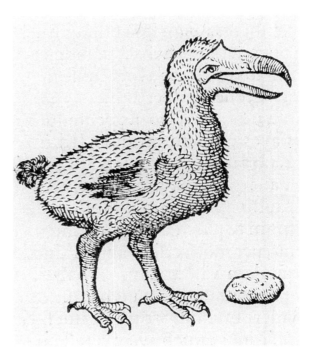

Fig. 7 Kangaroo rat. Woodcut from Ulisse Aldrovandi,
De quadrupedibus digitatis viviparis, Bologna, 1637.

Fig. 8 Dodo. Woodcut from Charles L'Ecluse,
Exoticorum libri decem, Leiden, 1605.

119

less, every animal marvel discovered by 1600 found its place in Aldrovandi's volumes. Readers could now contemplate four different chameleons, five birds of paradise, and five different kinds of South American rodents, including the paca, the guinea pig, and the kangaroo rat (*fig. 7*).

While Aldrovandi took another giant step toward normalizing the marvelous by swallowing them up, there were other contemporary naturalists who tended to focus, as Belon did, on singularities. Charles L'Ecluse's *Exoticorum libri decem* of 1605 is an up-to-date presentation of unfamiliar animals and plants, mostly brought from the New World.[11] Here Europeans got their first good glimpse of a dodo (*fig. 8*) and a penguin, as well as revised views of previously discovered animals, such as the sloth and the marmoset. L'Ecluse's book was extremely influential, both on later zoological literature and on wonder room collections.

A similar kind of compilation, although much less original, was Juan Nieremberg's *Historia naturae* (1635).[12] Its title notwithstanding, this book is a presentation of exclusively New World natural history. Nieremberg was pretty much a stay-at-home Jesuit encyclopedist, but he did have access to the unpublished manuscripts of Francisco Hernandez and to a great deal of information sent back by fellow Jesuits in the New World. He is particularly useful for having gathered in one place all previous information about New World animals; here, for example, are three armadillo drawings, as done by Belon and L'Ecluse. But there are also some true novelties in Nieremberg: a manatee, for example, and the first published illustration of a Virginia opossum, complete with young in pouch (*fig. 9*).

Fig. 9 Virginia opossum. Woodcut from Juan Eusebius Nieremberg, *Historia naturae*, Antwerp, 1635.

120

These then are the sourcebooks for contemporary knowledge about exotic animals. Collectors like Ferrante Imperato, Basil Besler, and Olé Worm used these books to guide their collecting and, as if they were describing their own specimens, cited them frequently in their own catalogue descriptions and ruthlessly pirated their illustrations. There is one other book of this type that should at least be mentioned, namely Willem Piso and Georg Marggraf's *Historia naturalis Brasiliae* (1648; cat. no. 118), but it had such a stupendous impact on the entire conception of the marvelous, and its role in reshaping the wonder room after mid-century was so important, that it merits a separate discussion below.

A Sampling of Singularities

Having alluded in passing to many of the animals and birds that were considered to be marvels, it might be helpful at this point to discuss several of these singular beasts in more detail, considering how they were first discovered and described, in what form they first entered the zoological literature, how they became established as marvels, and the extent to which they were represented in wonder rooms.

QUADRUPEDS

The most popular quadruped in seventeenth-century collections seems to have been the armadillo.[13] Armadillos were first described in 1518 and were already appearing on maps by 1527. The first reasonably accurate illustration appeared in Belon's *Observations* (1553), and a slightly different version was included in Gesner's *Thierbuch* (1563).[14] L'Ecluse illustrated two more species in 1605, Nieremberg collated the two of L'Ecluse with that of Gesner in 1635 (*fig. 10*), and the 1637 volume of Aldrovandi presented yet one more variant.[15] The armadillo was popular for several reasons. First, it met all the criteria for the preternatural, with the behavior (and tail) of a pig; the feet, head, and ears of a horse; and a body covered with the shell of a tortoise, as an early observer described it.[16] Second, because of its shell-like carapace, it preserved well and kept its shape (unlike the sloth; see below), so it was easy to collect and display. Consequently, every respectable wonder room had an armadillo; one can be spotted somewhere on the illustrations of the interiors of the Imperato, Worm, Calceolari, and Besler museums, and the creature is listed in the descriptions of the contents of all of the others. The catalogue of the Olearius collection in Gottorp includes a plate with a good illustration of its specimen (*fig. 11*). Another armadillo is readily visible in the engraved view of Worm's museum, hanging from a peg on the upper right wall (*fig. 1*).

Another quadruped omnipresent in the wonder rooms was the chameleon. It is not a New World creature at all—it is native to the southern Mediterranean—but it was certainly marvelous. Although the animal was often illustrated in emblem books in the early part of the century, the illustrations were quite fanciful; it was Belon who in 1553 first gave us an illustration done from life, an illustration that became directly or indirectly

121

Fig. 10 Armadillos. Woodcuts from Juan Eusebius Nieremberg, *Historia naturae*, Antwerp, 1635.

Fig. 11 Armadillo, sloth, iguana, hyena. Engraving from Adam Olearius, *Gottorffische Kunst-Kammer*, Schlesswig, 1674.

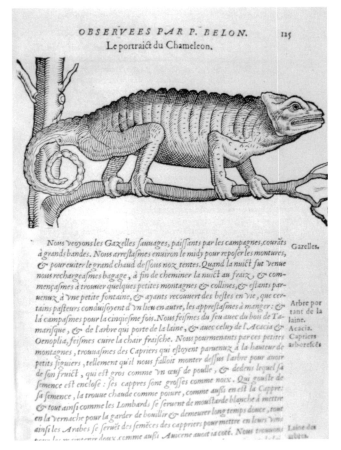

Fig. 12 Chameleon. Woodcut from Pierre Belon,
Les Observations de plusieurs singularitez et choses memorables, Paris, 1553.

the prototype for most chameleon figures for at least a century (*fig. 12*).[17] The chameleon had collection appeal mostly because it was thought to avoid solid food and live entirely on air. Thus the chameleon was often chosen to represent the element air in allegories of the four elements. But unlike the phoenix, its fiery counterpart, the chameleon really existed, and specimens could be collected and mounted for display. There is a chameleon visible on the right-hand shelf in the frontispiece view of Basil Besler's museum (cat. no. 15).

The rhinoceros was also a favorite marvel. Edward Topsell in 1607 called it the second wonder of nature (the elephant being the first).[18] It was a marvel because it is the only animal with a horn on its nose, or so says Topsell. No one had a stuffed rhinoceros (except for Pope Leo X, who kept one at court for a brief period around 1516),[19] but rhino pieces were quite common. Worm had a horn, a piece of skin, and two teeth; the Royal Society had the entire skin of a young animal, a horn, and a piece of hide from a second specimen.[20] Most other museums had some scrap of rhino in their collections.

4°
DE SIMIVVLPA. SIC ENIM FINGO
NOMEN, NE SIT ANONYMOS HAEC BESTIA:
cuius imaginem addidi, qualis in tabulis Geographi-
cis depingi solet.

5°

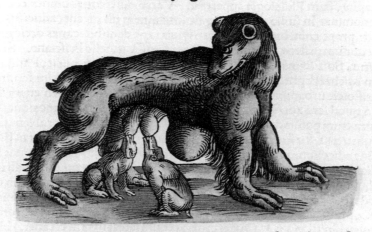

60 I qui noftra memoria Payram regionem luftrarunt, beftiam dicunt fe uidiffe quadrupe=
dem, ex anteriore parte uulpem, ex pofteriore fimiam: præterquàm quòd humanis pedi.
bus fit, & noctuæ auribus; & fubter communem uentrem, inftar marfupij alium uentrem

Fig. 13 Simivulpa or opossum.
Woodcut from Konrad Gesner, *Historia animalium, Lib. I. de quadrupedibus viviparis*, Zurich, 1551.

There were two other animals that were widely acclaimed by zoologists as among God's most amazing creations but that did *not* find wide representation in the zoological cabinets, mainly because their remains were hard to come by. These were the best-known of Brazilian curiosities, the opossum and the sloth. The opossum was one of the very first New World animals to become known to Europe; it was first described in 1500 by Vincente Pinzon, one of Columbus's admirals, and it was figured on the famous Waldsee-müller world map as early as 1516.[21] As a marvel it was a perfect candidate, for as a contemporary writer enthused, it was "a monstrous beaste, with a snout like a foxe, a tail like a monkey, ears like a bat, hands like a man, and feet like an ape, bearing her young about her in an outward belly, much like a great bag or purse."[22] The opossum grew in popularity as a map motif, and it entered the zoological literature in the first volume of Gesner's *Historiae animalium*. Gesner canonized it as a marvel with his newly coined name, the simivulpa, or ape fox.[23] His image was derived from the Waldseemüller map, and it would be the official picture for another hundred years (*fig. 13*).

The sloth made its presence known a bit more slowly, as it does most things. The first description appeared in Gonzalo Fernández de Oviedo's *Natural History of the Indies* in 1526, but it was Thevet's *Singularitez* that established the sloth as a marvel. Thevet described it as an animal with the size of a monkey, the face of a child, the fur of a bear, and three large claws on each foot. Thevet also provided the first image, and although quite

124

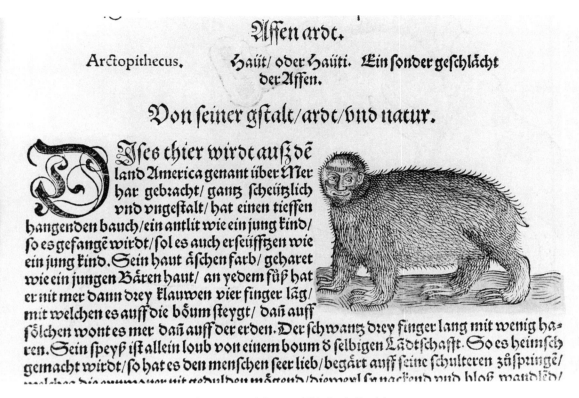

Fig. 14 Arctopithecus or sloth. Woodcut from Konrad Gesner, *Thierbuch*, Zurich, 1563.

inaccurate, it persisted in the literature for some time.[24] It was Gesner, in an appendix to his *Historiae animalium*, who blessed it with a name suitable for a marvel: arctopithecus, the bear ape (*fig. 14*). Fifty years later Charles L'Ecluse saw an actual sloth skin, and he published two rather different illustrations of the animal in 1605. His images competed with Thevet's for another century. It is not known what happened to L'Ecluse's sloth skin; if it entered a cabinet, the location is unknown. Olé Worm, who had practically every rarity imaginable in his collection, did not mention either a sloth or an opossum. Olearius claimed to have a sloth, but one would never know it from his illustration, which is just a copy from L'Ecluse (see *fig. 11*).

BIRDS

Among the marvels of the air that were commonly found in wonder rooms, birds of paradise seem to have been the most widely represented, probably because their skins were trade items and could always be obtained (for a price). The first birds of paradise were brought back from New Guinea by Magellan's crew in 1521, and by 1600 at least three species were known. L'Ecluse has good woodcuts of two of them, the Lesser and the King (*fig. 15*). Their most marvelous attribute was not their coloring, which is indeed stupendous, but their lack of feet, which confined them to a lifetime aloft. Most collectors recognized that these birds achieved their footless status courtesy of the captor's knife,

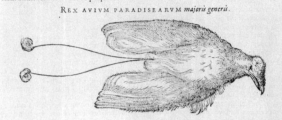

Fig. 15 King bird of paradise. Woodcut from Charles L'Ecluse, *Exoticorum libri decem*, Leiden, 1605.

Fig. 16 Anser Magellanicus or penguin. Woodcut from Charles L'Ecluse, *Exoticorum libri decem*, Leiden, 1605.

but they were such a wonderful emblem of otherworldliness that no collector could resist. Worm, however, quite proudly described one of his specimens as "a lesser variety, *with feet*" (his emphasis).[25]

If a footless bird was a wonder, then even more so were wingless or flightless species, since their handicap seemed to contradict the essential nature of being a bird, which was to fly. The ostrich, being known to antiquity, had less of the mysterious about it, but the penguin was a novelty to the Renaissance. Its discovery was another byproduct of the voyage of Magellan, but, surprisingly, the penguin was not illustrated until L'Ecluse provided a picture in 1605 (*fig. 16*).[26] By that time wonder rooms were already beginning to acquire and display the Magellanic Goose, as the penguin was called. Some collectors, however, confused the penguin with the great auk, a bird of the North Atlantic that is also flightless (or was; it is now extinct). The mistake is understandable, since the name penguin was applied to the auk first, then later transferred to the southern bird. Worm had a true penguin in his museum, if the engraving of the interior is accurate (see *fig. 17*), but in the text he mentions a live penguin that he kept as a pet, and the accompanying engraving (*fig. 18*) reveals that it was a great auk (as does his statement that his penguin came from the Faeroe Islands, northwest of Scotland).[27]

Two other prized bird specimens, which were often confused, were the rhinoceros

126

Fig. 17 Detail of fig. 1, interior of Worm Museum (cat. no. 17).

Fig. 18 Great auk. Engraving from Olé Worm, *Museum Wormianum seu historia rerum rariorum*, Leiden, 1655.

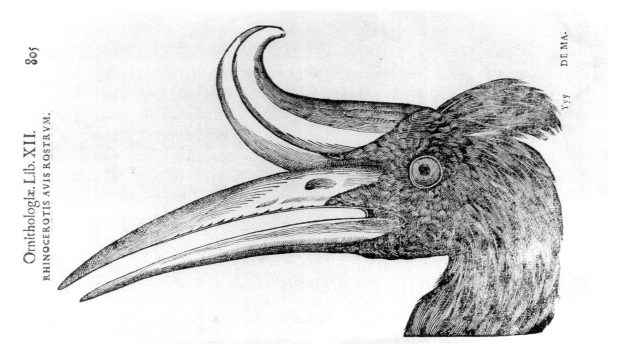

Fig. 19 Rhinoceros hornbill. Woodcut from Ulisse Aldrovandi, *Ornithologiae hoc est de avibus historiae*, Bologna, 1599.

127

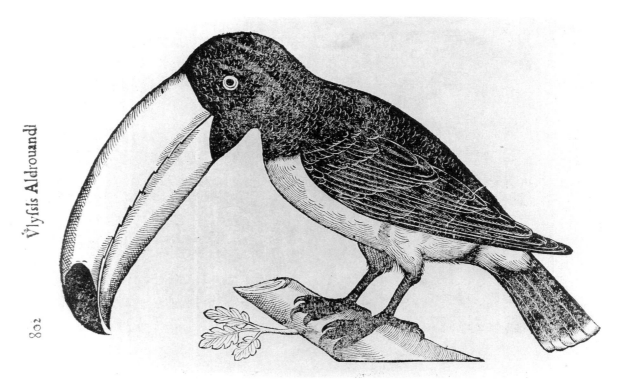

Fig. 20 Toucan. Woodcut from Ulisse Aldrovandi, *Ornithologiae hoc est de avibus historiae*, Bologna, 1599.

hornbill and the toucan. Some species of the hornbill are common to Africa and were mentioned by Pliny, but the rhinoceros hornbill is found only in Borneo, and it is quite unmistakable, with its appearance of two giant bills welded back to back. Aldrovandi presents one of the first images of the beak, and it rapidly turns up in most of the major wonder rooms (*fig. 19*).[28] The toucan has an equally impressive bill; it became known earlier than the hornbill, when Belon added a woodcut of the bill to the end of his chapter on water birds (it must have become available to him just as the book was going to press). Belon called it "un oyseau des terres neufues, incognu aux anciens."[29] Thevet printed a woodcut of the entire bird in 1557, and it eventually made its way into Aldrovandi (*fig. 20*).[30] Although Thevet had used the native name of toucan, Aldrovandi called it a Pica Bressilica, or Brazilian magpie, a name it would keep through most of the century. Practically every museum had at least one toucan beak, and a few the entire bird.[31]

MARINE LIFE

There were many kinds of sea creatures represented in the zoological museums. One of the most ubiquitous marine specimens was the spiral tusk of the narwhal. In the earlier collections this was the famous "unicorn's horn," but already by 1630 its true nature as the product of a marine animal was becoming known. This of course did not diminish its appeal but made it even more marvelous, since animals with horns were a common

128

WORMIANUM. 285

Figurâ triangulari ferme in longitudinem protenfâ, à vertice ad extremitatem pro-
bofcidis, feu tenuioris ejus partis, cui dens inferitur, duos exactè habebat pedes Ro-
manos. Ab extremitate unius latioris proceffus, qui cilia firmabat & oculum dextrum
muniebat, ad extremitatem proceffus, qui finiftrum tegebat, Cranii latitudo erat pedis
unius cum femiffe, eâ enim parte erat latiffimum: gracilefcere deinde & imminui cœpit
in extremum ufque oris. Occipitium verfus etiam paululum extenuabatur parte fupe-
riore, fed inferior eandem tenebat latitudinem, quam occupat linea ab unâ oculorum
orbitâ ad alteram ducta. Occipitium totum per Diametrum pedem unum paulo fupe-
rabat. Sed roftrum feu extremitas oris parte finiftrâ, cui dens inferebatur, erat polli-
cum trium cum dimidio. Dextro latere, ubi nullus erat alveus, qui dentem capere
poffet, craffa erat unciam cum dimidiâ, fubftantiâ fungofâ.

Tribus circiter pollicibus ab occipitii apice, duo ampla extabant foramina, tanta ut
Cranii fuperiore fuperficie duos digitos junctos caperent. Hæc cranium obliquè per-
forantia in palato definebant, ubi ampliora aliquantulum, fepto offeo & valido fatis
diftincta. Per hæc refpirabat & aquam fuperfluam ejaculabatur. Canales enim duo
magni à faucibus orti in hæc terminantur, ut à ventriculo expulfa, ductu recto & com-
modiore huc ferri poffent. In fupremâ Cranii fuperficie corniculata quafi duo tuber-
cula, foramina dicta cingebant, in acutum proceffum terminata, quæ per ejus medium
excurrentia, lineâ feu canali à reliquis offibus fegregabantur, ipfum verò horum fora-
minum feptum, in frontis fummitate monticulum quafi criftatum conftituebat. Utrin-
que minora alia vifebantur foramina, quorum maximum, minimum digitum vix ad-
mittebat, nervis è cerebro in cutem & fuperficiem capitis excurrentibus & mufculorum
tendinibus recipiendis apta.
Poft oculorum orbitas duo fimul ampli vifuntur finus feu meatus, ex offe Zygomatis
& Syncipitis conftituti, utrinque unus; oblongi, ad palati interiora tendentes, longitu-
dine pollicum fex cum dimidio: latitudine, quâ fe maximè extendunt, duorum cum
femiffe, verfus occipitium in angulum acutum definentes. An in his organa auditus,
aut oculorum mufculi latituerint, ignoro. A monticulis, qui foramina ejaculatoria fti-
pant, offa duo oblonga, plana & lævia, per longitudinem Cranii excurrunt, quæ utrin-
que aliis offibus fpongiofis & afperis fibrifque membraneis horridis muniuntur. Hæc
in latere dextro aliis uniuntur, & nullam conftituunt cavitatem, In finiftro verò ma-
gnum & profundum exhibent alveum, denti ifti maximo recipiendo aptum. Qui al-
veus ab extremitate oris ad foraminum ejaculatoriorum parietem tendit, profunditate
pedis unius, cum quatuor pollicibus.
Interiorem ejus fuperficiem afperam & horridam reddebant ligamentorum mem-
branarumque, quibus dentis radix obvolvebatur in fuo alveo, reliquiæ. Diameter ejus
erat pollicum trium cum dimidio, ipfi denti refpondens.

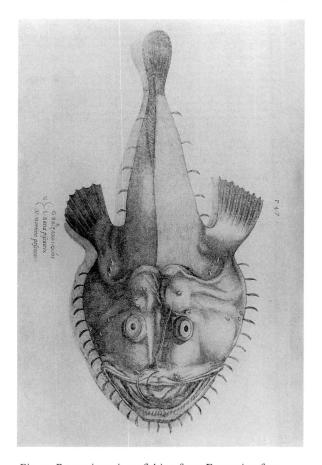

Fig. 21 Narwhal tusk and skull. Engraving from Olé Worm,
Museum Wormianum seu historia rerum rariorum, Leiden,
1655.

Fig. 22 Rana piscatrix or fishing frog. Engraving from
Ippolito Salviani, *Aquatilium animalium-historiae*, Rome,
1554–58.

sight, but a whale with one seven-foot tusk was a decided rarity. Worm was one of the
first collectors to reclassify the unicorn horn—indeed he devoted a number of pages to a
discussion of the supposed unicorn's horn in the description of his museum—and he
included an engraving of a tusk in place in a narwhal skull (*fig. 21*). The interior view of
his museum shows the same skull at left, as well as a horn by itself on a shelf in the fossil
section (see *fig. 1*).

Two other aquatic creatures that were quite popular were the sea snake and the
so-called fishing frog. They are mentioned together because they emanate from the same
source: Ippolito Salviani's *Aquatilium animalium historiae* (1554–58).[32] Salviani was a
contemporary of Pierre Belon; his book is noteworthy for being the first work of natural
history to use copperplate engravings instead of woodcuts for the illustrations. Most of
his illustrations are of local and ordinary fish, but his depictions of the fishing frog and
the sea snake had a certain evocative power, and they quickly joined the ranks of marine
marvels (*figs. 22, 23*). Most museums had specimens of both. What is particularly interest-
ing about the museum specimens is that the illustrations were almost invariably copied

129

Fig. 23 Sea snake. Engraving from Ippolito Salviani, *Aquatilium animalium historiae*, Rome, 1554–58.

directly from Salviani. One can see Salviani's fishing frog hanging from the ceiling in Worm's museum (see *fig. 1*), and Salviani's sea snake is coiled on a shelf below the bird of paradise in Besler's museum (cat. no. 15).

One could run through a similar account for the remaining rarities—crocodiles, iguanas, skinks, flamingos, spoonbills, puffer fish, sawfish, and more—but by now it should be evident that inclusion in a wonder room was reserved for those creatures that were singular in some special way. They either had attributes unique to their class (hornbill, narwhal) or they represented a crossing of the lines of traditional species (pig horse, bear ape, pearly nautilus). If the point is not yet evident, let us consider one further cabinet, that of the Library of Sainte-Geneviève in Paris. Most of this collection was devoted to coins and medals, but there were sections for animal and bird specimens. Figure 24 shows the *entire* quadruped collection. And what do we have? In order of numbering, there is an armadillo, a pangolin, a rhinoceros horn, a narwhal tusk, a lemming, an Egyptian skink, an iguana, a wild boar tusk, a chameleon, a marine tortoise shell, a hippopotamus tooth, a walrus skull, and a crocodile. Every specimen is something extraordinary. It truly was a room of wonders.[33]

130

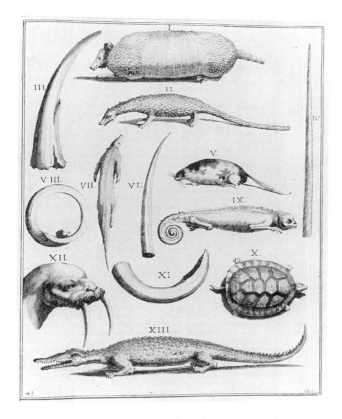

Fig. 24 Various quadruped specimens. Engraving from
Claude du Molinet, *Le Cabinet de la Bibliothèque de Sainte-Geneviève*, Paris, 1692.

The Role of the Marvelous

The question that must now be asked is why museum collections limited themselves, for the most part, to oddities—to the wonderful and marvelous. One is tempted to answer, why not? Why shouldn't a wonder room specialize in wonders? But *wonder room* is a descriptive term, telling us what was collected, rather than a *modus operandi*, a guide to collecting. The early collections were intended to reflect nature in microcosm, a place where one could contemplate the natural order within one or two rooms. In fact they were dominated by marvels. How then did nature come to be delineated by her singularities? This is perhaps the most fundamental question raised by seventeenth-century zoological collections.

To answer the question, we must return first to the monster literature of the late Renaissance. In discussions of prodigies, the contrast was between the natural and the supernatural. Monsters were portents, signs from God, and were outside the ordinary course of nature. One studied them to learn about Providence, not nature. But beginning with Paré the marvelous was gradually separated from the monstrous, and marvels came

131

to be seen as either nature in jest or nature in error; but either way, they were the products of nature at work. If marvels were nature's handiwork, then the study of marvels might well reveal more about nature than the study of ordinary natural objects. The fabric of nature, it was felt, is determined as much by the gaps—the marvels—as by the warp and weft of normal things. The principal architect of this view of marvels, or at least the man who best put it into words, was Francis Bacon.

BACON AND MARVELS

In *The Advancement of Learning* (1605), Bacon divided natural history into several branches. "HISTORY OF NATURE," he said, "is of three sorts: of NATURE IN COURSE; of NATURE ERRING, or VARYING; and of NATURE ALTERED or wrought." These three parts correspond to, in his terms: "HISTORY OF CREATURES, HISTORY OF MAR-VAILES, and HISTORY OF ARTS." Natural history per se is in good shape, says Bacon, but the other two are deficient. In particular, "a substantial and severe Collection of the HETEROCLITES, or IRREGULARS of NATURE" is not to be found, and Bacon strongly recommends that this deficiency be corrected by the collection and study of marvels. Bacon concludes by stating that it is only by following nature in her wanderings that we will ever discover her true paths.[34]

What Bacon provided was an ethos for the wonder room. Most collectors were not explicitly following Bacon's directions as they shaped their collections, but they clearly shared the same attitude toward nature and her manifestations. Nature shines best through the cracks. The sentiment pervading all of the museum books is that one can learn more about the nature of the animal world by studying armadillos, birds of paradise, and fishing frogs than by looking at squirrels, sparrows, and sardines.

EMBLEMATIC ANIMALS

But one does occasionally see ordinary animals in wonder rooms. The view of the Imperato museum, for example, shows a pelican, a crane, and a stork perched on top of some exhibit cases (cat. no. 14); many other museums also contained these same birds. And yet they were quite common and hardly exotic. Does their presence call into question the conclusion that museum collections focused on the marvelous and excluded the ordinary? In fact, such specimens are the exceptions that prove the rule. Though the pelican, stork, and crane were commonplace, they were nevertheless singular, because each was a bird with a strong emblematic association. The pelican had long represented parental devotion, with its purported habit of nourishing its young with its own blood; the crane, which held a rock in its upraised foot when asleep, was emblematic of vigilance; the stork stood for filial devotion, since it took care of its parents in old age. Their singularity lay then not in their exotic origin, but in their function as signifiers of moral values. By including such emblematic animals in their museums, collectors confirmed the principle that it is the oddities of nature that instruct us.

132

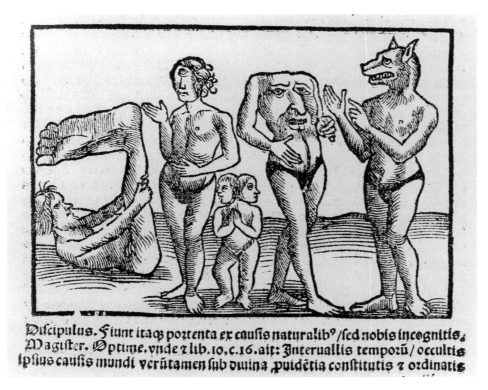

Fig. 25 Human monsters. Woodcut from Gregor Reisch, *Margarita Philosophia*, 1517.

Marvelous Humans

So far we have considered only zoological marvels, and indeed there is yet more to be told of the zoological story, since animal singularities changed in status once more after 1650. But this seems an appropriate place to discuss an interesting episode of parallel evolution, namely the way in which accounts of marvelous humans changed between 1550 and 1650. We have already noted that in the monster literature of the mid-sixteenth century animal monsters and human monsters came under the same rubric, and we have seen how animal monsters become marvelized, then naturalized. Representatives of human monsters also changed. But the change was of quite a different order.

Human monsters before 1550 can be divided into three basic types. First were the generically monstrous, those races that shared and inherited certain monstrous features. Such races included the sciapods, with one leg and one large foot; the acephaloids, with no head and facial features in the chest; the cynocephaloids, or dog-headed people, and so on. Most of these monstrous races were described in Pliny's *Natural History* (cat. no. 2), and their images became a staple of Renaissance cosmographical literature. They were thought to exist at the fringes of the inhabited world, in Ethiopia, in the Orient, and in the Hyperborean lands (*fig. 25*).[35] A second type were the mixed monsters, those thought

133

to be the product of breeding with animals. And the third were the prodigies, those byproducts of divine foreknowledge whose distorted features carried a portent of future events. Zoological lore had exact counterparts to each of these monstrous types, which is why they all got mixed together in the monster literature.

But a curious thing happened in the 1550s and later, especially with regard to the first group, the monstrous races. When new *animals* were discovered in the East and West, they proved to be even more remarkable than the mystical marvels of old, the unicorn, basilisk, and phoenix. When new *humans* were discovered, they proved to be much *less* monstrous than the cyclops and sciapods of medieval lore. But because of their close resemblance to Europeans, they were viewed as even more remarkable, because culturally they were literally in a different world. In other words, sciapods were monstrous because they looked so different; New World natives were not monstrous, because they looked human, but they were deemed marvels, because they did not behave at all like Europeans.

The story of the discovery of the normality of New World natives is an interesting one. A number of illustrations of New World inhabitants were published in the first half of the sixteenth century, but few were at all realistic and none were especially threatening to traditional views of human monsters. But in the 1550s Europeans got their first accurate glimpses, via narrative and illustration, of the way New World humans looked and behaved. André Thevet's *Singularitez*, in addition to its revelations about sloths and toucans, contained descriptions and woodcuts of Tupinamba Indians cutting down trees, smoking tobacco, starting fire by friction, making beer, and preparing an unwilling visitor for dinner. And while the Tupinamba's habit of dismembering and roasting their captives might argue for their retention in the monster category, everything else about them suggested that they were human just like us. The natives looked quite well proportioned and healthy, and they showed pleasure and pain (cat. no. 113). It was their behavior that set them apart as marvels.[36]

A similar, if more gruesome, picture is painted by Hans Staden's *Warhaftige Historia und beschreibung eyner Landschafft de Wilden* (1557). Staden was actually held captive by the Tupinamba, so much of his narrative is taken up with the ritual of cannibalism. But his woodcuts show all kinds of native artifacts and adornments, which seemed quite remarkable to European eyes.[37]

Later narratives of the 1560s and 1570s buttressed this image of the New World Indian as singular but emphatically human. Girolamo Benzoni's *La historia del mondo nuovo* (1565; cat. no. 114) provided glimpses of the natives of Central America, while Jean de Léry's *Histoire d'un voyage fait en la terre du Brésil* (1578; cat. no. 115) contained new visual information on Tupinamba culture, including an illustration of Indians dancing and another of the custom of greeting by weeping.[38] But there is no doubt that the greatest revolution in European views of New World humans came about as a result of one of the most remarkable publishing ventures of the age, Theodor de Bry's *America* series (1590–1634; see cat. no. 117).

De Bry's New World

Theodor de Bry was an engraver turned publisher who had visions of publishing some of the narratives of the voyagers to the New World, *with illustrations*. He had the good fortune to obtain first the paintings of Jacques Le Moyne, which depicted scenes from the French expedition to Florida in 1565–66, and then the watercolors of John White, which recorded native Indian life in the Virginia colony in 1585 and 1587.[39] De Bry transformed the drawings into splendid engravings, and in 1590 the first volume of what would turn out to be a thirteen-volume series appeared: *A Briefe and True Report of the New Found Land of Virginia*, with text by Thomas Harriot and twenty-three large engravings by de Bry (see cat. no. 117).[40] The book also appeared simultaneously in French, German, and Latin translations. Almost immediately de Bry followed with *A Brief Narration of Events which Occurred in Florida* (1591), using as a text the narratives of Le Moyne and Nicolas Le Challeux, and with forty-three engravings by de Bry based on Le Moyne's paintings.[41] (This volume, like subsequent volumes, appeared only in Latin and German editions.) A year later he followed with part three of *America* (1592), which is devoted to Brazil and features the accounts of Hans Staden and Jean de Léry.[42] For this volume, lacking any artwork of the quality of White's and Le Moyne's, de Bry raided already pub-

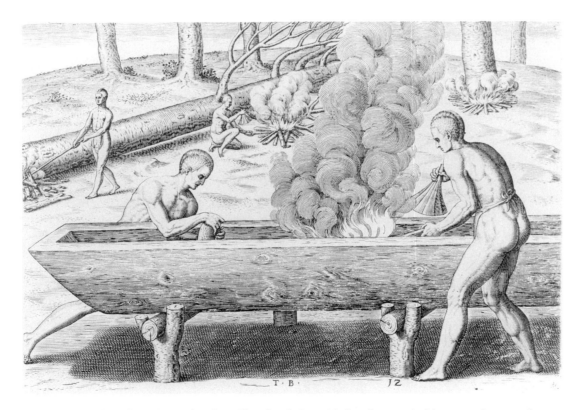

Fig. 26 Algonquin Indians. Engraving from Theodor de Bry, *Admiranda narratio fida tamen, de commodis et incolarum ritibus Virginiae*, Frankfurt, 1590.

135

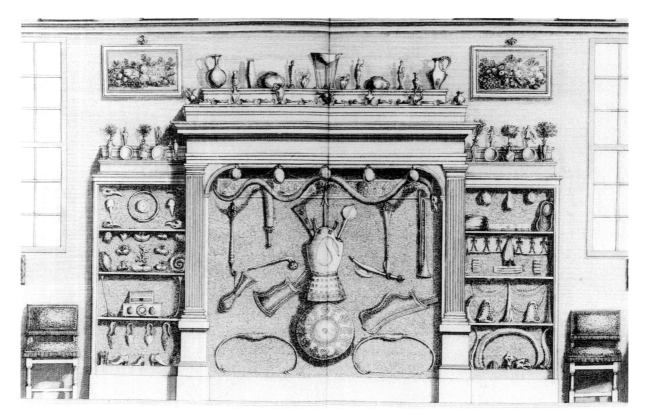

Fig. 27 Cabinet with ethnological artifacts.
Engraving from Claude du Molinet, *Le Cabinet de la Bibliothèque de Sainte-Geneviève*, Paris, 1692.

lished books for woodcuts, which he transformed into engravings. More volumes would follow, but these first three were the real stunners, revealing native life in the New World as never before. Now Europeans could observe natives making dugout canoes, planting corn, smoking fish, killing alligators, burying their dead—in fact, engaging in every type of cultural activity (*fig. 26*). Moreover, de Bry could not slough off his artistic training, so most of the natives portrayed have classical proportions and stand in elegant contrapposto poses. The effect was rather like reading an illustrated Ovid and encountering stories of mythological deities of the Golden Age, except the characters in this case were still alive and the stories were brand new.[43]

The early de Bry volumes effectively killed any remaining notions that non-European races were monstrous. At the same time, the status of the natives as marvels was confirmed many times over. Consequently, artifacts of New World culture became suitable material for inclusion in wonder rooms, and most collections had an ethnological component. Feather fans were quite popular, as were beadware, arrowheads, flaked knives, war clubs, anchor axes, and ceremonial batons.[44] One display cabinet at the abbey of Sainte-Geneviève contained a whole host of Brazilian artifacts (*fig. 27*). Most other collections had something very much like this.

136

The other effect of the elevation of non-Europeans from monstrous to marvelous was the reshaping of the genre of human monstrosities. In the seventeenth century books of human monsters effectively went their own way, separated from the marvels and prodigies with which they were previously intertwined. They tended to be written by physicians, and the interest became teratological. Aldrovandi compiled an exhaustive encyclopedia of monsters, but its publication (1642) was proceeded by those of Johann Schenck (1609; cat. no. 106) and Fortunio Liceti (1616; cat. no. 107).[45] These three compendia shared many illustrations, which tend to depict Siamese twins, two-headed children, humans with animal features, and the like. They were certainly marvelous in their own way. But the books excluded the notion of monstrous races. Furthermore, human monsters lost their status as prodigies and became just another example of "nature wandering."

Marvels and 'Nature in course'

Marvels continued to rule most of the zoological cabinets until well into the eighteenth century. But one senses a change in tone in some of the collections shortly after 1650. Nehemiah Grew, curator of the Royal Society collections, called for a new "inventory of nature" that would give less prominence to rarities and more attention to the ordinary.[46] Even in the collections that continued to emphasize marvels, such as the abbey of Sainte-Geneviève, the descriptions of the specimens began to lose the aura of wonder that pervaded earlier catalogues and became much more matter of fact.

This turning point in the status of marvels, at least with respect to zoology, was the result of the publication of just one book: Willem Piso and Georg Marggraf's *Historia naturalis Brasiliae* (1648; cat. no. 118).[47] This was the first book devoted entirely to the natural history of one localized region in the New World, in this case the Dutch colony in Brazil. It devotes far more space to plants than to animals, but nevertheless the zoological sections, written by Marggraf, were stunning and eye-opening to contemporary Europeans. *Every* quadruped, fish, or bird described there was singular, and there were scores of them: coatis, capybaras, pacas, howler monkeys, tapirs, agoutis, anteaters, as well as the more familiar but still exotic opossum and sloth (*fig. 28*). However, Marggraf did not treat them as singular or as marvels. He treated them as part of the order of nature, not as part of the seams. And, of course, in their native country, they were not prodigies—they were ordinary. Marggraf describes the animals in a matter-of-fact fashion. He studied them alive and studied them dead; he dissected and he classified them as best he could. He pointed out their singular features without resorting to the hyperbole that characterizes a Thevet or Nieremberg. His volume reads very much like Francis Willughby's *Ornithology* of 1678 (cat. no. 123). But Marggraf preceded Willughby by almost thirty years, and he was dealing with totally unfamiliar animals to boot. His is one of the most remarkable zoological treatises of the century, and eventually it was responsible for

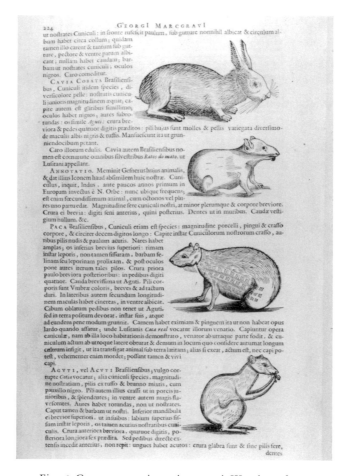

Fig. 28 Cavy, paca, guinea pig, agouti. Woodcuts from
Willem Piso and Georg Marggraf, *Historia naturalis Brasiliae*, Leiden, 1648.

removing the marvel from the ranks of "Nature wandering" and transferring it to "Nature in course."[48]

One collector who felt the impact of Marggraf almost immediately was Olé Worm. He acquired the volume and was so impressed that he used it as a typographic model for the publication of his own museum collection, even going so far as to choose the same publishing house, Elzevir.[49] He followed the style of Marggraf and his editor, Johannes de Laet, in describing living specimens when possible. We have already mentioned that Worm had a great auk for a pet; he also kept a coati around the house, and a lemming, and assorted other fauna.[50] Worm had been collecting a long time before the *Historia naturalis Brasiliae* appeared, and his collection still focused on wonders, to the exclusion of the normal, but his descriptions as a whole come much closer to "natural" history than do those of most of his predecessors and many of his successors.

Mainstream works of natural history were also affected by Marggraf. The successor to Aldrovandi's *Natural History* was the six-volume set of Joannes Jonston, published in

1650–53.[51] Jonston was the first to incorporate Marggraf's descriptions and illustrations, and he incorporated them all, which was rather amazing, considering the small time interval between the two works. Moreover, Jonston was so impressed by Marggraf's objective descriptions, which were in strong contrast to the highly emblematic and myth-laden accounts of Aldrovandi and Gesner, that he altered the descriptions of Old World animals to fit the New World style of Marggraf.[52] The face of natural history was altered forever.

Microscopic Marvels

Ironically, just as the marvelous was about to become fully naturalized in the latter half of the seventeenth century, a new class of singular creatures was discovered that gave new life to marvels. These were the insects, whose remarkable attributes were revealed by a new scientific instrument, the microscope.

The microscope was invented by Galileo early in the seventeenth century. Though sporadic observations were made with it in ensuing decades, it was not until the publication of Robert Hooke's spectacular *Micrographia* in 1665 that the world of the small was opened up for all to see (cat. no. 129). Hooke's oversize engravings of a flea, a louse, a mite, and other tiny insects were more grotesque than any monster illustration of the past century (*fig. 29*).[53] These of course were not monsters, but were, in the most intimate sense, an integral part of our ordinary world.

Successive investigators enlarged, quite literally, contemporary knowledge of the microscopic world. Marcello Malpighi, working in Bologna, began to unravel the anatomy of insects, especially the silkworm, and carefully drew their circulatory and digestive systems (cat. no. 130). His published illustrations had quite an impact on a world raised with the Aristotelian belief that insects were so small, and so primitive, that they had no internal parts at all.[54] Jan Swammerdam undertook to investigate the formidable problem of metamorphosis, the process by which maggots turn into flies and caterpillars into butterflies (cat. no. 131). Metamorphosis in general was a favorite subject of the baroque era, since it entailed defiance of categories and the obscuring of boundaries, and the transformation of insects was naturally appealing, especially when Swammerdam revealed that the adult butterfly already existed in a preformed state within the larval caterpillar.[55] Perhaps the most marvelous discovery was Anton van Leeuwenhoek's revelation that tiny living things, heretofore unknown, existed in rainwater. These "animalcules," as he called them, are the ultimate zoological marvel, for they lay totally outside every known category of living things (cat. no. 132; *fig. 30*).[56]

The effect of this new microcosm of marvels on wonder rooms was limited. A cockroach hanging from the ceiling does not have quite the same effect as a crocodile. But although the subjects were not suitable for exhibition, the instrument certainly was, and most late-seventeenth-century wonder rooms had several, from the tiny single-lens

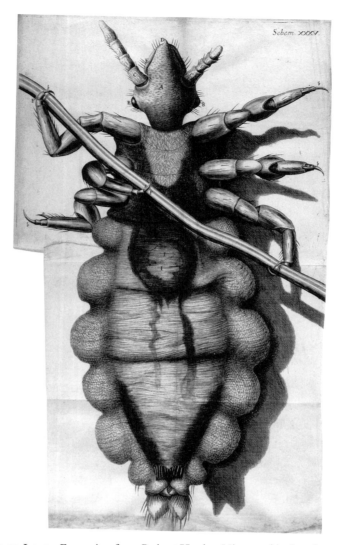

Fig. 29 Louse. Engraving from Robert Hooke, *Micrographia*, London, 1665.
Dartmouth College Library, Hanover, New Hampshire (cat. no. 129).

microscopes that Leeuwenhoek used to the more impressive leather and brass models utilized by Hooke and other investigators. Moreover, since most collections were described in printed books, it was possible to print illustrations of the insect wonders, even if the specimens could not be satisfactorily displayed. Filippo Buonnani took this approach, and his volume describing the Kircher museum in Rome (1709; cat. no. 21) has an entire section devoted to illustrations of microscopic life.[57] For Buonnani, they are clearly the new marvels of the age.

The Waning of Marvels

Although given new life by the microscope, the age of the marvelous was clearly winding down by the end of the seventeenth century. The principal cause of the demise of marvels

was not a lack of interest in marvelous objects, but rather the fact that marvels lost their status as keys to understanding nature. In the Baconian scheme, nature was best understood through her singularities. In the scheme of the Royal Society sixty years later, "nature in course" had become the proper subject of scientific inquiry. Singular beasts were still of interest, but only as natural objects, not as preternatural exceptions.[58] And once the marvelous had become fully naturalized, once it lost its status as an independent genre, the wonder rooms lost their independence. Cabinets of curiosities were gradually transformed into museums in the modern sense. The age of reason was at hand.

Fig. 30 Bacteria. Engraving from Anton van Leeuwenhoek, *Anatomia seu interiora rerum, cum animatarum tum inanimarum, ope & nebeficio exquisitissimorum microdetecta*, Leiden, 1687.

NOTES

1. Konrad Gesner, *Historia animalium*, 4 vols.: *Lib. I. de quadrupedibus viviparis* (Zurich, 1551); *Lib. II. de quadrupedibus oviparis* (Zurich, 1554); *Lib. III. de avium* (Zurich, 1555); *Lib. IIII. qui est de piscium et aquatilium animalium natura* (Zurich, 1558).

2. Konrad Gesner, *Thierbuch* (Zurich, 1563); *Vogelbuch* (Zurich, 1563); *Fischbuch* (Zurich, 1563). These German editions were abridged, but they did incorporate all the new animals that had been discovered since the volume on quadrupeds went to press in 1551.

3. On monster and prodigy literature, see Katherine Park and Lorraine J. Daston, "Unnatural conceptions: the study of monsters in sixteenth- and seventeenth-century France and England," *Past and Present* 92 (1981):22–54; Rudolf Wittkower, "Marvels of the East: A Study in the History of Monsters," in *Allegory and the Migration of Symbols* (Boulder, Col.: Westview Press, 1977), pp. 45–74; Jean Céard, *La Nature et les prodiges: L'insolite au 16ᵉ siècle, en France* (Geneva: Droz, 1977).

4. Konrad Lycosthenes [Wolffhart], *Prodigiorum ac ostentorum chronicon* (Basel, 1557), pp. 21–22.

5. Ambroise Paré, *Des Monstres et prodiges* (Paris, 1573). I have used the enlarged version that was included in his *Oeuvres* (Paris, 1585), pp. 1019–97. There is also a convenient modern edition, *On Monsters and Marvels*, trans. Janis L. Pallister (Chicago: University of Chicago Press, 1982).

6. Pierre Belon, *L'Histoire naturelle des estranges poissons marins* (Paris, 1551); *Les Observations de plusieurs singularitez et choses memorables* (Paris, 1553). On Belon's interest in singularities, see Joan Barclay Lloyd, *African Animals in Renaissance Literature and Art* (Oxford: Clarendon Press, 1971), pp. 34–36 and *passim*. For a more detailed study, see Paul Delaunay, *Pierre Belon, Naturaliste* (Le Mans: Monnoyer, 1926).

7. Pierre Belon, *L'Histoire de la nature des oyseaux, avec leurs descriptions, et naifs protraicts retirex du naturel* (Paris, 1555); see p. 249 for the woodcut of the turkey.

8. André Thevet, *Les Singularitez de la france antarctique* (Paris, 1557).

9. André Thevet, *La Cosmographie universelle*, 2 vols. (Paris, 1575). The 1573 edition of Paré's work obviously could not avail itself of Thevet's cosmographical book, but the 1585 edition of Paré's *Oeuvres*, which reprints "On Monsters and Marvels," incorporates many of Thevet's illustrations, often using the same woodblocks.

10. Aldrovandi's encyclopedia is usually called his *Natural History*, even though none of the twelve volumes actually carries that title. The series began with his *Ornithologiae, hoc est de avibus historiae* (Bologna, 1599) and ended with the *Musaeum metallicum in libros IIII distributum* (Bologna, 1648); in between there were two more volumes on birds, three on quadrupeds, and one each on fish, serpents and dragons, insects, marine invertebrates, and monsters. A later volume on plants (1668) is sometimes included in the list, swelling the number to thirteen. On the last eight volumes of Aldrovandi, see Giuseppe Olmi, *Ulisse Aldrovandi: Scienza e natura nel secondo Cinquecento* (Trent: University of Trent, 1976); Sandra Tugnoli Pattaro, *Metodo e sistema delle scienze nel pensiero di Ulisse Aldrovandi* (Bologna: CLUEB, 1981).

11. Caroli Clusii (Charles L'Ecluse), *Exoticorum libri decem* (Leiden, 1605). Many of the L'Ecluse drawings of animals and plants still survive in Poland; see P.J.P. Whitehead, G. van Vliet, and W. T. Stearn, "The Clusius and Other Natural History Pictures in the Jagiellon Library, Krakow," *The Archives of Natural History* 16 (1989):15–32.

12. Joannis Eusebio Neirembergii, *Historia naturae*, naturae, maxime peregrinae, libris XVI (Antwerp, 1635).

13. Wilma George did a census of the most commonly collected zoological specimens in seventeenth-century cabinets, and I have followed her popularity ratings; see "Alive or Dead: Zoological Collections in the Seventeenth Century," in *The Origins of Museums: The Cabinet of Curiosities in Sixteenth- and Seventeenth-Century Europe*, ed. Oliver Impey and Arthur MacGregor (Oxford: Clarendon Press, 1985), pp. 179–87, figs. 67–70.

14. Belon, *Observations*, fol. 211r; Gesner, *Thierbuch*, p. 95; see Wilma George, "Sources and Background to Discoveries of New Animals in the Sixteenth and Seventeenth Centuries," *History of Science* 18 (1980):79–104, esp. 83, and Wilma George, *Animals and Maps* (Berkeley: University of California Press, 1969), pp. 63, 69.

15. L'Ecluse, *Exoticorum*, pp. 109, 204; Aldrovandi, *De quadrupedibi digitatis viviparis libri tres* (Bologna, 1637), p. 480; Nieremberg, *Historia naturae*, p. 158.

16. See George, *Animals and Maps*, p. 69.

17. Belon, *Observations*, p. fol. 125r. On the tradition of chameleon illustration, before and after Belon, see William B. Ashworth, "Marcus Gheeraerts and the Aesopic Connection in Seventeenth Century scientific Illustration," *Art Journal* 44 (1984):132–38.

18. Edward Topsell, *The Historie of Foure-footed Beastes* (London, 1607), p. 594.

19. Silvio A. Bedini, "The Papal Pachyderms," *Proceedings of the American Philosophical Society* 125 (1981):75–90; Leo X's rhinoceros was the famous Lisbon specimen which, before it drowned on the voyage to Rome, inspired Dürer's well-known woodcut.

20. Nehemiah Grew, *Musaeum Regalis Societatis, or a Catalogue and Description of the Natural and Artificial Rarities Belonging to the Royal Society and preserved at Gresham College* (London, 1681), pp. 29–31 and pl. 2.; Worm, *Museum*, p. 336 (not illustrated).

21. George, "Sources and Background," p. 81; George, *Animals and Maps*, pp. 61–63.

22. Peter Martyr Anghiera, *The Decades of the Newe Worlde or West India*, trans. Rycharde Eden (London, 1555); the translation has been modernized here.

23. Gesner, *Historiae animalium, Lib. I.*, p. 981.

24. Thevet, *Singularitez*, fol. 99v.

25. Worm, *Museum*, p. 294.

26. L'Ecluse, *Exoticorum*, p. 101.

27. Worm, *Museum*, p. 301.

28. Aldrovandi, *Ornithologiae I*, p. 805.

29. Belon, *L'Histoire des oyseaux*, p. 184.

30. Aldrovandi, *Ornithologiae I*, p. 802; Aldrovandi had the hornbill and toucan back to back in his volume, indicating that he too thought them to be related marvels.

31. Both a toucan and a hornbill beak can be seen hanging from hooks in Worm's museum (see *fig. 1*).

32. Ippolito Salviani, *Aquatilium animalium historiae* (Rome, 1554–58).

33. Claude de Molinet, *Le Cabinet de la Bibliothèque de Sainte-Geneviève* (Paris, 1692), pl. 41.

34. Francis Bacon, *The Tvvoo Bookes of Francis Bacon of the proficience and advancement of Learning, divine and humane* (London, 1605), book 2, fol. 7v–9r; for an illuminating discussion of Bacon relative to marvels, see Parks and Daston, "Monsters," pp. 43–46.

35. Gregor Reisch, *Margarita Philosophiea* (Basel 1517), fol. Dir.

36. An excellent account of all depictions of New World natives from 1502 to 1588 may be found in William C. Sturtevant, "First Visual Images of Native America," in *First Images of America*, ed. Fredi Chiappelli (Berkeley: University of California Press, 1976), vol. 1, pp. 417–54. Thevet is discussed on pp. 435–38, where three of his woodcuts are reproduced.

37. Hans Staden, *Warhaftige Historia und beschreibung eyner Landschafft de Wilden* (Marburg, 1557). On Staden, see Sturtevant, "First Visual Images," pp. 433–35, which reproduces two woodcuts.

38. Girolamo Benzoni, *La Historia del mondo nuovo* (Venice, 1965); Jean de Léry, *Histoire d'un voyage fait en la terre du Brésil* (1578); I have used the Geneva 1580 edition. See Sturtevant, "First Visual Images," pp. 438, 442.

39. The original drawings of both Le Moyne and White have been published; see Paul Hulton, ed., *The Work of Jacques Le Moyne de Morgues: A Huguenot Artist in France, Florida and England*, 2 vols. (London: British Museum Publications, 1977); Paul Hulton, *America 1585: The Complete Drawings of John White* (London: British Museum Publications, 1984). White also made a number of drawings of the fauna of Virginia, and some of his sketches were the basis for illustrations in various natural history books of the seventeenth century.

40. Thomas Harriot, *A briefe and true report of the new found land of Virginia* (Frankfurt am Main, 1590); the Latin edition was titled *Admiranda narratio fida tamen, de commodis et incolarum ritibus Virginiae*.

41. Theodoro de Bry, *Brevis Narratio eorum quae in Florida Americae Provicia Gallis acciderunt* (Frankfurt am Main, 1591).

42. Theodoro de Bry, *Dritte Buch Americae* (Frankfurt, 1593).

43. If one does not mind ploughing through a Lévi-Strauss-inspired structuralist thicket, there is a great deal of information and much insight concerning European perceptions of non-Europeans in Bernadette Bucher, *Icon and Conquest: A Structural Analysis of the Illustrations in de Bry's Great Voyages*, trans. Basia Miller Gulati (Chicago: University of Chicago Press, 1981).

44. Christian Feest, "Mexico and South America in the European 'Wunderkammer'," in Impey and MacGregor, *The Origins of Museums*, pp. 237–44, figs. 88–92; Detlef Heikamp, "American Objects in Italian Collections of the Renaissance and Baroque: A Survey," in Chiappelli, *First Images of America*, vol. 1, pp. 455–82.

45. Johanne Giorgio Schenckio, *Monstrorum historia memorabilis* (Frankfurt, 1609); Fortunio Liceti, *De monstrorum caussis, natura, et differentiis libri duo* (Padua, 1616; later eds. in 1634, 1665).

46. Grew, *Musaeum*, fol. A4v; see the discussion in Michael Hunter, "The Cabinet Institutionalized: The Royal Society's 'Repository' and Its Background," in Impey and MacGregor, *The Origins of Museums*, pp. 159–68, fig. 62.

47. Willem Piso and Georg Marggraf, *Historia naturalis Brasilia* (Leiden, 1648).

48. On Marggraf, see P.J.P. Whitehead, "Georg Markgraf and Brazilian Zoology," in *Johan Maurits van Nassau-Siegen, 1604–1679: A Humanist Prince in*

143

Europe and Brazil, ed. E. van den Boogaart (The Hague: The Johan Maurits van Nassau Stichting, 1979), pp. 424–71; P. J. P. Whitehead, "The Original Drawings for the 'Historia naturalis Brasiliae' of Piso and Marcgrave (1648)," *Journal of the Society for the Bibliography of Natural History* 7 (1976):409–22; P. J. P. Whitehead and M. Boeseman, *A Portrait of Dutch Seventeenth-century Brazil: Animals, Plants and People by the Artists of Johan Maurits of Nassau* (Amsterdam: North Holland Pub. Co., 1989).

49. H. D. Schepelern, "Natural Philosophers and Princely Collectors: Worm, Paludanus and the Gottorp and Copenhagen Collections," in Impey and MacGregor, *The Origins of Museums*, pp. 121–27, figs. 50–53; see esp. p. 123.

50. Worm, *Museum*, pp. 319, 322–25.

51. Joannes Jonston, *Historia naturalis*, 6 vols. (Frankfurt, 1650–53).

52. Or perhaps Jonston preferred the Aldrovandi style but was so depressed at the thought of trying to come up with emblematic connotations to make Marggraf conform to Aldrovandi that he took the easy way out. A fuller account of Marggraf, Jonston, and the reformation of zoological style may be found in William B. Ashworth, Jr., "Natural History and the Emblematic World View," in *Reappraisals of the Scientific Revolution*, ed. David C. Lindberg and Robert S. Westman (Cambridge: Cambridge University Press, 1990), pp. 303–32.

53. Robert Hooke, *Micrographia, or Some Physiological Descriptions of Minute Bodies Made by Magnifying Glasses* (London, 1665); among the many secondary studies, see John T. Harwood, "Rhetoric and Graphics in 'Micrographia'," *Robert Hooke: New Studies*, ed. Michael Hunter and Simon Schaffer (Woodbridge: Boydell Press, 1989), pp. 119–47; Hellmut Lehmann-Haupt, "The Microscope and the Book," *Festschrift für Claus Nissen* (Wiesbaden: Pressler, 1973), pp. 471–502.

54. Marcello Malpighi, *Dissertatio epistolica de bombyce* (London, 1669); see Luigi Belloni, "Marcello Malpighi and the Founding of Anatomical Microscopy," in *Reason, Experiment, and Mysticism in the Scientific Revolution*, ed. M. L. Righini Bonelli and William R. Shea (New York: Science History Publications, 1975), pp. 95–110.

55. Edward G. Ruestow, "Piety and the Defense of Natural Order: Swammerdam on Generation," in *Religion, Science, and Worldview: Essays in Honor of Richard S. Westfall*, ed. M. J. Osler and P. L. Farber (Cambridge: Cambridge University Press, 1985), pp. 217–41.

56. Dobell Clifford, ed., *Anton van Leeuwenhoek and his 'Little Animals'* (New York: Dover Publications, 1960), esp. pp. 109–66.

57. Filippo Buonanni, *Musaeum Kircherianum* (Rome, 1709), pp. 322–91.

58. Park and Daston maintain that the Royal Society "failed to conjoin the histories of nature erring and nature in course" ("Unnatural Conceptions," p. 50), but this assessment does not, I hope, conflict with mine. The subject of their study was monsters, which at the time of the Royal Society was a term being applied only to the teratological. Marvels were no longer considered monsters, nor were marvels treated as examples of "nature erring."

A Paradise of Plants:
Exotica, Rarities, and Botanical Fantasies

Elisabeth B. MacDougall

TWO DIFFERENT DEVELOPMENTS IN THE FIFTEENTH century set the stage for a phenomenon of the sixteenth and seventeenth centuries—the evolution of botanical books and florilegia. The voyages of discovery to the Far East and the Americas stimulated interest in the study of plants, especially the exotics encountered in faraway places, while the invention of movable type for printing made it possible to disseminate the new information widely and rapidly. Coupled with this was the desire of the intellectuals of the period to organize information about the natural world into structured and hierarchical systems, a desire made all the more pressing by the flood of importations of unknown flora and fauna and the discovery of new human races. The study of plants and attempts to organize them into families was the beginning of the modern science of botany and botanical taxonomy; that is, the study of the life processes of plants and "the orderly classification of plants according to their presumed natural relationships."[1]

The earliest printed botanical books were compilations of traditional information about medicinal plants and their use. They began to appear soon after Johann Gutenberg's great invention (the first dated European printing from movable type was in 1454). Examples in Latin, German, and French all were issued before the end of the fifteenth century; their function was denoted by titles such as *Hortus Sanitatis, Gard der Gesundheit*.[2] Their contents were largely based on materials drawn from treatises by Theophrastes, Dioscorides, and Galen that had survived from antiquity, numerous manuscript copies of which were to be found in libraries throughout Europe.[3] Since identification of the plants to use in medicines was important, these early printings were illustrated (cat. nos. 136, 137), as many of the manuscript editions had been; but the crudeness of the woodcuts suggests that they were made by the printers, not by professional artists.

By the fourth decade of the sixteenth century both the content and the illustrations

Fig. 1 Cedar of Lebanon. Woodcut from John Gerard,
The Herball; or, General Historie of Plantes, London, 1597.

of botanical books had begun to change. Reliance on ancient authorities diminished as
scientists had to cope with the description and analysis of plants unknown in the ancient
world. Their interest expanded beyond studying the medicinal uses of plants to learning
about all their properties and to devising the first taxonomic systems. This required ever
more accurate depictions of the whole plant with its roots, leaves, buds, blossoms, and
seeds; increasingly, trained artists were employed to illustrate the books. At first illustra-
tions tended to be kept small and to be restricted by the shape of the wood block (*fig. 1*);
but as engraved metal plates became the most common medium, illustrations frequently
occupied the entire page, and the plant forms were distributed in curvilinear decorative
shapes (cat. no. 141).[4] Finally, when florilegia (books depicting ornamental plants and

146

with little or no descriptive text) began to appear early in the seventeenth century, aesthetic interests dominated the design, although botanical accuracy was not sacrificed (cat. no. 148).[5]

The content of this new type of book varied greatly; some were simply continuations of traditional types of plant lore and beliefs, others were reports on discoveries made on voyages of exploration outside Europe or botanical research in lesser-known parts of the continent. Some were catalogues of plants for sale, others recorded exotica in the collections of princely patrons, while a few were early examples of taxonomic studies.

In this era at the beginning of modern scientific botany, many myths and misconceptions were retained from earlier centuries. The belief in the magical and medicinal qualities of the mandrake, for instance, was still current. Even patrons as enlightened and scientifically advanced as Pope Urban VIII and his family displayed in their palace in Rome a mandrake root and a rhinoceros horn along with their collection of coins and medals and a series of tulip paintings in a sort of *Wunderkammer* that also contained an aviary ("un'uccelliera maestosa").[6] Traditional horticultural lore was repeated as well. For example, the myth that a plant's odor or color could be changed by pouring perfume or dye into cuts in its roots was repeated in the first treatise to be devoted solely to the culture of flowering plants for ornamental gardens, Giovanni Battista Ferrari's *De florum cultura*, of 1633 (cat. no. 160).[7]

Another belief that survived from medieval times was the Doctrine of Signatures, which held that divine Providence had created plants and animals with resemblances to parts of the human body to indicate the ailments they would cure. Giovanni della Porta in his *Phytognomonica* of 1588, for instance, illustrated several composite flowers with central disks surrounded by raylike petals and discussed their uses in healing inflammations, infections, and defects of vision in eyes (cat. no. 151; *fig. 2*). The overall form of the flower, root, or plant was important for identification with the human analogue, but other characteristics, such as odor or taste, were also guides to the medicinal use of the plant. The concept of resemblance, which goes back to the ancient Greeks, has left its mark in modern plant nomenclature. The name for the *orchidaceae* family, for instance, derives from *orchis*, a flower whose roots were believed to resemble testicles, which in Greek is ὄρχις.

Although the distinction between plant and animal life had been recognized by Aristotle and other writers in antiquity, people found it possible to believe in strange transformations of plants into living beasts—marvels supposedly seen by travelers to distant lands and illustrated in works such as Claude Duret's *Histoire admirable des plantes* (1605; cat. no. 138) or Johann Zahn's "Flores et fructus producendi mirabiles" (1696; see cat. no. 139). Another such myth was that the leaves of the Credulity Tree turn into fish or birds depending on whether they fall in water or on the ground. Among the most frequently repeated stories was that of the Scythian lamb, a shrub that grew in the steppes of Asia. Its woolly blossoms were said to grow in the form of a sheep and at maturity to drop off the stem to become a living beast. According to some authorities the live animal

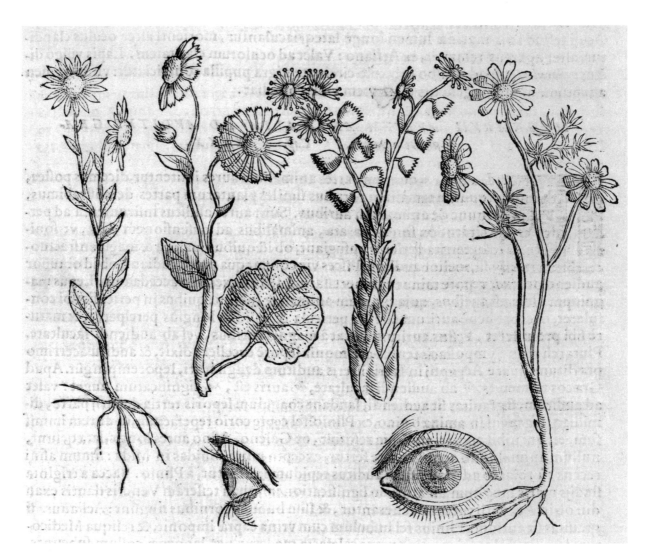

Fig. 2 Flowers appropriate for treatment of eye disease.
Engraving from Giovanni Battista della Porta, *Phytognomonica* . . . , Naples, 1588.

remained fixed to a treelike trunk but grazed on grasses growing near it. There is, in fact, a plant indigenous to that region which at a distance may easily be mistaken for a sheep; the rest is purely imagination. Like the mythical inhabitants of the Antipodes, such exotic forms occurred only in strange and rarely visited lands—no specimens were ever to be found in collections of curiosities.

The astounding richness and variety of plants discovered by the explorers of the eastern and western hemispheres perhaps made botanical writers and plant collectors more prone to believe in these fantasies. For Europeans, whose flora had been devastated by the glaciers that covered most of the continent in the Ice Age, two factors stood out. One was the tremendous variety of genera and species that were unknown in the European ecology, the other was the brilliance of coloring and diversity of form of the tropical and semitropical plants they found.

148

Information about discoveries, and plants themselves, were brought home by explorers, invaders (such as the Spanish troops in Central and South America), missionaries, and merchants traveling in the Near and Far East. Their travels were described in myriad books with contents ranging from truly scientific observation to fantasies such as those published by Duret. Some of the earliest were by Spaniards who accompanied expeditions to the Americas and the Far East. Their writings were circulated widely and translated into other languages. Nicolás Monardes's *Primera y segunda y tercera partes de la historia medicinal de las cosas que se traen de nuestras Indias Occidentales que siruen en medicina* of 1574 appeared in English translation with the title *Joyfull Newes out of the Newe Founde Worlde* in 1577 (cat. no. 143), illustrated with woodcuts that appear to be copied from the Spanish edition. It contains the first depictions of the tobacco plant and of a sassafras tree. In his 1582 book *Stirpium & aliarum exoticarum rerum* (cat. no. 144) Charles L'Ecluse, a Flemish botanist, published information he had obtained in England about some plants brought back from Sir Francis Drake's circumnavigation of the world in 1577–79 plus descriptions and illustrations (a banyan) from Christoforo Acosta's *Tractados de las Drogas* of 1578; L'Ecluse's book also appeared in an Italian translation in 1585. Not all the reports reached print; many of the discoveries made in Mexico were recorded only in manuscript form, but they nevertheless still circulated. A Spanish manuscript with extensive descriptions of Aztec medicinal plants and their uses was in the possession of the grand duke of Florence and is now in the Magliabecchiano Library in Florence.[8]

The earliest accounts concentrated on medicine and food, although ornamental flowering plants were also mentioned. Obviously, seeds and tubers were brought back by the explorers, and we find that extra-European plants were grown in many locales. Although many of the discoveries have become part of our normal diet, such as corn, potatoes, certain kinds of beans, and tomatoes, they were adopted slowly and cautiously for human consumption. Corn (*zea mays*) appeared early in descriptions and illustrations.[9] Although it is indigenous to the Americas, it was usually called "Turkie corn" because of the belief that the Americas were outlying islands of Asia. A common attitude to the new foods is expressed by John Gerard in his *The Herball; or, General Historie of Plantes* (cat. no. 147):

We have as yet no certaine proof or experience concerning the vertues of this kind of corn, although the barbarous Indians which know no better, are constrained to make a vertue of necessitie, and think it a good food; . . . whereas we may easily judge that it nourisheth but little, and is of hard and evill digestion, a more convenient food for swine than for men.[10]

No such hesitation seems to have hindered the adoption of some new indulgences. Tobacco was described and illustrated early (cat. no. 149), and its use spread rapidly in Europe. Hot chocolate, made from the cacao bean native to the equatorial Americas, also became very popular, especially in Spain, where it was first introduced, and coffee, of Near Eastern origin, soon followed.

New ornamentals also had a tremendous impact on plant growers, especially aristo-

crats who collected imported exotics as avidly as they collected paintings and other works of art. Great numbers of new flowering plants were imported and established in private and botanical gardens. The frequent presence, in plant lists, of names such as *Constantinapolitana, africana, indico, peruana, canadense* is an indication of the number and variety of plants imported during the sixteenth and seventeenth centuries.

Perhaps stimulated by the evidence of the variety of the plant world, perhaps as part of the movement to organize coherent systems to describe the plant world, European botanists also began to explore their native flora, both in the areas surrounding their towns and in more remote areas such as Hungary or the Pyrenees in Spain. Their discoveries were reported in books such as Charles L'Ecluse's *Rariorum aliquot stirpium* or Rembert Dodoen's *Florum* (cat. no. 145).[11] An example of the description of the plants found near a town was often bound in with Pietro Andrea Mattioli's various commentaries on Dioscorides.[12] Many European flowering plants, hitherto found only in the wild, also appeared in cultivation for the first time, as names like *lusitanica, hispanica,* and *pannonica* indicate.

Botanists struggled to fit the new species and families into the plant nomenclature in use, which was a system basically derived from plant names known from antiquity. New discoveries were assigned names like lilionarcissus, combining the names of two plants, lily and narcissus, that survived from antiquity (cat. no. 159).[13] There was no standardization of nomenclature, although plant collectors all over Europe corresponded and traded plants and seeds frequently. Hence Abraham Munting (cat. no. 146, p. 1585) calls the passionflower (*Passiflora* L.) a clematis, while other botanists of the period referred to it as grenadilla.

The generation of botanists that flourished in the mid-sixteenth century laid the foundation of the modern science of botany, and their publications continued in use well into the eighteenth century. A consistent feature of all their work was the rejection or at least the reexamination of traditional information that had survived from antiquity. Although they all attempted to include all types of botanical writing in their publications, some emphasized the accuracy of their depictions of plants (Otto Brunfels and Leonhart Fuchs, cat. nos. 140, 141), others concentrated on the study and description of the plants, while a few, like Mattioli, wrote on ancient treatises, introducing new discoveries and ideas in their commentaries.[14]

Many of the most influential publications of the sixteenth century result from attempts to create order in the flood of importations and local discoveries. Our present binomial taxonomic nomenclature has its origins in these centuries, although there was little agreement on which characteristics constituted proof of relationship. The most primitive systems classed plants by their period of bloom or fruit, others by the type of fruit, and those nearest our present system by the shape of their flowers (see Dodoens, cat. no. 145).[15]

Information about the new discoveries and their place in the botanical world was also

organized and disseminated in the botanical gardens that were first established in the 1560s at universities with medical faculties. The two earliest were at the universities of Padua and Pisa, but they were soon followed by others in Italy and at Leiden, where Charles L'Ecluse was the first director, and at Oxford.[16] Originally these gardens were intended for the use of physicians and medical students and included only medicinal and culinary plants. Gradually new discoveries of all sorts, ornamental as well as medicinal, were included. L'Ecluse, for instance, grew tulips in Leiden; they were a present from Ogier Ghiselin de Busbecq, the Austrian ambassador to Constantinople, who brought the first recorded specimens to Europe.[17] Many schemes were devised for planting these gardens; at first their designs were similar to those of pleasure gardens of the period, with intricate interlaced planting patterns, but gradually the plants began to be organized systematically by size, by function, or by genus (*fig. 3*).

Although the discoveries of new foods and drinks, new medicines and drugs were hailed by botanists, physicians, and scholars, the greatest impact of the importations and

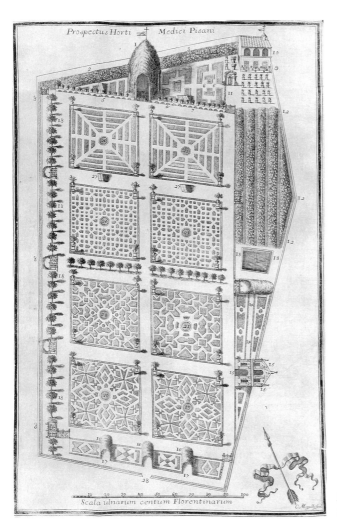

Fig. 3 View of the botanic garden at Pisa. From M. Tilli, *Catalogus plantarum horti Pisani*, Florence, 1723.

151

explorations was the enormous expansion of stock for pleasure gardens. First came the bulbs—tulips, hyacinths, anemones, narcissus, lilies, and fritillaries—in bewildering variety and quantity. Then there were the tropical or semitropical plants: flowers like geraniums (*pelargonia*), marigolds (*tagetas*), nasturtiums (*tropolaeum*); shrubs like lilacs (*syringa*) and roses (Persian and Chinese species); and trees like the palms and magnolias. All were eagerly collected and traded throughout Europe.[18] The exotics were sought by wealthy and aristocratic garden owners; Cardinal Farnese's garden on the Palatine Hill in Rome had plants such as a yucca (*yucca gloriosa* L.) from the Americas and a type of amaryllis from the East Indies. They were depicted in a book by Tobia Aldini (cat. no. 159) along with a dozen other plants originally from countries of all parts of the world: India, South Africa, Peru, Brazil, and North America. Some of the collections became enormous. The plants assembled by the bishop of Eichstätt (Franconia), as recorded by Basilius Besler in *Hortus Eystettensis* (1613), numbered 660 botanical species and more than 400 horticultural varieties.[19] Similar collections were assembled by other members of the aristocracy and by rulers, such as Count Charles d'Arenberg of Brussels; Francesco Caetani, duke of Sermoneta; and Gaston d'Orléans, brother of Louis XIII, whose collection laid the foundation for Colbert's and Louis XIV's Jardin des Plantes in Paris.[20]

The introduction of so many new plants led to the development of a new genre of horticultural treatise, one that dealt solely with ornamental flowering plants. Earlier treatises on agriculture had sometimes included information on growing trees and shrubs and on laying out a plan;[21] not until the seventeenth century did much information begin to appear about the culture of ornamentals. An early example of this is in the sixth book of Olivier de Serres's treatise *Le Théâtre d'agriculture et mesnage des champs*, a section of which is devoted to the *boquetier*, a term for a pleasure garden with trees and shrubs as well as flowers.[22] Of the writers of the period only de Serres included instructions for growing specific plants, and not until Ferrari's *De florum cultura* (cat. no. 160) came out in 1633 was there a book entirely devoted to flowering garden plants. This treatise contains descriptions of the flowers, leaves, stems, and roots of the plants most popular at the time—plants like hyacinths, narcissus, and anemones—with all the variations of color and growth habit in each, and includes instructions for growing them.

The bulbous and tuberous plants also figure largely in the new genre of florilegia that began to appear at the end of the sixteenth century. Clearly these flowers, for the most part importations or newly domesticated wildflowers, occupied the most prominent role in the new ornamental gardens that were widespread throughout Europe. Although the most popular plants were new to European horticulture, it is clear that they were no longer the exotics they had been in the early sixteenth century. A market and a trade had developed for them, and there were even catalogues in circulation depicting the stock of a given plant seller.[23]

What was the basis for the popularity of these new garden plants, aside from their obvious beauty? At first rarity was certainly a key factor. To be the possessor of plants

from the most distant parts of the world appealed to the wealthy, as did the other "marvels" that were brought back by expeditions. They were proof of status, wealth, influence. The ability to grow plants from climates so different from Europe's was also important; a dead specimen was not as impressive as a growing one. There was also a fascination with the changes undergone by bulbous and tuberous plants. In an era intrigued by the idea of metamorphosis, the transformation of the knobby or onionlike objects into flowers of such beauty and variety must have seemed miraculous. The life cycle of herbaceous plants was understood, as were the methods of growing plants from seeds, but plants that generated from eyes (tubers) or had miniature stems and leaves within an ugly, anonymous sphere were wondrous. Ways to identify bulbs and tubers and the discovery of ways to grow them became a preoccupation of horticultural writers and botanists.

Their propagation was another concern, because the few methods in use were not suitable. Grafting, common for fruit-bearing trees, was not feasible for herbaceous plants, and plants did not necessarily come true from seeds. Cross-pollinization by hand was unknown and the cause of changes in a genus not understood. Variations seem to have occurred only through mutation and natural, accidental cross-pollinization. Such variations were highly treasured, as we know from the great variety of the popular ornamentals listed and depicted in contemporary sources.[24] That the mechanism was not understood is proven by the enormous prices paid for tulip bulbs. A bulb, unlike a seed, was certain to be a replica of the variety desired. This certainty plus the fact that increase in stock for bulbous plants is slow assured the high value placed on tulip bulbs.

Yet neither rarity nor the mysterious metamorphosis of the new plants accounts entirely for their popularity. In an era when allegory and symbolism were employed and expected in all forms of art, similar significance was sought in the new plants. The New World, especially, was seen as a "Garden of Eden," as it is depicted in the frontispiece to John Parkinson's *Paradisi in sole paradisus terrestris* (1629; cat. no. 152). In a scene surmounted by an image of the sun (*sole*) and God, we see a clearing in a jungle with exotic wild animals and plants, among them cactus, pineapples, palm trees, the Scythian woolly lamb, and tulips. In the center Adam is standing by the Tree of Wisdom. The implication is that we are seeing a pre-Fall scene or, to use the concept of the title, the terrestrial paradise, which denotes an age of innocence, a golden age during which there was no war, no poverty, and no sin. At the deepest level this image also invoked contemplation of the richness of God's gift in creating a world so bounteous.

The shapes and colors of individual plants were also assumed to have allegorical content. An example is the passionflower of South America, whose stamen were believed to represent the Instruments of Christ's Passion. This was interpreted as evidence that the new discoveries were God's creation and that the whole world was a reflection of his power and munificence.

The use of the recently invented microscope to investigate the composition of plant

Fig. 4 Detail of Daniel Seghers,
A Garland of Flowers on a Carved Stone Medallion (cat. no. 155).

tissues is symptomatic of the mixture of scientific inquiry and wonder at God's creations that typified the period. In his painstaking illustrations of the microscopic structure of roots and twigs, Nehemiah Grew in his book *The Anatomy of Plants* (1682; cat. no. 161), prepared the ground for modern knowledge of plant physiology while marveling at the hitherto unknown world as a sign of the mysteries of God's creations.

It is hard to imagine today the overlay of mystical, allegorical, and mythical interpretations of all natural phenomenon in this period. The planets influenced man's temperament and the character of plants, as did the four elements (fire, water, air, earth). The signs of the zodiac could influence the growth of plants, and early botanical gardens may have been laid out to demonstrate this principle.[25] Even colors of flowers were subject to allegorical interpretation. As an example, Ferrari referred to the red American Cardinal flower (*Lobelia Cardinalis*) as a creation honoring his patron, Cardinal Francesco Barberini (a cardinal's robes are brilliant red).

Allegory and symbolism are believed to underlie the flower paintings that became popular toward the end of the sixteenth century. On the surface they appear to represent the kind of elaborate floral arrangements used at banquets and to decorate reception rooms of mansions; Ferrari gives elaborate instructions for their creation in his *De florum cultura* and describes how they should be displayed. However, the presence in many of them of dying flowers and insects symbolic of death and resurrection has led to their interpretation as *memento mori*; in a few this theme is verified by the presence of a skull, an obvious reference to death.[26] Some flowers had traditional associations with religious themes, such as the Madonna lily, which figures so prominently in the painting by Hendrik van Balen and Jan Brueghel the Younger, *Madonna and Child in a Floral Garland* (cat. no. 154). At other times a plant could be used as a mnemonic, like the spiny eryngium

in Daniel Seghers's *A Garland of Flowers on a Carved Stone Medallion* (cat. no. 155; *fig. 4*), which was intended to recall Christ's Crown of Thorns.

 With few exceptions, the plants still considered exotics today—the tropical importations from Asia and the Americas—do not appear in these paintings. The flowers that dominate the bouquets, although once genuine rarities, could now be found in every garden.[27] Their "domestication" is symbolized by the use of a sunflower, called among "the rarest and excellentest flowers" by Crispijn de Passe in 1614 (cat. no. 148)[28], as an allegory for God's grace in a 1654 emblem book (*fig. 5*) and the presence of tulips and anemones, exotic imports in the sixteenth century, in the 1670 painting *Allegory of Europe* by Jan van Kessel and Erasmus Quellinus (cat. no. 13).[29] By the end of the seventeenth century the assimilation of the former botanical marvels was so complete that few people remembered the excitement of their discovery or the novelty of their colors and forms.

Fig. 5 Emblem with sunflower. Engraving from Joachim Camerarius,
Symbolorum et emblematum ex re herbaria, Nuremberg, 1654.

155

NOTES

1. *Webster's Ninth New Collegiate Dictionary* (Springfield, Mass., 1984), s.v. "taxonomy."

2. Gundolf Keil, "Hortus Sanitatis, Gard der Gesundheit, Gaerde der Sunthedt," in *Medieval Gardens*, ed. E. B. MacDougall (Washington, D.C.: Dumbarton Oaks, 1986), pp. 55–68.

3. Theophrastus, *De historia et de causis plantarum* (Treviso, 1483); Dioscorides, *De materia medica* (Colle, 1478); Galen's several treatises on medicine were published as *Opera Omnia* (Venice, 1490).

4. Leonhart Fuchs employed two artists, Heinrich Füllmaurer and Albert Myer, to make the drawings and a skilled engraver to cut the plates.

5. A short history of botanical illustration appears in Wilfred Blunt and Sandra Raphael, *The Illustrated Herbal* (New York: Metropolitan Museum of Art, 1979), and more detailed studies in Claus Nissen, *Die botanische Buchillustration* (Stuttgart: Hiersemann, 1966). For histories of the science of botany, see Agnes Arber, *Herbals: Their Origins and Evolution* (London, 1950); and Edward L. Greene, *Landmarks of Botanical History*, ed. Frank Egerton (Stanford: Stanford University Press, 1983).

6. "Indice di medaglie, di miniature rappresentanti fatti storici o cose naturali, che si contenavano in CXII Casette," in the Barberini manuscript collection at the Vatican Library; Biblioteca Apostolica Vaticana, Ms. Barb. Lat. 4236. This volume is bound with parchment printed with the coat of arms of Francesco Barberini, who was made a cardinal in 1623 and died in 1679. In addition to the items already mentioned, the 112 display cases of the collection contained such curiosities of nature as minerals, fossils, and some dried insects. Forty cases held the paintings of tulips. Science in seventeenth-century Rome is discussed by Lucia Tongiorgio Tomasi, "Francesco Mingucci 'Giardiniere' e pittore naturalista: Un aspetto della committenza Barberiniana nella Roma seicentesca," *Federico Cesi*, Atti dei Convegni Lincei 78 (Rome, 1986): 277–306.

7. Ferrari, a Jesuit priest in the employ of the Barberini family, dedicated his volume to Princess Anna Colonna, wife of Prince Matteo Barberini. An Italian edition appeared in 1639.

8. See Debra Hassig, "Transplanted Medicine: Colonial Mexican Herbals of the Sixteenth Century," *Res* 17/18 (1989): 30–53.

9. For a history of early descriptions and depictions of American corn, see John J. Finan, *Maize in the Great Herbals* (Waltham, Mass.: Chronica Botanica Co., 1950). *Corn* is a word derived from Latin, meaning grain. It is used as a name for other cereals—wheat in England, oats in Scotland and Ireland, for example.

10. John Gerarde, *The Herball; or, General Historie of Plantes* (London: A. Islip, J. Norton, and R. Whitakers, 1597), p. 77.

11. Caroli Clusii (Charles L'Ecluse), *Rariorum aliquot stirpium per Hispanias observatorum historia* (Antwerp, 1576); Remberto Dodonaeo, *Florum et coronarium odoratarumque nonnullarum herbarum historia* (Antwerp, 1568), includes indigenous flora of the Netherlands as well as recent importations.

12. *Accessit . . . Opusculum de itinere, quo e Verona in Baldum montem plantarum refertissimum itur* bound in with Pietro Andrea Mattioli, *De plantis epitome . . . Compendium de plantis omnibus* (Venice, 1586).

13. See Georgina Masson, "Italian Flower Collectors' Gardens," in *The Italian Garden*, First Dumbarton Oaks Colloquium on the History of Landscape Architecture, ed. David Coffin (Washington, D. C.: Dumbarton Oaks, 1972), p. 67, for a list of exotic plants called hyacinth or narcissus in the seventeenth century.

14. See above, note 12.

15. An example is Basilius Besler, *Hortus Eystettensis . . .* (Eichstätt, 1613). See Gérard G. Aymonin, *The Besler Florilegium: Plants of the Four Seasons*, trans. Eileen Finletter and Jean Ayer (New York: Harry N. Abrams, Inc., 1989). For classification by type of fruit, see Johannes Jonstonus, *Dendographias; sive, Historiae naturalis de arboribus et fructibus . . .* (Frankfurt am Main, 1662). Remberto Dodonaeo, *Stirpium historiae pemptades sex, Sive, Libri XXX* (Antwerp, 1583), uses terms such as *umbelliferis* and *coronaris* (contemporary names for plant families) to classify both ornamental and medicinal plants.

16. For a brief review of the history of botanical gardens, see Lucia Tongiorgio Tomasi, "Projects for Botanical and Other Gardens: A Sixteenth-Century Manual," *Journal of Garden History* 3 (1983): 1–34. See also J. Prest, *The Garden of Eden: The Botanical Garden and the Re-Creation of Paradise* (New Haven: Yale University Press, 1981).

17. Wilfrid Blunt, *Tulipomania* (London, 1935).

18. This is discussed by Masson, "Italian Flower Collectors' Gardens," *passim*.

19. See above, note 15.

20. Discussed by Masson, "Italian Flower Collectors' Gardens," 52–60. Many of the royal gardens were described and illustrated in books, as the Far-

nese garden on the Palatine had been. See, for example, Dionys Joncquet, *Hortus regius* . . . (Paris, 1665), for a list of the plants in the Jardin des Plantes.

21. Claudia Lazzaro, *The Italian Renaissance Garden* (New Haven: Yale University Press, 1990), pp. 2–6, and p. 289, n. 35, discusses the content of some of the fifteenth- and sixteenth-century Italian treatises. See also R. Calkins, "Piero de' Crescenzi and the Medieval Garden," in MacDougall, ed. *Medieval Gardens*, for the late-medieval agricultural treatise and its instructions on laying out and planting "royal" gardens.

22. Olivier de Serres, *Le Théâtre d'agriculture et mesnage des champs* (Paris, 1605), bk. 6, chap. 10, pp. 550–609. Book 6 has the subtitle "Des Iardinages, Pour Avoir des Herbes & Fruits Potagers: des Herbes & Fleurs odorantes: des Herbes medecinales, des Fruits, des Arbres, etc." He discusses shrubs such as roses, jasmine, and box; trees such as cypress and laurel; plants for borders of beds, which included herbs like lavender and thyme and flowering plants like dianthus, wallflowers, violets, cockscomb, lilies, anemones, crown imperials, and even some tulips.

23. Emmanuel Sweert, *Florilegium* (Frankfurt am Main, 1612), advertised plants for sale at his nursery in Amsterdam.

24. For example, Francesco Caetani had 230 forms of anemones and more than 15,000 tulips growing in his garden at Caserta in the 1640s (Masson, "Italian Flower Collectors' Gardens," p. 77). Cardinal Antonio Barberini had more than 30 different kinds of tulips and a similar number of anemones in his small *giardino secreto* behind the palace in Rome. These are listed in the 1630s inventory of the plants in the garden (Bibliotica Apostolica Vaticana, Ms. Barb. Lat. 4265).

25. Tongiorgio Tomasi, "Projects," pp. 21–23.

26. There is an ample literature on this subject. See Svetlana Alpers, *The Art of Describing: Dutch Art in the Seventeenth Century* (Chicago: University of Chicago Press, 1983).

27. See the lists made by Sam Segal of the flowers in six paintings in the exhibition catalogue *A Flowery Past: A Survey of Dutch and Flemish Flower Painting from 1600 to the Present* (Amsterdam: Gallery P. de Boer, 1982), pp. 83, 95, 99, 104, 109, 113.

28. Crispijn de Passe, II, *Hortus floridus* . . . (1614), English ed. John Frampton (1615).

29. Emblem LXIX in Joachimo Camerario, *Symbolorum et emblematum* . . . (Frankfurt, 1654).

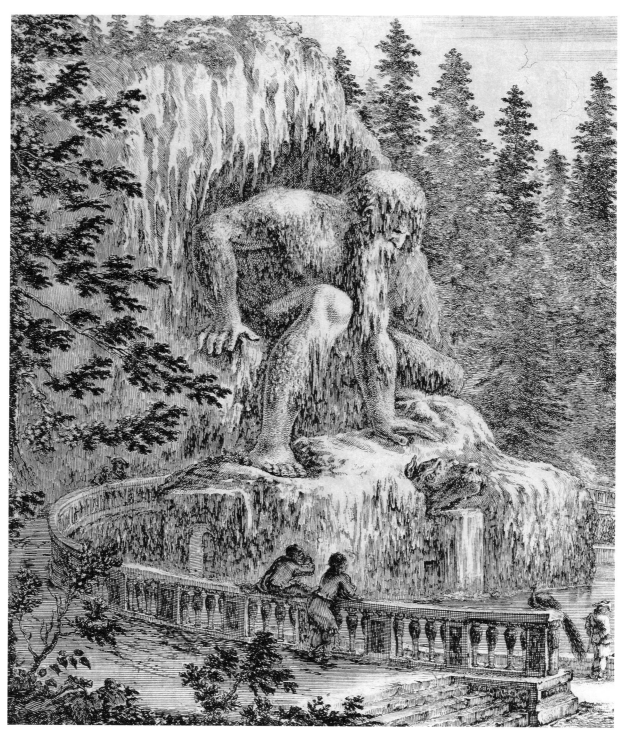

Fig. 1 Stefano della Bella, *Views of the Villa at Pratalino: Colossal Statue of the Apennines* (detail), ca. 1652. Etching. Cleveland Museum of Art, Cleveland, Ohio. Gift of The John D. Proctor Foundation. (cat. no. 179).

Love, Monsters, Movement, and Machines: The Marvelous in Theaters, Festivals, and Gardens

Mark S. Weil

In flower beside that great palace is
a spacious garden, a marvelous precinct.
Neither misery nor hardship entered there:
delights and loves, idleness and pleasure abound.
Fearing no bitter Fate, beautiful Venus
therein escorted the beautiful youth,
exchanging heaven for that happy place
that looks like heaven, or to heaven little yields.[1]

THUS GIAMBATTISTA MARINO BEGINS HIS DESCRIPTION of the garden of Venus on the Island of Cyprus in the sixth canto of his epic-length poem *L'Adone* which was published in 1623. The garden is a false paradise, magically formed by Venus with the aid of Mercury to distract Adonis from pursuits other than those of love and pleasure.[2] The marvelous quality of the garden lies not only in its appearance, which reflects the perfection of God's plan for nature, but also in the excellence with which it has been crafted. Similarly, in the fifth canto of the poem, Mercury serves Venus by designing a marvelous theatrical performance much like those created for sixteenth- and seventeenth-century Italian courts. Marino describes elaborate sets that represent the beauty and perfection of nature and that change instantly to reveal wonders such as Mount Parnassus occupied by Pegasus as well as Apollo and the Muses; fighting centaurs; ships and monsters fighting on a sea that resembles real water; and the Feast of the Gods on Mount Olympus. As was true with the garden, the reader finds the marvelous not only in the theatrical illusions, but also in the mechanics through which the illusions are created and the verse describing them.

These two cantos of Marino's poem reflect common experiences of Renaissance courts. Between 1550 and 1700 patrons and artists exploited the marvelous in their festival,

159

theater, and garden designs for the sake of entertaining courtiers and diverting them from more serious enterprises. Pre-1550 images of the marvelous were didactic, amazing viewers with unexpected images of evil and salvation. The didactic played a subordinate role in the festivals and gardens of the later Renaissance. The mechanics of the marvelous—elaborate plots, fabulous costumes, exotic animals, colossal statues (*fig. 1*) and fountains, automata that moved or played music, elaborate pageant wagons, stage sets that changed their form in the middle of a performance, and flying machines and traps by which figures entered the stage from heaven or the underworld—were more important than any meaning conveyed.

The art of creating theatrical illusion was not new to the Renaissance. During the later Middle Ages Italian artists created illusions of hell and of the descent of angels and saints for religious festivals. In May 1304, for example, the Florentines created the image of a fiery hell on boats and barges in the Arno River. The tableaux included demons torturing the damned, who "cried, shrieked, and raged" in their agony.[3] A second example is the performance of the *Annunciation* staged by Filippo Brunelleschi in the church of the SS. Annunziata in Florence for the participants of the church council held in that city in 1439.[4] The action of the play was performed on two stages. One, representing God and his angels in a heaven composed of concentric circles of clouds, was placed on a scaffold above the main entrance of the church. The other, representing the Virgin's chamber, was placed on a platform between the nave and the chancel. During the play Gabriel descended from heaven; that is, he was lowered by means of a windlass from heaven to the main stage, a distance of approximately 175 feet. The descent was followed by the dialogue of the Annunciation, after which the entire church seemed to fill with fire that emanated from heaven and that lit lamps throughout the building. Gabriel ascended to heaven as the fire spread; he moved his arms as if he were flying and sang a hymn of joy.

Leonardo da Vinci secularized such theatrical marvels in the settings he produced for comedies performed at the Sforza court in Milan.[5] He increased the wonder of the spectacles by treating ancient mythology in a manner previously reserved for the representation of God, saints, and angels, and by enhancing the opulence of the sets. In January 1489 Leonardo produced a ballet, *Del Paradiso*, the second part of which was danced in a set resembling the interior of a half-egg. The set was gilded and illuminated with numerous lights representing stars and the twelve signs of the zodiac. The performers, who represented the planets, sang and danced in niches placed at various levels within the curved wall of the set. A contemporary observer informs us that the set and performance stupefied the spectators.[6] In January 1491 Leonardo staged Baldassare Taccone's *Danaë*, with sets that included a starlit heaven inhabited by Jupiter and other gods. Special effects included the descent of Mercury, which was reminiscent of the descent of Gabriel in performances of the *Annunciation*; a shower of gold by which Jupiter possessed Danaë; and the ascent of Danaë to heaven, where she was transformed into a star.[7]

By 1545 machine-generated marvels had become a common enough part of stage productions to be described by Sebastiano Serlio in his treatise on perspective.[8] By the later sixteenth century they had become very elaborate and were enhanced by the design of court theaters. This is illustrated by Jacques Callot's etching, *"The Liberation of Tyrrhenus and Arnea"* . . . *A Courtly Ballet in the Uffizi*, 1617 (cat. no. 169), which illustrates a small space in which the action of the play is quite close to the spectators. The seats are arranged along the walls, allowing the action of the ballet to progress from the illusionistic set with which the stage is decorated to the floor of the auditorium.

In 1589 Girolamo Bargagli's comedy *La pellegrina* was staged in a similar theater built in the Uffizi for the occasion. The comedy itself is not well known, but the intermezzi, the scenic interludes performed between the acts of the play, remain famous for the sets and action designed and engineered by Bernardo Buontalenti. These are described in contemporary pamphlets and summarily illustrated in etchings by Agostino Carracci.[9] The third intermezzo may stand as an example of the marvels created by Buontalenti. It began with the transformation of a set representing a cityscape into a forest ("a sylvan glade"). In the center of the forest was a rocky, blackened cave devoid of vegetation. During the course of the intermezzo, a fire-breathing, winged dragon emerged from the cave. It was greenish black in color, with gaping jaws that contained three rows of teeth. The insides of its wings were set with mirrors that sparkled in the light. A life-size puppet, representing Apollo, flew into the scene, surveyed the situation, and descended to the stage. The puppet quickly was replaced by an actor, who performed a dance pantomime in which he slew the dragon by driving his arrows into the beast's back. Black blood gushed from the wounds, and after a good deal of thrashing about the dragon died. This action was preceded and followed by singers representing ancient Delphians; their song identified the dragon as the Python of the Oracle and the victorious god as Apollo.

The intermezzi of *La pellegrina* are typical of comedies staged between 1550 and 1670 in Florence. During this period machines and special effects were produced in ever-increasing numbers and complexity in order to keep audiences from becoming bored. In 1608, for example, Giulio Parigi staged Michelangelo Buonarotti the Younger's *Il giudizio di Paride* (The Judgment of Paris) with six spectacular intermezzi.[10] The fourth intermezzo, *The Ship of Amerigo Vespucci on the Shores of the Indies* (cat. no. 168), was another constantly changing set. It was made more marvelous through the illusion of water flowing toward the audience as well as the inclusion of sea creatures and flora, fauna, and primitive men indigenous to the New World.

In 1637 the most elaborate of Florentine comedies, *Le nozze degli dei* (The Wedding of the Gods) was staged in the courtyard of the Pitti Palace on a colossal stage.[11] Giulio Parigi's son, Alfonso designed six separate sets for the play (cat. no. 170). Each contained magical illusions of the types previously described, but the fifth and sixth scenes must have been especially impressive. The fifth took place in hell, which seemed to burn before the eyes of the audience (*fig. 2*). The sixth was a ballet danced on clouds with stage

161

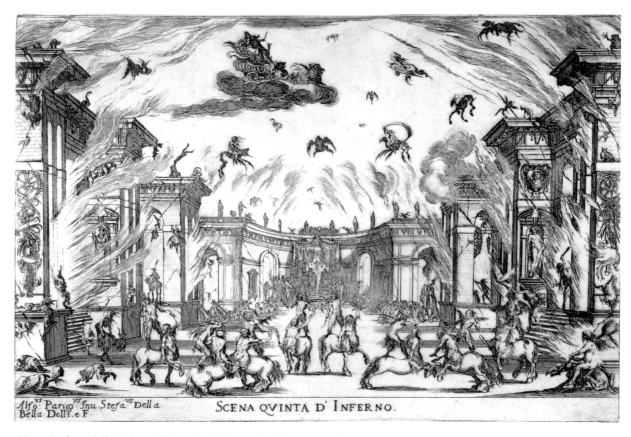

Fig. 2 Stefano della Bella, etching after Alfonso Parigi, Scene V of *Le nozze degli dei*, 1637 (cat. no. 170).

openings on four different levels. The dancers on the top level, which included horses, were actually performing on the apron of the Boboli Gardens, which was adjacent to the rear wings of the palace and rose a full story above the courtyard.

Such Florentine stage sets were designed around most of the elements associated with the marvelous. They included characters, animals, and settings designed to amaze the viewers with their strange and threatening qualities. Dominating the performances were scenes of metamorphoses and celestial illusions that were rendered in a way that made them seem real. Fiction was transformed into reality. All of this was made possible by the perfection of stage devices that had existed since antiquity. Giulio Parigi, for example, reinvented ancient *periaktoi*, triangular or rectangular pillars, with a portion of a set painted on each surface.[12] These were placed in rows at either side of the stage and joined in such a manner that one man turning a crank could cause them to move in unison and in so doing change the set in a matter of seconds. Similarly, winches, ropes, and trap doors were used to create flying machines, the front surfaces of which were decorated to resemble clouds or with the accoutrements of flying chariots.

The widespread popularity and importance of such machines during the sixteenth and seventeenth centuries is reflected by the numerous treatises explaining how to make

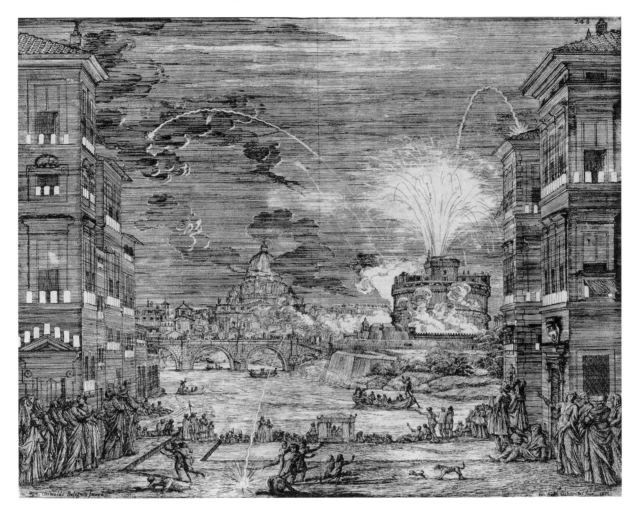

Fig. 3 G. B. Galestruzzi, etching after G. F. Grimaldi, *Fire Works on the Castle Sant'Angelo*, 1658. Finale of Marco Marazzoli, *La vita humana overo il trionfo della pietà*. Etching.

and use them,[13] as well as by descriptions and engravings of such spectacles held in cities and at courts throughout Italy and eventually all of Europe. In seventeenth-century Rome, for example, Gian Lorenzo Bernini and his contemporaries not only staged comedies in the Florentine manner, but also used the marvelous imagery developed by stage designers to add impact to the design of religious spaces. Bernini was both the greatest artist and the greatest stage designer of the period. For the comedies he produced in the 1630s he created spectacular sets, including one in which the Tiber overflowed its banks and another which seemed to catch on fire. Both events sent their audiences fleeing in panic. Other artists produced machines in which heavenly figures flew in and out of the sets, and in one case, a set with a view of the Castel Sant'Angelo, which included a display of fireworks (*fig. 3*).[14] In addition, artists working in Rome designed special effects for tournaments and fireworks displays mounted to celebrate special events, for funerals for which monumental catafalques were built, and for religious ceremonies such as the canonization of saints and the Devotion of the Forty Hours held annually during

163

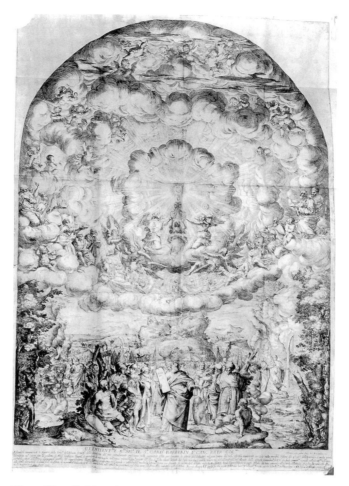

Fig. 4 Niccolò Menghini, *Moses and the Israelites in the Desert*, 1640.
Engraving. Set for the Devotion of the Forty Hours.

Carnival, for which colossal tableaux were erected. These tableaux illustrated the miracle
of salvation by focusing on a heavenly monstrance surrounded by a glory of light, clouds,
and angels. The monstrance floated at the top of the tableau, where, as part of the
representation of a biblical or emblematic scene, it often symbolized God's intervention
for the salvation of his people. The tableau erected in the Gesù during Carnival in 1640,
for example, represented three scenes from the history of Moses and the Children of Israel
in the Desert (*fig. 4*).[15]

Bernini transformed this popular art form into high art in such works as his Cornaro
Chapel, Santa Maria della Vittoria, Rome (1645–52; *fig. 5*) in which the Ecstasy of Saint
Teresa is treated as a theatrical vision. Divine light and angels appear to descend from
the vault of the chapel, and the saint herself floats on a cloud while receiving a vision
from a beautiful, young angel standing beside her. Similarly, the *Cathedra Petri* (1665)
decorating the liturgical east end of Saint Peter's seems suspended in air, mystically sup-
ported by divine light and clouds that pour in through the window behind it.[16]

Fig. 5 Gian Lorenzo Bernini, Cornaro Chapel,
Santa Maria della Vittoria, Rome, 1645–52.

Elaborate theatrical marvels also remained popular in Northern Italian courts at
Parma, Modena, and Mantua as well as in Venice, where Giacomo Torelli created similar
illusions for commercial theaters. Torelli was invited to Paris in 1645 by the dowager
queen, Anne of Austria.[17] The most famous of his Parisian sets were those for Corneille's
Andromède (1650) and the opera-ballet *Les Noces de Pelee et de Thétis* (1654; cat. no. 173).
These made use of stage machines of the Italian type that allowed for instant changes of
scenery as well as flying and cloud machinery. The images preserved in drawings and
engravings are adapted to the French taste for classicism and hence are a bit dry compared
to contemporary Italian images.

Another Italian expatriate, Ludovico Burnacini, carried Italian stage practices to the
imperial court in Vienna.[18] Burnacini exploited imperial wealth to create a profusion of
marvels that could not be surpassed and therefore helped speed the decline of the genre.
In 1664 he designed an ornate imperial opera house with three tiers of balconies, an
illusionistic fresco that extended the architecture of the auditorium toward heaven, and
an elaborately decorated proscenium. Within this theater he staged Antonio Draghi's

165

opera *Il pomo d'oro* (The Golden Apple), which included twenty-three changes of scenery. One of the scenes, *The Mouth of Hell* (act 2, scene 6; cat. no. 175), might serve as a summation of the marvelous in stage decoration. Melchior Küssel's etching shows that it included a fearsome flaming mask, flying devils, and a smaller-scale image of Charon rowing his boat on the River Styx.

Stage productions were not the only aspect of the court and public life to be touched by the marvelous. Another was the dramatized tournaments held in public places as celebrations of the power and authority of the ruling family. I use the word "tournament" because these were an outgrowth of medieval jousting tournaments, which developed into highly stylized, choreographed events including equestrian ballets, processions in which knights appeared in exotic dress and rode all sorts of mounts, processions of ships dedicated to gods and heroes of antiquity, and staged land and sea battles.[19] As was the case with theater, the Florentines in general and the Medici court in particular were pioneers in the staging of such events.

In February 1469 the Medici celebrated the marriage of Lorenzo (the Magnificent) to Clarice Orsini by staging a tournament in the Piazza Santa Croce. Not only did Lorenzo win the tournament, but his entry into the lists reflected the glory of the new leader of the Florentine people. Lorenzo was preceded by trumpets, drums, and fifes. He wore a velvet hat set with pearls and carried a shield decorated with a great diamond. Over his armor he wore a scarf decorated with withered and fresh roses and bearing the motto "Le temps revient" written in pearls.[20]

Such festivals maintained their appeal by becoming increasingly elaborate. Participants came dressed in fabulous costumes or entered on fantastic pageant wagons, and they were often accompanied by retainers dressed as wild men and exotic animals. The tournaments themselves developed into choreographed events reminiscent of stage performances. The tournament held in the courtyard of the Pitti Palace as part of the Medici marriage festivities of 1589 is an excellent example. The participants entered on triumphal carts that were decorated to produce wonder. One was pulled by a dragon and contained concealed musicians. Another was pulled by donkeys disguised to represent two bears and a lion. An aristocrat playing the role of Mars entered on a mountain pulled by a crocodile. There was also a procession of knights riding on giant geese.

Alois Nagler, whose description is based on contemporary sources, notes: "The greatest excitement was caused by a garden which, propelled by invisible forces, moved into the courtyard and unfolded on all sides to the twittering of birds. In the garden were imitations of towers, fortresses, pyramids, ships, horsemen, and animals all made out of greenery. A cloud of birds swarmed up before the Grand Duchess and one of the animals landed in the bride's lap, a good omen."[21] The procession and garden were followed by a choreographed joust that concluded with a massive display of fireworks. The tournament continued after a break for dinner with a mock sea battle between Christian and Turkish galleys, held in the courtyard, which had been flooded with water. An etching

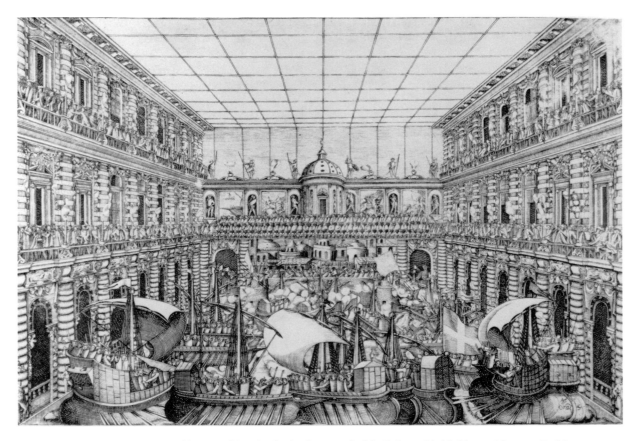

Fig. 6 Orazio Scarabelli, *Naumachia* (Naval Battle) *in the Courtyard of the Palazzo Pitti held on 11 May 1589.* Etching.

of the event by Orazio Scarabelli shows eighteen ships of various dimensions doing battle in front of a miniature fortress (*fig. 6*).

Such festivals were intended to amaze invited guests with their visual effects and to impress them with the wealth and power of the court. They also served to reinforce political dogma, such as the superiority of Christian forces over those of the Turk. In 1564–65 Catherine de' Medici, queen regent of France, and her young son and ward, King Charles IX, and their court toured France to cement the unity of that country, which had been torn by civil war. Festivals aimed at illustrating the power of the king were held throughout the voyage. In Bayonne, on the Spanish border, an especially luxurious festival was mounted to celebrate a planned meeting between Catherine and her son-in-law, King Philip II of Spain, and the treaty she hoped they would sign. Unfortunately, Philip failed to attend. The opulent and marvelous character of the festival is represented by Antoine Caron's drawing of the water fête, which illustrates the royal barge figuratively threatened by a sea monster that is overcome by courtiers dressed as classical heroes (*fig. 7*). In the background on the left is a sketch of Neptune in his sea chariot.[22]

In 1608 a water festival was held on the Arno River in celebration of the marriage of Prince Cosimo, son of the grand duke Ferdinand, to the Habsburg archduchess Maria

167

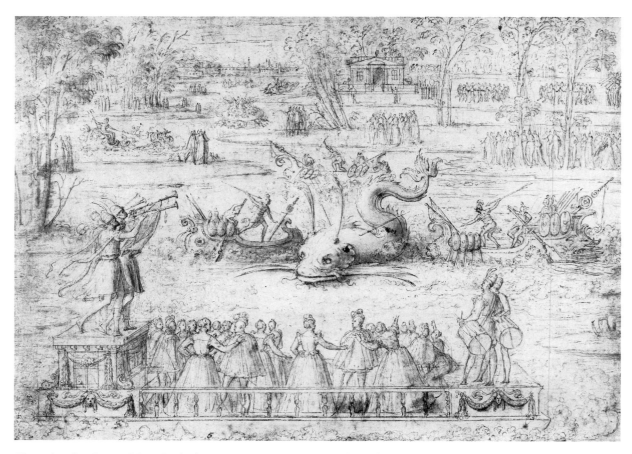

Fig. 7 Antoine Caron, *Water Festival at Bayonne, June 24, 1565.* Drawing. The Pierpont Morgan Library, New York.

Magdalena. The festival, which represented Jason's seizure of the Golden Fleece, focused on the battle between the Argonauts and an armada protecting the island that harbored the fortress containing the Golden Fleece (cat. no. 164). Instead of sailing in one ship, as they did in the myth, the Argonauts entered in sixteen ornate galleys, one for each of the heroes. Each nobleman playing the role of one of the heroes commissioned his own ship, and each competed to show his wealth and elegant wit, as is illustrated by *Ship of Amphion, Guided by Mercury* (cat. no. 165), which was designed by Ludovico Cigoli, one of the leading artists of the Medici court. Jacopo Ligozzi, an artist famous for costume design and watercolors of natural wonders, designed the two most unusual floats. One represented a peacock on which three of the Argonauts rode (cat. no. 167). Every so often the peacock would spread its tail of colored feathers and mirrors. Ligozzi also designed a giant lobster representing Periclymenus, who, according to the myth, had the power to change shapes as he pleased (cat. no. 166). The lobster, which appeared to move on the Arno under its own power, ultimately transformed itself into a boat on which Periclymenus sat dressed as a knight.[23]

In the mid-seventeenth century, at a time when the Medici family had ceased to be a

168

major political power, two spectacular outdoor festivals alluding to the grandeur of Medicean Florence were held in the amphitheater of the Boboli Gardens. The first was held in 1652 as part of a joust staged in honor of visitors from the Austrian court (cat. no. 171). The event began when an enormous whale emerged from a grotto at the end of the theater. The whale was the ship of Columbus, which Neptune had transformed into a whale to punish the navigator for challenging the realm of the sea. Once inside the amphitheater, the whale was miraculously transformed in some mechanical fashion. It became a boat and was pulled around the amphitheater, accompanied by numerous cavaliers, foot soldiers, and trumpeters. The transformation and parade were followed by an equestrian ballet performed to the accompaniment of music.[24]

The grander of the two festivals was staged in 1661 in honor of the wedding of Grand Duke Ferdinand's son, Prince Cosimo III, to Marguerite Louise of Orléans. The performance was an equestrian ballet, *Il mondo festeggiante* (The Rejoicing World; cat. no. 172), which began with a colossal statue of Atlas being drawn into the amphitheater. A singer inside the statue explained that Atlas was visiting Florence to announce that Apollo and Diana had descended from the heavens to attend the nuptials and that knights from all over the world had come to meet Hercules, who was played by the bridegroom. Chariots carrying Apollo and Diana, accompanied respectively by the twelve hours of the day and the twelve hours of the night, proceeded into the amphitheater. The statue of Atlas then opened up to form Mount Atlas, on the peak of which sat boys representing the four continents. Squadrons of cavaliers, representing Europe, America, Africa, and Asia, were also present in the theater, as were singers and musicians, who performed an anthem in praise of the grand duke and duchess and the newlyweds.[25]

Staging these last two events in the Boboli Gardens allowed the organizers to combine the marvels of dramatic spectacle with the equally popular marvels of landscape gardening. Every sixteenth- and seventeenth-century family of means had a country estate to which they could retire in the heat of the summer or simply to escape the formalities of urban life. The gardens of these estates were designed in emulation of Pliny the Younger's descriptions of ancient Roman villas and were inspired by the remains of ancient ruins such as Hadrian's Villa at Tivoli or the Temple of Fortuna at Palestrina.[26]

Some sixteenth-century patrons and designers saw such gardens as places of contemplation, where owners and guests could consider the history and meaning of the world while entertaining themselves. These were places where natural wonders, exotic animals, rare plants, and man-made monuments of all sorts could be arranged as a microcosm of nature.[27] Vicino Orsini, the owner-creator of the Sacro Bosco (Sacred Grove) a mid-sixteenth-century garden at Bomarzo (*fig. 8*),[28] explicitly communicated this message by having the following inscription carved into a bench in his garden: "You who have traveled the world wishing to see great and stupendous marvels, come here, where there are horrendous faces, elephants, lions, bears, orcs, and dragons."[29] The inscription refers to the colossal monuments carved from the living rock of the valley, which include wrestling

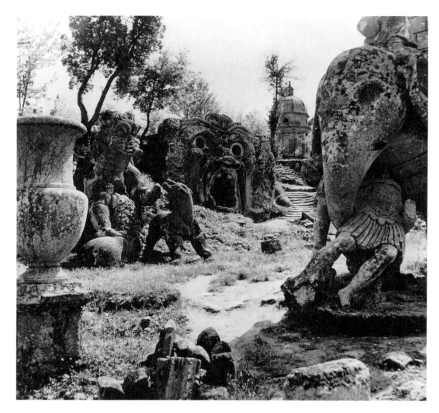

Fig. 8 View of a portion of the Sacro Bosco, ca. 1950.

giants, a colossal turtle carrying a statue of Fame, a war elephant, a pair of lions fighting a dragon, and a hell mouth. The monuments not only amused the visitors through their colossal scale and crude execution, but also often contained special effects that referred to fear of the unknown in a witty manner. A staircase beside the turtle descended to a tunnel, through which one saw the open mouth of an orc (sea monster) waiting to swallow anyone foolish enough to venture near. A Pegasus fountain tilted to one side, spilling water from its basin. The hell mouth contained a cavelike chamber, which amplified the conversations held within it to a roar that reverberated throughout the garden.

These marvels were accompanied by inscriptions and arranged in a manner that reminded the literate visitor of the structure of Dante's *Divine Comedy*, wherein the author must pass through Hell and Purgatory before climbing to Paradise. They also refered to specific passages in Petrarch's lyric poems and Ludovico Ariosto's popular epic *Orlando Furioso*, as well as to Latin classics and modern emblem books. The literary passages to which the inscriptions and sculpture referred all point to the human need to overcome the false paradise of earthly love through an understanding of divine love. For example, the inscription quoted above refers to Torquato Tasso's *Gerusalemme liberata*, in which a similar inscription tempts one of the protagonists, Rinaldo, to step onto an

170

island, which is a love trap.[30] The trap has been conjured up by Armida, who carries Rinaldo off to an even more magical realm, where the two lead a life of pleasure until Rinaldo is returned to his senses by divinely inspired messengers. Rinaldo ultimately reaffirms his Christian faith and dedicates his life to fulfilling God's purpose.

The Sacro Bosco, therefore, could be understood on a variety of levels. It amused the average visitor, who enjoyed the relaxed atmosphere of the garden and who marveled at the irreverent appearance of the colossal monuments and was amused by the playful fearsomeness of their appearance. The educated visitor understood the garden's references to the geocentric structure of nature, on which the classics are based, and further that the mock terror caused by the monstrous statues could be overcome only by using one's intellect to fit them into that structure.

The most famous of all Italian gardens, the Villa d'Este in Tivoli, is also composed of wonders placed in a geometric setting reflecting the order of the cosmos (cat. no. 177). Pirro Ligorio, who designed the garden for Cardinal Ippolito d'Este beginning in 1551, set it within a rigidly defined rectangle of land that rises from an entrance at the bottom of a steep hill to the cardinal's palace.[31] The space within the rectangle is divided by paths into equally rigid geometric areas. Within these areas are numerous fountains, wonders of hydraulic engineering that send gallons of water cascading down artificial waterfalls or shooting high into the air as water jets (cat. no. 178). The fountains are shaped into seemingly natural landscape formations and decorated with imaginative sculpture, as is the case with the dragon fountain (*fig. 9*), and playful architecture such as the fountain complex that reproduces ancient Rome.

The iconography of the garden relates both to ancient mythology and to the ambitions of Cardinal d'Este. It refers to the story of the adolescent Hercules's choice between Virtue and Vice, a moralizing legend about the choice that everyone must make upon entering adult life. This myth was selected because the Este family traced its ancestry back to the ancient hero. Cardinal d'Este, like his ancient forebear, was shown to have chosen Virtue. Among his accomplishments was his patronage of the arts, which is celebrated in a sequence that begins with a statue of Pegasus in the upper left corner of the garden above the fountain of Tivoli. Below the fountain water cascades into a delightful waterfall, under which the visitor can walk to enjoy the cool air and to view the garden through the water. A path leads the visitor from the fountain of Tivoli down an avenue of fountains, which once were decorated with reliefs showing tales from Ovid's *Metamorphoses*, to the fountain of Rome—making the point that the arts flowed from the Cardinal d'Este's villa to Rome along with the waters of the Tiber River.

In spite of the complex iconography of the Villa d'Este, its marvels were physical rather than philosophical. The beauty and scale of the garden and its fountains created wonder, as did the seemingly magical devices that caused special effects. For example, the garden contained water-driven, musical automata that were among its most popular marvels. Michel de Montaigne described two of these in his diary in April 1581:

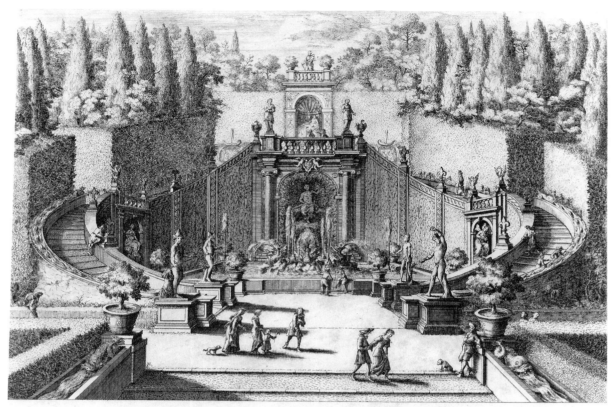

FONTANA DE DRAGHI DETTA LA GIRANDOLA SOTTO IL VIALONE DELLE FONTANELLE

Gio:Francesco Venturini del.et inc. *Gio: Giacomo Rofsi le ftampa in Roma alla Pace con Priu. del S. P. 11*

Fig. 9 Giovanni Battista Venturini, *Dragon Fountain at Villa D'Este*. Engraving from Part IV of G. B. Falda, *Le Fontane di Roma*, Rome, 1665. Dumbarton Oaks, Trustees for Harvard University, Washington, D.C. (cat. no. 178A).

The Music of the organ, which is real music and a natural organ, though always playing the same thing, is effected by means of water, which falls with great violence into a round arched cave and agitates the air that is in there and forces it . . . through the pipes of the organ. Another stream of water, driving a wheel with teeth on it, causes the organ key board to be struck in a certain order; so you hear an imitation of the sound of trumpets. In another place you hear the song of birds, which are little bronze flutes . . . and then by other springs they set in motion an owl, which appearing at the top of the rock, makes this harmony cease instantly, for the birds are frightened by his presence, and then he leaves the place to them again. This goes on as long as you want.[32]

Similarly, the Parnassus fountain in the Room of Apollo in Villa Aldobrandini, Frascati (begun 1615), concealed a water organ that automatically created music, which seemed to issue from the statues of Apollo and the muses decorating it. The statues and the mountain were polychromed, which added to the verisimilitude.[33] The operation of such water organs and other water-driven automata are illustrated in numerous books on hydraulic engineering, including one of 1615 by Salomon de Caus (cat. no. 183). One of his engravings features Polyphemus seated in a grotto playing his pipes as an expression of his love for Galatea, who appears to float by on a shell pulled by a sea creature.

172

Caus's engraving is based on an automaton in one of the grottoes of the Villa Medici at Pratolino, which was laid out for Francesco I, grand duke of Tuscany, between 1568 and 1588. The garden at Pratolino (cat. nos. 179, 180), like the one at the Villa Aldobrandini but unlike those at Tivoli and Bomarzo, was neither political nor moralizing in intent. It was a vast retreat where its owners and their courtiers could go to escape the summer heat and crowding of the city. The colossal fountains, waterworks, grottoes, and automata within the garden were loosely based on Ovid's *Metamorphoses*, a book that stimulated the imagination to think of endless marvels based on the mythical ability of nature to transform its shape.[34]

The overwhelming richness and marvelous character of such gardens are well expressed in the not quite accurate description of the Medici Villa at Pratolino by the English diarist John Evelyn, who wrote:

The house is a square of 4 Pavilions, with a faire platform about it, balustr'd with stone, 'tis situate in a large meadow like an amphitheater, ascending, having at the bottom a huge rock, with Water running in a small Chanell like a Cascade, on the other side the gardens, the whole place seemes Consecrated to pleasure, & retirement in the summer. . . . The Gardens delicious & full of fountains: In the Grove sits Pan feeding his flock, the Water making a melodius sound through his pipe, & Hercules whose Club yields a Showre of Water, which falling into a huge *Concha* has a Naked Woman riding on the backs of Dolphins: In another grotto is *Vulcan* & his family, the walls richly composed of Coralls, Shells, Coper & Marble figures; with the huntings of Severall beasts, moving by the force of Water: Here having ben well wash'd for our curiosity, we went down a large Walk, at the sides whereof gushes out of imperceptible pipes, couched under neath slender pissings of Water, that interchangeably fall into each others Chanells, making a lofty & perfect arch, so as a man on horseback may ride under it and not be wet with one drop, nay so high, as one may walk with a speare in ones hand under each spout, this Canopi or arch of Water was mi thought one of the surprizings[t] magnificences I had ever seene, & exceedingly fresh during the heate of summer, at the end of this very long Walk stands a Woman in white marble in posture of a Laundressee wringing Water out of a piece of linnen very naturaly, into a vast Lavor, the work and invention of the famous *Michael Angelo Buonarotti* [actually it was by Valerio Cioli]: Hence we ascended to *Monte Parnasso* [Mount Parnassus], where the Muses plaid to us on Hydraulic Organs; neere this a greate Aviarie: The sourse of all these Waters from the Rock in the Garden, on which the statue of a Gyant representing the *Appenines* . . . : Last of all we came to the Labyrinth in which a huge Colosse of *Jupiter*, that throws out a streame over the Garden; This Moles [monument] is 50 foote in height, having in his body a pretty Square chamber, his Eyes and mouth serving for the Windos & dore.[35]

A great deal of the sculpture, including the *Appenino*, was designed by and executed under the supervision of Giovanni da Bologna and other major artists of the Florentine court. The elegance of the works of art and the expanse of the setting in which they were placed added greatly to their appeal and contributed to their influence on later garden design.

Later Italian and Northern European designers divided gardens into carefully arranged geometric areas that emphasized man's control over nature. Fountains and grottos containing automata continued to be built, but were subordinate to the size and formality

173

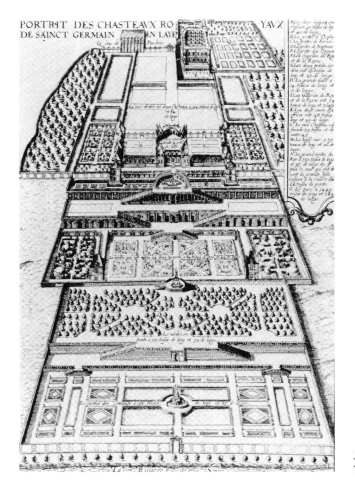

Fig. 10 Engraving after Alessandro Francini,
Terraced gardens at Saint-Germain-en-Laye, 1614.

of the park. This is already true of King Henri IV's garden at Saint-Germain-en-Laye
(begun before 1610), which is arranged in ascending terraces on a hillside in the manner
of the Villa Lante at Bagnaia, to which it has been compared (*fig. 10*). It is even more remi-
niscent of sixteenth-century reconstructions of the Temple of Fortuna at Palestrina.[36]
John Evelyn visited the garden in 1644 and was impressed by the overall layout, the
statues, and the grottoes under the steps, which sheltered automata, including one in
which Orpheus played his lyre and was surrounded by dancing animals and another in
which a young woman seemed to play an organ.[37]

In the seventeenth century landscape gardens replaced gardens of the marvelous in
European taste. Roman gardens continued to be decorated with fountains, but the
formal layout of large parcels of land was more important than small details. One need
only page through the plans and views of seventeenth-century gardens found in Giovanni
Falda's *I giardini di Roma* (Rome, 1670; see cat. no. 178) to see the extent of the change
in the taste of Roman aristocrats. The same taste is reflected in views of the major gardens
of Northern Europe, including those at Wilton House and Versailles, where this tendency

was carried to an extreme as the expanse of the gardens equals the size of seventeenth-century Paris. The individual grottoes, amphitheaters, and fountains at Versailles are dwarfed by the garden's size and by its careful organization. Indeed, it is the epic scale of the garden that best reflected the power and the glory of Louis XIV and his court.

The new taste for space and scale as opposed to marvels manifested itself in court theater and festivals as well as gardens. A case in point is the performance of the *Plaisirs de l'îsle enchantée*, a festival lasting several days that was organized at the request of Louis XIV and held in the gardens of Versailles in May 1664.[38] The festival, which was a reflection of the wealth and power of the court, included processions, plays written by Molière, ballets danced to the music of Lully, mock battles, vast sets and machines designed by Carlo Vigarani, and fireworks. The main theme of the festival was taken from the sixth and seventh cantos of Ludovico Ariosto's *Orlando Furioso*, in which Ruggiero is imprisoned by the witch Alcina on an enchanted island. The magic island served as the inspiration for the sets and special effects used during the first three nights of the event. The set for the third day, which is illustrated in an etching by Israel Silvestre (cat. no. 185), was an artificial lake, in the center of which was the Palace of Alcina. Whales and sea monsters swam around the lake. The island was also guarded by giants, dwarfs, demons and other spirits, who kept the knights from escaping. Silvestre's print shows that this set differed from earlier sets in that it emphasized the vastness of the space. Whereas the marvelous impressed the audience by bringing them in contact with the action of the performance, Vigarani impressed the audience with grandness of scale, which echoed the grandness of the king.

Louis XIV preferred the control of classicism to the flamboyance of the baroque. Plays staged at his court and the decoration of his garden at Versailles stressed control and great expanses of space rather than visions and unexpected occurrences. Such occurrences implied a world of limited scope in which the unexpected, whether good or evil, was supernatural; a world in which divine intervention was a necessary part of salvation. By the late seventeenth century, rulers and philosphers believed in the power of the human mind to control both personal and national destinies. Louis XIV and other European monarchs had become all powerful and hence eschewed images that might question their power to control men and nature.

NOTES

1. Giambattista Marino, *L'Adone* 6:7:
Infiora il lembo di quel gran palagio
spazioso giardin, mirabil orto.
Miseria mai, né mai v'entrò disagio,
v'han delizie ed amori, ozio e diporto.
Colà senza temer fato malvagio
Venere bella il bel fanciullo ha scorto,
cangiando il ciel con quel felice loco,
che sembra il cielo o cede al ciel di poco.

2. A garden as a false paradise in which a woman uses witchcraft to trap the men whom she desires is a traditional part of epic poetry. See A. Bartlett Giamatti, *The Earthly Paradise and the Renaissance Epic* (Princeton: Princeton University Press, 1966), *passim*.

3. This festival and the sources in which it is described are discussed in Alessandro D'Ancona, *Origini del teatro italiano*, 2nd ed. (Turin: Ermano Loescher, 1891), pp. 94ff.

4. This is one of three such productions attributed to Brunelleschi. The others were the *Ascension* staged in Santa Maria del Carmine, also in 1439, and the *Annunciation* staged annually in Santa Felice in Piazza. Contemporary descriptions of the plays of 1439 were first published by A. Wesselovsky, "Italienische Mysterien in einem russischen Reisebericht des XV. Jahrhunderts," *Russische Revue* 10 (1877): 425–41; and in Italian by D'Ancona, *Origini del teatro italiano*, vol. 1, pp. 246–53. Peter Meredith and John E. Tailby, eds., *The Staging of Religious Drama in Europe in the Later Middle Ages: Texts and Documents in English Translation* (Kalamazoo: Medieval Institute Publications, Western Michigan University, 1983), pp. 243–47, provides an English translation based on the German and Italian texts. Ludovico Zorzi, et al., *Il luogo teatrale a Firenze* (Milan: Electa, 1975), pp. 55ff., reconstructs the churches and the staging of the *rappresentazioni* of 1439. Brunelleschi's authorship of the *Annunciation* in the SS. Annunziata is generally accepted despite the lack of documentary evidence; see Ludovico Zorzi, *Il teatro e la città, saggi sulla scena italiana* (Turin: G. Einaudi, 1977), pp. 66ff., which is the most complete discussion to date of Brunelleschi's theater designs.

5. Leonardo da Vinci was only one of a number of artists who created machine settings for plays produced in Northern Italy. D'Ancona, *L'origini del teatro italiano*, vol. 2, *passim*, discusses the development and spread of *sacre rappresentazioni* as well as the staging of comedies by Plautus in Ferrara. In appendix 2 he discusses theater in Mantua in the sixteenth century.

6. For two different interpretations of this set, see Marialuisa Angiolillo, *Leonardo feste e teatri* (Naples: Società Editrice, 1979), pp. 38–45; and Carlo Pedretti, *Leonardo Architect*, trans. Sue Beill (New York: Rizzoli, 1981), p. 290.

7. Leonardo might also have been the first to use instantaneous changes of scenery. His drawings for a production of Poliziano's *Orfeo* include designs for a revolving stage. See Angiolillo, *Leonardo feste e teatri*, pp. 55–75; and Pedretti, *Leonardo Architect*, pp. 290–94.

8. Sebastiano Serlio, *Tutte l'opere d'architettura et prospettiva* (Venice: G. de'Franceschi, 1619), fols. 43v–48v. The text is tranlated into English and discussed in Bernard Hewitt, ed., *The Renaissance Stage: Documents of Serlio, Sabbatini and Furttenbach* (Coral Gables: University of Miami Press, 1958), pp. 18–42.

9. The descriptions have been summarized in English and the etchings illustrated by A. M. Nagler, *Theatre Festivals of the Medici 1539–1637*, trans. George Hickenlooper (New Haven: Yale University Press, 1964), pp. 70–92; and Arthur R. Blumenthal, *Theater Art of the Medici* (Hanover: Dartmouth College Museum, 1980), pp. 7–13.

10. Nagler, *Theatre Festivals*, pp. 162–73; Blumenthal, *Theater Art*, pp. 39–57.

11. Nagler, *Theatre Festivals*, pp. 162–73; Blumenthal, *Theater Art*, pp. 161–79. The importance of this play is reflected in the title of the standard study of the history of Italian baroque theatre, Cesare Molinari, *Le nozze degli dèi, un saggio sul grande spettacolo italiano nel seicento* (Rome: M. Bulzoni, 1968).

12. Blumenthal, *Theater Art*, p. 38, reproduces a sketch by Michelangelo Buonarotti the Younger of the *periaktoi* used for the staging of his *Il giudizio di Paride* in 1608. *Periaktoi* are also illustrated by Josef Furttenbach, *Architectura Recreationis* (Augsburg: Johann Schultes, 1640). See Hewitt, *The Renaissance Stage*, p. 195.

13. The most important of these were written by Sebastiano Serlio, Nicola Sabbatini, and Josef Furttenbach (see note 8).

14. Bernini's theatrical productions have been discussed by Irving Lavin, *Bernini and the Unity of the Visual Arts*, 2 vols. (New York: The Pierpont Morgan Library, 1980), vol. 1, pp. 146–57, who cites earlier literature. F. Hammond, "Bernini and the 'Fiera di Farfa'," in *Gianlorenzo Bernini: New Aspects of His Art*

and Thought, ed. Irving Lavin (New York: College Art Association, 1985), pp. 117–25, discusses a specific intermezzo designed by Bernini. Donald Beecher and Massimo Ciarolella, "A Comedy by Bernini," in Lavin, *Gianlorenzo Bernini*, pp. 64–109, discuss and publish an English translation of the only extant play written by Bernini. Other productions of note include Stefano Landi's opera *Sant'Alessio* (1637), which included a scene of hell and another in which Sant'Alessio appeared floating on clouds surrounded by music-making angels, and Marco Marazzoli's *La vita humana, overo il trionfo della pietà* (Human Life or the Triumph of Piety), which included the set with fireworks. See Mark S. Weil, *Baroque Theatre and Stage Design* (St. Louis: Washington University Gallery of Art, 1983), pp. 20–23. See also Margaret Murata, *Operas for the Papal Court* (Ann Arbor: UMI Research Press, 1981), for a thorough discussion of opera in seventeenth-century Rome.

15. This material has been surveyed by Maurizio Fagiolo dell'Arco and Silvia Carandini, *L'effimero barocco, strutture della festa nella Roma del '600*, 2 vols. (Rome: Bulzoni Editore, 1987, 1988). See also Mark S. Weil, "The Devotion of the Forty Hours and Roman Baroque Illusions," *Journal of the Warburg and Courtauld Institutes* 37 (1974): 218–48.

16. The relationship of Bernini's work to baroque theater has been discussed by many authors, including Maurizio and Marcello Fagiolo dell'Arco, *Bernini, una introduzione al gran teatro del barocco* (Rome: Mario Bulzoni Editore, 1967), especially chapters 2 and 8; Molinari, *Le nozze*, pp. 105–20; Lavin, *Bernini and the Unity of the Visual Arts, passim*; and Mark S. Weil, "The Relationship of the Cornaro Chapel to Mystery Plays and Italian Court Theater," in *Art and Pageantry in the Renaissance and Baroque* (University Park: Papers in Art History from the Pennsylvania State University, 6, 1990), pp. 458–87.

17. Per Bjurström, *Giacomo Torelli and Baroque Stage Design* (Stockholm: Almquist and Wiksell, 1962), is an excellent monograph outlining Torelli's career and his contribution to the art of stage design.

18. See Flora Biach-Schiffmann, *Giovanni und Ludovico Burnacini. Theater und Feste am Wiener Hof* (Vienna and Berlin: Krystall-Verlag, 1931).

19. George R. and Portia Kernodle, "Dramatic Aspects of the Medieval Tournament," *Speech Monographs* 9 (1942): 161–72; and Roy Strong, *Art and Power* (Berkeley: University of California Press, 1973), pp. 11–16, discuss the development of the pageantry accompanying tournaments in Northern Europe. Strong (p. 187, n. 10) notes that there is no modern

history of the tournament and then gives a survey of existing literature.

20. The tournament is widely described in secondary literature, most notably by André Rochon, *La Jeunesse de Laurent de Médicis (1449–1478)* (Paris: Les belles lettres, 1963), pp. 97ff., who cites the original sources and earlier literature.

21. Nagler, *Theatre Festivals*, pp. 91–92. See also Blumenthal, *Theater Art*, pp. 15–27, who reproduces etchings of the proceedings.

22. Strong, *Art and Power*, pp. 106–9, discusses the festival at Bayonne.

23. The Argonautica is described by Nagler, *Theatre Festivals*, pp. 111–15, and by Blumenthal, *Theater Art*, pp. 57–86, who reproduces all of the illustrations of the various ships.

24. Blumenthal, *Theater Art*, pp. 183ff.

25. Ibid., pp. 194–99.

26. David R. Coffin, *The Villa in the Life of Renaissance Rome* (Princeton: Princeton University Press, 1979), gives an overview of the development of villas and gardens around Rome that reflects developments all over Italy. In part 4 (pp. 241–364) he discusses the relationship of Renaissance villas to the antique. See also David R. Coffin, *The Villa d'Este at Tivoli* (Princeton: Princeton University Press, 1960), pp. 3ff., who notes that Pirro Ligorio began excavating Hadrian's Villa in 1550; and Gian Giorgio Zorzi, *I disegni delle antichità di Andrea Palladio* (Venice: N. Pozzo, 1959), pp. 85–90, 99–100, figs. 200–13b, 244–46, who discusses and reproduces Palladio's drawings of the Temple of Fortuna at Palestrina, an imaginary temple of Hercules as Victor at Tivoli, and Hadrian's Villa.

27. Eugenio Battisti, "*Natura Artificiosa* to *Natura Artificialis*," in *The Italian Garden*, ed. David Coffin (Washington, D.C.: Dumbarton Oaks, 1972), pp. 4–6. Bartolommeo Taegio, *La villa* (Milan, 1559), pp. 8ff., discusses the villa garden as a microcosm of the cosmos, as does Marino in *L'Adone*, canto 6.

28. The dating of the Sacro Bosco is unclear. The only known documents relating to it are letters written by the patron, and these rarely refer to specific parts of the garden. Work may have begun as early as 1552, the year of the only dated inscription in the garden, and continued almost up to the death of Vicino Orsini in 1584. The two most recent studies of the garden are Margaretta J. Darnall and Mark S. Weil, "*Il Sacro Bosco di Bomarzo*, Its 16th-Century Literary and Antiquarian Context," *Journal of Garden History* 4 (1984): 1–94; and Horst Bredekamp, *Vicino Orsini und der heilige Wald von Bomarzo, ein Fürst als Künstler und Anarchist* (Worms: Werner'sche Verlags-

gesellschaft, 1985), both of which contain complete bibliographies of earlier literature.

29. VOI CHE PEL MONDO GITE ERRANDO / VAGHI DI VEDER MARAVIGLIE ALTE ET / STUPENDE, VENITE QVA, DOVE SON / FACCIE HORRENDE, ELEFANTI, LEONI / ORSI, ORCHI ET DRAGHI.

30. Tasso's lines read: "'O chiunque tu sia, che voglia o / peregrinando adduce a queste sponde, / meraviglie maggior l'orto o l'occasio / non ha di ciò che l'isoletta asconde. / Passa, se vuoi vederla'" (14:58). Vicino might have learned the contents of the *Gerusalemme liberata* in 1575 when Tasso visited Rome and circulated a draft of the poem, which was first published in 1581.

31. Most of the work on the gardens was carried out between 1560 and 1572. My discussion of the Villa d'Este is based on David Coffin, *The Villa d'Este*.

32. *Montaigne's Travel Journal*, trans. Donald M. Frame (San Francisco: North Point Press, 1983), p. 99. A machine of this type is illustrated by Isaac de Caus, *New and Rare Inventions of Water-Works . . .* (London: Joseph Moxon, 1659), p. 26, pl. XIV, who notes that such an effect had been produced by Hero of Alexandria.

33. John Dixon Hunt, *Garden and Grove, the Italian Renaissance Garden in the English Imagination: 1600–1750* (Princeton: Princeton University Press, 1986), p. 45, quotes the description of the organ by John Raymond, *Il Mercurio Italico. An Itinerary Contayning a Voyage Made Through Italy in the Yeare 1646 and*
1647 (1648), p. 119. Cesare D'Onofrio, *La villa Aldobrandini di Frascati* (Rome: Staderini Editore, 1963), pp. 126–41, discusses and documents the decoration of the Room of Apollo.

34. Chapter 4 of Hunt, *Garden and Grove*, is titled "Ovid in the Garden."

35. E. S. de Beer, ed., *The Diary of John Evelyn*, 6 vols. (Oxford: Clarendon Press, 1955), vol. 2, pp. 418–19. In writing this description, Evelyn drew upon sources that are cited by de Beer and quoted in full by Luigi Zangheri, *Pratolino. Il giardino delle meraviglie* (Florence: Gonelli, 1979), who discusses the history of the garden and includes transcriptions of the most important documents and early descriptions of it.

36. Hunt, *Garden and Grove*, p. 145, draws the parallel to the Villa Lante. For a sixteenth-century reconstruction of one temple of fortune, see Zorzi, *I disegni delle antichita*, pp. 85ff., figs. 200–5.

37. De Beer, ed., *The Diary*, vol. 2, p. 111. Alfred Marie, *Jardins français créé à la Renaissance* (Paris: Editions Vincent Fréal and Co., 1955), pp. 30–33, discusses the history of the garden and reproduces Abraham Bosse's etchings of some of the grottoes and fountains.

38. There are several contemporary descriptions of the festival, which are published in J. B. P. de Molière, *Théâtre* (Paris: Editions Hachette, n.d.), vol. 4, pp. 89–268. See also Margarete Bauer-Heinhold, *The Baroque Theatre: A Cultural History of the 17th & 18th Centuries* (New York: McGraw-Hill, 1967), pp. 9–10.

Trompe-l'oeil Painting:
Visual Deceptions or Natural Truths?

Arthur K. Wheelock, Jr.

I SAY THAT A PAINTER, WHOSE WORK IT IS TO FOOL THE sense of sight, also must have so much understanding of the nature of things that he thoroughly understands the means by which the eye is deceived."[1] Samuel van Hoogstraten offered this succinct statement about the nature of art in his all but succinct treatise on painting published in 1678. Without any hesitation he states that the artist's work is to fool the eye, to make the viewer believe that the image he is seeing is reality itself. The success of such an undertaking is not determined by a quick wit and fluid brush, but by a thorough understanding of the laws of nature and "the means by which the eye is deceived." For Hoogstraten the "means" explicitly include the optics of vision and the theories of perspective, but implicitly as well an understanding of the psychological expectations of a viewer as he encounters an illusionistic image.

It is clear from the fascination with *trompe-l'oeil* in Dutch art that artists shared Hoogstraten's enthusiasm for works that deceived the eye. At the same time, however, art theorists, including Hoogstraten, stressed that "the highest and most distinguished level in the Art of Painting, which is above all others, is the representation of the most memorable histories."[2] For Hoogstraten, as for Carel van Mander before him, depictions of biblical, mythological, or allegorical subjects demonstrated both the artist's imaginative genius and his ability to portray human figures interacting at moments of great historical and moral consequence.[3] Just how these seemingly contradictory recommendations are reconciled in Dutch art and art theory is the problem I would like to face in this essay. All too often historians have focused on one aspect of Dutch art to the neglect of the other; yet, in fact, their uneasy equilibrium is one reason Dutch art of the seventeenth century is so dynamic and multifaceted.

Hoogstraten's recommendation that an artist should deceive the eye is advice he followed in a number of his own paintings, among them a life-size view through a

179

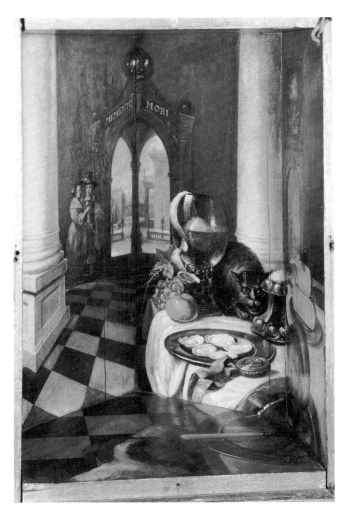

Fig. 1 Samuel van Hoogstraten, *View down a Corridor*, 1662.
Oil on canvas. Dyrham Park, Gloucestershire, A. Mitchell, Esq.

doorway into an interior space (*fig. 1*). When Samuel Pepys first encountered this work in a private home in London, he was completely fooled by the illusion. With great admiration for the work, he wrote that when the owner opened the closet door he saw "that there is nothing but only a plain picture hung upon the wall."[4] A similar response greeted the small, triangular perspective box that John Evelyn describes in the entry in his diary from February 5, 1656: "so rarely don, that all the artists and painters in towne flock'ed to see and admire it" (cf. *fig. 2*).[5] The admiration for the illusionistic qualities of the view of the "greate Church of Harlem" in the perspective box is also felt in the delightful story recounted by Roger de Piles about an illusionistic image of a servant girl that Rembrandt placed in his window: "Everybody who saw it was deceived, until the painting had been exhibited for several days, and the attitude of the servant being always the same, each one finally came to realize that he had been deceived."[6] The illusion worked not only because of the scale, colors, and textures of Rembrandt's image (*fig. 3*),

180

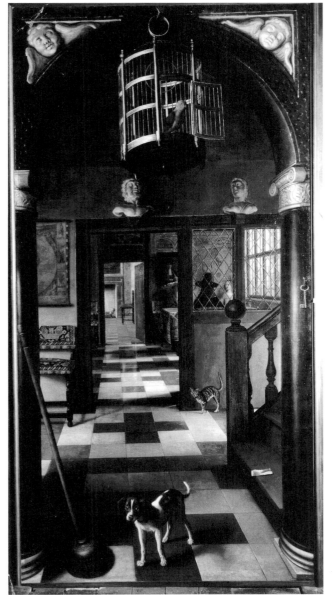

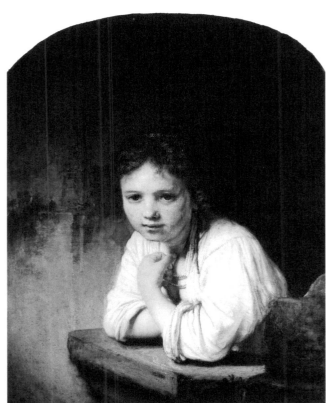

but also because the expectation of those passing by Rembrandt's window was that a real person would be leaning out and not a counterfeit one. The success of a *trompe-l'oeil* painting, indeed, was due not only to the careful application of the laws of perspective and illusionistic painting technique, but also to the ability to engage the viewer in the work of art itself.

The ideal of artists exploring ways to make objects so real that they could be confused with nature itself became widespread in the Netherlands in the seventeenth century. This interest in illusionism is evident not only in the extraordinary realism of so much of the

art, but also in the recommendations of those who wrote about painting. *Trompe-l'oeil* effects were recommended even if the painting was not conceived as a *trompe-l'oeil* work of art. In 1641 Jan Orlers described the wonderment of viewing Gerard Dou's careful technique for depicting figures, animals, insects, and other objects from life.[7] In the following year Philips Angel also cited the wonder invoked by Dou's remarkable technique for recording the smallest details in a lifelike manner, for, according to Angel, painting that is most admirable is that which comes closest to nature.[8] Angel stressed that it was important to delight the viewer's eye with illusionistically conceived representations of materials and textures of natural objects.[9] Careful observation of nature, such as that which allowed Jan Brueghel or Jan Davidsz. de Heem (cat. nos. 154, 157) to produce convincing images of flowers, was essential to any artist who sought to create an illusionistic painting. By studying the shapes and colors of petals, the rhythms of leaves and stems, and the delicate translucency of their forms, the artist could translate their qualities into paint and elicit the admiration of his patron. Cornelis de Bie, writing in 1662, admired the still-life painter Daniel Seghers because he created flowers so real that live bees would want to settle on them (cat. no. 155). He continued, "Life seems to dwell in his art."[10] "A perfect painting," wrote Samuel van Hoogstraten, "is like a mirror of Nature, in which things that are not there appear to be there, and which deceives in an acceptable, amusing, and praiseworthy fashion."[11]

 As justification for this ideal of illusionistic painting, theorists repeatedly turned to the ancients, specifically the skills for recreating reality attributed to Zeuxis and Parrhasius. Zeuxis's ability to paint fruit so realistically that birds came to peck at their image was so renowned that the story was endlessly repeated and reformulated in art theory. Cornelis de Bie's statement that bees would want to settle on Daniel Seghers's flower painting is but one such example. Painted bees and bugs that are so often seen alighting on fruits and flowers in Dutch still lifes are but another manifestation of this same story. Of course, Zeuxis lost the competition with Parrhasius for creating the most illusionistic painting when he tried to pull aside the curtain that covered his rival's image, only to discover it was not real, but painted. So intent was Zeuxis upon seeing Parrhasius's efforts that he was completely fooled by the deceit. The lesson was not lost upon Hoogstraten when he painted his doorway, or Cornelis Gysbrechts his cupboard (cat. no. 197), or upon others when they included *trompe-l'oeil* curtains to obscure much of their "image": the success of an illusionistic painting was often determined by the psychological expectations of the viewer. So successful was Gerard Dou in this regard that in one poem he was referred to as "de Hollandsche Parrhasius."[12]

While such attitudes indicate the broad acceptance of illusionism as an artistic ideal in both theory and practice, the reality of the situation was far more complex. Since Dutch theorists also subscribed to the notion that history painting was at the highest echelon of the visual arts, they appeared to recommend mutually exclusive artistic ideals. While they agreed on the one hand that artists should strive to fool the eye with illusionistic

images, they also recommended that artists should produce idealized, morally uplifting scenes that would offer guidelines to the proper conduct of human life. A number of components helped create this particular dichotomy in Dutch art theory, but particularly the confluence of northern artistic traditions and sixteenth-century Italianate art theory.

From the illusionistic borders of fifteenth-century illuminated manuscripts to the exquisite detail of paintings by Jan van Eyck, Rogier van der Weyden, and Hans Memling, northern artists had long given inordinate care and attention to the exact recording of the physical world. The foundations of this approach were related to the *devotio moderna*, where the devotional character of the painting was to be made more immediate by conceiving the pictorial image as an extension of the world.[13] Philosophically this insistence on accurate representation was grounded in a conviction that all of God's creation was worthy of representation, the smallest as well as the largest. As Thomas à Kempis wrote in *The Imitation of Christ*: "There is no creature so small and object that it representeth not the goodness of God."[14] At the beginning of the sixteenth century Albrecht Dürer created a number of individual studies of plants and animals that were likewise masterpieces of careful observation of natural forms. His motivation, however, was more philosophic than devotional. These sensitively rendered life studies were a means by which Dürer could come closer to understanding the underlying truths of nature. As Dürer wrote: "For, verily, 'art' [that is, knowledge] is embedded in nature, he who can extract it has it."[15]

Sixteenth-century fascination with *trompe-l'oeil* drew from many sources of inspiration. Reminiscences of the devotional traditions of illusionistic painting are evident in the remarkable depiction of the *Open Missal* by Ludger tom Ring the Younger (cat. no. 189). The scientific naturalism of Dürer was practiced by Joris Hoefnagel at the court of Rudolf II in Prague at the end of the sixteenth century during the so-called Dürer Renaissance. In his remarkable illustrated manuscript *The Four Elements*, Hoefnagel created a compendium of thousands of images of living creatures organized around the traditional framework of the four elements. Among them, illustrated in the volume entitled *Ignis*, were dragonflies, which he created by gluing actual wings onto the painted images of their bodies (*fig. 4*). Such artistic conceits, in which the image produced by the artist's hand remained indistinguishable from the object depicted, were considered marvels that matched those of nature itself, and they were greeted with great astonishment. Finally, the tremendous influx of newly discovered plants, animals, and shells from the explorations of the Americas reinforced these tendencies toward illusionism for yet a different reason. These discoveries were enthusiastically collected, described, and categorized by naturalists and recorded by artists as diverse as Georg Flegel, Jan Brueghel, Ambrosius Bosschaert, and Roelandt Savery. Although their realistic images of flora and fauna were related in spirit to Dürer's scientific naturalism, they were largely created to celebrate the richness and beauty of God's creations.

Such northern ideas of illusionism encompassed a world view that was quite different

Fig. 4 Joris Hoefnagel, *Three Dragonflies*, ca. 1575/80. Watercolor, gouache, and dragonfly wings on vellum.
From *The Four Elements*, vol. 1 (*Animalia rationalia et insect (ignis)*), plate 54.
National Gallery of Art, Washington, D.C., Gift of Mrs. Lessing J. Rosenwald, 1987.20.5.55.

from the one that formed the basis of the sixteenth-century Italian artistic theories that provided the intellectual foundations for Hoogstraten's theoretical precepts. Italian theorists, particularly G. P. Lomazzo in his *Idea del tempio della pittura* (1590), had been greatly influenced by the abstract metaphysics of Neoplatonic thought that had evolved in the Florentine Accademia Platonica at the end of the fifteenth century under the guidance of its chief spokesman, Marsilio Ficino (1433–99).[16] An important aspect of Ficino's philosophy was his conception of the nature of Beauty. Beauty, or in his terms the Idea, emanates from God in the form of divine rays. It is propagated to the angels, to man, and to nature in descending degrees of purity. The Idea is obscurely reflected by nature because the physical matter of the world corrupts it. Consequently, man must not seek to find the Idea in nature, but within his own spirit. By looking inward rather than outward, man can hope for a truer understanding of God's order of the entire world. In

exceptional moments of intellectual intuition, when the spirit in a state of ecstasy leaves the body, true knowledge of the Idea is possible.

The peculiar character of the visual sense enables it to assist in a fuller understanding of divine Beauty. Our eyes perceive not the physical matter of bodies, but the "light of the sun, painted with the colors and shapes of all the bodies it strikes. . . . [The] entire order of the world, which is visible, is perceived with the eyes, not in the matter of bodies, but in the light which flows into the eyes. And because this order is in the light, separated from matter, it is necessarily incorporeal."[17] Visual impressions of nature are thus purer and more closely related to the Idea than is nature itself. Nevertheless, they reveal merely the appearance of reality rather than the essence of the Idea.

This philosophical approach had many repercussions in the visual arts. It emphasized the importance of the imagination in the creation of a work of art over the role of observation and depiction of reality. The ideal beauty that was sought was not to be found in nature, but could be created by the artist if he selected its most beautiful parts and recreated them into an artistic whole. To this end Zeuxis was once again brought into the discussion, but in an entirely different manner from the competition with Parrhasius to see who could paint the most illusionistic painting. This story related to his method for painting the ideal image of a woman, Helen, which was to select the most beautiful features of five virgins and combine them into one whole.[18] This approach stressed the importance of idealizing natural forms to depict morally uplifting stories drawn from the Bible and mythology.[19] It also had great appeal because it reinforced attempts to raise the theoretical, social, and economic status of artists. Artists should be differentiated from craftsmen, who achieved their success through diligence and training but whose efforts, unlike those of an artist, involved neither inspiration nor an understanding of the divine principles that order the universe.

Hoogstraten, who saw himself as continuing within the framework of Italian art theory and who incorporated most of its ideas into his own writings, nevertheless strongly emphasized the importance of close observation of nature and the ability to "fool the sense of sight." He certainly did not accept the premise that the specifics of nature were unworthy of representation. This viewpoint undoubtedly derived from his familiarity with northern artistic traditions. His specific fascination with *trompe-l'oeil* effects was also reinforced by developments in perspective theory, particularly the interest in anamorphosis and in the camera obscura.

Although the Neoplatonists believed that true knowledge was gained by inspiration and not by reason, the essential characteristics of the Idea were, themselves, rational and mathematical. Those worldly beings that best preserved qualities of number and proportion reflected most closely the Idea in the divine intellect.[20] One of the clearest examples of number and proportion was architecture. When Ficino wished to demonstrate the relationship of the Idea to nature, he metaphorically equated it with the relationship of the architect to his architecture. He argued that an architect preconceives an Idea and

185

then translates it into matter. Architecture, he emphasized, should be judged "for a certain incorporeal order rather than for its matter."[21]

Closely allied with the importance given to architecture in Neoplatonic art theory was that attached to perspective. As with architecture, perspective was a science based on numerical order and geometric projections. Sixteenth-century perspective theory, which developed from ideas first articulated in 1435 by Leon Battista Alberti in his *De pictura*, continued to be based on Euclidean optics. Application of perspective to pictorial problems was of less importance to theorists than the abstract principles that underlay it. When Daniele Barbaro discussed the nature of regular solids in his important treatise *La pratica della perspettiva* in 1569, for example, he emphasized their symbolic equivalents in Platonic thought.[22]

Neoplatonism thus had a dual impact on the visual arts. While it emphasized the purity of mathematical and geometrical forms, it also called into question the validity of sensual knowledge. The consequences were many. The mimetic character of painting was not valued since no universal truths could be found in careful description of nature. Deceptions that revealed the unreliability of one's vision, on the other hand, were enjoyed. As Giovanni Paulo Lomazzo wrote in his *Trattato dell'arte della pittura, scoltura et architettura* in 1584: "Now the skill of the workeman consisteth in shewing False and deceitfull sightes, insteede of the true; which very few can exactly attaine vnto: because it is wholly occupied about shortnings, intersections, &c."[23]

Anamorphic images, such as those Lomazzo described, had definite magical overtones. The subject of an apparently meaningless arrangement of lines and colors would be revealed only when the spectator viewed the picture from the proper vantage point (see cat. nos. 201, 202).[24] Barbaro, in part six of his treatise on perspective, described an even more involved type of anamorphosis. He demonstrated that through anamorphosis an artist could create a painting with a certain subject matter, which would totally change upon viewing it from a different viewpoint.

The predilection of the Neoplatonists for gaining knowledge through intuition and, in a related sense, through revelation, paralleled the widespread fascination in the sixteenth century with emblem books, astrology, and natural magic. Natural magic was the study of the occult and mysterious forces of nature, but it professed that its means were neither superstitious nor supernatural. As Giovanni Battista della Porta wrote in the dedication to Phillip II of the 1564 edition of his remarkable treatise *Magia naturalis*: "This sublime science searches after causes and effects, and while it wishes to penetrate the secrets of nature, not only does it lead to ordinary effects, but, without any superstition, it produces miracles and monsters and has supremacy over all sciences."[25] Despite its fascination with the marvelous, natural magic, in its observation of nature, approached the methods of experimental science. Although it often based "experiments" on hearsay evidence and on old written sources rather than empirical evidence, it sought to understand the laws of nature and to use this information to produce rare and unusual effects.

Its point of departure as well as its intent were thus radically different from the lofty goals of Neoplatonic thought.

Natural magic was not directly concerned with artistic representation, but its experiments with optics had a tremendous impact on the visual arts since they stressed the importance of careful observation of nature. Natural magicians, who preyed upon the imagination of the viewer rather than upon his reason, emphasized optics because of the visual deceptions that could be created with mirrors, lenses, and the camera obscura. These deceptions were often incomprehensible to the intellect if the underlying natural principles were not understood.

The camera obscura was the most fascinating of these devices because it created images of the outside world in a dark chamber. Della Porta, who was the first to recommend placing a lens over the hole through which light enters the camera obscura, describes how one could then see "the countenances of men walking, the colours, Garments, and all things as if you stood hard by; you shall see them with so much pleasure, that those that see it can never enough admire it." He goes on to marvel how the beholder can see "Birds flying, the cloudy skies, or clear and blew, Mountains that are afar off; and in a small circle of paper (that is put over the hole) you shall see as it were an Epitomy of the whole world, and you will much rejoyce to see it." [26] Not only could the vast variety of nature be thus projected into a dark room, but, to increase the marvel, one could also stage "Huntings, Banquets, Armies of Enemies, Plays, and all things else that one desireth." Scenery could be created so that the observer could not "tell whether they be true or delusions." [27]

The camera obscura created such marvels, but it also had philosophical and artistic implications. Della Porta emphasized that this optical device resolved an ancient debate in optical theory by demonstrating that the eye, like the camera obscura, sees by receiving light rays rather than by emitting them.[28] Important for the discussion at hand is that della Porta also recommended using the image created in a camera obscura as a basis for an artist's drawing of nature.

Barbaro, in his perspective treatise of 1569, adapted della Porta's discussion of the camera obscura, but, in the process, broadened its philosophical implications. The camera obscura, wrote Barbaro, is important for understanding perspective. It demonstrates how "nature delights in teaching us the various proportions of objects and helps us to define the precepts of art, provided that we are diligent observers on every occasion." [29] Nature, thus, is portrayed as a teacher, whose lessons painters should carefully follow. Within the camera obscura "nature shows us the various aspects of things not only the outline of the whole but also of their parts as well as of their colours and shadows."

By the early seventeenth century the camera obscura was well known in the Netherlands, where even greater value was attached to the image it created. When Constantijn Huygens described the image he had seen in a camera obscura constructed by Cornelis Drebbel in London, he wrote, "It is not possible for me to reveal the beauty to you in

words; all painting is dead by comparison, for here is life itself or something more elevated if one could articulate it."[30] Huygens, who was one of the most perceptive art critics of his day, as well as an important statesman, poet, and musician, recognized that the "beautiful brown picture" nature created within the camera obscura had lifelike characteristics, including the movement of the trees and clouds, that no contemporary artist had achieved. Almost certainly he saw it as a standard against which Dutch artists should measure their work in their efforts to create naturalistic images.

The camera obscura thus was understood to reveal fundamental ideas about nature and art that reflected broader concerns than just those associated with this particular optical device. The camera obscura demonstrated that nature provides lessons that artists should strive to follow: nature teaches not only the art of perspective, but also the proper distribution of light and shadow.

The renewed appreciation of the lessons to be learned from careful observation of the natural world was at the same time reinforced by theologians who had begun to celebrate the blessings of God that could be found in the variety and beauty of his creations.[31] This attitude was particularly evident in the writings of theologians in the circle of Cardinal Federico Borromeo, but it was shared by Protestants and Catholics alike. The tremendous influx of newly discovered plants, animals, and shells from the explorations of the Americas discussed above gave added substance to this theological approach, since these wonders demonstrated the vastness of God's power. By studying carefully each and every one of these creations, a naturalist or an artist would give homage to God.

The effect of this theological approach to the world meant that a realistic representation of nature signified a sensitivity to the variety and beauty of God's creations. Cardinal Federico Borromeo's description of the enjoyment he received from viewing a flower still-life painting by Jan Brueghel must be understood in this light. When he wrote, "when winter encumbers and restricts everything with ice, I have enjoyed from sight— and even imagined odor, if not real-fake flowers . . . expressed in painting,"[32] he was expressing his admiration not only for the artist's observation and technical prowess, but also for his profound understanding of the nature of the image he had depicted.

Cornelis de Bie expressed similar sentiments in his treatise of 1661.[33] According to de Bie, nature is perfect beauty, without blemish. After the Fall of man, human understanding of nature was obscured, even though nature itself remained untainted. Only through effort and industry of the enlightened mind, which is granted by God's grace, can nature be rediscovered. Imitation of nature thus signifies God's power.[34] De Bie, for example, writes about the landscape painter Jan Both: "When we perceive the power of nature in the green growth of the earth, daily nourished by the grace of God, we are reminded of the origin of life. Jan Both painted this with such talent that the heart of the observer of his work is inspired with virtue."[35] Even more explicit on this subject were the church fathers in Delft when they wrote on behalf of the famed Delft microscopist Anton van Leeuwenhoek in 1677 that "nothing contributes more to the honour of God, the Creator

of everything, or incites us more to the admiration of Him who alone is Goodness, Wisdom, and Power, than the exact observation of creation." [36]

The exact observation of creation, however, did not necessarily mean that painters should not select from nature. Dutch artists, in particular, carefully chose those elements they wished to include in their compositions, for both stylistic and thematic reasons. Although they did not choose, as did Zeuxis, the most attractive parts from a variety of models to create one perfect one, they would choose, as did de Heem, beautiful flowers that bloom at different seasons of the year to include in one sumptuous bouquet (cat. no. 157). Thus, artists created by this means a composition that was as idealized in its own way as was Zeuxis's Helen.

The added component of such an illusionistic image, which was purely Dutch, was the moralizing message that resulted from the specific selections the artist had made. Whether the message of the painting was the bounty of God's creations, the need for moderation and restraint, the vanity of worldly possessions, the transience of life, or the lasting power of artistic creation, such works of art were marvelous vehicles for transmitting important reminders of the nature of existence and the moral codes by which one should conduct one's life.

Although not all *trompe-l'oeil* images convey moralizing messages, and many seem to have been created as artistic conceits, the primary function of illusionistic painting in the seventeenth century had become compatible with that of history painting. Even though history painting continued to be ranked at the highest echelon of artistic creation because it focused on the actions of the human figure, the fundamental changes that had occurred in man's appreciation of nature since the early sixteenth century also meant that illusionistic painting could be valued as a conveyer of significant moralizing messages that addressed man's moral code of conduct.

Despite such serious connotations, it is also clear that the visual deceptions that artists created with their illusionistic windows, doors, and niches, with their curtains hanging over objects or over a portion of their "painting," with their flies and insects, with their rich fabrics and delicate petals of flowers, with their reflections in silver and glass globes, and with their extraordinary perspective boxes, were admired for their artistry and the joy that they elicited in the viewer. That fascination has never faded, and today we look upon these works with as much wonder as viewers did some three hundred years ago.

NOTES

1. Samuel van Hoogstraten, *Inleyding tot de Hooge Schoole der Schilderkonst: anders de Zichtbaere Werelt* (Rotterdam, 1678), p. 274: "Maer ik zegge dat een Schilder, diens werk het is, het gezigt to bedriegen, ook zoo veel kennis van de natuur der dingen moet hebben, dat hy grondig verstaet, waer door het oog bedroogen wort."

2. Ibid., p. 79: "den hoogsten en voornaemsten trap in de Schilderkonst, die alles onder zich heeft, geport en genreven, welk is het uitbeelden der gedenkwaerdichste Historien."

3. See Albert Blankert "General Introduction," *Gods, Saints & Heroes: Dutch Painting in the Age of Rembrandt* (Washington, D.C.: National Gallery of Art, 1980), p. 16.

4. The account, written by Pepys after visiting the house of Thomas Povey in Lincoln Inn Fields, London, in 1663, is quoted in *The Treasure Houses of Britain* (Washington, D.C.: National Gallery of Art, 1985), p. 146.

5. *Memoirs of John Evelyn, Esq., F.R.S.*, ed. William Bray (London: Frederick Warne and Co., n.d.), p. 246.

6. Roger de Piles, *Abregé de la vie des peintres . . .*, 2nd ed. rev. and corr. (Paris, 1715), p. 423.

7. J. J. Orlers, *Beschrijvinge der Stadt Leyden* (Leiden/Delft, 1641), p. 377.

8. Philips Angel, *Lof der Schilder-konst* (Leiden, 1642), pp. 53–54.

9. Ibid., pp. 54–55. For an excellent discussion of Dutch art theory as it relates to the Leiden "feinschilders," see Eric J. Sluijter, "Schilders van 'cleyne, subtile ende curieuse dingen': Leidse 'fijnschilders' in contemporaine bronnen," in *Leidse Fijnschilders* (Waanders: Zwolle, 1988), pp. 14–55.

10. Cornelis de Bie, *Het Gulden Cabinet van Edel de vry Schilderconst* (Antwerp, 1661), p. 215: "Dat door Freer *Zeghers* const het leven in haer woont." For an excellent assessment of de Bie's treatise, see E. S. de Villiers, "Flemish Art Theory in the Second Half of the 17th Century—an Investigation on an Unexplored Source," *South African Journal of Art History* 2 (1987): 1–11.

11. Hoogstraten, *Inleyding*, p. 25: "Want een volmaekte schildery is als een spiegel van de Nateur, die de dingen, die niet en zijn, doet schijnen te zijn, en opeen gesorlofde vermakelijke en prijslijke wijze bedriegt."

12. The poem, written by Dirk Traudenius, is cited in Sluijter, "Schilders van 'ceyne, subtile ende curieuse dingen'," p. 21.

13. I would like to thank Jean Caswell for discussing this point with me.

14. As quoted by Baron Joseph van der Elst, *The Last Flowering of the Middle Ages* (Garden City, N.Y.: Doubleday, 1944), p. 81. I would like to thank John Hand for bringing this reference to my attention.

15. As quoted in Fritz Koreny, *Albrecht Dürer and The Animal and Plant Studies of the Renaissance* (Boston: Little, Brown & Co., 1988), p. 14.

16. For further discussion of these issues see Erwin Panofsky, *Idea: A Concept in Art Theory*, trans. Joseph J. S. Peake (Columbia, S.C.: University of South Carolina Press, 1968), pp. 128–53; Arthur K. Wheelock, Jr., *Perspective, Optics, and Delft Artists Around 1650* (New York: Garland, 1977).

17. Marsilio Ficino, *Sopra lo amore o ver convito di Platone* (Florence, 1544), Or. 5, chap. 4, as trans. by Victor A. Velen and quoted in Panofsky, *Idea*, p. 133.

18. Gio. Pietro Bellori, *Le vite de' pittori, scultori et architetti moderni* (Rome, 1672), as discussed by Panofsky, *Idea*, pp. 156, 157.

19. The preeminence of history painting had already been established by Alberti in 1436: "the greatest work of the painter is the *Istoria*." See L. B. Alberti, *On Painting*, trans. John Spencer (London: Routledge & Kegan Paul, 1956), p. 70.

20. E. H. Gombrich, "Icones Symbolicae: The Visual Image in Neo-Platonic Thought," *Journal of the Warburg and Courtauld Institutes* 11 (1948): 168ff.

21. Ficino, *Sopra lo amore*, chap. 5, as trans. in Panofsky, *Idea*, p. 137.

22. Daniele Barbaro, *La pratica della perspettiva* (Venice, 1569), p. 37.

23. Giovanni Paulo Lomazzo, *A tracte containing the artes of curious paintinge, carvinge, buildinge*, trans. R. Haydocke (Oxford, 1598), pp. 188f. (Originally published as G. P. Lomazzo, *Trattato dell'arte della pittura, scoltura et architettura* (Milan, 1584).

24. Bramantino and Vignola even adapted Dürer's mechanical devices, which had been devised to ensure an accurate pictorial image of physical objects, for such purposes. Although Bramantino never seems to have published a perspective treatise, his ideas were incorporated by Lomazzo into his treatise. See Lomazzo, *A tracte*, pp. 217f. For Vignola see G. B. de Vignola, *Le due regole della prospettiva pratica* (Rome, 1583), p. 96. For an excellent general history of per-

spective and the use of perspective devices, see Martin Kemp, *The Science of Art: Optical Themes in Western Art from Brunelleschi to Seurat* (New Haven: Yale University Press, 1990).

25. Giovanni Battista della Porta, *Magia naturalis* (Antwerp, 1564), p. 3, translation in Guillaume Libri, *Histoire des sciences mathematiques en Italie, depuis la renaissance des lettres*, 4 vols. (Paris, 1838–41), vol. 4, p. 120: "Cette sublime science recherche les causes et les effets, et tandis qu'elle veut penetrer dans les secrets de la nature, non-seulement elle conduit à des effets vulgaires, mais, sans aucune superstition, elle produit des miracles et des monstres, et à la suprématie sur toutes les sciences." The first edition of this frequently republished book appeared in Naples in 1558.

26. John Baptista Porta, *Natural Magick* (London, 1558); facsimile edition, ed. Derek J. Price (New York: Basic Books, 1957), p. 364.

27. Ibid., pp. 364–65.

28. For further discussion of this matter see Arthur K. Wheelock Jr., "Constantijn Huygens and Early Attitudes Towards the Camera Obscura," *History of Photography* 1 (1977): 93–103.

29. Barbaro, *La practica*, p. 192. This translation is taken from Wheelock, *Perspective, Optics, and Delft Artists Around 1650*, p. 96.

30. Constantijn Huygens, *De Briefwisseling (1608–1687)*, 6 vols., ed. J. A. Worp (The Hague: M. Nijhoff, 1911–17), vol. 1, p. 94, as translated in Wheelock, *Perspective, Optics, and Delft Artists Around 1650*, p. 93.

31. This issue is discussed by Pamela M. Jones, "Federico Borromeo as a Patron of Landscapes and Still Lifes. Christian Optimism in Italy ca. 1600," *The Art Bulletin* 70 (1988): 261–72, and in Arthur K. Wheelock, Jr., "Still Life: Its Visual Appeal and Theoretical Status in the Seventeenth Century," in *Still Lifes of the Golden Age: Northern European Paintings from the Heinz Family Collection* (Washington, D.C.: National Gallery of Art, 1989), pp. 11–25.

32. As quoted in Jones, "Federico Borromeo," p. 269.

33. The following analysis is taken from de Villiers, "Flemish Art Theory," p. 2.

34. De Bie, *Het Gulden Cabinet*, p. 66: "het leven wijst den wegh van perfectie en gheeft den sin van Godt's Mogentheydt." He continues: "Het leven (dat alleen van Godt voortcompt) leert alle dinghen. Ergo soo moet de Const van *Pictura* (die naer het leven uytghewerckt is ende het leven afschaduwende) onghelijck meerder cracht hebben als het gene gecopieert wordt naer den schijn van het leven."

35. Ibid., p. 156, as quoted by de Villiers, "Flemish Art Theory," p. 2. The original text reads: "Dat is het soet ghewas t'gen' doegh'lijckx wordt ghegheven / Door Godes zeghen uyt de groen en vruchtbaer aert. / Dit wist *Both* met t'pinceel soo wonder af te malen / Dat al sijn maelery door haere geesticheyt / Den Mensch (die Const bemindt) met jever can bestraelen / En menichmael het hert tot haere deught verleyt."

36. A. van Leeuwenhoek, *Collected Letters* (Amsterdam, 1952), vol. 4, p. 257.

191

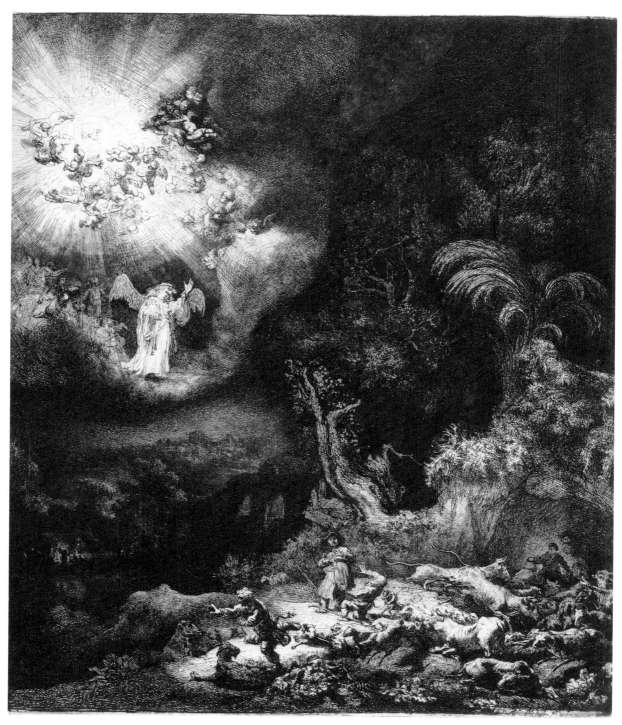

Fig. 1 Rembrandt van Rijn, *The Angel Appearing to the Shepherds*, 1634. Museum of Fine Arts, Boston, Massachusetts, Anonymous Gift (cat. no. 208).

of the sixteenth century and slowly spreading through the rest of Europe, the reserved Eucharist was kept in a centralized location, in a tabernacle right on the altar, rather than in more peripheral locations as before.[9] Thus the tabernacle was visible from the moment one entered a church. As people drew close to the altar, another innovation, the communion rail, encouraged them to change their bodily position.[10] This low barrier prompted the faithful to kneel, a pose conducive to humility and adoration.

When mass ended the reserved Eucharist was not always hidden away. After the Council of Trent (1545–64) the Catholic church exposed the host for adoration with unprecedented frequency while highlighting its importance through such devices as the monstrance, which usually had metallic rays.[11] Candlelight or daylight falling on the rays suggested radiance moving out from the host itself.

Exposed on the altar, the monstrance sometimes stood surrounded by temporary painted and three-dimensional stage effects that seemed to bring angels and clouds right into the church (cat. no. 224). The Devotion of the Forty Hours became a particularly popular and, at times, a grandly staged ceremony (cat. no. 225). The devotion began in Milan around 1530, but from the end of the sixteenth century spread gradually to other parts of Europe. Bernini was the first to stage particularly spectacular effects (cat. no. 223). Intense light radiated from the Eucharist, visibly touching the faithful as they drew near. In a staging of 1628, for example, Bernini showed "the Glory of Paradise shining with tremendous brightness without one's seeing any light except that which emanated from more than two thousand lamps hidden behind the clouds." Light at this level would have had great impact because low illumination, even shadow, was still the norm in most interior spaces. An Englishman in Rome in 1581 wrote that a Devotion of the Forty Hours "semeth a glimpse of paradise."[12]

The Miraculous Experiences and Deeds of the Saints

Beginning in the thirteenth century representations of miracles involving saints who lived after the early Christian period increased markedly, and by the end of the sixteenth century these were the miracles, denied by Protestants, that were the most often represented (cat. no. 217; *fig. 2*). In 1588 the Catholic church ended a period of sixty-five years with no canonizations.[13] Those who joined the ranks of saints in 1622 included well-known reformers who had died during the second half of the previous century: Teresa of Avila (cat. no. 218), Ignatius Loyola (cat. no. 219), and Francis Xavier (*fig. 2*). Official recognition of the holiness of nonmartyrs required proof that the candidate was a miracle worker and had worked miracles after death. Beatification required two officially accepted posthumous miracles, and canonization two more.[14] Peter Paul Rubens's paintings of Francis Xavier (*fig. 2*) and Ignatius Loyola (Vienna, Kunsthistorisches Museum) demonstrate that imagery could play an active role in recording miracles. Neither Jesuit had been canonized and only Francis Xavier had been beatified when Rubens featured them

195

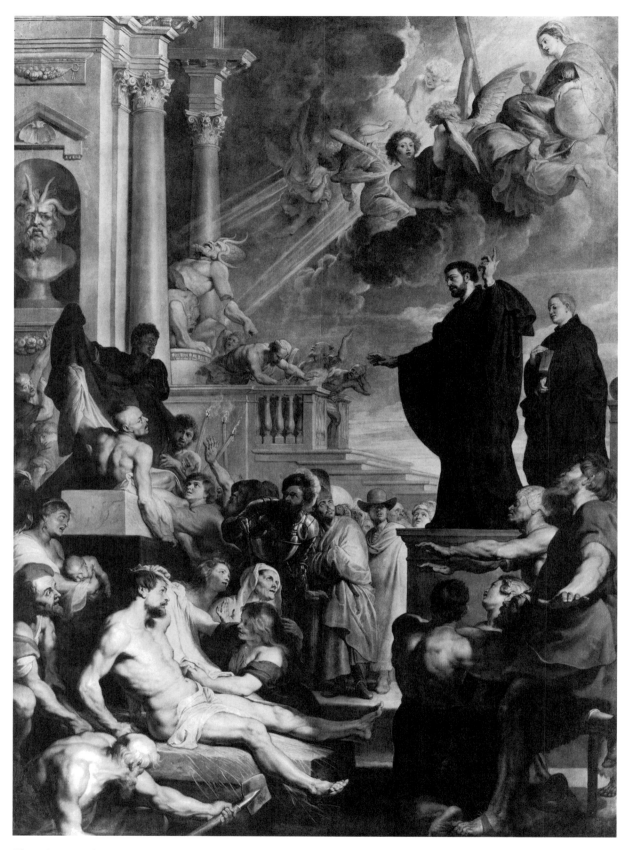

Fig. 2 Peter Paul Rubens, *The Miracles of Saint Francis Xavier* (ca. 1619).
Oil on canvas. Kunsthistorisches Museum, Vienna.

in altarpieces for the Jesuit church in Antwerp. The vivid life-size scenes thus served a propagandistic as well as a devotional function; by presenting the two men as miracle workers, the paintings argued for canonization while creating the climate of belief for further miracles to take place.[15] Those attending actual canonization ceremonies in Rome saw images identifying the new saints prominently displayed on the facade and in the interior of Saint Peter's; looming larger than life in these monumental depictions, the saints worked miracles, beheld visions, ascended to heaven in glory, or displayed other supernatural signs of divine favor.[16]

Although artists represented a wide range of miraculous situations during the period considered by this exhibition, roughly 1550 to 1700, they and their patrons favored one subject above others. In image after image they focused on distinctly visual phenomena, on visions, and on saints as visionaries.[17] For example, the official images displayed in 1622 at the canonization of five new saints showed four of the saints looking up at visions. No pose proved more characteristic of portrayals of saints during this period than eyes turned heavenward (*fig. 3*).

A common definition of "vision" was "what the blessed in heaven see,"[18] and indeed in most depictions of visions a bit of heaven seems to have descended toward earth. Clouds frame the sacred apparition, which radiates brilliant light (cat. nos. 217, 222). Mary, holding the infant Christ, appears most often at the center of the radiance. The traditional pairing of the two in a visionary context served to rebut the Protestant position that Mary was the mother of the human but not the divine Christ.

Other very different celestial bodies "which have never been seen before" also became visible during this time. The Dutch invention of the telescope in 1608 made possible moments when the moon and the stars suddenly seemed much closer to earth, up to thirty times closer, according to Galileo (see cat. no. 95).[19] This technological breakthrough occurred when the subject of heavenly visions was unprecedentedly popular; paradoxically, both developments made heaven more accessible to earthly viewers. During the early seventeenth century attempts to visually grasp realms beyond the natural capacity of human sight characterized not only the emerging new science, but also the centuries-old religion of Catholicism.

Sanctity is more readily recognized and appreciated if it follows a familiar pattern, so new representations of visions and other miracles drew on known prototypes. The familiar references, which made the new images more accessible, carried the additional benefit of prestigious associations. When, for example, a Flemish follower of Rubens, probably Abraham van Diepenbeeck, painted the guiding vision that preceded the founding of the Jesuit order (cat. no. 219), he patterned it on an earlier vision recounted in the Apocryphal Gospels. According to Saint Ignatius's own report, he was several miles from Rome in 1537 when he had the experience of being with Christ and with God the Father. The cross Christ carries in the painting was not, however, mentioned in Ignatius's account but was added in 1566 by his official biographer, Pedro de Ribadeneira, and then depicted re-

Fig. 3 Francisco de Zurbarán, *Saint Francis.*
Oil on canvas. Museum of Fine Arts, Boston, Herbert
James Pratt Fund, 38.1617.

peatedly by artists.[20] The motif's presence enhanced Ignatius's role as founder of the
Jesuit order by linking his vision to one experienced on the outskirts of Rome by Saint
Peter, the first pope.

Another work that elaborated on the report of a vision to bring out its significance
is *Fray Julián's Vision of the Ascension of the Soul of King Philip II of Spain*, which Bartolomé
Esteban Murillo painted for the monastery of San Francisco in Seville in the mid-1640s
(cat. no. 220). Here the subject is prophecy, a particularly prominent theme in Spanish
hagiographic literature.[21] Fray Julián was a Franciscan monk who lived in the early
seventeenth century, and though credited by contemporaries with at least six hundred
miracles, he was never canonized. On a bare hillside at night, a group of men witness the

198

fulfillment of what Fray Julián had predicted earlier on that September day in 1603: shortly after nine in the evening, two radiant clouds would appear from opposite directions in a cloudless sky and join as a sign that the soul of King Philip II of Spain left the flames of purgatory and entered the glory of heaven.[22] No one in 1603 who witnessed the strange clouds also reported seeing the flames of purgatory or Philip II entering heaven; their inclusion in the painting explained the event by projecting what Fray Julián had said onto what people saw.

The presence of amazed witnesses, the highly naturalistic handling of the life-size scene, and especially the now-weathered inscription under the picture all contributed to the work's documentary effect. The Franciscan chronicler who recorded the event in 1610 had likewise aimed for an aura of authenticity, citing witnesses and appending signatures of those who affirmed the prophecy.[23] His procedure was not unusual. Documentation of miracles had become standard and widespread at this time. A case in point are church records of supernatural healings, which usually present these miracles as objective historical events, describing in a dozen or two lines what had happened, when, and to whom.[24]

While saints lived God favored them with visions; when they died he sometimes furnished visible and lasting proof of their holiness by arresting the natural action of time on their corpses. On September 15, 1587, six years after Saint Teresa of Avila had died, Master Fray Luis de Leon wrote in a letter, "Her body has been found miraculously incorrupt, and this and other miracles taking place daily have set her sanctity beyond all doubt."[25] Artist's recreations of the incorrupt corpses make them look still fresher. An engraving by Hieronymus Wierix shows Saint Cecilia, an early Christian martyr, lying gracefully on her side in the position in which she was discovered on December 20, 1599, well over a thousand years after her martyrdom in the church of Saint Cecilia in Rome (cat. no. 214). Few were allowed to contemplate the marvel, which remained under the thin green veil that had covered the body for burial, until the pope had her magnificently reentombed.[26] In a painting by Francisco de Zurbarán, Saint Francis, the thirteenth-century founder of the Franciscan order, stands open-eyed in his tomb, just as Pope Nicholas V (according to Franciscan legend) saw him more than two hundred years after his death (*fig. 3*). As another sign of sanctity, some incorrupt corpses reportedly gave off a beautiful odor, described as the smell of paradise.[27]

During this period artists pictured saints as active miracle workers far less often than as passive visionaries. Nevertheless, in quite a few examples saints perform such supernatural acts as healing the sick and resurrecting the dead (*fig. 2*, lower left). Francesco Solimena's preparatory sketch (cat. no. 222) for a large allegorical painting, *The Miracle of Saint John of God*, produced within a year of that saint's canonization in 1690, credits the flying saint with having stopped the plague in Naples. Saint John at one time worked as a bookseller who also carried holy pictures, but seventeenth-century viewers would have interpreted the octagonal picture he holds with angelic assistance as an *ex-voto* given as promised by the grateful figure in bed, who probably represents the recovering city of

199

Fig. 4 Bartolomé Esteban Murillo, *The Angels' Kitchen*, 1645–48. Oil on canvas. Musée du Louvre, Paris.

Naples.[28] Healings and other active miracles reminded people of biblical accounts about Christ, such as the resurrection of Lazarus. Compositional similarities between works depicting activities of Christ and of the saints reinforced this connection, through which the saint gained in prestige (cat. no. 209; *fig. 2*).

In paintings and sculpture artists often portrayed both female and male saints as passive recipients of divine favor, especially of visions, but they virtually never portrayed female saints as workers of miracles. Though less true of prints, in paintings and sculpture this active and powerful role remained the precinct of male saints, foremost among them Saint Peter.[29] Imagery thus supported the hierarchical structure of the Catholic church. Yet biographies of female saints, including those who had died recently, recorded comparable deeds, and both men and women reported being healed at shrines dedicated to female saints.[30] According to her autobiography and contemporary reports, Saint Teresa of Avila healed the blind and the incurably ill, multiplied food, brought rain, and prophesied.[31] In paintings and sculpture, however, her only roles were those of a visionary, a swooning mystic (cat. no. 218), or less often a recipient of divine inspiration while writing.

Levitation occurred involuntarily, and Saint Teresa struggled unsuccessfully against leaving the ground in public. As she wrote, "When I tried to resist these raptures, it seemed that I was being lifted up by a force beneath my feet so powerful that I know nothing to which I can compare it."[32] Artists represented levitation either as simply floating above the ground unsupported or as being borne aloft by clouds or angels; the former looked like rising, the latter like being raised. Variables such as age, ecclesiastic or lay status, or when and where the saint (or artist) lived had no effect on portrayals of the saint's levitation, but gender did. In paintings and sculpture from this period only male saints walk on water or levitate without any apparent assistance (*fig. 4*), though

200

both male and female saints (including Gian Lorenzo Bernini's renowned sculpture of Saint Teresa in Santa Maria della Vittoria, Rome) float above ground with the support of clouds or angels. Levitations of female saints thus invariably appeared as passive as the Assumption of Mary, the model of submissive holiness.[33]

Active miracles by female saints had not always been ignored. For example, Italian paintings from the late Middle Ages show female saints as miracle workers, even in such dramatic contexts as saving the shipwrecked at sea. Though less often than their male counterparts, they too heal the sick, cure the blind, and raise the dead.[34] These subjects were not completely absent from imagery during the period considered here, but were virtually limited to engravings. In images printed on paper contemporaries could sometimes see female saints performing such miracles as supernatural healing, multiplying matter, or exorcising the possessed (*fig. 5*).[35] Engravings, though more numerous and accessible to individual possession, had less of a sensory impact than oil paintings, especially large altarpieces, because of their small size and lack of color. They were images

Fig. 5 Cornelis Galle, *Scene from the Life of Saint Catherine of Siena: an exorcism.* Engraving from *D. Catherinae Senensis Virginis SSmàe Ord. Praedicatorum vita ac miracula selectiora.* Text by Michel Ophovias. Antwerp, 162?, reissue of 1603 edition. Spencer Collection, The New York Public Library, Astor, Lenox and Tilden Foundations.

201

intended for private, not public viewing. Even in this medium and unlike most other engraved depictions, however, the engraved scenes of women as miracle workers usually lacked the prominence of independent images. They belonged to series. They were included among the tiny narrative scenes that framed a larger devotional representation of the saint, and among the illustrations to her biography. Few women in the audience had full access to this visual material because the accompanying text tended to be in Latin, a language of international discourse rarely included in their education. Thus the text kept at a distance those whom the prints could have empowered.

In general, the more public and active the representation of a saint as a worker of miracles, the less likely the featured saint is a woman. Artists pictured the suspension of such forces of nature as death, and sickness by the saints, but only rarely did they picture the suspension of social expectations that women be passive but men active and that their power be unequal. Even in the case of saints, artists and their patrons found it easier to imagine situations contrary to the order of nature than to the order of society.

Many Europeans readily imagined women flying through the air or supernaturally changing the physical condition of others, but their supernatural powers were deemed to come from Satan, not God. The decades between the mid-sixteenth century and the late seventeenth were the high point of the witch hunt that infected much of Europe.[36] Although witchcraft was not a common subject of art, probably because the whole topic was somewhat dangerous, some paintings as well as prints depict the practice. Consistent with the real accusations, these images connected this un-Christian magic almost exclusively with women.[37]

A Time Fertile in Miracles

The plausibility of the pictured miracles increased because the audience heard about new miracles in their own region and may even have witnessed events classified as miracles. "The miracle is everywhere," concluded the historian Henri Platelle about the city of Lille in the first half of the seventeenth century, a time he described as "fertile in miracles." [38] He referred not to representations of miracles, although that certainly would be true, but to the numerous reports of actual miracles he found in local accounts. Lille was hardly unique among the Catholic cities of Europe. The works from this period exhibited out of context in the museums of today cannot convey the degree to which the miraculous was a part of life for many Catholics.

Pictorial images intensified the presence of the miraculous in complex ways. In their original locations, altarpieces featuring saints often served as reminders that right below the altarpiece, or near it, there existed a direct physical link with the saint in heaven. For example, *The Miracle of Saint Justus* by Rubens (Bordeaux, Musée des Beaux-Arts), with the nine-year-old decapitated saint carrying his own head, was originally hung in the church of the Annunciate nuns in Antwerp above the altar where the saint's head had

been kept since 1629.[39] Relics required for functioning altars were popularly believed to carry some of the miracle-working power of the saint, and so clergy disassembled saints' corpses to supply all parts of Europe with bits of their bodies. Reports of healing through physical contact with a relic or by simple proximity peaked right after its arrival but also appeared in subsequent years. Reported miracles strengthened the plausibility of the pictured miracles, which in turn increased belief in the saint's capacity for miraculous intercession, a possibility denied by Protestants.[40]

Today's museum visitors rarely see, or realize they are seeing, some of the many paintings and sculptures that Catholics of the seventeenth century described as miraculous. This term could designate an image's origin, its capacity to move, weep, or otherwise seem animate on one or more occasions, and its supernatural effects on people and environments.[41] This interconnection between image and miracle, Catholics thought, would demonstrate to the Protestants (foremost among them Calvinists) who barred the use of paintings and sculptures in churches that God permitted such works to be vehicles of his mercy or power, either directly or through his saints.

While Protestants mocked Catholic credulity, whole cults grew up around images esteemed as miraculous. According to the Gospels, Mary worked no miracles in her lifetime; but during the late sixteenth and seventeenth centuries she was credited with working countless miracles, especially healings and resurrections of infants, through hundreds of images of her as Madonna.[42] The resurrections of infants were temporary, only sufficiently long to baptize the newborns who had died without this sacrament. Paintings and statues credited with such miracle-working properties had various origins. Few of the works were acknowledged to be new, more were thought to be old and even attributed to Saint Luke the Evangelist, but most were believed to have simply appeared where no image had existed before. Depending on the local terrain, common sites for the discovery of the images (and for apparitions) were springs and caves (especially in Spain) and trees (especially in the Southern Netherlands).[43] The popular association of miraculous Madonnas with trees may well have affected how contemporaries reacted to naturalistic paintings of Mary seated with Christ under a tree.[44] Although some miraculous images were found in other locations, such as on an outside wall of an ordinary house (for example, that which is rarely visible but magnificently placed above the main altar in Santa Maria in Vallicella, Rome), the majority appeared in the countryside beyond town and city, as if the book of nature were revealing the truth of Catholic belief in the importance of Mary and the appropriateness of religious imagery.

French shrines with miraculous images of the Madonna tended to be near Protestant territory. Reports of miracles at such shrines reached a high point from the 1590s through the 1640s.[45] Comparable studies are not available for boundary areas in other countries, but in the Southern Netherlands (roughly present-day Belgium) the largest number of sculptures of the Madonna that were reported to work miracles seem to have been found in the 1620s and 1630s.[46]

Even if discovered in natural settings, the images did not remain there long. Shrines and large churches grew up around the works to honor them and accommodate their pilgrims. The fame of the images spread not only by word of mouth, but also through numerous miracle books. Books giving the history of images at specific shrines and describing miracles reported there began to be published in the late sixteenth century and continued to be produced in quantity through the seventeenth century. In 1663 a Parisian publisher contracted to print within half a year a huge edition (36,000 copies) of a book about the miracle-working sculpture of Our Lady of Liesse.[47] In the seventeenth century compendia of miraculous images from a given region or country, or even various countries, appeared.[48]

People from all ranks and professions, including heads of state and scholars, believed in the power of such Madonnas. The philosopher Justus Lipsius left his silver pen as a votive offering with the Madonna at Halle, where he was healed. He also wrote a book published in 1605 describing the miracles that occurred there through faith (cat. no. 221).[49] The Archduchess Clara Eugenia Isabella, daughter of Philip II of Spain and regent of the Southern Netherlands, donated rich mantles for several Madonnas (including Our Lady of the Branch in Antwerp cathedral) as well as two golden crowns with diamonds.[50]

The power of the miraculous images became increasingly manifest through changes in their appearance and that of their immediate surroundings. Heads of state and others provided the figures with precious mantles, golden crowns, and sometimes scepters. Only the faces and hands of the statues remained visible. The Madonna was transformed into the queen of heaven. Gradually the space around the sculpture or painting changed as well, as petitioners left objects testifying to Mary's powerful intervention. The *ex-votos* included representations of healed body parts and occasionally small and rudimentary pictures of miracles she had worked. A description written in 1638 of the Chapel of Our Lady at Douai gives a sense of how such spaces looked: "The walls of the chapel, all around, high and low, were adorned with brackets, votive paintings, with pictures append-aged with legs, arms, feet, hands, with other figures of men, women and children all of wax, lead, iron."[51] Together, the *ex-votos* and the rich clothing created a religious and aesthetic ensemble to which people from all ranks of society had contributed. These gifts turned the hundreds of images that had started out as simple figures of the Virgin Mother holding Christ into exceptional public representations of a female miracle worker. At most of the European sites this process now has been reversed and the *ex-votos* removed. Many of these works, now just ordinary religious paintings and sculptures, had previously publicly localized the sites of miracles.

The Miracles that Justified Images

Calvinists and some other Protestant sects were hardly the first Christians to oppose the use of religious images; however, in the late sixteenth and seventeenth centuries it was

particularly the Calvinist position against which Catholics responded. The Council of Trent took a clear stand at its last session in 1563, reaffirming the validity of images and establishing some guidelines to prevent abuses.[52] Catholics also referred to the miraculous aspects of images in order to counter charges against them.

The supposed supernatural origin of certain images furnished proof that God approved of religious art. None was more famous than the veil of Veronica, on which Christ miraculously left an imprint of his face during his climb to Calvary. As its name indicates, the veil was revered as a *vera icona* (a true image) not made by human hands. The original relic is believed to survive in Rome. Artists who represented Veronica's veil for devotional purposes (cat. no. 212) could believe they were recreating the portrait authored miraculously by Christ himself.[53]

People in distress who found human help insufficient sometimes promised to donate a sculpture or painting in exchange for supernatural assistance.[54] The averted disaster then provided proof that the promised image was indeed welcome to the heavenly being to whom the plea had been addressed. If the rescue was particularly striking, the donated work might continue to be associated with supernatural power, as is evident from subsequent reports of miracles. The case history of a few miraculous Madonnas bears out this belief. Even when no miracles followed, the donated work functioned as an *ex-voto* testifying to the original miracle. A case in point is Solimena's painting for the Ospedale di Santa Maria della Pace in Naples, for which the oil in cat. no. 222 is a preparatory study; the painting, itself an *ex-voto*, also illustrates the giving of one.

Even with recently canonized saints miracles not only were represented in and documented by works of art, but also occurred through them. For example, pictures and holy medals of saints Ignatius Loyola and Francis Xavier generated reports of miraculous healing that were cited and accepted as valid at their canonization hearings in 1622.[55]

The Waning of the Miraculous

By the end of the seventeenth century the gulf between the Protestant and Catholic views of the miraculous had narrowed, and it was the Catholic position that had shifted. The conception of the physical world as open to frequent supernatural adjustments of its natural order was beginning to be eclipsed by a belief that God's power is most manifest in maintaining, not suspending, the laws he himself established. New developments in science and philosophy emphasizing reason and the mathematical order of the universe made many Catholics increasingly skeptical about the possibility of miracles. Even the clergy took this position, among them Nicolas Malebranche, an ordained Oratorian and an influential writer.[56] The educated were the most affected, though surprisingly during the late decades of the seventeenth century the shift in attitude was apparently not limited to them. People from all ranks of society reported miracles less frequently. For example, in France at the pilgrimage shrines where miracles had been common, they became

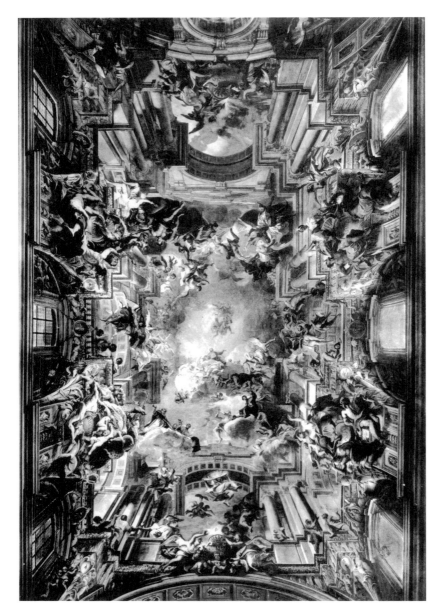

Fig. 6 Fra Andrea Pozzo, *The Glorification of Saint Ignatius*, 1691–94.
Ceiling fresco in the nave of Sant'Ignazio, Rome.

infrequent by the 1660s and rare by the 1670s.[57] Although some miraculous shrines continue to function even today, they have increasingly become exceptions. At the time of the waning of the miraculous, reports of black magic also declined. During the second half of the seventeenth century increasing numbers of both Protestants and Catholics began to doubt whether witches existed.[58]

Miraculous situations represented at the close of the seventeenth century often seemed less physically immediate than those favored in previous centuries, and not just

because of the general change in style. From the early Christian period until the second half of the sixteenth century artists and patrons had most often chosen as subjects active miracles that transformed the physical condition of bodies. From the late sixteenth century they favored miracles perceived through sight. Although at times the heavenly figures touched the saints, or even handed them objects, the event centered on seeing, and seeing through the intermediary of a saint positioned close at hand. At the end of the seventeenth century, however, artists frequently located saints in the heavenly vision itself rather than on earth, near the viewer. The subject that they and their patrons increasingly favored was a timeless glorification of the saint aloft in the sky surrounded by clouds.

By 1700 not only did miraculous events become a less frequent subject, but when shown they often appeared to be at a considerable distance from the actual viewer (such as Fra Andrea Pozzo's renowned fresco *The Glorification of Saint Ignatius*, ca. 1691–94, Rome; *fig. 6*). Many Catholic viewers who looked up at such scenes experienced a sense of greater distance between miracles and their daily life than had existed for their parents and grandparents. The century in which the miraculous was still a strong presence in much of Western Europe was over.[59]

Acknowledgments

I am grateful to Francis Oakley for support that provided research time, to Anna Blume, John Filipczak, Renata Holod, and Joy Kenseth for their helpful comments on an earlier draft, and to Jane Sweeney for improving the text.

NOTES

1. John Tillotson, quoted by Samuel Johnson, *A Dictionary of the English Language*, vol. 2 (London, 1755), entry under "miracle." His statement follows in the tradition of Martin Luther, *Sämmltiche Werke* (Erlangen, 1830), L:86–87. Historical discussions of attitudes toward the miraculous include W. E. H. Lecky, *History of the Rise and Influence of Rationalism in Europe*, 2 vols.(New York, 1878), e.g., pp. 164–68; Louis Monden, S. J., *Signs and Wonders: A Study of the Miraculous Element in Religion* (New York: Desclee Co., 1969), esp. pp. 41–50, 295; and the introductory chapters in Benedicta Ward, *Miracles and the Medieval Mind* (Philadelphia: University of Pennsylvania Press, 1982), pp. 1–32.

2. William A. Christian, Jr., *Apparitions in Late Medieval and Renaissance Spain* (Princeton: Princeton University Press, 1989), pp. 200–1.

3. Damian Joseph Blaher, *The Ordinary Processes in Causes of Beatification and Canonization: A Historical Synopsis and a Commentary* (Washington, D.C.: Catholic University of American Press, 1949); witnesses had been interrogated during the Middle Ages, but during the seventeenth century, under Pope Urban VIII, the questions were standardized and included the following: "Did the witness know what is meant by a miracle? If he did, he was to furnish an explanation. Did he ever hear that the Servant of God [the candidate for sainthood] performed miracles during life or after death? Where and from whom did he hear this? . . . Did some state the contrary by maintaining that those things which were reputed as miracles were accomplished with the help of medicines or with some other natural means?" (Blaher, pp. 49–50, n. 13).

4. Gertrud Schiller, *Iconography of Christian Art*,

trans. Janet Seligman(Greenwich, Conn.: New York Graphic Society, 1971), vol. 1, p. 162.

5. Rudolf Berliner, *Die Weihnachtskrippe* (Munich: Prestel Verlag, 1955), p. 30. Note the immediacy of the experience conveyed by switching to the present tense. "Contemplation seeing the place" was part of the *Spiritual Exercises* designed by Ignatius de Loyola, but whereas during the exercises one must use individual concentration to "behold the place or the cave of the Nativity, how large or how small, how low or how high it may be, how it was finished" and later "to see the persons" and "to consider and contemplate what they are saying," with the crèches the raw material for this imaginative recreation is right there (Antonio de Nicolas, *Powers of Imagining: Ignatius de Loyola* [Albany: State University of New York Press, 1986], pp. 42, 126).

6. For comparison of Protestant and Catholic positions on the Eucharist, see Darwell Stone, *A History of the Doctrine of the Holy Eucharist* (London: Longmans, Green, 1909), pp. 88–89.

7. Ricardo Arias, *The Spanish Sacramental Plays* (Boston: Twayne Publishers, 1980), 41; a shepherd repeats this statement four times in Luis de Granada's sacramental play *Sermon on the Feast of the Most Blessed Sacrament*, written in the mid-sixteenth century. According to Arias (p. 92), an exceptionally large number of plays focusing on the Eucharist were written in Spain during the last two decades of the sixteenth century and the first decade of the seventeenth.

8. As Howard Hibbard points out in connection with his discussion of Caravaggio's early *Supper at Emmaus*, this is the interpretation given in Jerome Nadal's widely consulted *Evangelicae Historiae Imagines* of 1593 (*Caravaggio* [New York: Harper & Row, 1983], p. 80).

9. Joseph Braun, *Der Christliche Altar in seiner Geschichtlichen Entwicklung* (Munich: Alte Meister Guenther Koch, 1924), vol. 2, pp. 590–645.

10. Josef A. Jungmann, S. J., *The Mass of the Roman Rite: Its Origin and Development (Missarum sollemnia)* (New York: Benziger, 1951), vol. 1, pp. 375–76.

11. Ibid., 150; Neil C. Brooks, *The Sepulchre of Christ in Art and Liturgy with Special Reference to the Liturgic Drama* (Urbana: University of Illinois, 1921), pp. 45, 66, indicates that exposition of the host became a common part of the sepulcher ritual at the end of the sixteenth century.

12. Constanzo Cargnone, "Quarante-Heures," in *Dictionnaire de spiritualité ascetique et mystique, doctrine et histoire* (Paris, 1937–), vol. 12, pp. 2702–24; Mark S. Weil, "The Devotion of the Forty Hours and Roman Baroque Illusions," *Journal of the Warburg and Courtauld Institute* 37 (1974): 218–48, quotations from pp. 222, 227. For a psychoanalytic discussion of the Devotion of the Forty Hours, see Michael P. Carroll, *Catholic Cults and Devotions: A Psychological Inquiry* (Kingston): McGill-Queen's University Press, 1989, Ont. pp. 104–13.

13. Emile Mâle, *L'Art religieux après le Concile de Trente: étude sur l'iconographie de la fin du XVIe siècle, du XVIIe, du XVIIIe siècle* (Paris: A. Colin, 1932), p. 98. The statistical data of Pierre Delooz, *Sociologie et Canonisations* (Liège: Faculté de droit, 1969), p. 263, indicates that proportionately far fewer of the saintly women who died during the second half of the sixteenth century were canonized than during any other half century between 1100 and 1950.

14. Pierre Delooz, "Towards a Sociological Study of Canonized Sainthood in the Catholic Church," in *Saints and Their Cults*, ed. Stephen Wilson (Cambridge: Cambridge University Press, 1983), pp. 202–12. Canonization procedures set up in 1625 and 1634 have been largely followed up to the present (Blahar, *The Ordinary Processes*, pp. 31, 36).

15. Saint Ignatius died in 1556, and the Jesuits' efforts to have their founder canonized were frustrated because there were no immediate postmortem miracles. Efforts increased and involved the use of imagery such as an unauthorized depiction of unrecognized miracles and the decoration of his grave with votive images and a portrayal of Ignatius himself. Finally miracles began to be reported in 1591. See Ursula König-Nordhoff, *Ignatius von Loyola* (Berlin: Mann, 1982), pp. 38–115. For the altarpieces see Julius S. Held, *The Oil Sketches of Peter Paul Rubens: A Critical Catalogue*, 2 vols. (Princeton: Princeton University Press, 1980), vol. 1, pp. 564–66, 560–62.

16. Thomas F. Macken, *The Canonisation of Saints* (Dublin: M.H. Gill & Son, Ltd., 1910), pp. 235–48; Mâle, *L'Art religieux*, p. 102.

17. Mâle, *L'Art religieux*, pp. 151–201, provides the best general discussion of the depictions of visions. Biographies and autobiographies of many sixteenth- and seventeenth-century saints report visions: for example, *The Complete Works of Saint Teresa of Jesus*, trans. and ed. E. Allison Peers (London: Sheed and Ward, 1946), vol. 1, pp. 177–83, 343, 350; for Saint Ignatius, *The Autobiography of St. Ignatius Loyola*, ed. John C. Olin (New York: Harper & Row, 1974), pp. 38, 88, 93.

18. Henriette Lucius, *La Littérature visionnaire en France au début du XVIe au début du XIXe siècle* (Bienne: Arts graphiques Schüler, 1970), pp. 47, 113, 142.

19. Alexandre Koyré, *From the Closed World to the Infinite Universe* (Baltimore: Johns Hopkins University Press, 1957), pp. 88–90.

20. Nicolas, *Powers of Imagining*, pp. 294, 243.

21. Donald Weinstein and Rudolph M. Bell, *Saints and Society: The Two Worlds of Western Christendom, 1000–1700* (Chicago: University of Chicago Press, 1982), pp. 188–89.

22. Diego Angulo Iñiguez, "Murillo: La profécia de Fray Julián de San Augustín, de Williamstown," *Archivo Español de Arte* 177 (1972): 56–57. The reference to purgatory reaffirmed the existence of this transitional place of punishment, which Protestants denied.

23. Ibid.

24. Jean de Viguerie, "Le Miracle dans la France du XVIIe siècle," *XVIIe Siècle* 140 (1983): 313–31. One of the examples Viguerie cites is a declaration taken down by Oratorian chaplains at Our Lady of the Fountain at Ardilliers in 1634:

The eight of the month of June 1634 Nicollas Arnou ferryman living in the town of Gien and Marie Mourrain his wife declared to us that they brought Marie Arnou their daughter for the action of the Grace of God to have her cured through the intercession of the Sacred Virgin Mary of an incurable and unknown sickness and that after having used the remedies that the doctors had ordered. . . . They came up *before the image of the virgin* then their daughter was sweating and changing color and recognized some easing of her malady which continued up to the same day that she was entirely healed. (p. 315, my emphasis)

I thank Catherine Lowe for checking my translation.

25. Peers, *Complete Works of Saint Teresa*, vol. 3, pp. 374.

26. Ludwig Freiherr von Pastor, *The History of the Popes* (London, 1933), vol. 24, pp. 520–26.

27. Mâle, *L'Art religieux*, pp. 480–83. Some attempts were made during the seventeenth century to explore natural causes of preservation, such as, Théophile Raynaud, S.J., *De incorruptione cadavarum* (Oranienburg, 1651). For a general discussion of such incorruptibility see Pierre Saintyves, *Les reliques et les images légendaires* (Paris, 1987), pp. 708–40.

28. Norbert McMahon, *St. John of God* (New York, 1951), p. 54.

29. Giovanni Serodine's *Miracle of Saint Margaret* (Madrid, Prado) is an exception, as it shows a female saint working a miracle.

30. Weinstein and Bell, *Saints and Society*, pp. 136, 189, 229, include statistical analyses of the frequency with which miraculous deeds are mentioned in hagiographic literature from different centuries and countries, and according to the age and sex of the saint. For specific female saints as miracle workers, see pp. 40, 53, 62, 88, 102. For a discussion of miracles produced during the first half of the seventeenth century by the relics of a female saint, Saint Fare, a Merovingian abbess, see Hérve Barbin and Jean-Pierre Duteil, "Miracle et pélerinage au XVIIe siècle," *Revue l'histoire de l'église de France* 61 (1975): 250–53.

31. Peers, *Complete Works of Saint Teresa* vol. 1, pp. 278–89, prophesied and healed; vol. 3, p. 333 (report of P. Pedro Ibáñez); vol. 3, p. 351, produced rain (report of Master Fray Domingo Báñez).

32. Ibid., vol. 1, pp. 120–21.

33. Other paintings showing saints levitating without support include J. de Mesa(?), *Saint Ignatius* (König-Nordhoff, *Loyola*, pl. 98), and Vincenzo Carducho, *Assumption of Diego of Alcalá* (Valladolid, Museo de la Pintura). Preparatory oil sketches suggest that Rubens planned an altarpiece for Tours showing Saint Francis de Paolo levitating without apparent support (see Held, *Oil Sketches*, vol. 1, pp. 554–58). Saint Hyacinth walks on water (T. Boeyermans, Antwerp, Church of Saint Andrew), as does Saint Peter of Alcantara (P. van Lint, Antwerp, Koninklijk Museum voor Schone Kunsten). Irving Lavin, *Bernini and the Unity of the Visual Arts*, 2 vols.(New York: The Pierpont Morgan Library, 1980), pp. 118–21, discusses levitation without reference to the variable of gender. For the more passive version of holiness expected of women, see Marina Warner, *Alone of All Her Sex: The Myth and the Cult of the Virgin Mary* (New York: Vintage Books, 1983), pp. 177–91.

34. George Kaftal, *Saints in Italian Art* (Florence: Sansoni 1952), includes a number of examples, among them vol. 1, figs. 268, 572, 576, 623, 756. Elizabeth Beasley Nichtlinger, "The Iconography of Saint Margaret of Cortona" (Ph.D. thesis, George Washington University, 1982), pp. 34–83, cites biographical accounts of miracles performed by Saint Margaret (1247–92) during her lifetime and discusses several medieval works, especially frescoes from the 1330s, that represented her miracles, such as healing the blind and the mute, resurrecting the dead, exorcizing, and rescuing seafarers in a storm. Except for a manuscript of 1634 that copied the fourteenth-century frescoes, artists did not represent her miracles during the sixteenth and seventeenth centuries. Only her visions and ecstasies were depicted beginning in the seventeenth century.

35. Cornelis Galle (plates) and Michel Ophovius (text), *D. Catherinae serensis virginis SSmæ ord. praedicatorum vita ac miracula selectioria* (Antwerp, 162?; reissue of 1603 edition); the illustrations include

exorcism and healing. Another print series that shows a female saint as miracle worker is the *Vita B. Virginis Teresiae a Jesu* (Antwerp, 1613), of which Cornelis Galle was the engraver. Plate V shows her resurrecting a child, plate XXI exorcizing, plate XVII levitating on a cloud. Matthäus Greuter's famous engraving *Canonization of Sts. Teresa, Isidore, Ignatius of Loyola, Francis Xavier and Philip* (1622) includes tiny narrative scenes of Saint Teresa multiplying flour (a one-month supply increased sixfold) and healing the sick, both during her life and after death, when her incorrupt body gave off a beautiful odor.

36. Jeffrey B. Russell, *A History of Witchcraft: Sorcerers, Heretics, and Pagans* (London: Thames and Hudson, 1980), pp. 83, 91.

37. Among the artists who depicted witches were Salvator Rosa, Jacques de Gheyn, and Frans Francken II.

38. Henri Platelle, *Les Chrétiens face au miracle. Lille au XVII^e siècle* (Paris: Editions du Cerf, 1968), p. 45. Significantly, he did not make the same generalizations about the second half of the century.

39. Held , *Oil Sketches*, vol. 1, p. 573; about the connection between the relics of Saint Francis de Paolo and Rubens's painting of his levitation see vol. 1, p. 556. Also Hans Vliege, *Saints* (London: Phaidon, 1973), vol. 2, pp. 83, 112; Zirka Zaremba Filipczak, "Van Dyck's 'Life of St. Rosalie'," *Burlington Magazine* 131 (1989): 695–96.

40. Jean Calvin, *Traité des reliques*, introd. Albert Autin (Paris: Editions Bossard, 1921).

41. See David Freedberg, *The Power of Images* (Chicago: University of Chicago Press, 1989), pp. 283–316.

42. De Viguerie, "Le Miracle," pp. 313–31. Jean Delumeau, *La Mort des pays de cocagne* (Paris: Université de Paris, Centre de recherches d'histoire moderné, 1976), pp. 170–83, indicates that at the shrine of Saint Anne d'Auvrey reports of healings increased from around 1630 and reached a high point in the mid-1640s.

43. Auguste Joseph de Reume, *Les Vierges miraculeuses de la Belgique* (Brussels, 1856), pp. 6, 60, 94, 347; Christian, *Apparitions*, p. 17.

44. Flemish examples include the depiction of Mary and Christ under an apple tree on the outer wings of the Ildefonso altarpiece (Vienna, Kunsthistorisches Museum), painted by Rubens around 1631 and paid for by the same Archduchess Clara Eugenia Isabella who patronized several miraculous statues of Madonnas that had been found in trees (Reume, *Les Vierges miraculeuses*, pp. 8, 61, 157, 170, 352). The apple tree also referred to the Fall of man, whom Christ

redeemed, and to the *Song of Songs* of Solomon, whose imagery was often applied to Mary (see Held, *Oil Sketches*, vol. 1, pp. 569–71). A Flemish drawing attributed to Abraham van Diepenbeeck (C. G. Boerner Gallery, Düsseldorf; *Neue Lagerliste* 44 [1966], no. 27) represents two saints kneeling before a picture of a Madonna, which is propped up between the branches of a tree.

45. De Viguerie, "Le Miracle," pp. 313–31.

46. Generalization reconstructed from specific examples cited in Reume, *Les Vierges miraculeuses*. Arnold de Gennep, *Le Folklore de la flandre et du hainaut français* (Paris, 1933), vol. 1, p. 483, recounts that in 1625 the Jesuit director of the college at Valenciennes, Peter Bouille, had a statue of the Madonna affixed to an oak in the forest of Raismes in 1625. The miracles that afterward took place here were reported in publications of 1630 and 1667. The statue itself was made from the wood of a tree that had supported another miracle-working sculpture.

47. Henri-Jean Martin, *Livre, pouvoirs et société à Paris au XVII siècle (1598–1701)* (Geneva: Droz, 1969), vol. 1, p. 153. The book apparently never appeared.

48. William A. Christian, *Local Religion in Sixteenth-Century Spain* (Princeton: Princeton University Press, 1981), p. 39. Freedberg, *The Power of Images*, pp. 99–135, esp. pp. 113–15.

49. Justus Lipsius, *Diva virgo Hallensis: Beneficia eius et Miracula fide atque ordine descripta* (Antwerp, 1605), p. 80, mentions leaving the silver pen. The engraving by Cornelis Galle, which shows the statue in context, identifies it as the *statua sacra*. The copy in this exhibition is bound with Lipsius's publication of 1605 about the miracles of the Madonna at Scherpenheuvel.

50. Reume, *Les Vierges miraculeuses*, pp. 8, 35, 78, 120.

51. Martin L'Hermité, *Histoire des saints de la Province de Lille-Dovay-Orchies* (Dovay, 1638), p. 560, cited in Platelle, *Les Chrétiens*, p. 560. For general discussion of *ex-votos*, see Freedberg, *The Power of Images*, pp. 136–60.

52. David Freedberg, "The Structure of Byzantine and European Iconoclasm," in A. Bryer and J. Herrin, eds., *Iconoclasm* (Birmingham, 1977), pp. 165–77, and "The Hidden God: Image and Interdiction in the Netherlands in the Sixteenth Century," *Art History* 5 (1982): 133–53.

53. Freedberg, *The Power of Images*, pp. 207–12.

54. Reume, *Les Vierges miraculeuses*, p. 73. Occles near Brussels received a statue of Our Lady of the Angels in 1634 in fulfillment of a vow made during a storm on the Mediterranean.

55. For example, on March 12, 1622, Cardinal del Monte told Pope Gregory XV about the cure in 1599 of a glandular swelling by the imposition of a portrait of Saint Ignatius and of the same procedure curing black ague in 1603, and the pope accepted these reports as true (E. Cobham Brewer, *A Dictionary of Miracles: Imitative, Realistic, and Dogmatic* [Philadelphia, 1884], p. 266). In Matthäus Greuter's engraving *Canonization of Sts. Teresa, Isidore, Ignatius of Loyola, Francis Xavier, and Philip Neri* (1622) a small narrative scene represents healing through a picture of Saint Philip Neri.

56. Paul Hazard, *The European Mind, 1680–1715* (New York: Meridian Books, 1963), pp. 155–78; Keith Thomas, *Religion and the Decline of Magic* (Harmondsworth: Penguin Books, 1973), pp. 172–73, 765–73.

57. De Viguerie, "Le Miracle," pp. 330–31.

58. Russell, *A History of Witchcraft*, pp. 100–25; Thomas, *Religion and the Decline of Magic*, pp. 301–32.

59. The direction of the change can be summarized by contrasting the wording in two royal surveys, both Spanish. In 1575 local administrators were to list "the notable relics that the churches and towns possess . . . and the miracles that have taken place." The survey of 1782 included no question about actual miracles, but only inquired "if there is any shrine or celebrated image, give its name" (Christian, *Local Religion*, pp. 6, 198).

THE CATALOGUE

Note to the Reader

Dimensions are given in centimeters, with the equivalent measure in inches in parentheses. Height precedes width, which precedes depth, unless otherwise noted. The dimensions of books when closed are given.

In the listing of each book the city of publication is given, followed when possible by the name of the publisher as it appears in the book and the date of publication.

The bibliography at the end of each entry gives sources for the information provided and suggestions for further reading on the subject.

The natural specimens, antiquities, and the majority of non-European works exhibited in the *Kunst- und Wunderkammer* are not listed in the catalogue.

The venues at which an object will be shown are indicated by the following abbreviations. If none are indicated, the object will be presented at all four venues.

DC Hood Museum of Art, Dartmouth College, Hanover, New Hampshire
NC North Carolina Museum of Art, Raleigh, North Carolina
HO The Museum of Fine Arts, Houston, Texas
HI High Museum of Art, Atlanta, Georgia

COLOR PLATES

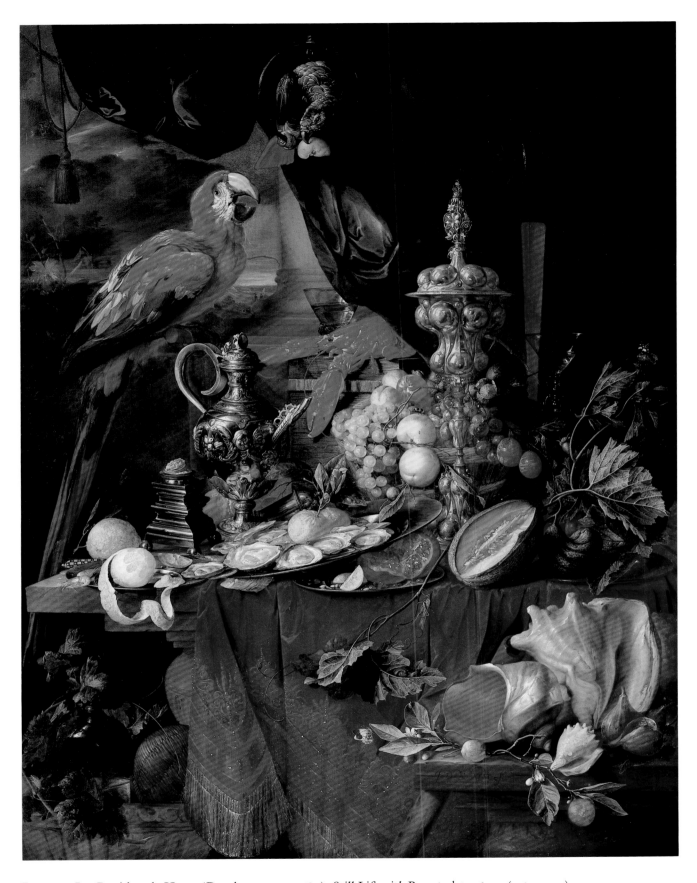

PLATE 1 Jan Davidsz. de Heem (Dutch, 1606–ca. 1684), *Still Life with Parrots*, late 1640s (cat. no. 11)

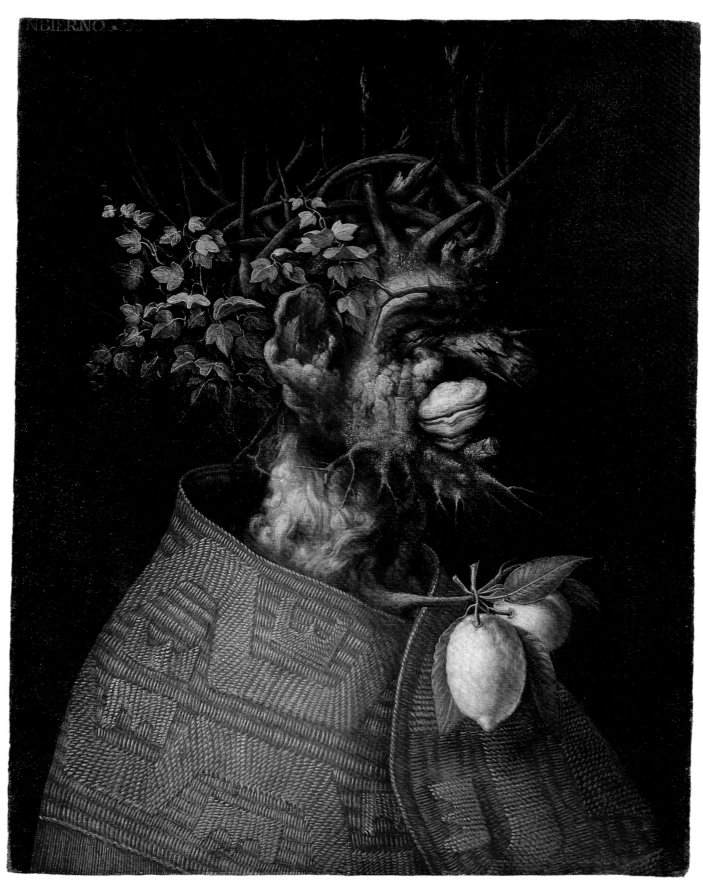

PLATE 2 Giuseppe Arcimboldo (Italian, 1527–93), *Allegory of Winter*, ca. 1572 (cat. no. 26)

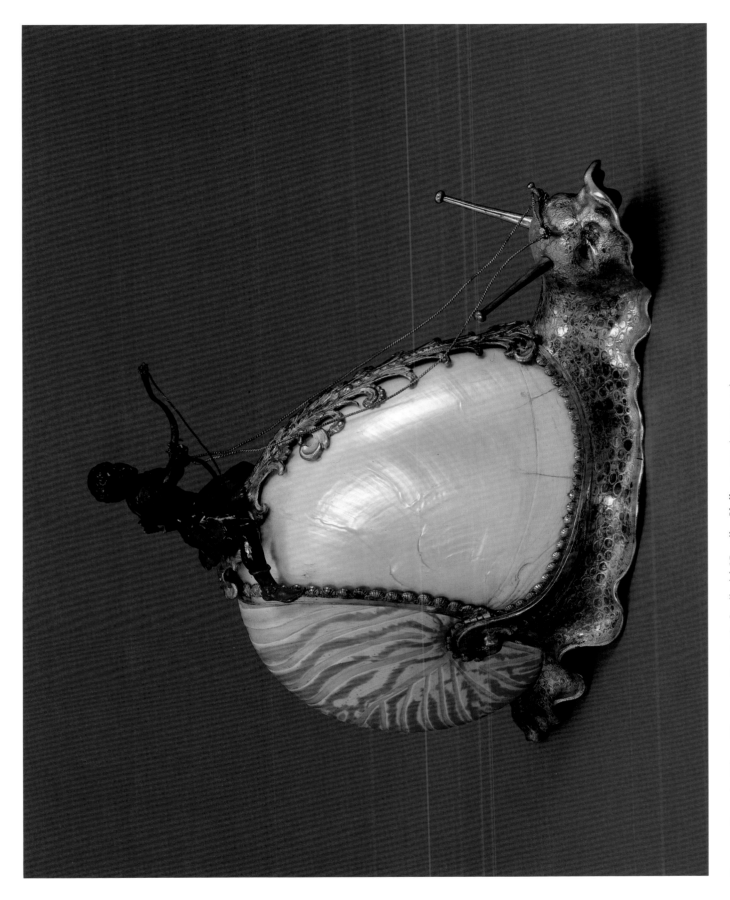

PLATE 3 Jeremias Ritter (German, 1582–1646), *Snail with Nautilus Shell*, ca. 1630 (cat. no. 30)

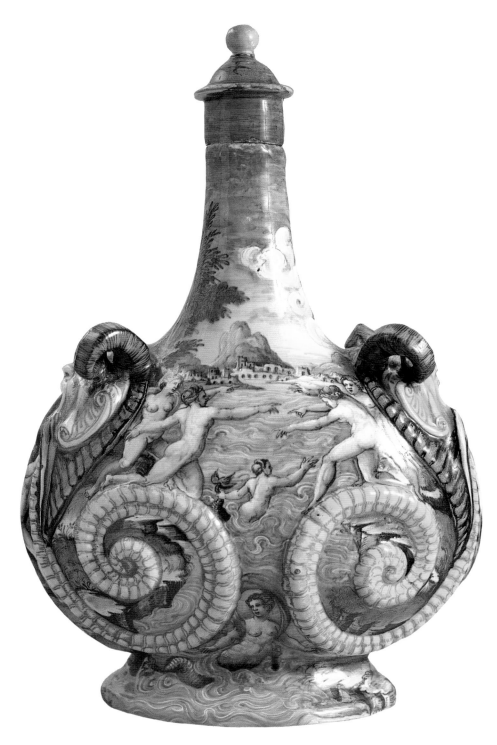

PLATE 4 Attributed to Orazio Fontana (Italian, 1512–97), *Majolica Bottle in the Form of a Pilgrim Flask with Scenes of Pluto and Persephone and Sea Nymphs*, 16th century (cat. no. 47)

South German, *Morion-Burgonet Helmet*, 1585 (cat. no. 64)

PLATE 5 Armor: attributed to Desiderius Helmschmied (German, active 16th century); etched decoration: attributed to Jörg T. Sorg the Younger (German, ca. 1522–1603); *Pair of Gauntlets from an Armor for Philip II of Spain when Hereditary Prince*, ca. 1548 (cat. no. 63)

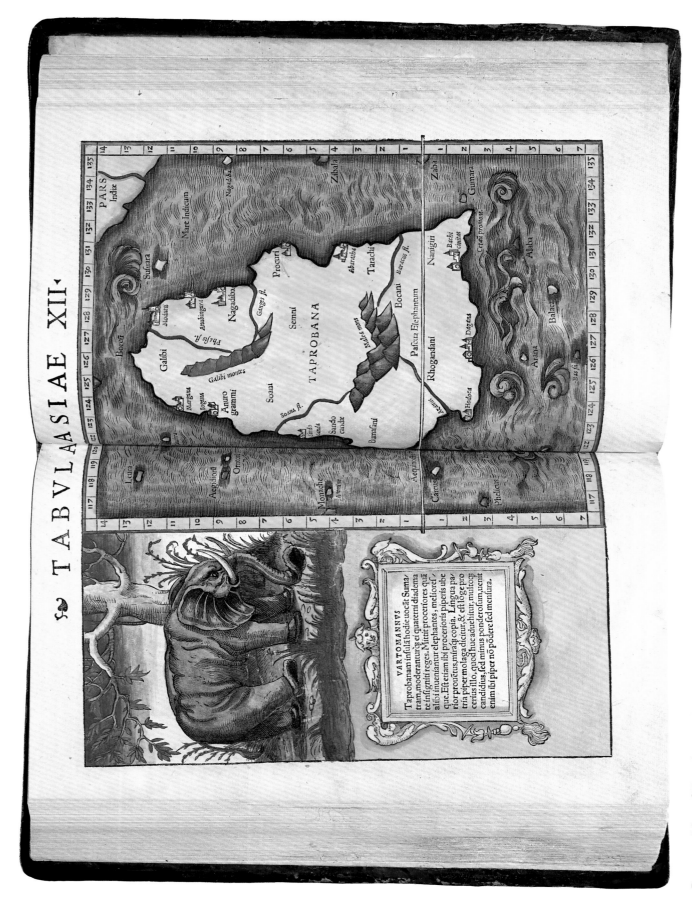

PLATE 6 Map of Taprobana (Sri Lanka) from Claudius Ptolemy (Greek, ca. 90–168 A.D.), *Geographia universalis, uetus et nova, complectens*, Basel, 1540 (cat. no. 76)

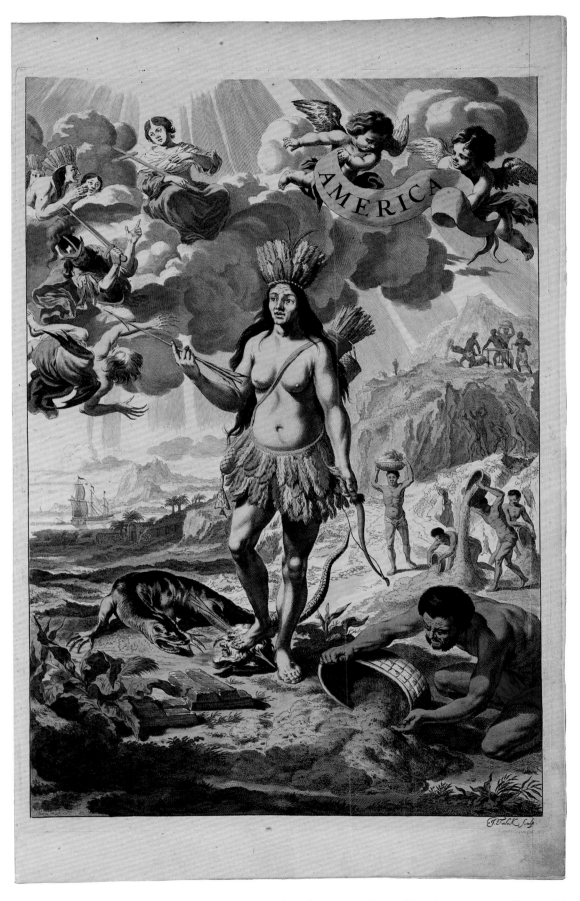

PLATE 7 Allegorical figure of America. Frontispiece from Joan Blaeu (Dutch, 1596–1673), *Geographia maior; sive, cosmographia blaviana*, Volume II, Amsterdam, 1662–65 (cat. no. 90)

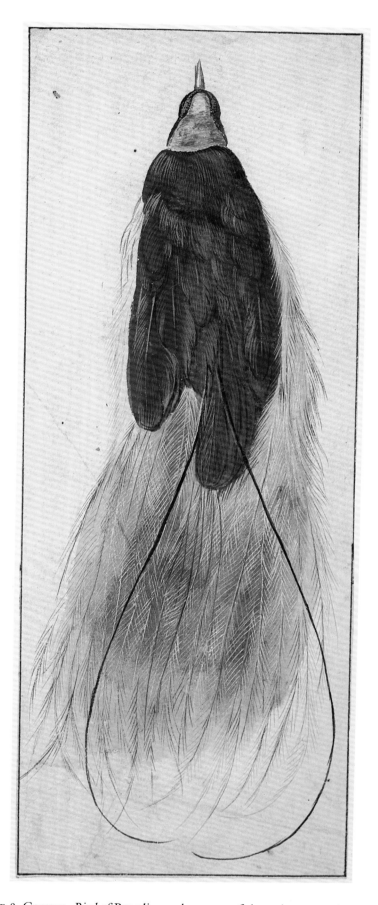

PLATE 8 German, *Bird of Paradise*, 2nd quarter of the 17th century (cat. no. 122)

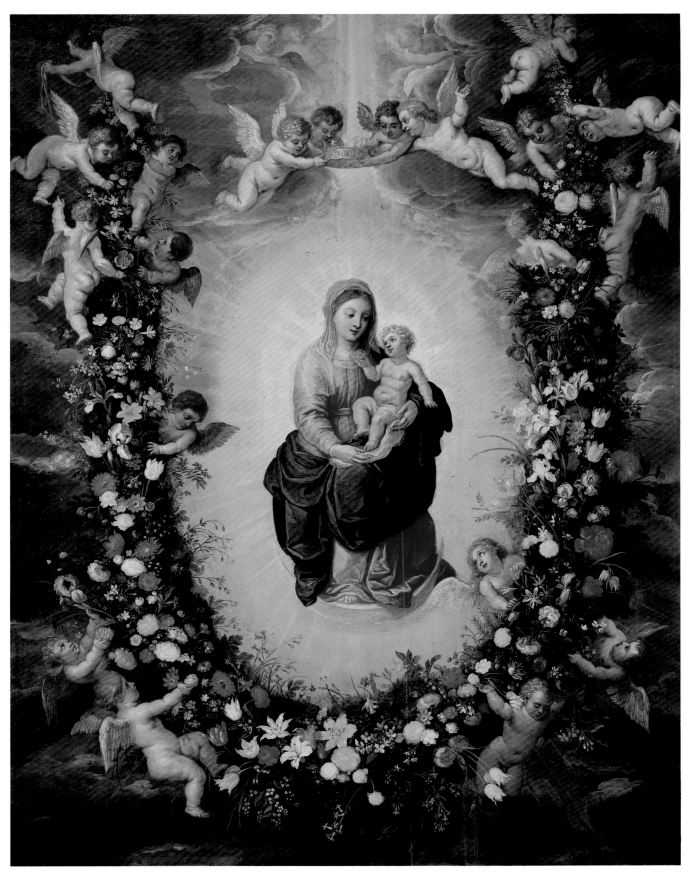

PLATE 9 Hendrik van Balen and Jan Brueghel the Younger (Flemish, 1575–1632, and Flemish, 1601–78),
Madonna and Child in a Floral Garland ca. 1625 (cat. no. 154)

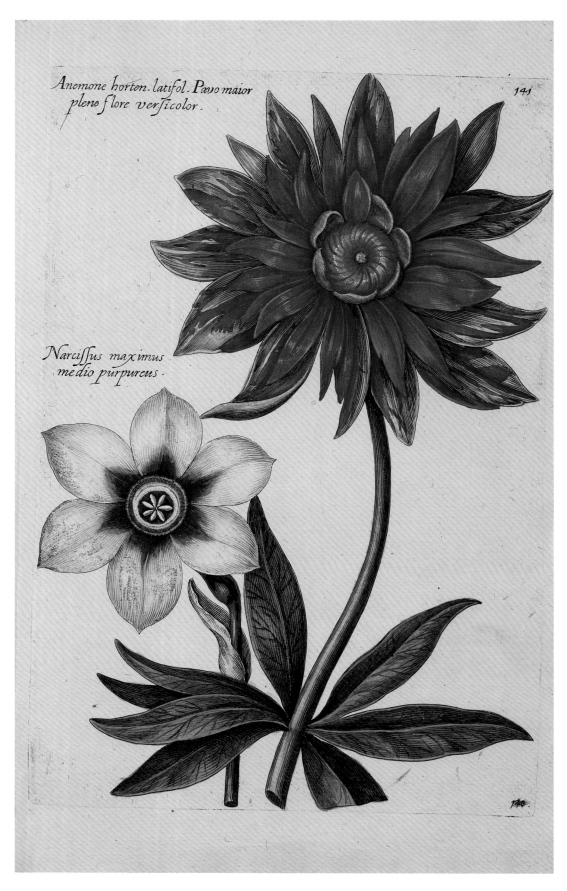

Anemone horten. latifol. Pavo maior plene flore versicolor.

141

Narcissus maximus medio purpureus.

PLATE 10 Anemone and narcissus from Johann Theodor de Bry (Flemish, 1561–ca. 1623), *Florilegium renouatum et auctum*, Frankfurt-am-Main, 1641 (cat. no. 156)

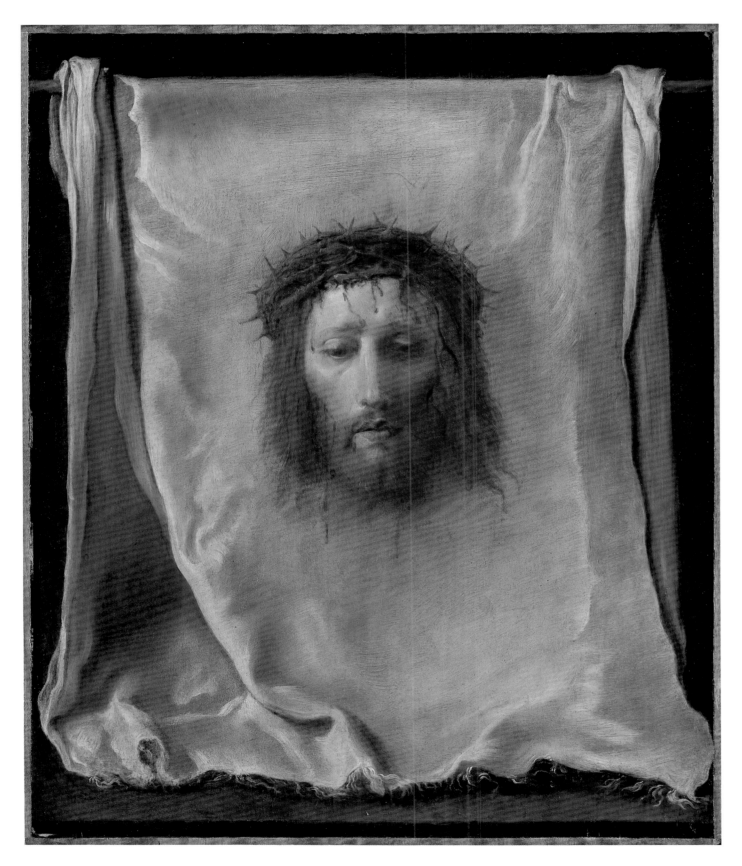

PLATE 15 Domenico Fetti (Italian, ca. 1589–1624), *The Veil of Veronica*, ca. 1615 (cat. no. 212)

PLATE 16 Bartolomé Esteban Murillo (Spanish, 1617–82), *Fray Julián's Vision of the Ascension of the Soul of King Philip II of Spain*, 1645–48 (cat. no. 220)

INTRODUCTION

THE OPENING SECTION of the exhibition sets the subject of the marvelous within a historical and cultural context. The texts of Aristotle, Pliny, and Ovid were among the most important ancient sources of the marvelous, while such works as the French *Le Livre des merveilles du monde* and the *Nuremberg Chronicle* provided images of fabulous human races and strange beasts that had excited the European imagination since the Middle Ages. One manifestation of the period's interest in marvels was a new literary genre, the wonder or prodigy book. These texts, which dealt exclusively with wondrous things or phenomena, compiled information from both earlier sources and more recent reports. Pierre Boaistuau's *Histoires prodigieuses* is a particularly famous example. Nathaniel Wanley's *The Wonders of the Little World*, by comparison, is little known, yet it is of interest because it demonstrates the persistence of the genre well into the seventeenth century.

The engravings after Jan van der Straet commemorating the voyages of Columbus, Magellan, and Vespucci draw attention to the events that greatly stimulated the vogue for the marvelous, while Willem Blaeu's famous map of the world reveals all the territories and waterways that had been discovered up to the year 1606. This chart is of further interest because its decorative borders include images of the Seven Wonders of the Ancient World as well as allegories of the planets, the four elements, and the four seasons. The known world is thus associated with the marvels of the past and seen within a framework that relates to the encyclopedic character of numerous sixteenth- and seventeenth-century paintings, natural histories, and cabinets of curiosities.

Diversity, encyclopedism, and a preference for the out of the ordinary were features of a majority of collections established in this period. The catalogues exhibited here offer interior views of these early museums, notable for their heterogeneity and their remarkable intermingling of natural and artificial items. Many paintings of the time represented collections of objects, and with their dense accumulations of natural and man-made forms, they often evoked the appearance of early museums. This is the case, especially, with Jan Davidsz. de Heem's *Still Life with Parrots*: a triumph of seventeenth-century illusionism, it offers a rich and varied display of natural marvels and wondrous works fashioned by man. Finally, the introductory section contains a splendid bronze statue of *Hercules Supporting the Universe*. Many cabinets and *Kunst- und Wunderkammern* included statues representing this famous subject from classical mythology, for not only was Hercules's labor the most spectacular of human achievements, but it also came to symbolize the collector's effort to bring the world and all its marvels into the small space of his museum.

Installation view of *The Age of the Marvelous*, Hood Museum of Art, Dartmouth College, 1991.

ARISTOTLE
Greek, 384–322 B.C.

1A *Rhetoric*

Contained in George of Trebizond
(Greek, 1396–1486)
Continentur hoc volumine
Venice, Aldi, et Andreae Asulani, 1523
Book
31.8 x 22.2 x 4.5 cm. (12½ x 8¾ x 1¾ in.)
Dartmouth College Library, Hanover,
New Hampshire
Acc. no. Presses A365ge

ARISTOTLE
Greek, 384–322 B.C.

1B *Poetica d'Aristotele vulgarizzata et sposta*

Translated and with commentary by Lodovico
Castelvetro, Italian, ca. 1505–71
Basel, Pietro de Sedabonis, 1576
Book
22.5 x 18.2 x 6.4 cm. (8⅞ x 7⅛ x 2½ in.)
Dartmouth College Library, Hanover,
New Hampshire
Acc. no. 881/A8hp/1576

Aristotle, "the master of those who know" as Dante called him, wrote on all the fields of learning known to Greeks in the fourth century B.C. The medieval world knew of Aristotle's writings only indirectly, that is through Latin translations that were based on earlier Arabic translations. But with the efforts of Renaissance humanist scholars to recover the works of ancient writers in their original languages and to subject them to new critical and scholarly standards, Aristotle's views acquired new meaning and a greatly enhanced authority for Europeans. Of all the Greek philosopher's known writings, the *Rhetoric*, which deals with the various methods of persuasion, and the *Poetics*, the first treatise devoted entirely to literary criticism, were the most influential in shaping the sixteenth- and seventeenth-century view of the marvelous, particularly as it pertained to the literary arts and the theater. Europeans had been familiar with the *Rhetoric* long before the sixteenth century, but they knew very little of the *Poetics* until about the 1530s. One of the discoveries of the Renaissance period, the *Poetics*, as Baxter Hathaway notes, was in large part responsible for the flowering of literary criticism in the sixteenth century (p. 9). Aristotle

argued that poetry not only should imitate life but should also contain elements that are marvelous. An apparently irreconcilable opposition, it stood at the center of most literary debates in the late sixteenth and early seventeenth centuries. The *Rhetoric* also was a crucial text in those debates for, as many Renaissance theorists discovered, it provided numerous justifications of wonder as a desirable stylistic or aesthetic goal.

Aristotle's *Rhetoric* was printed for the first time in 1508 in an edition (the *Rhetores Graeci*) brought out in Venice by the famous publishing firm established by Aldo Manuzio (1449–1515). The volume exhibited here was a later publication from the Aldine press which brought together numerous treatises in rhetoric—Aristotle's as well as those by other ancient authors. Aldine editions of ancient Greek and Roman texts were printed between the years 1490 and 1597. Immensely popular on account of their scholarly accuracy and their convenient octavo size, they played a significant role in the revival of the classics.

Lodovico Castelvetro's translation of and commentary on the *Poetics* was first published in 1570. A work that was criticized severely by other literary critics, it nonetheless became one of the most important commentaries on Aristotle's treatise. In his extended discussion of Aristotle's views, Castelvetro argues that poetry should be aimed at increasing the marvelous. However, as he also observes, "things have to be credible to be marvelous."

BIBLIOGRAPHY

Hathaway, Baxter. *Marvels and Commonplaces: Renaissance Literary Criticism*. New York: Random House, 1968.
Renouard, Antoine. *A Bibliographical Sketch of the Aldine Press at Venice*. Trans. and rev. by Edmund Goldsmid. Edinburgh: E. & G. Goldsmid, 1887. Esp. p. 97.

PLINY THE ELDER
Roman, ca. 23–79 A.D.

2 *Secundi historiae mundi libri XXXVII*

Lyons, Ioannem Frellonium, 1553
Book
35.5 x 25.1 x 8 cm. (14 x 9⅞ x 3⅛ in.)
Dartmouth College Library, Hanover,
New Hampshire
Acc. no. Bindings 149

The most important ancient source on the subject of natural marvels was the *Natural History* of Pliny the Elder (Gaius Plinius Secundus). A scientific en-

cyclopedia divided into thirty-seven books, it deals with a myriad of subjects ranging from celestial and meteorological phenomena to ethnography, zoology, botany, and mineralogy. The author provides a wealth of factual and useful information in this famous text, but at the same time his belief in the power of *ingegnosa natura* leads him to accept a great deal of material drawn from folklore. Here one finds descriptions of fabulous human races inhabiting remote parts of the world; one also reads of unicorns, tritons, and other imaginary creatures, treated with the same seriousness accorded lions and elephants.

In addition to discussing the various natural marvels, Pliny gives accounts of *mirabiles* fashioned by man—the paintings made by Apelles, Zeuxes, and Parrhasius, for instance, as well as the celebrated monuments known as the Seven Wonders of the Ancient World. A rich storehouse of information that was well known in the Middle Ages, it came to have widespread influence in the Renaissance and baroque periods when it was made available in printed form. First published in 1469, it went through at least forty-six editions by the year 1550. As the coat of arms on its calf binding indicates, this copy of the *Natural History* came from the library of Louis XIV.

BIBLIOGRAPHY

Kleks, Arnold. "Incunable editions of Pliny's *Historia naturalis*." *Isis* 24 (1935–36): 120–21.

Sarton, George. *The appreciation of Ancient and Medieval Science during the Renaissance (1450–1600)*. Philadelphia: University of Pennsylvania Press, 1955.

Stillwell, Margaret Bingham. *The Awakening Interest in Science during the First Century of Printing, 1450–1550*. New York: Bibliographical Society of America, 1970.

OVID
Roman, 43 B.C.–ca. 17 or 18 A.D.

3 *Metamorphosis [Metamorphoses]*

George Sandys, editor and translator
Oxford, John Lichfield, 1632
Illustrated book
Each approx. 31.5 x 22.8 x 6.4 cm. (12⅜ x 9 x 2½ in.)

Copy A: Library Company of Philadelphia, Philadelphia, Pennsylvania
Acc. no. *STC 18966/LOG 811.F (S. Preston)
Venues: DC, NC

Copy B: Dartmouth College Library, Hanover, New Hampshire.
Gift of Matt B. Jones, Class of 1894
Acc. no. Rare Book PA/6522/M2/S3/1632
Venues: HO, HI

The enthusiastic interest in Ovid's *Metamorphoses* during the sixteenth and seventeenth centuries is evident from the countless editions appearing not only in the original Latin, but also in Italian, French, German, Dutch, and English. What distinguished these editions from earlier translations was the inclusion of printed illustrations, which appeared as early as 1497 (Venice) and became progressively more elaborate in the next two centuries. Ovid's description of the supernatural, metamorphic changes of the pagan gods was a popular source for artists working in a wide range of media, from poetry and sculpture to theatrical performances. Ovid's work not only provided a classical source, a foundation of sorts, for unusual, supernatural effects, but it was also a backdrop against which marvels from the New World could be displayed.

The 1632 translation of Ovid's work on exhibit was composed by George Sandys, treasurer and resident of the English colony at Jamestown, Virginia, from 1621 to 1625. Sandys translated the first five books of the *Metamorphoses* before leaving for America, completed two more books during his sojourn in Virginia, and published a complete edition on his return to London in 1626 and then again in 1628 (see Davis 1941, pp. 255–76, for the details about Sandys's early translations). Between 1628 and 1632 he revised his translation, to which he brought "what perfection [his] pen could bestow; by polishing, altering, or restoring, the harsh, improper, or mistaken, with a nicer exactnesse." His renewed attention to Ovid's work produced a greatly expanded, extensively revised edition that is replete with illustrations.

A striking feature of Sandys's translation is the weaving into his commentary of details and descriptions of the New World. He drew not only from his own observations of Virginia, but also from published accounts of Florida, the West Indies, Mexico, and Peru that were readily available toward the end of the sixteenth century (Rubin, pp. 165–66). The result is a mixture of fresh observation and stylized perceptions.

Illustrated here is one of the fifteen elaborate intaglio prints that Sandys considered a significant aspect of his 1632 translation. They were designed by Francis Cleyn (1582–1658) and executed by Salomon Savery (ca. 1594–ca. 1665). Acting as a visual analogue to the text, they introduce the wondrous, metamorphic changes in each chapter. Prominently displayed in the foreground of the print preceding book 2 is the fall of Phaeton, whose sisters below turn into poplar trees, while his friend is transformed into a swan. Within the landscape are representations of the rape

3B Frontispiece to book 2. Metamorphoses, including the fall of Phaeton. Etching.

of Europa and the escapades of Mercury, Apollo, Jove, and Callisto, among others. Unlike other illustrators of Ovid, Cleyn gives a sense of dramatic movement to the figures, which conveys the process of transformation.

BIBLIOGRAPHY

Davis, Richard B. "America in George Sandys' Ovid." *The William and Mary Quarterly.* 3rd ser. 4: 1 (July 1947): 297–304.

Davis, Richard B. "Early Editions of George Sandys's 'Ovid': the Circumstances of Production." *Papers of the Bibliographical Society of America* 35 (4th Quarter, 1941): 255–76.

Davis, Richard B. *George Sandys: Poet-Adventurer: A Study in Anglo-American Culture in the Seventeenth Century.* London: The Bodley Head, 1955.

Hulley, Karl K., and Stanley T. Vandersall, eds. *Ovid's Metamorphosis Englished, Mythologized, and Represented in Figures, by George Sandys.* Foreword by Douglas Bush. Lincoln: University of Nebraska Press, 1970.

Rubin, Deborah. *Ovid's Metamorphoses Englished: George Sandys's Translator and Mythographer.* New York: Garland, 1985.

JOUVENEL DES URSINS GROUP
French

4 *Le Livre des merveilles du monde*

Angers?, ca. 1460
Illustrated manuscript
29.5 x 23.5 x 6.6 cm. (11⅝ x 9¼ x 2⅝ in.)
The Pierpont Morgan Library, New York
Acc. no. Manuscript 461
Venues: DC, NC

This superbly illustrated French manuscript describing the wonders of the world is one of the most remarkable examples of travel literature in the fifteenth century. The work is dated in relation to a sister manuscript, formerly in the collection of Madame la Baronne de Charnacé, which appears to have been made around 1450. Both manuscripts were illustrated by artists known as the Jouvenel des Ursins group. Differences in script and initial type suggest that the Pierpont Morgan manuscript was made after the Charnacé work, perhaps five to ten years later. While it is uncertain whether the Jouvenel des Ursins group was centered in Nantes, Angers, Saumur, or Tours (or a combination of these locations), this particular manuscript is associated with Angers and the court of René d'Anjou. In one of the miniatures the Anjou coat of arms appears next to the gateway to the city of Naples. This clearly alludes to d'Anjou's unsuccessful claim to this southern Italian kingdom.

Le Livre des merveilles du monde is a compilation of texts translated from the original Latin into French. Among others, the works included were *Historia naturalis* by Pliny the Elder, *De memorabilibus mundi* by Gaius Julius Solinus, and *Otia imperialia* by Gervase of Tilbury. This last work was translated by Harent of Antioch, who is believed to be the compiler of this manuscript as well.

Le Livre des merveilles du monde is organized alphabetically according to region. Each chapter describing the unusual features of an area is preceded by one of fifty-seven miniatures. Harent of Antioch describes the "Wonders of Arabia," the "Animals of Africa," the "Monsters of Egypt" and of Ethiopia, as well as the "Marvelous Beasts of Germany" and the "Wonders of Spain." The more familiar regions of Europe, along with distant countries like India, Libya, and Syria, are described. Even imaginary places are included, like Traponce and Ululande. With such a wide geographical span, the ethnocentric focus of the compiler and the artists is evident. In both descriptions and illuminations, the "less unusual a race is in

4 The land of Traponce, where people live in shells.
Ink and watercolor.

its appearance or description, the more convention-
ally it is dressed" (Friedman, p. 160). In other words,
the definition of a marvel (be it a marvel of nature or
of man) is determined by its affinities to and sim-
ilarities with European culture at the time. The more
exotic and the more marvelous aspects of a culture
were perceived to be, the more removed they were
from Western experience.

The "Giant Snails of Traponce," illustrated here,
emphasize another aspect of what was considered to
be a marvel. In the imaginary island of Traponce (near
India) people lived in the shells of the world's largest
snails. Such an unexpected inversion of scale was
cause for wonderment, like the juxtaposition of a
bone of a hummingbird with that of a whale in a
Wunderkammer.

BIBLIOGRAPHY

Friedman, John Block. *The Monstrous Races in Medieval Art
and Thought*. Cambridge: Harvard University Press, 1981.

Husband, Tim. *The Wild Man: Medieval Myth and Sym-
bolism*. New York: The Metropolitan Museum of Art,
1980.
Plummer, John. *The Last Flowering: French Painting in
Manuscripts, 1420–1530, from American Collections*. New
York: The Pierpont Morgan Library, 1982.

HARTMANN SCHEDEL
German, 1440–1514

5 *Liber cronicarum* [Nuremberg Chronicle]

Nuremberg, Anthonius Koberger, 1493
Illustrated book
47.3 x 32.4 x 5.6 cm. (18⅝ x 12¾ x 2¼ in.)
Dartmouth College Library, Hanover,
 New Hampshire
Acc. no. Incunabula 112

The *Nuremberg Chronicle*, as this magnificent vol-
ume is popularly known, was one of the monumen-
tal achievements of fifteenth-century printing and is
second in fame only to Johann Gutenberg's *Bible*.
Produced under the aegis of the Nuremberg physi-
cian Hartmann Schedel, the *Chronicle*'s editor-in-
chief, it was printed by Anton Koberger and illus-
trated by such master artists as Michael Wolgemut
and Wilhelm Pleydenwurff as well as Wolgemut's
apprentice, Albrecht Dürer. The *Liber cronicarum*
gives a mammoth account of the history of the
world from the time of creation to 1493 and closes
with the apocalyptic vision of Saint John and the
Last Judgment of mankind.

No earlier printed work was so lavishly illus-
trated, and the fame of the *Chronicle* rests largely on
these illustrations. The 1,809 woodcuts, printed
from 645 different blocks, include depictions of
events from the Old and New Testaments and from
the lives of the saints; portraits of prophets, popes,
kings, and heroes; depictions of prodigious phe-
nomena; and panoramic views of cities. Among the
beautifully rendered and robust illustrations is a
map of the world loosely based on Ptolemaic con-
figurations. It is bordered by twelve wind heads and
supported at three of its corners by figures from the
Old Testament—Ham, Shem, and Japheth—who,
according to biblical account, colonized the world
after the great Noachian Deluge.

Of particular interest, however, are the figures rep-
resented in the panel to the left of the *mappamondo*
and in the two columns on the preceding page. These
are the fabulous human races as described by Pliny

222

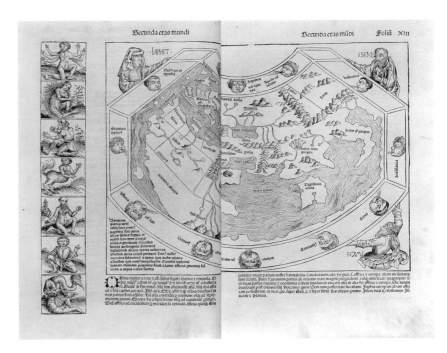

5 The fabulous human races. Woodcut.

5 Map of the world with illustrations of the fabulous human races in the side margins. Woodcut.

the Elder, Herodotus, Pomponius Mela, and Solinus and reported to have been seen by such authors as Sir John Mandeville. Some of these figures—the cyclops, centaur, and satyr, for example—are drawn from ancient mythology. Representatives of other races, based on ancient as well as medieval tales, include a dog-headed man from the Simian mountains, a man whose head grows in his breast rather than upon his shoulders, a man with ears as large as winnowing fans, a crane-necked man, and one of the four-eyed men presumed to live in Ethiopia. The crook-legged man represented in the *Chronicle* was able to get around by sliding rather than walking, while the sciapod, a creature with one large foot, used his remarkable appendage as protection against the sun. These images of fanciful and outlandish peoples aroused such great interest among Europeans that they were copied frequently, not only in prodigy and wonder books, but also in a great many natural histories.

BIBLIOGRAPHY

British Museum. *Catalogue of Books Printed in the Fifteenth Century Now in the British Museum.* Vol. 2. Ed. Alfred W. Pollard. London: British Museum, 1908–72. Esp. p. 437 (IC. 7451).

Goff, Frederick Richmond, ed. *Incunabula in American Libraries: A Third Census of Fifteenth-Century Books Recorded in North American Collections.* New York: Bibliographical Society of America, 1964. Esp. ref. s–307.

Shaffer, Ellen. *The Nuremberg Chronicle: A Pictorial World History from Creation to 1493.* Los Angeles: Dawson's Book Shop, 1950.

Wilson, Adrian. *The Making of the Nuremberg Chronicle.* Assisted by Joyce Lancaster Wilson, with introduction by Peter Zahn. Amsterdam: A. Asher, 1976.

PIERRE BOAISTUAU [ET AL.]
French, d. 1566

6 *Histoires prodigieuses extraictes de plusieurs fameux autheurs*

Volumes 1–6, bound in 3
Paris, 1560–98
Illustrated book
11.7 x 7.8 x 2.5 cm. (4⅝ x 3⅛ x 1 in.)
Dartmouth College Library, Hanover, New Hampshire
Acc. no. 398.38/B63h

The *Histoires prodigieuses*, published between 1560 and 1598, was the most popular example of a new literary genre that emerged in the second half of the sixteenth century—the prodigy book. While there was a long tradition of writing on monsters and prodigies (they had been a subject of interest from the time of classical antiquity and had been dis-

DES HIST. PRODIG. 113

Oſtre Sauueur a mis telle difference
entre le ſerf, & le frãc, que ceſtuy ſçait
qu'elle eſt la volonté du ſeigneur, & l'au-
tre n'ignore quel eſt le deſſein de ſon
maiſtre. Et à la mienne volonté , que la
pluſ-part des hommes ſe prit diligemment Ieã. 15.
garde à ceſte difference : d'autant que par
là on pourroit aiſément iuger & diſcerner
quels ſont les reprouuez , & ceux qui
n'ont point receu de rechef l'Eſprit de ſer-
uitude en crainte, ains pluſtoſt ont eu le
don de ceſt eſprit qui rend teſmoignage
à la conſcience des enfans de Dieu . Ces
enfans choiſis , veillent & trauaillent ſans
ceſſe & diligemment de s'enquerir du pere.
Car il y a pluſieurs choſes que nul niera, qui
H

6 A monster found in the Tiber River in 1496. Woodcut.

mult, monstrous births and other prodigious events had apocalyptic associations and seemed to fulfill frightening biblical prophecies. Indeed, as Céard and Schenda both have demonstrated, the sixteenth century saw a great many publications that dwelt on the subject of monsters and prodigies as signs of God's wrath.

The purpose of the *Histoires prodigieuses*, as its author claimed, was to "discover the secret judgment and scourge of the ire of God." This publication, which was the work of Boaistuau and numerous other writers, drew material from Kaspar Peucer's *Commentarius de praecipuis divinationum generibus* (1553), Konrad Lycosthenes's *Prodigiorum ac ostentorum chronicon* (1557), and the texts of Konrad Gesner and other natural scientists. An extraordinarily popular work, it went through no fewer than thirty editions.

The subject matter of the *Histoires* is wide-ranging. Everything from human and animal monsters to visions and celestial apparitions is discussed. The monsters and fabulous creatures of ancient myth are recorded, as are contemporary prodigies, such as the "horrible and marvelous monster born in Italy in 1578" and the "tree covered with rosary beads that miraculously grew in an instant in 1575 Ireland." The illustration exhibited here shows a monster that was said to have been fished out of the Tiber River in 1496. A particularly interesting example from the *Histoires*, it is based on the woodcut executed by the German artist Lucas Cranach and published in the pamphlet by Luther and Melanchthon. Called the "pope-ass of Rome" in the pamphlet, Melanchthon saw its monstrous anatomical parts as corresponding to the vices of the church. In the *Histoires*, a Catholic publication, all anti-papal elements have been excised. The Castel Sant'Angelo (for centuries the center of conflict between the popes and their enemies) is gone from the woodcut, as is a banner with the papal insignia. Additionally, the monster is depicted more benignly: its stance is not fixed and its scaly limbs and donkey-head are no longer sharply defined.

cussed often in medieval and early Renaissance bestiaries, geographies, and chronicles such as that by Hartmann Schedel), it was the Protestant Reformation, as Park and Daston have shown, "that opened the floodgates for a deluge of prodigy literature" (p. 25).

In their jointly authored and widely influential pamphlet *Deuttung der zwo grewlichen Figuren, Bapstesels zu Rom und Munchkalbs zu Freyberg jn Meyssen funden* of 1523, Martin Luther and Philipp Melanchthon argued that monsters signaled the downfall of the church. Luther did not see such phenomena as portents of worldwide disaster, but for many Christians in this period of religious tu-

BIBLIOGRAPHY

Céard, Jean. *La Nature et les prodiges: l'insolite au XVI^e siècle, en France*. Geneva: Librairie Droz, 1977.
Park, Katharine, and Lorraine J. Daston. "Unnatural Conceptions: The Study of Monsters in Sixteenth- and Seventeenth-Century France and England." *Past & Present: A Journal of Historical Studies* 92 (August 1981): 20–54.
Schenda, Rudolf. *Die französische Prodigienliteratur in der zweiten Hälfte des 16. Jahrhunderts*. Munich: M. Hueber, 1961.

NATHANIEL WANLEY
English, 1634–80

7 The Wonders of the Little World:
or, a General History of Man

London, T. Basset, 1678
Book
38 x 25 x 4 cm. (15 x 9⅞ x 1⅝ in.)
Dartmouth College Library, Hanover,
New Hampshire
Acc. no. AG/241/W35/1678

Nathaniel Wanley was the vicar of Trinity Church in Coventry, England. As he states in his preface, it was Lord Verulam (Francis Bacon) who had suggested that a collection be made of the "ultimities" or "summities" of human nature. Valerius Maximus and Pliny the Elder, Wanley notes, had not achieved this in their own works, and thus there was "field-room" for anyone to take on this task if he had the leisure and inclination. Even though he had a "poverty" of freedom, leisure, and learning, Wanley found himself undertaking the project anyway. His friends had encouraged him to do so, and by making it public, he states, "it might not be unuseful nor unacceptable to some sorts of men." In fact, Wanley's publication is a late example of the many wonder books produced during the late sixteenth through seventeenth centuries.

Like other texts of this genre, it repeats descriptions of marvels found in ancient and medieval sources while at the same time reporting on more recent prodigies, both real and fictitious. The book does not aim to give an encyclopedic account of all natural and supernatural phenomena, but its subject—the "little world" of man—is large enough. After enumerating many of the familiar marvels (monstrous births, giants, pygmies, the "memorable old age of some"), the author considers a host of related topics: the worst vices and greatest virtues of man; incidents of unusual human behavior; the famous achievements of artists, orators, and writers; and such things as prognostications and sleepwalking. Anything that lies outside the commonplace excites Wanley's attention, and throughout the volume he speaks of the "little world" in terms of the marvelous, the wondrous, and the surprising.

BIBLIOGRAPHY

Gordon, Alexander. "Nathaniel Wanley." *Dictionary of National Biography.* Vol. 20. Reprint. Oxford: Oxford University Press, 1921–22, pp. 746–47.

7 Title page.

JAN VAN DER STRAET
Flemish, 1523–1605

8A–D *Americae retectio: Title Page, Christopher Columbus, Ferdinand Magellan, Amerigo Vespucci*

ca. 1580
Set of four engravings
Image size: each approx. 21.3 x 28 cm.
 (8⅜ x 11 in.)
Hood Museum of Art, Dartmouth
 College, Hanover, New Hampshire
Acc. nos. PR.964.38.1–4

Jan van der Straet (also known as Giovanni Stradanus), a Flemish painter who was one of the principal assistants to Vasari when he was working on the Palazzo Vecchio, was born in Bruges and trained in Antwerp. In 1546, a year after becoming a master of the Antwerp guild, he moved to Florence where, aside from travels to various parts of Italy and Europe, he remained until his death in 1605. He executed several works for the Palazzo Vecchio (from 1561 on), worked on festival decorations for the Medici family, and designed cartoons for tapestries, including the *Twelve Months* and the *Four Seasons*.

This set of four prints commemorates the discovery of America by Columbus, Magellan, and Vespucci less than one hundred years after they made their renowned voyages. Drawn by van der Straet and thought to be engraved later by J. Collaert, these prints primarily celebrate the Italian contribution to exploration rather than present factual information about the New World. They are populated with Greek and Roman gods and goddesses, fantastic creatures, and exotic peoples. The inscriptions at the bottom of each print name the explorers and give the dates of their voyages—1492, 1497, and 1522, respectively.

Through emblems and allegorical figures, the title page stresses the exploration by Vespucci, born in Florence in 1454, and Columbus, born in Genoa in 1451. The figures of Flora and Janus, who stand respectively for Florence and Genoa, pull back a cloak to reveal the globe on which the continents of Europe, Africa, and the Americas are sketched. A faint figure of a ship appears on the ocean near the West Indies. The two figures and globe are suspended over the outline of the coast of Italy, where the cities of Fiorenza and Genoa are prominently represented. Above the heads of Flora and Janus are roundels containing portraits of Vespucci and Columbus, and hanging next to them are instruments of navigation. To the left of Flora and the roundel with Vespucci, the figure of a Roman soldier holds a shield with the seal of Tuscany; to the right of Columbus and Janus, Neptune holds a shield with the seal of Savoy.

In the three other prints, each devoted to one explorer, the men are shown on the decks of their ships. Mythical figures and marine monsters populate the waters surrounding them. The print of Columbus identifies him clearly by name under his feet and in the bottom margin. He wears armor and holds a banner showing the Crucifixion. The mast flies the banner of the houses of Castile and Aragon, the patrons of Columbus. The goddess Diana emerges in the water to the left of the ship, accompanied by naked

8A Title Page.

8B Christopher Columbus.

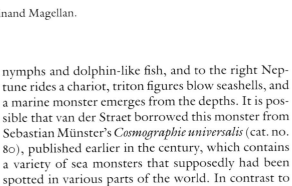

8c Ferdinand Magellan.

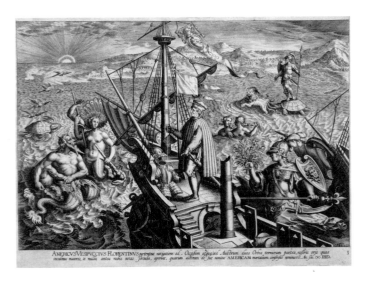

8d Amerigo Vespucci.

nymphs and dolphin-like fish, and to the right Neptune rides a chariot, triton figures blow seashells, and a marine monster emerges from the depths. It is possible that van der Straet borrowed this monster from Sebastian Münster's *Cosmographie universalis* (cat. no. 80), published earlier in the century, which contains a variety of sea monsters that supposedly had been spotted in various parts of the world. In contrast to the overpopulated waters of the ocean, the land at the right is curiously uninhabited.

With some variation the same scene is presented in the print of Vespucci, with the exception of the two figures at the left, one female and one male, both part human and part monster, who hold parts of a body. The female monster with the feather headdress may be an allegorical figure of America, and the severed arm she holds in her hand is perhaps a reference to cannibalism. The seagulls and the turtle are the only inhabitants of the waters that Vespucci might actually have seen. The broken mast on the ship perhaps refers to disasters at sea or is a symbolic reference to the broken pillars of Hercules. These were the rocks at the end of the Mediterranean that were thought in antiquity to mark the end of the known world. Vespucci, unlike Columbus, who carries no navigational equipment, holds a quadrant in his hand.

The print of Magellan depicts him traveling between two outcropings of land, the left side billowing fire and smoke from the shore—a reference to the land of fire, Tierra del Fuego—and the right side pre-senting the only depictions of native inhabitants in the set. The huge bird in the skies at the left is a roc, the mystical creature reputedly strong enough to carry an elephant in its talons. Apollo hovers to the left of the ship and carries a lyre, while Magellan uses an astrolabe and calipers to navigate. The banner of the Habsburgs—he made the voyage under the patronage of Charles I, later Charles V, Holy Roman Emperor—is attached to the mast. A native at the right, wearing a loincloth made of leaves, swallows an arrow, while at his feet a marine monster emerges from the depths.

Although they are intended to be allegorical representations, these prints demonstrate the continuing belief, even at the end of the sixteenth century, that the newly explored world was full of strange and wondrous beings and creatures.

BIBLIOGRAPHY

Benisovich, Michel N. "The Drawings of Stradanus (Jan van der Straeten) in the Cooper Union Museum for the Arts of Decoration, New York." *Art Bulletin* 38 (December 1956): 249–51.

Boase, T.S.R. *Giorgio Vasari: The Man and the Book.* Princeton: Princeton University Press, 1979.

Dartmouth College Galleries. *The Other Side of Dreams: The Baroque: An Age of Voluptas, An Age of Dementia.* Hanover, N.H.: Dartmouth College, 1970.

University of Notre Dame Art Gallery. *The Age of Vasari.* South Bend: University of Notre Dame, 1970.

227

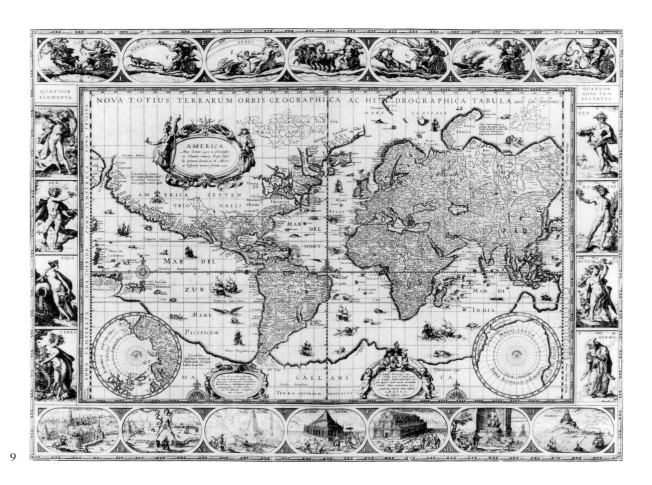

9

WILLEM JANSZ. BLAEU
Dutch, 1571–1673

9 *Nova totius terrarum orbis*

1606
Engraving
41.2 x 52 cm. (16⅛ x 20½ in.)
The Newberry Library, Chicago, Illinois
Acc. no. Novacco 4F 21
Venues: DC, NC

In 1599 Willem Blaeu founded a cartographic firm that was to become one of the most famous in Holland, if not all of Europe. In 1605, together with Herman Alartsz., he printed for the Dutch States-General a large-scale world map (it consisted of twenty engraved sheets and measured 134 by 244 cm.) that, despite some errors in the rendering of North America, was notable for taking into account the most current reports of exploration and discovery. The following year Blaeu produced the smaller world map exhibited here. Printed under his patro-

nym Janszoon (Gul. Jansonius), it is considered one of the supreme achievements of map making, especially in the fineness of its engraving and its rich decorative borders.

As in the case of the 1605 map and like the world maps by earlier cartographers, Blaeu here hypothesizes a vast Austral-Antarctic land mass or "Terra australis incognita." South America remains attached to the Antarctic (Willem Cornelis Schouten of Hoorn would not sail around the southernmost tip of the continent until 1616), while North America, its northernmost regions as yet undiscovered and its western coast still not well understood, is given extraordinary breadth. Blaeu's map nonetheless enjoyed great popularity, and although later world charts provided more up-to-date information, it remained in circulation for the next half century.

The most remarkable feature of the *Nova totius terrarum orbis* is its border decoration. Allegories of the sun, the moon, and the five known planets appear in the top border, while figures representing the four seasons and the four elements (earth, air, water, and

228

fire) appear in the left and right borders. Along the bottom Blaeu has included images of the Seven Wonders of the Ancient World: the Hanging Gardens of Babylon, the Colossus at Rhodes, the Pyramids, the Mausoleum of Halicarnassus, the Temple of Diana at Ephesus, the statue of Jupiter at Olympia, and the lighthouse (Pharos) of Alexandria. Ingeniously then, and in a small space, the cartographer has juxtaposed the worlds of nature and of art and has shown the present, or the present knowledge of the earth's extent, in relation to the past. As in the case of sixteenth- and seventeenth-century *Wunderkammern* and cabinets of curiosities, Blaeu's map is nothing less than universal in its content.

Blaeu had issued the world map in four states. This splendid impression is a rare example of the first state, which lacked the signature of the engraver, Josua van den Ende.

BIBLIOGRAPHY

Shirley, Rodney W. *The Mapping of the World: Early Printed World Maps, 1472–1700*. London: The Holland Press, Ltd., 1983. Esp. no. 253, pp. 268–69.

Stevenson, Edward L. *Willem Janszoon Blaeu, 1571–1638: A Sketch of His Life and Work with an Especial Reference to His Large World Map of 1605*. New York: [De Vinne Press], 1914.

Wagner, Henry R. *The Cartography of the Northwest Coast of America to the year 1800*. Berkeley: University of California Press, 1937 [1968 reprint].

Attributed to GIROLAMO CAMPAGNA
Italian (Venice), 1549–1625

10 *Hercules Supporting the Universe*

16th century
Bronze
H (without base): 76.2 cm. (30 in.)
Michael Hall, Esquire, New York

This exceptionally fine bronze statue of Hercules supporting the heavens is characteristic of late-sixteenth- and early-seventeenth-century bronze work produced in Venice. At this time four artists dominated the production of Venetian bronzes: Alessandro Vittoria (1525–1608), Girolamo Campagna (1549–1625), Tiziano Aspetti (1565–1607), and Niccolò Roccatagliata (active 1593–1636). Distinctions among the work of these four Venetian artists are not always clear, but the statue of Hercules has been attributed to Campagna.

The characteristics of this bronze reflect the rich-

ness of artistic activity in Venice. The lightness of Hercules's step under the extreme weight of the heavens and the billowing folds of the lion cloak suggest the energetic movement of Tintoretto's paintings. The definition of the musculature relates to the work of Michelangelo as seen, perhaps, through the filter of Tintoretto or Alessandro Vittoria.

Small bronze statues were familiar objects in *Kunst- und Wunderkammern* throughout Europe in the sixteenth and seventeenth centuries. While the known provenance of the bronze Hercules does not reveal whether or not it belonged to such a collection, a similar statue is depicted in the frontispiece of the catalogue to the Calceolari Museum (cat. no. 16).

In the early sixteenth century Isabella d'Este included small bronze statues in the *studiolo* of the palace at Mantua. Later in the century Francesco de'Medici also included them in his *Kunstkammer* of precious objects. In addition to the frontispiece of the Museum Calceolari catalogue (1622), the title pages

10

of the *Museum Wormianum* (1655, cat. no. 17) and the *Musaeum Celeberrimum* (1678, cat. no. 20) show small statues as part of the collections. Enthusiasm for bronze work spread north of the Alps in the sixteenth century and remained strong through the next century. Numerous examples exist in Germany and the Netherlands, but small bronzes were especially popular in the imperial houses of Europe and are abundant in the Habsburg collections in Vienna and Prague. Bronze work played an important role in Rudolf II's *Kunst- und Wunderkammer*.

The most common subjects of bronze statuettes found in curiosity cabinets are topics taken from classical mythology. Invoking associations with the culture of antiquity, even imitating the sculptural works of some antique artists, these bronze statues were prized for these allusions as well as for the artistic skill of the "modern" sculptors who made them. The artists gained prestige by taking up the challenge of the antique and by successfully rivaling, or even surpassing, the achievements of antique sculptors.

The superhuman feat of Hercules supporting the heavens was in itself worthy of representation in a *Kunst- und Wunderkammer*. Moreover, Hercules, as Zirka Filipczak suggests, personified the path of virtue taken by the scholar in pursuing knowledge (p. 71); in the case of the collector, the wider and more varied the collection the greater his erudition.

BIBLIOGRAPHY

Fogelman, Peggy, and Peter Fusco. "A Newly Acquired Bronze by Girolamo Campagna." *The J. Paul Getty Museum Journal* 16 (1988): 105–10.

Leithe-Jasper, Manfred. *Renaissance Master Bronzes from the Collection of the Kunsthistorisches Museum, Vienna*. Washington, D.C.: Scala Books, 1986.

Planiscig, Leo. *Venezianische Bildhauer der Renaissance*. 2 vols. Vienna: Anton Schroll, 1921.

Pope-Hennessy, John. *Italian High Renaissance and Baroque Sculpture*. London: Phaidon Press, 1963.

Timofiewitsch, Wladimir. *Girolamo Campagna: Studien zur venenzianischen Plastik um das Jahr 1600*. Munich: Fink, 1972.

JAN DAVIDSZ. DE HEEM
Dutch, 1606– ca. 1684

11 *Still Life with Parrots*

Late 1640s
Signed *F. D. De Heem.f*
Oil on canvas
150.5 x 117.5 cm. (59¼ x 46¼ in.)
The John and Mable Ringling Museum of Art, Sarasota, Florida
Acc. no. SN 289
Venues: HO, HI

This spectacular painting is the work of Jan Davidsz. de Heem, a native of Utrecht who spent most of his adult life in the city of Antwerp. An artist of exceptional abilities, he was highly esteemed during his lifetime for his exquisitely rendered and often very lavish still-life pictures. Even though de Heem had his rivals among painters of still lifes, it is nonetheless true that his contemporaries saw him as something of a marvel. In his 1661 *Het Gulden Cabinet*, for example, Cornelis de Bie speaks constantly of the "wonder" of de Heem's art, especially his uncanny ability to simulate the appearance of fruit, beautiful objects in silver, and other natural and artificial forms (de Bie, pp. 216–19).

One of the finest paintings to come from de Heem's hand, *Still Life with Parrots* is a work that satisfies many, if not most, of the criteria for the "marvelous." A triumph of illusionism in its rendering of textures and the effects of light, it presents a rich accumulation of natural objects, most of which were not indigenous to the Netherlands: an African gray parrot, a scarlet macaw from Brazil, exotic fruits from southern climes, and rare seashells from the East and West Indies. In addition to these *naturalia*, the painting also shows off exemplary works fashioned by man: a tall, elegant flute glass; a richly decorated silver ewer; and a magnificent standing gilt goblet, similar to those produced by Nuremberg artisans in the early seventeenth century.

Like de Heem's other still-life pictures, the Sarasota painting has a complex symbolism centering on the themes of temperance and the vanity of earthly pleasures. While most of the items displayed—especially the gold- and silverware, the blue jewelry box, and the shells—allude to the vanities of collecting and to spending money on costly, worldly goods, other elements admonish the beholder against overindulgence. Melon, for instance, was sometimes thought

to produce insanity when consumed in large quantities (Segal, p. 149). Oysters, on the other hand, because of their presumed qualities as an aphrodisiac, were traditionally reported as leading to sexual excess. One of the most striking items in this extravagant display is the bright red boiled lobster. An expensive food that has to be fished from the ocean bottom, it sometimes symbolized instability because of its irregular method of locomotion (Segal, p. 150).

By contrast, the virtue of steadfastness is perhaps symbolized by the nautilus shell in the right foreground. In the seventeenth century the "paper" nautilus (and also the *Nautilus pompilius*, which is represented here) was compared to a ship's admiral, who is always in control of the sea, and to the pious man, who in the course of life must guide his ship to "land at last at heaven's safe coast where he will gain forever the supreme reward" (Philibert van Borsselen, cited in Segal, p. 80). Such an interpretation is supported by other objects in the picture that allude to spiritual strength (the unbroken column) and salvation through Christ (the bread, wine, and grapes all have Eucharistic associations). Additionally, the picture contains figs and oranges (both allusions to the fruit of the Tree of Knowledge) as well as peaches and a pomegranate, traditional symbols, respectively, of salvation and the Resurrection.

The underlying Christian content of the painting is enhanced further by the presence of the parrots. Although these creatures sometimes signified mindless, reflexive actions, it is unlikely that they have this meaning here. Rather, because of their ability to imitate the human voice, parrots often were viewed as symbolizing man in his praise of God. As Segal has shown (p. 157), this can be related to the exhortation of Physiologus: "Man, imitate the voices of the Apostles who praise the Lord, and you should praise Him too. Imitate the Congregation of the Righteous so that you deserve to achieve their radiating place."

As a whole, de Heem's painting might be regarded as an invitation to praise God's wondrous work—the abundant and delicious fruits, the splendid shells, and the flamboyant macaw—and to admire, at the same time, the achievements of man, who, by virtue of his god-given powers, is able to create works of exceptional beauty. The *naturalia* and *artificialia* are set next to each other for comparison, as they were so often in contemporary *Kunst- und Wunderkammern*. Like many of the encyclopedic collections also, *Still Life with Parrots* evokes a universal theme by offering to the beholder's sight objects representing the four elements: the birds of the air, the oysters and shells from ocean waters, the fruits of the earth, and metal

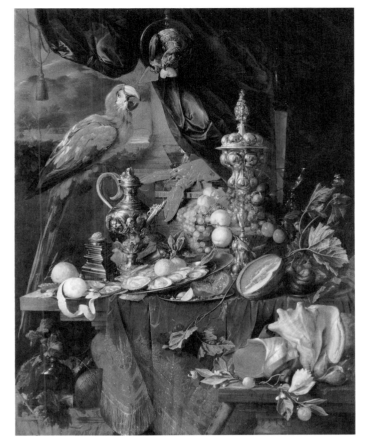

11

works that required the heat of fire for their manufacture. Throughout the picture de Heem presents objects of contrasting scale (the large lobster versus tiny shrimp, for example), shape (irregular versus geometric forms), and texture (feathers and velvet, shiny metals, and lustrous shells). In every instance these objects have been depicted with meticulous attention to visual truth. Owing to the profusion and variety of its forms, its rich coloration, and its brilliant optical effects, the painting has a celebratory air: the depicted things arouse marveling and delight, second only to that evoked by de Heem's masterful rendering.

BIBLIOGRAPHY

de Bie, Cornelis. *Het Gulden Cabinet van de Edel vry Schilderconst*. [1622]. Ed. G. Lemmens. Soest: Davaco Publishers, 1971.

Brown, Beverly Louise, and Arthur K. Wheelock, Jr., *Masterworks from Munich: Sixteenth- to Eighteenth-Century Paintings from the Alte Pinakothek*. Washington, D.C.: National Gallery of Art, 1988. Esp. cat. no. 45.

Homann, Holger. *Studien zur Emblematik des 16. Jahrhunderts*. Utrecht: Haentjens Dekker & Gumbert, 1971.

Janson, Anthony F. *Great Paintings from the John and Mable Ringling Museum of Art*. Sarasota and New York: John and Mable Ringling Museum of Art and Harry N. Abrams, Inc., 1986.

Ripa, Cesare. *Iconologia, overo Descrittione d'imagini delle virtù*. Padua: P. P. Tozzi, 1611. Facsimile ed. New York and London, 1976.

Robinson, Franklin W., and William H. Wilson, ed. *Catalogue of the Flemish and Dutch Paintings 1400–1900*. With contributions by Larry Silvers. Sarasota: John and Mable Ringling Museum of Art, 1980.

Segal, Sam. *A Prosperous Past: The Sumptuous Still Life in the Netherlands 1600–1700*. Ed. William B. Jordan. The Hague: SDU Publishers, 1988.

Suida, William E. *A Catalogue of Paintings in the John and Mable Ringling Museum of Art*. Sarasota: John and Mable Ringling Museum of Art, 1949.

HENDRIK VAN DER BORCHT
Dutch

12 *A Collection of Ancient Objects*

17th century
Signed *H. V. Borcht*
Oil on copper
25.7 x 21 cm. (10⅛ x 8¼ in.)
Collection Julius S. Held

Although this picture is signed H. V. Borcht, it is unclear whether it is the work of the elder (1583–1660) or the younger Hendrik van der Borcht (1614–ca. 1690). Both father and son were painters and both were collectors of antiquities. Their interest in objects of ancient origin—coins, medals, cameos, and statuary—was shared by a great many Europeans of the time, including one of their most famous contemporaries in Flanders, the painter Peter Paul Rubens.

The objects represented in this painting very likely belonged to the van der Borchts themselves. As they are depicted with an unsparing attention to detail, many of them, as James Welu has shown, can be identified. Among the Greek and Roman coins, for example, are a Greek silver coin from Chalcis (with eagle and serpent), a Roman bronze sestertius (marked *S C*), and a gold coin from Greece with the head of Alexander (framed by cameos in the bottom row). The larger objects depicted here include a marble torso of Aphrodite, a bronze female bust of Hellenistic or Roman origin, and a terra cotta jug and tall glass, both presumably dating from ancient Roman times.

The artist has also represented in this picture numerous sixteenth- and seventeenth-century imitations of the antique: the urinating Hercules, for example, the gold and silver statue of a seated woman, and several of the coins and medals in the foreground area.

A Collection of Ancient Objects was no doubt partly intended to serve as a document. The precious items are carefully arranged within the picture space so that each can easily be identified. The items represented testify to their owner's erudition and connoisseurship and in general offer a glimpse of his activities as a collector. The painting conveys the sense that we are looking at an isolated part of a cabinet of rarities and that the objects assembled there are meant to be seen not only for their beauty, but also for the insight they might give about the culture of a distant past.

BIBLIOGRAPHY

Plietzch, E. *Die frankenthaler Maler: Van der Borcht*. Leipzig: E. A. Seemann, 1910.

Welu, James A. *The Collector's Cabinet: Flemish Paintings from New England Private Collections*. Worcester, Mass.: Worcester Art Museum, 1983. Esp. pp. 26–29.

12

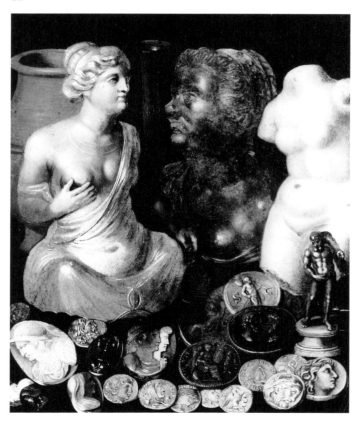

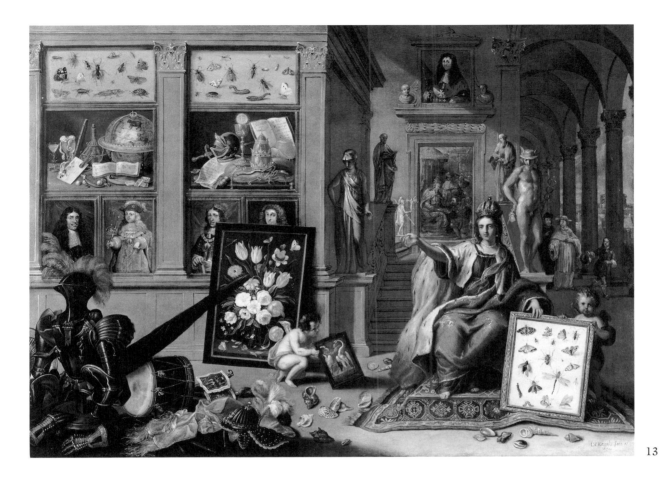

13

JAN VAN KESSEL THE ELDER AND
ERASMUS QUELLINUS II
Flemish, 1626–79, and Flemish, 1607–78

13 *Allegory of Europe*

Signed and dated *I. V. Kessel, fecit A°/1670*
Oil on copper attached to cradle
49.5 x 68.5 cm. (19½ x 27 in.)
Private Collection, on loan to Worcester Art
 Museum, Worcester, Massachusetts

Jan van Kessel was a native of Antwerp and a member of a distinguished family of painters that included Jan Brueghel the Elder (his grandfather) and Jan Brueghel the Younger (his uncle). Best known for his meticulously rendered images of animals, flowers, and insects, van Kessel often collaborated with other artists. In the *Allegory of Europe* he probably was assisted by Erasmus Quellinus II, who contributed to the foreground figures (Welu, p. 82).

The *Allegory of Europe* is closely related to another of van Kessel's pictures, made between 1664 and 1666 as part of a series illustrating the four conti-

nents. The complete series, now in the Alte Pinakothek, Munich, evidently was quite popular. Several versions were made after it, including at least two by the artist's son, Ferdinand (Brown and Wheelock, p. 104). As James Welu has shown (pp. 82–85), the *Allegory of Europe* has a rich iconography that centers on the idea of that continent's preeminence in the secular and religious spheres and in the sciences, commerce, and the arts. Splendidly arrayed and holding a miniature statue of victory in her hand, Europe is depicted "enthroned" in the foreground space. The background vignette of the pope receiving an emissary, the golden statues of saints Peter and Paul, and the still-life painting of a bible, chalice, and papal regalia allude to Europe's spiritual authority; while the jousting armor, portraits of monarchs, and another still life, showing a terrestrial globe, refer to her leading role in worldly matters. Europe's superiority in the arts and commerce is signified not only by the statues of Minerva and Mercury, but also by the collection of paintings and such exotic imports as shells and a Turkish carpet.

Van Kessel's exquisite painting, in addition to sym-

233

bolizing Europe's favored status in the world, seems to have been conceived as an evocation of seventeenth-century cabinets of curiosities, for, like many *Kunst- und Wunderkammern* of the time, it presents a wide array of *naturalia* and *artificialia*. Wonders of the natural world are represented by the seashells and by paintings—very similar to van Kessel's own (see cat. no. 126)—that show insects, exotic flamingos, and superb botanical specimens. Complementing the *naturalia* is evidence of human achievement in the arts of painting, sculpture, weaving, and metalworking. Like many collectors' cabinets, van Kessel's palatial interior includes portraits of the famous: images of Charles II of England, Charles II of Spain, the Holy Roman Emperor Leopold I, and the governor of the Spanish Netherlands appear on the wall to the left, while that of Louis XIV is displayed above the doorway in the background. The variety of items in the *Allegory of Europe* suggests an encyclopedic collection, therefore, or a little world where nature's marvels and those of men can be admired simultaneously.

BIBLIOGRAPHY

Brown, Beverly Louise, and Arthur K. Wheelock, Jr. *Masterworks from Munich: Sixteenth- to Eighteenth-Century Paintings from the Alte Pinakothek*. Washington, D.C.: National Gallery of Art, 1988.

Honour, Hugh. *The New Golden Land: European Images of America from the Discoveries to the Present Time*. New York: Pantheon, 1975.

Krempel, Ulla. *Jan van Kessel D. Ä 1626–1679: Die vier Erdteile*. Munich: Alte Pinakothek, 1973.

Laureyssens, W. "Jan van Kessel de Oude." In *Brueghel: Een Dynastie van Schilders*. Brussels: Paleis Voor Schone Kunsten, 1990.

Stilleben in Europa. Munster: Westfälisches Landesmuseum, 1979.

Welu, James A. *The Collector's Cabinet: Flemish Paintings from New England Private Collections*. Worcester, Mass.: Worcester Art Museum, 1983.

FERRANTE IMPERATO
Italian, 1550–1625

14 *Dell'historia naturale, libri XXVIII*

Naples, Costantino Vitale, 1599
Illustrated book
30.2 x 21.7 x 5.5 cm. (12 x 8½ x 2¼ in.)
Smithsonian Institution Libraries,
 Washington, D.C.
Acc. no. qQH41.I34 CRLS RB

Although conceived as a natural history, this vol-

ume has earned its fame as one of the earliest printed museum catalogues and as the first text in which an image of a museum's interior is included. Ferrante Imperato, the author of the *Historia*, was a Neopolitan pharmacist and naturalist who assembled a collection of *naturalia* in his home, primarily as a professional resource. In contrast to many other collections of the time, it contained few examples of *artificialia*. As Imperato himself declared, "My Theater of Nature consists of nothing but natural things, such as minerals, animals, and plants" (Neviani, p. 257). Mineral specimens made up the greater part of Imperato's collection, and it was in the area of geology that he made some scientific advances. He demonstrated, for example, that "Jew Stones" were in fact the petrified points of an echinus and that the "toad stone" did not grow out of a toad's head, since, he observed, such specimens can be found in rocks and are very similar to fungi.

Not surprisingly, given Imperato's profession, a great many of the objects in his collection were valued for their marvelous curative or prophylactic properties. In addition to medieval herbs and plants, he possessed a fossil bezoar known to have saved a physician who cared for the sick during a great pestilence. Both Ferrante and his son Francesco, like most people at the time, believed in the occult virtues of gems. "Small in size," so Francesco observed, "they produce wonderful effects" (*De fossilibus opusculum* [Naples, 1610], pp. 40–46). An amethyst, for example, when worn in the navel, frees a person of intoxication. Sapphire cleanses the eyes and extinguishes lust. Crystal restrains poisonous draughts, while nephrite guards against gravel in the kidneys and stomachaches. A compound of topaz, sapphire, sardonyx, hyacinth, and granite is an excellent antidote to poisons; wearing jasper, on the other hand, prevents hemorrhage and menses and facilitates the natural virtues of the stomach.

The illustration of the Museo Imperato shows many of these remarkable mineral specimens arranged along the top shelves together with coral branches, stuffed birds, and mammals. Presumably, other minerals and gems filled the cabinets below. The most striking feature of Imperato's museum is the manner in which the objects have been displayed: birds and rocks, an armadillo, and animal skins are placed side by side; the saw of the sawfish emerges from a bookshelf; the large skull and bill of a pelican are installed below a stuffed seal; and covering the ceiling is a bewildering mixture of shells, starfish, a walrus, crustaceans, serpents, and fish. The prized specimen, however, is the huge crocodile. Dominat-

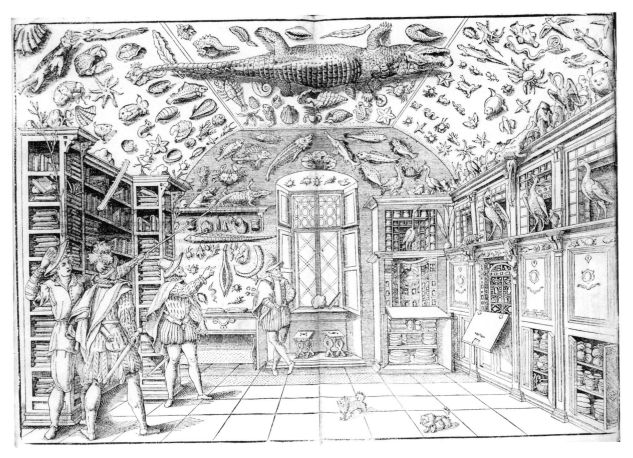

14 Frontispiece. Interior view showing Imperato's collection. Woodcut.

ing all the other exhibits, it was among the greatest of nature's wonders and for the Imperati had special significance as their family emblem.

By today's standards Imperato's installation of objects seems confused, yet such arrangements were typical in the sixteenth and seventeenth centuries and often, as in this case apparently, resulted from a lack of sufficient exhibition space. The disorder of Imperato's installation, however, is not reflected in his catalogue, for in the first twelve books he discusses the wonders of nature according to the traditional categories of the four elements. The *naturalia* in his collection were seen in the context of earth, water, air, and fire, and together they formed for Imperato and for his guests a universe in microcosm, a "Theater of Nature."

BIBLIOGRAPHY

Accordi, Bruno. "Ferrante Imperato (Napoli 1550–1625) e il suo contributo alla storia della geologia." *Geologica Romana* 20 (1981): 43–56.

Balsiger, Barbara Jeanne. "*The Kunst- und Wunderkammern*: A Catalogue Raisonné of Collecting in Germany, France, and England, 1565–1750." Ph.D. dissertation, University of Pittsburgh, 1970.

Neviani, A. "Ferrante Imperato speziale e naturalista napoletano con documenti inediti." *Atti e Memorie Accademia di Storia dell'arte sanitaria*. 2nd ser. 2 (1936): 57–74, 124–45, 191–210, 243–67.

Thorndike, Lynn. *A History of Magic and Experimental Science*. Vol. 7. New York: Columbia University Press, 1923–58.

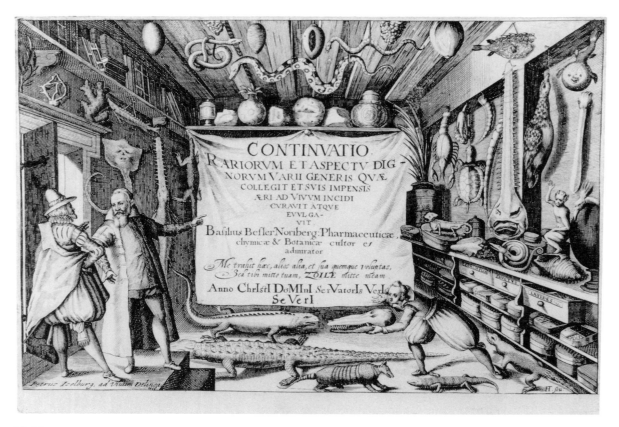

15 Museum in Nuremberg. Engraving.

BASILIUS BESLER
German, 1561–1629

15 *Continuatio rariorum et aspectu dignorum varii generis quae collegit et suis impensis aeri ad vivum incidi curavit atque evulgavit*

Nuremberg, 1622
Illustrated book
35.6 x 25.4 x 1.9 cm. (14 x 10 x ¾ in.)
Linda Hall Library, Kansas City, Missouri
Acc. no. QH41.B38 1642 folio

Basil Besler was a Nuremberg apothecary and botanist who was put in charge of the garden belonging to the bishop of Eichstätt in Bavaria. The research he conducted in connection with that superintendency resulted in the famous four-volume publication *Hortus Eystettensis* (1613), written in part by his brother Jerome. As this botanical study shows, the bishop's garden was notable for its rare and exotic plants, many of which came from the Americas. Besler also became a collector of some renown, and the museum he established was one of the first in Germany devoted to the three kingdoms of nature. Besides the plants that were of special interest to him, the botanist assembled numerous animal and mineral specimens, such as tortoise shells, monocerous horn, puffers, an armadillo, the saws of sawfishes, coral branches, and figured stones. As with other universal cabinets of the time, the emphasis was on variety and on the exotic, unusual, and rare.

The book displayed here is one of Besler's illustrated catalogues to his collection. Its frontispiece shows that the installation of objects resembled those in the museums of Imperato and Calceolari (cat. nos. 14, 16): animal, plant, and mineral specimens are freely intermixed and take up all the available space in the room.

BIBLIOGRAPHY

Balsiger, Barbara Jeanne. "The *Kunst- und Wunderkammern*: A Catalogue Raisonné of Collecting in Germany, France, and England, 1565–1750." Ph.D. dissertation, University of Pittsburgh, 1970.

Janssens, Johannes. *History of the German People at the Close*

of the Middle Ages. Vol. 13. Trans. A. M. Christie. New York: AMS Press, Inc., 1966. Esp. p. 535.

Murray, David. *Museums: Their History and Their Use.* Glasgow: James MacLehose and Sons, 1904. Esp. vol. 1, pp. 98–99.

BENEDETTO CERUTO
AND ANDREA CHIOCCO
Italian, d. 1620, and Italian, 1562–1624

16 *Musaeum Franc. Calceolari*

Verona, A. Tamum, 1622
Illustrated book
29.5 x 20 x 6 cm. (11⅝ x 7⅞ x 2⅜ in.)
Harvey Cushing/ John Hay Whitney
Medical Library, Yale University,
 New Haven, Connecticut
Acc. no. 16th century +, Ceruti

The northern counterpart to Imperato's museum in Naples was that founded in Verona by Francesco Calceolari (ca. 1521– ca. 1606). Like Imperato, Calceolari was a pharmacist who saw his collection as a professional resource. A combination reference collection and laboratory, it served as a place of study for Calceolari's pupils and was a mecca for visitors, especially botanists, physicians, and other pharmacists. While the museum contained *artificialia*, such as the feather pieces given as gifts in 1584 by four Japanese converts to the Jesuit Order, the overwhelming majority of its contents were natural specimens (plants, animals, and minerals), most of which were believed to have special healing powers. The collection gradually came to include more and more exotica and curiosity items, especially when it was taken over by Calceolari's heir, Francesco the Younger. Arms and armor were added to the museum, as were lighting devices, statuary, Egyptian artifacts, and ancient inscriptions.

The contents of the museum were first catalogued in 1584 by Giovanni Battista Oliva (*De reconditis, et praecipuis collectaneis ab honestissimo et solertissimo Francisco Calceolario Veronensi in musaeo adservatis*). This catalogue reflected Francesco the Elder's conception of the museum as an adjunct to his pharmacy. The second catalogue, on the other hand, the 1622 publication exhibited here, demonstrates how with the addition of many more *artificialia* and strange items the museum had been transformed into a cabinet of curiosities.

The new and expanded catalogue was mostly the work of Andrea Chiocco, who assumed its authorship upon the death of Benedetto Ceruto. The illustrated text describes the moral significance of many of the natural specimens and frequently dwells on their most wondrous qualities. Chiocco states that a piece of "true" monocerous (unicorn) horn was in the collection and notes that this antidote to poison had been sent to the elder Francesco in 1565 by Emperor Maximilian of Austria. He mentions a barnacle goose (a bird of Scandinavia, and thought by others to be from Ireland and Scotland, that supposedly is hatched from shell-like objects that grow on trees; see cat. no. 138) and supplies a picture of one "delineated to the life." There are "toad stones" in the museum, he says, that are effective against poison and other maladies; and, contrary to the opinion of some (Imperato), they come from the heads of toads. Elsewhere in the catalogue he describes remarkable plant specimens. Lunaria, for instance, is a mysterious herb with magnet-like properties that, according to lore, has the power to extract nails from the hoofs of horses grazing in mountain fields.

An illustration of one of the museum's three rooms bears a striking resemblance to that in the Imperato catalogue, and certain details suggest that it may have been partly modeled after Imperato's. For instance,

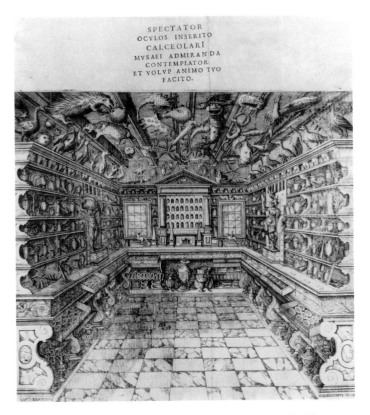

16 Frontispiece. Interior view showing the collection. Etching.

the juxtaposition of a "smiling" puffer and a crested bird (either a pelican or a spoonbill) in the upper left corner mirrors the arrangement of similar specimens in the upper right corner of the Museo Imperato. As in the Naples museum, Calceolari's collection of *naturalia* and *artificialia* fills all the available space in the room: mammals, lizards, fish, and a monstrous head hang from the rafters; stuffed birds, coral branches, and starfish are placed on top of wall cabinets; the cabinets themselves are lined with shells, plant specimens, antique ointment jars, miniature obelisks, and statuettes; mineral specimens and what appear to be figured stones or fossils are arranged in drawers, while large pots and jars are set on the floor.

An interesting feature of Calceolari's museum, detectable also in Imperato's, is the manner of displaying objects in aesthetically satisfying groups. Symmetrical (or nearly symmetrical) arrangements can be seen along the back walls of both rooms, on the ceiling of Imperato's museum, and in the facing wall cabinets of Calceolari's room. An "alternating microsymmetry," similar to that which Laura Laurencich-Minelli has detected in the late-sixteenth-century collection of Antonio Giganti, is evident in Calceolari's museum, especially in the sequential ordering of jars and shells on the side shelves. By such methods of installation Calceolari, like Giganti and Imperato, was able to give his encyclopedic collection a visual harmony that evoked the harmonious structure of the macrocosm. The museum thus became a *theatrum mundi*, a miniature world giving insight into the whole of nature and art.

BIBLIOGRAPHY

Laurencich-Minelli, Laura. "Museography and Ethnographical Collections in Bologna during the Sixteenth and Seventeenth Centuries." In *The Origins of Museums*. Ed. Oliver Impey and Arthur MacGregor. Oxford: Clarendon Press, 1985.

Thorndike, Lynn. *A History of Magic and Experimental Science*. Vol. 8. New York: Columbia University Press, 1923–58.

OLE WORM
Danish, 1588–1654

17 *Museum Wormianum*

Leiden, Iohannem Elsevirium, 1655
Illustrated book
35.5 x 23.2 x 3.5 cm. (14 x 9⅛ x 1⅜ in.)
Smithsonian Institution Libraries, Washington, D.C.
Acc. no. fQH70.D42C789 CRLS RB

Olé Worm was one of seventeenth-century Europe's most famous polymaths. A teacher of Latin and Greek and the founder of Nordic archaeology, he served as professor of medicine and natural philosophy at the University of Copenhagen from the early 1620s until his death in 1654. The museum he created in these years was designed for the edification of his students, but it soon came to the attention of foreign visitors and dignitaries, who regarded it as one of the city's major attractions. Works of art and a significant number of ethnographic materials were to be found in the collection, but the majority of items were *naturalia* that revealed Worm's preference for the rare and the unusual.

The catalogue of Worm's museum, published in 1655, gives a complete account of the natural and man-made objects and is accompanied by a detailed illustration of the interior. This engraving, as H. D. Schepelern has demonstrated, offers a fully reliable picture of the museum as it appeared in Worm's lifetime. Ethnographic objects, statuary, stuffed animals, and stones were crammed into every space and, in contrast to many other collections of the time, were installed without any attempt to create satisfying aesthetic arrangements.

BIBLIOGRAPHY

Balsiger, Barbara Jeanne. "The *Kunst- und Wunderkammern*: A Catalogue Raisonné of Collecting in Germany, France, and England, 1565–1750." Ph.D. dissertation, University of Pittsburgh, 1970.

Dam-Mikkelsen, Bente, and Torben Lundbaek, eds. *Etnografiske Genstande det Congelige danske Kunstkammer: 1650–1800 (Ethnographic Objects in the Royal Danish Kunstkammer: 1650–1800)*. Copenhagen: Nationalmuseet, 1980.

Schepelern, H. D. *Museum Wormianum, dets Forudsaetninger og Tilblivelse*. Odense, Denmark: Wormianum, 1971.

Schepelern, H. D. "The *Museum Wormianum* Reconstructed: A Note on the Illustration of 1655." *Journal of the History of Collections* 2: 1 (1990): 81–85.

Schepelern, H. D. "Natural Philosophers and Princely Collectors: Worm, Paludanus and the Gottorp and Copenha-

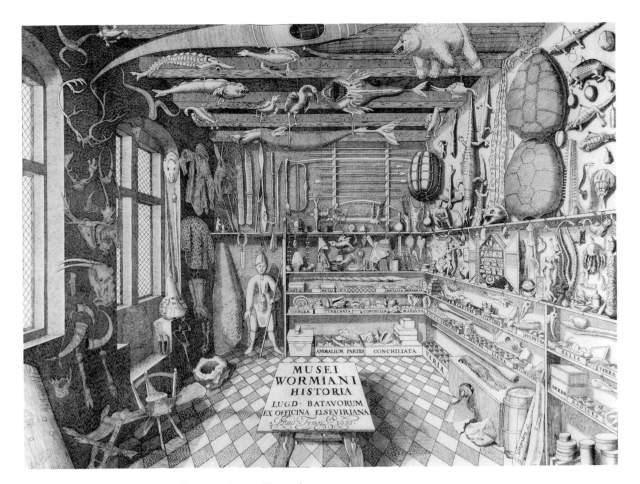

17 Interior of Worm's museum in Copenhagen. Engraving.

gen Collections." In *The Origins of Museums*. Ed. Oliver Impey and Arthur MacGregor. Oxford: Clarendon Press, 1985. Esp. pp. 121–27.

PAOLO MARIA TERZAGO
Italian, d. 1695

18 *Musaeum septalianum*

Illustrated book
Tortona, Elisei Violae, 1664
21.5 x 16 x 2 cm. (8½ x 6¼ x ¾ in.)
Smithsonian Institution Libraries, Washington, D.C.
Acc. no. DG664.5.M87T33 1664 NMAH RB

The most famous encyclopedic museum of seventeenth-century Milan was that belonging to Manfredo Settala, canon of San Nazaro in Brolo. The nucleus of the collection, formed by his father Lodovico, a physician, consisted primarily of *artifi-*

cialia such as philosophical instruments (that is, scientific and mathematical apparatuses), objects made from glass and metal, cameos, medals, and various chemical preparations. Manfredo greatly expanded this original assemblage of materials and by the 1660s had created a major cultural institution that with the variety, rarity, and abundance of its contents elicited the admiration of numerous visiting scholars and dignitaries.

Installed in four rooms of Settala's home in via Pantano, the collection contained a full range of natural and man-made items: zoological and mineral specimens; products of the vegetable kingdom; *ethnographica* from America, Asia, and Africa; weapons; musical instruments; and a significant number of paintings, drawings, archeological materials, and books. Figured stones and skeletons were on display, as were automata, burning glasses, perpetual-motion devices, and clocks. The exhibits above all reflected Settala's many-sided technical and scientific activi-

239

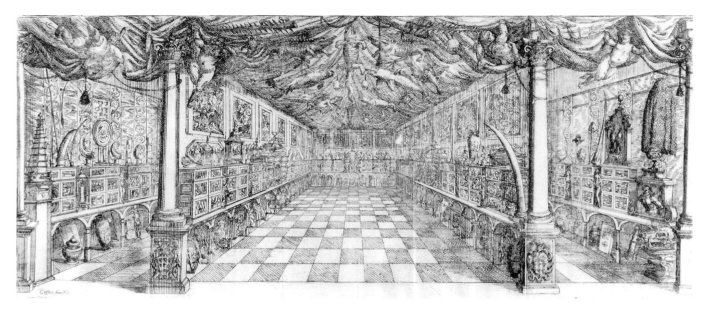

18 Interior view of Manfredo Settala's collection. Engraving.

ties. He was a skilled maker of optical instruments as well as a master of lathe turning, and many objects of his own manufacture—lenses, microscopes, decorative wood turnings—were installed in the museum along with the items acquired through purchase and donation.

The earliest published catalogue of Settala's collection appeared in 1664. Compiled by Paolo Maria Terzago, it is accompanied by an illustration showing the interior of one of the museum's four rooms. Although this engraving is now regarded "as a stylized arrangement rather than a realistic depiction of the disposition of the objects" (Aimi, et al., p. 27), it nonetheless provides the viewer with some sense of the diversity and quantity of objects that were in the Settala's possession.

BIBLIOGRAPHY

Aimi, Antonio, Vincenzo de Michele, and Alessandro Morandotti. "Towards a History of Collecting in Milan in the Late Renaissance and Baroque Periods." In *The Origins of Museums*. Ed. Oliver Impey and Arthur MacGregor. Oxford: Clarendon Press, 1985. Esp. pp. 24–28.

Balsiger, Barbara Jeanne. "The *Kunst- und Wunderkammern*: A Catalogue Raisonné of Collecting in Germany, France, and England, 1565–1750." Ph.D. dissertation. University of Pittsburgh, 1970.

Bedini, Silvio A. "Citadels of Learning: The Museo Kircheriano and Other Seventeenth-Century Italian Science Collections." In *Enciclopedismo in Roma Barocca*. Ed. M. Casciato, M. G. Ianniello, and M. Vitale. Venice: Marsilio Editori, 1986. Esp. pp. 249–67.

Fogolari, Gino. "Il Museo Settala, contributo per la storia della colture di Milano nel sec. XVII." *Archivio Storico Lombardo* 14: 17 (1900): 58–126.

de Michele, Vincenzo, L. Cagnolaro, Antonio Aimi, and Laura Laurencich-Minelli. *Il museo di Manfredo Settala nella Milano del XVII secolo*. Milan, 1983.

Tavernari, Carla. "Il Museo Settala 1660–1680." *Critica d'Arte* 163–65 (1980): 202–20.

Terzago, P. M. *Musaeum septalianum Manfredi Septalae patritii Mediolanensis industrioso labore constructum* Tortona, 1664.

LORENZO LEGATI
Italian, d. 1675

19 *Museo Cospiano Annesso a quello del famoso Ulisse Aldrovandi*

Bologna, Giacomo Monti, 1677
Illustrated book
32 x 23 x 5 cm. (12½ x 9 x 2 in.)
Smithsonian Institution Libraries, Washington, D.C.
Acc. no. QQH41.L4X NMAH RB

This catalogue, compiled by Lorenzo Legati and first published in 1667, describes and illustrates the collection of Marchese Ferdinando Cospi, a relative of the Medici in Florence and their agent for Tuscan affairs in the province of Lombardy. Cospi's collection, begun when he was a youth, consisted

primarily of ethnographic materials, Roman and Etruscan artifacts, and objects of mythological interest such as idols from Egypt and Mexico. The marchese's holdings grew substantially, however, when in the first decade of the seventeenth century he acquired the famous museum of the recently deceased Ulisse Aldrovandi (d. 1605; cat. no. 108).

This huge assemblage of zoological, botanical, mineralogical, and ethnographic specimens had been formed by Aldrovandi in connection with his activities as professor of natural history at the University of Bologna. Intended from the start to serve his professional and intellectual interests, it contained additionally an important library of ancient and modern texts plus thousands of tempera illustrations and woodblocks that were used to illustrate his own publications on the history of the natural world.

The scientist's program, according to Giuseppe Olmi (p. 8), "can be viewed as an attempt to transfer the entire world of nature from the often inaccessible outdoors to the restricted interior of the museum." The ambitious project, which occupied Aldrovandi for over forty years, was marked by a realism and an objectivity not evident in other museums of the time. Yet the collection was not lacking in marvels. Like his contemporaries, Aldrovandi had a taste for the rare, the unusual, and the bizarre; and among the items in his museum visitors found monstrous animals, exotic flora and fauna, and numerous mineral specimens having extraordinary curative and prophylactic powers.

The illustration shows part of Aldrovandi's collection after its annexation by Cospi. The objects are disposed in an orderly way in wall cabinets and on the walls. As in museums of the period, the ceiling is also used as exhibition space, in this case for rare and fascinating *naturalia*.

BIBLIOGRAPHY

Bedini, Silvio A. "Citadels of Learning: The Museo Kircheriano and Other Seventeenth-Century Italian Science Collections." In *Enciclopedismo in Roma Barocca*. Ed. M. Casciato, M. G. Ianniello, and M. Vitale. Venice: Marsilio Editori, 1986. Esp. pp. 249–67.

Balsiger, Barbara Jeanne. "The *Kunst- und Wunderkammern*: A Catalogue Raisonné of Collecting in Germany, France, and England, 1565–1750." Ph.D. dissertation. University of Pittsburgh, 1970. Esp. vol. 1, pp. 62–4.

Laurencich-Minelli, Laura. "Museography and Ethnographical Collections in Bologna during the Sixteenth and Seventeenth Centuries." In *The Origins of Museums*.

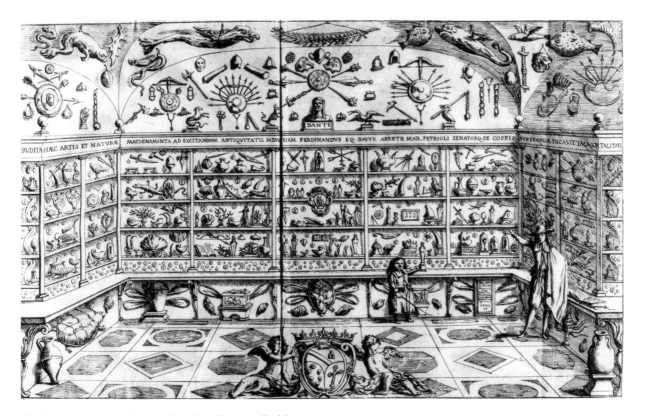

19 Frontispiece. Ferdinando Cospi's collection. Etching.

Ed. Oliver Impey and Arthur MacGregor. Oxford: Clarendon Press, 1985. Esp. pp. 17–23.

Murray, David. *Museums: Their History and Their Use.* Glasgow: James MacLehose and Sons, 1904. Esp. vol. 1, pp. 69, 78–80.

Rodriquez, F. *Il museo Aldrovandiano nella Biblioteca Universitaria di Bologna.* Bologna, 1956.

Comelli, Giambattista. "Ferdinando Cospi e le origine del Museo Cospiano de Bologna." *Atti e memorie della Regia Deputazione di storia patria per le province di Romagna.* 3rd ser. 7 (1888–89): 96–129.

Olmi, Giuseppe. "Science-Honour-Metaphor: Italian Cabinets of the Sixteenth and Seventeenth Centuries." In *The Origins of Museums.* Ed. Oliver Impey and Arthur MacGregor. Oxford: Clarendon Press, 1985. Esp. pp. 5–16.

ATHANASIUS KIRCHER
German, 1602–80

20 *Romani Collegii Societatis Jesu Musaeum Celeberrimum*

Amsterdam, Jassonio-Waesbergiana, 1678
Illustrated book
40 x 26 x 6.3 cm. (15¾ x 10¼ x 2½ in.)
Library Company of Philadelphia, Philadelphia, Pennsylvania
Acc. no. Sev Kirc 6367.EI
Venues: DC, NC

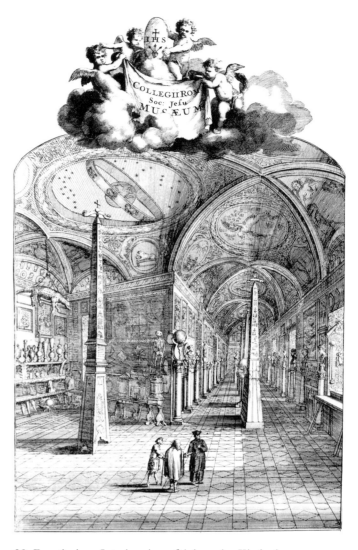

20 Frontispiece. Interior view of Athanasius Kircher's collection. Etching.

Athanasius Kircher was a German Jesuit priest who for most of his long life was a professor of mathematics and languages at the Roman College of the Society of Jesus. Said by a contemporary to have "produced more works than warriors poured forth from the Trojan horse" (see Thorndike, vol. 7, p. 568), he published over thirty-five volumes treating such subjects as magnetism, ancient hieroglyphics, optics, astronomy, music, the hidden mysteries of numbers, the subterranean world, and the history of the Flood. As Lynn Thorndike notes (vol. 7, p. 571), "Kircher makes a great show of experimental method in his writings": he enthusiastically recorded the numerous experiments and observations he himself made, but many of these were of dubious worth and did not lead to any new scientific laws. Kircher was frequently criticized for his credulity and for his methodology, which drew upon numerous occult traditions. As one of many at the time who continued to believe in the theory of signatures, in the agreement of the macrocosm and microcosm, and in the power of imagination, he moved in a direction opposite from that taken by Galileo. Not-

withstanding the backwardness of his thinking, Kircher was an indefatigable compiler of information (many of his publications are a thousand or more pages in length), and his industry and the encyclopedic breadth of his knowledge aroused the admiration of critics and supporters alike.

The museum that Kircher formed at the Collegio Romano reflected his wide-ranging interests. It was developed chiefly as a resource for his "scientific" and linguistic studies. The nuclei of the collection were Egyptian artifacts that had been given to him by Nicolas Claude Fabri de Peiresc, a French scholar and collector of antiquities whom Kircher had visited while on his journey to Rome. To this original collection Kircher added scientific and mathematical in-

struments, mechanical devices of his own making, clocks, ethnographic materials, animal, plant, and geological specimens, musical instruments, skeletons, and works of art. Many objects had been picked up by Kircher on trips to such places as Malta and Sicily, but the most important sources for acquisitions were the Jesuit missionaries who sent or brought to their Roman headquarters exotic *ethnographica* and natural specimens from all parts of the world—China, Japan, Africa, India, and the Americas.

Kircher's "cabinet" was at first accommodated in a little hall or study that was part of the college's library. But as the number of objects grew, and particularly after Alfonso Donnino, secretary to the Roman Senate, bequeathed his collection of classical antiquities to the Collegio Romano in 1651, larger exhibition space was required. The new location for the museum was a spacious hall, three hundred feet long, adjacent to the library. It is this exhibition space that is illustrated in the first catalogue of the collection, compiled and published in 1678 by Kircher's *custos musaei*, Giorgio de Sepi. Down the length of the hall are models of Egyptian obelisks, antique portrait busts, statues, and globes. Scientific apparatus, stuffed animals, weapons, and ethnographic objects hang on the walls along with pictures, many of which represent saints and Jesuit martyrs. Smaller items—pottery, bones, tusks, and other *naturalia*—are arrayed along open shelves, while a crocodile is suspended from the vaulted ceiling, which is decorated with paintings of the constellations and signs of the zodiac.

Even though the museum functioned as a place of study and as the laboratory where Kircher conducted many of his experiments, it became famous to visitors as "a gallery of curiosities." Ordinary and familiar items—pulleys and levers, for instance—were among the exhibits, but the objects that aroused particular interest were the exotica, the oddities of nature (monstrous eggs, a ten-ounce stone from the bladder of a fellow Jesuit, the skeleton of a bird with three legs), and such things as Kircher's "perpetual motions," his "magic lantern," alchemical furnaces, and musical automata.

When Kircher died in 1680, his carefully prepared exhibits rapidly fell into decay. "Father Kircher's cabinet in the Roman College was formerly one of the most curious in Europe," observed François Misson in 1688, "but it has been much mangl'd and dismember'd" (vol. 2, pp. 195–98). In the early eighteenth century, Filippo Buonanni (cat. no. 21) oversaw the restoration of the collection, but despite his efforts the destruction, dismembering, and pillaging of exhibits continued. Once a monument to Kircher's

universal interests, his curiosity, and his love for the marvelous, the museum in the Collegio Romano eventually suffered the same fate as many other collections of the era.

BIBLIOGRAPHY

Bedini, Silvio A. "Citadels of Learning: The Museo Kircheriano and Other Seventeenth-Century Italian Science Collections." In *Enciclopedismo in Roma Barocca*. Ed. M. Casciato, M. G. Ianniello, and M. Vitale. Venice: Marsilio Editori, 1986. Esp. pp. 249–67.

García Villoslada, Riccardo. *Storia del Collegio romano dal suo inizio (1551) alla soppressione della Compagnia di Gesù (1773)*. Rome: Universitatis Gregorianae, 1954.

Mission, François. *New Voyage to Italy*. Vol. 2. London, 1739.

Reilly, P. Conor, S. J. *Athanasius Kircher: Master of a Hundred Arts*. Wiesbaden and Rome: Edizioni del Mondo, 1974.

Thorndike, Lynn. *A History of Magic and Experimental Science*. Vol. 7. New York: Columbia University Press, 1923–58.

FILIPPO BUONANNI
Italian, 1638–1725

21 *Musaeum Kircherianum; sive, musaeum a Padre Athanasio Kircherio in Collegio Romano Societatis Jesu*

Rome, 1709
Illustrated book
Each approx. 38.2 x 26.3 x 6.8 cm.
(15 x 10¼ x 2¹¹⁄₁₆ in.)
Copy A: Library Company of Philadelphia, Philadelphia, Pennsylvania
Acc. no. *Am 1709 Kir 6205.F
Venues: DC, NC

Copy B: Library, Academy of Natural Sciences of Philadelphia, Philadelphia, Pennsylvania
Acc. no. QL 41 B93 1709 F
Venues: HO, HI

By 1698 the museum established by Athanasius Kircher (cat. no. 20) at the Jesuit College in Rome was in total chaos. In that year Filippo Buonanni, one of the most learned Jesuits of the time and Kircher's successor as professor of mathematics at the Collegio Romano, was assigned the task of reorganizing and cataloging the collection. Buonanni transferred the museum to more spacious quarters on the upper floor of the college and made numerous additions to its holdings, including mathe-

21A Frontispiece to section devoted to shells. Etching.

Buonanni produced his catalogue as part of his efforts to restore Kircher's museum. An amply illustrated volume, it reflects the order that Buonanni imposed on the collection, namely dividing the exhibits into twelve classes. With this arrangement, generally, works of art and antiquities were separated from *naturalia*. However, many of Buonanni's classes, far from demonstrating a modern scientific approach to exhibition, continued the practice of assembling dissimilar materials. The fourth class, for instance, was comprised mostly of antiquities (funeral lamps and statues), but it also contained tokens of Christ, tokens of torture, seafish, shoes, and the remains of an elephant. Class seven, designated as "things travelers have collected," was an even more striking hodgepodge of curiosities, exotic ethnographic objects and *naturalia*. Here, for example, one found Indian clothing and weapons, a bird of paradise, mummies, Chinese hats, a bearskin, a sea lion, and a little chameleon that had been sent to Kircher from Palestine.

In contrast to these sections, the final class in Buonanni's catalogue is highly specialized, being devoted to shells exclusively. The illustrations found here had appeared earlier in Buonanni's study of mollusks, the *Ricreatione dell'occhio e della mente* (first published in 1681, expanded and lavishly illustrated in 1684). Buonanni is not known for making any major contributions to the study of marine life or conchology, but the engravings of shells in his printed books are notable for their beauty and, generally, for their accuracy. Some of these illustrations, in addition, show fanciful configurations of shells that resemble the composite portraits invented by Arcimboldo as well as the compositions of shells, stones, and other natural materials that decorated late-sixteenth- and seventeenth-century garden grottos.

matical instruments, natural history specimens, ethnographic items, and his own important collection of mollusks. Although the museum flourished under Buonanni's direction, it lacked proper security. Objects were still pillaged, causing Pope Clement XI to issue an edict threatening excommunication to anyone who violated the collection. Long after Buonanni's death in 1725 the oddities, ingenious machines, and abundant antiquities of the museum continued to attract the attention of the curious, but, as numerous visitors reported, the exhibits were in great confusion and showed years of neglect. In 1870 the Museo Kircheriano finally met its end. The government of the newly formed Italy confiscated the collection along with other Jesuit properties, and most of the exhibits were united with other objects to form the Museo Nazionale Preistorico ed Etnografico.

BIBLIOGRAPHY

Bedini, Silvio A. "Citadels of Learning: The Museo Kircheriano and Other Seventeenth-Century Italian Science Collections." In *Enciclopedismo in Roma Barocca*. Ed. M. Casciato, M. G. Ianniello, and M. Vitale. Venice: Marsilio Editori, 1986. Esp. pp. 249–67.

García Villoslada, Riccardo. *Storia del Collegio romano dal suo inizio (1551) alla soppressione della Compagnia di Gesù (1773)*. Rome: Apud sedes Universitatis Gregorianae, 1954.

Reilly, P. Conor, S. J. *Athanasius Kircher: Master of a Hundred Arts*. Wiesbaden and Rome: Edizioni del Mondo, 1974.

Thorndike, Lynn. *A History of Magic and Experimental Science*. Vol. 8. New York: Columbia University Press, 1923–58. Esp. pp. 42–43.

NEHEMIAH GREW
English, 1641–1712

22 *Musaeum Regalis Societatis; or, a Catalogue and Description of the Natural and Artificial Rarities Belonging to the Royal Society and Preserved at Gresham College*

London, W. Rawlins, 1681
Illustrated book
33 x 21.1 x 4.6 cm. (13 x 8¼ x 1⅞ in.)
Dartmouth College Library,
 Hanover, New Hampshire
Acc. no. QH/41/G7/1671

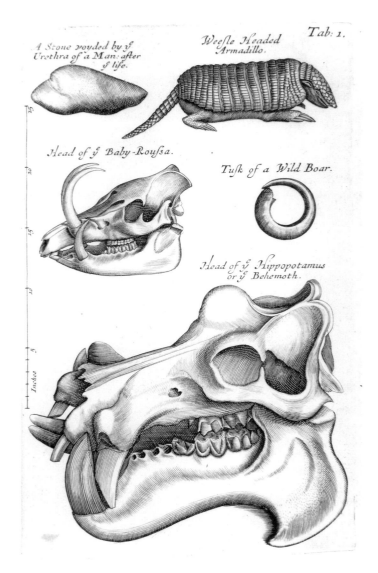

22 Plate 1. Various specimens from the collection, including a babirusa or "baby-roussa" pig skull. Engraving.

This catalogue of the Museum of the Royal Society at Gresham College, London, was compiled by the botanist Nehemiah Grew, one of the society's members and its secretary in the late seventeenth century. The Royal Society was founded in 1660 with the specific purpose of furthering scientific research, and it quickly began to accumulate objects for a museum. Some items came by way of private donation, but not until the society purchased the cabinet of curiosities of Robert Hubert in 1666 did it have the basis for a true collection. Hubert's cabinet consisted of rarities, exotica, and other marvels, all of them natural. A great many natural as well as man-made items were given to the museum over the next two decades, and by 1681 the collection had grown to nearly three times its original size.

Nehemiah Grew and a number of his colleagues in the society generally disdained collections that consisted mostly of oddities, for it was their intention to create a complete "Inventory of Nature" or a mirror of the world that included, according to Grew, "not only things strange and rare, but the most known and common amongst us." But the museum never took on this comprehensive character. Many, if not most, of the society's members were *virtuosi*, and their preferred donations to the museum were curiosities, exotica, and such rare items as double-eggs, rhinoceros horns, armadillos, and crocodiles. Man-made marvels, such as a box of a hundred turned cups, were also on display, as was the remarkable piece of wood from Hubert's collection, which had grown in the form of Saint Andrew's cross. All in all, the ordinary and commonplace were heavily outweighed by the extraordinary and outlandish. Grew catalogued them all. To give some idea of the unusual items that were part of the collection, the page from the book reproduced here shows the head of a hippopotamus or Be- hemoth, the tusk of a wild boar, the skull of a babirusa, an armadillo, and "a stone voided by yᵉ urethra of a man after yᵉ life."

BIBLIOGRAPHY

Hunter, Michael. "The Cabinet Institutionalized: The Royal Society's 'Repository' and Its Background." In *The Origins of Museums*. Ed. Oliver Impey and Arthur Mac-Gregor. Oxford: Clarendon Press, 1985. Esp. pp. 164–65.
Murray, David. *Museums: Their History and Their Use.* Vol. 1. Glasgow: James MacLehose and Sons, 1904.

KUNSTKAMMERET. COPENHAGEN

23 *Museum regium*

Copenhagen, 1696
Illustrated book
34.9 x 22.9 x 2.87 cm. (13¾ x 9 x 1⅛ in.)
Linda Hall Library, Kansas City, Missouri
Acc. no. R.B.R. QH71.C6A5 1696 folio

One of the greatest collections assembled in seventeenth-century Europe was that of the Danish court in Copenhagen. Founded by King Frederick III (1609–70) sometime before 1650, the collection was substantially enlarged in 1655 with the purchase of Olé Worm's entire museum and later with acquisi-

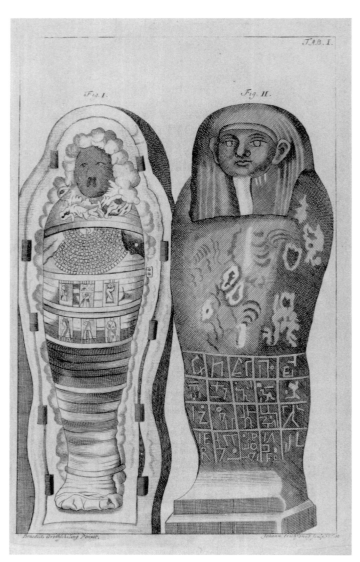

23 Mummy caskets. Etching.

tions made by Christian V (1670–90) and his successor, Frederick IV (1671–1730). In 1687 a professor of philosophy and medicine at the University of Copenhagen, Holger Jacobsen (Oliger Jacobaeus), was assigned the task of writing a complete catalogue of the museum. The work that resulted was the 1696 publication the *Museum regium*.

The catalogue, accompanied by numerous engravings, reveals the extraordinary variety and abundance of items that had been collected in less than a half century. Part 1, having to do with *naturalia*, includes Egyptian mummies, quadrupeds, birds, fish, shells, reptiles, insects, plants, minerals, and soils. Part 2, *artificialia*, embraces everything from objects made of wood, ivory, bone, and amber to ethnographic items, antiquities, and scientific and mechanical apparatuses. Guns and Turkish weapons were on display, as were objects from America, India, and China.

Jacobsen's catalogue shows that the collection was divided into distinct categories, according to principles noticeably different from those of the early *Kunst- und Wunderkammern*: *naturalia* were separated from *artificialia*; paintings, ethnographic objects, and scientific instruments were each displayed in rooms of their own. Among the items that merited illustration were Egyptian mummies (phenomenal *naturalia* that had medico-historical significance) and the "Oldenburgicum Horn," a magnificent example of late-fifteenth-century German goldsmith work and one of the prized possessions of the Danish kings (see fig. 7, Kenseth Introduction).

BIBLIOGRAPHY

Balsiger, Barbara Jeanne. "The *Kunst- und Wunderkammern*: A Catalogue Raisonné of Collecting in Germany, France, and England, 1565–1750." Ph.D. dissertation. University of Pittsburgh, 1970.

Dam-Mikkelsen, Bente, and Torben Lundbaek, eds. *Etnografiske Genstande det Congelige danske Kunstkammer: 1650–1800.* (*Ethnographic Objects in the Royal Danish Kunstkammer: 1650–1800*). Copenhagen: Nationalmuseet, 1980.

Gundestrup, Benet. "From the Royal *Kunstkammer* to the Modern Museums of Copenhagen." In *The Origins of Museums.* Ed. Oliver Impey and Arthur MacGregor. Oxford: Clarendon Press, 1985. Esp. pp. 128–35.

Murray, David. *Museums: Their History and Their Use.* Glasgow: James MacLehose and Sons, 1904. Esp. vol. 1, pp. 103–6, 126; vol. 2, p. 190.

KUNST- UND WUNDERKAMMER

THE MOST STRIKING evidence of European interest in the marvelous was the proliferation of collections in which wonders of nature such as biological oddities, zoological rarities, and astounding geological specimens were exhibited together with unusual, rare, or superbly crafted works of art. The ancestors of modern museums, these early collections (most frequently called *Kunst- und Wunderkammern*, cabinets of curiosities, closets of rarities, or museums) were established by members of the professional classes, princes, and wealthy aristocrats. While the museums varied widely according to the special interests of the collector, his financial resources, and the amount of space available for the display of objects, they typically revealed a fondness for anything outside the ordinary.

The *Kunst- und Wunderkammer* part of the exhibition evokes the general appearance of the early museums and emphasizes the kind of objects that frequently were exhibited as marvels. While not a recreation of any specific cabinet of curiosities, it is partly based on the illustrations of museum interiors found in the catalogues of Ferrante Imperato, Manfredo Settala, Olé Worm, and Francesco Calceolari. Like these and other museums of the period, our cabinet presents a dense accumulation of materials within a limited space: the ceiling is used as part of the display space, and wall cases and drawers are filled with natural and artificial items.

Our room of wonder recalls the diversity of materials found in collections during the age of the marvelous. All the works of *artificialia* are of the type that would have been found in European cabinets, and many of them are documented as having been part of the great collections of the period. These include:

§ objects of historical interest or works that represent or belonged to the famous, such as a piece of stone believed to have come from the altar where Abraham offered his son Isaac to God, an equestrian statue of Emperor Rudolf II, a gun from the collection of the French kings Louis XIII and Louis XIV, and the gauntlets worn by Philip II of Spain;

§ antique coins and Renaissance medals valued for their rarity, historical interest, or craftsmanship;

§ artifacts from exotic places, such as a Turkey hacha from Peru, pre-Columbian gold pendants, Egyptian objects with hieroglyphs, and Chinese porcelain;

§ man-made objects distinguished for their beauty and technical virtuosity, such

247

as Bessman's *Nautilus* beaker, Giambolgna's *Mercury*, a wheel-lock rifle inlaid with staghorn, embossed, etched, and gilded armor for the field, and a boxwood rosary bead with miniature carved scenes of the crucifixion and resurrection. Other works that demonstrate a clever reworking of prized natural materials include Clauss's ostrich egg ewer, Ritter's snail with nautilus shell, a carved rhinoceros horn cup, and Müller's coconut goblet;

§ ingenious mechanical devices such as the drinking cup depicting Diana and the Stag;

§ works of art notable for their bizarre or marvelous subject matter, such as the Arcimboldo "composite" portraits and the majolica bottle and boxwood statue of Apollo and Daphne;

§ religious artifacts or images of biblical or holy subjects, such as the chalice formed from a human skull, the silver statue of the Virgin Mary on the crescent moon, and a limoges compote showing the construction of the Tower of Babel.

The *naturalia* also are of the type frequently exhibited in the early museums. These include:

§ natural specimens (or amulets fashioned from them) such as magnets, bloodstone, agate, coral, and "adders' tongues" (fossilized sharks' teeth) that were thought to have magical properties or remarkable curative and prophylactic powers;

§ animals or animal fragments that were valued for their emblematic meaning or that according to legend had magical attributes: a peacock (a symbol of eternity because, according to belief, its flesh never decayed), a pelican (traditionally a symbol of Christ's sacrifice), and "unicorn horns" (narwhal tusks);

§ strange *naturalia* from the Americas and other exotic worlds such as armadillo skins, a toucan, a rhinoceros hornbill, a footless bird of paradise, Indo-Pacific shells, and an alligator;

§ wondrous *naturalia* found at home, including "figured stones" (fossilized animals and plants), "giants' bones" (dinosaur fragments), and pieces of amber containing insects.

In its diversity and organization, our cabinet recalls the programs of universality or encyclopedism that informed many of the *Wunderkammern*. Those early collections were designed as microcosms reflecting the greater variety of God's universe or the macrocosm. In keeping with the view that God's creative power was most clearly revealed in exceptional and odd natural specimens or that nature herself could best be understood by study-

ing her most unusual forms, this part of the exhibition contains specimens notable for their rarity, their extraordinary scale, their monstrous or queer shapes, or their beauty.

Following the practice of many early collectors, we have juxtaposed *artificialia* with natural specimens to allow a comparison between man's handiwork and nature's, or between human ingenuity and God's creative power. Thus, a rock crystal amulet is displayed next to raw quartz, a superbly executed agate cup is shown near samples of agate, objects made of coral or gemstones are set next to corresponding specimens in their natural state, and objects made from feathers are exhibited next to stuffed birds. In general the objects are organized according to materials, in a scheme advised by the sixteenth-century museographer Samuel Quiccheberg and that derived ultimately from Pliny's *Natural History*. Thus, regardless of place of origin or time of execution, works made from the same material are shown together: Renaissance and baroque bronzes are in one cabinet; Mexican goldwork appears next to European objects in gold; items in wood are placed together, as are things fashioned from minerals and rocks. Sometimes the early collectors arranged their objects so to create surprising or striking contrasts. Thus, in this room, very large items are juxtaposed with the very small—an ostrich egg and the egg of a hummingbird is one instance, a "giant's" (dinosaur's) bone and the bone of a bat is another. Finally, many of the objects in our cabinet have been displayed with a view to creating aesthetically satisfying arrangements. Open drawers show artful compositions of shells, insects, or other natural specimens, similar to arrangements made by early collectors. Elsewhere objects are displayed symmetrically or according to an alternating sequence, thereby recalling the visual harmony of certain museums that evoked the whole of art and nature.

ABRAHAM JANSSENS
Flemish, 1575–1632

24 *Allegory of the Four Elements*

17th century
Oil on canvas
164.5 x 198.7 cm. (64¾ x 78¼ in.)
Sarah Campbell Blaffer Foundation,
 Houston, Texas
Acc. no. 77.3

In a *Wunderkammer* objects were typically organized according to the four elements: earth, air, fire, and water. The prevailing theory was that all matter in the universe was composed of one or more of these basic materials. Unlike many sixteenth-century artists, who organized representations of the four winds, the four parts of the day, the four continents, the four quarters of the world, or the five senses into a series of indi-vidual compositions, Abraham Janssens incorporates all the elements into one allegorical scene.

In *Allegory of the Four Elements* each Rubenesque figure is identified by her attributes. Thus Fire, in the upper left, carries both a flame and a lightning bolt; Air has wings sprouting from her back and holds a bird in her arms; Water, her head crowned with reeds, reclines upon a conch shell next to the edge of a stream with a crab and shells; and the older figure of Earth, crowned with a small model of a medieval walled city, holds a cornucopia of fruits and vegetables. This painting is one of the best surviving examples of Janssens's work.

BIBLIOGRAPHY

Wright, Christopher. *A Golden Age of Painting: Dutch, Flemish, German Paintings, Sixteenth-Seventeenth Centuries, from the Collection of The Sarah Campbell Blaffer Foundation*. San Antonio: Trinity University Press, 1981.

24

THE CATALOGUE

GIUSEPPE ARCIMBOLDO
Italian, 1527—93

25 *Allegory of Summer*

1572
Oil on canvas
92.3 x 70 cm. (36⅜ x 27½ in.)
The Denver Art Museum, Denver, Colorado
Museum Purchase
Acc. no. 1961.56

25

Hailed as "ingegnosissimo pittor fantastico" by his contemporary Gregorio Comanini, Giuseppe Arcimboldo is still regarded as a painter of supreme wit and ingenuity. While Arcimboldo may be best known today for his composite portraits, two of which are illustrated here, he engaged his talent in a variety of projects that brought him equal fame in his own time.

Arcimboldo was born in 1527 in Milan, where he began his artistic training with his father. He designed cartoons for stained glass windows for the Milan cathedral, and later designed cartoons for tapestries for the cathedral at Como. In 1562 he accepted an invitation from the Holy Roman Emperor, Maximilian II (1527—76), to come to the imperial court in Vienna. Arcimboldo in fact served three Habsburg rulers. He painted portraits for Ferdinand I (1503—64) and designed tournaments and lavish festivals in Vienna and Prague at the courts of Maximilian II and his successor, Rudolf II (1552—1612). In addition, he painted portraits, purchased antiquities, invented waterworks, and conceived of a color system for musical notation (Kaufmann, p. 89).

In 1563 Arcimboldo began his famous series of portraits representing the seasons and the elements. They were presented to Maximilian II on New Year's Day in 1569. This series was so popular that Arcimboldo made copies to be given as gifts to foreign courts of Europe (*Winter*, in the Musée du Louvre, Paris, was one such copy sent to Elector Augustus of Saxony by Maximilian), and other painters copied his inventions. Arcimboldo interwove the shapes and textures of natural materials representative of the seasons and objects associated with the four elements to create portraits that simultaneously alluded to specific Habsburg rulers. While imitating the forms of nature, the artist transformed these discrete elements into portraits existing only within the realm of the imagination.

Arcimboldo's portraits also cleverly allude to antiquity. Classical authors, like Horace and Vitruvius, were interested in imaginary forms produced by a recombination of an object's parts. While these au-

thors actually condemned such fanciful images, like chimerae, their texts were used in the sixteenth century to support a keen interest in grotesque ornament. As a composite portrait, *Allegory of Summer* stands as a superb demonstration of Arcimboldo's intellect and his wit.

BIBLIOGRAPHY

Hulten, Karl Gunnar Pontus, et al. *The Arcimboldo Effect: Transformations of the Face from the Sixteenth to the Twentieth Century.* Venice: Palazzo Grassi, and New York: Abbeville Press, 1987.

Kaufmann, Thomas DaCosta. *The School of Prague: Painting at the Court of Rudolf II.* Chicago: University of Chicago Press, 1988.

251

26

accompanied the paintings when they were presented to Maximilian II in 1569. Thomas DaCosta Kaufmann believes that the poems were written with the approval and knowledge of the artist (Kaufmann, 1976, pp. 276–7).

Fonteo constructed an elaborate series of dialogues among the portraits of the *Seasons* and the *Elements* that build on the visual correspondences Arcimboldo created. The portraits of *Summer* and *Winter* both face to the right, while the other two seasons face to the left. As *Winter* looks toward *Spring* and *Summer* pushes forward to *Autumn*, Arcimboldo visually interlocks the seasons in perpetual motion. Fonteo embellished these connections to create a *summa concordia*—a complete harmony within the realm of nature which then reflects the harmonious rule of the emperor. Heraldry closely associated with the Habsburg family is subtly included in these composite portraits. The cyclical movements of the seasons implies that the imperial family will rule in perpetuity. As the seasons are represented by portraits that become progressively older, Arcimboldo also succeeds in embellishing the cycle of nature with an allusion to the four ages of man. Winter, the old man, is Maximilian's season. The cloak in the portrait bears his initial. Although Maximilian's portrait may suggest the end of the human cycle, the Romans, according to Fonteo, saw winter as the beginning of the year, the *caput anni*. Hence, the emperor stood at the beginning of time (the seasons) and at the beginning of eternal rule.

GIUSEPPE ARCIMBOLDO
Italian, 1527–93

26 *Allegory of Winter*

ca. 1572
Oil on canvas
93.2 x 71.5 cm. (36⅝ x 28⅛ in.)
The Menil Collection, Houston, Texas
Acc. no. x360

In addition to the classical allusions, Arcimboldo wove a complex imperial allegory into the general scheme of the *Seasons* and *Elements* series. Through it Arcimboldo suggests that Maximilian II, Holy Roman Emperor, ruler of men, is also the ruler of the natural world. Such an interpretation is made possible by the rediscovery of several texts written by Giovanni Battista Fonteo, a humanist and designer who collaborated with Arcimboldo at the imperial court. Fonteo wrote several poems about Arcimboldo's *Seasons* and *Elements*, and at least one version

BIBLIOGRAPHY

Hulten, Karl Gunnar Pontus, et al. *The Arcimboldo Effect: Transformations of the Face from the Sixteenth to the Twentieth Century.* Venice: Palazzo Grassi, and New York: Abbeville Press, 1987.

Kaufmann, Thomas DaCosta. "Arcimboldo's Imperial Allegories: G. B. Fonteo and the Interpretation of Arcimboldo's Painting." *Zeitschrift für Kunstgeschichte* 39 (1976): 275–96.

Kaufmann, Thomas DaCosta. *The School of Prague: Painting at the Court of Rudolf II.* Chicago: University of Chicago Press, 1988.

HENDRICK GOLTZIUS
Dutch, 1558–1617

27 *The Farnese Hercules*

ca. 1592–93
Engraving
41 x 29.2 cm. (16 x 11½ in.)
Museum of Fine Arts, Boston, Massachusetts
Harvey D. Parker Collection
Acc. no. p7206
Venues: DC, NC

Considered by his contemporaries as one of the most brilliant engravers of his time, Hendrick Goltzius has been no less admired by subsequent generations. He was born at Mühlbracht in the Rhine country in 1558 and later moved with his family to Duisberg, where he studied with his father, a glass painter. His formal training as an engraver began around 1575 when he became an apprentice to Dirck Volckertsz. Coornhert, who was living in exile in Germany. When Coornhert returned to Haarlem, Goltzius moved with him to the thriving artistic community.

In 1590 Goltzius traveled to Italy to study the artistic achievements of both the ancient and modern masters. At the end of 1591, having spent approximately six months in Rome, he returned to Haarlem, where he continued to draw inspiration from his experience in Italy. Around 1600 he ended his career as a printmaker, leaving some 350 engravings, 20 woodcuts, and a series of etchings and some dry-point prints. Although he devoted himself to painting at this time, his style of engraving was continued in the work of his pupils: Jacob Matham, Jacques de Gheyn II, and Jan Saenredam.

Illustrated here is one of the engravings Goltzius executed in Haarlem from the numerous drawings he did during his trip to Italy. It represents the antique statue of Hercules owned by Cardinal Farnese. The sculpture, discovered in the Baths of Caracalla around 1540, was a signed copy by "Glycon after an original by Lyssipos" (Ackley, cat. no. 6). It was restored by Guglielmo della Porta, who replaced the head and the lower legs, which had broken off.

One of the most significant features of this statue is its enormous size. Through his artistry, Goltzius is able to capture the physical presence of this colossal statue. The low viewpoint accentuates the height of the statue, while the two spectators in the lower right corner reinforce the sense of scale. Goltzius enhances the sense of three-dimensionality by vigorously defining the musculature of Hercules. In this print Goltzius has successfully taken up the challenge of the

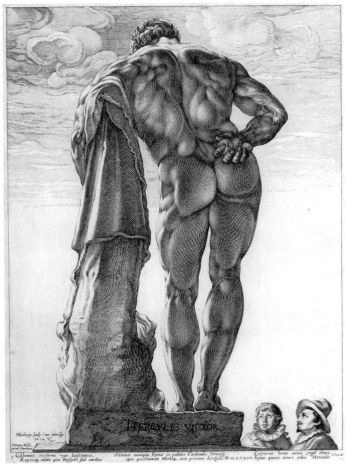

27

antique—the challenge of colossal form—as well as that of his era: to create another wonder of the world.

The date of the print is disputed. An inscription on the print indicates that it was published posthumously in 1617. However, Reznicek (pp. 337, 419) makes a strong case, on the basis of stylistic analysis, for dating the print to the years immediately following Goltzius's return from Italy.

BIBLIOGRAPHY

Ackley, Clifford S. *Printmaking in the Age of Rembrandt.* Boston: Museum of Fine Arts, ca. 1981.

Haverkamp-Begemann, Egbert, with Carolyn Logan. *Creative Copies.* New York: The Drawing Center, 1988.

Hand, John Oliver, J. Richard Judson, William W. Robinson, and Martha Wolff. *The Age of Bruegel: Netherlandish Drawings in the 16th Century.* Washington, D.C.: National Gallery of Art, and [New York]: Cambridge University Press, 1986.

Reznicek, Emil Kavel Josef. *Die Zeichnungen von Hendrick Goltzius.* Utrecht: Haentjens Dekker and Gumbert, 1961.

ATHANASIUS KIRCHER
German, 1602–80

28 *Oedipi Aegyptiaci*

Volume 3: *Theatrum Hieroglyphicum*
Rome, Vitalis Mascardi, 1654
Illustrated book
35.2 x 24.2 x 6.4 cm. (13⅞ x 9½ x 2½ in.)
Dartmouth College Library, Hanover,
 New Hampshire
Acc. no. Rare Book PJ/1093/K57

Oedipi Aegyptiaci is a grandiose work. Almost two thousand pages long, it was the culmination of Kircher's life-long fascination with Egyptian hieroglyphics. His interest in this subject began with his studies of the Coptic language, undertaken while he was a young man living in Germany. These studies led him to a meeting with Nicolas Claude Fabri de Peiresc, who had a famous collection of antiquities; when Kircher entered Rome he had in his possession a great many Egyptian objects presented to him by the French collector. The core of what was to become Kircher's own museum, these items prompted him to investigate the meaning of Egyptian hieroglyphs. In the course of his long life, the Jesuit priest published more than nine books on the subject; but despite all these mental wanderings, his efforts did not compare with that of Oedipus in cracking the riddle of the sphinx. However, Kircher thought he had uncovered the secret meaning of this ancient writing. As he saw them, hieroglyphs were symbols or signs that expressed the theological teachings of the Egyptians. Not knowing that hieroglyphs are a combination of ideographs and phonetic signs (a fact that would not be discovered until the nineteenth century), his translations were completely erroneous.

Many of Kircher's contemporaries were skeptical of his claims to having unlocked the mystery of hieroglyphs; on the other hand, there were a great many others who saw him as the expert in this field of study. Pope Innocent X, for instance, called upon him to translate the hieroglyphs on the obelisk surmounting Bernini's fountain in the Piazza Navona. Even though fragments of the obelisk were lost, Kircher was able to supply the missing parts, he said, because the Holy Spirit had given him the key to the inscriptions (Reilly, p. 59).

Notable among Kircher's supporters were the Habsburg emperors. Ferdinand II paid generous sums for the production of *Oedipi Aegyptiaci*, and it is to him that the book is dedicated. As a result of the imperial benefices, Kircher was able to hire the finest

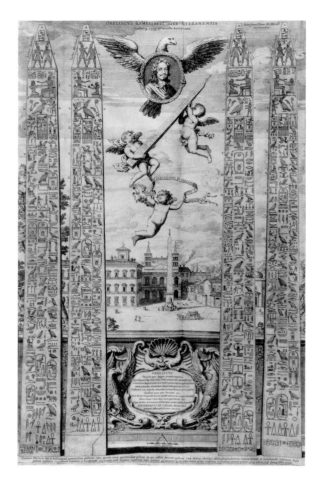

28 An obelisk—view of its four sides. Engraving.

engravers and printers for the work. Although worthless as a study of the Egyptian language, the *Oedipi* is a triumph aesthetically. Not only does it contain new type fonts for ancient and exotic languages, it is also embellished with superb engravings of obelisks, mummy cases, and other artifacts of ancient Egyptian culture. One of these is an impressive foldout image of mummy cases. Another large foldout shows the four sides of the obelisk erected in the piazza before San Giovanni in Laterano. In a most effective way, the engraving conveys the impressive size of this monument, the largest—over 105 feet high—of the obelisks in Rome.

Kircher's history of the wonders and mysteries of ancient Egypt was one of his proudest achievements. It included a great deal of information about the exotic Egyptian objects in his own collection, and when Sepi published the catalogue of the Museo Kircheriano, it was listed among the contents.

254

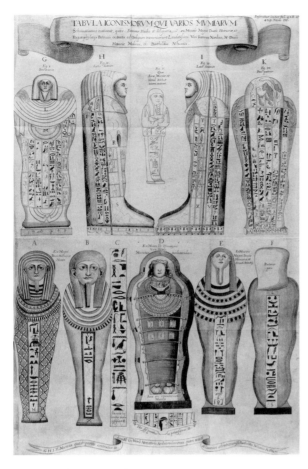

28 Mummies. Engraving.

BIBLIOGRAPHY

Godwin, Joscelyn. *Athanasius Kircher. A Renaissance Man and the Quest for Lost Knowledge*. London: Thames and Hudson, 1979.

McCracken, G. E. "Athanasius Kircher's Universal Polygraphy." *Isis* 39 (1952): 385ff.

Pope, Maurice. *The Story of Archaeological Decipherment from Egyptian Hieroglyphics to Linear B*. New York: Charles Scribner's Sons, 1975.

Reilly, P. Conor, S. J. *Athanasius Kircher S. J.: Master of a Hundred Arts*. Wiesbaden and Rome: Edizioni del Mondo, 1974.

Rivosecchi, Valerio. *Esotismo in Roma Barocca, Studi sul Padre Kircher*. Rome: Bulzoni Editore, 1982.

CORNELIUS BELLEKIN
Dutch, active second half of 17th century

29 *Nautilus Cup*

ca. 1680
Carved and engraved nautilus shell with silver-gilt mounts; accompanying box
Vienna mark from 1699 and maker's mark "MA" on mounts
Shell: 24.3 x 18.7 x 9.5 cm. (9⅝ x 7⅜ x 3¾ in.)
Mounted: H: 23.1 cm. (9¹³⁄₁₆ in.); DIAM. of base: 8.9 cm. (3½ in.)
Box: 29.2 x 21.6 x 11.4 cm. (11½ x 8½ x 4½ in.)
Royal Ontario Museum, Toronto
Acc. no. 988.254.1.1–3

This decorative cup, like the snail in the following entry (cat. no. 30), is fashioned from the shell of the chambered nautilus (*Nautilus pompilius*), a marine animal that lives in Indo-Pacific waters, especially in the rim of the western Pacific Ocean. Brought to Europe by sailors and explorers, nautilus shells were avidly sought by collectors who would sometimes pay several thousand dollars for a single specimen (Segal, p. 77). These marvels of nature were not only exceptionally beautiful, but also had a curious internal structure (a series of chambers formed in logarithmic progression), which made them especially appealing to the collectors who had scientific interests and who, furthermore, saw in such forms a confirmation of the mystical numerological dimensions of the natural world. Wealthy collectors often had their treasured nautilus shells set in elaborate gold or silver mounts; in other instances the shells were engraved and enhanced with painted decoration.

This engraved cup is the work of Cornelius Bellekin, an Amsterdam artist who specialized in the painting and engraving of shells. Mounted on a silver-gilt foot, the shell has been carved on its front and back ends with delicate curving grapevines and clusters of fruit, perhaps alluding to the liquid the vessel was intended to contain. The broad sides of the shell feature finely engraved scenes, rubbed with black pigment. These two scenes illustrate favorite marine subjects drawn from ancient mythology: the marriage of Poseidon and Amphitrite and the birth of the goddess of love, Venus, from the sea. The choice of these subjects, with their themes of love and marriage, suggests that this was designed as a wedding cup. Indeed, a celebratory mood is conveyed by the trumpeting Tritons and by the many naiads, dolphins, and other sea creatures that populate the two scenes. The natural luster of the mother-of-pearl has been

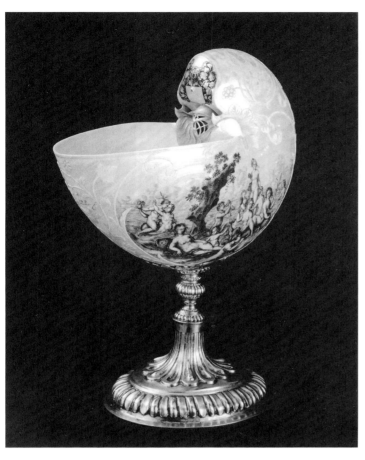

29

European Silver. Trans. P. S. Falla and Anna Somers Cocks. New York: Vendome Press, 1986.

Peelen, J. C. E. "Bellekin (Belkin, Bellequin) Cornelius." *Allgemeines Lexicon der Bildenden Künstler.* Vol. 3. Ed. Ulrich Thieme and Felix Becker. Leipzig: Wilhelm Engelman, 1909, pp. 241–42.

Segal, Sam. *A Prosperous Past: The Sumptuous Still Life in the Netherlands 1600–1700.* Ed. William B. Jordan. The Hague: SDU Publishers, 1988.

Stix, Hugh and Marguerite, and Robert Tucker Abbott. *The Shell: Five Hundred Million Years of Inspired Design.* New York: Harry N. Abrams, Inc. [1968].

JEREMIAS RITTER
German, 1582–1646

30 *Snail with Nautilus Shell*

Nuremberg, ca. 1630
Nautilus shell, enamel, silver gilt
19.7 x 26.7 cm. (7¾ x 10½ in.)
Wadsworth Atheneum, Hartford, Connecticut
Gift of J. Pierpont Morgan
Acc. no. 1917.260
Venue: DC

The artist of this work is assumed to be Jeremias Ritter, who became a master craftsman in Nuremberg in 1605–6. Ritter's work, however, is often difficult to distinguish from that of his son, Christoph III, who was an apprentice to his father and who for a period of time used Jeremias's maker's mark.

A superb example of baroque craftsmanship, this object is formed of a nautilus shell, the back part of which has a pattern of cut-out stripes. Ingeniously, the artist has transformed the shell of the marine animal into the shell of another animal, the snail. This type of visual pun was widely admired in the late sixteenth and seventeenth centuries as a demonstration of the artist's wit and of his ability to make clever use of natural materials. The contemporary fascination for the exotic and for the wondrously small is seen in the miniature figure of the Moor, who is shown riding on the snail's back. He holds a bow in his right hand and in his left the tiny reins, which are wound around the frontal horns of the snail. The realistic treatment of the snail's body adds considerably to the work's charm and gives the impression that the animal is gliding along in a lively, undulating motion.

heightened by polishing, and in a particularly ingenious way Bellekin has exploited "the built-up layers of the nacre radiating from the center of the shell to suggest rays of sunlight bursting down upon each scene."* At the top of the shell, the artist delicately engraved a knight's helmet and shield. The hole below this decoration very likely was outfitted with a silver family shield. The beautifully designed cup no doubt was considered a treasured item, for it was given its own special protective case, which is covered in fine brown leather, with gold tooling, and is lined with purple velvet and gold braid.

* Dr. Howard Creel Collinson of the Royal Ontario Museum kindly provided the relevant information about this work.

BIBLIOGRAPHY

Dance, S. Peter. *Shell Collecting: An Illustrated History.* Berkeley: University of California Press, 1966.

Müller, Hannelore. *The Thyssen-Bornemisza Collection,*

BIBLIOGRAPHY

Guide to the Loan Exhibition of the J. Pierpont Morgan Collection. New York: Metropolitan Museum of Art, 1914.

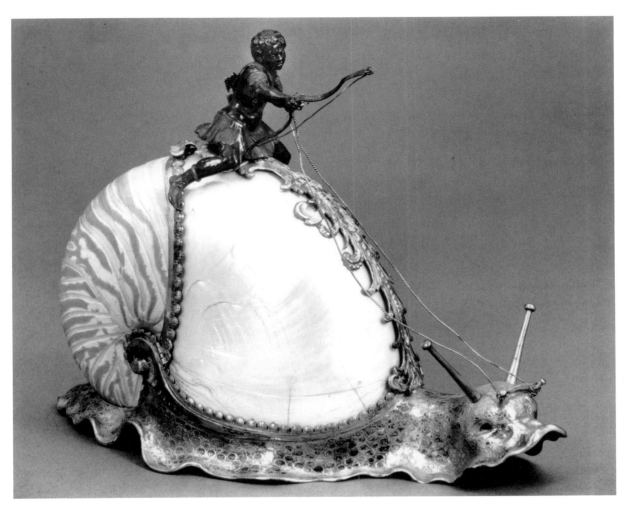

30

Roth, Linda Horvitz, ed. *J. Pierpont Morgan, Collector:
European Decorative Arts from the Wadsworth Atheneum.*
Hartford: Wadsworth Atheneum, 1987. Esp. p. 88.
Wadsworth Atheneum Handbook. Hartford: Wadsworth
Atheneum, 1958.

HANS I CLAUSS
German, d. 1671

31 *Ostrich Egg Ewer*

Nuremberg, ca. 1630
Ostrich egg with silver-gilt mounts
H: 49.5 cm. (19½ in.)
Wadsworth Atheneum, Hartford, Connecticut
Gift of J. Pierpont Morgan
Acc. no. 1917.272
Venue: DC

This diverting and splendidly crafted ewer in the
shape of an ostrich was made by Hans I Clauss, master
goldsmith from the German city of Nuremberg.
Fashioned of gilded silver and an ostrich egg, the bird
has a detachable head and is shown with a rock in his
right claw and a horseshoe in his beak. He stands on
a two-tiered socle that features exquisite filigree ap-
plications and miniature figures of animals (a lobster,
frog, lizards, and snail), some of which, in the tradi-
tion of the Nuremberg goldsmith Wenzel Jamnitzer,
have been cast from nature (Roth, p. 94). Clauss's
vessel, which may have been designed as a container
for wine, is one of the finest objects of its type, espe-
cially in its lavish use of gold and its highly naturalistic
effects. The artist has perfectly captured the bird's
aggressive yet wary posture and in a thoroughly con-
vincing manner has simulated the rough skin of its
legs and its fluffy plumage.

Ewers and cups composed of ostrich eggs had wide

257

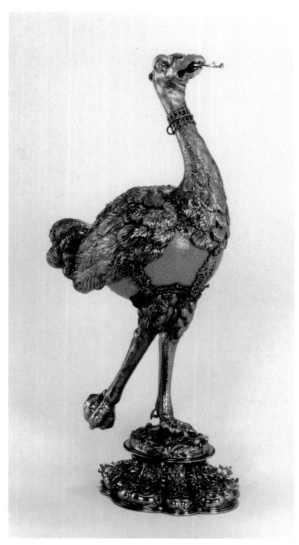

31

the time were skeptical about this latter remarkable ability (ostriches neither digested nor expressed interest in iron, according to their observations), the legend was repeated throughout the seventeenth century in much of the medical literature and other "scientific" texts.

BIBLIOGRAPHY

Art of the Renaissance Craftsman. Cambridge, Mass.: Fogg Art Museum, 1937.

Guide to the Loan Exhibition of the J. Pierpont Morgan Collection. New York: The Metropolitan Museum of Art, 1914.

Jones, E. Alfred. *Catalogue of the Gutmann Collection of Plate now the property of J. Pierpont Morgan, Esquire*. London: Bemrose and Sons, 1907.

Laufer, Berthold. *Ostrich Egg-Shell Cups of Mesopotamia and the Ostrich in Ancient and Modern Times*. Chicago: Field Museum of Natural History, 1926.

Thorndike, Lynn. *A History of Magic and Experimental Science*. 8 vols. New York: Columbia University Press, 1923–58. Esp. vol. 5, p. 647; vol. 6, p. 220; vol. 7, pp. 243, 329; vol. 8, p. 632.

HANS MULLER
German, active second half of the 17th century

32 *Coconut Goblet*

ca. 1600
Coconut and silver gilt
H: 29.3 cm. (11½ in.)
Busch-Reisinger Museum, Harvard University, Cambridge, Massachusetts
Purchase in memory of Eda K. Loeb
Acc. no. BR61.58a,b

appeal in the late sixteenth and seventeenth centuries, especially when, as in this instance, they exhibited technical virtuosity and made clever use of the natural material. The large eggs sometimes were thought to come from the griffin or phoenix and were believed to have magical powers; alternatively, they were taken as a symbol of the virgin birth. Clauss's ewer would also have aroused interest because of its references to the ostrich's legendary peculiarities. An animal known for its combative nature and reputed to have the power of warding off poison, it holds the rock in its claw as a symbol of watchfulness. The horseshoe, on the other hand, alludes to the belief that the ostrich, owing to its hot temperament or to some unknown marvelous property of its stomach, was capable of digesting iron. Even though many writers of

Coconuts mounted in silver and used as goblets or cups are known to have been made by Europeans as early as the thirteenth century. Such objects did not become fashionable, however, until the sixteenth century, when greater numbers and varieties of coconuts were imported to Europe from distant tropical lands. Of the new varieties those originating from the Seychelles islands were valued especially for their rarity, their great size, and their supposed effectiveness against poison. Wonders of the first rank, they were fashioned into ewers and cups (for example, those made for Rudolf II) or, as in the case of Philipp Hainhofer's famous *Kunstschrank*, were incorporated into the design of large decorative works. The shape and imperviousness of the coconut shell made it an ideal material for drinking vessels. Moreover, because the

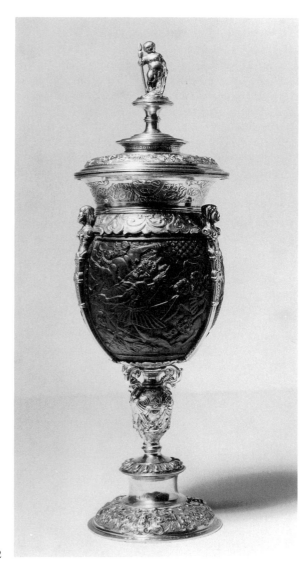

32

ary feats: carrying the doors of Gaza, slaying the lion with his bare hands, and battling the Philistines. Not surprisingly, the stories of Samson, like those of the mythical Hercules, were favorite subjects of Renaissance and baroque art. Samson's remarkable deeds and his prodigious physical strength appealed to Europeans' sense of wonder, specifically to their interest in extraordinary human accomplishment and in those figures who were larger than life.

BIBLIOGRAPHY

Kuhn, Charles L. *German and Netherlandish Sculpture 1280–1800: The Harvard Collections.* Cambridge, Mass.: Harvard University Press, 1965. Esp. no. 50, pp. 95–96.

Fritz, Rolf. *Die Gefässe aus Kokosnuss in Mitteleuropa: 1250–1800.* Mainz: P. von Zabern, 1983.

Kunsthistorisches Museum, Vienna. *Prag um 1600: Kunst und Kultur am Hofe Kaiser Rudolfs II.* Vol. 2. Freren: Luca Verlag, 1988. Esp. nos. 686, 687.

Parke-Bernet Galleries, New York. *Valuable Objects of Art . . . from the Collection Formed by the Late Edward J. Berwind.* Sale no. 139. November 10, 1939. Esp. lot no. 393, pp. 109–10.

German

33 *Carved Rhinoceros Horn Cup*

Augsburg, mid-17th century
Rhinoceros horn and ivory with silver-gilt and gold
 mounts, amethysts, and turquoise
38 x 35 cm. (15 x 13¾ in.)
Ruth Blumka Collection, New York

This extraordinary cup probably was produced in Augsburg around the middle of the seventeenth century. An object that would have been admired both for its artistic ingenuity and its marvelous natural materials, it compares in several ways to a covered cup made of rhinoceros horn that once was part of the *Kunstkammer* of the Elector of Saxony in Dresden. The Augsburg vessel, its cover, and its base have been fashioned from rhinoceros horn, a material that was valued for its magical powers, especially as an antidote to poison. An ivory stem, carved in the shape of an embracing couple, supports the vessel, while little ivory figures of a dog and a nude woman with a quiver decorate the top edge of the vessel and the cover, respectively. The entire ensemble is enriched with silver-gilt and gold mounts, amethysts, turquoise, and delicate bands of filigree enamel.

The iconography of the cup centers on the theme of hunting: all sorts of exotic animals—a monkey, a

shell takes a high polish and is carved easily, cups and other vessels made from it could be fashioned into highly decorative objects.

This goblet has been attributed to Hans Müller, a goldsmith who worked in Breslau during the years 1588–1606. The base and framework of the cup as well as its lid are fashioned of gilded silver and are decorated with reliefs of birds, animal heads, seashells, mask-like faces, and various scroll and plant forms. The goblet's cover is adorned with a little cupid who, with his shield, sword, and armor, perhaps signifies love as conqueror. The note of triumph conveyed by this figure complements the scenes of heroic struggle carved in relief on the coconut. Here the biblical figure Samson is shown engaged in three of his legend-

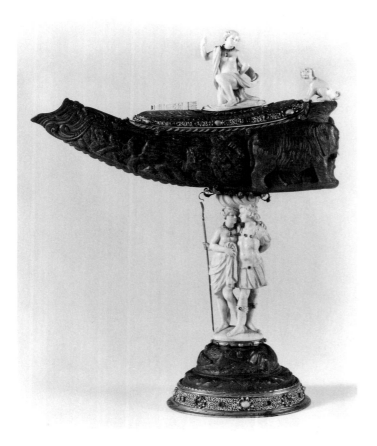

33

elephant uses his tusk to combat the figure of the horned rhinoceros. This contest between the two animals may also reflect what seems to have been a subject of some interest in the seventeenth century. For instance, when in 1637 the members of the Royal Society in England sent out questionnaires to various authorities on the natural sciences, one of the questions they sought to have answered was "whether the rhinoceros have such an antipathy against elephants as is commonly related" (cited in Thorndike, vol. 8, p. 257).

BIBLIOGRAPHY

Honour, Hugh. *The European Vision of America*. Cleveland: The Cleveland Museum of Art, 1975. Esp. no 110.

Rathke-Köhl, Sylvia. *Geschichte des Augsburger Goldschmiedegewerbes vom Ende des 17. bis zum Ende des 18 Jahrhunderts*. Augsburg: Vorwort, 1964.

Sponsel, J. L. *Das Grüne Gewölbe zu Dresden: eine Auswahl von Meisterwerken der Goldschmiedekunst*. 4 vols. Leipzig: K. W. Hiersemann, 1925–32 Esp. vol. 4, p. 154.

Thorndike, Lynn. *A History of Magic and Experimental Science*. Vol. 8. New York: Columbia University Press, 1958.

German
Silversmith: Jörg Ruel

34 *Agate Standing Cup Carved as a Shell*

Nuremberg, early 17th century
Agate with gilt mounts
H: 21.7 cm. (8½ in.)
The Minneapolis Institute of Arts, Minneapolis, Minnesota
The Lillian Z. Turnblad Fund
Acc. no. 53.5
Venue: DC

pair of fighting leopards, an elephant, a rhinoceros— have been carved in relief on the horn, while the ivory figure of the woman surmounting the piece can be identified as the huntress Diana. The ancient goddess, who once held a bow in her hand, has set her quiver aside and, accompanied by one of her hounds, is shown resting after her exertions.

The identity of the young couple forming the cup's stem is more difficult to determine. Given the female's resemblance to the figure on the cover, however, she might be Diana in her other guise, as the goddess of the moon. Each night, according to legend, the goddess visited the beautiful Endymion and embraced him in his eternal sleep. As the story sometimes is represented in the visual arts, Endymion is shown awake, welcoming Diana's loving embrace.

The cup has yet another feature that would have elicited an admiring response from seventeenth-century observers. At the widest end of the horn, the artist has given the elephant a tusk made of its own ivory. In a witty allusion to the combination of ivory and rhinoceros horn in the cup as a whole, the

One of the most highly esteemed crafts of the late Renaissance and baroque periods was the carving of vessels or decorative objects from hard stones. The finest works demonstrated the artisan's ability to overcome the obduracy of the natural material and, depending on the type of stone, to make ingenious use of its colored striations or patterns. The standing cup exhibited here is a beautiful example of this challenging and difficult craft. Identified as the work of Jörg Ruel, it consists of three separate pieces of agate set in gilt mounts. The bowl of the cup has been carved as a shell and is decorated with the miniature head of a ferocious lion and a twin-tailed mermaid,

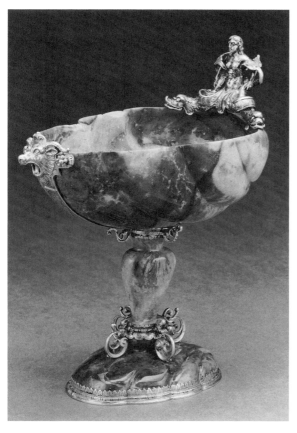

34

Spanish

35 *Chalice*

Padul, 1650
Inscribed: SACRE CARTVSIAE PADVLAE. 1650
Human skull, copper-gilt base
H: 26 cm. (10¼ in.)
Michael Hall, Esquire, New York

This chalice or cup, as the inscription on its base indicates, was made in 1650 for the Order of Carthusian monks in Padul, Spain.* Nothing is known about this work's history or the specific reasons for its manufacture, but the inscription connecting it with the Carthusians suggests that it was designed as a chalice, or vessel for the consecrated wine of Holy Communion. An unusual object, it consists of two parts: a stem and base of gilt-copper, and a bowl fashioned from a human skull. The skull is a traditional symbol of death. In this instance it would have referred specifically to Golgotha ("the place of the skull"), where Christ was crucified, and also to the

35

the latter being one device of the city of Nuremberg (Hayward, p. 385).

Apart from its beauty, this standing cup may have been valued for the marvelous properties often associated with agate. Powdered agate was said to cure people who had been poisoned; because its virtues were derived from celestial bodies, agate was said to bestow charm upon its wearer. In the late seventeenth century the British chemist and physicist Robert Boyle (1627–91) saw no reason to doubt the long-held belief that agate, when worn about the neck, checked bleeding. Finally, as noted in the 1683 proceedings of the German Academiae Naturae Curiosorum, a certain type of agate was known to be an aphrodisiac.

BIBLIOGRAPHY

Hayward, John Forrest. *Virtuoso Goldsmiths and the Triumph of Mannerism, 1540–1620*. New York: Rizzoli International, 1976.

Thorndike, Lynn. *A History of Magic and Experimental Science*. 8 vols. New York: Columbia University Press, 1923–58. Esp. vol. 5, p. 478; vol. 8, pp. 175, 247, 268, 330.

legend that the Cross rested on the skull and bones of Adam. If used for the service of the Eucharistic wine ("the blood of the new testament"), the skull would have given powerful immediacy to the meaning of Christ's sacrifice–the sin of Adam is washed away by the redeeming blood of Christ; in Christ's death is eternal life.

Europeans rarely used human bones for either religious or secular objects (except when contained in reliquaries), but very early they heard of such practices in other parts of the world. While visiting the court of Genghis Khan in 1253, William of Rubruk, a Flemish Franciscan, learned that Tibetans made bowls from human crania. Much later, in 1624, a Portuguese Jesuit who visited Tibet gave an account of the local tradition of fashioning the skulls of the dead into *kapala* or drinking cups. Remarkably, a human cranium was put to similar use in the late nineteenth century. After Fr. Brieux, a French missionary priest, died in 1881, his skull was apparently turned into a cup.†

Human skeletal remains frequently were used by Europeans, however, for their supposedly miraculous medicinal virtues. In 1576, for example, the Brescian physician Giovanni Francesco Olmo reported how a little powdered human skull "has wonderful efficacy in routing epilepsy, which too Savonarola used in quartan fever as a great secret" (Thorndike, vol. 6, p. 233). Well into the seventeenth century, in fact, books on medicine and the occult sciences advised using the powder, salts, or oils of human crania for the treatment of epilepsy, nervousness, and other hysterical maladies.

* For information on the Carthusians and their monastery of St. Lawrence in Padul, see the relevant chapter in *Les Ordres religieux*.

† All of this information has been drawn from *Ivory: An International History and Illustrated Survey*. Since no citations are given in the text, the original sources for this information could not be consulted.

BIBLIOGRAPHY

Le Bras, Gabriel, Jacques Hourlier, and M. Cocheril. *Les Ordres religieux, la vie et l'art*. Paris: Flammarion, 1979.

Thorndike, Lynn. *A History of Magic and Experimental Science*. 8 vols. New York: Columbia University Press, 1923–58. Esp. vol. 6, p. 233; vol. 7, p. 509; vol. 8, pp. 137, 147, 523.

Vickers, Michael, et al. *Ivory: An International History and Illustrated Survey*. New York: Harry N. Abrams, Inc., 1987. Esp. p. 279.

Attributed to MELCHIOR DINGLINGER
German, 1664–1731

36 *Dromedary*

Dresden, ca. 1680–1700
Two pearls and gold
H: (with base) 10 cm. (4 in.)
Blumka Gallery, New York

Melchior Dinglinger was one of the most original artists working at the court of August the Strong (1670–1733). His artistic virtuosity and his powers of imagination are evident in this statuette of a dromedary. He has transformed the irregular shapes of natural pearls into a highly refined work of art. Such a surprising use of the pearls would have been cause for delight and wonder. In addition to their value as ornaments, the pearls were perceived as marvelous substances composed in part of celestial dew and having the power to cure "pestilent fevers" and ailments of the heart. The combination of the artist's imagination and the belief in the special properties of the pearl make this dromedary representative of the type of objects highly prized in *Kunstkammern* of the seventeenth century. Of particular interest here is one of the derivations of the word "baroque." Only in the nineteenth century was the word first used to charac-

36

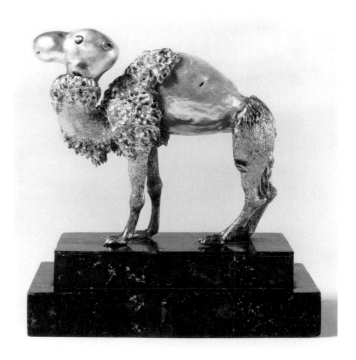

terize the art of the seventeenth century. In Portuguese the *barocco* means a "rough or imperfectly shaped pearl."

BIBLIOGRAPHY

Sutton, Denys. "Works of Art from the Paul Wallraf Collection." *The Connoisseur* (June 1961): 2–14. Esp. p. 12.

Thorndike, Lynn. *A History of Magic and Experimental Sciences*. 8 vols. New York: Columbia University Press, 1923–58. Esp. vol. 7, pp. 196–97, 243–44.

German

37 *Crystal Amethyst Amulet*

17th century
Gold, amethyst, and enamel
H: 4.3 cm. (1¾ in.)
Busch-Reisinger Museum, Harvard University, Cambridge, Massachusetts
Gift of John Davis Hatch in honor and admiration of Philip Hofer
Acc. no. BR83.4

This tiny pendant, an example of the jewelsmith's art, originally would have been worn as a protective amulet. It consists of a miniature skull—a remembrance of death—and an amethyst set in a delicate gold mount. This gem traditionally was believed to

have several occult virtues: it helped to dissipate noxious fumes and, as noted by Giovanni della Porta and Francesco Imperato, freed its bearer from intoxication when worn around the neck or on the navel.

BIBLIOGRAPHY

Thorndike, Lynn. *A History of Magic and Experimental Sciences*. 8 vols. New York: Columbia University Press, 1923–58. Esp. vol. 6, p. 419; vol. 7, p. 248.

German or Spanish

38 *Pendant*

ca. 1500
Coral and pearl with gold and silver-gilt mounts
L: 6.8 cm. (2¹¹⁄₁₆ in.)
The Metropolitan Museum of Art, New York
Gift of Alastair Bradley Martin, 1951
Acc. no. 51.125.6

This coral and pearl pendant was fashioned by either a German or Spanish craftsman, sometime around the turn of the sixteenth century. Made to be worn on a chain around the neck, it would have been valued not only as a decorative ornament, but also for the talismanic powers of its natural materials, especially those associated with red coral. Traditionally coral

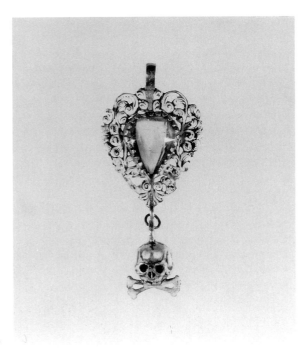

37

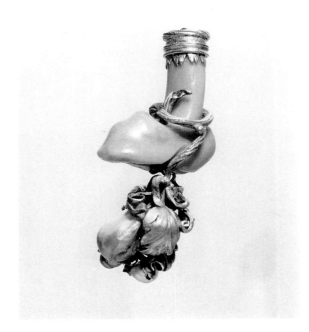

38

was believed to be effective against pestilence, the evil eye, and poisons. In the sixteenth century, as in ancient times, branches of red coral frequently were worn around the neck and hands. The Italian Antonio Brasavola particularly recommended this practice, seeing that it protected boys from fascination, epilepsy, and apoplexy.

BIBLIOGRAPHY

Thorndike, Lynn. *A History of Magic and Experimental Science*. 8 vols. New York: Columbia University Press, 1923–58. Esp. vol. 5, p. 455.

Keith, D. Graeme, et al. *The Triumph of Humanism: A Visual Survey of the Decorative Arts of the Renaissance*. San Francisco: The Fine Arts Museums of San Francisco, 1977.

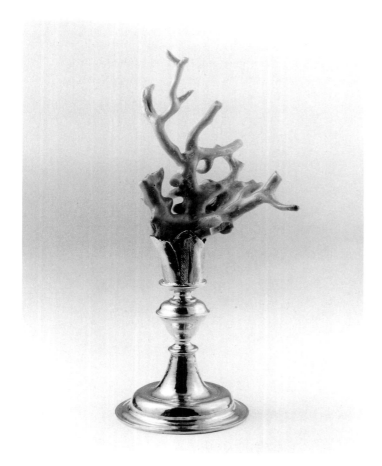

39

German (?)

39 *Mounted Branch of Red Coral*

17th or early 18th century
Red coral with silver gilt
H: 25.5 cm. (10 in.); DIAM. of base: 9 cm. (3½ in.)
Royal Ontario Museum, Toronto
Acc. no. 922.19.26

Owing to its supposed magical powers, coral was commonly displayed in *Kunst- und Wunderkammern*. Branches of the natural material were shown without adornment, or, as in this case, on silver or silver-gilt mounts. Specimens collected by wealthy patrons often became part of exceptionally elaborate and intricately worked compositions made of rock crystal, ostrich eggs, and other natural materials.

BIBLIOGRAPHY

Impey, Oliver, and Arthur MacGregor, eds. *The Origins of Museums*. Oxford: Clarendon Press, 1985. Esp. pp. 26, 32–33, 38, 41–44, 72, 80, 82, 87, 93, 97, 99, 170, 174, 179.

Lugli, Adalgisa. *Naturalia et mirabilia: il collezionismo enciclopedico nelle Wunderkammern d'Europa*. Milan: Gabriele Mazzota editore, 1983. Esp. tav. V.

40 *Rock Crystal Amulet*

ca. 1600
Rock crystal and enameled gold
6 x 5 cm. (2⅓ x 2 in.)
Ruth Blumka Collection, New York

40

Rock crystal was a prized natural material, valued not only for its beauty but also for its supposed ability to ward off the effects of poison. According to Francesco Imperato, "crystal by its frigidity restrains poisonous draughts, and as the celestial rainbow announces coming rain and fair weather, so the crystal may be taken for future adversity or felicity" (Thorndike, vol. 7, p. 248). This protective amulet, fashioned from two pieces of rock crystal, probably was meant to contain other natural materials believed to have magical curative or prophylactic properties. A great variety of *naturalia* were thought to have such powers: bits or pieces of animal bones, seeds of many types, herbal compounds, coral, and even such things as frog's eyes, which were said to relieve a patient's body of tertian fever.

The time and place of this amulet's manufacture is not known. Rock crystal objects were made in many parts of Europe; two of the most famous centers were Milan and the court of Rudolf II in Prague. The smooth cutting of the amulet, however, and its bold, clearly defined facets suggests that it may have been made by an artisan in the circle of Ottavio Miseroni (1567–1624).

BIBLIOGRAPHY

Kunsthistorisches Museum, Vienna. *Prag um 1600: Kunst und Kultur am Hofe Rudolfs II.* Vol. 2. Freren: Luca Verlag, 1988. Esp. cat. no. 705.
Thorndike, Lynn. *A History of Magic and Experimental Science.* 8 vols. New York: Columbia University Press, 1923–58. Esp. vol. 5, p. 560; vol. 7, p. 248.

41 *Sphere*

Rock crystal
DIAM: 9.7 cm. (3⅞ in.)
Michael Hall, Esquire, New York

Crystal spheres have a long history, dating as far back as ancient Rome, where women carried them in the summer to keep their hands cool. In the Middle Ages crystal came to symbolize virginity, chastity, and innocence; and balls fashioned from crystal were believed to have magical influences. (MacGregor, pp. 252–53). A great many of these objects were produced in the sixteenth and seventeenth centuries and were used primarily by those whose activities centered on magic, astrology, and the occult sciences. One of the most famous practitioners of crystallomancy was John Dee (1527–1608), an English mathematician, astronomer, and magician, who instructed Queen Elizabeth I in astrology. In his diary, which was titled when published in 1659, *A True and faithful Relation of what passed for many years between Dr. John Dee and some Spirits, Tending (had it succeeded) to a general alteration of most States and Kingdomes in the World*, he recounts how he had attended a *séance* in which the seer used "a great crystalline globe." One of the spheres in his possession, which he described as a "shewstone . . . most bright, most clere and glorious, of the bigness of an egg" had been given to him, he said, by the child angel Uriel (Tait, pp. 198–207). It can be found today in the British Museum. Rudolf II, whose interests in astrology and the occult are well known, also had many of these crystal balls in his possession. While many people of the time believed

265

41

these objects were useful in divining the future or even, as in the case of some Protestants, in determining the location of hidden treasure, there were others who denounced them as diabolical instruments.

The date and origin of this crystal sphere are not known. Cut from a large piece of rock crystal, it does not have the extraordinary clarity that was particularly desired by collectors or astrologers of the time.

BIBLIOGRAPHY

Firenze e la Toscana dei Medici nell'Europa del Cinquecento: Astrologia, magia e alchimia. Florence: Centro di Edizioni Alinari Scala, 1980. Esp. cat. no. 3.5.18, illus. p. 365.

Kunsthistorisches Museum, Vienna. *Prag um 1600: Kunst und Kultur am Hofe Rudolfs II*. Vol. 1. Freren: Luca Verlag, 1988. Esp. cat. no. 405.

MacGregor, Arthur, ed. *Tradescant's Rarities: Essays on the Foundation of the Ashmolean Museum*. Oxford: Clarendon Press, 1983.

Tait, Hugh. "The Devil's Looking Glass: The Magical Speculum of Dr. John Dee." In W.A. Smith, *Horace Walpole: Writer, Politician, and Connoisseur*. New Haven: Yale University Press, 1967. Esp. pp. 195–338.

Thorndike, Lynn. *A History of Magic and Experimental Science*. 8 vols. New York: Columbia University Press, 1941. Esp. vol. 6, p. 498.

Yates, Francis A. *Theater of the World*. Chicago: The University of Chicago Press, 1969. Esp. chapter 1.

Italian

42 *Cameo: Head of Christ*

Milan, 17th century
Heliotrope (bloodstone)
H: 7.6 cm. (3 in.)
The Metropolitan Museum of Art, New York
The Milton Weil Collection, Gift of
 Ethel S. Worgelt, 1939
Acc. no. 39.22.11

During the sixteenth and seventeenth centuries, bloodstone (or heliotrope) was commonly believed to be an effective agent against bleeding. The British chemist Robert Boyle recommended that the gem be hung around the neck to check nosebleeds, while Johann Lorenz Bausch, a physician and president of the German Academiae Naturae Curiosorum wrote an entire treatise (1665) on its powers in preventing hemorrhage. Such virtues probably were associated with this cameo representing the head of Christ. The little object is also of interest for the way in which the artisan exploited the natural material. By carefully rendering its tiny red flecks in relief, he created an image of the suffering Christ, whose blood was shed for the redemption of mankind.

BIBLIOGRAPHY

Thorndike, Lynn. *A History of Magic and Experimental Science*. 8 vols. New York: Columbia University Press, 1923–58. Esp. vol. 8, pp. 175, 247.

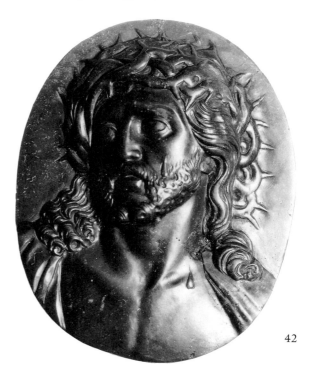

42

Flemish

43A *Hercules and Antaeus*

17th century
Ivory plaque
13.7 x 10.8 cm. (5⅜ x 4¼ in.)
The Nelson-Atkins Museum of Art, Kansas City,
 Missouri
Gift of Mr. and Mrs. Jack Linsky
Acc. no. 59−75/1

Flemish

43B *Hercules, Deïaneira, and Nessus*

17th century
Ivory plaque
14 x 10.5 cm. (5½ x 4⅛ in.)
The Nelson-Atkins Museum of Art, Kansas City,
 Missouri
Gift of Mr. and Mrs. Jack Linsky
Acc. no. 59−75/2

43A

Since ancient times, ivory has been used in the fashioning of decorative objects, luxury items, and sculpture. A natural material treasured for its beautiful color and fine-grained, sensuous texture, it has a hard-elastic quality that makes it easy to cut or carve, polish, and work on the lathe. The production of works in ivory declined during the Renaissance when bronze, wood, and marble became the preferred materials for sculpture and when attention shifted to the making of large-scale works, especially those for public display. Late-sixteenth-century Europe saw a resurgence of this art, however, when the supplies of ivory from Africa and India increased and when the taste for small, ingeniously carved items—objects for private appreciation—became widespread. Statuettes, reliefs, tankards, and decorative pieces rendered in ivory were produced in large numbers and put on display in cabinets of rarities and *Kunst- und Wunderkammern*. Princes and wealthy patricians especially collected such works, valuing them not only for their aesthetic beauty, but also sometimes for the presumed prophylactic properties of the natural material (ivory commonly was believed to be an effective antidote to poison).

These handsome ivory plaquettes have been attributed by Theuerkauff (1983, p. 34) to an artist influenced by David Heschler (1611−67), a Fleming who specialized in ivory work and who had a workshop in the southern German city of Ulm. They may even be by Heschler himself. Bold and lively in their execu-

43B

267

tion, the reliefs show two of the adventures of Her-
cules: his wrestling match with the giant Antaeus,
and his rescue of Deïaneira from the satyr Nessus. In
the first of these, Hercules is shown squeezing the life
from Antaeus, who was invincible so long as he
touched the earth, his mother Terra. While the giant
struggles to get free, Hercules, standing in a graceful
contrapposto pose, carries out his feat effortlessly. In
the second relief, the action is much more dramatic.
The satyr's attempted rape of Deïaneira is foiled by
Hercules, who in a single powerful motion pulls his
wife free and raises his club against his adversary. As
Theuerkauff has observed, the two reliefs are indi-
rectly inspired by Italian art (1983, p. 34). While the
Hercules and Antaeus brings to mind any number of
sixteenth-century Italian statues, the Hercules and
Deïaneira ultimately derives from Bernini's famous
sculpture of Pluto and Persephone.

These reliefs may have belonged to a series showing
the labors and other exploits of Hercules. Moreover,
given their fine craftsmanship and their finish, it is
likely that they were meant to adorn a *Kunstschrank*,
or type of treasure chest that became popular in the
late sixteenth and seventeenth centuries.

BIBLIOGRAPHY

Coe, Ralph T. "Small European Sculptures." *Apollo* 96, no.
130 (December 1972): 521–23, illus. no. 20.
Taggart, Ross E. *The Gods of High Olympus*. Kansas City:
Nelson-Atkins Museum of Art, 1983. Esp. p. 15, nos. 57 and
60.
Taggart, Ross E., and George L. McKenna, eds. *Handbook
of the Collections in the William Rockhill Nelson Gallery of
Art and Mary Atkins Museum of Fine Arts*. Vol. 1 (Art of
the Occident). Kansas City: Nelson-Atkins Museum of
Art, 1973. Esp. p. 123, illustration.
Theuerkauff, Christian. *Die Bildwerken in Elfenbein des 16.-19
Jahrhunderts*. Berlin: Staatliche Museen Preussischer
Kulturbesitz, 1986.
Theuerkauff, Christian. "Fragen zur Ulmer Kleinplastik im
17./18. Jahrhundert—1. David Heschler (1611–1667) und
sein Kreis." *Alte und Moderne Kunst* 190/191 (1983): 33–34,
illus. no. 28.
Vickers, Michael, et al. *Ivory: An International History and
Illustrated Survey*. New York: Harry N. Abrams, Inc.,
1987.

Flemish

44 *Rosary Bead: Crucifixion and Resurrection*

ca. 1500
Boxwood
DIAM: 5 cm. (2 in.)
The Walters Art Gallery, Baltimore, Maryland
Acc. no. 61.132

This rosary bead or prayer nut, as it is sometimes
called, is a most extraordinary example of Netherlan-
dish craftsmanship. On a bead not more than two

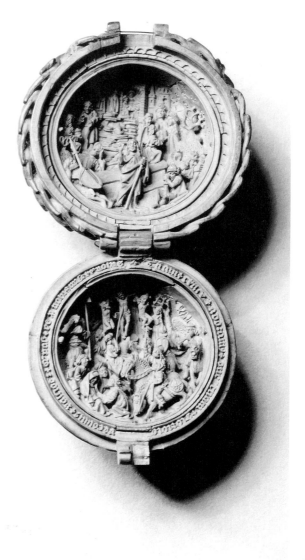

44

inches in diameter the artist has rendered two episodes from the Passion of Christ: the Crucifixion and the Resurrection. The degree of detail achieved in these multifigured scenes seems to defy the size of the object. Fascination with minute forms, and particularly with minute forms of life, was just as strong in the sixteenth and seventeenth centuries as it was in antiquity. Vasari wrote about the micro-sculptures carved in antiquity from small nuts, like walnuts, and from the stones of cherries. Poets wrote odes to fleas. The interest in these minute sculptures and forms of life is related to the belief that God's wisdom, the beauty and complexity of his design, is clearly evident even in the smallest particles of life. Micro-sculptures such as this prayer nut were objects prized in *Kunst-und Wunderkammern* for their artistic virtuosity.

BIBLIOGRAPHY

Lugli, Adalgisa. *Naturalia et mirabilia: il collezionismo enciclopedico nelle Wunderkammern d'Europa*. Milan: Gabriel Mazzotta editore, 1983. Esp. tav. V, pp. 115, figs. 70, 72.

Schrader, J. L. *The Waning Middle Ages: An Exhibition of French and Netherlandish Art from 1350 to 1500*. Lawrence: University of Kansas Museum of Art, 1969.

German (Upper Rhine)

45 *Flayed Figure*

ca. 1600–50
Lindenwood
H: 27 cm. (10⅝ in.)
Busch-Reisinger Museum, Harvard University, Cambridge, Massachusetts
Purchase, Association Fund
Acc. no. BR59.33

This statuette, carved from a single piece of wood, belonged originally to a set of eight figures personifying Death. Figurines of this type first were made in the early sixteenth century, but representations of Death as a skeleton or cadaver have a much longer history, dating back to the thirteenth century. During the Renaissance and baroque periods, these statuettes were designed as collectors' pieces and displayed in cabinets as reminders of the transience of earthly life. A work such as the one exhibited here, however, would also have been appreciated for its virtuosity, specifically for its meticulous rendering of details. The artist of this piece, most likely a sculptor from the Upper Rhine, has represented all the gruesome aspects of a decomposed cadaver: flesh tears away

from the body to expose parts of the skeleton, and snakes are shown winding through and around the figure's trunk and limbs. Because the figure has been rendered with the view to achieving a high degree of realism, its effect on the beholder is especially shocking. Horrific as it is, the statuette has a strange beauty. The pose of the figure is languid and graceful, while the decayed flesh exhibits a beautiful smoothness and surface sheen.

According to Kuhn (p. 101), this figure of Death probably once was outfitted with a bow and arrows and perhaps a spade. Weapons were familiar attributes of death, while implements such as the spade or hoe alluded to Adam, who, by sinning, brought death to the world. Man's first sin is symbolized here by one of the snakes: wound about one of Death's legs, it is shown with an apple in its mouth.

BIBLIOGRAPHY

Kuhn, Charles L. *German and Netherlandish Sculpture 1280–1800: The Harvard Collections*. Cambridge, Mass.: Harvard University Press, 1965. Esp. no. 55, pp. 101–3.

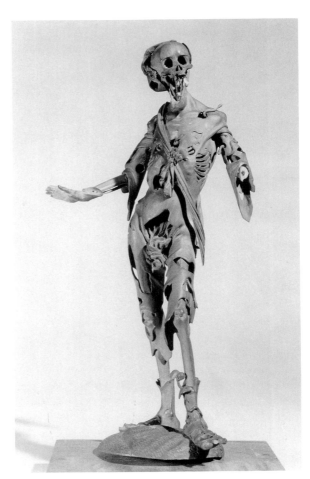

45

German

46 *Apollo and Daphne*
(after the marble statue by Gian Lorenzo
Bernini in the Galleria Borghese, Rome)

17th century
Boxwood
H: 39.7 cm. (15⅝ in.)
The Nelson-Atkins Museum of Art, Kansas City,
 Missouri
Gift of Mr. and Mrs. Milton McGreevy through the
 Mission Fund
Acc. no. F.61−39

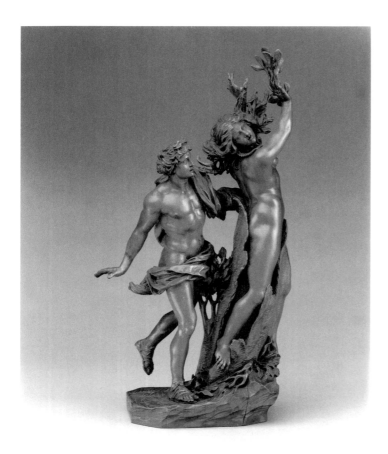

46

This boxwood statuette is a small-scale version of
Gian Lorenzo Bernini's *Apollo and Daphne*, a marble
sculpture made between the years 1622 and 1625. Both
works illustrate a story from Ovid's *Metamorphoses*:
the pursuit of Daphne by Apollo, and Daphne's even-
tual metamorphosis into a laurel tree. The story, like
many others from Ovid's epic poem, was immensely
popular in the late sixteenth and seventeenth cen-
turies; but of all the painted and sculpted images of
it, Bernini's was by far the most remarkable. On ac-
count of its extraordinary illusionistic qualities, its
lively movement, and its technical virtuosity, the
statue was hailed as one of the great marvels of the
age. Everyone in Rome rushed to see it when it was
finished, and for many at the time, as Baldinucci
relates, it was nothing less than "a miracle of art"
(p. 284).

The fame of such a work inspired the production
of replicas, portable and miniature versions that paid
homage to the original but that could also be ap-
preciated as objects in their own right. This boxwood
statuette, fashioned by an unknown German sculp-
tor, is a particularly fine example of this widespread
practice. The artist has replicated quite faithfully both
the general impression of Bernini's group and its
smaller details — Apollo's sandals, the bark of the tree
trunk, Daphne's flying ropes of hair, and the leaves
that sprout from her fingers, for instance. An object
that most likely was intended for a collector's cabinet,
the *Apollo and Daphne* was a charming substitute in
wood for the marvel that was in Rome.

BIBLIOGRAPHY

Baldinucci, Filippo. *Notizie dei Professori del Disegno* (1682).
 Ed. F. Ranelli. Florence: V. Batelli e compagni, 1846.
 Reprint (7 vols.). Florence: Eurografica, 1974−75. Esp.
 vol. 4.
Coe, Ralph T. "Small European Sculptures." *Apollo* 96, no.
 130 (December 1972): 519−23. Esp. p. 514, illus. no. 4.
Taggart, Ross E., and George L. McKenna, eds. *Handbook
 of the Collections in the William Rockhill Nelson Gallery of
 Art and Mary Atkins Museum of Fine Arts.* Vol. 1 Kansas
 City: Nelson-Atkins Museum of Art, 1973. Esp. p. 123,
 illustration.
Taggart, Ross E. *The Gods of High Olympus.* Kansas City:
 Nelson-Atkins Museum of Art, 1983. Esp. p. 12, no. 35, and
 p. 22, illustration.

Attributed to ORAZIO FONTANA
Italian, 1512−97

47 *Majolica Bottle in the Form of a Pilgrim
Flask with Scenes of Pluto and
Persephone and Sea Nymphs*

16th century
Polychromed glazed ceramic
H: 42 cm. (16½ in.)
Spencer Museum of Art, The University of Kansas,
 Lawrence
Acc. no. 60.76

During the course of the sixteenth century, the quality of majolica (or maiolica) produced in Italy reached a new level of artistic virtuosity and sophistication. With the introduction of motifs from monumental, narrative art in the second decade of the century, majolica became a surface receptive to the artistic innovations of High Renaissance and mannerist art. The combination of the artistic skills required by the process and the introduction of narrative art played a significant role in changing the way majolica was appreciated. It was no longer simply a decorative utilitarian object, but had been transformed into a highly prized object of art. Twenty-six pieces of majolica ware, reclassified from the category of functional objects, were displayed in the *Kunstkammer* of Albrecht V. It was collected by Isabella d'Este, the Medici family, and the duke of Urbino as well as by aristocrats and ecclesiastical princes. It was even deemed a worthy gift to Philip II of Spain by the duke of Urbino.

Majolica pottery was highly prized for several reasons. First, the process demanded a high degree of skill. The artist had to be a master draughtsman because each touch of the artist's brush was instantly and permanently recorded in the metal-oxide glazes. Second, the artistic process, which included three firings under carefully controlled conditions, involved a complete transformation of common clay into an object that has the appearance of precious metal.

It is not altogether clear how the technique was transmitted to Italy. Primitive, yet related, techniques were already in use throughout Italy in the eleventh to twelfth centuries. The greatest impetus for producing majolica, as it was known from the High Renaissance on, came from Islam via Spain and, in particular, the Spanish island of Majorca. During the fifteenth century this Hispano-Moresque pottery was imported to Italy and was also directly commissioned from local artisans by Italian patrons, such as the Medici and Borgia families. Majolica was produced primarily in the regions of Tuscany, Umbria, and the Emilia-Romagna. Especially in Urbino, around 1520, artisans making majolica began to adopt motifs from the monumental, narrative art of Raphael, Giulio Romano, Rosso Fiorentino, and Baccio Bandinelli, among others.

The pilgrim flask exhibited here is attributed to Orazio Fontana, who worked in Urbino in the 1560s. He continued the tradition of *istoriato* ware practiced by his father, Guido Durantino, in Urbino as early as 1520. Favorite motifs were grotesques inspired by the work of Raphael and the mythological subjects of Ovid's *Metamorphoses*. Here we see how the sculp-

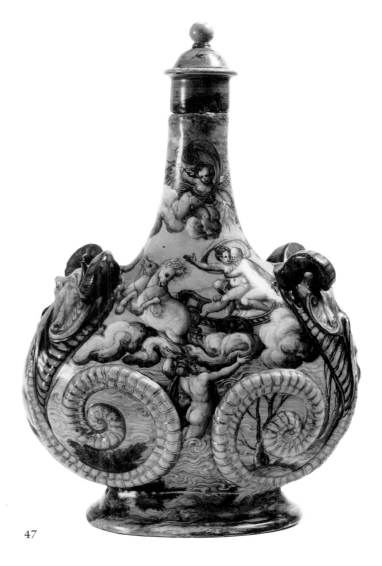

47

tural form serves to enhance the narrative subject. On the side of the flask Pluto drags Persephone to the underworld. We only have to rotate the piece to see Persephone, now a prisoner, through the mouth of the grotesque. The integration of the sculptural form with the narrative content makes this an exceptionally fine piece of majolica.

BIBLIOGRAPHY

Ladis, Andrew. *Italian Renaissance Maiolica from Southern Collections*. Athens, Ga.: Georgia Museum of Art, 1989.
Watson, Wendy M. *Italian Renaissance Maiolica from the William A. Clark Collection*. London: Scala Books, 1986.
Wilson, Timothy, et al. *Ceramic Art of the Italian Renaissance*. Austin: University of Texas Press, 1987.

271

JEAN DE COURT
French, 16th century

48 *Tazza with Image of the Tower of Babel*

1555–85
Limoges ware with colored enamels
H: 11.43 cm.(4½ in.); DIAM: 26.7 cm. (10½ in.)
Blumka Gallery, New York

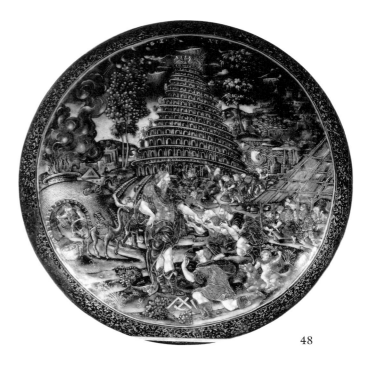

48

Works rendered in enamels have long been admired for their opulence, the richness or translucency of their colors, and the exacting methods of their manufacture. A glasslike compound, enamel is heated to a molten state, at which point various carbonates or metallic oxides are added to produce a variety of colors. After it has been cooled, the enamel is ground into a powder and then applied to a metal (usually copper) surface. The enamel is fused to this base by firing it under extremely high temperatures. During the Renaissance, painting with enamels became a highly sophisticated technique: first, a ground layer of white enamel was fused to the base; then, through successive stages of firing and cooling, additional layers of enamel could be superimposed on the prepared ground. Around the middle of the sixteenth century, grisaille enamels came into fashion. With this method, a black ground was applied to the base then painted over with white enamel. By drawing with a needle into the still soft white enamel, the artist could expose the underlying dark ground, thereby creating effects of shading.

The most important center of painted enamelwork was Limoges. The *tazza* exhibited here was fashioned by Jean de Court, one of the city's finest practitioners of the art in the second half of the sixteenth century. Highly esteemed in his lifetime and patronized by French royalty, he was claimed to be the "new Apelles" in an ode written in 1582 by the poet Jacques Blanchon (Verdier, p. xxv). With Jean de Court and his contemporaries, polychrome enamels came back into fashion. Characteristically, they enriched the grisaille with layers of semi-opaque colored enamels and translucent enamels on foils. Additionally, they often modeled the enamelled colors with gilding. As can be seen in this *tazza*, exceptionally rich effects could be achieved through this combination of techniques.

The painting inside the *tazza* represents a subject from Genesis (11:1–9); the construction of the Tower of Babel. A favorite theme in the late Renaissance period, it gave artists the opportunity to depict a variety of exotic peoples and animals as well as to imagine the fantastic structure that was supposed to reach to the heavens. The painting on the exterior of the *tazza* reveals Jean de Court's close connection to the school of Fontainebleau. Like the paintings and stucco work made by mannerist artists for the gallery of Francis I and the palace at Fontainebleau, it is decorated with a strapwork motif, grotesque heads, *fleurs de lis*, and a pattern of leaves and vines. The decoration of the cup is closely related to other works by Jean de Court executed between the years 1555 and 1585 (see for example the *tazzas* in the Walters Art Gallery, Verdier, nos. 173, 174). The fine quality of the work as a whole, its decorative motifs, and its fascinating subject matter would have made it a suitable object for display in a cabinet of rarities. Indeed, during the late Renaissance and baroque periods Limoges painted enamels often became valued items in European collections.

BIBLIOGRAPHY

Michaels, Peter. "Technical Observations on Early Painted Enamels of Limoges." *Journal of the Walters Art Gallery* (1964–65): 21–43. Esp. pp. 27–28.
Verdier, Philipppe. *Catalogue of the Painted Enamels of the Renaissance*. Baltimore: The Walters Art Gallery, 1967. Esp. pp. 318–23.

272

BERNARD PALISSY
French, ca. 1510–ca. 1589

49 Oval Dish

Second half of the 16th century
Lead enamelled earthenware with reliefs of shells,
leaves, and aquatic animals
W: 56 cm.; BASE: 44.5 cm. (W: 22 in.; BASE: 17½ in.)
Museum of Fine Arts, Boston, Massachusetts
Arthur Mason Knapp Fund and Anonymous Gift
Acc. no. 60.8

The French ceramist Bernard Palissy drew constant inspiration from the natural sciences when he created his exquisite enamel-glazed earthenware. His first métier was glass painting. He traveled throughout France, Germany, and the Netherlands before settling down in Saintes in 1539. He began to experiment with local materials in an attempt to imitate the bright, opaque colors of the enamelware he encountered during his travels. He relied on his observations of nature and on his knowledge of chemical reactions to guide his experiments, which by one account lasted sixteen years. In the end he could produce a subtle range of enamel colors that closely imitated colors found in nature.

As a potter he specialized in dishes with relief decorations taken from casts of small animals and plants, like lizards, snakes, snails, insects, fishes, and leaves. The combination of the living casts and natural colors created an effect of striking realism. His work won him the patronage of Anne de Montmorency, Connétable de France, and later that of Catherine de Medici. He was enormously successful in France, producing the dishes decorated with casts of natural specimens as well as dishes with figural decorations illustrating episodes from mythology.

The oval dish illustrated here is a superb example of Palissy's artistry. It is a carefully orchestrated composition of actual plant and animal specimens. At the center is a snake surrounded by a narrow stream replete with fish. The border is composed of leaves, lizards, frogs, and crustaceans and is dotted throughout with snails. Palissy has created the appearance of a microcosm teeming with life. The success of his simulation is due to more than his use of casts made from actual plant and animal specimens. It is his creative arrangement of those specimens, his keen attention to texture, and his sensitive use of enamel glazes that achieve this stunning realism.

BIBLIOGRAPHY

Dupuy, Ernest. *Bernard Palissy. L'homme, l'artiste, le savant, l'écrivain.* Geneva: Slatkine Reprints, 1970.

Hayward, John Forrest. *Virtuoso Goldsmiths and the Triumph of Mannerism, 1540–1620.* New York: Rizzoli International, 1976.

Palissy, Bernard. *De l'art de la terre, de son utilité, des esmaux et du feu.* Introduction by Jean-Yves Pouilloux. Caen: L'Echoppe, 1989.

Shearman, John. *Mannerism.* New York: Penguin Books, 1967.

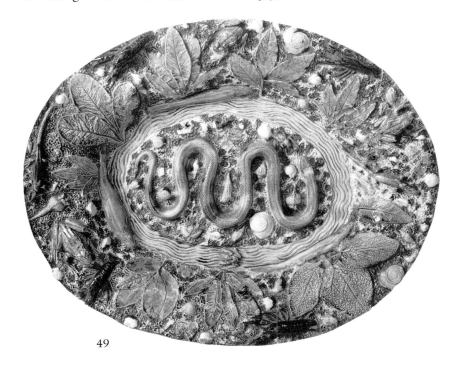

49

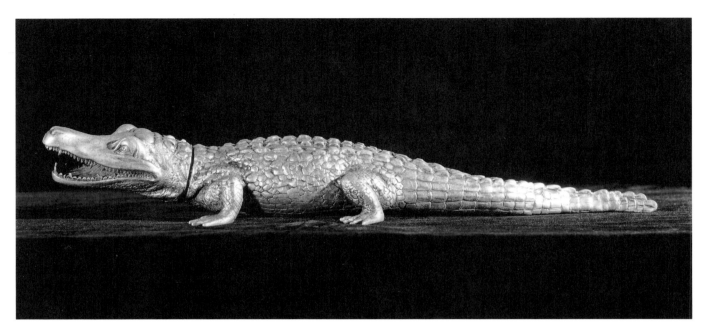

50

German

50 *Crocodile Sand Container*

Nuremberg, ca. 1575–1600
Silver, gilded
L: 32.5 cm. (12¾ in.)
Busch-Reisinger Museum, Harvard University
 Cambridge, Massachusetts
Gift of Stanley Marcus
Acc. no. BR65.15

Utilitarian objects in animal forms were produced in large numbers by German craftsmen of the sixteenth and seventeenth centuries. This crocodile was made in Nuremberg, one of the major centers of the goldsmith trade, and seems to be contemporary with Wenzel Jamnitzer's famous inkstand (now in the Kunsthistorisches Museum, Vienna)—an object that is decorated with numerous small animals modeled from nature (Kuhn, p. 94). Similar to zoomorphic objects fashioned by other Nuremberg artisans, the crocodile is rendered with a concern for naturalistic effects: the reptile's bumpy and rough skin has been

admirably simulated and, in addition, his threatening, creeping posture has been effectively captured. The crocodile no doubt appealed as a representation of an exotic animal and as a miniaturization of a large animal. Such miniaturization has an interesting parallel in works that were produced in the ancient world. As Onians has noticed, the creation of small objects (sculptures of the infant Hercules, for instance) afforded ancient artists the opportunity to persuade people that something physically tiny "could embody all the strength of something huge" (p. 126). The crocodile, designed as a container for sand, originally formed part of a desk set. After detaching the head, sand could be shaken through an embossed screen set into the upper body of the crocodile.

BIBLIOGRAPHY

Kuhn, Charles L. *German and Netherlandish Sculpture 1280–1800: The Harvard Collections*. Cambridge, Mass.: Harvard University Press, 1965. Esp. no. 49, p. 94.
Onians, John. *Art and Thought in the Hellenistic Age: The Greek World View 350–50 BC*. London: Thames and Hudson, 1979.

Circle of ANDREA BRIOSCO
(called IL RICCIO)
Italian, 1470–1532

51 *Hinged Box: Crab*

Padua, 16th century
Bronze
11.4 x 6.4 cm. (4½ x 2½ in.)
Michael Hall, Esquire, New York

Attributed to ANDREA BRIOSCO
(called IL RICCIO)
Italian, 1470–1532

52 *Inkwell and Pen Holders: Two Lizards and a Frog*

Padua, 16th century
Bronze
9.4 x 18.9 cm. (3¾ x 7½ in.)
Michael Hall, Esquire, New York

Attributed to ANDREA BRIOSCO
(called IL RICCIO)
Italian, 1470–1532

53 *Lizard*

Padua, 16th century
Bronze
L: 15.2 cm. (6 in.)
Michael Hall, Esquire, New York

Italian

54 *Coiled Snake*

Padua, 16th century
Bronze
W: 12.8 cm. (5 in.)
Michael Hall, Esquire, New York

Italian

55 *Toad with a Young Toad on Its Back*

Padua, first quarter of 16th century
Bronze
6.7 x 12.1 x 12.1 cm. (2⅝ x 4¾ x 4¾ in.)
The Metropolitan Museum of Art, New York
Gift of Ogden Mills, 1925
Acc. no. 25.142.24

Andrea Briosco, called Il Riccio, was born in Padua and by 1504 was well known in humanist circles in the city, the most important center of classical studies in northern Italy and site of a venerable university. Riccio, who worked in terra cotta, marble, and, bronze, is described by John Pope-Hennessy as the great Italian master of the bronze statuette. He succeeded not merely in imitating the works of classical antiquity, but also in revivifying and reinterpreting the classical spirit.

By 1500 the practice of casting from nature, inspired by antique techniques, was well established in Italy; in the fourteenth century the Italian artist Cennino Cennini described the method. The cast of the crab included here was made from an extremely rare type of crab, and the bronze is quite possibly unique. The separately cast carapace is hinged to the body at the back; lidded pieces like these were cast after antique models. The toads and coiled snakes were also cast from nature, while the inkwell was derived from such casts. The lizards' claws hold open the mouth of the frog, which serves as an inkwell, while their throats are drilled to serve as holders for quill pens. Ursula Schlegel has noted that such pieces reflect contemporary interest by collectors in antiquarianism, science, the imitation of nature, and, in the case of casts of crabs, astrology.

Despite early attributions to Riccio or his studio by Bode and Planiscig, there is no secure evidence that Riccio made such casts from nature. On the other hand, Padua remains a likely place of origin. We know that such casts and inkwells were popular in the region. From Padua the production spread in the sixteenth century to Germany and France.

BIBLIOGRAPHY

Bode, Wilhelm von. *Die Italienischen Bronzestatuetten der Renaissance—Kleine neu bearbeitete Ausgabe*. Berlin: Cassirer, 1922.

Leithe-Jasper, Manfred. *Renaissance Master Bronzes from the Collection of the Kunsthistoriches Museum, Vienna*. Washington, D.C.: Scala Books, 1986.

Planiscig, Leo. *Andrea Riccio*. Vienna: A. Schroll & Company, 1927.

Pope-Hennessy, John. *An Introduction to Italian Sculpture*. Vol. 3. London: Phaidon, 1963.

Schlegel, Ursula. "Riccio's 'Nachter Mann mit Vase'—Zur Deutung einer Gruppe italienischer Kleinbronzen." In *Festschrift Ulrich Middeldorf*. Berlin, 1968. Esp. pp. 350–57.

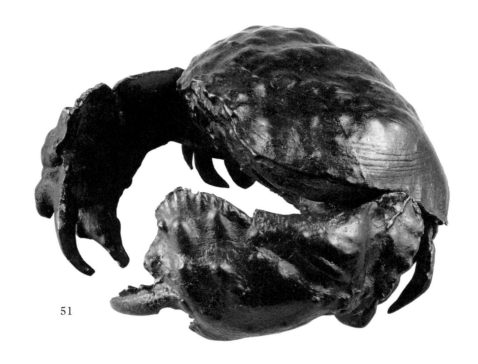

51

52

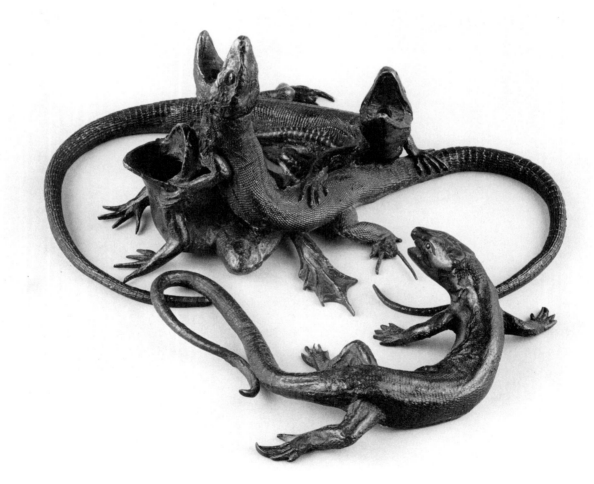

53

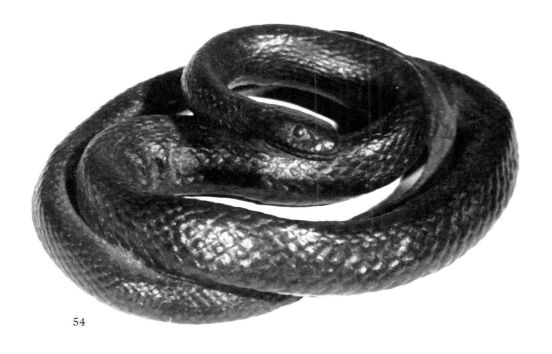

54

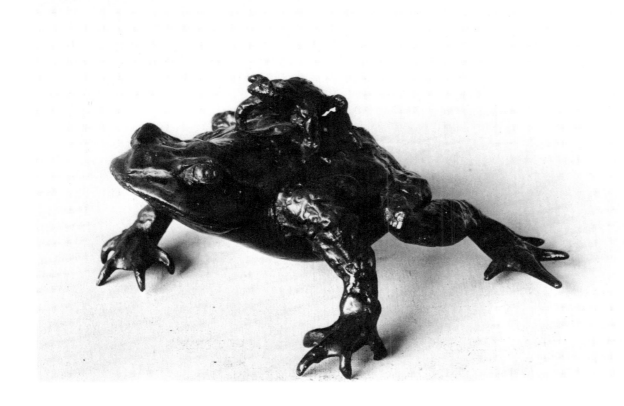

55

277

GIOVANNI DA BOLOGNA AND
ANTONIO SUSINI
Italian, 1529–1608, and Italian, d. 1624

56 *Mercury*

Late 16th century
Bronze
H: 64.8 cm. (25½ in.)
Michael Hall, Esquire, New York

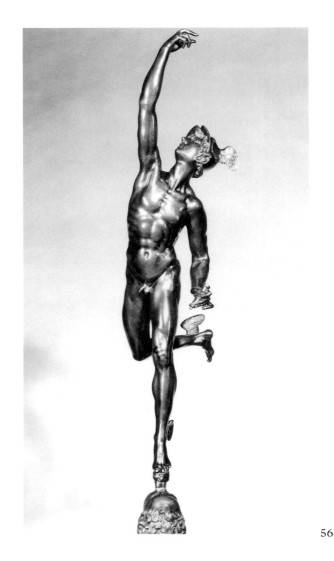

56

Born in Douai in 1529, Giovanni da Bologna was trained in the north but established his reputation in Italy, to which he traveled about 1554. His first major commission was the fountain of Neptune in Bologna (1563–66), and by the late 1550s he had gained the patronage of the Medici in Florence. His most celebrated marble ensemble is undoubtedly *The Rape of the Sabines* in the Loggia dei Lanzi in Florence, which was unveiled in January 1583. An artist of remarkable creativity and versatility, he is, according to John Pope-Hennessy, "after Michelangelo, the outstanding sculptor of his century, and though his sculptures, with few exceptions, were carved or cast in and for Florence, his style became a universal language through the small bronzes that were turned out in his studio" (p. 381).

His earliest statuette of Mercury (Museo Civico, Bologna, ca. 1563) was developed into a bronze that was sent to Emperor Maximilian II. Pier Donato Cesi, bishop of Narni and papal vice-legate in Bologna from 1560 to 1565, intended to install the statue on a column in the courtyard of Palazzo del Arciginnasio at the university in Bologna (Tuttle, cited in Leithe-Jasper, p. 198). Cesi explained that "since in antiquity reason and truth were signified by this god, he was to be placed here in order that students might readily recall that wisdom comes down from heaven and is a gift of God" (cited in Leithe-Jasper, p. 198). The celebrated *Medici Mercury* (Museo Nationale, Florence) dates to 1580, while small-scale bronze versions at Vienna and Naples date to about 1575–79.

The *Mercury* exhibited here is based on the one in Vienna. The Vienna figure, however, does not stand on a head of Boreas. The pointing index finger of the upraised hand, bent up in the Vienna version to extend the height of the figure, here has been bent down. Otherwise, the figures are virtually identical. The Hall *Mercury*, in which the modeling is more literal than in the Vienna version, probably was made in the studio of Giovanni Bologna by his chief assistant, Antonio Susini. Mercury is presented as the messenger of the gods. He points to Jupiter, who has sent him on his mission. As various scholars have noted, while the source of the pose can be traced to angels in *Annunciations*, such as that by Leonardo, a more immediate prototype is that of the image on the reverse of a 1551 medal of Emperor Maximilian II by Leone Leoni. That medal shows Mercury racing over clouds and pointing; the inscription, in Latin, reads "Whither fate calls me."

BIBLIOGRAPHY

Leithe-Jasper, Manfred. *Renaissance Master Bronzes from the Collection of the Kunsthistoriches Museum, Vienna*. Washington, D.C.: Scala Books, 1986.
Pope-Hennessy, John. *An Introduction to Italian Sculpture*. Part III. New York: Vintage Books, 1985.
Tuttle, R. *New Light on Giambologna's Works in Bologna*. Unpublished paper given in Edinburgh in August 1978.
Vermeule, Cornelius. "An Imperial Medallion of Leone Leoni and Giovanni Bologna's Statue of the Flying Mercury." *Spinks' Numismatic Circular* (November 1952): 506–10.

ADRIAEN DE VRIES and an unknown
South German artist
Dutch, ca. 1546–1626

57 *Equestrian Portrait of Emperor Rudolf II*

ca. 1610
Bronze
47.6 x 26 x 12.1 cm. (18¾ x 10¼ x 4¾ in.)
Spencer Museum of Art, The University of Kansas,
 Lawrence
Gift of the Solon Summerfield Foundation
Acc. no. 58.8

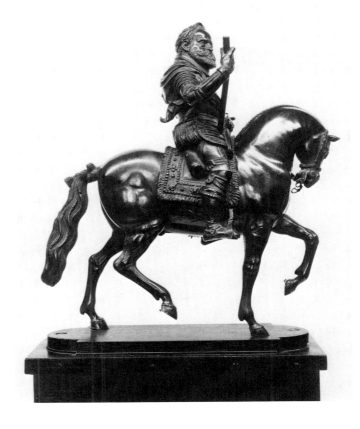

57

Rudolf II (1552–1612), a member of the Habsburg dynasty and Holy Roman Emperor, was one of the greatest patrons of the arts in Europe in the sixteenth century. At his court in Prague he gathered not only painters, sculptors, architects, jewelers, writers, but also scientists and mathematicians, including the astronomers Tycho Brahe and Johannes Kepler. Rudolf was well known for his patronage of the Flemish mannerist Bartholomaus Spranger (1546–1611), was the chief painter at the imperial court in the 1580s. Rudolf engaged both Spranger and Arcimboldo in the acquisition of works for his collection (Kaufmann, p. 32). He himself was an astrologer and astronomer who had an abiding interest in natural history. This latter interest led him to patronize the artist and naturalist Georg Hoefnagel (1542–1600), from whom he commissioned four volumes of illustrations of insects, flowers, fruits, birds, fish, and beasts, all catalogued according to the four elements.

One of the most famous sculptors at Rudolf's court was Adriaen de Vries, to whom this esquestrian statue was first attributed. It was subsequently cited by Lars Olof Larsson as an imitation of an equestrian statue by Giovanni da Bologna of Cosimo I, grand duke of Tuscany. Larsson also suggested that this work was created by an unknown artist active in southern Germany in the first decade of the seventeenth century. More recently K. Sobotnik has postulated that the figure of the horse closely resembles the many statuettes of horses executed by Adriaen de Vries, while the figure of Rudolf was executed by another hand.

BIBLIOGRAPHY

Hyland, Douglas, and Marilyn Stokstad, ed. *Catalogue of the Sculpture Collection, Spencer Museum of Art*. Lawrence: University of Kansas, 1981.
Kaufmann, Thomas DaCosta. *The School of Prague: Painting at the Court of Rudolf II*. Chicago: University of Chicago Press, 1988.

DAVID BESSMANN
German, active 1640–77

58 *Nautilus Beaker*

1645–50
Gilded silver
H: 35.5 cm. (14 in.)
The Saint Louis Art Museum, St. Louis, Missouri
Gift of Miss Effie and Miss Stella Kuhn
Acc. no. 79:54

This luxurious beaker is the work of David Bessmann, one of the many master goldsmiths who worked out of Augsburg in the seventeenth century. The beaker consists of two parts: a large cup in the shape of a nautilus shell and a figured support that shows a double-tailed Triton emerging from a two-tiered socle embossed with a pattern of waves. The nautilus shell, itself embossed with various marine forms, can be removed from its base and used as a drinking vessel.

The various parts of the beaker have been rendered with great liveliness and with an equally impressive fidelity to naturalistic detail. The Triton, for instance, is most wonderfully observed: the texture of his scaly

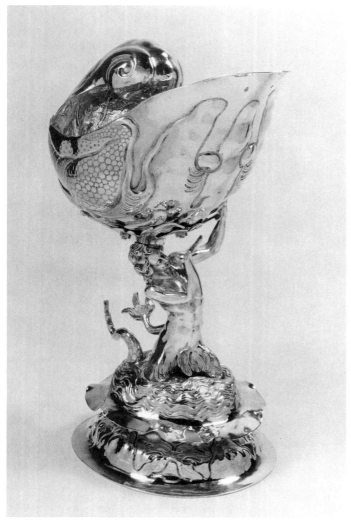

58

lower limbs is distinguished from his sleek, seemingly wet, body; and his torso swivels in a convincing effort to raise the large shell. The impression the whole ensemble makes is that the Triton has just emerged from the sea in order to proffer some delicious liquid to the nearby beholder. The watery theme is superbly conveyed, furthermore, by the glossy surface of the precious metals and by the undulating shapes that appear throughout the composition. Although designed as a vessel for drinking, the nautilus beaker is the type of object which, on account of its beauty and its splendid craftsmanship, was more suitable for display in the cabinet of a collector.

BIBLIOGRAPHY

Rathke-Köhl, Sylvia. *Geschichte des Augsburger Goldschmiedegewerbes vom Ende des 17. bis zum Ende des 18. Jahrhunderts*. Augsburg: Vorwort, 1964.

The Saint Louis Museum: Handbook of the Collections. St. Louis: Saint Louis Art Museum, 1975.

MATTHAUS WALBAUM
German, 1554–1632

59 *Diana on the Stag*

Augsburg, 1600–10
Partially gilded silver, jewelled
34.3 x 26.7 x 11.5 cm. (13½ x 10½ x 4½ in.)
The Lee Collection, on loan to the Royal Ontario
 Museum from the Massey Foundation
Acc. no. L960.9.153

Matthäus Walbaum was a native of Kiel who settled in Augsburg sometime before 1579. One of Augsburg's most distinguished craftsmen, he produced a great many cabinets, caskets, and other such objects, all of which were profusely decorated in silver. The most important work constructed by Walbaum was the *Kunstschrank* designed by Philip Hainhofer for Duke Philipp of Pomerania-Stettin. This famous work, which was destroyed during the Second World War, was followed by another *Kunstschrank* made for Gustavus Adolphus of Sweden. Hainhofer, who had designed this cabinet as well, is reported to have said that "many held it to be the eighth wonder of the world" (Boström, p. 101).

As a sculptor in silver, according to Hayward, "Walbaum ranks amongst the leading masters of his time" (p. 229). One of the most remarkable objects that he executed in this medium is *Diana on the Stag*. An intricately designed vessel for wine, it also functioned as a mechanical toy. The main feature of the composition is the group of Diana, the goddess of the hunt, and the stag. Beneath these figures appear Diana's hounds, a hare, a miniature equestrian, and numerous little land animals such as lizards. The goddess is outfitted with a quiver and bow and is connected to her lead dog by a tiny linked chain. A small cupid is perched on the stag's hind quarters, and the stag himself is adorned with delicate silver and bejewelled trappings.

When the sculpture was used at the table, the head of the stag was removed and his body filled with wine. The clockwork (concealed in the octagonal base) was wound up, thereby propelling the whole ensemble around the table. The guest before whom it came to rest was then expected to empty its contents in a single draught. The Diana group evidently was one of the most popular mechanical *meraviglia* of the age, for

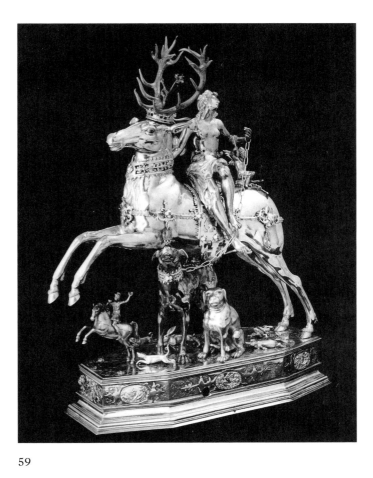

59

Attributed to THOMAS STOR the Elder
German, d. 1611

60 *Automaton: Wine Glass in the Shape of
a Cavalier with Grape Cluster on His
Head, Encircled by Miniature Soldiers*

Early 17th century with later additions
Gilded silver and brass clockwork mechanism
H: 38.3 cm. (15 in.)
S. J. Phillips, London and Blumka Gallery,
New York

This is an example of the type of automaton that also
serves as a drinking vessel. It operates by a clockwork
mechanism concealed within the base. The release
action of the clockwork propels the cup in a forward
direction, which simultaneously causes the miniature
soldiers to dance around the cavalier. The person in
front of whom the cup came to rest would have been
required to empty its contents in a single draught.
The cup itself, similar to many standing goblets pro-
duced in Nuremberg, originally had a cover.

BIBLIOGRAPHY

Hayward, John Forrest. *Virtuoso Goldsmiths and the Tri-
umph of Mannerism, 1540–1620.* New York: Rizzoli In-
ternational, 1976.

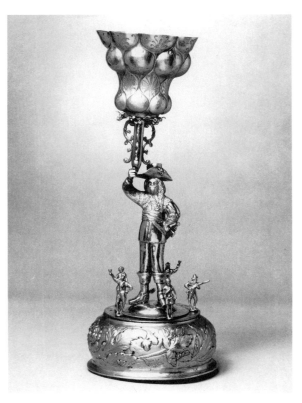

60

almost thirty versions of it are known to have been
made (Hayward, p. 387).

BIBLIOGRAPHY

Boström, Hans-Olof. "Philipp Hainhofer and Gustavus
Adolphus's *Kunstschrank* in Uppsala." In the *The Origins
of Museums.* Ed. Oliver Impey and Arthur MacGregor.
Oxford: Clarendon Press, 1985.

Hayward, John Forrest. *Virtuoso Goldsmiths and the Tri-
umph of Mannerism, 1540–1620.* New York: Rizzoli Inter-
national, 1976.

Löwe, Regina. *Die Augsburger Goldschmiedewerkstatt des
Matthäus Walbaum.* Munich and Berlin: Deutscher
Kunstverlag, 1975.

Rathke-Köhl, Sylvia. *Geschichte des Augsburger Gold-
schmiedegewerbes vom Ende des 17. bis zum Ende des 18 Jahr-
hunderts.* Augsburg: Vorwort, 1964.

German

61 *Madonna in Glory*

Augsburg, ca. 1600
Partially gilded silver on wooden base
H (with base): 35.3 cm. (14 in.)
Busch-Reisinger Museum, Harvard University,
 Cambridge, Massachusetts
Purchase, Antonia Paepcke DuBrul Fund
Acc. no. BR64.31

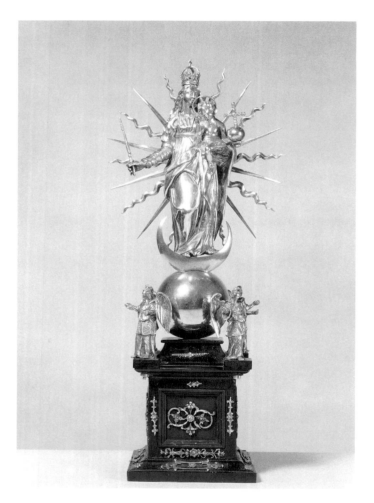

61

Madonna in Glory probably was made for an important patron, either for display in a *Kunst- und Wunderkammer* or as an object of private devotion. A finely crafted and opulent work, its silver figures, partially gilded, are set on a wooden base embellished with silver rosettes, scrollwork, and foliate ornaments. Owing to its close similarities to bronzes by Hubert

Gerhard, it has been identified as the work of an Augsburg goldsmith and dated around the year 1600.

While this subject has a long history in European art, its popularity in the late sixteenth and seventeenth centuries was stimulated by the Catholic church's efforts to promote the veneration of Mary. This work, like other images of the time, emphasizes the virgin's special role as the Queen of Heaven. Her majesty is indicated by the crown, the glittering rays of the sun, and by her large size relative to that of the angels. While the crescent moon alludes to her chastity, the large orb represents the earth over which she, as the symbol of the Mother Church, reigns. The moon and the sun (represented on the back of the Virgin) were common symbols in representations of Mary and derive from the medieval world's association of the virgin with the Shulamite maiden who, in the Song of Solomon (6:10), is described as "beautiful as the moon, and bright as the sun." Wholly in keeping with this vision, the artist of *Madonna in Glory* has given his composition an extraordinary splendor.

BIBLIOGRAPHY

Kuhn, Charles L. *German and Netherlandish Sculpture 1280–1800: The Harvard Collections.* Cambridge, Mass.: Harvard University Press, 1965. Esp. no. 51, pp. 96–97.

Armor: Attributed to
DESIDERIUS HELMSCHMIED
Etched Decoration: Attributed to
JORG T. SORG THE YOUNGER
German, ca. 1522–1603

62 *Armor for the Field, from a Garniture*

Possibly made for Ludwig Ungnad von
 Weissenwolf auf Sunegg
South German (Augsburg), ca. 1522
Steel with embossed, etched, blackened, and gilded
 decoration; modern brass, velvet, and steel
 replacements
198 x 69.3 x 56 cm. (78 x 27¼ x 22 in.)
Higgins Armory Museum, Worcester,
 Massachusetts
Acc. no. 2582

"The best adornment and treasure of a prince and sovereign includes . . . his possession of magnificent munitions and military equipment." So wrote Gabriel Kaltemarckt in 1587 when advising Christian I of Saxony on the formation of a *Kunstkammer*. That fine armor held an important place in any such grouping

had been long recognized. In medieval times, however, arms and armor were grouped together with other artifacts, trophies, or treasure and generally not separately evaluated on grounds of individual artistic or historic importance. With the development of the *Kunstkammer*, and the establishment of various categories of classification and criteria for study and appreciation, the collecting of fine armor came into its own. As *artificialia*, armor examined man's ingenuity and demonstrated at once technical expertise, virtuosity, and the ability to master difficult natural materials.

The finest and most significant examples of arms and armor entered into the *Kunstkammer* proper, while lesser pieces found their place in secondary *Harnisch-* (armor) and *Rüstkammern* (arms). Since each collection mirrored personal taste, criteria for acquisitions and presentation differed widely. The typical collection, however, mixed privately obtained pieces, gifts, ancestral mementos, and war trophies. As an attribute of leadership, armor suggested military prowess, which in a highly martial age was a most desirable personal quality. The most prolific collector of the day, and probably the greatest of all time, was Ferdinand I, archduke of the Tyrol. Nephew of Emperor Charles V, he assembled a first-class *Kunstkammer*, housed at Schloss Ambras near Innsbruck. The focal point of his collection was the more than 120 important armors belonging to great historical personages. He displayed each with a portrait of the owner.

An armor such as this possesses criteria Ferdinand actively sought. It is from a garniture, a complex multipurpose set whose components were carefully made to work with or supplement one another. Research suggests a historic provenance; the armor was perhaps that built for Ludwig von Weissenwolf, a distinguished veteran of imperial service. Quality and craftsmanship are of the highest caliber; the intractable steel plates are artfully wrought and embossed, and they are enhanced by etched decoration alternately blackened or fire-gilded.

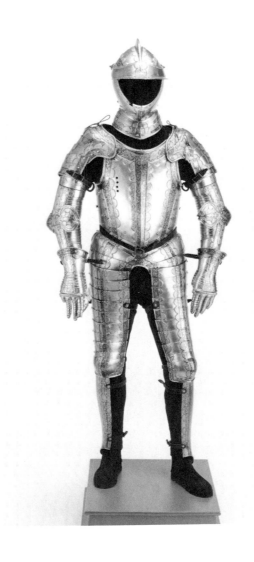

62

BIBLIOGRAPHY

"An Exhibition of Armor." *Worcester Art Museum Bulletin and Calendar* (April 1940): 2.

Becher, Charlotte, et al. *Das Stuttgarter Harnisch-Musterbuch, 1548–1563*. Vienna, 1980. Esp. pp. 68–71, fol. 22v–24.

Farmer, John D. *The Virtuoso Craftsman: Northern European Design in the Sixteenth Century*. Worcester, Mass.: Worcester Art Museum, 1969. Esp. no. 81.

Grancsay, Stephen V. *Loan Exhibition of European Arms and Armor*. New York: Metropolitan Museum of Art, 1931. Esp. no. 7.

Grancsay, Stephen V. *Catalogue of Armor: The John Woodman Higgins Armory Museum*. Worcester, Mass.: Higgins Armory Museum, 1961. Esp. pp. 62–63.

The Clarence H. Mackay Collection. Privately printed, 1931. Esp. p. 13.

Puricelli-Guerra, Arturo. *Armi in Occidente*. Milan, 1966. Esp. pp. 32, 34, 38.

Armor: Attributed to
DESIDERIUS HELMSCHMIED
Etched Decoration: Attributed to
JORG T. SORG THE YOUNGER
German, ca. 1522–1603

63 *Pair of Gauntlets from an Armor for Philip II of Spain when Hereditary Prince*

South German (Augsburg), ca. 1548
Steel with embossed, acid-etched, blackened, and
 gilded decoration; brass, modern leather, and
 steel restorations
Length of each: 22.2 (8¾ in.)
Higgins Armory Museum, Worcester,
 Massachusetts
Acc. no. 423

Individual components of armor and arms were also
found in *Kunstkammern*. Some objects were obtained
because they were peculiar or unique variations of
more common types. Others were sought because
they represented the acme of the armorer's craft,
bringing together the decorative and functional arts
in a particularly admirable manner. Even more desirable
were those items not only of artistic precedence
but also of important provenance. Such premier
pieces bore witness to one's refinement and collecting
taste.

These gauntlets possess such attributes. Superbly

crafted and tastefully decorated, they are glovelike
in their supple mechanics. They are also of royal
lineage, being part of an armor built for Prince (later
King) Philip of Spain and recorded in the Titian portrait
housed in the Prado. The greater part of Philip's
armor remains preserved in the Royal Armory in
Madrid.

BIBLIOGRAPHY

Becher, Charlotte, et al. *Das Stuttgarter Harnisch-Muster-buch, 1548–1563*. Vienna, 1980. Esp. pp. 42–43.
Dean, Bashford. *Catalogue of a Loan Exhibition of Arms and Armor*. New York: Metropolitan Museum of Art, 1911. Esp. no. 20.
De Valencia, Don Juan. *Catálogo histórico descriptivo de la Real Armería de Madrid*. Madrid, 1898. Esp. p. 74.
Duval, Cynthia P., and Walter J. Karcheski, Jr. *Medieval and Renaissance Splendor*. Sarasota, Fla.: John and Mable Ringling Museum of Art, 1983. Esp. pp. 12, 20–22, no. 6.
Grancsay, Stephen V. *Catalogue of Armor: The John Woodman Higgins Armory Museum*. Worcester, Mass.: Higgins Armory Museum, 1961. Esp. pp. 72–73.
M. Henry Collection. Sale catalogue. Paris: Hôtel Drouot, 1886, lot no. 2.
Karcheski, Walter J., Jr. "Steel Men . . . Man of Steel." *Man at Arms* 12 (January/February 1990): 14.
Malatesta, Enzio. *Armi ed armaioli*. Milan, 1939. Esp. p. 32.
M. le Chevalier Raoul Richards Collection. Sale catalogue. Rome, 1890, lot no. 1301.
"Notes of the Month." *International Studio*. (May 1931): 42–43.

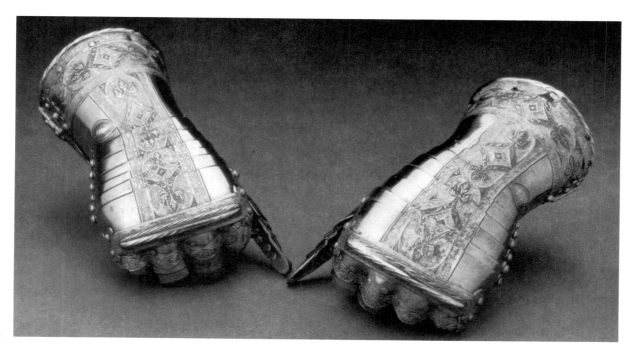

63

THE CATALOGUE

South German

64 *Morion-Burgonet Helmet*

1585
Steel with acid-etched, blackened, and fire-gilded
 decoration, brass
25.5 x 23 x 40.8 cm. (10 x 9 x 16 in.)
Higgins Armory Museum, Worcester,
 Massachusetts
Acc. no. 1191

A *Kunstkammer* often housed a sampling of the equipment of the collector's personal bodyguard. The presence of these high-quality arms served to emphasize the individual splendor, importance, and taste of the patron. This fine headpiece was probably worn by a member of such a unit.

The inspiration for this piece was almost certainly the Italian-influenced series of undecorated helmets prepared in 1565 by Hans Hörburger the Elder of Innsbruck, at the request of Emperor Maximilian II. This helmet is one of four surviving examples of a series of helmets with similar decorations. Two of these, including the one exhibited here, bear the date 1585 etched on small banderoles. The reverence for and influence of the antique is embodied in the acid-etched decoration. While from an undoubtedly south German, probably Augsburg, hand, the motifs combine both contemporary and classical objects and themes. Spread freely throughout the etched bands are representations of period and "ancient" weapons and armor, martial artifacts, fantastic creatures, and mythological themes. On the sides of the tall comb, for example, are vignettes from *Ovid's Metamorphoses*: on the left is Leda and the Swan; and on the right, in the presence of Amor, Antiope is possessed by Jupiter, who is in the guise of a satyr.

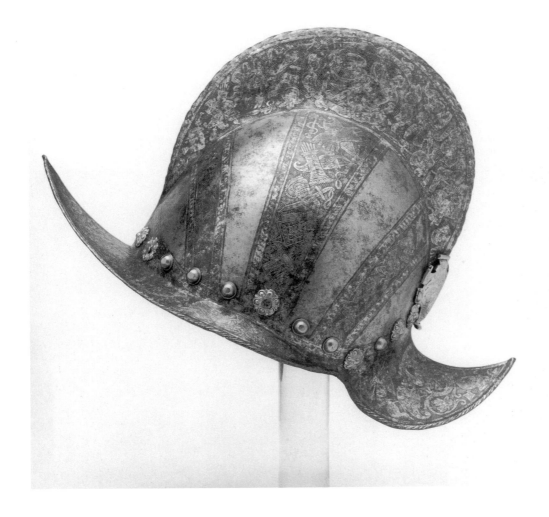

64

South German

65 *Wheel-lock Gun*

ca. 1570
Cherry, inlaid with engraved staghorn
L: 110 cm. (43³/16 in.); barrel: 82.7 cm. (32½ in.);
 caliber: .56
The Clay P. Bedford Collection, Lafayette,
 California
Venue: DC

This wheel-lock gun belongs to a small group of profusely decorated firearms that were made in southern Germany in the third quarter of the sixteenth century. An outstanding example of the gun-maker's art, it has a cherry stock inlaid with engraved staghorn and numerous small elements dyed green. The blue barrel, lock plate, and wheel cover are damascened in silver and gold, while most of the remaining metal parts are gilded, thus heightening the gun's overall decorative effect.

In an apparent *horror vacui*, the anonymous maker of the firearm has embellished nearly all of its surfaces with geometric and naturalistic forms. These include heraldic devices (a lion and griffin in combat; seahorses supporting urns) and, appropriately for a sporting weapon, numerous figures of game animals such as lions and deer. On both sides of the gun a field of finely articulated grape clusters and leaves serves as a background for scenes pertaining to the hunt: one of these shows a soldier and his dogs overtaking a bear; another represents Hercules strangling an animal, perhaps the Nemean lion (although it does not

have a mane). In contrast to these views of the hunter/ hero performing feats of courage and strength, a third vignette, recalling medieval images of the *mundus inversus*, or "the world turned upside down," shows a group of hares and dogs parading as human hunters and their horses.*

The follies and virtues of hunting are indicated additionally by numerous allegorical figures, most of which are engraved on the underside of the stock. Winged Fortune is contrasted with Despair (who stabs himself), while figures framed in columned niches represent Fortitude (a soldier in armor), geometry (one of the liberal arts, often associated with the virtues), Venus (perhaps symbolizing earthly vanities), Hope, and Mercury (the god who vanquished the monster Argus and who, in the presence of Venus, often signifies reason). Rich and varied in its decorative elements, the wheel-lock gun compares to other firearms of the late sixteenth and seventeenth centuries that were valued as collector's pieces and that were meant to be admired for their beauty and for the fineness of their craftsmanship.

* Robert L. McGrath of the Department of Art History, Dartmouth College, kindly identified the subject of this vignette.

BIBLIOGRAPHY

Gusler, Wallace B., and James D. Lavin. *Decorated Firearms 1540–1870 from the Collection of Clay P. Bedford*. Williamsburg, Va.: The Colonial Williamsburg Foundation, 1977. Esp. no. 43, p. 114.

65

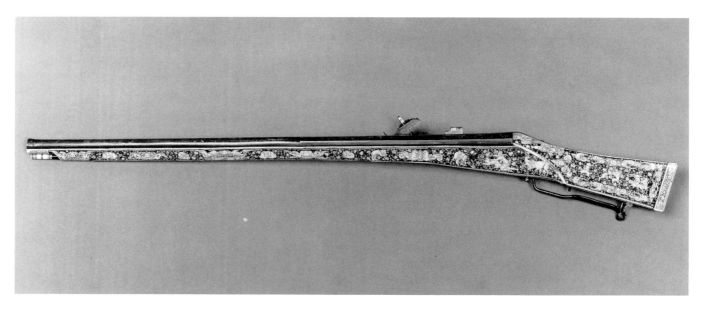

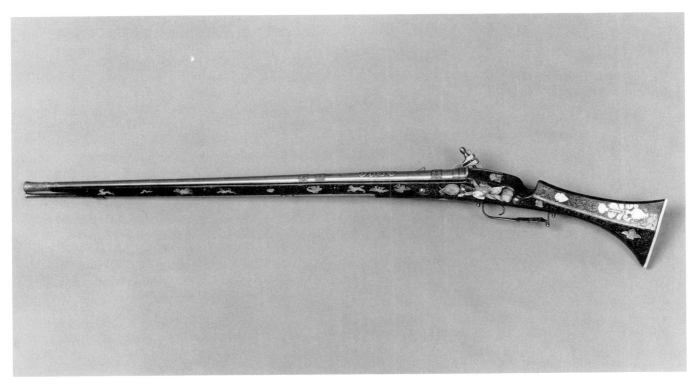

66

French

66 *Snaphaunce Gun*

1622 (ca. 1630)
Fruitwood, inlaid with engraved plaques of mother-
of-pearl; bone; silver
L: 129.5 cm. (51 in.); barrel: 92 cm. (36¼ in.);
caliber: .58
The Clay P. Bedford Collection, Lafayette,
California
Venue: DC

This beautiful firearm originally belonged to the
French monarchs Louis XIII and Louis XIV. In the
inventory of the Cabinet d'Armes, ordered by Louis
XIV and completed in 1673, it is described as "a fusil
in the English style." As Gusler and Lavin have ob-
served (pp. 14–16), the gun does not simply imitate
the general form of English firearms; its lock (dated
1622) and trigger guard were both manufactured in
England. In all other respects, however, the gun ac-
cords with decorated firearms made in France ca.
1630. The fruitwood stock, inlaid with silver and brass

wires and engraved mother-of-pearl, is especially
characteristic of French design. The wire inlays have
been fashioned into an elegant pattern of curling
vines, interspersed with tiny six-pointed stars.
Against this background, a variety of designs ren-
dered in mother-of-pearl have been introduced: two
vases with flowers, trophies, draped classical heads,
winged cherubic heads, insects, dogs, and birds. The
stock designs are complemented by those on the bar-
rel: a relief of four serpents and a satyr and six bands
chiseled in decorative patterns. Subtle, refined, and
restrained in its decoration, the snaphaunce gun con-
trasts strikingly with the profusely ornamented Ger-
man guns in this exhibition (see cat. nos. 65, 67).

BIBLIOGRAPHY

Gusler, Wallace B., and James D. Lavin. *Decorated Firearms
1540–1870 from the Collection of Clay P. Bedford.* Wil-
liamsburg: Va.: The Colonial Williamsburg Foundation,
1977. Esp. no. 3, pp. 14–16.

German (Landshut)

67 *Wheel-lock Rifle*

ca. 1695
Signed on the butt plate engraving:
 SAMUEL KLVGE . LANDSHUT; Maker's mark *HF*
 on upper breech flat; Stocker's (?) initials *W.S.*
 and 95 inscribed in the butt-trap
Cherry, inlaid with engraved staghorn, decorated
 with naturalistic and fanciful figures
L: 127.3 cm. (50¹⁄₁₆ in.); barrel: 96.6 cm. (38 in.);
 caliber: .51
The Clay P. Bedford Collection, Lafayette,
 California
Venue: DC

When this splendidly decorated rifle was made, the production of snap flint-lock arms had replaced the traditional wheel lock in almost all parts of Europe except Germany. Similar to earlier German firearms (see cat. no. 65), it shows a wealth of details, both highly naturalistic and fanciful in their rendering. The cherry stock, inlaid with engraved staghorn, is ornamented with numerous vignettes of hunters chasing their prey—a wild boar, deer, and hares. The naturalism of these little scenes is considerably enhanced by the foreshortened views of the animals, the lively action of all the figures, and by the finely described trees and undergrowth of the forest settings. The stock is further enriched by a profusion of tiny stars and flowers and by delicately rendered volutes of stylized leaves and vines. Harmonizing with the stock decoration is that of the gilded-brass plaque covering the lock: its pierced and engraved design shows another hunting scene and an interlace of whorling leaves.

The superb craftsmanship of this rifle and the beauty of its design suggest that it was made for a special patron. Indeed, this is indicated by the monogram engraved on the saddle blanket of the horse depicted on the cheekpiece. The opposed C initials surmounted by a crown, according to Gusler and Lavin, indicate that the owner was either King Charles XI of Sweden, an enthusiastic collector of guns, or his contemporary, King Christian V of Denmark. Gusler and Lavin also suggest that the equestrian shown on the rifle's cheekpiece represents the royal patron.

BIBLIOGRAPHY

Gusler, Wallace B., and James D. Lavin. *Decorated Firearms 1540–1870 from the Collection of Clay P. Bedford.* Williamsburg, Va.: The Colonial Williamsburg Foundation, 1977. Esp. 57, p. 146.

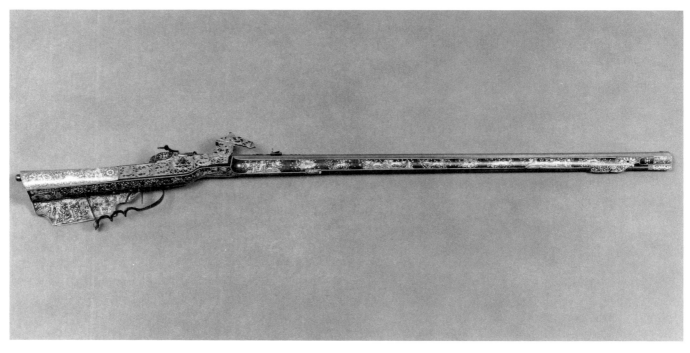

67

ANTONIO PISANO, called PISANELLO
Italian, ca. 1395–1455

68 *Emperor John VIII Paleologos*

Inscribed (translated) on recto: *John, King and
Emperor of the Romans, Paleologos*; inscribed
(translated) on verso: *Work of Pisano the Painter*
ca. 1438
Bronze medallion
DIAM: 10 cm. (3 ¹⁵⁄₁₆ in.)
Collection of Roger Arvid Anderson,
Lent in Memory of Victoria Blumka

Antonio di Puccio Pisano, known as Pisanello, was
active in Verona and the courts of Mantua, Milan,
Ferrara, and Naples. During his life he was primarily
esteemed as a painter, but he also has been lauded
as the founder of the modern medal and the greatest
practitioner of that branch of art. Although his fresco
work and his exquisite depictions of animals in ink
and metalpoint are noteworthy for synthesizing a
late-Gothic lyricism of long, elegant lines with an
engaging naturalism in details, his medals are distin-
guished by their clarity of design.

The portrait of John VIII Paleologos commemo-
rates the historic visit of the Byzantine emperor to
Ferrara between February 29, 1438, and January 10,
1439, and to Florence between July 6 and August 26,
1439. The emperor is depicted on the front as de-
scribed by contemporary chroniclers: a handsome
man attired in the Greek dress and coiffure of the
period and wearing a tall crown. On the reverse he is
shown on horseback, pausing before a shrine in a
mountainous landscape.

The medal is taken from an early lead casting; soft
lead was used only in first castings or trial proofs of
the artist. Pisanello's first essay in the genre, the medal
was based on ancient Roman examples and a group
of gold medallions of Roman Christian emperors
created in Paris around 1400 for Jean, duc de Berry.
What distinguishes this early masterpiece from its
prototypes, however, is its concision of design—into
which even the inscriptions are integrated—and the
infusion of a new, humanist naturalism into the work.
The emperor's profile on the front is rendered care-
fully, yet with simplicity and monumentality; on the
reverse, the artist has radically foreshortened the
equestrian page and carefully observed the manner in
which the emperor sits forward on his horse in devo-
tion. This medal has been sought by collectors since
its creation in the fifteenth century.

BIBLIOGRAPHY

Goldfarb, Hilliard T. "European Art in Dartmouth Collec-
tions." In *From Titian to Sargent: Dartmouth Alumni and
Friends Collect*. Hanover, N.H.: Hood Museum of Art,
1987.

68r

68v

LEONE LEONI
Italian, 1509–90

69 *Emperor Charles V* (recto)
The Infante Philip II on
Horseback (verso)

Late 1540s
Bronze medallion
DIAM: 10 cm. (3¹⁵⁄₁₆ in.)
Collection of Roger Arvid Anderson,
 Lent in Memory of Victoria Blumka

Charles V, Holy Roman Emperor and King of Spain, consolidated the largest empire since that of ancient Rome. *Emperor Charles V* was executed in the late 1540s by the leading and most experienced Tuscan portrait sculptor of the High Renaissance, Leone Leoni. His first recorded commission, a portrait medal of Pietro Bembo created for a competition in 1537, had been judged by the daunting triumvirate of Ti-

tian, the sculptor Jacopo Sansovino, and the satirist and art critic Pietro Aretino as superior to all other submissions, including one by Benvenuto Cellini. In rendering Charles V, Leoni deliberately suppressed both psychological interpretation and naturalistic details, including the emperor's disfiguring lantern jaw, in order to present an appropriately monumental and ennobled profile in the tradition of the imperial medallions of ancient Rome. On the reverse the Infante Philip II, son of Charles V and heir to the throne of Spain, is presented in an equestrian pose derived from the *Marcus Aurelius* in Rome and from Titian's masterpiece, the equestrian portrait of *Charles V at Mühlberg* (1548).

BIBLIOGRAPHY

Goldfarb, Hilliard T. "European Art in Dartmouth Collections." In *From Titian to Sargent: Dartmouth Alumni and Friends Collect*. Hanover, N.H.: Hood Museum of Art, 1987.

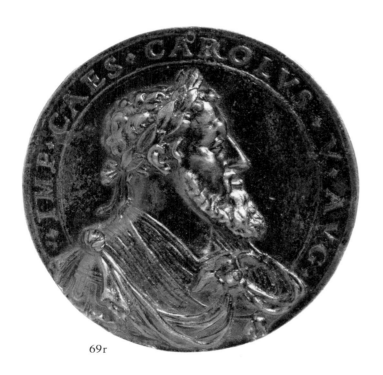

69r

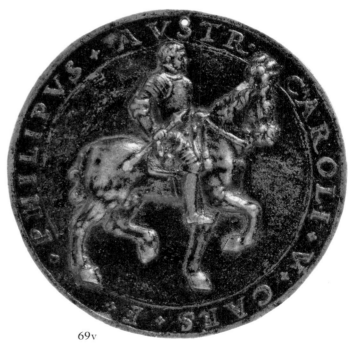

69v

290

Attributed to HANS JAMNITZER II
German, 1538–1603

70 *Samuel Anointing David*

After 1571
Bronze relief (plaquette)
DIAM: 16.5 cm. (6½ in.)
Collection of Roger Arvid Anderson,
 Lent in Memory of Victoria Blumka

Attributed to HANS JAMNITZER II
German, 1538–1603

71 *Judgment of Solomon*

After 1571
Bronze relief (plaquette)
DIAM: 16.5 cm. (6½ in.)
Collection of Roger Arvid Anderson,
 Lent in Memory of Victoria Blumka

Hans Jamnitzer, who signed his works with the monogram *H.G.*, was the eldest son of Wenzel Jamnitzer (1508–85), the most important Nuremberg sculptor after 1540. The Jamnitzer workshop was preeminent in Germany, comparable in standing and clientele—including Rudolf II—to that of Benvenuto Cellini in Italy. Collectors were attracted by the fine chiseling and chasing, by the complex details, and by the sumptuous finishes. In addition to executing and overseeing the creation of statuettes, plaquettes, and reliefs for a variety of decorative purposes, Wenzel published mathematical treatises.

Hans Jamnitzer followed his father's style as a goldsmith. His finest works are the medallion reliefs he executed during the later 1560s and the 1570s. The hollow-cast bronze roundels of *Samuel Anointing David* and *Judgment of Solomon* are remarkable for their detailed compositions based on Franco-Flemish sources, their careful chasing, and their fine condition. Possibly designed for the decoration of an ecclesiastical vessel, they are stylistically later than the *Rebecca and Eliezar* plaquette at the Allen Art Museum, Oberlin, Ohio, which is dated variously from before 1565 to ca. 1571. By comparison, the present plaquettes are significantly more spatially sophisticated, and the figures are more massive and monumental. Recently the scholar Ingrid Weber has questioned the attribution to Hans Jamnitzer of these two roundels, which bear no monogram, and has placed them tentatively in the Jamnitzer workshop after 1575.

BIBLIOGRAPHY

Goldfarb, Hilliard T. "European Art in Dartmouth Collections." In *From Titian to Sargent: Dartmouth Alumni and Friends Collect*. Hanover, N.H.: Hood Museum of Art, 1987.

Weber, Ingrid. *Deutsche, Niederländische und Französische Renaissance Plaketten 1500–1600*. 2 vols. Munich: Bruckmann, 1975. Esp. vol. 1, pp. 163–65.

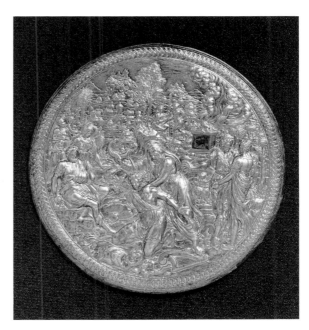

70

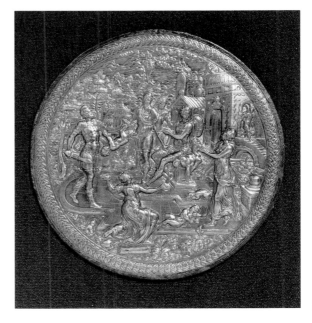

71

Central American

72 *Bird*

Pre-Columbian
Gold
9.5 x 11.4 cm. (3¾ x 4½ in.)
Worcester Art Museum, Worcester, Massachusetts
Acc. no. 1951.133

72

73

Central American (Panama)

73 *Pendant in the Form of a Human Figure*

Pre-Columbian, 1000–1500 A.D.
Gold
H: 7.9 cm. (3⅛ in.)
Worcester Art Museum, Worcester, Massachusetts
Gift of Mr. Aldus C. Higgins
Acc. no. 1946.12

Mexican (Veracruz)

74 *Turkey Hacha*

Classic Veracruz culture, 500–1000 A.D.
Stone
20.6 x 14.3 cm. (8⅛ x 5⅝ in.)
Worcester Art Museum, Worcester, Massachusetts
Acc. no. 1942.3

74

NATURE'S WONDERS AND THE WONDERS OF NEW WORLDS

THE ILLUSTRATED books, paintings, prints, drawings, and scientific apparatus displayed in part three of the exhibition focus attention on wondrous *naturalia* and on the discoveries of strange new worlds. These works have been organized into three major sections, each of which considers wonders of fable or legend, the actual marvels of faraway worlds, and the marvels observed (or, in the case of botanical specimens, cultivated) at home. Many of the books on exhibit show how the fantastic and empirically unverifiable wonders of ancient or medieval legend continued to arouse the interest of Europeans in the Renaissance and baroque periods. But over time, as the generally chronological arrangement of materials reveals, the *naturalia* that fascinated were increasingly concrete and observable facts.

MARVELOUS NEW WORLDS: THE HEAVENS AND THE EARTH

The sixteenth and seventeenth centuries were marked not only by major geographical and astronomical discoveries, but also by a concerted effort to document these findings in a variety of cartographic materials. The printed maps, geographies, and atlases produced in this period record Europeans' changing view of the world. From the 1513 geography printed in Strasbourg (the first Ptolemaic geography to include maps of the New World) to the handsome maps of the continents made by Jaillot at the end of the seventeenth century, we can trace their increasing awareness of the earth's vast size and the diversity of its parts. Although many of the maps contain errors or misconceptions about the configuration of certain regions, atlases like those published by Abraham Ortelius and Joan Blaeu clearly demonstrate that the map makers intended to provide the most up-to-date information, recorded as accurately as possible.

The invention of the telescope led to the discovery of new celestial worlds and to more accurate descriptions of the heavens. Among the works displaying these astronomical observations are Galileo's *Sidereus nuncius* and Johannes Hevelius's *Selenographia*. The new constellations of the Toucan and the Bird of Paradise appear in a lavishly decorated chart of the southern sky by Andreas Cellarius, and the rings of Saturn are visible in the intriguing painting *Divine Cosmos* by Dominicus van Wynen, which puts recent discoveries within the context of the old cosmology.

Early maps generally were decorated with images of fanciful creatures. A map of Iceland from the later edition of Ortelius's atlas and a description of Scandinavian seas

293

by Sebastian Münster, for example, are liberally adorned with the strange and monstrous beasts of folklore and of travelers' exaggerated reports. Gradually, however, these fictional creatures were replaced with images of the flora, fauna, and people of foreign lands that were derived from illustrated natural histories and travel accounts. Rosaccio's large *mappamondo* is especially famous for its numerous vignettes of New World inhabitants and animals. In other, smaller maps—by John Smith, Samuel de Champlain, and Georgius Spilbergius, for example—newly charted territories are embellished with the animals, plants, and people indigenous to particular regions. The great glory of seventeenth-century cartography was the multivolume *Atlas maior* produced by Joan Blaeu in 1662. In these splendid volumes, Europeans not only were supplied with the latest information about world geography, but also were given a multitude of images depicting the diverse peoples, the animals, and the architectural wonders to be found on earth.

ANTHROPOLOGICAL AND ZOOLOGICAL WONDERS

Many of the works in this section testify to the extraordinary interest generated by fabulous and anomalous human beings and by monsters both fictional and real. The encyclopedic natural histories of Konrad Gesner and Ulisse Aldrovandi, for example, provide a multitude of images depicting anthropological and zoological marvels: many of these were based on legendary accounts or myth, but others represented the actual workings of nature. With Ambroise Paré's famous study, *Regis primarii et parisiensis chirurgi*, the separation of monsters, especially those viewed as portents, from actual strange animals began. The astounding creatures from exotic lands and the aberrations found at home were now regarded as a distinct class of marvels, and it was through the study of these marvels that one could best gain an understanding of nature herself. Later books such as those by Johann Schenck and Fortunio Liceti, however, continued to give equal emphasis to the monsters of legend and of fact. Indeed, in both these works, every imaginable type of human or animal oddity is represented. Anomalous forms of life, examples of nature out of course, rarely failed to arouse interest, as can be seen in a very early work from the period, Albrecht Dürer's *Monstrous Pig of Landser*, and in the later *Portrait of the Daughter of Pedro Gonzalez* by Lavinia Fontana.

Most of the works in this section focus on the New World discoveries. The illustrated histories of Gesner and Aldrovandi include descriptions of many of these exotica, but other works focus on them exclusively. Most important among these are André Thevet's *Les Singularitez de la france antarctique*, Theodor de Bry's famous volumes on America, and Willem Piso and Georg Marggraf's natural history of Brazil. While these texts offer abundant images of the inhabitants of the New World, and its flora and fauna, the painter Frans Post recorded the strange beauty of the Brazilian landscape from his firsthand observations.

Finally, this section draws attention to the minute forms of life that were revealed by the microscope. Several early microscopes are exhibited here along with the surprising

views of miniature life recorded by Robert Hooke, Jan Swammerdam, and Antoni van Leeuwenhoek.

BOTANICAL WONDERS

The third part of the exhibition closes with a display of works representing marvelous plants. Botanical fantasies of medieval legend, namely plants with strange attributes or magical powers, continued to excite interest in the sixteenth and seventeenth centuries. The credulity tree and Scythian lamb, for example, appear in Claude Duret's *Histoire admirable des plantes*. Other illustrated texts, such as a German herbarium, Johann Zahn's *Specula physico-mathematico-historica*, and Giovanni Battista della Porta's *Phytognomonica*, describe the magical mandrake, an extraordinary anthropomorphic root, or curious plants that resembled the part of the human body for which they had curative properties.

When actual botanical *meraviglie* were brought back to Europe by traders and explorers, they were carefully recorded in paintings and botanical publications. Numerous representations of these curious and unfamiliar plants are displayed here. Some of the earliest images of the new specimens appear in Leonhart Fuchs's *De historia stirpium* and in Giovanni Battista Ramusio's *Delle navigationi et viaggi*. The tobacco plant is given special attention in Johann Neander's *Tabacologia*, while flora discovered on Sir Francis Drake's first voyage are introduced in the botanical history of Charles de L'Ecluse. Some of the most impressive images on display include Crispijn de Passe's Peruvian sunflower (from his *Hortus Floridus*), and Abraham Munting's pineapple (from *Naauwkeurige Beschryving*).

Other plants perceived as marvels were the home-grown specimens, including hybrids of exotic imports. Spectacular varieties of tulips, anemones, and other flowers were developed by botanists and were celebrated in a great number of flower paintings and florilegia. These remarkable ornamentals appear, for example, in Jan Davidsz. de Heem's *Vase of Flowers* and in Juan de Arellano's *A Basket of Flowers*. Finally, two other pictures in this segment of the exhibition, Daniel Seghers's *A Garland of Flowers on a Carved Stone Medallion* and Hendrik van Balen and Jan Brueghel the Younger's *Madonna and Child in a Floral Garland*, reveal the effort of artists to represent a great variety of plants in a single image. These "encyclopedias" of rare, exotic, and beautiful flowers depicted a paradise of flora and offered to the viewer abundant evidence of God's wondrous workings on earth.

CLAUDIUS PTOLEMY
Greek, ca. 90–168 A.D.

75 *Mathematice discipline, philosophi
doctissimi geographie opus nouissima
traductione*

Strasbourg, 1513
Illustrated book
45.6 x 32.3 x 4.3 cm. (18 x 12¾ x 1¾ in.)
Dartmouth College Library, Hanover,
 New Hampshire
Acc. no. McGregor 141

Long after his death in the second century, Claudius
Ptolemy held an unchallenged position in the field of
cartography. His most important work was the *Geo-
graphia*, a compilation of earlier sources that pro-
vided tables of geographic coordinates for approxi-
mately eight thousand locations (Shirley, p. xviii).
This work was copied frequently in manuscript form
and embellished with maps, the earliest of which date
from the twelfth century. Near the beginning of the
fifteenth century copies of the text arrived in Italy
from Constantinople, and in the course of the century
other transcriptions of it were made. The first printed
edition of Ptolemy's work appeared in 1477, and from
that time until the early eighteenth century a great
many geographies bearing his name were produced.

The 1513 Ptolemy is universally regarded as the
grandest and most important of all the printed edi-
tions. The work of Martin Waldseemüller, a scholar/
geographer from Saint-Dié in Lorraine, and his as-
sociate Mathias Ringmann, it was edited and pub-
lished by two Strasbourg citizens, Jacob Eszler and
Georg Ubelin. This geography offered in addition to
the twenty-seven Ptolemaic maps twenty new maps
that took into account recent information about the
New World.

Two of those maps, the *Orbis typus* and the *Terra
nova* are described in the text as having been made
according to information obtained by the "Admiral"
—that is, Christopher Columbus. While the regional
map of the New World gives numerous details about
place names and the islands south of Florida, the
world map is rather sketchy and unsure in its deline-
ation of the new discoveries. It is possible that this
map was rendered sometime around 1505–6, when
Waldseemüller began work on the *Geographia*, and
that it was left unrevised when the atlas went to press
in 1513.

The two bold woodcuts, probably executed by
Waldseemüller himself, do not identify the recently
discovered lands as "America," a name Waldseemüller

suggested in his 1507 *Cosmographiae introductio*. Hav-
ing read Amerigo Vespucci's published accounts of
his voyages (in one of these Vespucci insisted that he
had found "what we may rightly call a New World"),
Waldseemüller argued, "Now truly these parts
[Europe, Africa, Asia] have been more widely
explored, and another, fourth, part has been discov-
ered by Americus Vespucci . . . and I do not see why
anyone should rightly forbid naming it Amerige—
land of Americus, as it were, after its discoverer
Americus, a man of acute genius—or America, since
both Europe and Asia have received their names from
women" (see Morison, pp. 288–89). Indeed, a large
wall map printed by Waldseemüller in the same year
as the *Cosmographiae introductio* included the name
America in large block letters. At some point during
the preparation of the 1513 *Geographia*, Waldseemüller
learned that Vespucci had exaggerated his own role
in the discovery of the New World, and thus he did
not enter the name America in his new maps. The
emendation came too late however; Waldseemüller's
Cosmographiae was well known in Europe and his
suggested name for the new continent was already
widely adopted.

BIBLIOGRAPHY

Brown, Lloyd A., ed. *The World Encompassed*. Baltimore:
 The Walters Art Gallery, 1952. Esp. cat. no. 56.
Lynam, Edward. *The First Engraved Atlas of the World: The
 Cosmographia of Claudius Ptolemaeus*. Jenkintown: The
 George H. Beans Library, 1941.
Morison, Samuel Eliot. *The European Discovery of America:
 The Southern Voyages A.D. 1492–1616*. New York: The Ox-
 ford University Press, 1974. Esp. pp. 288–92.
Nordenskiöld, Nils Adolf Erik. *Facsimile Atlas to the Early
 History of Cartography with Reproductions of the Most Im-
 portant Maps Printed in the Fifteenth and Sixteenth Cen-
 turies*. Trans. Johan Adolf Ekelöf and Clements R. Mark-
 ham. Stockholm: [Printed by P. A. Norstedt], 1889; re-
 printed in 1973. Esp. pp. 19–20.
Shirley, Rodney W. *The Mapping of the World: Early Printed
 World Maps 1472–1700*. London: The Holland Press, 1983.
 Esp. nos. 34–35, pp. 38–40.
Skelton, Raleigh Ashlin. *Introduction to the 1513 Strasbourg
 edition of* Geographia, *by Claudius Ptolemy*. Facsimile ed.
 Amsterdam: Theatrum Orbis Terrarum, 1966.

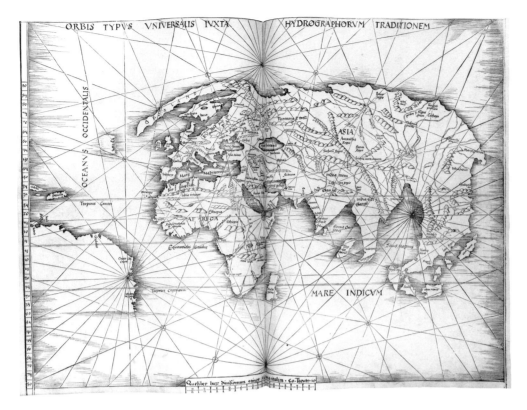

75 Map of the world. Woodcut.

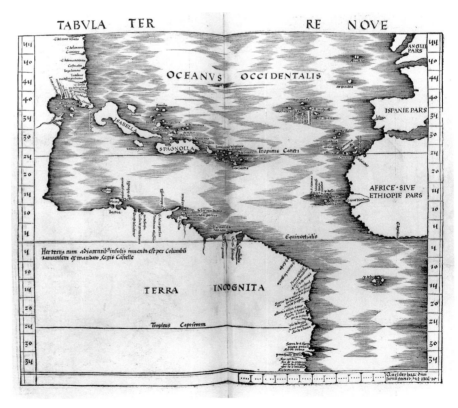

75 Double-page map of the New World. Woodcut.

CLAUDIUS PTOLEMY
Greek, ca. 90–168 A.D.

76 *Geographia universalis, uetus et nova, complectens*

Basel, Henricum Petrum, 1540
Atlas
31.7 x 20.8 cm. (12½ x 8³⁄₁₆ in.)
Arthur and Charlotte Vershbow, Boston,
 Massachusetts
Venue: DC

This edition of Ptolemy's *Geographia* was produced by Sebastian Münster, a professor of Hebrew at the University of Basel (see cat. no. 80). An eminent mathematician and geographer who became a friend of Martin Luther, he left the order of Franciscan monks and converted to the reformed religion. Sometimes called the "German Strabo," Münster revered

the authority of the ancients but at the same time took pride in keeping up with the latest information about the world and its inhabitants.

The 1540 *Geographia* perfectly demonstrates these aspects of his learning. In addition to the twenty-seven standard maps rendered "according to Ptolemy," the professor offers his readers twenty-one new woodcuts showing America and other remote parts of the world. Many of the new maps are populated with spectacular animals and peoples, some of which are fictitious and others "entirely foreign to the nature of the country" (Brown, cat. no. 58). Among the most important woodcuts in this edition is the new map of the world. Although, as in earlier maps, it shows a huge sea (the false Sea of Verrazzano) nearly bisecting "Terra Florida" and "Francisca" (the land explored by the French in the time of François I) and although Newfoundland is shown stretching across the Atlantic to join with Scandinavia, this view

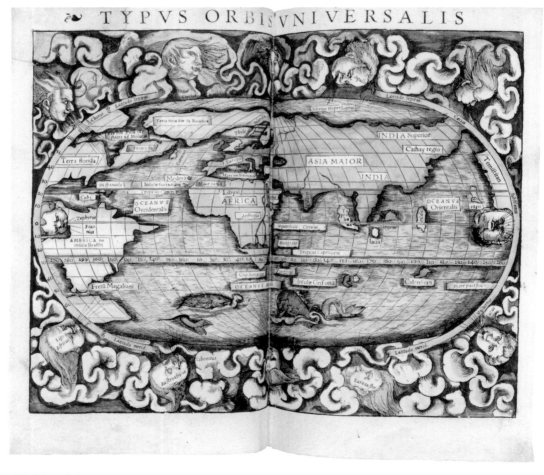

76 Map of the world. Hand-colored woodcut.

of the world was an improvement on earlier images and reveals a knowledge of many of the most important discoveries. The Straits of Magellan are clearly represented, and, as Shirley notes (p. 87), for the first time on a printed map the Pacific Ocean (the *mare pacificum*) is given its name.

The *Geographia* exhibited here is exceptional not only for its fine condition, but also because it is one of the few copies that was fully hand-colored at its time of publication.

BIBLIOGRAPHY

Brown, Lloyd A., ed. *The World Encompassed*. Baltimore: The Walters Art Gallery, 1952. Esp. no. 58.

Büttner, Manfred, and Karl H. Burmeister. "Sebastian Münster 1488–1552." *Geographers (Bibliographical Studies)*. Vol. 3. Ed. T. W. Freeman and Philippe Pinchemel. London: Mansell, 1979. Esp. pp. 99–106.

Ruland, H. L. "A Survey of the Double-page Maps in Thirty-five Editions of the *Cosmographia Universalis* 1544–1628 of Sebastian Münster and in His Editions of Ptolemy's *Geographia* 1540–1552." *Imago Mundi* 16 (1962): 84–97.

Shirley, Rodney W. *The Mapping of the World: Early Printed World Maps 1472–1700*. London: The Holland Press, 1983. Esp. nos. 76–77, pp. 86–87.

Skelton, Raleigh Ashlin. *Introduction to the 1513 Strasbourg edition of* Geographia, *by Claudius Ptolemy*. Facsimile ed. Amsterdam: Theatrum Orbis Terrarum, 1966.

ABRAHAM ORTELIUS
Belgian, 1527–98

77 *Theatrum orbis terrarum*

Antwerp, Coppenium Diesth, 1571
Illustrated book
41 x 28.8 x 3.4 cm. (16⅛ x 11⅜ x 1⅜ in.)
Dartmouth College Library, Hanover,
 New Hampshire
Acc. no. Rare Book G/1006/T5/1571

Abraham Ortelius was one of the most important figures in the history of cartography. A native of Antwerp, he began his career as a colorist and illuminator of maps. On the advice of his friend, Aegidius Hooftman, Ortelius set out to produce an atlas unlike any other: it would contain maps rendered according to a uniform format; the maps of a given region would be based on the works of the same, rather than different, authors; and instead of inserting the maps randomly in the volume, they would be arranged in logical relation to one another. In carry-

ing out this prodigious work, Ortelius gathered all the best and most up-to-date maps of the world's regions. These, in turn, were reengraved in a set of seventy maps on fifty-three sheets. As Ortelius acknowledged in the preface, the splendid and precisely rendered maps were "the result of the skill of Frans Hogenberg, by whose tireless diligence, almost all these plates were engraved" (Brown, no. 136). The *Theatrum orbis terrarum* was first published in 1570 and is usually considered the first modern geographical atlas (Brown, no. 135).

Two of the maps in Ortelius's atlas, *Typus orbis terrarum* and *Americae sive novi orbis, nova descriptio*, are often referred to as "mother maps" since they had a significant impact on the making of later charts showing the world and the western hemisphere. The

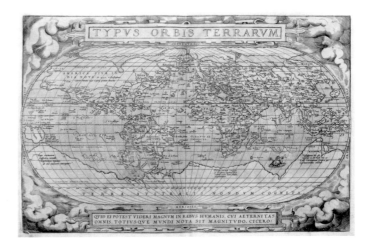

77 Map of the world. Hand-colored engraving.

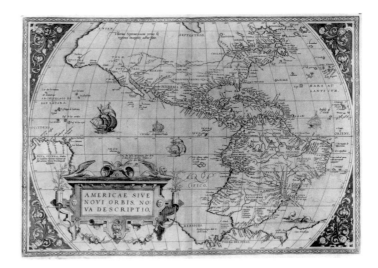

77 Map of the New World. Hand-colored engraving.

world map is a simplified version of a large map produced by Gerhard Mercator in 1569, and in both, as well as in the map devoted to the New World, South America is given an unusual "bulge." *Americae sive novi orbis* is a particularly elegant image that shows California as a peninsula and that includes such places of interest as the "Sierra nevada," "Cannaveral," "Apalchen," and Cape Cod (here called "C. de arenas").

Unlike many of his contemporaries, Ortelius credited all the cartographers whose work he used as the basis for his own atlas. This rare demonstration of intellectual honesty was praised by Mercator, who in a letter complimented Ortelius "on the care and elegance with which you have embellished the labours of the authors, and the faithfulness with which you have preserved the production of each individual which is essential to bring out geographical truth, which is so corrupted by mapmakers" (Tooley, p. 88). The publication of Ortelius's outstanding atlas established the Netherlands as preeminent in cartographic production, a distinction that would continue for the next hundred years.

BIBLIOGRAPHY

Bagrow, Leo. *History of Cartography*. 2nd ed. Chicago: Precedent Publishing, 1985. Esp. pp. 179–80.
Brown, Lloyd A. *The World Encompassed*. Baltimore: The Walters Art Gallery, 1952. Esp. nos. 135, 136.
Koeman, Cornelis. *The History of Abraham Ortelius and His Theatrum Orbis Terrarum*. Lausanne: Sequoia, 1964.
Nordenskiöld, Nils Adolf Erik. *Facsimile Atlas to the Early History of Cartography with Reproductions of the Most Important Maps Printed in the Fifteenth and Sixteenth Centuries*. Trans. Johan Adolf Ekelöf and Clements R. Markham. Stockholm: [Printed by P. A. Norstedt], 1889; reprinted in 1973. Esp. p. 90.
Shirley, Rodney W. *The Mapping of the World: Early Printed World Maps 1472–1700*. London: The Holland Press, 1983. Esp. no. 122, pp. 144–45.
Skelton, Raleigh Ashlin. *Introduction to the 1570 edition of Theatrum Orbis Terrarum, by Abraham Ortelius*. Facsimile ed. Amsterdam: Theatrum Orbis Terrarum, 1966.
Tooley, Ronald V. *Collector's Guide to Maps of the African Continent and Southern Africa*. London: Carta Press, 1969. Esp. p. 88.

ABRAHAM ORTELIUS
Belgian, 1527–98

78 *Chinae*

Separate sheet from *Theatrum orbis terrarum*
1584
Engraving, hand colored
37 x 50.4 cm. (14½ x 9⅞ in.)
Barry L. MacLean

Ortelius's *Theatrum orbis terrarum* became so successful after its first printing in 1570 that three other editions were produced in the same year, followed by almost fifty different editions between 1571 and 1612. International demand for this first convenient collection of maps led to Dutch, French, German, Spanish, and Italian translations, in addition to the standard Latin text. The map on display here, from the 1584 Latin edition, gives a close-up view of China and is decorated with a number of details referring to characteristic aspects of the region.

BIBLIOGRAPHY

Bagrow, Leo. *History of Cartography*. 2nd ed. Chicago: Precedent Publishing, 1985. Esp. pp. 179–80.
Koeman, Cornelis. *The History of Abraham Ortelius and His Theatrum Orbis Terrarum*. Lausanne: Sequoia, 1964.
Shirley, Rodney W. *The Mapping of the World: Early Printed World Maps 1472–1700*. London: The Holland Press, 1983. Esp. no. 122, pp. 144–45.

ABRAHAM ORTELIUS
Belgian, 1527–98

79 *Theatrum orbis terrarum*

Antwerp, Ex Officina Plantiniana, 1595
Illustrated book
42 x 31.5 x 7.5 cm. (16½ x 12¼ x 3 in.)
Library Company of Philadelphia, Philadelphia Pennsylvania
Acc. no. **Am 1595 Ort/1013.F
Venues: DC, NC, HO

Among the maps that were introduced into later editions of Ortelius's atlas is the double-page topographical chart of Iceland. A richly adorned engraving, indeed one of the most decorative maps in all the editions of the atlas, it shows a great variety of marine animals and monstrous fish inhabiting the waters off the coast of the northern isle. These creatures, most of them fanciful, are derived ultimately from the famous *Carta marina* of Olaus Magnus, a map that also

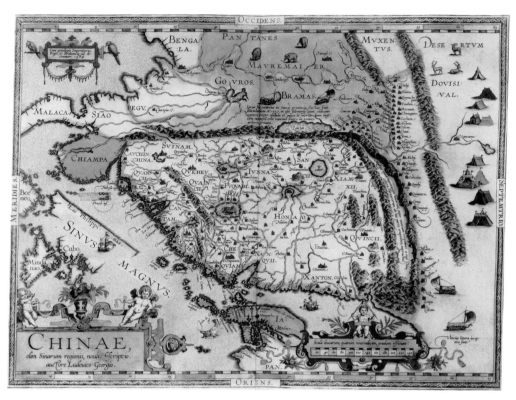

78

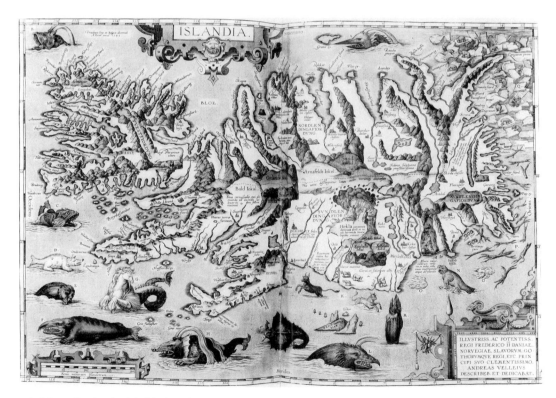

79 Map of Iceland with fabulous beasts. Hand-colored engraving.

301

inspired the fabulous images in Sebastian Münster's *Cosmographiae universalis* (cat. no. 80).

This copy of the atlas, produced in Antwerp in 1595, is distinguished by its superb contemporary hand coloring.

BIBLIOGRAPHY

Bagrow, Leo. *History of Cartography.* 2nd ed. Chicago: Precedent Publishing, 1985. Esp. pp. 179–80.

Koeman, Cornelis. *The History of Abraham Ortelius and His Theatrum Orbis Terrarum.* Lausanne: Sequoia, 1964.

Shirley, Rodney W. *The Mapping of the World: Early Printed World Maps 1472–1700.* London: The Holland Press, 1983. Esp. no. 122, pp. 144–45.

SEBASTIAN MUNSTER
German, 1489–1552

80 *Cosmographiae universalis*

Basel, Henrichum Petri, 1550
Illustrated book
34 x 25.4 x 10.2 cm. (13⅜ x 10 x 4 in.)
Dartmouth College Library, Hanover, New Hampshire
Acc. no. Rare Book G/113/M7/1550

Sebastian Münster's *Cosmographiae*, first issued in 1544, reproduces many of the maps from his 1540 edition of Ptolemy (cat. no. 76). A gazetteer rather than a cosmography, it was the first printed book to give a separate map of each of the four continents as well as a *tabula moderna* of the principal countries of the

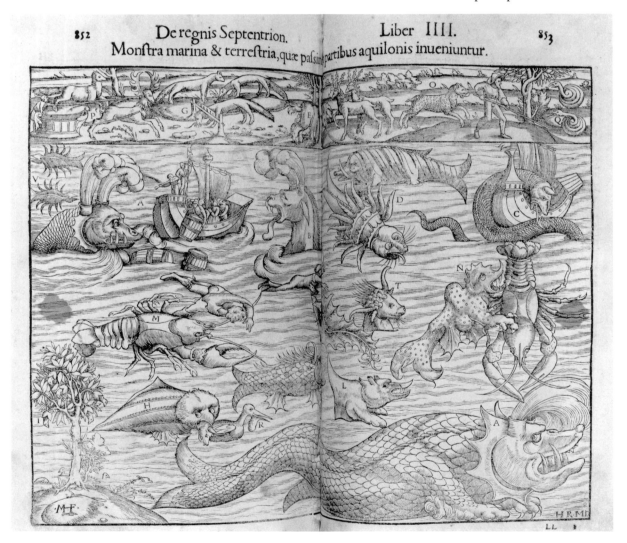

80 Sea monsters and mythic animals thought to inhabit the northern area of Europe and the Atlantic. Woodcut.

world. Moreover, Münster included in this volume carefully drawn city plans that were based on firsthand descriptions provided by local officials.

In 1550 Münster greatly enlarged the *Cosmographiae*: fifty-two new maps were added and the text was revised. This edition is especially interesting since it shows how Münster, while aiming for accuracy, was also a captive of fabulous tales and superstition. Modern knowledge of the world easily coexists in this volume with information drawn from ancient and medieval lore and from exaggerated stories of travelers. The woodcut of the North Atlantic is a case in point. Based on the 1539 *Carta marina* by Olaus Magnus, it is a striking rendering of sea monsters and notable animals found in northern lands, Scandinavia in particular. According to the key provided by Münster, this part of the world is inhabited by such creatures as huge fish the size of mountains (A), serpents two or three hundred feet in length who throw themselves on ships and are extremely troublesome to sailors (C), an insatiable glutton who squeezes itself between trees to empty its belly and then rushes off to eat some more (E), trees that produce ducks (I), crabs so large and strong that they can kill a swimmer caught in their claws (M), and a monster resembling a rhinoceros that is able to devour a crab twelve feet long (N) (Cumming, p. 44).

BIBLIOGRAPHY

Brown, Lloyd A., ed. *The World Encompassed*. Baltimore: The Walters Art Gallery, 1952. Esp. no. 272.

Cumming, W. P., Raleigh Ashlin Skelton, and D. B. Quinn. *The Discovery of North America*. New York: American Heritage Press, 1972. Esp. p. 44.

Oehme, Ruthardt. *Introduction to the 1550 edition of* Cosmographia *by Sebastian Münster*. Facsimile ed. Amsterdam, 1968.

Ruland, H. L. "A Survey of the Double-page Maps in Thirty-five Editions of the *Cosmographia Universalis* 1544–1628 of Sebastian Münster and in His Editions of Ptolemy's *Geographia* 1540–1552." *Imago Mundi* 16 (1962).

GIUSEPPE ROSACCIO
Italian, ca. 1530–1620

81 *Universale descrittione di tutto il mondo di Gioseppe Rosaccio Cosmographo*

Venice, 1597 [1647]
Engraving, 4th state
Each approx. 108 x 185 cm. (42½ x 72⅞ in.)

Copy A: Arthur Holzheimer Collection, Highland Park, Illinois
Venues: DC, NC

Copy B: Map Collection, Yale University Library, New Haven, Connecticut
Venues: HO, HI

This large and finely detailed map of the world stands as one of the great achievements of Italian map making. Designed in 1597 by Giuseppe Rosaccio and engraved by Giovanni Battista Mazza, it surpassed earlier world maps in the quality of its workmanship and in its wealth of information about the Americas. Rosaccio announced the plan of this great planisphere the year before in his book *Il Mondo*. Evidently proud of the research he had undertaken in preparing the *mappamondo*, he wrote that he had consulted all the famous cosmographers of earlier times as well as a great many navigational charts from Portuguese, Venetian, and English sources. The map was revised a few times in the next half century and was published in second and third states around 1620, in a fourth state in 1647, and in a final issue in 1657. The copies in this exhibition are from the fourth state.

The large oval map contains numerous textual inserts describing the discoveries of the great navigators and is adorned with four large allegorical figures representing the continents. Flying fish and other strange forms of marine life are depicted in the oceans, while numerous scenes showing the life and customs of the American Indians appear in the vast southern continent and in North America. These vignettes, based on Theodor de Bry's *Americae pars quarta*, include the hunting of alligators, the drying of fish and lizards, the spring festival of the Floridians, the ritual of making tobacco, the punishment of a Floridian sentinel, the making of dug-out canoes, the queen-elect of the Floridians being carried in a procession, and a view of the idol, Kewas, in the temple of the Secota.

BIBLIOGRAPHY

Almagià, Roberto. "Un grande planisfero di Giuseppe Rosaccio." *Rivista Geografica Italiana* 31 (1924).

Gallo, R. "Some Maps in the Correr Museum in Venice." *Imago Mundi* 15 (1960): 46–51.

Shirley, Rodney W. *The Mapping of the World: Early Printed World Maps 1472–1700*. London: The Holland Press, 1983. Esp. no. 205, pp. 222–24.

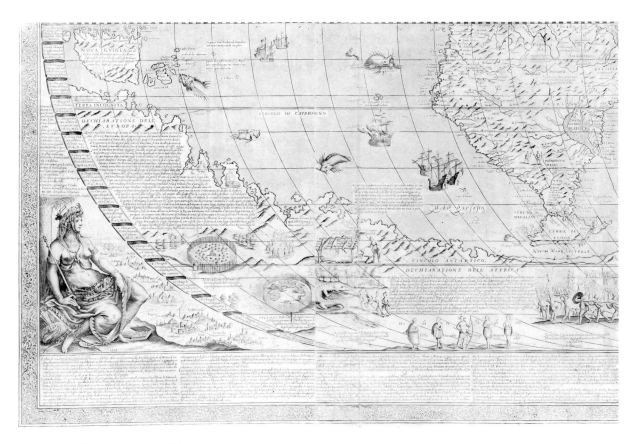

81 Detail of Rosaccio's map of the world.

JOHN SMITH
English, 1580–1631

82A *A Map of Virginia with a Description of the Countrey, the Commidities, People, Government and Religion*

Oxford, Joseph Barnes, 1612
Illustrated book
37 x 57 x 2 cm. (14½ x 23 x ¾ in.)
The Newberry Library, Chicago
Acc. no. Vault Ayer 150.5, V7 S6 1612 box
Venue: DC

82B *The Generall Historie of Virginia, New England, and the Summer Isles*

London, Michael Sparkes, 1624
Illustrated book
Open with map: 36 x 62 cm. (14⅛ x 24⅜ in.)

John Work Garrett Collections, Milton S. Eisenhower Library, The Johns Hopkins University
Acc. no. F229.S643 1624

In 1606 King James I of England chartered two companies to establish permanent colonies in America. One of these, the London company, underwrote an expedition to settle in the region found between latitudes thirty-four and forty-one degrees north. The three ships, under the command of Captain Christopher Newport, set sail on December 20, 1606, and arrived at Chesapeake Bay in late April 1607. The first settlement, called Jamestown in honor of the king, originally seemed destined to fail: within the first six months of its existence more than a third of the 144 colonists had perished. Thanks to the leadership of Captain John Smith, a soldier of fortune who was appointed president of Newport's council, the colony endured and peaceful relations were estab-

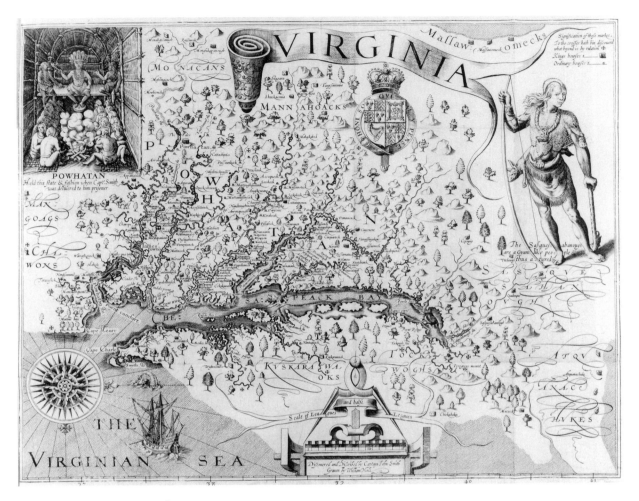

82A Map of Virginia. Engraving.

lished with the chief of the Algonquian-speaking Indians, Wahunsonacock, or Powhatan as he was known to the English settlers. One of the Jamestown colonists, John Rolfe, had a significant part in maintaining this peace when he married Pocahontas, Powhatan's daughter, in 1614.

John Smith left Virginia in 1609. Although he never made a return voyage, he first published his impressions of the region in the 1612 edition of the book exhibited here. Its most celebrated feature is its single illustration, a folding engraved map. Called the "mother map" of Virginia and the most important rendering of the area until 1873, it was engraved by the Englishman William Hole on the basis of descriptions given to him by Smith. The map, which is oriented with the north to the right, delineates the topography of the coastal plain as well as the hilly region of the Piedmont. The map abounds in fascinating details: Indian villages are designated by little houses, different species of trees are carefully distin-

guished, place names such as Appamatuck, Poynt Comfort, Cape Henry, and the "Russels Iles" are indicated. The most striking embellishments, however, are the inset in the upper left corner showing Powhatan in his council chamber and the impressive figure of an Indian, one of the Sasquesahanough, who, according to the accompanying inscription, "are a giant like people and are thus attired."

BIBLIOGRAPHY

Barbour, Philip L. *The Three Worlds of Captain John Smith*. Boston: Houghton Mifflin, 1964.

Cumming, W. P., Raleigh Ashlin Skelton, and D. B. Quinn. *The Discovery of North America*. New York: American Heritage Press, 1972. Esp. pp. 256–61.

McCary, Ben Clyde. *John Smith's Map of Virginia: with a Brief Account of its History*. Charlottesville: University Press of Virginia, 1981.

Sabin, Joseph, Wilberforce Eames, and R. W. G. Vail. *Bibliotheca Americana. A Dictionary of Books Relating to*

America. 29 vols. New York: Bibliographical Society of America, 1868–1936. Esp. vol. 20, no. 82832.

Schwartz, Seymour I., and Ralph E. Ehrenberg. *The Mapping of America*. New York: Harry N. Abrams, Inc., 1980. Esp. pp. 89–95.

SAMUEL DE CHAMPLAIN
French, 1567–1635

83 *Carte geographique de la nouvelle franse*

1612 [1613]
Engraving, hand colored
45 x 79 cm. (17¾ x 31⅛ in.)
Barry L. MacLean

The founder of French Canada, Samuel de Champlain, had made at least five and possibly six voyages to the New World before this map was engraved in 1612. He first went to Canada in 1603 and then in the following year made a return trip, this time as a member of an expedition led by Pierre du Gua who had managed to gain a monopoly of the fur trade. After three years of exploration, especially along the coast of New England and in the area of the Bay of Fundy, Champlain made a short visit to his homeland. Other expeditions to New France followed in 1608–9, 1610, and 1611. In 1612 Champlain was ap-

pointed lieutenant to the viceroy of New France and in 1632 was named governor of the colony.

The *Carte geographique* reflects the 1608, 1610, and 1611 excursions into southeast Canada and New England. One of the most famous early maps of the region, it was engraved by David Pelletier on the basis of the explorer's own design and was published ultimately in Champlain's 1613 book *Les Voyages du Sieur de Champlain*. The map contains a wealth of information about this part of the New World: the settlements of Quebec, Port Royal, and Ile de Sable are indicated; and among the lakes shown is that which Champlain discovered in 1609 and named after himself. Lake Ontario, which he heard about from the Indians but did not reach until 1615, is here quaintly named "Lac contenant 15 Journées des canaux des sauvages."

This splendid map bears numerous embellishments: wild fauna including a moose, polar bear, porcupine, and beaver are represented on the mainland, while a whale, horseshoe crab, seal, bull-fish, and other marine creatures are depicted in the coastal waters. In the lower left corner are representatives of the Montaignais (Indians who inhabited the area near the Saguenay River) and of the Almouchicois, who lived in Nova Scotia and New Brunswick. Along the bottom of the map is a beautiful border decoration consisting of a key to the major sites in the region and illustrations of the local fruits—among which can

83

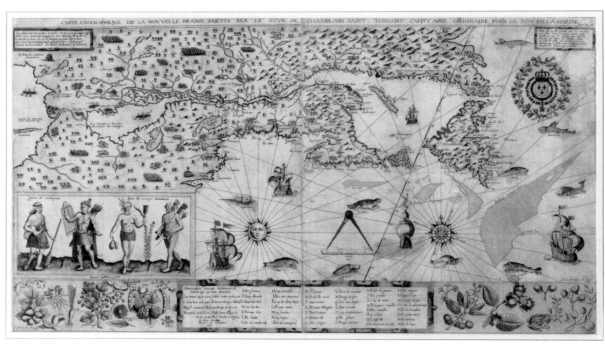

be distinguished acorns, currants, plums, summer squash, and hickory nuts.

BIBLIOGRAPHY

Armstrong, Joe C. W. *Champlain*. Toronto: Macmillan of Canada, 1987.

Gagnon, François Marc. *Ces Hommes dits sauvages: l'histoire fascinante d'un préjugé qui remonte aux premiers découvreurs du Canada*. Montréal: Libre Expression, 1984.

Harper, John Murdock. *Dominus domi; or, The Château Saint-Louis*. Québec: Chien d'or Stationery Depot, 1898.

Heidenreich, Conrad E. *Explorations and Mapping of Samuel de Champlain*. Toronto: B. V. Gutsell, 1976.

Morison, Samuel Eliot. *Samuel de Champlain, Father of New France*. Boston: Little, Brown, 1972.

Tyrrell, William G. *Champlain and the French in New York*. Albany: University of the State of New York, 1959.

GEORGIUS SPILBERGIUS
Netherlandish, 1568?–1620

84 *Speculum orientalis*

Leiden, Nicolaum à Geelkercken, 1619
Illustrated book
17.4 x 47.6 cm. (6⅞ x 18¾ in.)
American Antiquarian Society, Worcester, Massachusetts

Georgius Spilbergius (or Joris van Spilbergen), an explorer and map maker from the Netherlands, embarked on his return journey from Java around 1617. He was joined by Willem Cornelis Schouten, a more distinguished navigator who had argued with his sponsors, the Dutch East India Company, and needed escort back to Holland. During his journey to Java under the command of Jacob Le Maire, Schouten was the first to map what is now known as Drake's Passage, the strait between the South Shetland Islands and the southern tip of South America. (Sir Francis Drake had mistakenly discovered it when his ship was blown southward after passing through the Straits of Magellan in 1578.)

The map exhibited here, which is contained in Spilbergius's *Speculum orientalis*, first published in Leiden in 1619, shows the Straits of Magellan, complete with inhabitants greeting Europeans and a native penguin. It was probably mapped on Spilbergius's return journey with Schouten. Magellan had first traveled through these straits in 1520, but because wind, fog, tidal rips, and a tidal range of 60 feet made navigation difficult, this route was for the most part ignored by explorers, traders, and others in favor of overland routes in Central America. As a depiction of a remote and rarely traveled region of the world, this map of the straits was of practical use to few, but it was of great interest to the many who were curious about this distant land.

BIBLIOGRAPHY

Parry, J. H. *The Discovery of South America*. New York: Taplinger Publishing Co., 1979.

Sabin, Joseph, Wilberforce Eames, and R. W. G. Vail. *Bibliotheca Americana. A Dictionary of Books Relating to America*. 29 vols. New York: Bibliographical Society of America, 1868–1936. Esp. vol. 22, no. 89450, pp. 556–60.

Shirley, Rodney W. *The Mapping of the World: Early Printed World Maps 1472–1700*. London: The Holland Press, 1983. Esp. no. 304, pp. 235, 317, 322, 323.

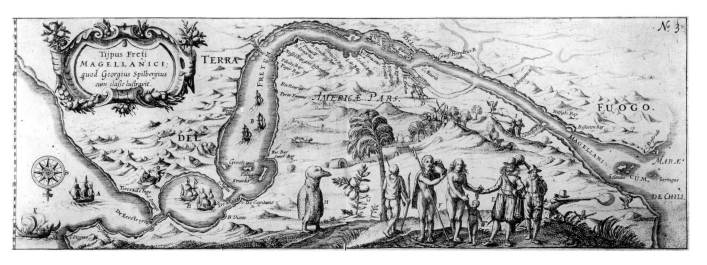

84 Straits of Magellan with Europeans, natives, and penguins. Engraving.

GERHARD MERCATOR
Flemish, 1512–94

85 *Atlas sive cosmographicae meditationes de fabrica mundi et fabricati figura*

Amsterdam, Henrici Hondij, 1630
Illustrated book
47.3 x 31.5 x 7.8 cm. (18⅝ x 12⅜ x 3 in.)
Dartmouth College Library, Hanover,
 New Hampshire
Acc. no. Rare Book G/1007/M4/1630

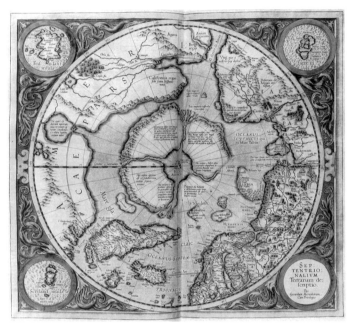

85 North Pole projection. Hand-colored engraving.

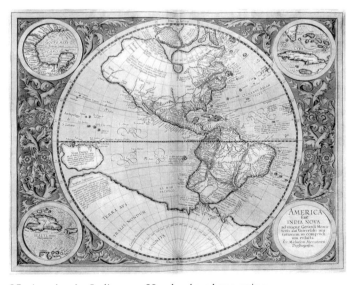

85 *America sive India nova*. Hand-colored engraving.

Gerhard Mercator, who coined the word "atlas" as a name for a bound collection of maps, was called "the Ptolemy of our age" by his friend Abraham Ortelius (cat. nos. 77–79). A gifted artist and engraver as well as astronomer and cartographer, he invented what is now called the Mercator projection, which allows all compass bearings on a map to be drawn on straight lines. The great atlas envisioned by Mercator reflected a lifetime's effort to modernize cartography and to liberate it as much as possible from the old and still influential Ptolemaic system (Brown, no. 134). The first part of his *Atlas* was published in 1585 and a second part was printed in 1589. The complete work, however, did not go to press until 1595, a year after Mercator's death.

In 1604 the copper plates for the maps were purchased from Mercator's heirs by the Flemish cartographer Jodocus Hondius, and in 1606 the first edition of the Mercator-Hondius atlas was produced. When, in 1629, the Hondius firm was threatened by the successes of rival cartographic publishers, especially Willem Blaeu, Henricus Hondius (the son of Jodocus) and his partner Jan Jansson decided to publish a revised edition of the *Atlas*. The enlarged volume was printed in 1630 and thereafter went into a great many editions.

Two maps based on the original Mercator copper plates are shown in this exhibition. The first of these, *America sive India nova*, is, by 1630 standards, quite old-fashioned and does not take into account information that had been learned about the Americas since 1595. The second map, *Septentrionalum terrarum*, is a North Pole projection that depends on a 1531 map of the world by Oronce Fine. In contrast to Mercator's earlier (1538) projection of the North Pole in a double-cordiform world map, where he accidentally gave a correct representation of a single large polar mass, this map has been revised in favor of polar islands separated by four rivers originating at the pole (Shirley, p. 84). America is shown as a great land mass and is separated from the Asian continent by a broad Strait of Anian. Though the many editions of the Mercator-Hondius atlas competed successfully with rival productions and though many of its maps have a handsome appearance, it has to be admitted that both in accuracy and in the quality of its engravings it was surpassed by the Blaeus' extraordinary *Atlas maior* of 1662 (cat. nos. 87–90).

BIBLIOGRAPHY

Bagrow, Leo. *History of Cartography*. Chicago: Precedent Pub., 1985. Esp. pp. 118–19, 180–81.

Brown, Lloyd A., ed. *The World Encompassed*. Baltimore: The Walters Art Gallery, 1952. Esp. nos. 132, 134.

Koeman, Cornelis. *The History of Abraham Ortelius and His Theatrum Orbis Terrarum*. Lausanne: Sequoia, 1964. Esp. p. 12.

Shirley, Rodney W. *The Mapping of the World: Early Printed World Maps 1472–1700*. London: The Holland Press, 1983. Esp. nos. 74, 336, pp. 83–84, 359–61.

Skelton, Raleigh Ashlin. *Introduction to the 1636 English text edition of* Mercator-Hondius-Jansson Atlas. Facsimile ed. Amsterdam, 1968.

Tooley, Ronald V. *Collector's Guide to Maps of the African Continent and Southern Africa*. London: Carta Press, 1969.

NICOLAS SANSON
French, 1600–67

86 *Amerique septentrionale*

1650
Engraving, hand colored
42 x 57.5 cm. (16½ x 22⅝ in.)
Barry L. MacLean

The pioneer of map making in France was Nicolas Sanson of Abbeville. Following his move to Paris in the early 1630s, Sanson was appointed by Louis XIII to the position of engineer of the Province of Picardy and later became Géographe Ordinaire du Roi. The dynasty that Sanson founded (his business was passed on to his sons and then to his grandson) resulted in the shift of the center of cartographic production from the Netherlands to France. It has been said of Sanson that "he eschewed unnecessary decoration to the point of plainness." His maps are marked by clarity, delicacy, and an almost scientific precision, qualities that came to characterize late-seventeenth-century French maps.

The 1650 map of America was one of the most important produced by Sanson. Among the first to distinguish the Great Lakes, it delineates but does not name directly lakes Huron and Erie. Lake Ontario is named for the first time, as is Lake Superior. Lake Michigan is introduced here as "Lac des Puans," that is, the "Lake of Evil Smells." Sanson's map also shows Santa Fe as the capital of New Mexico, although it is located on the west bank of the Rio Grande. No less interesting is his rendering of California as an island,

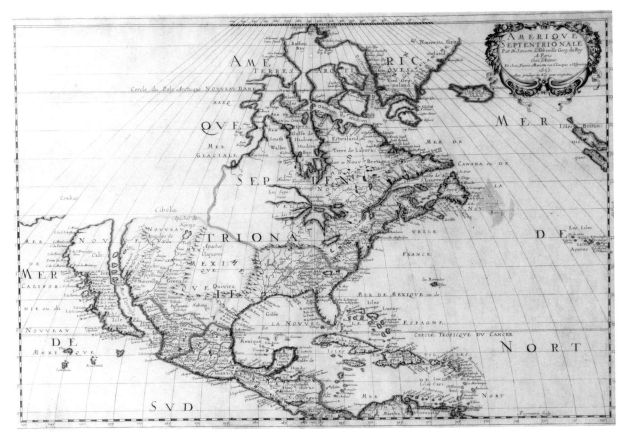

86

a concept first represented in a 1622 edition of Antonio de Herrera y Tordesillas's *Historia general de las Indias Ocidentales* and not disproved until 1701.

BIBLIOGRAPHY

Pastoureau, Mireille. "Le Premier atlas mondial français . . . de Nicolas Sanson d'Abbeville (1658)." *Revue français d'histoire du livre* 18 (1978).

Schwartz, Seymour I., and Ralph E. Ehrenberg. *The Mapping of America*. New York: Harry N. Abrams, Inc., 1980. Esp. pp. III–12.

Shirley, Rodney W. *The Mapping of the World: Early Printed World Maps 1472–1700*. London: The Holland Press, 1983. Esp. no. 390, pp. 414–15.

Tooley, Ronald V. *Collector's Guide to Maps of the African Continent and Southern Africa*. London: Carta Press, 1969.

JOAN BLAEU
Dutch, 1596–1673

87 *Geographia maior; sive, cosmographia blaviana*

Volume 1
Amsterdam, Joannis Blaeu, 1662–65
Atlas
53.5 x 34.5 x 6.0 cm. (21³⁄₈ x 13⁷⁄₈ x 2³⁄₈ in.)
Dartmouth College Library, Hanover,
 New Hampshire
Acc. no. Rare Book G/1015/B48/1662

The Dutchman Willem Blaeu was assisted in the administration of his cartographic firm by his two sons, Joan and Cornelius. The Blaeus were hard-nosed and successful businessmen who oversaw a vast and complex organization that included scores of engravers, printers, bookbinders, and colorists. They issued large wall maps, globes, nautical charts, land maps, and huge folio atlases. At the time of Willem's death in 1638 their fame had spread to most parts of Europe. Indeed, it was widely acknowledged at the time that the best maps were Dutch maps and that the finest were produced by the Blaeus (see Tooley, p. 28). Only when the publishing house was ravaged by fire in 1672 did the Blaeus' preeminence in the field of map making yield to the efforts of competing firms.

The famous *Atlas maior*, as this atlas is commonly known, was begun during Willem's lifetime and finally published as a complete set of eleven large volumes in 1662. This Latin edition was followed by editions of nine volumes in Dutch and German, and twelve and ten volumes in French and Spanish respec-

tively. A spectacular and monumental achievement, it has often been considered one of the marvels of seventeenth-century cartography—a production that in its size, its accuracy, and its beauty "has never been surpassed" (Brown, no. 149). The atlases could be purchased plain or in color. In special instances, when the set was purchased by a wealthy patron or a member of the nobility, the maps and other illustrations were heightened with gold.

Four of the volumes from Dartmouth's set are exhibited here. One of the finest sets to be found in an American collection, it is richly hand colored and is in nearly pristine condition. The first volume of the series, and the first of the folios devoted to Europe, includes a lavishly decorated double-hemisphere map of the world and a fascinating view of Tycho Brahe's observatory in Denmark. This latter image is but one of many depicting the observatory of the celebrated astronomer under whom the young Willem Blaeu trained as a scientist.

87 Observatory of Tycho Brahe. Hand-colored engraving.

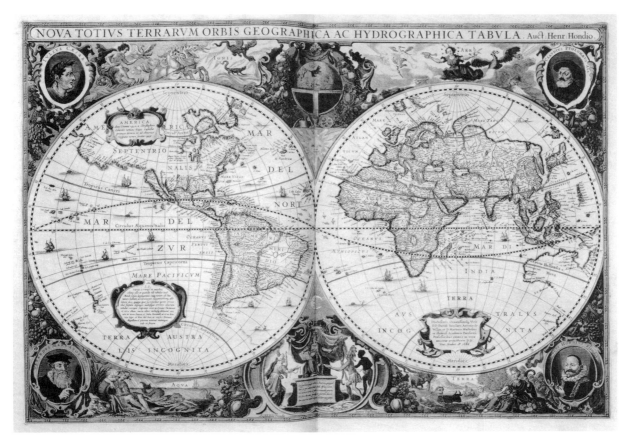

87 Double hemisphere. Hand-colored engraving.

BIBLIOGRAPHY

Brown, Lloyd A., ed. *The World Encompassed*. Baltimore: The Walters Art Gallery, 1952. Esp. no. 149.

Keuning, J. *Willem Jansz. Blaeu. A Biography and History of His Work as a Cartographer and Publisher*. Ed. Marijke Donkersloot-Vrij. Amsterdam: Theatrum Orbis Terrarum, 1973.

Koeman, Cornelis. *Joan Blaeu and His Grand Atlas*. London: George Philip and Son, Ltd., in cooperation with Amsterdam: Theatrum Orbis Terrarum, 1970.

Koeman, Cornelis. "Life and Works of Willem Janszoon Blaeu: New Contributions to the Study of Blaeu, Made During the Last Hundred Years." *Imago Mundi* 26 (1972). Esp. pp. 9–16.

Koeman, Cornelis. "Some New Contributions to the Knowledge of Blaeu's Atlases." *Tijdschrift van Het Aardrijkskundig Genootschap* 77 (1960): 278–86.

Richter, H. "W. J. Blaeu with Tycho Brahe on Hven and His Map of the Island." *Imago Mundi* 3 (1939): 53–60.

Tooley, Ronald V. *Collector's Guide to Maps of the African Continent and Southern Africa*. London: Carta Press, 1969. Esp. p. 28.

JOAN BLAEU
Dutch, 1596–1673

88 *Geographia maior; sive, cosmographia blaviana*

Volume 9
Amsterdam, Joannis Blaeu, 1662–65
Atlas
53.3 x 33.8. x 6.3 cm. (21¼ x 13½ x 2½ in.)
Dartmouth College Library, Hanover,
 New Hampshire
Acc. no. Rare Book G/1015/B48/1662

Volume 9 of the *Atlas maior* is devoted to Hispania and Africa. One of the most decorative images in this tome is the large double-page map of the African continent. Engraved in 1630 and published separately on numerous occasions from that time until 1667, it is enriched with borders showing principal cities and the representatives of the continent's major regions. Elephants and other native animals are depicted on

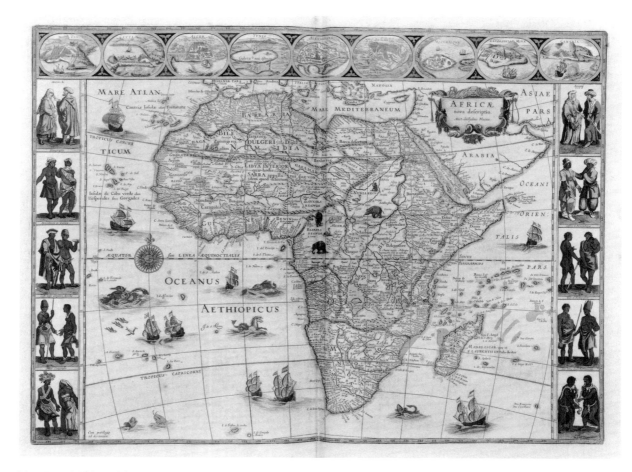

88 Map of Africa with natives in the margin. Hand-colored engraving.

the land mass, while sailing vessels, sea monsters, and flying fish are shown in the surrounding oceans.

BIBLIOGRAPHY

Tooley, Ronald V. *Collector's Guide to Maps of the African Continent and Southern Africa*. London: Carta Press, 1969. Esp. pp. 28–29.

Like the double-page maps of Africa and Europe, the map of Asia is surrounded by decorative and exquisitely rendered images of the natives in their characteristic dress. The succeeding maps in volume 10, each of which treats in detail a separate region of the continent, are enhanced by elaborately ornamented cartouches indicating the peoples and animals indigenous to a specific area.

JOAN BLAEU
Dutch, 1596–1673

89 *Geographia maior; sive, cosmographia blaviana*

Volume 10
Amsterdam, Joannis Blaeu, 1662–65
Atlas
52.7 x 34 x 7.7 cm. (20¾ x 13⅜ x 3 in.)
Dartmouth College Library, Hanover,
 New Hampshire
Acc. no. Rare Book G/1015/B48/1662

JOAN BLAEU
Dutch, 1596–1673

90 *Geographia maior, sive cosmographia blaviana*

Volume 11
Amsterdam, Joannis Blaeu, 1662–65
Atlas
53.5 x 34.5 x 6 cm. (21⅜ x 13⅞ x 2⅞ in.)
Dartmouth College Library,
 New Hampshire
Acc. no. Rare Book G/1015/B48/1662

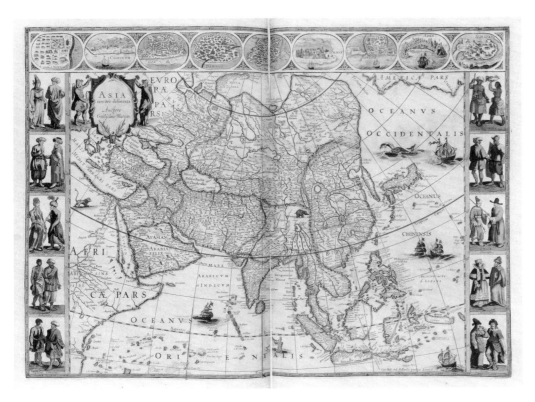

89 Map of Asia with depictions of natives in the margins. Hand-colored engraving.

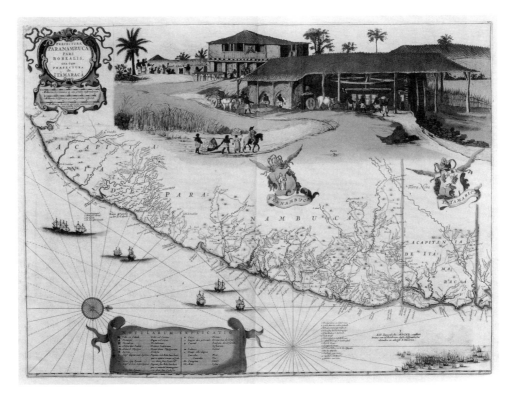

90 Pernambuco, Brazil. Hand-colored engraving.

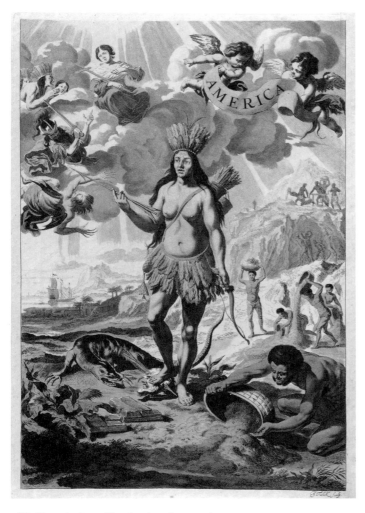

90 Frontispiece. Hand-colored engraving.

Volume II of the *Atlas Maior* is devoted exclusively to the continent of America. The frontispiece, apparently based on a design by Nicholas Berchem (now in The Metropolitan Museum of Art), presents an allegorical figure of the New World, complete with her feather headdress and bow and arrows. This extraordinarily beautiful image, which has been heightened with gold, obviously draws attention to the riches that could be acquired in the Americas: the mining of precious metals—either gold or silver—is shown in a vignette on the right side, while a European vessel appears in the background, no doubt ready to transport the precious cargo back home. The frontispiece also seems to allude to the rivalry between the Dutch Protestants and Portuguese Catholics in America, specifically in Brazil. As Hugh Honour has shown, there is "a distinctly Protestant figure

of Religion in the sky, casting down a helmeted and mustachioed figure of Iberian appearance" (p. 122).

Among the pages of this volume, one illustration of Brazil stands out. This shows a sugar cane factory in Pernambuco. A splendid and finely detailed rendering, it is based on a drawing by Frans Post, who had accompanied Prince Maurits of the Dutch Provinces on his expedition to Brazil.

BIBLIOGRAPHY

Honour, Hugh. *The European Vision of America*. Cleveland: Cleveland Museum of Art, 1975. Esp. no. 95, p. 122.

JOHANNES NIEUHOF
Dutch, 1618–72
ATHANASIUS KIRCHER
German, 1602–80

91 *An Embassy Sent by the East India Company of the United Provinces to the Grand Tartar Cham or Emperour of China*

London, John Ogilby, 1673
40.6 x 26.6 x 4.0 cm. (16¹/₁₆ x 10³/₈ x 1¹/₁₆ in.)
The New York Public Library
Astor, Lenox and Tilden Foundations
Rare Books and Manuscripts Division
Acc. no. *KC + 1673

Soon after returning from a trip to "East India" in the early 1650s, Johannes Nieuhof joined an embassy from the Dutch East India Company to the court of the emperor (at that time K'ang-Hsi [r. 1661–1722] of the Ch'ing dynasty) in the city of Peking. The long and dangerous journey, led by Peter de Goyer and J. de Keyser, was prompted by a report "that the port of Canton was to be opened to all trading nations" (Reilly, p. 133). The Dutch were economically motivated to take advantage of this possible opportunity, as European relations with the Chinese had been dominated by Jesuit missionaries. The founder of the Christian church in China, the Jesuit and scientist Matteo Ricci, had first arrived there in 1582 and from 1601 until his death was a respected member of the Chinese court.

Eleven years after Nieuhof's return in 1657, an account of his journey to China was published. Along with descriptions of people he encountered, the volume included engravings after his sketches of the countryside, towns, as well as "Beasts, Birds, Fishes,

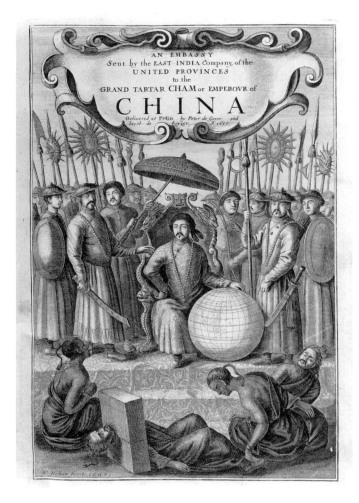

91 Frontispiece. Engraving.

ALEXIS–HUBERT JAILLOT
French, 1632–1712

92 *Amerique septentrionale*

1692
Engraving, hand colored and highlighted with
 gold
53.5 x 86.4 cm. (21⅛ x 34 in.)
Barry L. MacLean

ALEXIS–HUBERT JAILLOT
French, 1632–1712

93 *L'Asie*

1692
Engraving, hand colored and highlighted with
 gold
54.5 x 88.8 cm. (21½ x 35 in.)
Barry L. MacLean

Alexis–Hubert Jaillot succeeded Nicolas Sanson as
the leading cartographer of France. Appointed geog-
rapher to Louis XIV, he carried out the ambitious
plan of reengraving all of Sanson's maps on a larger
scale. His *Atlas nouveau*, which consisted of forty-five
of these elegantly engraved plates, was published in
1681; later editions contained over one hundred maps.
The two maps exhibited have come from a volume
published in 1692. Despite the fact that Jaillot's maps
did not always provide current information—a fail-
ing that resulted from the reissuing of old carto-
graphic materials—they were highly esteemed for
their beauty. The maps were issued either partially or
wholly hand colored, and in special instances, as was
the case for these two maps, they were heightened
with gold. Jaillot's illuminated maps are among the
finest examples of this decorative art and in their vi-
sual splendor were rarely surpassed by the works of
other cartographers.

BIBLIOGRAPHY

Pastoureau, Mireille. "Les Atlas imprimés en France avant
 1700." *Imago Mundi* 32 (1980).
Shirley, Rodney W. *The Mapping of the World: Early Printed
 World Maps 1472–1700*. London: The Holland Press, 1983.
 Esp. no. 550, pp. 551–52.

and Plants, and other Rarities never divulged . . .
heretofore" (p. 3). Soon after the book first appeared,
the Englishman John Ogilby brought out an English
translation, an example of which is exhibited here.
Ogilby used this book as an opportunity to publish a
section of Athanasius Kircher's famous *China Illus-
trata* (1667; second edition, 1672), a compendium of
earlier accounts of China by the Jesuit missionaries
Beneto de Goes, Heinrich Roth, and John Grueber.
The latter two were friends of Kircher who had tried,
as had de Goes, to find and document a feasible and
safe land route to China.

BIBLIOGRAPHY

Reilly, P. Conor, S. J. *Athanasius Kircher: Master of a Hun-
 dred Arts*. Rome: Edizioni del Mondo, 1974. Esp. chapter
 10, pp. 123–34.

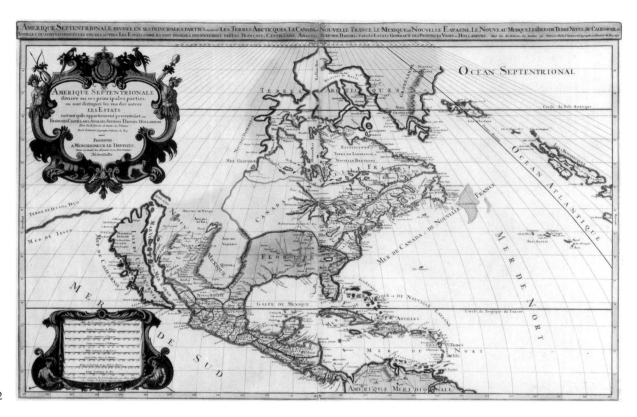

92

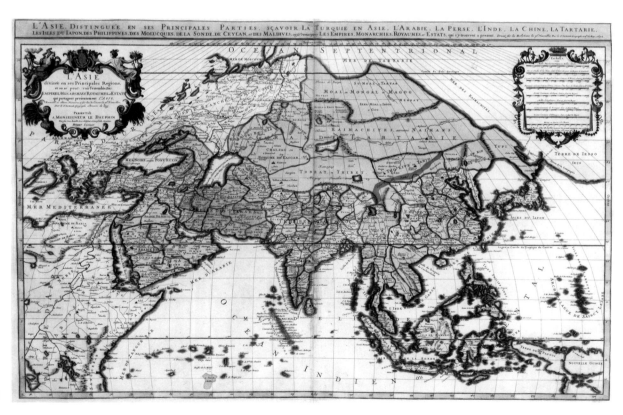

93

PETRUS APIANUS
German, 1495–1552

94 *Astronomicum caesareum*

Ingolstadt, 1540
Illustrated book
47 x 32 x 2.54 cm. (18½ x 12⅝ x 1 in.)
Swarthmore College, Swarthmore, Pennsylvania
Gift of Elizabeth Schickele in Memory of Margaret
 Ionides Cochran
Acc. no. Treasure Room QB41/ ++A64/ 1540

Petrus Apianus (or Peter Apian), a professor of mathematics in Vienna and Ingolstadt, is best known for his work as an astronomer, geographer, publisher, and map maker. One of his earliest publications, the 1524 *Cosmographicus liber*, earned him considerable fame and was reissued for over eighty years. But Apianus's most splendid achievement was the *Astronomicum caesareum*, a work that has been called "the most spectacular contribution of the bookmaker's art to sixteenth-century science" (Wolf, p. 173). Published by the author at his own press, it was designed for Emperor Charles V and his brother Ferdinand. Apianus was well paid for this extraordinary effort, for, in addition to receiving three thousand gold coins, he was elevated to the rank of hereditary nobility.

The *Astronomicum caesareum* on exhibit is an exceptionally beautiful copy of this publication. Its illustrations and astronomical diagrams are embellished with figures of dragons, griffins, and other fanciful creatures, and all are enhanced with rich hand coloring. Aside from its beauty, the volume was of great value for its scientific advances. The volvelles, or moveable paper diagrams, made it possible to easily determine planetary motions and to solve problems in spherical trigonometry. Apianus also noted that the tails of comets point away from the sun. Moreover, he offered new information about a comet seen in 1531 and eventually named after the English astronomer Edmund Halley (1656–1742), who predicted its cycle.

BIBLIOGRAPHY

Gingerich, Owen. "Early Astronomical Books with Moving Parts." *Cite AB* (October 23, 1989): 1505–08.
Wolf, Edwin, ed. *Legacies of Genius: A Celebration of Philadelphia Libraries*. Philadelphia, Pa.: Philadelphia Area Consortium of Special Collections Libraries, ca. 1988. Esp. no. 135.

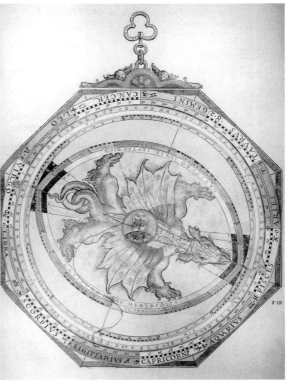

94 Volvelles. Hand-colored engravings.

95

95 *Galilean Telescope*

Replica of Galileo's telescope in the Museo di Storia
della Scienza, Florence, Italy
Cardboard covered with red leather, gilt
decoration
L: 94 cm. (37 in.); MAX. DIAM: 6.2 cm. (2 7/16 in.)
Smithsonian Institution, Museum of American
History, Washington, D.C.
Acc. no. 219,196

Although more than one hundred telescopes were
produced in Galileo's studio, only two surviving
examples (in the Museo di Storia della Scienza, Flor-
ence) can be attributed to him with certainty. Both
instruments, according to Galileo's correspondence,
were forwarded to Cosimo II de'Medici, the grand
duke of Florence and Tuscany. The first of these, the
"glass with which I discovered the planets and made
all my other observations," was by the scientist's own
admission "unadorned and soiled" since he had made
it for his own use. In contrast to this instrument,
made of wood and covered with paper, the second
telescope was "something better," being covered in
leather with gold decoration (Bonelli, p. 151; Galileo,
pp. 299–303).

On exhibit is a modern replica of the decorated and
smaller (thirty-seven inches long) of the two instru-
ments. The original, outfitted with two lenses—one
double-convex (the objective, or lens nearest to the
object observed) and the other concave (the
eyepiece)—had a magnifying power of 20x's. The
"unadorned" telescope, measuring forty-nine inches,
had a magnification of 14x's.

BIBLIOGRAPHY

Bonelli, M. L. *Catalogo degli Strumenti del Museo di Storia
della Scienza*. Florence: Leo S. Olschki, 1954. Esp. cat.
nos. 2427–8.

Consiglio d'Europe. *Firenze e la Toscana dei Medici nell'-
Europa del Cinquecento: La rinascita della Scienza*. Milan:
Electa, 1980. Esp. p. 228.

LEONARDO SEMITACOLO
Italian, fl. late 17th century–early 18th century

96 *Manual Telescope Decorated with Floral Design and Eagles*

ca. 1700
Cardboard and brass
L (closed): 24.1 cm. (9½ in.); DIAM: 3.8 cm. (1½ in.)
L (open): 45.7 cm. (18 in.)
Smithsonian Institution, Museum of American
History, Washington, D.C.
Acc. no. 248,009

This telescope is a signed work by its northern Italian
maker, Leonardo Semitacolo (or Semitecolo). Con-
structed of cardboard with horn fittings, it is a three-
section draw tube that extends eighteen inches end to
end when fully opened. In contrast to Galileo's in-
struments, it has a convex, rather than concave, lens
for the eyepiece. This was an improvement intro-
duced in the early part of the seventeenth century
(Johannes Kepler describes it in 1611) which magni-
fied the image formed by the objective and which,
among its other advantages, gave a considerably
larger field of view. A handy and compact item when
closed and outfitted with a sliding shield for the ob-
jective, it may have been made for a particular patron,
perhaps for use in the field or on outings. The tele-
scope is embellished with a repeating pattern of an
unidentified coat of arms—an eagle with a medallion
in its talons.

96

BIBLIOGRAPHY

Dewhirst, David W. *Notes for a Biographical List of Some British and Continental Scientific Instrument Makers from Medieval Times to the Close of the 19th Century.* Cambridge: Christ College, Cambridge University, n.d.

GALILEO GALILEI
Italian, 1564–1642

97 *Sidereus nuncius, magna, longeque admirabilia spectacula pandens*

Venice, Thomam Baglionum, 1610
Illustrated book
21 x 15.2 cm. (8¼ x 6 in.)
Professor Jay M. Pasachoff, Hopkins Observatory,
Williams College, Williamstown, Massachusetts

Galileo Galilei was born in the central Italian city of Pisa and was educated in Florence. He was a professor of mathematics first at the University of Pisa (1589) and later at the University of Padua (1592). Astronomer, physicist, and philosopher, he was recog-nized by one of his contemporaries as "that rare and unique genius, the inventor of the extraordinary tele-scope." Although the telescope had been in use since the late sixteenth century, Galileo was the first to pub-lish the discoveries he made with this instrument. His twenty-nine page booklet called "Sidereus nuncius" (or Starry Messenger) startled Europeans and, espe-cially troublesome for many, offered powerful sup-port for Copernicus's view of a heliocentric system. The telescope used by Galileo was weak by our mod-ern standards, but it enabled him to make detailed descriptions of the moon's surface and to calculate the height of the lunar mountains. Galileo also dis-covered moons circling the planet Jupiter, and this Jovian system, he observed, was similar to the plane-tary system of Copernicus.

Galileo's discoveries brought him instant fame: he was compared to the great navigators Columbus and Vespucci and was appointed philosopher to the grand duke of Florence, Cosimo de'Medici. When Johannes Kepler learned of the discoveries, he wrote in a burst of enthusiasm: "O telescope, instrument of much knowledge, more precious than any scepter! Is not he

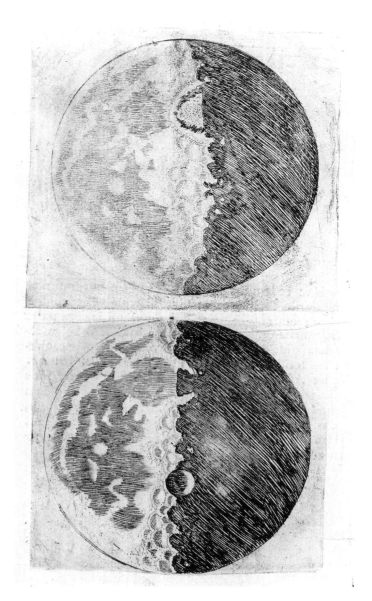

97 Illustration of phases of the moon. Engraving.

who holds thee in his hands made king and lord of the works of God!" (Carlos, p. 86). But Galileo's support of the heliocentric theory was his undoing. Seeing the Copernican theory as contradictory to the doctrines of Holy Scripture, the Roman Catholic church denounced it as heretical and warned Galileo not to defend it again. However, in his later publication, *Dialogue on the Two Principal World Systems* (1632), Galileo demolished the arguments in support of Ptolemy's geocentric system. The next year the astronomer was brought to trial and forced to recant the view that the earth moved around the sun. As

Boas (pp. 342–43) notes, however, the trial and conviction of Galileo "did more to promote Copernicanism than to discourage it."

BIBLIOGRAPHY

Boas, Mari. *The Scientific Renaissance: 1450–1630*. New York: Harper and Row, 1962.
Carlos, Edward Stafford, trans. *The Sidereal Messenger of Galileo Galilei and Part of the Preface to Kepler's Dioptrics*. London: Dawsons of Pall Mall, 1964.
Drake, Stillman. "Galileo's First Telescopic Observations." *Journal of the History of Astronomy* 7 (1976):153–68.
Galilei, Galileo. *Sidereus Nuncius or the Sidereal Messenger*. Trans. with text by Albert van Helden. Chicago: University of Chicago Press, 1989.

JOHANNES HEVELIUS
Polish, 1611–87

98 *Selenographia*

Danzig, Hünefeldianis, 1647
Illustrated book
Each approx. 35.3 x 23.5 x 5.6 cm. (13⅞ x 9¼ x 2¼ in.)

Copy A: Library Company of Philadelphia, Philadelphia, Pennsylvania
Acc. no. *Sev Heve 6072.F
Venues: DC, NC

Copy B: The New York Public Library
Astor, Lenox and Tilden Foundations
Science and Technology Research Center
Acc. no. OSH + Room 120
Venues: HO, HI

Johannes Hevelius (or Jan Heweliusz), the son of a brewer from Danzig, at first studied astronomy as a hobby. When he fell under the influence of Galileo and Kepler, however, he undertook these studies in earnest, and eventually became one of the most important astronomers of seventeenth-century Europe. With the income from his lucrative family business, which he took over in 1634, Hevelius constructed his own observatory and astronomical apparatus, including sophisticated lenses and some of the largest telescopes of the time.

Hevelius's first published account of his celestial observations, made over a five-year period, was *Selenographia*. In this ambitious work, the first complete lunar atlas, he gave names to many of the craters and mountains of the moon. The text is accompanied by many illustrations of the moon's surface as seen during all of its phases. These engravings, executed by Hevelius himself, provided readers with unprecedented

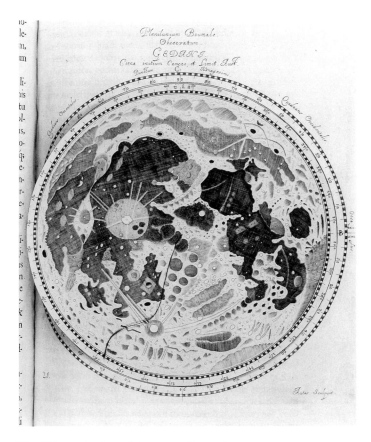

98A Telescopic view of the moon. Engraving.

A dearth of material is available on the life and the publications of Andreas Cellarius. Born around 1630, Cellarius was a native of Germany who spent most of his life in Holland. He died in Holland, although it is not known when. Three works by him are known: one on mathematics, another on architecture, and the work presented here, *Harmonia macrocosmica*, on astronomy. The title page of this last work indicates that Cellarius was a rector of the Schola Hornana in northern Holland. Apparently this was the college in the town of Hoorne off the coast of the Zuider Zee. *Harmonia macrocosmica*, which appeared in several editions between 1661 and 1708, contains over twenty superb double-page engravings of celestial charts. It was apparently published as a companion to the terrestrial atlases of Blaeu (*Atlas maior*, cat. nos. 87–90).

In two of his celestial charts, one of which is illustrated here, Cellarius renders the constellations not as mythological figures, which was the usual practice, but as biblical figures. Abraham, Isaac, King David, the three Magi, and even a figure of a pope are fully delineated; Noah's ark is also prominent. Isolated examples of such a rendition occur as early as the fourth century (Duerbeck, p. 408). The Irish Benedictine monk Bede (672–735) replaced the signs of the zodiac with figures of the twelve apostles. In 1627 Julius Schiller published his *Coelum stellatum Christianum*, which drew material from Bede as well as from Johann Bayer, with whom he worked around 1610. The stars appear in Schiller's work as they did in Bayer's *Uranometria* (1603), except that the mytho-

detailed information about the moon and at the same time revealed to them the dramatic beauty of this distant sphere.

BIBLIOGRAPHY

Volkoff, Ivan, Ernest Franzgrote, and A. Dean Larsen. *Johannes Hevelius and His Catalog of Stars*. Provo, Utah: Brigham Young University Press, 1971.

ANDREAS CELLARIUS
German, b. ca. 1630

99 *Harmonia macrocosmica*

Volume 1
Amsterdam, Joannem Janssonium, 1661
Illustrated book
52 x 31.5 x 6.2 cm. (20½ x 12⅜ x 2⅞ in.)
The New York Public Library
Astor, Lenox and Tilden Foundations
Map Division
Acc. no. Map Division, Vol. 1 (rebound 1945)

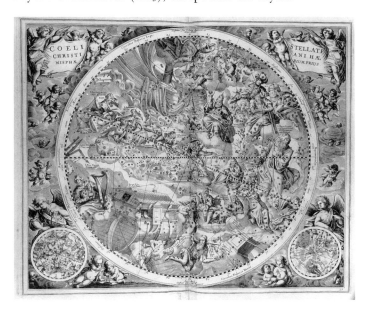

99 Map of the heavens with Christian figures as constellations. Engraving.

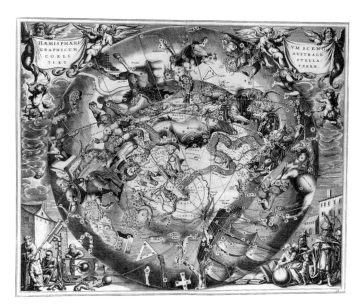

99 Chart of the southern sky with the new constellations of the Bird of Paradise and the Toucan. Engraving.

logical figures have been replaced by biblical figures from both the Old and New Testaments. Schiller's work exerted no influence on subsequent works of astronomy, with the exception perhaps of the *Harmonica macrocosmica*. Several figures in Cellarius's work resemble those in Schiller's charts; Noah's ark seems to be identical.

More representative of the celestial charts in Cellarius's work is the map of the southern hemisphere. With the increased navigation of the tropical seas came accurate observations of the stars in the southern sky. Reliable maps were possible because of the observations of explorers like Vespucci, Magellan, Friederich Houtman, and Petrus Theodori. Southern stars first appeared in the celestial charts of Bayer, Hondius, Adam von Bartsch, and Blaeu. As is quite evident from the celestial chart illustrated here, the organization of the southern stars into constellations was greatly influenced by Europeans' knowledge of the fauna of the Americas. Prominently displayed in Cellarius's chart are the constellations representing the toucan of Brazil and the bird of paradise.

BIBLIOGRAPHY

Brown, Basil. *Astronomical Atlases, Maps and Charts: An Historical & General Guide*. London: Dawsons of Pall Mall, 1968.
Duerbeck, Hilmar W. "Der Christliche Sternhimmel des Julius Schiller." *Sterne und Weltraum* 18 (1979):408–13.
Wolf, Dr. Rudolf. *Handbuch der Astronomie: ihrer Geschichte und Litteratur*. Amsterdam: Meridian Publishing Company, 1973 [originally published Zürich: F. Schulthess, 1892].

DOMINICUS VAN WYNEN,
called Ascanius
Dutch, 1661–after 1690

100 *Divine Cosmos*

Late 17th century
Oil on canvas
48 x 31 cm. (18⅞ x 12¼ in.)
Mr. and Mrs. John Walsh, Los Angeles

This remarkable painting, presumably by the Dutch artist Dominicus van Wynen, presents a curious combination of scientific discovery and religious belief. The picture shows in its lower half a large blue sphere of the physical universe surrounded by angels who hold krummhorns and a cornucopia. The upper half of the painting is dominated by a golden sphere signifying divinity. Four additional spheres probably represent the four elements: "the dark sphere of earth, the transparent blue sphere of water, the sphere of air that surrounds the earth, and finally the sphere of ethereal fire that was thought to lie beyond Earth's atmosphere" (Welu, p. 135).

Although when this picture was made (sometime after 1684), the heliocentric system of the universe was widely accepted by the scientific community, the Roman Catholic church continued to brand it as heretical. Van Wynen's painting shows the Ptolemaic or geocentric system that was defended by the church. Earth is represented in the center of the blue sphere of the universe, while around it are shown the sun (on the left) and the other planets (on the right). Nonetheless, the painting takes into account some of the most important discoveries of the seventeenth century: Saturn's rings (observed by Galileo in 1609) are represented, as is one of the four moons of this planet (discovered between the years 1655 and 1684). In addition, the sphere of fixed stars as described by the ancients seems to have been cast aside in favor of stars scattered throughout the heavens, a view that had been proposed by Thomas Digges in 1576 and that was repeated by William Gilbert in 1651.

In the lower left corner of the painting, an angel holds a book with an inscription that reads: "The gospel according to Saint John" (Evangel[icum secun]dum [Joannem]). This explicit reference to scripture makes it clear that van Wynen's image of the physical universe is meant to be understood within a Christological context. As if to emphasize this point, the largest of the angels points to the sun of the geocentric universe with one hand and to the Divine sphere with the other. Seven tongues of fire surrounding the Divine sphere and the Hebrew letters

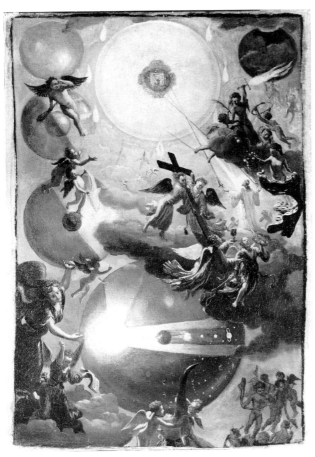

100

at its center allude to the Holy Spirit and to God the Father, respectively. Christ, the second person of the Trinity, is represented as a luminous figure at the center right of the composition. Surrounded by angels who hold the instruments of his passion, he seems to be ascending to the golden sphere while simultaneously receiving light from it. Van Wynen has arranged the various elements of the composition to demonstrate that the light of this world is divine in origin and that through Christ, "the light of the world" as Saint John refers to him, mankind would be saved. Thus, in spite of its references to modern scientific discoveries, the painting asserts firmly held religious beliefs: the earth is at the center of God's perfectly created universe, and God's redeeming light—his only begotten son—is the salvation of mankind.

BIBLIOGRAPHY

Welu, James A. *Seventeenth Century Dutch Painting: Raising the Curtain on New England Private Collections*. Worcester, Mass.: Worcester Art Museum, 1979.

ATHANASIUS KIRCHER
German, 1602–80

101 *Mundus subterraneus*

Amsterdam, Joannem Janssonium and Elizeum
 Weyerstraten, 1665
Illustrated book
Each approx. 40 x 24.5 x 8.5 cm.
 (15⅝ x 9⅞ x 3⅜ in.)

Copy A: Smithsonian Institution Libraries,
 Washington, D.C.
 Acc. no. fQ155.K6X NMAH RB

Copy B: Harvey Cushing/John Hay Whitney
 Medical Library, Yale University,
 New Haven, Connecticut
 Acc. no. 17th century +, Kircher

This imposing volume of almost one thousand pages was inspired by Athanasius Kircher's firsthand observations of volcanic eruptions during the late 1630s. According to the author's long subtitle:

It is a work in which are exposed the divine workmanship of the underground world, the great gifts of nature there distributed, the form, the wonder, riches and great variety of all things in the Protean region: the cause of all hidden effects are demonstrated and the application of those which are useful to mankind, by means of various experimental apparatus, and new and previously unknown methods, are explained.

The publication had many admirers, but for scientists such as John Webster it was another huge and barren volume by the "universal scribbler and rhapsodist" and not a solid piece of scholarship on minerals (Thorndike, p. 568). Indeed, a considerable amount of information in *Mundus subterraneus* has little practical value and is only remotely connected to mineralogy. The author repeats many fictions of the past, makes extraordinary hypotheses of his own, and ranges over a bewildering number of topics, including pyrotechnics, alchemy, agriculture, insects, fungi, poisonous waters, and the arcana of the mechanical arts. The central thesis of Kircher's great tome is that many of the natural phenomena visible on earth have their origin in numerous underground regions. All the world's rivers, oceans, and lakes, he supposes, are fed by occult channels leading from subterranean reservoirs. Violent winds, foul vapors, and suffocating gases come from hidden air chambers, while volcanic eruptions can be traced to underground cavities of fire.

Kircher's treatise is accompanied by beautiful engraved plates illustrating the phenomena of nature that he had both seen and imagined. One of these

323

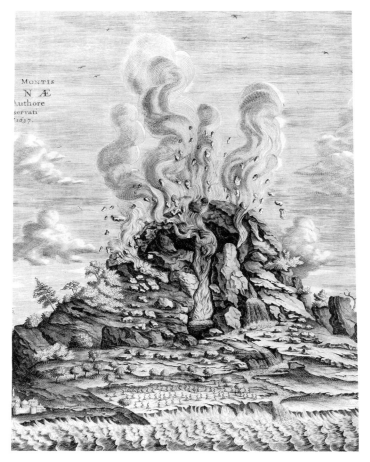

101A The eruption of Mount Aetna, as observed by the author in 1637. Engraving.

peatedly sees them in terms of the marvelous: they are the wonderful works of the terrestrial globe, they have prodigious and miraculous properties, they produce marvelous effects. His vast compendium, understandably a disappointment to anyone converted to the new science, was a hodge-podge of observed facts, fantasy, and old-fashioned ideas. Yet, like his other publications, it found an enthusiastic audience among those who had a continuing fascination with mysteries and the occult.

BIBLIOGRAPHY

Bedini, Silvio A. "Citadels of Learning: The Museo Kircheriano and other Seventeenth-Century Italian Science Collections." In *Enciclopedismo in Roma Barocca*. Ed M. Casciato, M. G. Ianniello, and M. Vitale. Venice: Marsilio Editori (1986), pp. 249–67.

Harms, Hans. *Themen alter Karten*. Oldenburg: Ernst Völker, 1979.

Reilly, P. Conor, S. J. *Athanasius Kircher: Master of a Hundred Arts*. Rome: Edizioni del Mondo, 1974.

Thorndike, Lynn. *A History of Magic and Experimental Science*. 8 vols. New York: Columbia University Press, 1923–58. Esp. vol. 7, pp. 266, 568.

ATHANASIUS KIRCHER
German, 1602–80

102 *Systema ideale pyrophylaciorum subterraneorum*

Diagram of the interrelation of volcanoes and the central fire
Separate sheet from *Mundus subterraneus*
1665
Engraving, hand colored
38.1 x 43.8 cm. (15 x 17¼ in.)
Smithsonian Institution, Museum of American History, Washington, D.C.
Acc. no. 236,083

offers a grandiose view of the eruption of Mount Aetna "as observed by the author in 1637." The volcano's walls have been opened up to reveal a raging fire within, and a stream of lava produces "marvelous effects" as it empties into the ocean. In another illustration Kircher depicts an assortment of "figured stones" in which he discerned strange images of animals "engraved by nature" (see Kenseth, "A World in One Closet Shut," fig. 4).

Kircher was entranced by such lapidary specimens, and in the second part of the *Mundus subterraneus* he dwells at length on their possible origin. Many of these, he believed, were the products of the underground world, which is inhabited by animals, demons, and men. Frogs, snakes, and fishes live there, as do fire-breathing dragons. Underground men, he states, include the cave dwellers he had met on the island of Malta in 1637. When considering figured stones or any other natural phenomena, Kircher re-

In this engraved sheet, from the fourth book of *Mundus subterraneus*, Kircher hypothesized a vast system of underground fires. The large plate (a double-page spread in the bound volume) shows a cross section of the earth, at the center of which is a huge fiery mass. Surrounding this central conflagration and linked to it by channels are many other, smaller fires. The fiery element then proceeds through a network of additional channels leading to the earth's surface, bursting forth finally as volcanoes both on the land and in the sea.

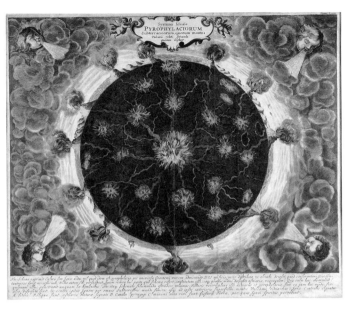

102

BIBLIOGRAPHY

Bedini, Silvio A. "Citadels of Learning: The Museo Kircheriano and other Seventeenth-Century Italian Science Collections." In *Enciclopedismo in Roma Barocca*. Ed M. Casciato, M. G. Ianniello, and M. Vitale. Venice: Marsilio Editori (1986), 249–67.

Harms, Hans. *Themen Alter Karten*. Oldenburg: Ernst Völker, 1979.

Reilly, P. Conor, S. J. *Athanasius Kircher: Master of a Hundred Arts*. Rome: Edizioni del Mondo, 1974.

Thorndike, Lynn. *A History of Magic and Experimental Science*. 8 vols. New York: Columbia University Press, 1923–58. Esp. pp. 266, 568.

ALBRECHT DÜRER
German, 1471–1528

103 *The Monstrous Pig of Landser*

ca. 1496
Engraving
Each approx. 11.8 x 12.7 cm. (4⅝ x 5 in.)

Copy A: The Metropolitan Museum of Art,
New York
Mr. and Mrs. Isaac D. Fletcher Fund,
1919
Acc. no. 19.73.107
Venues: DC, NC

Copy B: National Gallery of Art,
Washington, D.C.
Rosenwald Collection
Acc. no. 1943.3.3457
Venues: HO

The "monstrous pig" immortalized by the young Albrecht Dürer possessed four ears, two bodies, eight legs, and two tongues. It was born on March 1, 1496, in the town of Landser, just twelve miles south of Basel (Talbot, p. 116) and lived only a day after its birth, making it unlikely that Dürer, who lived in Nuremberg, saw it in the flesh.

The pig's strange deformations were thought to be of such a marvelous nature that news of its birth came to the attention of the artist, poet, and humanist Sebastian Brandt (1457–1521). A broadsheet by Brandt, announcing the birth as an evil portent and associating it with, among other things, the coming of the Antichrist, was published soon afterward. It contained verses and a rather primitive woodcut by Brandt depicting an adult version of the pig standing on its hind legs outside the walls of Landser. Some art historians conjecture that Brandt's woodcut is the most likely source for Dürer's print, not only because they both show adult animals, but also because the town of Landser is similarly depicted (Major, p. 327–30; Talbot, p. 116). The resemblance ends there, however, as Dürer, in a tour-de-force engraving, creates a realistically rendered sow standing on more than all fours. Despite its deformities, this pig is not much different from the animals depicted in another engraving by the artist, *The Prodigal Son Amid the Swine*, dated on stylistic grounds to the same year.

In the ensuing years Dürer was admired by his contemporaries not only for his startling abilities in a

103A

variety of media, but also for his realistic and finely detailed depictions of natural phenomena. *The Monstrous Pig of Landser* is an early example of the intense interest shown in documenting aberrations of nature during the sixteenth and seventeenth centuries, evident in later works by Johann Schenck, Ambroise Paré, and Ulisse Aldrovandi (cat. nos. 106, 108, 109). Beyond indicating that there was an audience for such depictions, this engraving points as well to Dürer's interest in portents; he wrote much later in his *Gedenkbuch* about a "miracle" he witnessed in 1503 and about having seen "a comet in the heavens" (Hutchison, pp. 76–77). Even at this early date a tension exists between the realistic depiction of such phenomena—giving an impression of precise, almost scientific, observation—and the supernatural and religious significance that these subjects must have had for both Dürer and the audience. As Ravenel and Levenson remark, "Dürer rendered and conceived an image that makes the incredible believable" (Talbot, p. 116).

BIBLIOGRAPHY

Glassman, Elizabeth, and Richard S. Field. *Reading Prints: A Selection of 16th- to Early 19th-Century Prints from the Menil Collection*. Houston: Menil Foundation, 1985. Esp. no. 54, p. 61.

Hutchison, Jane Campbell. *Albrecht Dürer: A Biography*. Princeton: Princeton University Press, 1990.

Major, Emil. "Dürer's Kupferstich 'die wunderbare Sau von Landser' im Elsass." *Monatshefte für Kunstwissenschaft* 6 (1913): 327–30.

Talbot, Charles W., ed. *Dürer in America: His Graphic Work*. Notes by Gailland F. Ravenel and Jay A. Levenson. Washington, D.C.: National Gallery of Art, 1971. Esp. no. 7.

works devoted to the study of animals. In the 4,500 pages and nearly 1,000 woodcut illustrations of *Historiae animalium*, Gesner treats mammals, birds, fish, and reptiles. He gives their names in the ancient as well as modern languages, and under each heading he discusses the animal's place in history and literature, its nutrition, and its medicinal uses. Gesner largely drew upon information provided by the ancients (especially Aristotle and Pliny), while he included several animals that had been recently discovered in the New World, like the opossum. *Historiae animalium* provides us with an excellent understanding of the state of zoology before the fauna of the New World demanded a critical review of the classical sources and a reorganization of the system of classification.

The text of this encyclopedia gives an abundance of information about real and fictitious animals, but the illustrations are its most distinctive and significant feature. Some of these woodcuts depict the fabulous creatures of ancient and medieval lore (the images of sea monsters, for example, depend on earlier fanciful representations by Olaus Magnus and Sebastian Münster; see cat. no. 80), while others are at a considerable remove from the animal originally observed (the rhinoceros, for instance, is based on a woodcut by Albrecht Dürer that, in turn, was a stylized version of images of an animal that arrived in Lisbon on May 20, 1515). But other illustrations, especially those of animals indigenous to Europe, are based on firsthand observation. Gesner's effort to *see* the animals and the attention he paid to the singular and exotic beasts of nature was a sign of things to come, in particular the displays of *naturalia* in cabinets of curiosities.

KONRAD GESNER
Swiss, 1516–65

104 *Historiae animalium*

Volumes 1 and 4
Zurich, Christ. Froschoverum, 1551–58
Illustrated book
38.5 x 25.6 x 8.6 cm. (15¼ x 10 x 3⅜ in.)
Dartmouth College Library, Hanover, New Hampshire
Acc. no. QL/41/G37

The "father of zoology," as Konrad Gesner has been called, was a professor of philosophy and a physician at the University of Zurich. A man of great learning and industry, he compiled a four-volume set of all the known animals that in its scope surpassed all earlier

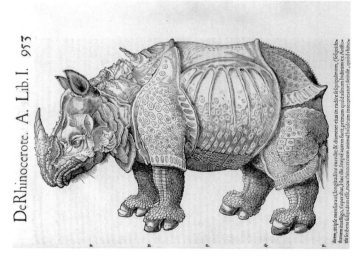

104 Rhinoceros. Hand-colored woodcut.

BIBLIOGRAPHY

Pilet, P. E. "Gesner, Konrad." *Dictionary of Scientific Biography*. Vol. 5. Ed. Charles Coulston Gillispie. New York: Scribner, 1972. Esp. pp. 378–79.

Rudwick, Martin J. S. *The Meaning of Fossils: Episodes in the History of Palaeontology*. 2nd ed. New York: Science History Publications, 1976. Esp. pp. 1–5, 9–10.

Wolf, Edwin, ed. *Legacies of Genius: A Celebration of Philadelphia Libraries*. Philadelphia, Pa.: Philadelphia Area Consortium of Special Collections Libraries, ca. 1988. Esp. p. 150.

EDWARD TOPSELL
English, 1572–1625?

105 *The History of Four-footed Beasts and Serpents*

London, E. Cotes for G. Sawbridge, 1658
Illustrated book
34.5 x 23.2 x 7.4 cm. (13⅝ x 9⅛ x 2⅞ in.)
Dartmouth College Library, Hanover,
New Hampshire
Acc. no. QL/41/q/T68

The minister and naturalist Edward Topsell is most famous for his encyclopedia of animals, the first major book of its kind printed in Great Britain in English (editions published in 1607, 1608, and 1658). This opus is based primarily on Konrad Gesner's systematic account of all the animals known since antiquity, *Historiae animalium* (cat. no. 104). In his account of serpents and insects, Topsell also incorporated the work of other naturalists, like Dr. Bonham (on bees, spiders, and earthworms) and Dr. Theodore Moufet (Moffet, 1553–1604, on insects). Topsell's volume on quadrupeds is most faithful to the first volume of Gesner's work. It demonstrates how the parameters of zoology were still defined by classical authors immediately prior to the empirical work of John Ray (1627–1705) and his pupil, Francis Willughby (1635–72) (cat. no. 123).

Displayed in the exhibition are pages with the fantastic beasts called the lamia and mantichora. The lengthy account of the lamia, a mythical beast who devours crying children, shows the author's uneasiness with the creatures of lore. Topsell cites a variety of mostly classical sources, rejects these accounts as fable, but then immediately asserts the existence of the lamia by citing other sources. He says:

To leave therefore these fables, and come to the true description of the Lamia, we have in hand . . . [S]o then we

shall take it for granted, by the testimony of holy Scripture, that there is such a Beast as this. Chrysostomus Dion also writeth that there are such Beasts in some part of Lybia, having a womans face, and very beautiful, also very large and comely shapes on their breasts, such as cannot be counterfeited by the art of any Painter, having a very excellent colour in their fore-parts without wings, and no other voice but hissing like Dragons.

In the case of the mantichora, we see how Topsell, like Gesner, populates distant and unknown countries with animals of pure fantasy. Topsell writes:

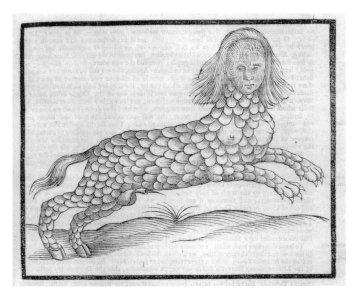

105 Lamia. Woodcut.

This beast or rather monster is bred among the Indians, having a treble row of teeth beneath and above, . . . and [his] feet are like a Lyons, his face and ears unto a mans, his eyes gray, and colour red, his tail like the tail of a Scorpion, of the earth, armed with a sting, casting forth sharp pointed quils . . . ; his wildeness such as can never be tamed, and his appetite is especially to the flesh of man.

Only later, when actual specimens from the New World had to be accounted for within the classical scheme, did naturalists begin to look more critically at the classical authors and rely more on their own observations.

BIBLIOGRAPHY

Topsell, Edward. *The History of Four-Footed Beasts and Serpents and Insects*. Introduction by Willy Ley. New York: Da Capo Press, 1967.

JOHANN GEORG SCHENCK
German, d. ca. 1620

106 *Monstrorum historia memorabilis*

Frankfurt, M. Beckeri, 1609
Illustrated book
20 x 15.8 x 1.6 cm. (7⅞ x 6¼ x ½ in.)
Dartmouth College Library, Hanover,
 New Hampshire
The Conner Collection
Acc. no. QM/691/S345

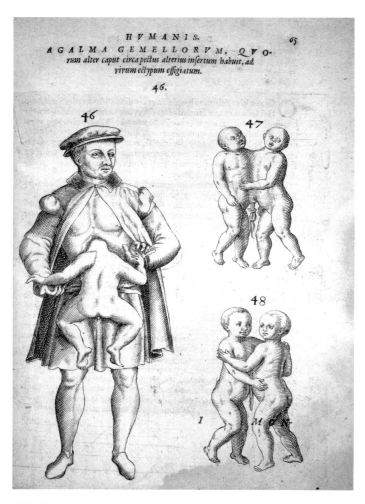

106 Siamese twins and man with the body of a child attached to his torso. Engraving.

Ever since ancient times, writers had exhibited a fascination with congenital birth defects. Hippocrates, Aristotle, Pliny, and Lycosthenes cited examples of human abnormalities and attempted to comprehend

the possible causes. At the end of the sixteenth century Ambroise Paré compiled his book on "monsters" (as they were called at the time) from these classical sources (cat. no. 109) and from more modern books like Pierre Boaistuau's *Histoires prodigieuses* (cat. no. 6). Paré attributed these abnormalities to various causes. He believed that they were engendered by either the wrath or the glory of God, or that they could be the work of devils and demons. The quantity of seed, be it too little or too much, and its quality were also on Paré's list. He believed as well that the posture of the mother during pregnancy was an important factor.

Johann Schenck's *Monstrorum historia memorabilis* includes the conjoined twins that were common in the "monster" literature, but there are more startling images as well. Among them is the engraving depicting a small body protruding from the torso of a grown man. While the arrangement seems inconceivable, recent genetic research suggests that it is indeed possible, albeit rare. The condition is called "parasitic ectopy."

BIBLIOGRAPHY

Paré, Ambroise. *On Monsters and Marvels*. Translated with an introduction and notes by Janis Pallister. Chicago: University of Chicago Press, 1982.
Tick, D. B., F. Greenberg, and J. M. Graham. *The Pattern and Form of Human Somatic Structural Ectopy*. Los Angeles: UCLA School of Medicine, and Houston, Tx.: Baylor College of Medicine, n.d.

FORTUNIO LICETI
Italian, 1577–1657

107 *De monstris. ex recensione Gerardi Blasii*

Amsterdam, Andreae Frisii, 1665
Illustrated book
20.6 x 16.6 x 3.0 cm. (8¼ x 6½ x 1¼ in.)
Dartmouth College Library, Hanover,
 New Hampshire
The Conner Collection
Acc. no. QM/699/L69

Fortunio Liceti, a professor of philosophy and medicine at the University of Padua, wrote on a variety of topics ranging from comets to the origin of nerves. Monsters and monstrous births claimed his attention and in 1616 he published his book on the subject, *De monstrorum causis natura*. The edition exhibited here

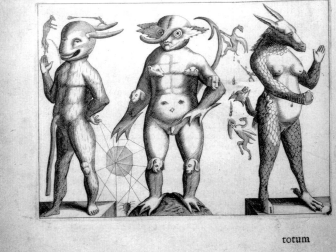

256 *Fort. Lic. de Monstrorum Cauſſis,*
ſcapulis accrevit; corpus totum inflatum, & rugo-
ſum, brachia in lumbis hæſerunt, pedes longè te-
nuiſſimi: ab umbilico autem ſpecies laxi inteſini de-
pendit ad pedes cacodæmonem referens, ut harum
prima figura refert, non minus quàm ſecunda, quæ
primum monſtrum præſefert, ac tertia, quæ deſi-
gnat monſtrum *Romæ in amne Tyberino* inventum
M CD XCVI. corpore humano, capite aſinino,
cujus manus una humanæ, altera verò elephantino
pedi ſimilis erat: pedum alter aquilinos ungues, al-
ter calceum corneum bovinum exprimæbat ven-
trem habuit femineum, mammis egregiè ornatum

totum

107 Monsters, including the "pope-ass." Engraving.

was brought out by Gerard Blasius and enlarged by
him to include new monsters. The composite beasts
described in the text draw from a long tradition of
written accounts of monsters and prodigies. For ex-
ample, the central figure on page 256 is related to one
of the fabulous races described in the *Nuremberg
Chronicle* (cat. no. 5). The creature also recalls the
monster with dogs' heads on its joints that was de-
scribed by Ulisse Aldrovandi (cat no. 108). On the far
right, Liceti illustrates a fabulous beast that is clearly
an allusion to the creature found in the Tiber River
and reported by Boaistuau (cat. no. 6). Blasius's pub-
lication testifies to the continuing interest in monsters
in the seventeenth century.

BIBLIOGRAPHY

Thorndike, Lynn. *A History of Magic and Experimental
Science.* 8 vols. New York: Columbia University Press,
1923–59. Esp. vol. 6, p. 286; vol. 7, pp. 52–53, 363; vol. 8,
p. 250.

ULISSE ALDROVANDI
Italian, 1522–1605?

108 *Monstrorum historia*

Bologna, Nicolai Tebaldini, 1642
Illustrated book
36.2 x 25.4 x 8.3 cm. (14½ x 10 x 3¼ in.)
Linda Hall Library, Kansas City, Missouri

In his attempt to give a complete documentation of
the natural world, Ulisse Aldrovandi (see cat. no. 19)
not only formed a collection of animal, mineral, bo-
tanical, and ethnographic objects, but also made
preparations for a multivolume encyclopedia in
which every specimen would be illustrated. Three
volumes of the immense compilation were printed
during his lifetime; another ten, edited by his stu-
dents, were brought out posthumously. *Monstrorum
historia*, one of the posthumous publications, deals
exclusively with human and animal monsters, many
of them legendary and others based on firsthand ob-
servation. One page, for example, shows representa-
tives of a fabulous human race discussed by Pliny and
described in numerous medieval bestiaries and cos-
mographies. (The illustration in fact is derived from

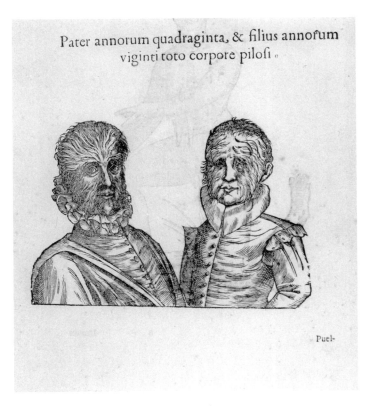

108 Pedro Gonzalez and his son. Woodcut.

those found in the *Nuremberg Chronicle* [cat. no. 5].)
The woodcut *Pater et filius pilosi*, by contrast, depicts
actual human anomalies. The illustration shows Pedro
Gonzalez and one of his four children, who like him
had a condition known as hirsutism. The family was
well known in Europe and came to the attention of
Aldrovandi while on a visit to Bologna sometime
after 1583 (see cat. no. 111).

BIBLIOGRAPHY

Caprotti, Erminio, ed. *Mostri, draghi e serpenti nelle silografie
dell'opera di Ulisse Aldrovandi e dei suoi contemporanei.*
Milan: Gabriele Mazzotta Editore, 1980.
Olmi, Giuseppe. *Ulisse Aldrovandi: Scienza e natura nel sec-
ondo Cinquecento.* Trent: University of Trent, 1976.

AMBROISE PARE
French, 1510?–90

109 *Regis primarii et parisiensis chirurgi*

Paris, Jacobum Du-Puys, 1582
Illustrated book
36.4 x 23.9 x 6.0 cm. (14⅜ x 9⅜ x 2⅜ in.)
Dartmouth College Library, Hanover,
 New Hampshire
The Conner Collection
Acc. no. R/128.7/P2/1582

Ambroise Paré, who was admitted to the Royal Col-
lege of Surgeons in 1554, was the chief surgeon to the
French kings Charles IX and Henri III. His publica-
tions—*Cinq livres de chirurgie* (1572), *Oeuvres complètes*
(1575, 1578, and 1582), and *Des monstres et prodiges* (first
published in 1573)—outraged many on the faculty of
medicine, not only because they dealt with issues con-
sidered "beyond his competence," that is, with mat-
ters appropriate to the physician rather than the sur-
geon, but also because, being illustrated and printed
in French rather than Latin, they revealed medical
secrets and "grossly indecent and immoral" subject
matter to women and children. Paré published a Latin
edition of the complete works in 1582, but nonetheless
defended his use of the vernacular. He wrote: "I es-
teem nothing in my book pernicious because it is
written in our vulgar tongue. Thus the divine Hip-
pocrates wrote in his language, which was known
and understood by women and girls, talking no other
language than that. As to me, I have not written ex-
cept to teach the young surgeon, and not to the end
that my book should be handled by idiots and me-
chanics, even if it was written in French."

Paré's didactic purpose also lies behind his publica-
tion on monsters. In contrast to writers of earlier
prodigy and monster books, he does not concern
himself primarily with monsters as portents or signs
of God's wrath but instead seeks to explain them as
the result of natural causes. Paré's novel way of seeing
monsters grew out of his interest in human reproduc-
tion, and in *Des monstres et prodiges* he states that while
some of these aberrations result from the glory or the
wrath of God, from demons, or from the "artifice of
wicked spital beggars [malingerers]," "there are a
great many others that are caused by such things as
too great or too little a quantity of seed," "the narrow-
ness or smallness of the womb," "the indecent posture
of the mother . . . when pregnant," "imagination,"
"accidents to the mother while pregnant," "heredi-
tary or accidental illness," or "rotten or corrupt seed."

Most of the subjects of Paré's treatise, as he read-
ily acknowledges, were drawn from a great many
sources—the writings of Lycosthenes, Pierre Boais-
tuau, Claude de Tesserant, Konrad Gesner, Pliny,
Aristotle, Olaus Magnus, and André Thevet. Others,
such as the dry and dissected remains of "two twin
children having only one head," were in the posses-
sion of the author. Human abnormalities such as
these and animal monstrosities (three-headed sheep
and a child that is part dog, for instance) take up most
of the first half of Paré's volume. In the final section
of *Des monstres*, however, animal wonders such as the
rhinoceros, bird of paradise, elephant, and toucan are
considered.

Two pages from the treatise on monsters, as pub-
lished in the 1582 (Latin) edition of his complete
works, give some idea of the range of Paré's subject
matter. One of these shows a variety of extraordinary
marine creatures described by earlier authors: "a Tri-
ton and a Siren" (found in the Nile, according to
Pliny), a monstrous fish with the head of a monk, a
monster resembling a bishop, "which was seen in Po-
land in 1531," and a marine monster, with the head of
a bear and the arms of a monkey, that Konrad Gesner
received as a gift from Hieronymous Cardanus. The
second page shows the animal called Haiit (the three-
toed sloth from South America), which had appeared
in Thevet's publications and which Paré says, repeat-
ing Thevet's observations, is "a very deformed ani-
mal" with "face and hands almost like those of a
child." He notes that "it heaves great sighs" when it
is caught, has only three claws to each paw, and "is a
strange case" since it lives on wind rather than food.

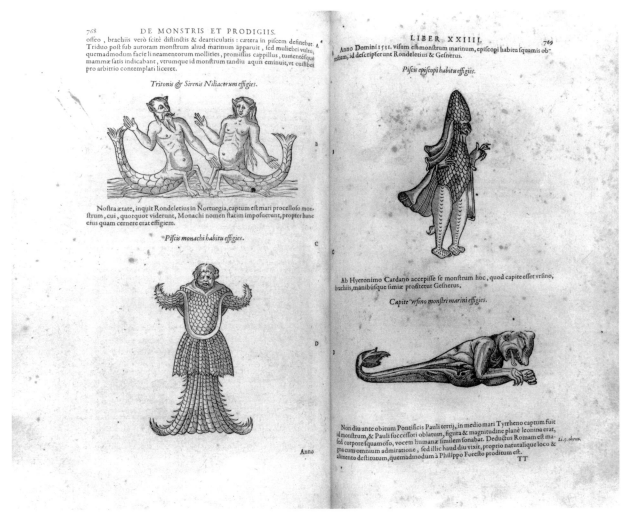

109 Monstrous marine effigies. Woodcut.

BIBLIOGRAPHY

Doe, Janet. *A Bibliography of the Works of Ambroise Paré*. Chicago: University of Chicago Press, 1937.

Paré, Ambroise. *Des monstres et prodiges*. Ed. with critical commentary by Jean Céard. Geneva: Librairie Droz, 1971.

Paré, Ambroise. *On Monsters and Marvels*. Translated with an introduction and notes by Janis Pallister. Chicago: University of Chicago Press, 1982.

HENDRICK HONDIUS THE ELDER
Dutch, 1573–after 1649

110 *Broadside Commemorating the Stranding of a Sperm Whale Physeter Macrocephalus near Berckhey in 1598*

Printed and published by Henrick Haestens, 1598
Engraving and etching
36.2 x 52.7 cm. (14¼ x 20¾ in.)
Hart Nautical Collections, Massachusetts Institute of Technology Museum, Cambridge, Massachusetts
Acc. no. ND3513

The migratory path of whales in the North Sea runs adjacent to the Low Countries, and whale strandings along the coast are common. Specific strandings during the late Renaissance and early baroque period, such as the one at Berckhey in 1598 depicted in this rare broadside, were recorded by Dutch artists like Esaias van den Velde (1587–1630), Adam Willaerts (1577–1664), Roelandt Savery (1576–1639), and Hendrick Goltzius. One of the most ambitious of these

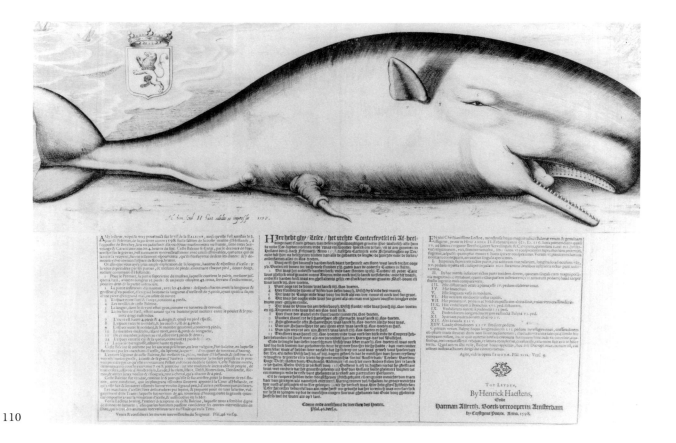

110

depictions, as well as the most well known, is a print by Jan Saenredam of the stranding at Beverwyck in 1601 (Ackley, no. 24, p. 44).

This broadside from the Hart Nautical Collections showing the Berckhey stranding is the only known extant copy. Five other prints published before 1600 show the same stranding; the one by Jacob Matham (1571–1631), "based on a sketch by Goltzius, became the most widely copied picture of a whale for the next two centuries" (Barthelmess, p. 188). The existence of a broadside such as this confirms that, like the birth of the pig at Landser (cat. no. 103), the strandings were newsworthy, marvelous events.

From the inscription we know the sheet was engraved by Hendrick Hondius the Elder and printed and published by Henrick Haestens, although it is uncertain who did the sketch on which the engraving is based. The lengthy text at the bottom, written in Dutch and repeated in Latin and French, describes

the condition of the whale in great detail. Apparently it is an accurate portrait of the effect of decomposition on the body of a whale, especially the way in which gases bloat and distend the body. The broadside could be bought either from Haestens in Leiden or from a bookshop in Amsterdam (Barthelmess, p. 188).

BIBLIOGRAPHY

Ackley, Clifford S. *Printmaking in the Age of Rembrandt.* Boston: Museum of Fine Arts, ca. 1981.

Barthelmess, Klaus. "The Sperm Whales Physeter Macrocephalus at Berckhey in 1598 and on the Springersplaat in 1606 — A Discovery in Early Iconography." *Lutra: Bulletin de la Société pour l'Etude et la Protection des Mammifères* 32 (1989): 185–89.

Frank, Stuart M. "The Legacy of Stranded Whales." Part 1. *Whalewatcher: Journal of the American Cetacean Society* 20:3 (Fall 1986): 3–4.

LAVINIA FONTANA
Italian, 1552–1614

111 *Portrait of the Daughter of Pedro Gonzalez*

ca. 1583
Red and black chalk drawing (bound in an
album)
9.5 x 7.7 cm. (3¾ x 3 in.)
The Pierpont Morgan Library, New York
Acc. no. IV, 158, folio 8
Venues: DC, NC

Lavinia Fontana executed a number of important commissions for altarpieces, but she was best known for her talents as a portrait painter. She was born in Bologna and was trained by her father, Prospero Fontana (1512–97), a leading artist who had trained with Perino del Vaga in Genoa and then worked in both Florence and Rome before returning to the Emilia. Drawing from her father's work, which reflected primarily the style of Giorgio Vasari, Lavinia developed her own conservative *maniera* style (Harris and Nochlin, p. 112).

Fontana was supported by aristocratic and ecclesiastic patrons. Her first commission for an altarpiece was for the Escorial in 1589. She later received important commissions for altarpieces in the churches of San Paolo Fuori le Mura and Santa Sabina in Rome. From the late 1570s she painted steadily, producing over one hundred recorded paintings in her lifetime; thirty-two signed and dated paintings survive today. She received the patronage of Gregory XIII and later Clement VIII, under whose papacy she moved to Rome in 1603.

Illustrated here is a beautiful red and black chalk drawing of the daughter of Pedro Gonzalez. It is one of nineteen portrait drawings by Fontana collected and bound into an album late in the seventeenth century. Most of the portraits are of "people of fashion" or of priests and nuns (Bean and Stampfle, no. 149). Within this context, the inclusion of a portrait of a young woman with a hairy face may seem strange; however, Pedro Gonzalez and his family were quite famous for their unusual appearance. The father was a learned man, educated at the court of Henri II in France. Gonzalez later lived in Flanders, where he married; he and his wife had four children, three of whom were afflicted with the father's condition. During a trip to Italy, the family met Ulisse Aldrovandi, who included images of these living marvels in his own encyclopedia (see cat. 108).

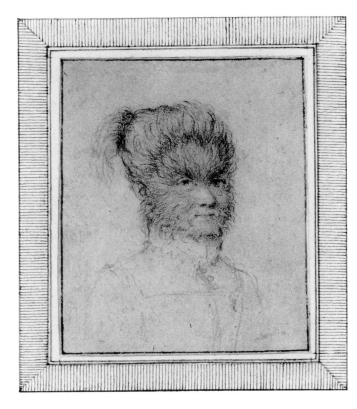

111

BIBLIOGRAPHY

Bean, J., and F. Stampfle. *Drawings from New York Collections I: The Italian Renaissance*. New York: The Metropolitan Museum of Art, 1965.
Cantaro, Maria Teresa. *Lavinia Fontana, bolognese: "pittora singolare" 1552–1614*. Milan: Jandi Sapi Editori, ca. 1989.
Harris, Ann Sutherland, and Linda Nochlin. *Women Artists: 1550–1950*. Los Angeles: Los Angeles County Museum of Art, 1976. Esp. pp. 111–14.
Tufts, Eleanor. "Ms. Lavinia Fontana from Bologna: A Successful 16th Century Portraitist." *Art News* 73 (1974): 60–64.

WENCESLAUS HOLLAR
Bohemian, 1607–77

112 *A New and Perfect Book of Beasts, Flowers, Fruits, Butterflies, and Other Vermine, Exactly Drawn after Life and Naturall*

London, John Overton, 1674
Illustrated book
19.5 x 29.7 cm. (7¹¹⁄₁₆ x 11¾ in.)
Arthur and Charlotte Vershbow, Boston, Massachusetts

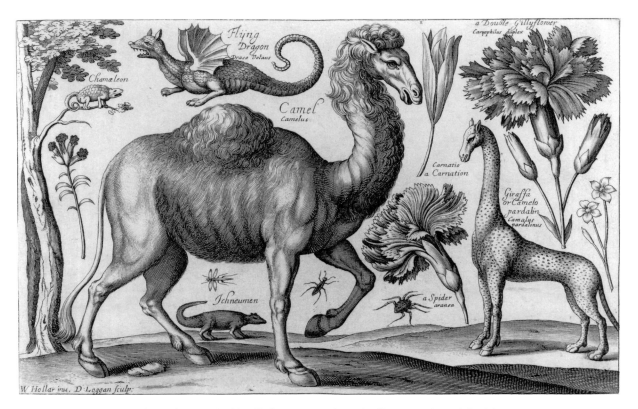

112 A camel, chameleon, flying dragon, double gillyflower, carnation, giraffe or *Camelo pardalin*, ichneumen, and spider. Engraving.

Wenceslaus Hollar was a virtuoso etcher who was able to embody his keen attention to detail in the wiry lines of his etchings. He was born in 1607 in Prague, when it was the temporary capital of the empire under Rudolf II. Although the imperial court was transferred back to Vienna in 1612, Hollar was probably familiar with the work of some of its artists because many were still living in Prague during his early years as an artist. He may, for instance, have known of the many insect studies of Joris Hoefnagel.

Hollar had a peripatetic career, working with the famous engraver and print publisher Matthaeus Merian in Frankfurt-am-Main and with a print seller in Strasbourg by the name of Jacob van der Heiden. Before entering the entourage of his most important patron, Thomas Howard, Earl of Arundel, he worked in Stuttgart and Cologne. The rest of his life was spent primarily in England, with an important sojourn in Antwerp from 1644 to 1652 and an expedition to Tangiers with Lord Henry Howard.

Illustrated here is an engraving after a design by Hollar from a suite of twelve entitled *A New and Perfect Book of Beasts, Flowers, Fruits, Butterflies, and Other Vermine, Exactly Drawn after Life and Naturall*. According to Pennington, "Of this set of twelve prints, only the title and the first three are by Hollar, although he made the drawings for numbers four and five" (p. 324). Although not representative of the enormous range of subjects found in Hollar's oeuvre (numbering over 2,700 plates), the set does reveal salient features of his work as well as attitudes characteristic of the age of the marvelous. Central to understanding Hollar's work is the fact that he produced sets of prints that were very popular with collectors (see cat. no. 127). He provided them with an alternate means of including objects, *naturalia*, and references to different parts of the world in their collections.

Hollar asserts that the natural specimens were drawn from life, but among them he places an illustration of a flying dragon. Such a mixture would have been a source of delight and wonderment, quite separate from the advancements toward a scientific and systematic study of nature well underway.

BIBLIOGRAPHY

Goddard, Stephen H. *Sets and Series: Prints from the Low Countries*. New Haven: Yale University Art Gallery, 1984.

Pennington, Richard. *A Descriptive Catalogue of the Etched Work of Wenceslaus Hollar, 1607–1677*. New York: Cambridge University Press, 1982. Esp. nos. 2064–75, pp. 324–26.

ANDRE THEVET
French, 1502–90

113 *Les Singularitez de la france antarctique autrement nommée amerique*

Illustrated book

Copy A: Antwerp, Christophe Plantin, 1558
17 x 10.5 x 2 cm. (6½ x 4¼ x ¾ in.)
Chapin Library of Rare Books, Williams College, Williamstown, Massachusetts
Venues: DC, NC

Copy B: Paris, Maurice de la Porte, 1558
25.3 x 17.8 x 2.1 cm. (10 x 7 x 13/16 in.)
Special Collections, Bailey/Howe Library, University of Vermont, Burlington
Acc. no. TR Thevet
Venues: HO, HI

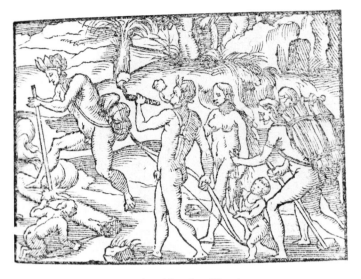

113A Indians smoking and making fire. Woodcut.

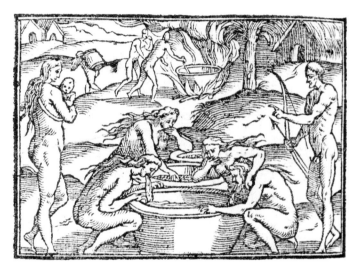

113A Brazilian Indian women making beer by chewing grain and spitting it into a vat for fermentation. Woodcut.

André Thevet was a Franciscan friar who joined the expedition led by Nicolas Durand de Villegegnon in 1555 to establish a French colony in Brazil. *Les Singularitez* was one of the earliest firsthand accounts of the New World to be published in book form with illustrations (most appeared as printed letters). He describes the indigenous people, the flora, and the fauna of the area around the colony called the Bay of Guanabara in Brazil. In addition, he presents what appears to be a firsthand account of Florida and Canada. The parts on North America should be read with caution, however, because Thevet became ill soon after he arrived in the New World and left Brazil within two months. It would have been impossible for him to have seen either Florida or Canada, so his text is based primarily on secondhand information.

Two woodcuts from Thevet's account of Brazil are illustrated here. One shows the smoking of tobacco, which was noted by several early explorers, including Christopher Columbus. Rembert Dodoens, the Flemish naturalist, specifically refers to Thevet's description of Brazilians smoking tobacco in his own herbal published in 1503 (cat. no. 145). Another depicts women making beer. *Les Singularitez* introduced Europeans to the natural wonders of Brazil, and it became a sourcebook for other authors. Ambroise Paré culled information from *La Cosmographie universelle*, a compendium of Thevet's travels published in 1575. More important still are the major seventeenth-century European authors who were interested in accounts of the New World and derived most of their knowledge from books. In this way, Thevet's account directly contributed to the perception of the New World as it was presented in the works of Politian, Ariosto, Tasso, Montaigne, More, Spenser, Bacon, Donne, and Shakespeare (see Honour, part IV).

BIBLIOGRAPHY

Honour, Hugh. *The European Vision of America*. Cleveland: Cleveland Museum of Art, 1975. Esp. no. 95, p. 122.
New York Public Library. *The Age of Atlantic Discoveries*. New York: Brazilian Cultural Foundation, ca. 1990.
Wolf, Edwin, ed. *Legacies of Genius: A Celebration of Philadelphia Libraries*. Philadelphia, Pa.: Philadelphia Area Consortium of Special Collection Libraries, ca. 1988. Esp. no. 100, p. 134.

GIROLAMO BENZONI
Italian, b. 1519

114 *La historia del mondo nuovo*

Venice, Francesco Rampazetto, 1565
Illustrated book
15 x 10 x 2 cm. (5¾ x 3¾ x ¾ in.)
Chapin Library of Rare Books, Williams College,
Williamstown, Massachusetts

Girolamo Benzoni, a native of Milan, traveled extensively throughout the Spanish colonies in the Americas during the middle of the sixteenth century. After a fifteen-year absence, he returned to Milan in 1556. His sparsely illustrated account of the New World was published in 1565, expanded in 1572, and

widely appreciated through numerous translations. He insisted on crediting Columbus with the discovery of America and is largely responsible for creating the legendary stature of Columbus. In his descriptions of the Spanish conquistadors, however, Benzoni was more historically accurate than earlier chroniclers like F. López de Gómara (1552–53) and P. Cieza de León (1553) in that he revealed the atrocities the conquerors had committed.

Benzoni's candid narrative brings us closer to understanding how Europeans perceived the New World. His excitement over America, Benzoni wrote, came from seeing "so many strange countries." Contrary to the monsters found in Pliny, and later believed to exist at the outer limits of the known world, the indigenous people of America physically resem-

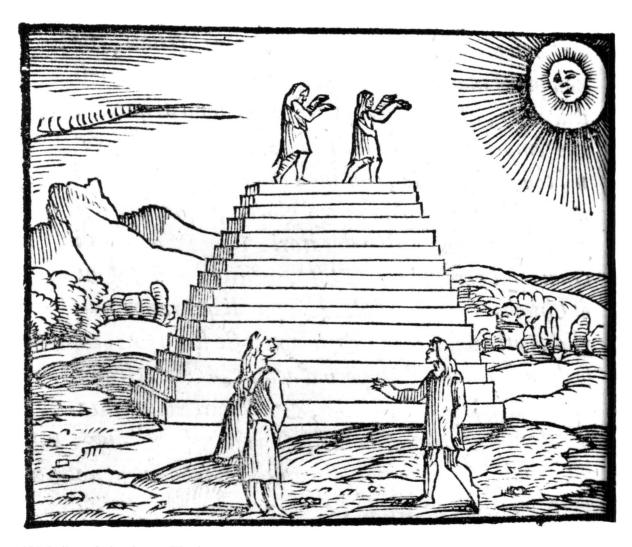

114 Indians adoring the sun. Woodcut.

bled the European explorers. As Benzoni's text and illustrations make clear, it was the behavior and actions of these Native Americans that distinguished them as marvels: he focused on their habits and customs, such as their methods for procuring food and preparing it, and even where they slept.

BIBLIOGRAPHY

Codazzi, Angela. "Benzoni, Gerolamo." *Dizionario Bio-grafico Degli Italia.* Vol. 8. Rome: Istituto Della Enciclopedia Italiana, 1966. Esp. pp. 732–33.
Honour, Hugh. *The European Vision of America.* Cleveland: Cleveland Museum of Art, 1975. Esp. no. 62.

JEAN DE LERY
French, 1534–1611

115 *Histoire d'un voyage fait en la terre du Brésil, autrement dite Amerique*

Geneva, Antoine Chuppin, 1578
Illustrated book
27.9 x 21.6 x 6.4 cm. (11 x 8½ x 2½ in.)
Princeton University Libraries, Grenville Kane
 Collection, Princeton, New Jersey
Acc. no. Kane collection

Jean de Léry, a young Calvinist, accompanied two ministers to the French colony in Brazil established by Nicolas Durand de Villegegnon. He arrived shortly after André Thevet had returned to France from the founding expedition in 1555. While Thevet published his account almost immediately (cat. no. 113), de Léry's almost contemporary observations of the same region did not appear until 1578. His work, especially the second edition (1580), is critical of Thevet's report, which contains many inaccuracies. De Léry's denunciation is perhaps too strong, as Thevet did provide Europeans with the earliest descriptions of Brazil, its people, and their customs.

Although his account of Brazil was published twenty-one years after Thevet's, de Léry emphasizes the novelty of his information. He stresses that it was collected in the field ("sur les lieux"—on the spot), evoking a sense of immediacy and freshness. He promises to present the European reader with "singular things, entirely unknown before." His account includes a description of the flora and fauna, the lyrics and music used in some Indian festivities, and a dialogue between a Frenchman and a Tupi Indian. He was interested in conveying "the customs and strange manner of living" of the indigenous people,

as well as in offering a description of their language. De Léry's volume also includes six full-page engravings. One illustration shows the custom called the "greeting of tears," in which people who have not seen one another in a long time recount the events of their lives in a stylized fashion that includes a ceremonial form of weeping (*The Age of Atlantic Discoveries*, p. 227). Another engraving, which is illustrated here, depicts the ritual performed when someone dies, which is very similar to the "greeting of tears." While de Léry's work was not a systematic study of a culture like that organized by Prince Maurits (see cat. no. 118) in 1637, it nonetheless fascinated Europeans eager to read about the exotic New World.

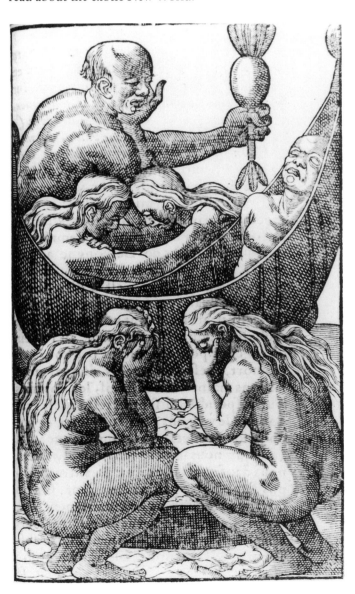

115 Ceremony for the dead. Engraving.

BIBLIOGRAPHY

Honour, Hugh. *The European Vision of America*. Cleveland: Cleveland Museum of Art, 1975. Esp. no. 61.

New York Public Library. *The Age of Atlantic Discoveries*. New York: Brazilian Cultural Foundation, 1990. Esp. no. 118, p. 227.

DIONYSE SETTLE
English, fl. 1577–80

116 *De Martini Forbisseri angli navigatione in regiones occidentis et septentrionis*

Nuremberg, Catharinae Gerlachin . . . Iohannis Montani, 1580

Illustrated book
16 x 10 x 1.2 cm. (6¼ x 4 x ½ in.)
Chapin Library of Rare Books, Williams College, Williamstown, Massachusetts

Sir Martin Frobisher was an Elizabethan navigator and explorer well known for his attempts to locate the Northwest Passage–a route from Europe to Asia through the northern extremities of North America. Though he failed to find the passage, he made three separate expeditions to Baffin Bay beginning in 1576. Dionyse Settle published an account of Frobisher's travels in 1577, and it rapidly appeared in French (1578), German (1580), and Latin (1580) translations.

Beginning with Christopher Columbus, voyagers to the New World brought back indigenous people, essentially as partial proof of cultures radically dif-

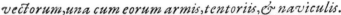
vectorum, una cum eorum armis, tentoriis, & naviculis.

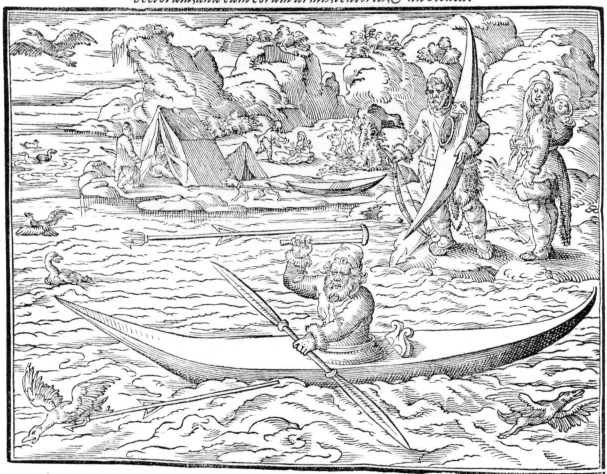

116 An Eskimo in a kayak. Woodcut.

ferent from that of Europe. Illustrated here is the Eskimo whom Frobisher brought back to England from either his first or second expedition to Baffin Bay. He was among the first North Americans to travel to Europe. In this illustration he is demonstrating his method of hunting duck from a kayak. As kayaks were unfamiliar on the continent, it drew considerable attention as an exotic artifact. Indeed, a kayak hung from the ceiling in Olé Worm's *Wunderkammer*, which contained a large collection of ethnographic material from North America (cat. no. 17).

BIBLIOGRAPHY

Best, George. *The Three Voyages of Martin Frobisher.* Ed. Vilhjalmur Stefansson. London: Argonaut Press, 1938.
Honour, Hugh. *The European Vision of America.* Cleveland: The Cleveland Museum of Art, 1975. Esp. no. 63.
Kenyon, Walter Andrew. *Tokens of Possession: The Northern Voyages of Martin Frobisher.* Toronto: Royal Ontario Museum, 1975.

THEODOR DE BRY, editor
Netherlandish, 1528–98

117 *Americae pars quarta*

Frankfurt-am-Main, 1594
Illustrated book
H: 34.6 cm. (13⅝ in.)
Copy A: Parts I–IV, Parts V–IX
American Antiquarian Society,
Worcester, Massachusetts
Acc. no. E.110.B915.G5901.1–4.F
Acc. no. E.110.B915.G5901.5–9.F
Copy B: Parts I–IV
Anne S. K. Brown Military Collection,
Brown University Library,
Providence, Rhode Island

The engraver and publisher Theodor de Bry initiated a thirteen-volume collection of travel literature, often called *The Great Voyages*, that played a fundamental role in shaping the European vision of America. The first volume of this monumental undertaking was published in 1590. After the death of de Bry in 1598, his son, Johann Theodor, continued the project, publishing the last volume in 1634.

The set was the most extensive collection of travel literature ever published. It began with Thomas Hariot's *A Briefe and True Report of the New Found Land of Virginia* (with engravings after John White), the narration by Jacques Le Moyne de Morgues of the French expedition to Florida, the voyages of Hans Staden and Jean de Léry to Brazil, and Girolamo Benzoni's account of the Spanish colonies in the Americas. Later volumes included accounts of Peru; the English expeditions of Sir Francis Drake, Thomas Cavendish, and Sir Walter Raleigh; and the voyages of Sebastian de Weert (to Mexico), Olivier de Noort, Amerigo Vespucci, and Joris van Spielbergen. The wide scope, plus the inclusion of an unprecedented number of engravings, brought the work a wide audience. The first volume on Virginia appeared simultaneously in French, German, and Latin; all other volumes appeared in German and Latin editions. De Bry's work was copied and imitated throughout the next century, and his presentation of these cultures had a deep and lasting influence on the way Europeans envisioned the New World.

The Great Voyages communicated an appreciation of these people who were so different from Europeans in their habits and customs. The text argues for the heroic and noble qualities of natives from the New World. Of the Indians of Virginia it says: "God has made these savages a wonderfully industrious people, although they are rough and simple. To speak truly, I cannot remember that I have ever seen a better or gentler folk than these." The illustrations reinforce this sympathetic portrait. Many of the engravings were after drawings made in the New World, though some were copied from already published woodcuts. Perhaps the most special illustrations are the ones appearing in the first four parts of the series, covering expeditions to Virginia, Florida, Brazil, and the West Indies. On a trip to England de Bry acquired drawings by both John White (recording the life and customs of the natives of Virginia) and Le Moyne. These illustrations surpassed in quality everything that had come before.

The engravings accurately convey ethnographic details (like costumes and artifacts), and the text below each illustration attempts to document these unfamiliar cultures. However, de Bry often eliminates any sense of horror or terror communicated by the explorers. He does not alter the actual accounts, but rather envisions a more gentle, placid scene. For example, in his depiction of natives from the Straits of Magellan, who were so fierce that they uprooted trees, the men have an air of classical ease. Even his engraving after John White of the "Marks of the Chief Men of Virginia" shows the Indian from behind with the slow curve of the contrapposto posture. Using the proportions and poses of antique statuary, de Bry was able to emphasize further his perception of the peoples in the New World as noble and heroic.

339

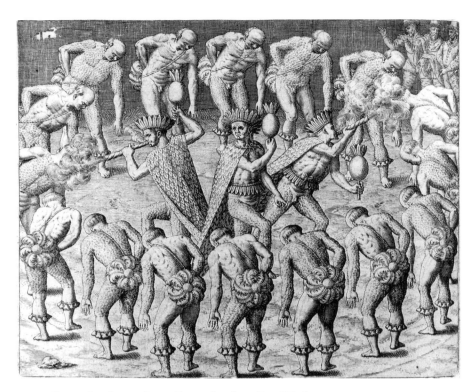

117A Shamanic tobacco dance. Engraving from Part III, fig. 29.

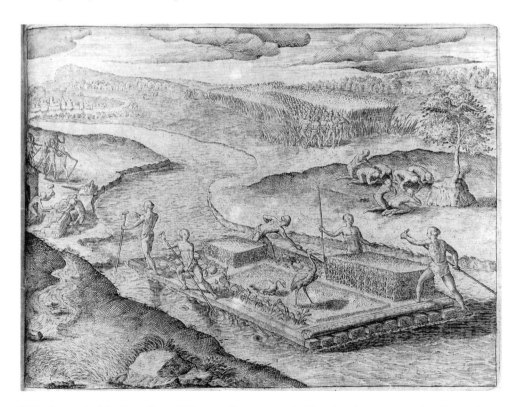

117A Legend of the founding of Mexico; discovery of the Tunal and floating garden. Engraving from Part IX, fig. 12.

BIBLIOGRAPHY

Cumming, William Patterson, Raleigh Ashlin Skelton, and David Beers Quinn. *The Discovery of North America*. New York: American Heritage Press, 1971.

Honour, Hugh. *The European Vision of America*. Cleveland: Cleveland Museum of Art, 1975. Esp. no. 65.

Lorant, Stefan, ed. *The New World; the First Pictures of America, made by John White and Jacques Le Moyne and engraved by Theodore De Bry, with contemporary narratives of the Huguenot settlement in Florida, 1562–1565, and the Virginia colony, 1585–1590*. New York: Duell, Sloan & Pearce, 1946.

WILLEM PISO AND
GEORG MARGGRAF
Dutch, ca. 1611–78, and German, 1610–44

118 *Historia naturalis Brasiliae*

Johannes de Laet, editor
Leiden and Amsterdam, Franciscum Hackium and
 Lud. Elzevirium, 1648
Illustrated book

Copy A: 40 x 24 x 4 cm. (15¾ x 9¾ x 1⅝ in.)
 Linda Hall Library, Kansas City,
 Missouri
 Acc. no. R.B.R. QH117.P5 1648 folio
 Venues: DC, NC

Copy B: 40 x 27 x 6 cm. (15¾ x 10¾ x 2⅜ in.)
 Library, Academy of Natural Sciences of
 Philadelphia, Pennsylvania
 Acc. no. QH 117/P67/1648/F
 Venues: HO, HI

Willem Piso and Georg Marggraf traveled to Brazil in 1636 under the aegis of Prince Johann Maurits of Nassau, who ruled the Dutch colony until 1644. Members of a larger entourage of scholars, artists, and scientists brought to Brazil by Maurits, Piso and Marggraf were employed by their patron to record their observations of nature. Their notes were published in Amsterdam in 1648.

The book is divided into two parts. The first, written by Piso, is traditional in its approach, while the second, written by Marggraf, takes an important step toward the systematic and objective study of nature. Piso describes the medicinal properties of the Brazilian flora. His focus reflects not only his professional interests as a physician, but also the lingering influence of sixteenth-century herbalists, who explored the curative powers of plant material from the New World.

In describing the flora and fauna of Brazil, Marg-graf chose not to present the natural specimens as atypical or extreme products of nature, but rather as specimens contained within nature's normal range of possibilities, albeit unfamiliar to him. From his careful observations, dissections, and specimen classifications, he produced a landmark work in the development of scientific natural history.

Compressed into the frontispiece shown here is a plethora of natural specimens discussed within the book. By displaying the fruits and nuts of the Brazilian flora so prominently and by including, at the same time, an extraordinary array of animals, the engraver conveys to his European audience the richness and abundance of the *naturalia* in Brazil. Indeed, the visual description reinforced the perception of the New World as a type of terrestrial paradise.

BIBLIOGRAPHY

Honour, Hugh. *The European Vision of America*. Cleveland: Cleveland Museum of Art, 1975. Esp. no. 78.

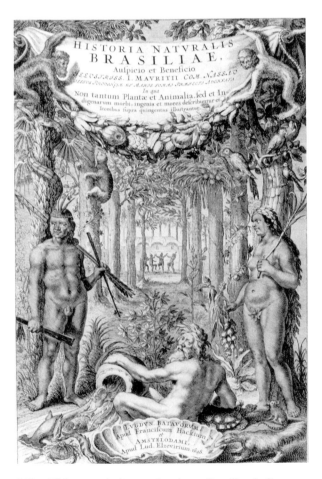

118A Title page. A river god and two Brazilian Indians surrounded by indigenous flora and fauna. Engraving.

ARNOLDUS MONTANUS
Dutch, 1625–83

119A *De Nieuwe en Onbekende Weereld*

Amsterdam, Jacob Meurs, 1671
Illustrated book
32 x 22 x 7.6 cm. (12¾ x 8⅝ x 3 in.)
John Hay Library, Brown University,
 Providence, Rhode Island
Lownes History of Science Collection
Acc. no. 1-SIZE E143 M78
Venues: DC, HO

JOHN OGILBY
English (Scotland), 1600–76

119B *America: Being the Latest, and
Most Accurate Description of
the New World*

London, John Ogilby, 1671
Illustrated book
41.4 x 28.5 x 7.5 cm. (16⅛ x 11¼ x 3 in.)
Dartmouth College Library, Hanover,
 New Hampshire
Acc. no. McGregor 129

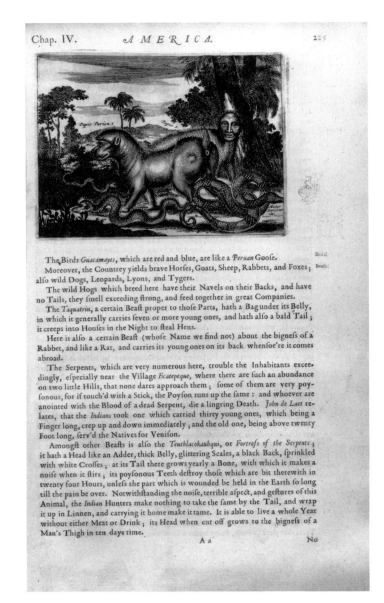

119B A baboon, sloth, and serpent from the New World. Engraving.

The circumstances surrounding the publication of Arnoldus Montanus's *De Nieuwe en Onbekende Weereld* and its translation by John Ogilby in the same year offer substantial insight into the role that publishers played in the rapid dissemination of information about the New World. The works describe the flora and fauna of the land and the customs, architecture, towns, and religions of the indigenous people. They foster the view of the New World as filled with strange and fabulous wonders of all kinds. That perception of America remained strong until the end of the seventeenth century, and even coexisted with the more objective and scientific studies that appeared at the same time.

These two works were conceived as part of a set of atlases on the four continents. The publisher Jacob van Meurs and Ogilby collaborated to produce Dutch and English editions of the works, with Ogilby providing the English translations. The volume on Europe was not realized, and the one on Asia covered only half the intended scope. Ogilby's only original contribution was organizing and publishing a survey of England, which appeared in 1675.

That van Meurs and Ogilby collaborated on these works was deduced by Margaret Schuchard through careful examination of the paper and prints in the volumes. The full-sized plates in *America* were printed by van Meurs in Amsterdam on his paper and sent to Ogilby in England for inclusion in his translation. The smaller plates in the Ogilby version, however, are printed on different paper. Schuchard believes that the plates must have been sent to Ogilby and then returned to van Meurs for subsequent editions. She also discusses a notice published by Ogilby to announce his forthcoming work on America. Since that notice predates the publication of Montanus's work in Amsterdam, Ogilby must have been working

with van Meurs to publish the accounts of the New World quickly and to reach the widest possible audience.

According to Hugh Honour, Montanus's account is a "somewhat indiscriminate summary of information and misinformation derived from histories of the *Conquista* and from travel books" (no. 39). The text emphasizes the exotic, strange, and unfamiliar aspects of a culture the author knew only from secondary sources. The illustrations range from observed views of New Amsterdam to fanciful beasts.

Ogilby did not change that essential perception of the New World for his English readers, but he did emend the text to suit his audience. He used mainly English sources, many original, to describe the English colonies. For example, he quoted sections of Captain John Smith's *General History of Virginia* (1632) to describe encounters with the Indians. His summary in *America* has a vividness that his other translations lack, perhaps because of his use of supplementary material. Ogilby was also concerned with producing a technically superb volume. He used imperial-sized folios, a very high quality paper, clear type, and large margins. The technical excellence of Ogilby's work as a publisher made a significant contribution to the printed travel book.

BIBLIOGRAPHY

Honour, Hugh. *The European Vision of America*. Cleveland: The Cleveland Museum of Art, 1975. Esp. nos. 39, 94.

Schuchard, Margaret. *A Descriptive Bibliography of the Works of John Ogilby and William Morgan*. Bern: Herbert Lang, and Frankfurt: Peter Lang, 1975.

Schuchard, Margaret. *John Ogilby, 1600–1676. Lebensbild eines Gentleman mit vielen Karrieren*. Hamburg: P. Hartung, 1973.

Van Eerde, Katherine S. *John Ogilby and the Taste of His Times*. Folkestone, England: Dawson, 1976.

FRANS JANSZ. POST
Dutch, 1612–80

120 *Brazilian Landscape with a Jesuit Church*

Signed and dated *F. Post 1665*
Oil on canvas, 1665
55.9 x 83.2 cm. (22 x 32¾ in.)
The Detroit Institute of Arts, Michigan
Founders Society Purchase, Membership and
 Donations Fund
Acc. no. 34.188

120

The painter Frans Post was born about 1612 in the Dutch city of Haarlem. One of six artists who accompanied Prince Johann Maurits to Brazil, he spent seven years painting and drawing the exotic landscape, specifically the coastal regions of the northeast. After returning to Holland in 1644, Post supplied designs for an illustrated account of Maurits's governorship in Brazil—*Rerum per octenium in Brasilia et alibi gestarum . . . historia*—written, and published in 1647, by Caspar Barlaeus. The views which appeared in this publication, as well as those made by Post while in Brazil, were repeated with variations in a large number of his landscapes during the following decades.

The painting exhibited here comes from this late period, and like other pictures of this time it reveals the artist's habit of rearranging and revising the various elements of a given site. A partly ruined Catholic church, to which Post added a pedimented portico, figures prominently in the left foreground. The flat expanse of a river basin stretches far into the distance, while, in the plane nearest to the viewer, a small catalogue of local flora and fauna is represented. These exotic specimens include several varieties of fruit trees and palms in addition to cactus and a pineapple plant, plus an armadillo, iguana, toad, and a cobra devouring a hare. Although the painting is not an exact topographical record, it gives a convincing impression of the strange and distant land where verdant jungle growth encroaches on coastal plains and can rapidly overtake man-made structures.

BIBLIOGRAPHY

Honour, Hugh. *The European Vision of America*. Cleveland: The Cleveland Museum of Art, 1975. Esp. no. 80, pp. 80–81.

Larsen, Erik. *Frans Post, interprète du Brésil*. Amsterdam and Rio de Janeiro: Colilbris Editora, 1962. Esp. no. 83, pp. 109, 197.

Montreal Museum of Fine Arts. *The Painter and the New World*. Montreal: Montreal Museum of Fine Arts, 1967. Esp. no. 9.

Smith, Robert C. "The Brazilian Landscapes of Frans Post." *Art Quarterly* 1 (1938): 257.

Sousa-Leào, Joaquim de. *Frans Post 1612–1680*. Amsterdam: A. L. van Gendt and Company, 1973. Esp. no. 48, pp. 88–89.

FRANS JANSZ. POST
Dutch, 1612–80

121 *Village of Olinda, Brazil*

ca. 1660
Oil on canvas
82.5 x 130.8 cm. (32½ x 51½ in.)

121

Elvehjem Museum of Art, University of
 Wisconsin-Madison, Madison, Wisconsin
Gift of Charles R. Crane, 1913
Acc. no. 13.1.16

No traces of the destruction of Olinda by fire in 1631 are visible in Frans Post's painting, except for a few partially reconstructed buildings. Pernambuco, its capital Olinda, and the coastal territory to the northeast, which generated a lucrative sugar trade, were at the center of bitter warfare between the Dutch and Portuguese settlers that lasted until the Dutch relinquished their control in 1654. In *Village of Olinda*, executed long after the artist had returned to Haarlem (in 1644), Post renders a view of the lush flora and fauna of Brazil while subduing the allusions to Olinda's violent history. An array of indigenous vegetables is displayed in the villagers' baskets, the palm bears its coconuts, a parrot is nestled in a tree, and an anteater is visible below. This is one of the many scenes of the Brazilian landscape Post executed in Haarlem. His compatriot Albert Eckhout, another member of the scientific and artistic entourage of Prince Maurits, also portrayed the native inhabitants and flora of Brazil upon his return to Holland, working from sketches made during his trip and embellished from memory.

BIBLIOGRAPHY

Boxer, C. R. *The Portuguese Seaborne Empire 1415–1825*. London: Hutchinson, 1969. Esp. pp. 111–25.
Honour, Hugh. *The European Vision of America*. Cleveland: The Cleveland Museum of Art, 1975.
New York Public Library. *The Age of Atlantic Discoveries*. New York: Brazilian Cultural Foundation, 1990. Esp. no. 138.

German

122 *Bird of Paradise*

2nd quarter 17th century
Watercolor, heightened with white
23.5 x 9 cm. (9¼ x 3½ in.)
Dian and Andrea Woodner, New York
Acc. no. WWA-67
Venues: DC, NC

This delicate watercolor was executed by an unknown German artist who may have been inspired by earlier images of the same subject. At one time it was thought to be a copy after a lost original by Albrecht Dürer. The finely rendered painting shows the

greater bird of paradise, which first arrived in Europe on September 6, 1522; it was brought from the Spice Islands by the surviving members of Magellan's crew. For a long time the bird was regarded as a marvel of nature because, it was believed, it had no feet. But the

122

explorers did not see the animal alive. Instead, they received dead specimens from the Moluccans and did not know that the natives had removed the legs.

The creature inspired an extraordinary mythology. The birds were said to feed on the heavenly dew and to rest nowhere but on trees, to which they entwined themselves with their long feathers. Their flesh never decayed, and the female of the species laid her eggs in a nook on the male's back. In his *Vogelbuch* (Book of Birds, see cat. no. 104), Konrad Gesner gave an elaborate account of the animal's wondrous qualities, and "this detailed and truthful description," he wrote, "is acknowledged by all new scholars, save only Antonius Pigafeta [a member of Magellan's crew], who quite falsely and wrongly says that this bird has a long beak, and legs a dwarf's hand long: for I, who have twice lifted and seen such a bird, have found it to be false." Despite the skepticism of some, the fables about this creature persisted. The miraculous bird of paradise was considered the greatest rarity and was eagerly sought by collectors for display in their wonder rooms. Specimens with feet eventually were brought to Europe, but when Linnaeus later classified them, he gave them, in jest, the scientific designation *Paradisaea apoda*. Although the bird was acquired by Europeans from the natives of the Spice Islands, it originated in New Guinea. Not until 1824 did they see it alive in its native habitat.

BIBLIOGRAPHY

Gilliard, E. T. *Birds of Paradise and Bower Birds*. London: Weidenfeld & Nicolson, 1969.

Impey, Oliver, and Arthur MacGregor, eds. *The Origins of Museums: The Cabinet of Curiosities in Sixteenth- and Seventeenth-Century Europe*. Oxford: Clarendon Press, 1985.

Koreny, Fritz. *Albrecht Dürer und die Tier-und Pflanzenstudien der Renaissance*. Munich: Prestel-Verlag, 1985.

FRANCIS WILLUGHBY
English 1635–72

123 *The Ornithology of Francis Willughby*

John Ray, editor and translator
London, A. C. for J. Martyn, 1678
Illustrated book
36.9 x 24.7 x 4.8 cm. (14½ x 9¾ x 1⅞ in.)
Dartmouth College Library, Hanover,
 New Hampshire
Gift of the Class of 1923
Acc. no. QL/673/W5

Important figures in the history of ornithology, Francis Willughby and John Ray (1627–1705) were the first to organize birds into a rational system of classification. Willughby and Ray, both Englishmen, attended Trinity College, Cambridge, together and became involved in a lifelong project to study and publish detailed descriptions of plants and animals. According to Jean Anker, it was Ray's job to undertake the study of the former and Willughby the latter. During the early 1660s the two men traveled around England and to Europe, where they examined collections, including Aldrovandi's in Bologna (see cat. no. 108), and gathered specimens for their own. Willughby, the wealthier of the two and in essence Ray's patron, purchased drawings and plates by other naturalists.

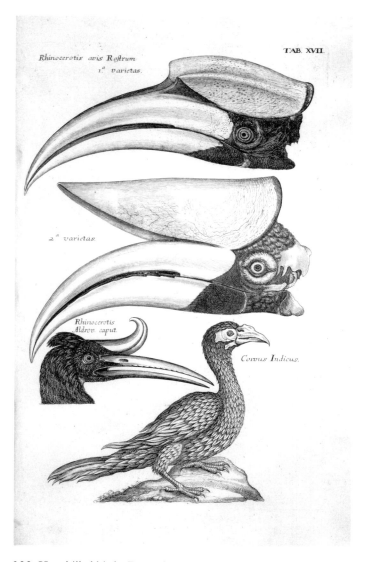

123 Hornbilled birds. Engraving.

THE CATALOGUE

The Ornithology, enlarged from the original Latin edition of 1676, was published by Ray after Willughby's death and based on Willughby's preparatory work (Anker, p. 19). Ray arrranged for new engravings to be made, which were paid for by Willughby's widow. Among them are a page with various types of hornbilled birds and one showing exotic birds from different parts of the world, such as the dodo, turkey, peacock, and "gallina africana." The work does not include the more fantastic and fabled creatures that populated earlier literature on birds, which demonstrates the solidity of the authors' scientific method (Anker, p. 20).

BIBLIOGRAPHY

Anker, Jean. *Bird Books and Bird Art: An Outline of the Literary History and Iconography of Descriptive Ornithology.* Copenhagen: Levin and Munksgaard and Ejnar Munksgaard, 1938.
Godine, David R., and Owen Gingerich. *Renaissance Books of Science from the Collection of Albert E. Lownes.* Hanover: Trustees of Dartmouth College, 1970. Esp. no. 17.
Thornton, John L., and R. I. J. Tully. *Scientific Books, Libraries and Collectors: A Study of Bibliography and the Book Trade in Relation to Science.* 3rd rev. ed. London: The Library Association, 1971. Esp. pp. 129–31.

NICOLAS ROBERT
French, 1614–84

124 *Cassowaries*

Separate sheet from *Recueil d'oyseaux les plus rares, tirez de la ménagerie royalle du parc de Versailles*
Paris, Audran, 1676
Engraving
22.3 x 31.9 cm. (8¾ x 12½ in.)
Museum of Fine Arts, Boston, Massachusetts
George Nixon Black Fund
Acc. no. n. 34.1463
Venues: DC, NC

Nicolas Robert was commissioned by Gaston d'Orléans to execute a collection of paintings on parchment of subjects from nature. Upon d'Orléans' death Louis XIV inherited the project. Robert later gained the title "peintre ordinaire du Roi pour la miniature" for his contributions to this collection which was primarily devoted to images of animals and plants. In addition to Robert, who made 727 paintings, Louis XIV engaged other artists to expand the collection. It eventually grew to over 6,300 sheets bound in 103

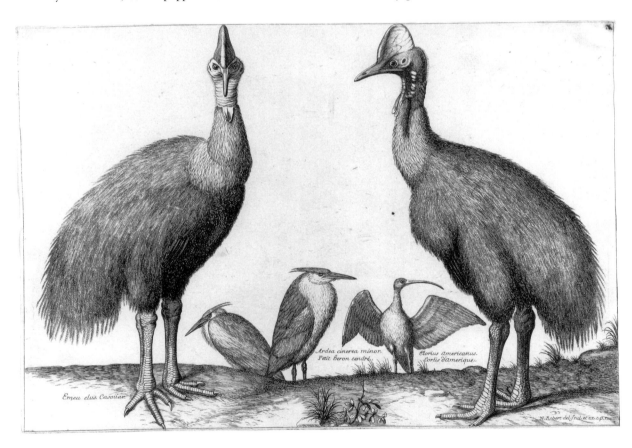

124

volumes, now located in the library of the Natural History Museum in Paris.

This engraving depicting New Guinea cassowaries is a single sheet from a related project. It is one of twenty-four plates Robert made to illustrate the rarest birds in the royal menagerie at Versailles. These plates were first issued in a two-part folio edition in 1676 and were later included in John Johnstone's *Collection d'oiseaux les plus rares* (1772–74). According to Claus Nissen, Robert intended his work to be used as a pattern book, a source of artistic motifs for the decoration of objects ranging from fabrics to furniture. In this way, it was similar to the earlier illustrated books of birds by Adriaen Collaert, Albert Flamen, and Francis Barlow.

Robert's engravings also serve as valuable documents of rare birds. Cassowaries, which became known to Europeans after the discovery of New Guinea in the sixteenth century, aroused interest both because of their great size (adults are six feet high) and because they were flightless birds.

BIBLIOGRAPHY

Anker, Jean. *Bird Books and Bird Art: An Outline of the Literary History and Iconography of Descriptive Ornithology.* Copenhagen: Levin and Munksgaard and Ejnar Munksgaard, 1938.

Denise, Louis. *Bibliographie historique & iconographique du Jardin des plantes: Jardin royal des plantes médicinales et Muséum d'histoire naturelle.* Ed. H. Darragon. Paris, 1903.

Hamy, Dr. Ernest Theodore. "Les Anciennes ménageries royales et la ménagerier nationale fondée le 14 brumaire an II (4 Novembre 1793)." Reprinted in *Nouvelles archives du muséum d'histoire naturelle* 4, 5 (1893). Esp. pp. 1–22.

Nissen, Claus. *Die illustrierten Vogelbücher: ihre Geschichte und Bibliographie.* Stuttgart: Hiersemann, 1953. Esp. pp. 38–39, nos. 787–88.

DAVID DE CONINCK
Flemish, 1636–99

125 *Menagerie of Birds*

ca. 1695–1700
Oil on canvas
124 x 169 cm. (48⅞ x 66½ in.)
Mrs. A. Alfred Taubman

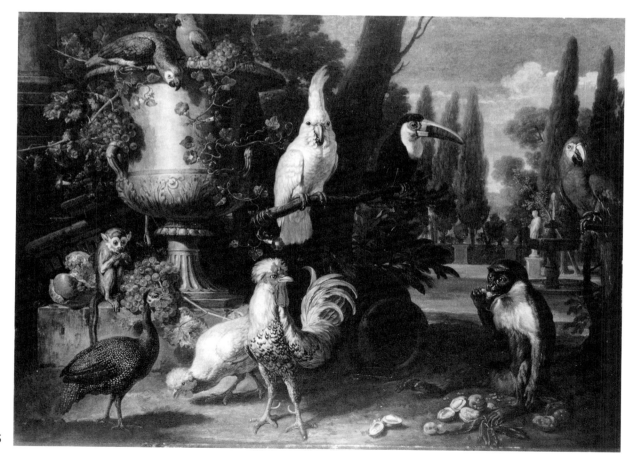

125

Although this picture is sometimes titled *American Menagerie*, it actually represents animals from Africa, Asia, New Guinea, and South America. A large and impressive work, it belongs to a category of paintings known as "animal parks" that became popular in the seventeenth century and that were usually made for the hunting lodges of wealthy patrons. Although it bears the signature of Jan Weenix (1640–1719), which was probably added after 1818, this painting of exotic birds was recently reattributed to David de Coninck. The African gray parrot, the macaw, the cockatoo, and the squirrel monkey are virtually identical to those appearing in other paintings by de Coninck, who specialized in such animal compositions painted in the style of his teachers, Pieter Boel and Jan Fyts. Here the artist has emphasized the most remarkable features of his animal models: the prominent beak of the Brazilian toucan is shown in profile, and the great crest of the cockatoo and the showy tail feathers of the junglefowl are dramatically set against a dark background.

During the late sixteenth and seventeenth centuries, menageries were established in many parts of Europe. Conceived as collections of living wonders, they were the counterparts to the *Wunderkammern* and cabinets of curiosities with their assemblages of dead *meraviglié*. De Coninck's images of rare and exotic animals reflect a firsthand study of creatures kept in such menageries, but at the same time they show the animals in ideal arrangements. These half-documentary and half-idealized views of birds were widely popular in the seventeenth century.

BIBLIOGRAPHY

Honour, Hugh. *The European Vision of America*. Cleveland: The Cleveland Museum of Art, 1975. Esp. no. 126.
Sotheby's, London. *Old Master Paintings*. Sales auction catalogue, July 6, 1988. Esp. lot. no. 36, pp. 58–59.
Meijer, Fred. Catalogue raisonné of the work of David de Coninck. Forthcoming publication.

JAN VAN KESSEL
Flemish, 1626–79

126 *A Study of Butterflies, Moths, Spiders, and Insects*

17th century
Oil on panel
18.3 x 30.5 cm. (7¼ x 12 in.)
Sarah Campbell Blaffer Foundation,
 Houston, Texas

This small painting demonstrates Europeans' fascination with tiny forms of life. The artist Jan van Kessel,

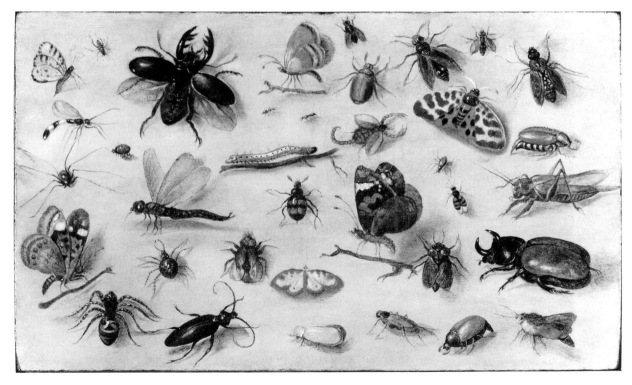

126

is known to have made numerous paintings show-
ing insects, and he characteristically emphasizes their
special features by placing them against a light back-
ground.* Here he depicts a dragonfly, caterpillar,
daddy longlegs, four butterflies, several moths, two
ants, flies, a ladybug, and a locust. A huntress spider
appears in the lower left corner, and next to it is a
longicorn beetle. Two of the most striking specimens
are the large stag beetle at the upper left and the
boldly shaped and glossy rhinoceros beetle in the
lower right corner. Van Kessel has rendered each of
these insects with the greatest attention to veracity of
detail; and rather than bringing them together in an
obvious unified composition, he has arranged them
loosely on their background support, as if insisting
that they be regarded, and enjoyed, by the spectator
as separate and individual forms. Such a way of pre-
senting natural specimens, emphasizing the variety
of forms within a class, has parallels in contemporary
natural histories and in the arrangements of *naturalia*
in many wonder rooms.

 * Dr. Marie-Louise Hairs of the University of Liège sup-
ports the attribution to van Kessel.

BIBLIOGRAPHY

Wright, Christopher. *A Golden Age of Painting: Dutch,
Flemish, German Paintings, Sixteenth-Seventeenth Cen-
turies, from the Collection of The Sarah Campbell Blaffer
Foundation*. San Antonio: Trinity University Press, 1981.
Esp. pp. 85–86.

WENCESLAUS HOLLAR
Bohemian, 1607–77

127 *Muscarum scarabeorum vermiumq
varie figure & formae*

Antwerp, 1646
Set of twelve etchings of butterflies and insects
8.2 x 11.8 cm. (3¼ x 4⅝ in.)
Arthur and Charlotte Vershbow, Boston,
 Massachusetts

Wenceslaus Hollar was one of the most prolific etch-
ers of the seventeenth century. He executed prints
covering an encyclopedic range of subjects from re-

127 Butterflies. Etching.

ligious, mythological, and historical scenes to bird's-eye views of cities, portraits, costumes, architectural monuments, and even natural objects. He was a virtuoso etcher, able to render the most complex textures through the printed line. His technical skill and powers of observation created a high demand for his etchings, which was reinforced by two external factors. First, he was frequently employed by print publishers to make sets of prints. Second, and equally important, was the demand for prints of an encyclopedic nature by collectors themselves. In fact, Hollar's work (and the demand for it) might best be understood in terms of the encyclopedic collections of the sixteenth and seventeenth centuries.

Illustrated here, for example, is an etching of carefully rendered butterflies after colored drawings in the collection of one of the most important patrons in England, Thomas Howard, Earl of Arundel. Hollar met Lord Arundel in Cologne, where he joined the collector's entourage and traveled with it to Prague and then finally to England. Arundel may have wanted Hollar to etch works of art in his collection for a catalogue (Pennington, p. xxii). Although Hollar never completed such a project, a small number of etchings, like those of the insects and butterflies, do bear the phrase "ex Collectione Arundeliana." Twenty prints made after works of art in the Arundel collection were published in 1646, during Hollar's long stay in Antwerp (1644–52) and when he was no longer directly employed by Arundel.

The significance of these prints rests within the tradition of the *Kunstkammer*. Not only would their explicit provenance attract attention, but their subject, as a category within an encyclopedic collection, would have made these prints a very desirable purchase. We can see a pivotal point within the history of *Kunstkammern*: through the medium of etchings, collectors with lesser means could nonetheless have a complete collection of rare objects.

BIBLIOGRAPHY

Goddard, Stephen H. *Sets and Series: Prints from the Low Countries.* New Haven: Yale University Art Gallery, 1984. Esp. pp. 34–37.

Pennington, Richard. *A Descriptive Catalogue of the Etched Work of Wenceslaus Hollar, 1607–1677.* New York: Cambridge University Press, 1982. Esp. nos. 2164–75, pp. 334–36.

MARIA SIBYLLA MERIAN
German, 1647–1717

128 *Der Raupen wunderbare Verwandlung und sonderbare Blumennahrung*

Nuremberg, 1679
Illustrated book
20 x 16.5 x 2 cm. (7⅞ x 6½ x ⅞ in.)
Museum of Fine Arts, Boston, Massachusetts
William A. Sargent Fund
Acc. no. 60.1460 (S)
Venues: DC, NC

Maria Sibylla Merian, daughter of the renowned German engraver and print publisher Matthaeus Merian, devoted herself to a life's study of insects and their metamorphoses. Her talent developed first as a flower painter under the direction of her stepfather, Jacob Moreel. Initially she copied the work of Nicolas Robert (cat. no. 124), but she developed an interest in tropical butterflies and insects when she saw the varieties brought back by the Dutch West India Company.

Der Raupen wunderbare Verwandlung und sonderbare Blumennahrung (1679) illustrates the wonderful metamorphosis of caterpillars and their diet of strange flowers. The process of metamorphosis was considered a miracle through which the death of one form gave life to another. The idea of seeing in the transformation of the caterpillar the possibility of eternal life appears in the last stanza of a poem included in Merian's work:

> Liebster Gott/so wirst du handlen
> auch mit uns/zu seiner zeit;
> wie die Raupen sich verwandlen/
> die/durch ihre Sterblichkeit/
> wiederum lebendig werden/
> gleich den Todten/in der Erden:
> Lass mich armes Würmelein
> Dir alsdann befohlen sein!
> Dearest God, thus you will do
> also with us when the time comes;
> just like the caterpillars are transformed
> and through their mortality
> become alive again
> like the dead in the earth:
> Let me poor little worm
> Then be entrusted to your mercy!

In 1699 Merian sailed to the Dutch colony of Surinam to study the insect life and remained until 1701. Four years later her drawings were published in a beautiful volume with seventy-two hand-colored, engraved

17

128 Metamorphosis of caterpillar. Engraving.

plates. The *Metamorphosis insectorum Surinamsium* made a significant contribution to the history of tropical entomology as well as to the history of botanical illustration.

BIBLIOGRAPHY

Harris, Ann Sutherland, and Linda Nochlin. *Women Artists: 1550–1950*. Los Angeles: Los Angeles County Museum of Art, 1976. Esp. pp. 153–55.

Honour, Hugh. *The European Vision of America*. Cleveland: Cleveland Museum of Art, 1975. Esp. pp. 83–85.

Nissen, Claus. *Die illustrierten Vogelbücher: ihre Geschichte und Bibliographie*. Stuttgart: Hiersemann, 1953. Esp. nos. 1340–42, and pp. 86, 168.

Sotheby's. *A Magnificent Collection of Botanical Books: being the finest color-plate books from the celebrated library formed by Robert de Belden*. Uxbridge, Middlesex, Great Britain: Hillingdon Press, 1987.

ROBERT HOOKE
English, 1635–1702

129 *Micrographia; or, Some Physiological Descriptions of Minute Bodies Made by Magnifying Glasses*

London, John Martyn and James Allestry, 1665
Illustrated book
30.2 x 20.7 x 3.8 cm. (11⁷⁄₈ x 8⅛ x 1½ in.)
Dartmouth College Library, Hanover,
 New Hampshire
Acc. no. QH/271/H79/1665

Robert Hooke was a man of wide-ranging interests who made important contributions in the fields of technology, astronomy, physics, geology, architecture, and optics. Curator of Experiments of the Royal Society, which sought to reform scientific knowledge, he later was named Keeper of its Repository, or museum. Hooke is best known for his work in the area of optics, especially for the studies he made with the microscopes of his own design. His *Micrographia* is justly famous, for it was the earliest work devoted entirely to observations made with the microscope and the first book to be published on the subject in English. The book's outstanding feature is its engraved illustrations, a set of thirty-eight plates designed by Hooke and possibly engraved in collaboration with Sir Christopher Wren. These plates are of such high quality that they were included in textbooks on microscopy for nearly 150 years after the publication of *Micrographia*.

The images are breathtaking in their boldness and in their precision of detail. The most commonplace objects are considered by Hooke, but when he views them through his lens, he finds that they have a strange beauty and an extraordinary intricate structure. He looks at a bee's stinger, fish scales, feathers, sponges, the seeds of thyme, and he discovers "cells" in a piece of cork. Most surprising of all are the insects. As Hooke learns, the minute forms of a fly, a louse, a flea, and the eye of a gnat have a complex architecture when seen with the aid of his "magnifying glasses."

BIBLIOGRAPHY

Garrison, Fielding Hudson, and Leslie T. Morton. *A Medical Bibliography: An Annotated Check-list of Texts Illustrating the History of Medicine*. Aldershot, Hampshire: Gower, 1983.

Westfall, Richard S. "Hooke, Robert." *Dictionary of Scientific Biography*. Vol. 6. Ed. Charles Coulston Gillispie. New York: Scribner, 1972. Esp. pp. 481–88.

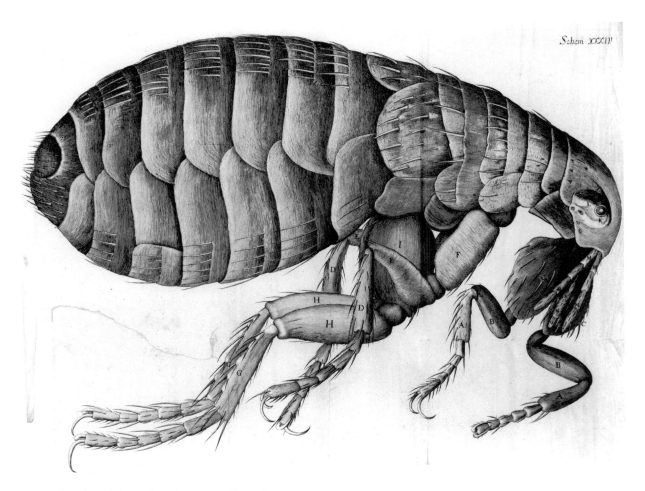

Schem XXXIV

129 A flea viewed through a microscope. Engraving.

Wolf, Edwin, ed. *Legacies of Genius: A Celebration of Phila-delphia Libraries*. Philadelphia, Pa.: Philadelphia Area Consortium of Special Collection Libraries, ca. 1988. Esp. no. 143, p. 181.

MARCELLO MALPIGHI
Italian, 1628–94

130 *Opera omnia seu thesaurus locupletissimus, botanico-medico-anatomicus*

Leiden, Petrum vander Aa, 1687
Illustrated book
24.2 x 21 x 6.4 cm. (9½ x 8¼ x 2¾ in.)
Special Collections, Bailey/Howe Library,
 University of Vermont, Burlington
Acc. no. Rare Book QH9.M2

The Bolognese Marcello Malpighi was one of the first scientists to make use of the microscope in the field of biology. By means of this instrument he discovered the existence of capillaries in the lungs of frogs and was the first to see capillary anastomosis between the arteries and veins. His pioneering work led to the discovery of corpuscles (the "Malpighian bodies"), the lowest layer of the epidermis (the "Malpighian layer"), and the excretory glands of insects and spiders (the "Malpighian tubules"). His studies of the circulatory and digestive systems of the silkworm were no less significant. Completely overturning the long-held view that insects have no internal parts at all, he discovered, on the contrary, that they possess an elaborate and complex inner structure. More so than his written account, Malpighi's elegant illustrations of the silkworm gave astonishing and abundant evidence of this biological truth.

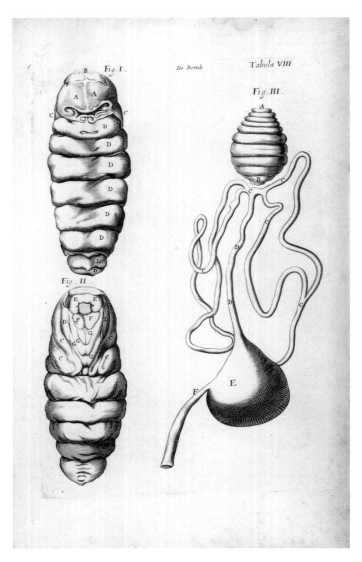

130 Cocoons of the silkworm. Engraving.

JAN SWAMMERDAM
Dutch, 1637–80

131 *Historia insectorum generalis*

Leiden, Jordanum Luchtmans, 1685
Illustrated book
20.5 x 15.6 x 3.0 cm. (8 x 6⅛ x 1¼ in.)
Dartmouth College Library, Hanover,
 New Hampshire
Acc. no. QL/362/S97

The Dutch biologist Jan Swammerdam has some-
times been called the greatest comparative anatomist
of the seventeenth century. Swammerdam and his
father, an apothecary, amassed a huge collection of
zoological specimens that included such "miracles of
nature" as flying lizards, stingers of honeybees, ani-
mal skeletons, human embryos, hummingbirds ("the
smallest bird known"), "the entire thoracic tract of a
forty-year-old man," "some rarities of calves," "the
lungs of a frog" and "of a very strange lamb," parts of
an elephant and a "Malaisian swine," "the womb of a
virgin," and thousands of insects, cocoons, and lar-
vae. It was the latter objects to which Swammerdam
directed his attention especially, and his *Historia in-
sectorum* describes the results of his studies of the
phenomenon of metamorphosis.

Swammerdam was particularly struck by the
anatomical structure of insects (the louse or mayfly,
for instance), and in a letter to a friend he declared
that with the aid of a microscope one could "find
wonder upon wonder and God's wisdom clearly ex-
posed in one minute particle" (Scheurlur, p. 120). A
deeply religious man in his later years, Swammerdam
saw the marvels of the insect world as the ingenious
creations of God. It was through God's grace, he said,
that mankind "can investigate these high and hidden
wonders and for the benefit of other men display the
same."

BIBLIOGRAPHY

Garrison, Fielding Hudson, and Leslie T. Morton. *A Med-
 ical Bibliography: An Annotated Check-list of Texts Illus-
 trating the History of Medicine.* Aldershot, Hampshire:
 Gower, 1983.

BIBLIOGRAPHY

Garrison, Fielding Hudson, and Leslie T. Morton. *A Med-
 ical Bibliography: An Annotated Check-list of Texts Illus-
 trating the History of Medicine.* Aldershot, Hampshire:
 Gower, ca. 1983. Esp. pp. 294, 860, 1211, 1724.
Winsor, Mary P. "Jan Swammerdam." *Dictionary of Scien-
 tific Biography.* Ed. Charles Coulston Gillispie. New York:
 Scribner, 1976. Esp. pp. 168–75.
Scheurlur, Th. H. Lunsingh. "Early Dutch Cabinets of
 Curiosities." In *The Origins of Museums.* Ed. Impey and
 MacGregor. Oxford: Clarendon Press, 1985.

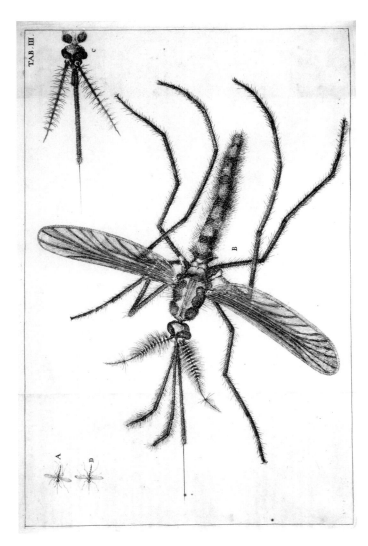

131 Mayfly. Engraving.

ANTONI VAN LEEUWENHOEK
Dutch, 1632–1723

132 *Anatomia; seu, interiora rerum*

Leiden, Cornelium Boutesteyn, 1687
Illustrated book
21.2 x 16.8 x 3.8 cm. (8¼ x 6⅝ x 1½ in.)
Dartmouth College Library, Hanover,
 New Hampshire
The Conner Collection
Acc. no. QK/641/L4/1687

Although Antoni van Leeuwenhoek was not a pro-
fessionally trained scientist, his microscopical obser-

vations of organic and inorganic structures earned
him the recognition of his contemporaries; in 1680 he
was elected a fellow of the Royal Society of London.
Leeuwenhoek's interest in natural science emerged
late in his life after he had apprenticed himself to a
cloth merchant and then begun a career as a civil
servant. He became chief warden of Delft in 1677 and
inspector of weights and measures in 1679. In 1671 he
built his first simple microscope, developing his idea
from the glasses used by drapers to inspect cloth.
During the next fifty years he would grind over 500
lenses and make no less than 247 microscopes.

 Leeuwenhoek never published his method for
making or mounting his lenses, but the greatest mys-
tery surrounding his work is his method of using his
microscopes. The results he achieved with the micro-
scope and the clarity of his observations surpassed
those of all of his contemporaries. Clifford Dobell
has suggested that Leeuwenhoek must have discov-

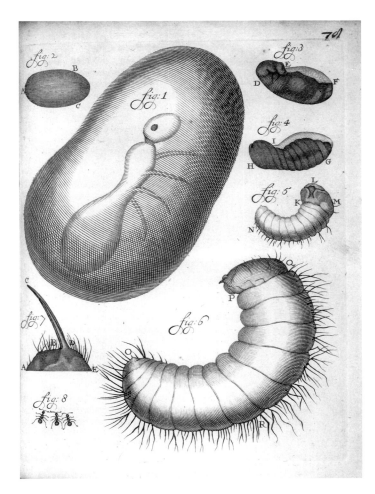

132 An ant's egg seen through a microscope. Engraving.

ered "some method of dark-ground illuminations," which "would explain all his otherwise inexplicable observations, without supposing him to have possessed any apparatus other than that which we now know he had" (Dobell, p. 331).

In 1674 he made his most important discovery: he realized that the microorganisms he saw under his microscope were in fact live animals. His work, in part, followed that of Swammerdam, because he used his observations to refute Aristotle's theory of spontaneous generation. Leeuwenhoek was able to use his examination of an ant's egg, illustrated here, to show that tiny insects did not originate from the putrefaction of organic material as Aristotle had thought. Even in the earliest stages of life, the insect's structure was clearly visible in its basic parts.

BIBLIOGRAPHY

Dobell, Clifford. *Antony van Leeuwenhoek and His "Little Animals."* London: John Bale, Sons and Danielsson, 1932.
Heniger, Johannes. "Antoni van Leeuwenhoek." *Dictionary of Scientific Biography.* Vol. 8. Ed. Charles Coulston Gillispie. New York: Scribner, 1973. Esp. pp. 126–30.

CHRISTOPHER COCK
English, fl. last quarter of 17th century

133 *Compound Monocular Microscope*

Designed and used by Robert Hooke (English, 1635–1702)
ca. 1670
Cardboard covered with leather, gold stampings
H: 55.2 cm. (21¾ in.); DIAM. (of base): 21.5 cm. (8½ in.)
The Historical Collections, National Museum of Health and Medicine of the Armed Forces Institute of Pathology, Washington, D.C.
Acc. no. AFIP 49004–66–1836–1

Sometime between the years 1590 and 1610 Hans and Zaccharis Janssen of Middleburg, Holland, constructed what is believed to be the first compound microscope, an instrument that contained two lenses and that could be focused by means of a sliding tube. This optical device, which revealed unimagined and minute worlds to the beholder, was first put to scientific use by Galileo. In the 1660s Robert Hooke (cat. no. 129) made numerous refinements in the construction of the microscope. He developed the field lens, devised a "stage" on which specimens could be placed, and invented a system by which the objects of study could be better illuminated.

The superb microscope exhibited here, although not signed, has been identified as one of the microscopes designed and used by Hooke. It is comprised of a large cardboard body tube and two draw tables,

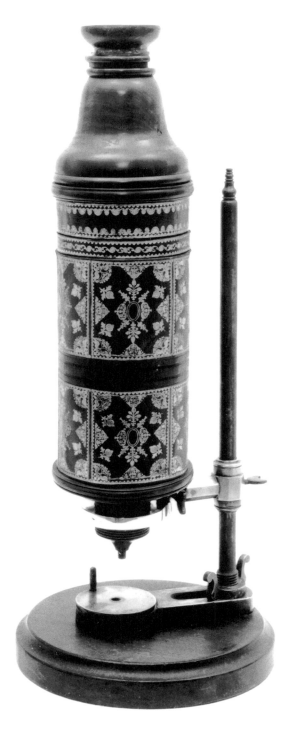

133

a vertical pillar, wooden mountings, base and eye-piece, brass fittings, and specimen holder. The field lens is mounted inside the lower end of the large body tube. Like many other scientific instruments made at the time, this microscope has been fashioned as if it were a work of art. The wood pieces are finely turned, the brass fittings are elegantly finished, and the cardboard tube is encased in gold-stamped chocolate leather.

With this instrument and others like it, Robert Hooke made his famous discoveries: the cell structure in a piece of cork; the configuration of feathers, fish scales, and a bee's stinger; the elaborate anatomies of the flea, the horsefly, and the louse.

BIBLIOGRAPHY

Daumas, Maurice. *Scientific Instruments of the Seventeenth and Eighteenth Centuries*. Ed. and trans. Mary Holbrook. New York: Praeger Publishers, 1972.

Ey, John A., ed. *The Billings Microscope Collection*. 2nd ed. Washington, D.C.: Armed Forces Institute of Pathology, 1987.

DEPOUILLY OF PARIS
French

134 *Simple Microscope with a Rotating Specimen Holder*

ca. 1686
Engraved brass and ivory

L: 14 cm. (5½ in.)
The Historical Collections, National Museum of Health and Medicine of the Armed Forces Institute of Pathology, Washington, D.C.
Acc. no. AFIP 49151–60–4713–355

The simple (or single-lens) microscope exhibited here perfectly illustrates the way Europeans embellished their scientific instruments with elegant decorative details as if they were art objects. The two sides of this microscope are beautifully engraved with floral and garland motifs and surrounded with miniature forms of scrolls and leaves. These two plates, made of brass, are joined to a turned ivory handle. A single lens is mounted between the two plates, as is a rotating brass wheel that has enough room for eight separate specimens. The viewer would have looked at his objects through the aperture on the back plate of the microscope. Focusing was achieved by turning a tiny wheel projecting beyond the edges of the plates. A cleverly designed instrument, especially on account of its rotating specimen holder, and an object of exquisite craftsmanship, it compares to many objects of *virtù* that were kept in sixteenth- and seventeenth-century cabinets of rarities and *Wunderkammern*.

BIBLIOGRAPHY

Ey, John A., ed. *The Billings Microscope Collection*. 2nd ed. Washington, D.C.: Armed Forces Institute of Pathology, 1987.

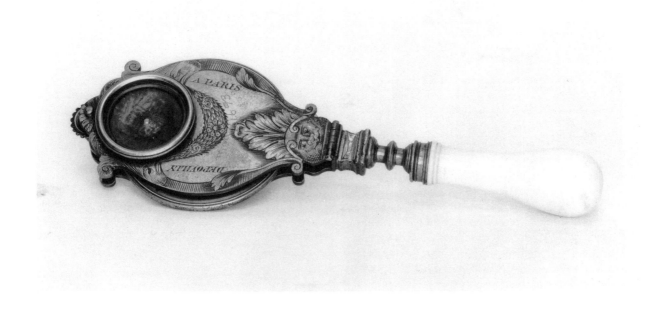

134

microscope. Since there are screw threads on both sides of the two pieces, it is likely that this ingeniously contrived and compact device originally had protective caps.

BIBLIOGRAPHY

Ey, John A., ed. *The Billings Microscope Collection*. 2nd ed. Washington, D.C.: Armed Forces Institute of Pathology, 1987.

French

136 *Le Grant herbier en françois*

Paris, Pierre Le Caron, ca. 1498
Illustrated book
25.7 x 20 x 2.3 cm. (10⅛ x 7⅞ x ⅞ in.)
The Newberry Library, Chicago, Illinois
Venue: DC

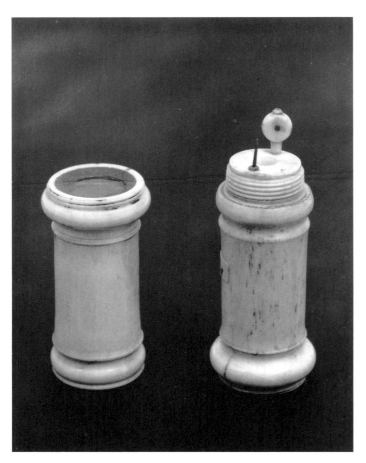

135

ANONYMOUS

135 *Simple Microscope (Flea Glass)*

ca. 1700
Bone
Each section, L: 5.1 cm. (2 in.)
The Historical Collections, National Museum of
Health and Medicine of the Armed Forces
Institute of Pathology, Washington, D.C.
Acc. no. AFIP 518853–66–6274

This bone flea glass is a humble cousin to the elegant pocket microscope discussed in cat. no. 134. A type of simple microscope that could be used by amateurs in viewing minute objects, it consists of two parts. The first section has a single lens and a viewing aperture at the opposite end; the second section has a lens at one end and a viewing aperture as well as lens and specimen holders at the other. These two parts could be screwed together not only for easy handling, but also to form what is technically speaking a compound

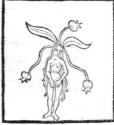

136 Female and male mandrakes. Woodcut.

German

137 *The Mandrake*

Separate sheet from *Herbarius*
Augsburg, Johann Schönsperger, 1485 (?)
Illustrated book
29.7 X 48.2 X 5 cm. (12 X 19 X 2 in.)
The Newberry Library, Chicago, Illinois
Venue: HO

The German *Herbarius* and French *Le Grant en her-bier en françois*, both among the earliest printed herb als, are probably based on manuscripts that draw from antique sources (Arber, p. 16). Until well into the sixteenth century both the scope and the format of herbals were based on the works of Theophrastus and Dioscorides, which botanists found inadequate only when they attempted to incorporate unfamiliar flora from the New World into the old categories and schemes.

The primary purpose of both these books was to provide remedies for illnesses, and they reveal the inextricable connection between botany and the study of medicine. Like many other botanical works from this period and later, they offer a significant amount of information drawn from folklore and superstition. For instance, both authors devote considerable space to the mandrake, a plant that was believed to have a variety of strange and marvelous properties. Because the thick, tuberous roots of the mandrake divide into leglike branches, it was commonly supposed to resemble a human being and usually, as here, was depicted as a man (or woman, in the case of the female-shaped root) dangling from the plant's leaves. Mandrake root, according to belief, healed a person possessed by demons (Rohde, pp. 11–12), but it also gave off deadly fumes when dug up from the ground. Thus, as Pliny observed, it was advisable to have a dog uproot the plant instead. The smell of the mandrake's fruit sometimes was said to induce sleep or forgetfulness; a powder made from its roots, on the other hand, was considered a good cure for impotency in men and sterility in women. The stupefying effects of the mandrake were associated not only with the ordinary garden variety of the plant, but also with the type believed to spring from the semen or urine of men hanged on gallows. The effects of these specimens were regarded as the work of the devil, however, since they were used to promote criminal behavior.

Many of the legends and magical cults surrounding the mandrake persisted far into the seventeenth century, despite having been refuted in such early works

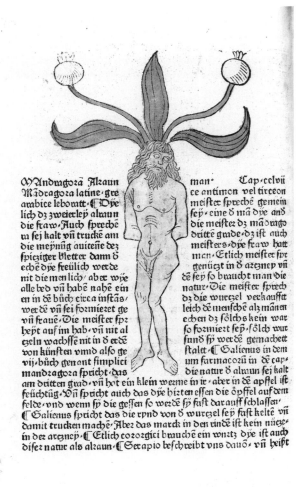

137 Mandrake. Woodcut.

as *The Grete Herbal* of 1526 and in the *Herbal* of 1551 by English botanist William Turner. Mandrake does not grow under gallows, Turner declared; moveover, as he noticed, the roots sold in England were counterfeits, trimmed by peddlers and thieves to look like "little puppettes and mammettes" with hair "and such forme as man hath" (Rohde, p. 91).

Early texts devoted to plants and their uses show a heavy reliance on secondhand reports, but with the German *Herbarius* there are some notable exceptions to this practice. An extraordinary feature of this work is that as many as 65 of its 379 woodcuts are based on drawings made from observations of actual plants. The author appears to have traveled as far as Mount Sinai to record herbs mentioned in antique sources but that did not grow in Germany. He writes: "That

my journey should not benefit my soul only, but the whole world, I took with me a painter of good sense, skilful and cunning. . . . In wandering through these kingdoms and countries, I diligently sought after the herbs there, and had them drawn and depicted in their true forms and colours" (Blunt and Raphael, p. 116). The inclusion of the artist in his project was an important step toward the accurate description of plant specimens. In fact, the employment of artists to make drawings after plants was one of the most significant aspects of the later work of Otto Brunfels and Leonhart Fuchs (cat nos. 140, 141). Such reliance on empirical observation would become necessary with the arrival of unclassified flora from the New World. For this reason, the German *Herbarius* set an important precedent in botanical illustration.

BIBLIOGRAPHY

Arber, Agnes. *Herbals, Their Origin and Evolution: A Chapter in the History of Botany 1470–1670.* 2nd ed. Cambridge: Cambridge University Press, 1938.

Blunt, Wilfrid. *The Art of Botanical Illustration.* London: Collins, 1950.

Blunt, Wilfrid, and Sandra Raphael. *The Illustrated Herbal.* New York: Metropolitan Museum of Art, 1979.

Greene, Edward Lee. *Landmarks of Botanical History.* Stanford: Stanford University Press, 1983.

Rohde, Eleanour Sinclair. *The Old English Herbals.* 2 vols. London: Longmans, Green, 1922.

Thorndike, Lynn. *A History of Magic and Experimental Science.* 8 vols. New York: Columbia University Press, 1923–58. Esp. vol. 8, pp. 11–133.

CLAUDE DURET
French, d. 1611

138 *Histoire admirable des plantes et herbes esmerveillables et miraculeuses en nature*

Paris, Nicolas Buon, 1605
Illustrated book
Each approx. 16 x 12 x 2.5 cm. (6¼ x 4¾ x 1 in.)

Copy A: Dumbarton Oaks, Trustees for Harvard University, Washington, D.C.
Acc. no. N–2–1
Venues: DC, NC

Copy B: Library of the Arnold Arboretum, Harvard University, Cambridge, Massachusetts
Acc. no. 22187, Apr. 1910
Venues: HO, HI

Claude Duret's publications encompass an unusual combination of subjects. He addressed vast topics like the history of languages (1613, 1619), the development and decline of monarchies and empires (1594), and the tidal movements of the ocean (1600). His works were ambitious compendia of written sources, both ancient and modern. Exhibited here is his last publication on the history of marvelous and miraculous plants found in nature. The botanical marvels he describes had existed for centuries and are recorded by Duret as they survived in their variant and embellished forms. As a compendium of early plant lore, *Histoire admirable* represents the phase of botanical history that preceded the establishment of a systematic and objective study of specimens. Early plant lore subscribed to the theory of the Great Chain of Being, in which all of God's creations were linked together, with no gaps in the chain of evolution and with no clear division between species. The theory welcomed the notion of hybrid plants such as the Credulity tree and the Scythian lamb. These hybrids were believed to be living products of the intersection between the plant and animal worlds. Of course, such hybrids existed only in myths, but those myths, and others like them, were included in botanical works throughout the seventeenth century, and constituted a living tradition that existed alongside the development of a more modern approach to botany.

The Scythian lamb or borometz is one of the fabulous plants described by Duret. According to reports dating back to the twelfth century, it was found in the land of the Tartars, or Scythia (*borometz* or *barometz* is the Tartar word for lamb). The woolly creature grew on a stalk and nourished itself by eating the surrounding grass. When all the grass was consumed, the lamb withered and died, and then, like other plants, propagated itself by seeds. The myth of the vegetable lamb, as Rohde states (pp. 144–45), evolved from ancient descriptions of the cotton plant (Herodotus said it had a fleece surpassing those of sheep); but it also is based on the *cibotium barometz*, a tree fern native to tropical Asia and the Malay peninsula that has shaggy leaves and a short trunk covered with glossy brown hairs.

Another marvel described by Duret is the tree called Credulity, whose fruit or leaves become fishes if they fall into the water or birds if they fall onto the ground. There were several variants of this myth. In one, the tree's fruit turned into geese when they dropped into the water; in another, geese hatched from shells (barnacles) attached to timbers floating in the sea. The mythological tree goose or barnacle goose has its origins in two actual species: a barnacle Lin-

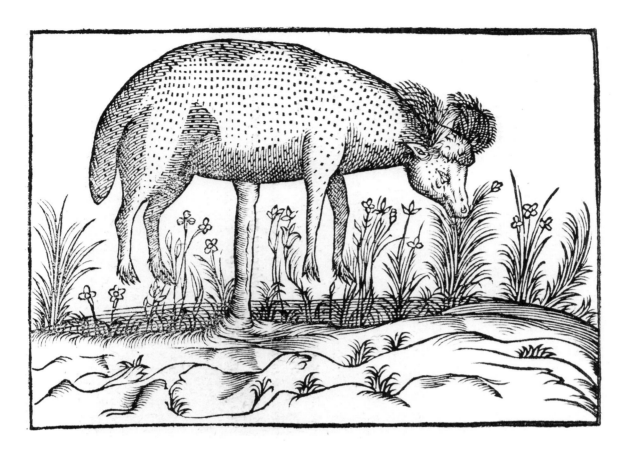

138A Scythian lamb. Woodcut.

naeus later called *Lepas anatifera* (or "goose-bearer") and a type of black goose called the *Branta bernicla* (or "barnacle"). The physical characteristics of the barnacle offered an appealing solution to the puzzling origin of the black goose (the fact that it lays its eggs on high cliffs was not discovered until 1907). These barnacles use featherlike antennae, called cirri, to sweep the water for nutrients. In addition, once the barnacle attaches itself to a log, it forms a pliable tube between itself and its support. As this tube can reach four inches in length, the animal could have been seen as a type of hybrid, having the characteristics of both plants and birds.

By 1605, when Duret published his *Histoire admirable*, the myth of barnacle geese had already been described in numerous manuscripts and printed texts.

In spite of periodic denouncements, the myth flourished in the sixteenth and seventeenth centuries, appearing in an impressive range of material from herbals to books of marvels, works on natural history, and even maps.

BIBLIOGRAPHY

Arber, Agnes. *Herbals, Their Origin and Evolution: A Chapter in the History of Botany, 1470–1670*. 2nd ed. Cambridge: Cambridge University Press, 1938.

Heron-Allen, Edward. *Barnacles in Nature and in Myth*. London: Oxford University Press, 1928.

Prest, John. *The Garden of Eden: The Botanic Garden and the Re-Creation of Paradise*. New Haven: Yale University Press, 1988. Esp. pp. 31–32.

Rohde, Eleanour Sinclair. *The Old English Herbals*. London: Longman, Greens, 1922.

JOHANN ZAHN
German, 1641–1707

139 *Specula physico-mathematico-historica notabilium ac mirabilium sciendorum*

Volume 2
Illustrated book
Nuremberg, Joannis Christophori Lochner, 1696
41 x 38.5 x 13 cm. (16⅛ x 15⅛ x 5⅛ in.)
Smithsonian Institution Libraries,
 Washington, D.C.
Acc. no. fQ155.Z3X v.2 NMAH RB

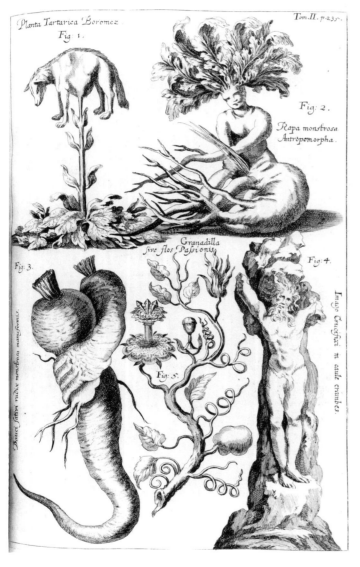

139 Scythian lamb, monstrous anthropomorphic turnip, monstrous hand-shaped carrot, image of a crucified man in a cabbage stem, and Granadilla or passionflower. Engraving.

This remarkable volume is one of several publications by Johann Zahn, a Premonstratensian* monk of Würtzburg and the leading figure in German monastic learning in the late seventeenth century (Gernsheim, p. 27). Zahn is best known for his studies on the camera obscura and camera lucida (cat. no. 207), but his interests were not limited to optical devices and their effects. Like many encyclopedic authors before him, Zahn investigated numerous different subjects and compiled information drawn from ancient as well as modern authors. He also had a fascination for the marvelous, as the present work plainly shows. The *Specula* offers "a physical-mathematical-historical overview of remarkable and wonderful things to be known," and in this volume, according to its author, the world of the marvelous is set forth for consideration by all curious natural philosophers (*curiosis omnibus cosmosophis*).

Zahn describes the many celestial marvels (comets and planets seen through the telescope) and then goes on to consider all the various terrestial wonders. Fact and fancy quite often are intermixed, as can be seen in one of the splendid engravings from the chapter titled "Marvelous Fruits and Flowers to Be Grown." Here, the reader is treated to a brief pictorial history of botanical *meraviglie*: the fabulous Scythian lamb, a monstrous anthropomorphic turnip, a carrot shaped like a hand, an image of a crucified man in a cabbage stem, and the exotic import from America, the passionflower.

* This religious order was founded in Prémontré, France, in the twelfth century.

BIBLIOGRAPHY

Gernsheim, Helmut, and Alison Gernsheim. *The History of Photography from the Camera Oscura to the Beginning of the Modern Era*. New York: McGraw-Hill, 1969.
Thomas, Joseph. *Universal Pronouncing Dictionary of Biography and Mythology*. Philadelphia: J.B. Lippincott, 1915. Esp. p. 2514.

OTTO BRUNFELS
German, 1489–1534

140 *Herbarum vivae eicones ad naturae imitationem*

Strasbourg, Ioannem Schottū, 1531–32
Illustrated book
29.5 x 20.2 cm. (11⅝ x 8 in.)
Arthur and Charlotte Vershbow,
 Boston, Massachusetts
Venues: DC, NC

362

Otto Brunfels belonged to a generation of herbalists who laid the foundation for the modern study of botany. A Carthusian monk who converted to Protestantism, he began to study medicine in 1524 and simultaneously developed an interest in the medicinal properties of plants. *Herbarum vivae eicones ad naturae imitationem*, Brunfels's first botanical publication, broke with tradition as it was illustrated solely with images made from direct observation. The large woodcuts designed by Hans Weiditz, a pupil of Dürer, fill the entire page and permit a clear view of the distinguishing characteristics of the foliage, blossoms, and buds of the plant. Particularly interesting is the frequent inclusion of details specific to the actual specimen chosen for illustration, such as foliage damaged by insects or bent stems. While the suppression of such details in favor of an illustration composed of more ideal and representative parts would become standard, this method of direct observation was a critical advance in the history of botanical illustration (Nissen, *Die botanische Buchillustration*, pp. 4, 40).

The text of the *Herbarum* was less innovative than its illustrations, but it is not without merit. Working primarily from classical sources, Brunfels compiled information on the therapeutic value of 258 species and varieties of plants, many of which grew around Strasbourg. It was a useful reference for doctors and apothecaries, because Brunfels correlated the Greek and Latin plant names with their names in the German vernacular. He based his text primarily on the works of Dioscorides, Theophrastus, and Pliny, especially as translated by and commented upon by Italian botanists of the late fifteenth and early sixteenth centuries. Even though he recounts many of the legends about the curative powers and properties of plants, his text is noticeably free of superstitious beliefs.

Brunfels did not restrict himself entirely to earlier sources. He offered fresh observations of his own and, in addition, he introduced 47 new species of plants. Each chapter was devoted to one plant and its curative properties. For instance, one chapter pertains to the herb satyrion (or satyrium). Because its bulbous roots were seen to resemble male or female genitalia, it was often regarded as a sexual stimulant or a cure for impotency. The illustration of the plant, however, is remarkably objective and makes no references whatsoever to its presumed similarity to human anatomy. Indeed, all of the illustrations in the *Herbarum* are characterized by this straightforward approach.

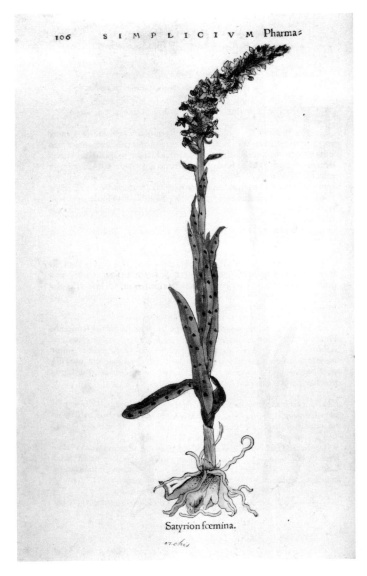

140 Satyrion. Woodcut.

BIBLIOGRAPHY

Arber, Agnes. "The Draughtsman of the 'Herbarum vivae eicones'." *The Journal of Botany, British and Foreign* 59 (May 1921): 131–32.

Arber, Agnes. *Herbals, Their Origin and Evolution: A Chapter in the History of Botany, 1470–1670.* 2nd ed. Cambridge: Cambridge University Press, 1938.

Blunt, Wilfrid, and Sandra Raphael. *The Illustrated Herbal.* New York: Metropolitan Museum of Art, 1979.

Catalogue of Botanical Books in the Collection of Rachel McMasters Miller Hunt. Compiled by Jane Quinby. Pittsburgh: The Hunt Botanical Library, 1958.

Church, A. H. "Brunfels and Fuchs." *The Journal of Botany, British and Foreign* 57 (1919): 233–44.

Lawrence, George H. M. "Herbals, Their History and Significance." *History of Botany*. Los Angeles: The Clark Memorial Library, and Pittsburgh: The Hunt Botanical Library, 1965.

Nissen, Claus. *Die botanische Buchillustration*. 2 vols. Stuttgart: Hiersemann, 1951–66. Esp. vol. 1, pp. 4, 39–44.

Nissen, Claus. *Herbals of Five Centuries: A Contribution to Medical History and Bibliography*. Trans. Werner Bodenheimer and Albert Rosenthal. Zurich: L'Art Ancien S. A., 1958.

Sprague, Thomas Archibald. "The Herbal of Otto Brunfels." *The Journal of the Linnean Society of London* 48 (December 1928): 79–124.

Stannard, Jerry. "Otto Brunfels." In *Dictionary of Scientific Biography*. Ed. Charles Gillispie. Vol. 2. New York: Charles Scribner's Sons, 1970. Esp. pp. 535–38.

ume and for each, Fuchs offers an account of its appearance, native habitat, and wondrous characteristics or medicinal properties. The author discusses several New World specimens such as Indian corn and pumpkin and, no less significant, draws attention to many European specimens that previously had been ignored in the botanical literature. The Eurasian plant foxglove, for example, is introduced as an important new source for medicine (the drug digitalis). Pictured here is Fuchs's illustration of *cannabis sativa*, an herb that was imported from temperate Asia. The seeds of *cannabis* were sometimes thought to cause epilepsy, but the plant was (and still is) best known as a source for the narcotic hashish.

LEONHART FUCHS
German, 1501–66

141 *De historia stirpium commentarii insignes, . . . adjectis earundem vivus plusquam quingentis imaginbus*

Basel, 1542
Illustrated book
Each approx. 37.2 x 25.1 x 6.9 cm.
 (14⅝ x 9⅞ x 2⅝ in.)

Copy A: Dartmouth College Library
Hanover, New Hampshire
Acc. no. QK/41/F7/1542
Venues: DC, NC

Copy B: Library, Academy of Natural Sciences of Philadelphia, Pennsylvania
Acc. no. QK 41/F91/1542/F
Venues: HO, HI

Leonhart Fuchs, for whom the colorful tropical plant fuchsia is named, was one of the great pioneers in the field of botany. A professor of medicine at the University of Tübingen, he was particularly interested in producing a comprehensive account of plants useful as drugs and curatives. His ambition was realized in this famous herbal, often regarded as one of the most beautiful botanical books ever published. Like Brunfels, Fuchs broke with tradition by illustrating his text with images of plants drawn directly from life. The splendid and highly accurate woodcut illustrations, as he acknowledges, were the work of his three collaborators—Albrecht Meyer, Heinrich Füllmaurer, and Rudolf Speckle.

Over five hundred plants are described in this vol-

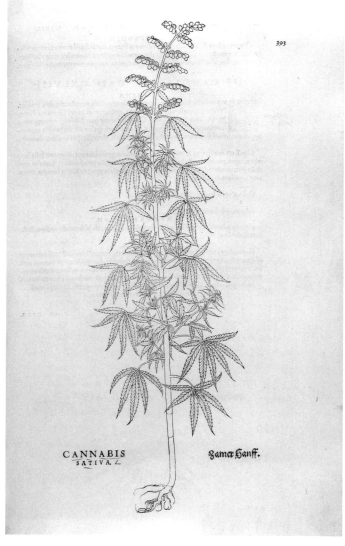

141A Cannabis. Woodcut.

BIBLIOGRAPHY

Arber, Agnes. *Herbals, Their Origin and Evolution: A Chapter in the History of Botany, 1470–1670*. 2nd ed. Cambridge: Cambridge University Press, 1938.

Church, A. H. "Brunfels and Fuchs." *The Journal of Botany, British and Foreign* 57 (1919): 233–44.

Nissen, Claus. *Die botanische Buchillustration*. 2 vols. Stuttgart: Hiersemann, 1951–66. Esp. vol. 1, pp. 4, 44–48.

Nissen, Claus. *Herbals of Five Centuries: A Contribution to Medical History and Bibliography*. Trans. Werner Bodenheimer and Albert Rosenthal. Zurich: L'Art Ancien S. A., 1958.

Sprague, Thomas A., and Ernest Nelmes. "The Herbal of Leonhardt Fuchs." *The Journal of the Linnean Society of London* 48 (October 1931): 545–642.

GIOVANNI BATTISTA RAMUSIO
Italian, 1485–1557

142 *Delle navigationi et viaggi*

Volume 3
Venice, Giunti, 1565
Illustrated book
32.5 x 22 x 7 cm. (12½ x 9 x 2¾ in.)
Chapin Library of Rare Books, Williams College,
Williamstown, Massachusetts

The Venetian Giovanni Battista Ramusio was responsible for disseminating the earliest firsthand accounts of the Americas. Beginning in 1550 Ramusio published collections of travel literature that include letters from Christopher Columbus's expedition to the Bahamas and Cuba in 1492 and Amerigo Vespucci's account of South America. His third collection, first published in 1556, contains accounts of the important voyages to North America of John Cabot (who reached Newfoundland in 1497), Giovanni di Verrazano (who sailed up the eastern coastline of America from Carolina to Maine in 1525), and Jacques Cartier (who reached the lower St. Lawrence River in 1534).

This historically important work is illustrated with woodcuts after notes and sketches made during many expeditions to the New World. It contains numerous topographical maps, plans of cities, as well as images of hammocks, native animals, and plants. Several varieties of cactus are represented, including the prickly-pear and the huge torch thistle.

As Hugh Honour observes, until Columbus brought back a sample of the prickly-pear, "Europeans had previously seen no form of cactus—an exclusively American family of plants and one which epitomized for them the strangeness of the New World" (pp. 45–46). The first illustration of a cactus was published by Oviedo y Valdez in 1554. Ramusio's publication, and those of many later authors, testifies to the plant's great impact on the European imagination. Cactus became identified with the New World; indeed, it rarely was absent from allegorical representations of America.

142 Prickly-pear cactus. Woodcut.

BIBLIOGRAPHY

Honour, Hugh. *The European Vision of America*. Cleveland: Cleveland Museum of Art, 1975.

Honour, Hugh. *The New Golden Land: European Images from the Discoveries to the Present Time*. London: Penguin Books, 1975.

Parks, George. B. "The Contents and Sources of Ramusio's *Navigationi*." *Bulletin of the New York Public Library* 52 (June 1955): 279–313.

NICOLAS MONARDES
Spanish, 1493–1588

143 *Joyfull Newes out of the Newe Founde Worlde*

London, W. Norton, 1577
Illustrated book
18.1 X 14.1 X 1.6 cm. (7⅛ x 5½ x ⅝ in.)
Beinecke Rare Book and Manuscript Library, Yale
 University, New Haven, Connecticut
Acc. no. Taylor 144
Venues: DC, NC

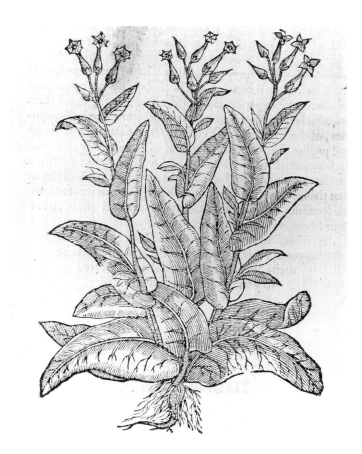

143 Tobacco plant. Woodcut.

Nicolás Monardes, a Spanish physician, was known primarily for his work on the flora and fauna of the New World. First published in two parts in Seville in 1569 and 1571, *Primera y segunda y tercera partes de la historia medicinal de los cosas que se traen de nuestras Indias Occidentales que siruen en Medicina* became an important source of information on the New World as it was rapidly disseminated throughout the conti-

nent in English, Latin, and Italian translations (Honour, no. 28).

In the preface to this "earliest American herbal," Monardes enthusiastically describes how the Spanish had found things not seen in any other parts of the world and how every day one hundred ships returned from the New World laden with incredible riches. Gold, silver, emeralds, and turquoises were brought to Spain in abundance, he reports, as were "Popingaies, Greffons, Apes . . . Sugars, Copper, Brasill [wood], the woode Ebano" and so on. But of special interest to him were the botanical specimens and their products—trees, plants, herbs, roots, juices, gums, fruits, and liquors—that had medicinal value. The virtues found in them, he says, have "verie great effects" by which the "Corporal healthe is more Excellent."

Monardes describes the various plants, herbs, and gums that had been brought from the Americas, in each case noting their usefulness in the treatment of infirmities and illnesses. He is the first to offer both an illustration and a written account of tobacco, a plant he considers a marvel since it could cure a wide range of ills from "paynes of the head . . . [or] any grief of the body" to "evil breath [and] venomous wounds." In addition to describing the virtues and marvels of tobacco as a "wound-herb," the author tells how American Indian priests smoked it in order to settle any matter of importance.

Sassafras also claims Monardes's attention. As instructed by the Indians, the Spaniards learned how to cure "themselves [of ague] with the water of this tree and it did in them great effects, that it is almost incredible." Monardes himself for a long time chewed pieces of sassafras together with lemon rind in order to preserve his health. He notes that its effects saved him from the fire in which physicians must enter, and goes on to state: "Blessed be our Lorde God that delivered us from so great evill and gave us this moste excellente Tree called Sassafrass."

BIBLIOGRAPHY

Arber, Agnes. *Herbals, Their Origin and Evolution: A Chapter in the History of Botany 1470–1670*. 2nd ed. Cambridge: Cambridge University Press, 1938.
Honour, Hugh. *The European Vision of America*. Cleveland: Cleveland Museum of Art, 1975. Esp. no. 28.
Rohde, Eleanour Sinclair. *The Old English Herbals*. London: Longmans, Green, 1922. Esp. pp. 120–33.

CHARLES L'ECLUSE
Flemish, 1526–1609

144 *Aliquot notae in garciae aromatum historiam: eiusdem descriptiones nonnullarum stirpium, & aliarum exoticarum rerum*

Antwerp, Christophori Plantini, 1582
Illustrated book
16.3 x 11 x .07 cm. (6½ x 4⅜ x ¼ in.)
Dartmouth College Library, Hanover,
 New Hampshire
Gift of Perc S. Brown
Acc. no. QK/41/L3

144 Banyan tree. Woodcut.

The Flemish botanist Charles L'Ecluse contributed significantly to the scientific advancement of botanical research and to the high quality of printed herbals in the sixteenth century. His illustrious career began with studies at various universities, culminating in Montpellier, where he worked with a gifted teacher, the botanist and physician Guillaume Rondelet. After leaving Montpellier, L'Ecluse traveled throughout Europe and made several trips to England. During this period he translated the herbal of his friend and compatriot Rembert Dodoens into French (cat. no. 145) and translated the works of Nicolás Monardes (cat. no. 143), Christoval Acosta, and Garcia de Orta into Latin.

This book by L'Ecluse, of which very few copies remain, reflects his passionate interest in exotic plants. Printed in one edition only, by the famous publishing firm of Plantin, it is the earliest book to mention Sir Francis Drake's circumnavigation of the globe. Drake returned from his voyage in September 1580 and the following year L'Ecluse met him in England. The descriptions of exotic plants in this volume depend largely on the information L'Ecluse gained from Drake and on his firsthand observation of botanical specimens that the famous navigator had brought to England with him. Cacao beans and various nuts and seeds from the New World are illustrated here, as are coconut trees, a Mexican jasmine, and one of the most remarkable of trees, the banyan (called by L'Ecluse *ficus indica*, or Indian fig tree). Varieties of banyan are found in tropical regions of America, as well as in India. As L'Ecluse's illustration shows, they are notable for their numerous aerial roots, which ultimately reach the ground and become trunk-like.

BIBLIOGRAPHY

Anderson, Frank. *An Illustrated History of the Herbals.* New York: Columbia University Press, 1977.

Arber, Agnes. *Herbals, Their Origin and Evolution: A Chapter in the History of Botany 1470–1670.* 2nd ed. Cambridge: Cambridge University Press, 1938. Esp. pp. 82–91, 155–57, 226–33, 277–82.

Catalogue of Botanical Books in the Collection of Rachel McMasters Miller Hunt. Compiled by Jane Quinby. Pittsburgh: The Hunt Botanical Library, 1958.

"Charles de l'Ecluse (Carolus Clusius), 1526–1609." *Janus* 31 (1927):39–151.

Festschrift anlässlich der 400 jährigen Wiederkehr der wissenschaftlichen Tätigkeit von Carolus Clusius (Charles de l'Éscluse) im pannonischen Raum. Sonderheft V. Eisenstadt: Burgenländischen Landesarchiv, 1973.

Hunger, Friedrich Wilhelm Tobias. *Charles de l'Escluse (Carolus Clusius) Nederlandsch kruidkundige, 1526–1609.* 'S-Gravenhage: Martinus Nijhoff, 1927–43. Esp. p. 145.

Lawrence, George H. M. "Herbals, Their History and Significance." *History of Botany*. Los Angeles: The Clark Memorial Library, and Pittsburgh: The Hunt Botanical Library, 1965. Esp. p. 16.

Michaud, J.F., and L.G. Michaud. *Biographie universelle ancienne et moderne*. 2nd edition. 45 vols. Paris: Madame C. Desplaces, 1854–65. Esp. vol. 23, p. 533.

Theunisz, Johan. *Carolus Clusius: het merkwaardige leven van een pionier der wetenschap*. Amsterdam: Kampen, 1939.

REMBERT DODOENS
Flemish, 1517–85

145 *Florum, et coronariarum,
odoratarumque nonnullarum
herbarum historia*

Antwerp, Christophori Plantini, 1569
Illustrated book

16.5 x 11.5 x 2 cm. (6½ x 4⅜ x ¾ in.)
Dartmouth College Library, Hanover,
New Hampshire
Acc. no. Presses P694dof

Rembert Dodoens was the first Flemish botanist to attain an international reputation. His first herbal, *Cruÿdeboeck* (1554), was quickly translated into French by Charles L'Ecluse (1557) and from the French into English by Henry Lyte (1578). He began his studies at Louvain and visited medical schools throughout France, Italy, and Germany. As is apparent from his writing, his early interest in botany grew from his training as a physician. In 1574 he was invited to Vienna to become court physician to Emperor Maximilian II and remained to serve Maximilian's successor, Rudolf II. In 1582 he became a professor of medicine at the University of Leiden. After 1563 Do-

145 Anemone and sunflower. Woodcut.

doens's botanical works were published by Christophe Plantin in Antwerp (Arber, p. 82).

Dodoens made significant contributions to the history of botany. He obtained plant specimens brought back from the New World by Sir Francis Drake, whom he met during a visit to England, and presented them in his publications. He also supplemented his knowledge by reading accounts of the New World, such as that by Thevet (cat. no. 113). Most interesting is the system of classification he used to incorporate these new specimens into an old structure. At the time there was little consensus about which plant features constituted a basis for comparison, so it is surprising that Dodoens's method of classification closely approaches our own. He was able to perceive natural affinities among large groups of plants. In many cases, he assembled genera which we now cluster within the same family. Part of his method involved classifying plants according to the shape of their blossoms. For example in *Florum, et coronariarum*, Dodoens implicitly compares the anemone and the New World sunflower (their petals are similarly shaped) by placing the illustrations on facing pages. The illustrations, such as that of the peonies, often fill the entire page, and in each of these the roots, leaves, and blossoms of the plant are carefully delineated.

BIBLIOGRAPHY

Anderson, Frank. *An Illustrated History of the Herbals*. New York: Columbia University Press, 1977. Esp. pp. 82–91, 155–57, 226–33.

Arber, Agnes. *Herbals, Their Origin and Evolution: A Chapter in the History of Botany 1470–1670*. 2nd ed. Cambridge: Cambridge University Press, 1938.

Catalogue of Botanical Books in the Collection of Rachel McMasters Miller Hunt. Compiled by Jane Quinby. Pittsburgh: The Hunt Botanical Library, 1958.

Hunger, Friedrich Wilhelm Tobias. "Dodoens e comme botaniste." *Janus* 22 (1917): 153–62.

Lawrence, George H. M. "Herbals, Their History and Significance." *History of Botany*. Los Angeles: The Clark Memorial Library, and Pittsburgh: The Hunt Botanical Library, 1965. Esp. p. 16.

ABRAHAM MUNTING
Dutch, 1626–83

146 *Naauwkeurige Beschryving der Aardgewassen*

Leiden and Utrecht, Pieter van der Aa and Francois Halma, 1696

Illustrated book
Each approx. 46 x 30 x 4.5 cm.
 (18⅛ x 11⅞ x 1¾ in.)

Copy A: Dumbarton Oaks, Trustees for Harvard University, Washington, D.C.
 Acc. no. K–3–3
 Venues: DC, NC

Copy B: The New York Public Library, New York Miriam and Ira D. Wallach, Division of Art, Prints and Photographs
 Acc. no. MEM ++ G597 mn 1696
 Venues: HO, HI

146A Pineapple. Engraving.

Abraham Munting and his father, Henricus, introduced to the Netherlands an extraordinary range of exotic plants from the American tropics and subtropics. Their interest in cultivating exotic as well as native botanical specimens was a logical extension of their education — both had degrees in medicine — and of their work at the University at Groningen as professors of botany. Henricus became interested in botany as a young apothecary traveling in Europe. Between 1605 and 1612 he met many prominent botanists in England, France, and Rome, including Mathias de l'Obel (1538–1616), who became important sources for the exceptionally fine collection of exotic plants the Muntings established (Andreas, pp. 40–41).

The Muntings' published works have a special place in the botanical literature of the Netherlands as extensive handbooks of actual plants grown in the north during the seventeenth century. Unlike their compatriots Rembert Dodoens and Charles L'Ecluse (cat. nos. 144, 145), they were more interested in describing their specimens than in reclassifying them. They were also interested in the medicinal properties of plants and primarily derived their information from older authors. Abraham Munting combines both botanical and medicinal knowlege in his *Naauw-keurige Beschryving der Aardgewassen*, later published under the title *Phytographia curiosa* (Andreas, pp. 68–69, 74–77). While his approach may appear regressive, this work was an ambitious undertaking that contained over 250 superb engravings.

The majestic treatment of the pineapple plant illustrated here is representative of the quality and artistry of the work as a whole. The pineapple was the most curious of all the plants brought from the New World, and writers found its taste extremely hard to describe (Honour, p. 46). John Evelyn, who had a piece sent from Barbados, remarked: "It falls short of those ravishing varieties of deliciousness which travelers had described," "but possibly it might or certainly was, much impaired in coming so far; it has yet a grateful acidity."

BIBLIOGRAPHY

Andreas, Charlotte Henriëtta. In *En om een botanische tuin: Hortus Groninganus 1626–1966*. Groningen: Erven B. van der Kamp, 1976. Esp. pp. 40–41, 67–69, 74–79, 198–99.

Honour, Hugh. *The New Golden Land: European Images from the Discoveries to the Present Time*. London: Penguin Books, 1975.

Kroon, J. E. In *Nieuw netherlandsch biografisch woordenboek*. 10 vols. Leiden: A. W. Sijthoff, 1911–37. [Reprint: Amsterdam: N. Israel, 1974.] Esp. vol. 6, col. 1043–45.

Nissen, Claus. *Die botanische Buchillustration*. 2 vols. Stuttgart: Hiersemann, 1951–66. Esp. vol. 2, nos. 1428–30.

JOHN GERARD
English, 1545–1612

147 *The Herball; or, General Historie of Plantes*

London, A. Islip, J. Norton, and R. Whitakers, 1636
Illustrated book
33.7 x 23.5 x 10.2 cm. (13¼ x 9¼ x 4 in.)
Dartmouth College Library, Hanover, New Hampshire
Acc. no. QK/41/G3/1636

John Gerard, a notable English horticulturalist, wrote one of the most popular herbals of his time. First published in 1597, *The Herball* remains in print today. In its encyclopedic listing of flora, Gerard includes fresh observations of extant plants alongside reports of those that exist only within the realm of fantasy. In the dedicatory epistle to Sir William Cecil Knight, Gerard presents his herbal as a collection of rare plants that reflect the perfection of God's creation. He writes:

For if delight may provoke mens labor, what greater delight is there than to behold the earth apparelled with plants, as with a robe of embroidered worke, set with Orient pearles, and garnished with great diversitie of rare and costly jewels? If this varietie and perfection of colours may affect the eie, it is such in herbes and floures, that no *Apelles*, no *Zeuxis* ever could by any art expresse the like. . . . But these delights are in the outward senses: the principal delight is in the mind, singularly enrich with the knowledge of these visible things, setting forth to us the invisible wisedome and admirable workmanship of almighty God.

Illustrated here are several varieties of "turky wheat" or corn, one of the earliest vegetables introduced into Europe from the New World. When explorers reached America they believed they were off the coast of Asia so corn was believed to have originated in Asia and was given an Eastern name. Although Rembert Dodoens (see cat. no. 145) correctly identified the plant as a species from America in 1583, Gerard gave it a double origin (1597). Only in the posthumous 1633 edition was turky wheat identified as originating solely in America.

BIBLIOGRAPHY

Arber, Agnes. *Herbals, Their Origin and Evolution: A Chap-*

147 Varieties of "Turky wheat." Woodcut.

ter in the History of Botany, 1470–1670. 2nd ed. Cambridge: Cambridge University Press, 1938.

Finan, John J. "Maize in the Great Herbals." Annals of the Missouri Botanical Garden 35 (1948): 149–91.

Gerard, John. The Herball; or, General Historie of Plantes. The complete 1633 edition as revised and enlarged by Thomas Johnson. New York: Dover Publications, Inc., 1975.

Honour, Hugh. The European Vision of America. Cleveland: Cleveland Museum of Art, 1975. Esp. no. 36.

Lawrence, George H. M. "Herbals, Their History and Significance." In History of Botany. Los Angeles: The Clark Memorial Library, and Pittsburgh: The Hunt Botanical Library, 1965.

CRISPIJN DE PASSE, II
Dutch, ca. 1593/4–ca. 1670

148 *Hortus floridus in quo rariorum et minus vulgarium florum icones ad vivam veramque formam*

Arnhem, Ioannem Ianssonium, 1614
Illustrated book
18.8 x 28 cm. (7⅜ x 11 in.)
Arthur and Charlotte Vershbow, Boston, Massachusetts

The engraver Crispijn de Passe produced his first independent work, *Hortus floridus*, when he settled briefly in Utrecht between 1612 and 1617. Both the organization and the selection of plants clearly indicate that this book had a different purpose from early sixteenth-century botanical works. The book is divided into four sections, each of which corresponds to a season and describes the flowers which bloom at that time. The garden presented here is not a *hortus medicus*, but a *locus amoenus*, a garden of "the most rarest and excellentest flowers, that the world affordeth: ministering both pleasure and delight to the spectator, and most especially to the well affected practitioner."

Appearing with multilingual inscriptions, *Hortus floridus* was intended to reach a wide audience. In fact, a 1614 Dutch edition contained the equivalent of advertisement sheets in the back, illustrating, for example, an apparatus to force tulip bulbs. Even instructions for growing these ornamentals were included in *Hortus floridus*. The book contributed significantly to the commercial and artistic interest in flowering bulbs, especially tulips (Nissen, pp. 73–75). Indeed, as Schama observes (p. 153), the reputation of the tulip was promoted especially by *Hortus floridus*. By the 1620s, tulips became "the unrivalled flower of fashion," a fashion that developed into the famous "tulip mania" of the 1630s.

Crispijn de Passe himself was responsible for most of the beautifully designed and skillfully executed etchings in the book (Nissen, p. 73). Set against a landscape with a low horizon, the flowers push out against the borders of the print. Such a monumental and dynamic treatment of the subject enhances the beauty of the flowers and increases their capacity to inspire awe. The most spectacular image in *Hortus floridus* may be the etching of a sunflower, the *chrysanthemum peruvianum maius*. Native to the Americas, this gigantic plant is now commonplace. But in 1614, as de Passe stated, "it was among "the rarest and excellentest flowers."

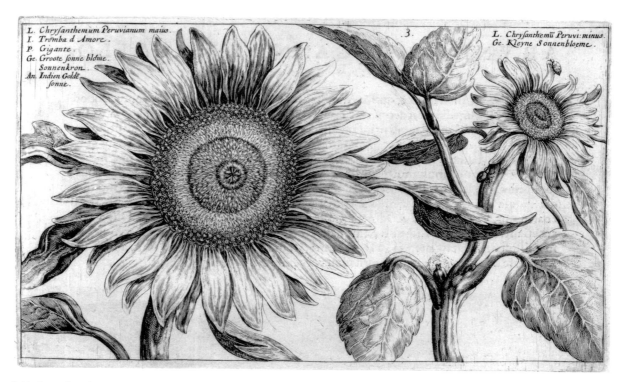

148 Peruvian chrysanthemums or sunflowers. Etching.

BIBLIOGRAPHY

Arber, Agnes. *Herbals, Their Origin and Evolution: A Chapter in the History of Botany, 1470–1670*. 2nd ed. Cambridge: Cambridge University Press, 1938.

Nissen, Claus. *Die botanische Buchillustration*. 2 vols. Stuttgart: Hiersemann, 1951–66. Esp. vol. 1, pp. 73–75.

Schama, Simon. *The Embarrassment of Riches: An Interpretation of Dutch Culture in the Golden Age*. New York: Alfred A. Knopf, 1987.

Sotheby's, London. *A Magnificent Collection of Botanical Books: Being the Finest Color-plate Books from the Celebrated Library Formed by Robert de Belder*. Uxbridge, Middlesex, Great Britain: Hillingdon Press, 1987. Esp. pp. 291–94, nos. 270–72.

JOHANN NEANDER
German, ca. 1596–ca. 1630

149 *Tabacologia: hoc est tabaci, seu nicotianae descriptio*

Leiden, Isaaci Elzeviri, 1626
Illustrated book
23.4 x 18.4 x 3.2 cm. (9¼ x 7¼ x 1¼ in.)
Dartmouth College Library, Hanover,
New Hampshire

Gift of Louis J. Heydt, Class of 1926
Acc. no. Presses E52n

In 1622 Johann Neander published his treatise on tobacco, which became one of the three leading references on the medicinal uses of tobacco throughout the seventeenth century. Neander was a philosopher and celebrated physician from Bremen whose sole interest in tobacco was "its preparation and use of in all the ailments of the human body." His work built upon that of Jean Liébault, who wrote the first book devoted to the medicinal value of tobacco (1570), and Nicolás Monardes, who devoted a chapter of his *Joyfull Newes out of the Newe Founde Worlde* (cat. no. 143) to the medicinal virtues of tobacco. Knowledge of tobacco was rapidly disseminated throughout Europe, and the plant soon became known as the "holy herb." Curiously enough, the explorers who learned about tobacco from the indigenous peoples of America, Venezuela, Cuba, Haiti, and Brazil never saw them use tobacco as a remedy for any illness (with the exception of asthma). Instead, they were fascinated by the novelty of smoking tobacco.

In his *Tabacologia* Neander expanded the number of ailments which tobacco could cure and also pro-

149 Tobacco plant. Woodcut.

GIOVANNA GARZONI
Italian, 1600–70

150 *Manuscript Herbal*

17th century
Illustrated manuscript
48 x 38 cm. (18⅞ x 15 in.)
Dumbarton Oaks, Trustees for Harvard
 University, Washington, D.C.
Acc. no. B–2–1
Venues: DC, NC

The miniaturist Giovanna Garzoni was a celebrated painter of minatures who was active in Florence, Naples, and Rome. Among her illustrious patrons were the Medici, who engaged her talent as a portrait painter at the Florentine court, and the Duke of Alcalá, Spanish viceroy of Naples (1629–31). During her residence in Florence she very likely worked with Jacopo Ligozzi, one of the most famous scientific

vided detailed recipes for his readers. He recognizes and accurately depicts three kinds of tobacco: *N. Tabacum*, in two varieties (one of which is illustrated here) and *N. rustica*. Neander offers a history of tobacco and pays close attention to how these types were identified by previous authors. For example, early herbalists like Dodoens, Mattioli, Pena, and de l'Obel associated tobacco with the genus *Hyoscyamus*, which includes 75 genera and almost 1800 species (Brooks, *Tobacco*, vol. 1, p. 9, n. 5). As such, the tobacco plant was loosely associated with some poisonous plants, like those in the nightshade family, as well as with some edible vegetables, like the potato, tomato, and eggplant.

BIBLIOGRAPHY

Brooks, Jerome E. *Tobacco: Its History Illustrated by the Books, Manuscripts and Engravings in the Library of George Arents, Jr.*. Vols. 1, 2. New York: The Rosenbach Company, 1937–38. Esp. no. 148, p. 85–91.
Brooks, Jerome E. "The Library Relating to Tobacco Collected by George Arents." *Bulletin of the New York Public Library* 48 (January 1944): 3–15. Esp. pp. 3–15.

150 Mandrake. Watercolor and ink.

illustrators of the time. When she moved to Rome around 1651, Garzoni became a member of the painter's academy, the Accademia di San Luca. The exceptional quality of her botanical work is known primarily through an album of twenty-two pen drawings of insects and flowers, which she bequeathed along with her estate to the Roman academy. Less known, but perhaps more remarkable than the album of pen drawings, is a large folio containing fifty full-page watercolors of flowers, once owned by the Strozzi family in Florence and now in the library at Dumbarton Oaks in Washington. The date of the manuscript is unknown; it has been suggested, however, that it was acquired by Lorenzo Francesco Strozzi around 1650.*

One of the flowers that appears in this manuscript is the mandrake (folio 11). Carefully observed and exquisitely rendered, it stands in complete contrast to earlier representations (cat. nos. 136, 137), where the mandrake is presented in an anthropomorphic manner. At the same time that Giovanna Garzoni is faithful to the natural characteristics of the plant, she creates a delicate, yet dramatic composition: the curve of the root sweeps upward, culminating in a radial spray of foliage. Garzoni thus effectively conveys a sense of the plant's organic life.

* This information was kindly provided by Dumbarton Oaks.

BIBLIOGRAPHY

Mongan, Agnes. "A Fête of Flowers: Women Artists' Contribution to Botanical Illustration." *Apollo* 119 (April 1984): 34–37.

"Garzoni, Giovanna." *Allgemeines Lexikon der Bildenden Künstler*. Vol. 13. Ed. Ulrich Thieme and Felix Becker. Leipzig: E. A. Seemann, 1920.

Harris, Ann Sutherland, and Linda Nochlin. *Women Artists: 1550–1950*. Los Angeles: Los Angeles County Museum of Art, 1976. Esp. pp. 135–36.

GIOVANNI BATTISTA DELLA PORTA
Italian, 1535–1615

151 *Phytognomonica*

Naples, Horatium Saluianum, 1588
Illustrated book
30 x 21 x 2.5 cm. (11¾ x 8¼ x 1 in.)
Chapin Library of Rare Books, Williams College, Williamstown, Massachusetts

Giovanni Battista della Porta, born in Naples around

1535, had a keen interest in both nature and science. With his brother Gian Vincenzo he collected materials for study (possibly for a type of curiosity cabinet) which he made available to other scientists. He established a forum for scientific discussion, later called the Accademia Secretorum Naturae, in which membership was contingent upon one's contribution to science, medicine, or philosophy.

Della Porta did indeed make valuable contributions in mathematics (*Elementa curvilinea*) and physics (*De refractione optices*), but his *Phytognomonica* (Plant Indicators) represents not a progressive step toward the scientific study of botany, but rather a backward glance toward medieval plant lore. Della Porta was a strong advocate of the theory called the Doctrine of Signatures, which had been notably argued by Theophrastus Bombast von Hohenheim (1493–1541), called Paracelsus. The theory suggests that the virtues of a plant (its healing powers) are related to—in fact can be deduced from—its external properties, such as its shape, texture, and structure. The *Phytognomonica* is a thorough application of this theory. Curiously enough, in this age when the scientific foundations of many fields were being laid, della Porta was not the last advocate of the Doctrine of Signatures. In 1657 William Cole held firm to the theory. For example, he states that "wall-nuts" have the "perfect signature of the head," so they will comfort "the brain and head mightily" (Cole, *Adam in Eden*, 1657; see Arber, p. 252). It was still in evidence in the work of Robert Turner (1664), and traces are to be found in Thomas Green's *Universal Herbal* (1816).

One of the plates from the *Phytognomonia* demonstrates clearly how the Doctrine of Signatures works (see MacDougall's essay, *fig. 2*). Shown on the same page are medicinal herbs and flowers that seem to resemble the human eye. Such loose similarity is the basis for believing that these are the plants that can cure the afflictions of the eye. Within this system, the outward form of the plant can also indicate the animal or insect bites the plant is able to cure. For example, in another illustration, a vegetable root and a scorpion are shown together because the nodular appearance of the root indicates that it can cure the sting of the scorpion. Such a flexible association between plants and their medicinal value enabled della Porta to include a wide range of both animals and plants in his work.

BIBLIOGRAPHY

Anderson, Frank. *An Illustrated History of the Herbals*. New York: Columbia University Press, 1977.

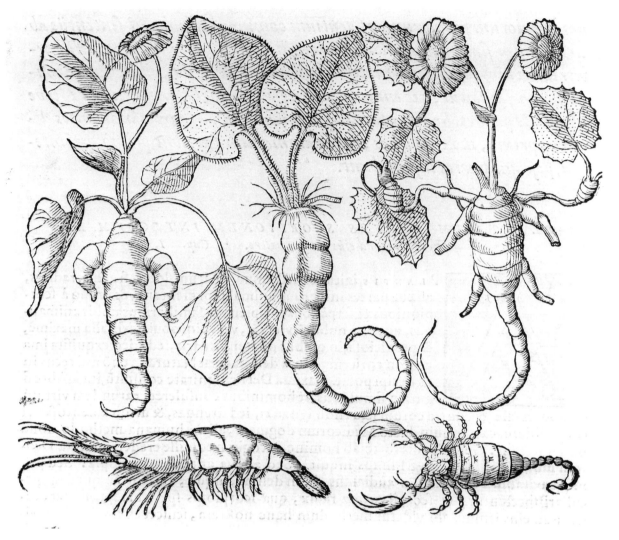

151 Nodular roots, a crustacean, and a scorpion. Woodcut.

Arber, Agnes. *Herbals, Their Origin and Evolution: A Chapter in the History of Botany, 1470–1670*. 2nd ed. Cambridge: Cambridge University Press, 1938.

Blunt, Wilfrid, and Sandra Raphael. *The Illustrated Herbal*. New York: Metropolitan Museum of Art, 1979. Esp. p. 141.

Schab, William H. *Three Centuries of Illustrated Books, 1460–1760*. New York: W. H. Schab, [1963?].

JOHN PARKINSON
English, 1567–1650

152 *Paradisi in sole paradisus terrestris. A Garden of All Sorts of Pleasant Flowers Which Our English Ayre Will Permitt to be Noursed Up*

London, Humfrey Lownes and Robert Young, 1629
32 x 22.2 x 4.3 cm. (12⅝ x 8¾ x 1⅝ in.)
Dartmouth College Library, Hanover, New Hampshire
Acc. no. Val. 635/P229p

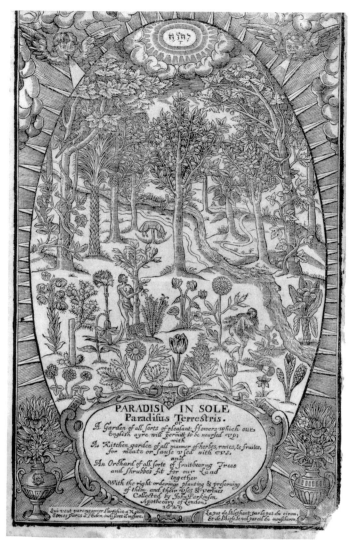

152 Title page showing the garden as a terrestrial paradise. Woodcut.

John Parkinson, apothecary to James I, wrote one of the most popular English garden books to appear in the seventeenth century. Still available in print, the book carries a Latin title which when translated into English is a clever pun on the author's name, "Park in Sun's Earthly Paradise." Over a thousand species of plants, mostly exotics that had been successfully cultivated in Great Britain, are illustrated in this work. Parkinson describes plants that were suitable for "a garden of pleasure and delight" and "set forth a garden of the chiefest for choyce [and the] fairest for show." Replete with practical instructions, including a discussion of plants cultivated for culinary use, *Paradisi in sole* offers an excellent view into the English garden of the early seventeenth century.

Illustrated here is the title page, designed and executed by Christopher Switzer. A great variety of plants, both real and imagined, are depicted in the terrestrial paradise described in the title. The plants include a Scythian lamb and a cactus, a species of plant discovered in the New World (see cat. no. 142). Their presence in this garden, along with the pineapple, tulip, and other recently introduced plants, implies that a garden that contained rare and exotic plants could more closely resemble the lost Garden of Eden. Thus in cultivating such a place on earth, one could literally create an earthly paradise, perhaps similar to the one from which Adam and Eve were banished.

BIBLIOGRAPHY

Anderson, Frank. *An Illustrated History of the Herbals.* New York: Columbia University Press, 1977.

Arber, Agnes. *Herbals, Their Origin and Evolution: A Chapter in the History of Botany, 1470–1670.* 2nd ed. Cambridge: Cambridge University Press, 1938.

Catalogue of Botanical Books in the Collection of Rachel McMasters Miller Hunt. Compiled by Jane Quinby. Pittsburgh: The Hunt Botanical Library, 1958.

Sotheby's, London. *A Magnificent Collection of Botanical Books: Being the Finest Color-plate Books from the Celebrated Library Formed by Robert de Belden.* Uxbridge, Middlesex, Great Britain: Hillingdon Press, 1987.

JOHN PARKINSON
English, 1567–1650

153 *Theatrum botanicum: The Theatre of Plants; or, An Herball of Large Extent*

London, Tho. Cotes, 1640
33.5 x 22 x 9.8 cm. (13¼ x 8⅝ x 3⅞ in.)
Dartmouth College Library,
 Hanover, New Hampshire
Acc. no. QK/41/P2/1640

John Parkinson published his second and most important botanical work, *Theatrum botanicum*, in 1640 at the age of seventy-three. Although his *Paradisi in sole* (1629; cat. no. 152) was more popular, this was the largest herbal printed in the English language. Parkinson intended it to be a complete account of medicinal herbs; it included nearly four thousand plants, almost a thousand more than Johnson's enlarged edition of John Gerard's *Herball* (1633; first edition, 1597). As was customary with herbals, Parkinson's images and text were at least partially borrowed from other

THE CATALOGUE

153 Brazil tree, Sorrowful tree, and Fountain tree. Woodcut.

sources, including sections of an unpublished manuscript by Mattias de l'Obel. Despite the use of borrowed material, however, most of the *Theatrum botanicum* is original. Drawing from his experience as a horticulturist and apothecary, he classified plants according to their purpose, their habitat, or their medicinal value. Though his is a regressive system that fails to acknowledge the importance of establishing a system of classification based on natural affinities, Parkinson nonetheless produced one of the greatest repositories of herbal literature (Anderson, p. 228).

This monumental volume contains some twenty-seven hundred woodcut illustrations of plants from the known world. The title page shows personifications of Europe, Asia, Africa, and America surrounded by their native flora. Of special interest are the sunflower, hedgehog thistle, passionflower, and cactus, which are shown near the figure of America; American corn or *zea mays* appears next to the figure of Asia, no doubt because corn was thought to originate from that continent (Honour, no. 36). In the dedication to Charles I (who made Parkinson the Botanicus Regius Primarius in 1629) Parkinson states that the book contains "approved Remedyes" so that all (especially the king) "may live in health as well as wealth, peace and godliness."

As the text shows, Parkinson is also interested in the products of these plants. The Brazil tree is used by "Dyers" to make ink, the flowers of the Sorrowful tree can be distilled and used to soothe the eyes or to comfort the heart, and the Fountain tree makes water. Parkinson, however, is more progressive in the range of plants he includes. Flora from Brazil, the Canary Islands, and America are discussed. He even publishes, for the first time, flora newly discovered in

377

England, like the ladyslipper (*cypripedium calceolus L.*), the Welsh poppy (*meconopsis cambrica vig.*), and the strawberry tree (*arbutus unedo L.*).

BIBLIOGRAPHY

Anderson, Frank. *An Illustrated History of the Herbals*. New York: Columbia University Press, 1977.

Honour, Hugh. *The European Vision of America*. Cleveland: Cleveland Museum of Art, 1975.

Sotheby's, London. *A Magnificent Collection of Botanical Books: Being the Finest Color-plate Books from the Celebrated Library Formed by Robert de Belden*. Uxbridge, Middlesex, Great Britain: Hillingdon Press, 1987. Esp. no. 267.

HENDRIK VAN BALEN AND
JAN BRUEGHEL THE YOUNGER
Flemish, 1575–1632, and Flemish, 1601–78

154 *Madonna and Child in a Floral Garland*

ca. 1625
Oil on copper
41.8 x 32.4 cm. (16½ x 12¾ in.)
Private Collection

Madonna and Child in a Floral Garland was once part of the collection of the Polish prince Vladislaus Sigismundus. In a painting of 1626 by the Frenchman Etienne de la Hayre, it is shown among other rarities—paintings, statuettes, sketchbooks, and fine jewels—on a table in the prince's *Kunstkammer*. Pictures that showed the Virgin and Infant Christ surrounded by a garland of flowers enjoyed great popularity in the seventeenth century and commonly were found in the cabinets of private collectors. The earliest works of this type were executed by Jan Brueghel the Elder in the first decade of the 1600s. Jan the Younger continued this specialty and for the present picture may actually have executed a project the Polish prince had commissioned from the father. The painting also shows the hand of Hendrik van Balen, an artist who frequently collaborated with the Brueghels and who, as in this work, supplied the central figural elements of their compositions.

The subject of the painting is derived from a passage in the book of Revelation (12:1) that traditionally was interpreted as a description of the Virgin: "And there appeared a great wonder in heaven, a woman clothed with the sun, and the moon under her feet, and upon her head a crown of twelve stars." The splendor of this vision is enhanced in the painting by the golden aureole about the Virgin and by the honorific garland of flowers. The flowers are introduced to magnify the beauty of the Virgin and Child, but at the same time they are revealed to be the products of divine creation. God's light flows through the crown of stars held by infant angels and surrounds the central figures; it then fans outward in a multitude of delicate rays toward the enframing garland. Here insubstantial light and pastel hues are transformed into physical substance and a display of vivid colors.

Brueghel has represented an astonishing number of flowers in this garland. Altogether 130 different species are depicted, "including at least thirteen varieties of tulip, eleven of iris, and ten of anemones" (Welu, p. 12). The garland is, in a sense, a botanical collection, and because its individual forms are painted with a miniaturist's eye for fine detail, it invites the spectator's admiring and concentrated attention.

BIBLIOGRAPHY

Welu, James A. *The Collector's Cabinet: Flemish Paintings from New England Private Collections*. Worcester, Mass.: Worcester Art Museum, 1983.

154

DANIEL SEGHERS
Flemish, 1590–1661

155 *A Garland of Flowers on a Carved Stone Medallion*

ca. 1650
Oil on canvas
114.3 x 95.2 cm. (45 x 37½ in.)
Sarah Campbell Blaffer Foundation,
 Houston, Texas

155

This painting is the work of Daniel Seghers, a Flemish artist who studied under Jan Brueghel the Elder and who, at age twenty-four, entered the religious order of the Jesuits. He became one of Europe's most highly esteemed painters of flowers, earning the praise of emperors and kings, poets, and other artists, including Rubens. For the paintings he gave (never sold) to royalty or dignitaries, he often received extraordinary gifts in return. The future William II of England, for instance, expressed his appreciation for a picture of flowers by forwarding to Seghers "gold brush-holders" and "a solid gold instrument with which to mix his colors" (Hairs, p. 122).

According to Seghers's own account, he had made a total of 239 flower paintings, in addition to drawings after nature. He often represented vases of flowers in niches or on simple stone ledges, but the compositions he popularized, and for which he is best known, show clusters or garlands of flowers enclosing a stone medallion or cartouche. Seghers's floral arrangements are usually accompanied by a religious motif, and here flowers surround a *grisaille* image of the Virgin contemplating the Crown of Thorns. Virtually all the flowers reinforce the meaning of this central image. Roses, for example, are commonly associated with Mary (the "rose without thorns") and also symbolize martyrdom. Anemones traditionally signify sorrow and death, while the thistles, brambles, holly branches, and datura ("thorn-apple") refer to Christ's suffering. In the lower right corner Seghers has introduced a New World specimen, the passionflower, so called because of the resemblance of its parts to Christ's wounds and to the implements of his Passion. The showiest flowers in the painting, the peonies, most likely refer to the promise of new life through Christ, since their name derives from the Greek physician, Paeon, who cured the gods' wounds during the Trojan war. As Virgil (*Aeneid* 7, v. 769) also tells, the young Greek Hippolytus was brought back to life by Paeonian herbs. To enhance the theme of rebirth or resurrection, Seghers has included several butterflies–beautiful insects that emerge from the "dead"

cocoons of caterpillars and that are, therefore, symbolic of the redeemed soul.

BIBLIOGRAPHY

Hairs, Marie-Louise. *The Flemish Flower Painters in the XVIIth Century*. Trans. Eva Grzelak. Brussels: Lefebure and Gillet, 1985.
Wright, Christopher. *A Golden Age of Painting: Dutch, Flemish, German Paintings. Sixteenth-Seventeenth Centuries. From the Collection of the Sarah Campbell Blaffer Foundation*. Houston: The Sarah Campbell Blaffer Foundation, 1981.

JOHANN THEODOR DE BRY
Flemish, 1561–ca. 1623

156 *Florilegium renouatum et auctum*

Frankfurt-am-Main, Matthaeo Merian, 1641
Illustrated book
32.8 x 21.3 cm. (12⅞ x 8 7/16 in.)
Arthur and Charlotte Vershbow,
 Boston, Massachusetts
Venue: DC

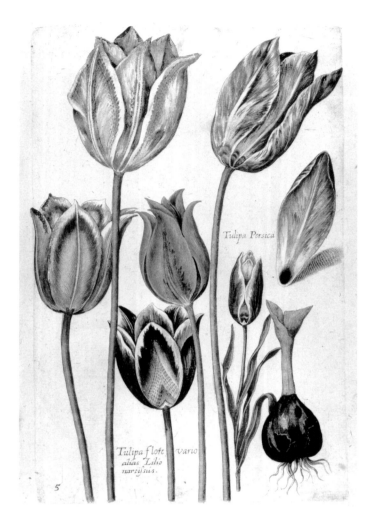

156 Tulips. Hand-colored engraving.

Johann Theodor de Bry belonged to the famous family of engravers and print publishers active in Frankfurt-am-Main. The de Bry firm, established by Johann's father, Theodor, and continued after Johann's death by his son-in-law Matthaeus Merian, published a series of important collections of travel literature (see cat. no. 128), botanical works, and city prospects. The *Florilegium renovatum et auctum*, published by Merian, is the third expanded edition of botanical prints published initially by Johann under the title *Florilegium novum* (1612–14). This publication and its subsequent editions demonstrate the rapid and persistent dissemination of visual material by publishers exchanging plates and imitating or reengraving prints already published. The *Florilegium novum* copied images from the recent publications of Pierre Vallet (*Le Jardin du roy*, 1608), Basilius Besler

(*Hortus Eystettensis*, 1612), and most importantly Crispijn de Passe (*Hortus floridus*, 1614; cat. no. 148), whose work was an influential artistic as well as commercial resource. The de Passe book promoted an appreciation for the beauty of tulips before the peak of "tulip mania" in Holland in 1636–37 (Schama, pp. 350, 353). In reissuing many of these images, the de Bry firm widened the influence of de Passe's work. There were various editions of the *Florilegium renovatum et auctum*. The third edition (shown here) included copies of the majestic images in *De florum culturae* by Giovanni Ferrari (1633; cat. no. 160). Comparisons among known copies of the *Florilegium renovatum* reveal substantial variations in the plates included in each copy.

One of the illustrations from this splendid hand-colored edition shows striped tulips. Tulip bulbs were first imported to Europe from Turkey in the sixteenth century. Originally it was a very exotic plant, extremely costly and treasured for its rarity. Eventually, however, through hybridization and domestic cultivation the more common varieties of yellow and red tulips, such as the Gouda, became more readily available to the population, while the rarer varieties remained prized commodities (Schama, p. 351). At the height of the tulip mania the rarer bulbs fetched extraordinary prices. One man, presumably a farmer, paid 2,500 florins for "a single Viceroy [a purple and white striped tulip] in the form of two *last* of wheat and four of rye, four fat oxen, eight pigs, a dozen sheep, two oxheads of wine, four tons of butter, a thousand pounds of cheese, a bed, some clothing and a silver beaker" (Schama, p. 358).

BIBLIOGRAPHY

Hunt, Rachel McMasters Miller. *Books, Drawings, Prints From the Botanical Collection of Mrs. Roy Arthur Hunt*. Annotations by Ruth Evelyn Byrd. Charlottesville: University of Virginia Press, 1952.

Nissen, Claus. *Die botanische Buchillustration*. 2 vols. Stuttgart: Hiersemann, 1951–66. Esp. vol. 1, pp. 73–75; vol. 2, pp. 27–28; and nos. 273–74.

Sotheby's. *A Magnificent Collection of Botanical Books: Being the Finest Color-plate Books from the Celebrated Library Formed by Robert de Belden*. Uxbridge, Middlesex, Great Britain: Hillingdon Press, 1987. Esp. no. 93, p. 105.

Schama, Simon. *The Embarrassment of Riches: An Interpretation of Dutch Culture in the Golden Age*. Berkeley: University of California Press, 1988. Esp. pp. 350–66.

JAN DAVIDSZ. DE HEEM
Dutch, 1606–ca. 1684

157 *Vase of Flowers*

ca. 1645
Oil on canvas
69.6 x 56.5 cm. (27⅜ x 22¼ in.)
National Gallery of Art, Washington, D.C.
Andrew W. Mellon Fund
Acc. no. 1961.6.1
Venues: DC, NC

This painting was executed by Jan Davidsz. de Heem (see cat. no. 11) during the middle years of his career after his move to Antwerp. An exquisite and arresting picture, it reflects the contemporary fashion for depicting rare, exotic, and exceptionally beautiful botanical specimens.

De Heem has depicted over twenty kinds of flowers, to which he has added peas, wheat stalks, and an abundance of insects. Radiating outward from the central white hydrangea is a spectacular display of prized and vividly colored flowers: roses, hyacinth, morning glory, checkered fritillaries, red-striped tulips, and poppy anemones of the carnation or peony type. Many of these specimens have symbolic meaning, as they often do in de Heem's flower still lifes. The wheat, which must die and fall to the ground as seed before producing new life, is a symbol of resurrection, as are the butterflies (Segal, p. 112; Wheelock, p. 17). Other suggestions of resurrection, or more generally of cycles of life and death, appear in the fallen carnation and the dried, opened pea pod at the left of the vase.

Very much in line with the scientific naturalism of the age, de Heem took the utmost care to record the distinguishing features of each botanical form in his painting. But beyond its documentary aspect, the *Vase of Flowers* is a superior achievement of art. The bouquet has a convincing three-dimensionality, and, in a brilliant illusionistic touch the artist depicted the reflection of his studio windows on the shiny glass vase. Dramatic shifts in light and dark areas, a great variety of hues, and irregular linear rhythms lend a visual energy to the composition as a whole and create the impression that the bouquet itself is bursting with life.

BIBLIOGRAPHY

Segal, Sam. *A Prosperous Past: The Sumptuous Still Life in the Netherlands 1600–1700*. Hague: SDU Publishers, 1988. Esp. pp. 93–112, 141–47.

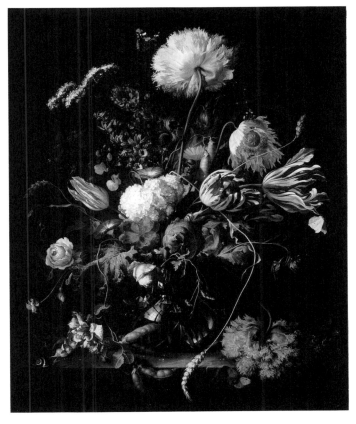

157

Walker, John. *National Gallery of Art, Washington, D.C.* New York: H.N. Abrams, 1975.
Wheelock, Arthur K., et al. *Still Lifes of the Golden Age.* Washington, D.C.: National Gallery of Art, 1989.

JUAN DE ARELLANO
Spanish, 1614–76

158 *A Basket of Flowers*

ca. 1670–76
Oil on canvas
83.8 x 104.8 cm. (33 x 41¼ in.)
Kimbell Art Museum, Fort Worth, Texas
Acc. no. ACF 65.5

Juan de Arellano was Spain's leading specialist in flower paintings during the seventeenth century. He was born in Santorcaz in 1614 and spent most of his career in Madrid, where he headed a large and active studio. Influenced by Daniel Seghers (cat. no. 155) and the Roman artist Mario dei Fiori (Mario Nuzzi),

158

both of whose paintings were collected by the Spanish nobility, Arellano is best known for his vibrant and highly decorative renderings of floral bouquets arranged in vases or, more commonly, in baskets. This magnificent painting is characteristic of Arellano's later style and like several of his works in the Prado Museum, it offers to the beholder a lavish and flamboyant display of flowers. The bouquet consists of a variety of botanical specimens, not all of which bloom in the same season. Prominent among these are daffodils, pinks, cornflowers (bachelor's buttons), striped tulips, roses, and poppy anemones.* Particularly striking in this bouquet are the double-blossomed poppies (*anemone coronaria*) with their huge "explosive" centers.

A theme of transience or of ephemeral beauty probably underlies this painting, since many of the blossoms are past their prime. However, like Arellano's other *floreros* it also conveys an impression of vigorous life—the flowers burst out of the open-weave basket and seem to be shaken by a sudden gust of wind (Pérez Sánchez). The picture gives a convincing account of these prized botanical specimens while at the same time celebrating their natural splendor.

* Roger Warren of Longacre's Nursery Center, Lebanon, New Hampshire, kindly helped to identify these flowers. Sam Segal provided information about the poppy anemones (also known as opium poppies) in a letter to William B. Jordan of the Kimbell Art Museum.

BIBLIOGRAPHY

Catalogue of the Collection 1972. Fort Worth: Kimbell Art Museum, 1972.
Handbook of the Collection. Fort Worth: Kimbell Art Museum, 1981. Esp. p. 155.
In Pursuit of Quality: The Kimbell Art Museum: An Illustrated History of the Art and Architecture. Fort Worth: The Kimbell Art Museum, 1977. Esp. p. 217.

382

Mitchell, Peter. *European Flower Painters*. London: Adam and Charles Black, 1973. Esp. pp. 35–37.

Pérez Sánchez, Alfonso E. *Pintura Española de Bodegones y Floreros de 1600 a Goya*. Madrid: The Prado Museum, 1983.

Sullivan, Edward J., et al. *Painting in Spain, 1650–1700: From North American Collections*. Princeton, N.J.: The Art Museum, Princeton University, and Princeton University Press, 1982. Esp. cat. no. 2.

TOBIA ALDINI
Italian, 17th century

159 *Exactissima descriptio rariorum quarundam plantarum*

Rome, Iacobi Mascardi, 1625
Illustrated book
Each approx. 33 x 22 cm. (13 x 8⅝ in.)

Copy A: Dumbarton Oaks, Trustees for Harvard University, Washington, D.C.
Acc. no. F–3–4
Venues: DC, NC

Copy B: Harvey Cushing/John Hay Whitney Medical Library, Yale University, New Haven, Connecticut
Acc. no. Herbals + (Gift of Dr. and Mrs. L. G. Strong)
Venues: HO, HI

Tobia Aldini's illustrated description of the rare and exotic plants cultivated in Cardinal Farnese's garden on the Palatine Hill in Rome is the only book in the exhibition representing such a specialized collection. The importation of plants from around the world had its greatest impact on the stock available for pleasure gardens. Exotic plants in particular were avidly collected and cultivated by members of the aristocracy and high-ranking officials of the church. The sheer difficulty of sustaining and successfully propagating botanical specimens from climates vastly different from Europe's enhanced the exotic value of such a collector's garden.

Among the wide variety of plants owned by Cardinal Farnese were aloe and yucca plants from the Americas. Illustrated here is the lilionarcissus, a type of amaryllis from the New World. Aldini's name for this plant demonstrates a problem that confronted botanists in this period. With the great influx of new and unfamiliar flora during the seventeenth century, they had to struggle to classify the material according to the existing nomenclature, which was established in antiquity. The lilionarcissus demonstrates the new practice of forging a name from the names of plants

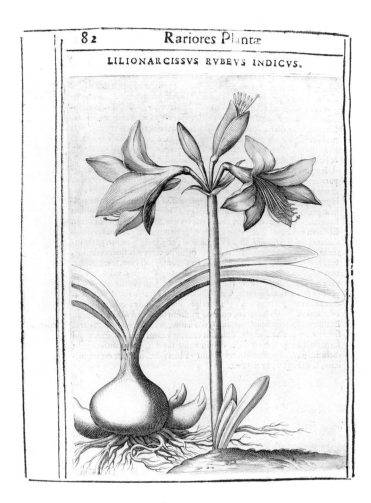

159A Indian red lily. Engraving.

that the unfamiliar specimens most closely resembled—in this case the lily and the narcissus.

BIBLIOGRAPHY

Masson, Georgina. "The Italian Flower Collectors' Gardens in Seventeenth Century Italy." In *The Italian Garden*. Ed. David R. Coffin. Washington, D.C.: Dumbarton Oaks, 1972. Esp. p. 67.

GIOVANNI BATTISTA FERRARI
Italian, 1584–1655

160 *De florum cultura libri* IV

Rome, Stephanus Paulinus, 1633
Illustrated book
24.8 x 18.5 x 4 cm. (9¾ x 7¼ x 1¾ in.)
Library, Academy of Natural Sciences of Philadelphia, Pennsylvania
Acc. no. QK 41 F37 1633

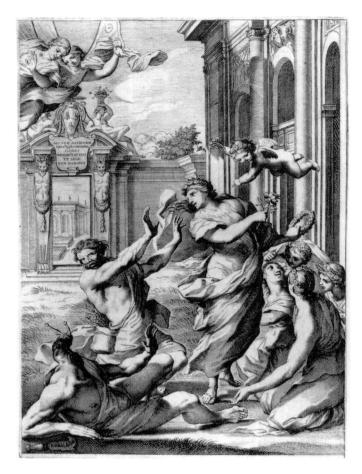

160 Metamorphosis of a bad gardener into a snail. Engraving.

seems probable, however, that through his patron Ferrari encountered the baroque masters whose designs illustrate several of his botanical books.

Pictured here is one of the seven allegorical prints in *De florum cultura* designed by one of the baroque artists. This is one of the most dramatic and inspired prints in the book. A bad gardener is being transformed into a snail: his body is caught by surprise as his head has already become the soft tissue of a snail. Behind him is the entrance to a garden of visual delight. An inscription over the archway admonishes the visitor:

> Hic ver assiduum
> Meli qua carmina
> Flores
> Inscribut. Oculis
> Tu Lege
> Non manibus
>
> Here [is] constant springtime
> where better flowers
> inscribe their song.
> Pluck them with your eyes
> and not your hands.

BIBLIOGRAPHY

Sotheby's London. *A Magnificent Collection of Botanical Books: Being the Finest Color-plate Books from the Celebrated Library Formed by Robert de Belden*. Uxbridge, Middlesex, Great Britain: Hillingdon Press, 1987.

De florum cultura was one of the earliest botanical works to be devoted entirely to flowering garden plants as well as the first in a series of sumptuously illustrated botanical books by Giovanni Ferrari. It is essentially a handbook for gardeners that gives instructions on cultivation and flower arrangement. The majestic plates, designed by Anna Maria Vaiani, describe the flowers, leaves, and roots of some of the most popular ornamental plants of the time. Also illustrated are plans of gardens, their watering systems, and even garden tools. Several of the plates in this volume show different types of bouquet arrangements in baskets and elaborate vases.

The exceptional quality of Ferrari's work is augmented by the contributions of Guido Reni, Andrea Sacchi, and Pietro da Cortona, all of whom received patronage from Francesco Barberini. Though Ferrari's work is dedicated to Barberini, it is not clear that the plans of the gardens or the flowers depict the gardens at Barberini's villa or palazzo in Rome. It

NEHEMIAH GREW
English, 1641–1712

161 *The Anatomy of Plants with an Idea of a Philosophical History of Plants*

London, W. Rawlins, 1682
Illustrated book
33.6 x 21.3 x 4.2 cm. (13⅜ x 8⅜ x 1⅝ in.)
Dartmouth College Library, Hanover,
New Hampshire
Acc. no. QK/41/G82

This book is the published record of a series of lectures that Nehemiah Grew (cat. no. 22) delivered to the Royal Society between 1671 and 1674. Treating the anatomy of roots, trunks, leaves, flowers, and seeds, he considers a great variety of plant specimens as seen through the microscope. Grew marvels at his own discoveries, calling them "Terrae Incognitae," comparable to the new worlds of geography. In the dedicatory pages to this volume he says, "I know not how,

even in this Inquisitive Age, that I am the first who has given a map of the country."

The map, or maps, that Grew supplied were engraved illustrations of the botanical specimens. Many of these, such as the "Oak Branch," are shown in cross section: the specimen is depicted both greatly enlarged, as viewed through the microscope's lens, and in actual scale, as it appears to the naked eye. The botanist was astonished by the magnified views of plants, for they revealed to him an internal structure that, he thought, was remarkably similar to that of animals. They consist of "several organical parts," he says, "some whereof may be called Bowels . . . [and] . . . it hath those parts which are answerable to lungs. So that a Plant is, as it were, an Animal in Quires; as an animal is a Plant, or rather several plants bound up into one volume." This way of drawing comparisons between widely different natural forms is found in the writings of other authors of the period, but it has a special significance in this case, as it was Grew who introduced the term "comparative anatomy."

There are some instances in the *The Anatomy of Plants* where Grew speaks of the mysterious nature or "secret intrigues" of fruits and flowers. But, as Thorndike has noticed, this text, like those of Malpighi (cat. no. 130), is "free from magical lore as to plants" (vol. 8, p. 71). The works of Grew and Malpighi represented a new direction in botany that gave prime consideration to the internal structure and growth of plants. Contemporary Europeans felt they had the means to attain a "perfect knowledge of plants," yet as a result of this confident attitude and the eighteenth-century preoccupation with classification, no major progress was made in the field of plant anatomy until the nineteenth century (Thorndike, vol. 8, p. 71).

BIBLIOGRAPHY

Arber, Agnes. "Nehemiah Grew (1641–1712) and Marcello Malpighi (1628–1694): An Essay in Comparison." *Isis* 34 (1942–43): 7–16.

Thorndike, Lynn. *A History of Magic and Experimental Science*. 8 vols. New York: Columbia University Press, 1923–58. Esp. vol. 8.

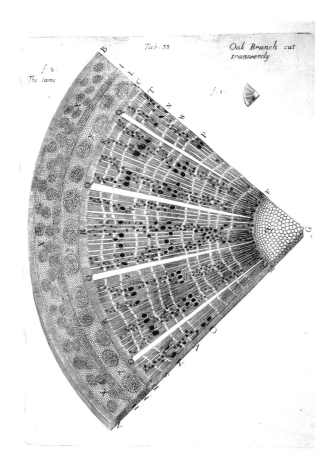

161 Oak branch cut transversely. Engraving.

MARVELS OF ART

THIS PART of the exhibition shifts attention from natural wonders to artificial *meraviglie*, or the unusual and surprising things fashioned by man. One category of artistic marvels appears in the *Kunst- und Wunderkammer*, namely the exquisite and finely crafted objects designed by sculptors and metalworkers. This section considers two other types of marvelous *artificialia* which, like objects of virtuosity, had the power to astonish and surprise the beholder.

SPECTACLES AND SET PIECES

The most elaborate *meraviglie* of the sixteenth and seventeenth centuries were devised for gardens, festivals, and theatrical performances. Fantastic products of the artist's imagination, they included hydraulic and pyrotechnic displays, colossal set pieces, automata, parade barges, and scenographic sets for the stage. The prints and festival books on exhibit emphasize the achievements of Italian designers and engineers, because they led the way in the creation of these works and because their inventions largely inspired the spectacular productions in northern European countries.

Apparatus for festivals and stage performances provoked wonder in the beholder by means of various surprising and seemingly magical effects. As represented in the commemorative volume by Jan Boch and Pieter van der Borcht (1595), a festival in Antwerp contained fantastic, large-scale barges in the shape of sea monsters. With the "Argonautica," a water festival held in Florence in 1608 and recorded in prints by Remigio Cantagallina and Matthias Greuter, bizarrely shaped floats were rigged to metamorphose as they passed spectators in the grandstands. The most extraordinary visual effects, however, were achieved in the theater—for productions of the *commedie* and for the new art form of the age, the opera.

Ultimately dependent upon Aristotle's observation that wonder may arise from spectacle, the creation of stupendous sets assumed an unprecedented level of importance by the end of the sixteenth century. In the productions of *La pellegrina* (represented by Agostino Carracci) and *Le nozze degli dei* (recorded by Stefano della Bella), audiences were treated to multiple changes of sets, illusionistic fires and floods, and painted sceneries that showed fantastic and otherworldly realms. As the seventeenth century progressed stage productions became increasingly elaborate, in large part to satisfy spectators' de-

mands for novelty. This change is clearly visible in the prints showing Giacomo Torelli's sets for the opera *Les Noces de Pelée et Thetis* (1654) and in Melchior Küssel's impressive engraving of a set designed for the performance of *Il pomo d'oro* (1667). Festivals of the period usually concluded with impressive pyrotechnic displays. Fireworks had been introduced into Europe well before the Renaissance, but in the sixteenth and seventeenth centuries they turned into elaborate productions in which the designer/technician was able to demonstrate his ingenuity and his inventive powers in this most ephemeral of art forms. As recorded in contemporary prints, such as those by Israël Silvestre, Jean Le Pautre, and Melchior Küssel, these pyrotechnic exhibitions became exceptionally dramatic affairs, especially in the great courts of Europe.

ILLUSIONS AND DECEPTIONS

Ancient writers spoke often of the "marvelous" effects achieved by artists in their highly illusionistic paintings or sculptures. The revival of this kind of illusionism occurred in the early Renaissance, but it probably reached its zenith in the baroque period and with the seventeenth-century Dutch painters in particular. Sometimes with the aid of optical devices like the camera obscura, but mostly not, they created dazzling *trompe-l'oeil* that fooled the viewer into thinking that the object was not a work of art but reality. An art of deception interested Europeans not only because it created an ambiguous relation between the illusion of reality and reality itself, but also because, when done well, it had the power to excite wonder on two levels: first, in response to the deception itself; second, in admiration of the artist's ability to create the deception.

A superb example of late-sixteenth century *trompe-l'oeil* is the *Open Missal* by Ludger tom Ring the Younger. Here the artist has given a tactile sense of reality to his subject, making it seem to exist within the beholder's space. In contrast to this bold and straightforward *trompe-l'oeil*, the *Still Life with Lobster* by Johannes Hannot and the still life by Willem Kalf present a rich accumulation of objects in which textured surfaces, the play of light, and differing shapes are convincingly simulated. Even more intriguing were the pictures, such as the one by Cornelis Gysbrechts, that seemed to roll away from their frames.

A type of visual deception that became widely popular in the seventeenth century was the anamorphosis, or scrambled image that must be seen from a particular point of view or with the aid of a mirror in order to become intelligible. Anamorphic images had their genesis in the early sixteenth century, developing out of that period's investigations into the science of perspective. Leonardo da Vinci made these curious constructions, as did the Nuremberg artist Erhard Schön. Schön's woodcuts, examples of elongated or accelerated perspective, present a maze of bewildering lines, but when seen from the side identifiable (and surprising) images come into view. Anamorphoses were regarded as fascinating entertainments, but at the same time they raised fundamental questions about perception and about the world of appearances. Behind the confusion of lines, a recogniz-

able form becomes visible. Behind uncertainty, a certainty could be found. Very often, the certainties discovered were religious—an image of a saint or of the crucifixion, for example. Anamorphic constructions appealed especially to those who sought to penetrate nature's mysteries or to discover the truths that were concealed behind the confusion of appearance. They were described by writers on natural and artificial magic and were of particular interest to Jesuit authors and members of the French order of Minims. Several of the most famous publications concerning anamorphoses are exhibited here, including those by Jean-François Nicéron, Mario Bettini, and Jean Du Breuil. These illustrated texts describe a wide variety of anamorphoses (some of which are reconstructed in the exhibition) and offer detailed instructions for their creation.

Like anamorphoses, the camera obscura and magic lantern were appealing because of the marvelous effects they produced. Described and illustrated in the texts of Johann Zahn and Athanasius Kircher, these mechanical devices astonished and amused spectators with a world of illusions. The vanity of this world of illusions, however, also was revealed, as can be seen in the images of skeletons and damned souls that were projected onto walls by Kircher's magic lantern.

AGOSTINO CARRACCI
Italian, 1557–1602
(after BERNARDO BUONTALENTI,
Italian, 1536–1608)

162 *"La pellegrina": Third Intermezzo, Apollo Slaying the Python*

1592
Etching and engraving
24.3 x 34.5 cm. (9½ x 13⅝ in.)
Harvard Theatre Collection, Harvard University,
 Cambridge, Massachusetts
Acc. no. *69F–17PF
Venues: DC, NC

Agostino Carracci, brother of Annibale and cousin to Ludovico, is best known as an engraver. During the 1580s he executed numerous engravings after the paintings of Veronese, Tintoretto, Titian, and Correggio, and over the next two decades produced more than two hundred prints, of both his and others' designs.

This print is one of only two known etchings by Agostino. It records Bernardo Buontalenti's design for the third intermezzo of Girolamo Bargagli's play *La pellegrina* (The Pilgrim), which on May 2, 1589, had been part of the marriage celebrations of Ferdinand I de' Medici and Christine of Lorraine. The six intermezzi were organized by Giovanni Bardi, count of Vernio, who selected as their theme the power of musical harmony, which had associations with the theme of the harmony of the universe. The latter theme gave the intermezzi specific political content, as the union of Ferdinand and Christine represented the power of order against disorder and of harmony against disharmony.

The scene occurs in a forest of Delphi, where Python is threatening the countryside. As staged in the Medici theater, Python entered center stage and spewed flames upon the fleeing people of Delphi. Agostino depicts the arrival of Apollo, who, flying in from above, performed a six-part dance, killed the dragon, and rescued the people.

The intermezzi were especially appreciated for their spectacular theatrics, elaborate stage machinery, and marvelous dramatic effects. In *Apollo Slaying the*

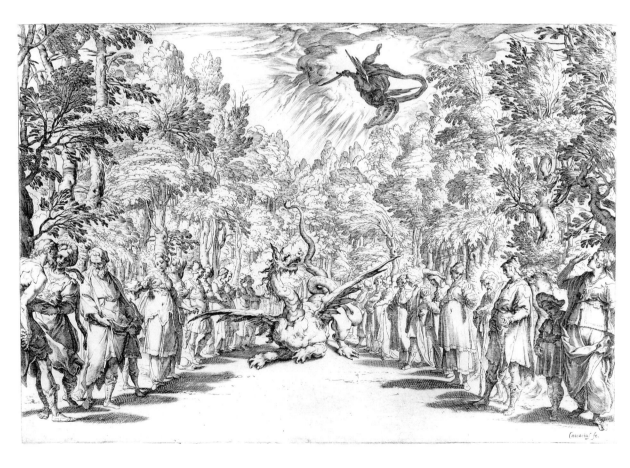

162

Python Agostino depicts the intermezzo's great fire-breathing dragon, the rich and varied costumes, and Apollo suspended above the rapidly receding landscape. It is the earthly equivalent of the design for the first intermezzo, *The Harmony of the Spheres*, which Agostino also etched (Bohlin, no. 153). There, Mother Necessity sits on a cloud at the apex of converging rows of personifications of the heavenly bodies and the virtues, who sit or stand amidst swirling clouds and shooting stars. As Agostino's prints were widely dispersed throughout Europe, they played a major role in the development of baroque scenography and theatrical marvels.

BIBLIOGRAPHY

Blumenthal, Arthur R. *Theater Art of the Medici*. Hanover, N.H.: Dartmouth College Museum and Galleries, 1980. Esp. pp. 7–13.

Bohlin, Diane DeGrazia. *Prints and Related Drawings of the Carracci Family: A Catalogue Raisonné*. Washington, D.C.: National Gallery of Art, 1979. Esp. pp. 266–71.

Nagler, A. M. *Theatre Festivals of the Medici, 1539–1637*. New Haven: Yale University Press, 1964. Esp. pp. 70–92.

Reed, Sue Welsh, and Richard Wallace. *Italian Etchers of the Renaissance and Baroque*. Boston: Museum of Fine Arts, 1989. Esp. pp. 113–14.

JAN BOCH and PIETER VAN DER BORCHT
Flemish, 1555–1609; Flemish, 1545–1608

163 *Descriptio publicae gratulationis spectaculorum et ludorum, in adventu sereniss. principis Ernesti Archiducis Austriae, Ducis Burgundiae*

Antwerp, Ex Officina Plantiniana, 1595
Illustrated book
39.7 x 24.8 cm. (15⅝ x 9⅞ in.)
Tobin Collection, McNay Art Museum,
 San Antonio, Texas
Acc. no. TL1984.1.28

This festival book is the collaborative effort of Pieter van der Borcht and Jan Boch, both natives of Flanders. Published by the famous Plantin Press of Antwerp, this volume has a text by Boch and numerous handsome engravings by van der Borcht. Considered by some to be van der Borcht's most important work, it contains three double-page plates, two engraved title pages, and thirty additional full-page illustrations.

Descriptio publicae commemorates the entry into Antwerp on June 14, 1594 of Archduke Ernest as imperial governor of the Low Countries. As the engrav-

163 Festival barge. Engraving.

ings show, the archduke, his knights, and army entered the city in a grand parade. Lavish triumphal arches were created for the occasion, and the new governor and assembled guests were treated to performances in open-air theaters and amphitheaters resembling the Colosseum. As part of the festivities the main square of Antwerp was illuminated with burning barrels, and used as the setting for a parade of carriages, equestrians, and the city's burghers. Among the elaborate floats created for the parades were the "Giant of Antwerp" and a sea monster or "whale," shown here.

Festivals and parades were by no means new to the Low Countries in 1594, but this spectacle was extraordinarily sumptuous. Boch and van der Borcht's book was a fitting memorial of the grandiose event, and it anticipated to the opulent *Pompa introitus* of 1641 by Peter Paul Rubens and his associates.

BIBLIOGRAPHY

Delen, Adrien Jean Joseph. *Histoire de la gravure dans les anciens Pays-Bas*. Reprint of 1924–35 edition. Vol. 2. Paris, F. De Nobele, 1969. Esp. pp. 95–96.

Gregor, Joseph. *Weltgeschichte des theaters.* . . . Zurich: Phaidon-Verlag, 1933. Esp. p. 170.

Marion Koogler McNay Art Musuem. The Tobin Wing. *Courtly Splendor*. San Antonio: Marion Koogler McNay Art Museum, 1988. Esp. p. 8, no. 5.

Martin, John Rupert. *The Decorations for the Pompa Introitus Ferdinandi*. Corpus Rubenianum Ludwig Burchard, pt. 16. London and New York: Phaidon, 1972.

William H. Schab Gallery. *Three Centuries of Illustrated Books: 1460–1760*. Catalogue 35. New York: William H. Schab Gallery, n.d. Esp. pp. 38–39, no. 27.

CAMILLIO RINUCCINI
Italian, active 1590–1620

164 *Descrizione delle feste fatte nelle reali nozze de' serenissimi principi di Toscana D. Cosimo de' Medici, e Maria Maddalena Arciduchessa d'Austria*

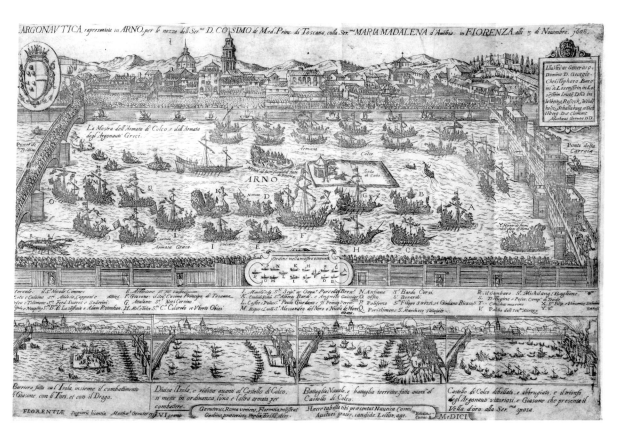

164B Matthias Greuter. *Argonautica on the Arno River*. Etching.

Florence, Giunti, 1608
Festival book with 5 etchings by Matthias Greuter
 (Alsatian, ca. 1565–1638)
Each approx. 28 x 40 x 24.5 cm. (11 x 15⅞ x 9⅝ in.)

Copy A: Anne S. K. Brown Military Collection,
 Brown University Library, Providence,
 Rhode Island
 Acc. no. IsC 1608 Tuscany
 Venues: DC, NC

Copy B: Tobin Collection, McNay Art Museum,
 San Antonio, Texas
 Acc. no. TL1984.1.433
 Venues: HO, HI

The wedding festivities of Cosimo de'Medici and
Maria Magdalena of Austria were among the best
documented of any of the period. Numerous illustrat-
ed descriptions were published by Cosimo's father,
Grand Duke Ferdinand I de'Medici, whose own wed-
ding twenty years earlier had been documented by
prints, including two etchings by Agostino Carracci
(cat. no. 162). The celebration is described in detail in
Camillio Rinuccini's *Descrizione delle feste . . .* , which
has etchings by Matthias Greuter, who was born in
Strasbourg, studied there, and worked briefly in
Lyons and Avignon before settling in Rome.

The festivities began on October 18, 1608, with the
triumphal entry of Maria Magdalena into Florence
accompanied by some fifteen thousand infantrymen
and hundreds of equestrians. The parade took several
hours to wind through the city of Florence, which
was decorated for the occasion with triumphal arches,
pavilions, and statues designed by Ludovico Cardi da
Cigoli. Over the next few days there were a banquet,
a musical *divertimento*, a play with intermezzi, an
equestrian ballet called "The Joust of the Winds," and
a mock naval battle on the Arno River.

The "Argonautica" is perhaps the best illustrated
event of the festivities, with at least twenty differ-
ent etchings and numerous drawings (Blumenthal,
p. 35). It occurred throughout the afternoon and
evening of November 3 and featured a mock battle
between the armada of the Greek Argonauts and the
armada of Colchis, the Asian country from which
Jason and the Argonauts recovered the Golden Fleece.
The ships circled the isle of Colchis while a whale,
giant turtle, giant lobster, floating reefs of river gods,
and nereids on huge shells sailed around the outer
waters. The use of the Tuscan fleet allowed Ferdinand
to associate the Florentines with the Greeks and Co-
simo with Jason, and thus to make a political event
of the water spectacle.

The "Agonautica" was the first of many festivals on
the Arno, but none was more spectacular. Indeed, the
entire wedding festivities would have a lasting influ-
ence on the future Grand Duke Cosimo II, who,
throughout his reign from 1610 to 1621, was a patron
of theatrical tricks and marvels. In addition, and of
special interest for this exhibition, Cosimo II admired
scientific marvels and was a supporter and patron of
Galileo Galilei.

BIBLIOGRAPHY

Blumenthal, Arthur R. *Theater Art of the Medici*. Hanover,
 N.H.: Dartmouth College Museum and Galleries, 1980.
 Esp. pp. 30–37.
Nagler, A. M. *Theatre Festivals of the Medici, 1539–1637*. New
 Haven: Yale University Press, 1964. Esp. pp. 101–15.

REMIGIO CANTAGALLINA
Italian, ca. 1582/3–1656
(after LUDOVICO CARDI DA CIGOLI,
Italian, 1559–1613)

165 *The "Argonautica": Ship of Amphion,
 Guided by Mercury*

1608
Etching
Each approx. 19.2 x 28.6 cm. (7⅝ x 11⅜ in.)

Copy A: Harvard Theatre Collection, Harvard
 University, Cambridge, Massachusetts
 Edwin Binney, 3rd, Collection
 Acc. no. Binney SD 503
 Venues: DC, NC

Copy B: Collection of Robert L. B. Tobin
 Acc. no. R 85.110.7
 Venues: HO, HI

REMIGIO CANTAGALLINA
Italian, ca. 1582/3–1656
(after JACOPO LIGOZZI, Italian, 1547–1626)

166 *The "Argonautica": Periclymenus in
 the Form of a Giant Lobster*

1608
Etching
Each approx. 18.1 x 27.1 cm. (7⅝ x 10⅝ in.)

Copy A: Harvard Theatre Collection, Harvard
 University, Cambridge, Massachusetts
 Edwin Binney, 3rd, Collection
 Acc. no. SD 510
 Venues: DC, NC

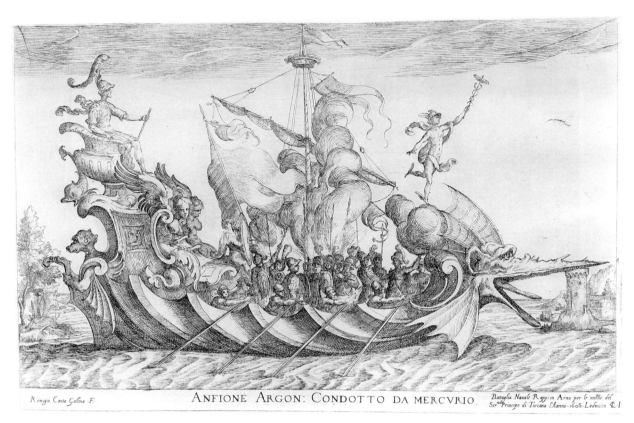

R.emigio Canta Gallina F. ANFIONE ARGON: CONDOTTO DA MERCVRIO. Battaglia Nauale Rapp: in Arno per le nozze del
Ser:mo Principe di Toscana l'Anno .1608. Lodouico C. I.

165

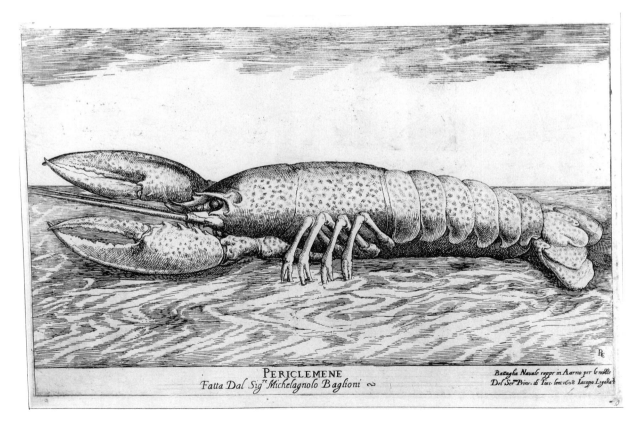

PERICLEMENE
Fatta Dal Sig:re Michelagnolo Baglioni Battaglia Nauale rappr in Aarno per le nozze
Del Ser: Prinr. di Tosc: len: 1608. Iacopo Ligozr:

166

393

REMIGIO CANTAGALLINA
Italian, ca. 1582/3–1656
(after JACOPO LIGOZZI, Italian, 1547–1626)

167 *The "Argonautica": Eurythus, Echion,
and Aethalides, Guided by Mercury
in the Form of a Peacock*

1608
Etching
Each approx. 20.1 x 27.4 cm. (8 x 10⅝ in.)

The ships in which the Tuscan Argonauts sailed in the "Argonautica," the final and most extraordinary event of the festivities marking the wedding of Cosimo de' Medici and Maria Magdalena in 1608 (see cat. no. 164), were, with three exceptions, designed by Giulio Parigi (1571–1635). Two of the three exceptions were designed by Jacopo Ligozzi (1547–1626), who had worked on the Medici weddings of 1579, 1589 (see cat. no. 162), and 1600; the third was designed by Ludovico Cardi da Cigoli. All nineteen ships were etched by Remigio Cantagallina, who was a noted draughtsman of landscapes, as well as Parigi's closest assistant and, before Jacques Callot, the etcher of his designs.

The extraordinary ships included representations of icicles, snow, giant shells and exotic fish, sea horses, a smoking volcano, and a rocky cavern, all of which were decorated with coral, shells, and algae and bore dozens of uniformed soldiers (Blumenthal, pp. 57–

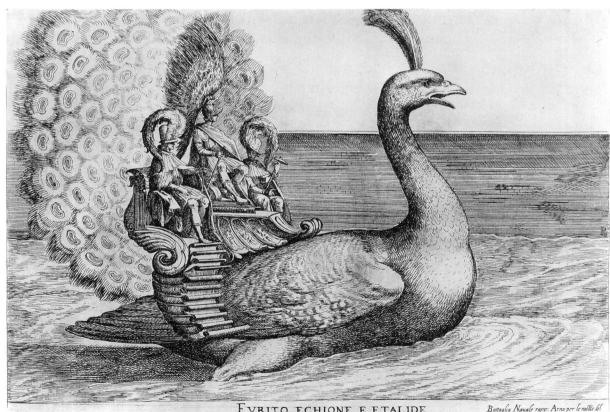

EVRITO ECHIONE E ETALIDE
Condotti da Mercurio fatta dal Sig.re Cont Alberto e Sig.re Carlo de
Bardi et Agnolo Gucciardini

Battaglia Nauale rapp: Arno per le nozze del
Ser.mo Princ: di Tosc: l'an 1608 Iacopo Ligozzi I.

167

86). One of the most fantastic was the ship in the form of a peacock, designed by Ligozzi for Count Alberti, Count Carlo de' Bardi, and Agnolo Guicciardini, three Florentine noblemen who had financed the ship and who rode amidst its tail feathers as three Argonauts, Eurythus, Echion, and Aethalides. As the ship sailed along the Arno River, the peacock spread its multicolored feathers, to the delight of the many spectators.

Just as fantastic was the ship in the form of a giant lobster. It represented Periclymenus, who had received from his grandfather, Neptune, the power to change himself into whatever form he wished. He was eventually killed by Hercules. As Ligozzi designed it, the lobster floated or was poled along the Arno until it passed the seats of the grand duke and duchess (letter V in Greuter's print, cat. no. 164), when it changed into a boat on which sat Michelangelo Baglione in the character of Periclymenus (Blumenthal, p. 75).

The ship of Amphion was designed by Ludovico Cardi da Cigoli, a student of Bernardo Buontalenti, whom we know as a designer for the 1589 wedding festivities of Cosimo's parents, Grand Duke Ferdi-

nand I de' Medici and Christine of Lorraine. Cigoli also designed many triumphal arches for the entry of Maria Magdalena into Florence at the beginning of the 1608 wedding festival (see cat. no. 164). The ship was a giant shell with a prow in the form of a sea monster. On a cloud near the prow stood a statue of Mercury.

BIBLIOGRAPHY

Blumenthal, Arthur R. *Theater Art of the Medici*. Hanover, N.H.: Dartmouth College Museum and Galleries, 1980. Esp. pp. 69–71, 73–75, 77–80.

Nagler, A. M. *Theatre Festivals of the Medici, 1539–1637*. New Haven: Yale University Press, 1964. Esp. pp. 101–15.

REMIGIO CANTAGALLINA
Italian, ca. 1582/3–1656
(after GUILIO PARIGI, Italian, 1571–1635)

168 *"Il giudizio di paride": Fourth Intermezzo, The Ship of Amerigo Vespucci*

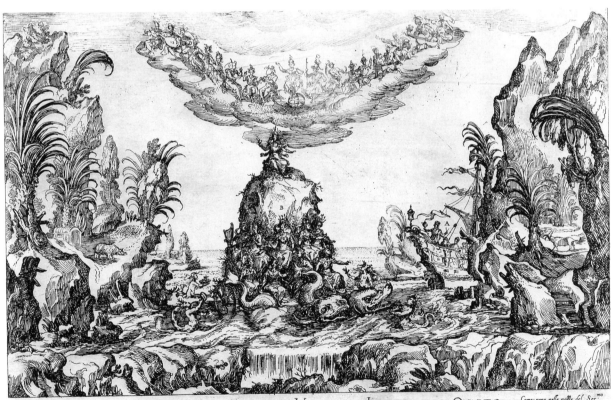

NAVE DI AMERIGO VESPVCCI INTERMEDIO QVARTO

168

1608
Etching
19.4 x 27.0 cm. (7⅝ x 10⅝ in.)
Harvard Theatre Collection, Harvard University,
 Cambridge, Massachusetts
Edwin Binney, 3rd, Collection
Acc. no. Binney SD 490
Venues: DC, NC

Written by Michelangelo Buonarroti the Younger
(1568–1646) especially for the wedding of Cosimo de'
Medici and Maria Magdalena (see cat. no. 164), *The
Judgment of Paris* is a pastoral retelling of the Greek
myth about the beauty contest among Juno, Venus,
and Minerva. It was performed in the Medici Theater
at the Uffizi on October 25 and designed by Giulio
Parigi. Remigio Cantagallina's etchings of the inter-
mezzi are of great importance to the history of stage
design because they recorded the types of settings
used by Italian stage designers during the first half of
the seventeenth century (Blumenthal, pp. 40–42).

Written by Giovambattista Strozzi, the fourth in-
termezzo of *The Judgment of Paris* transformed the
stage into an exotic seacoast with imposing cliffs,
reefs, palm trees, and exotic animals, all representing
the shores of the Indies as they were discovered by
Amerigo Vespucci (1458–1512). The three incidents of
the intermezzo are combined in the etching and are
labeled A, B, and C. A ship decorated with the Floren-
tine lion and lilies carried Vespucci across the stage
(A). A reef then rose out of the waters in center stage
(B), bearing the personifications of Tranquility,
Zephyrus, and "Gentle Winds." Finally, Immortality
appeared on a cloud in the sky, along with Apollo,
the nine muses, and ten poets (including Homer,
Horace, Virgil, Dante, and Petrarch), and sang a
madrigal praising Cosimo and Maria Magdalena (C).
The fantastic scene, like other intermezzi and events
in the wedding festival, was rich in political implica-
tions; in this case the glorification of Florentine
genius as encouraged by the Medici family. Its spec-
tacular landscape had a lasting influence, as it was
copied by Inigo Jones for a scene in the masque *The
Temple of Love*, performed in London in 1635 (Strong,
no. 74).

BIBLIOGRAPHY

Blumenthal, Arthur R. *Theater Art of the Medici*. Hanover,
 N.H.: Dartmouth College Museum and Galleries, 1980.
 Esp. pp. 39–40, 49–51.
Nagler, A. M. *Theatre Festivals of the Medici, 1539–1637*. New
 Haven: Yale University Press, 1964. Esp. pp. 107–8.
The Rudolf L. Baumfeld Collection of Drawings and Prints.
 Los Angeles: Grunwald Center for the Graphic Arts,
 1989. Esp. pp. 202–3.
Strong, Roy C. *Festival Designs by Inigo Jones*. Washington,
 D.C.: International Exhibitions Foundation, 1967–68.
 Esp. no. 74.

JACQUES CALLOT
French, 1592–1635
(after GIULIO PARIGI, Italian, 1571–1635)

169 *"La liberazione di Tirreno e d'Arnea,
autori del sangue toscano": End of
the First Scene on the Island of Ischia
with the Beginning of a Courtly
Ballet in the Auditorium of the
Uffizi Theater*

1617
Etching
28.7 x 20.4 cm. (11¼ x 8 in.)
Saint Louis Art Museum, St. Louis, Missouri
Gift of Henry V. Putzel
Acc. no. 192:1956

169

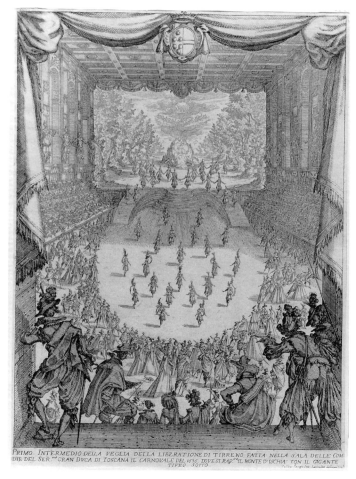

PRIMO INTERMEDIO DELLA VEGLIA DELLA LIBERATIONE DI TIRRENO FATTA NELLA SALA DELLE COM
DIE DEL SER.^{mo} GRAN DVCA DI TOSCANA IL CARNOVALE DEL 1616. DOVE SI RAP.^{ta} IL MONTE D'ISCHIA CON IL GIGANTE
TIFEO SOTTO

Callot was born in Nancy in the duchy of Lorraine and in 1607 was contracted to a local goldsmith, Demenge Crocq (Russell, p. 96). Sometime between 1608 and 1611 he traveled to Italy, where in Rome he learned printmaking from the French engraver Philippe Thomassin and worked with the celebrated Florentine printmaker Antonio Tempesta. By 1612 he was settled in Florence, where he worked with Remigio Cantagallina and executed etchings after designs by Giulio Parigi. Among the latter were prints that document the *veglia*, or "evening's entertainment," the main event of the 1617 festivities marking the wedding of Duke Ferdinand Gonzaga of Mantua and Caterina de' Medici, daughter of the Grand Duke Ferdinand I de' Medici and Christine of Lorraine.

Entitled "The Liberation of Tyrrhenus and Arnea," the *veglia* was held in the Medici theater at the Uffizi, following Ferdinand Gonzaga's triumphal entry into Florence the previous day. It was written by Andrea Salvadori, who drew upon Hesiod, Herodotus, and Ariosto to tell of the coming of Tyrrhenus to Italy and of the development of a pre-Roman civilization in present-day Tuscany. Though complicated and arcane, the *veglia* served as a demonstration of the close union between the Medici and Gonzaga families in their common, ancient, and noble heritage (Blumenthal, pp. 110–12).

This print shows the Medici theater at the end of the first scene of "The Liberation of Tyrrhenus and Arnea." The garden-like setting of the island of Ischia, as designed by Parigi, is visible at the back of the stage. Jupiter and his celestial choruses inhabit the clouds above the smoking cavern on the mount of Ischia, under which the monstrous giant Typhon is buried. The dancers, moving down from the stage and out among the spectators, are led by the grand duke and duchess, who as patrons are standing at the top of the stairs to receive the applause from the assembled guests.

Subsequent prints by Callot from this series show the realm of Pluto as a cavernous piazza-like space lined with crumbling and burning buildings and towers, and the Kingdom of Love as a noble piazza framed with handsome classical facades, on which a battle between Inconstancy and True Love is being quelled by Love (*Amore*), who is perched high on a cloud. This print, however, is the only one of the three to show the Medici theater itself; the others show the staging of the scene. The theater was a large hall on the second floor of the Uffizi. It had been remodeled into a theater *all'antica* by Bernardo Buontalenti in 1586. There, many of the Medici productions were performed, both at wedding festivals and on other occasions. In this theater the performance moves out onto the main floor so the spectacle is close to the audience. The spectacular designs made for this theater played a critical role in the development of opera and influenced later scenography.

BIBLIOGRAPHY

Blumenthal, Arthur R. *Theater Art of the Medici*. Hanover, N.H.: Dartmouth College Museum and Galleries, 1980. Esp. pp. 110–12.

Nagler, A. M. *Theatre Festivals of the Medici, 1539–1637*. New Haven: Yale University Press, 1964. Esp. pp. 131–33.

Russell, H. Diane, Jeffrey Blanchard, and John Krill. *Jacques Callot: Prints and Related Drawings*. Washington, D.C.: National Gallery of Art, 1975.

Weil, Mark S. *Baroque Theatre and Stage Designs*. St. Louis: Gallery of Art, Washington University, 1983. Esp. p. 10.

STEFANO DELLA BELLA
Italian, 1610–64
(after ALFONSO PARIGI, Italian, 1606–56)

170 *Le nozze degli dei*

1637
Set of 7 etchings
Each approx. 20.3 x 29.2 cm. (8 x 11½ in.)
Hood Museum of Art, Dartmouth College, Hanover, New Hampshire
Gift of Class of 1935
Acc. no. PR.979.66.1–7

The Wedding of the Gods, with libretto by Giovanni Carlo Coppola and music by five unknown composers, was performed in the open-air theater in the courtyard of the Pitti Palace as part of the nuptial celebrations of Grand Duke Ferdinand II de' Medici and Vittoria della Rovere, princess of Urbino (Nagler, pp. 162–73).

The marriage was, by all accounts, a misalliance. Arranged in 1623 by Christine of Lorraine, Ferdinand's grandmother, it was intended to unite the houses of Florence and Urbino, thereby increasing the territory and prestige of Tuscany. Pope Urban VIII, a Barberini, vehemently opposed Vittoria's inheritance of Urbino, however, and sent in troops to secure the duchy for the papacy. Meanwhile, Vittoria was in a convent in Florence, to which she had been sent following the death of her father, Federigo della Rovere, the duke of Urbino, in 1623. There she was to wait to marry Ferdinand, which she did fourteen years later at the age of seventeen. The complex and discordant political circumstances of the union were

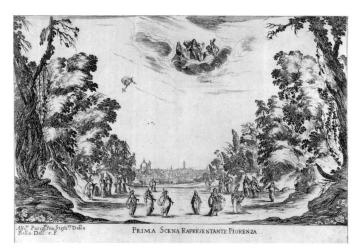

PRIMA SCENA RAPRESENTANTE FIORENZA

170 Prologue: The countryside outside Florence, with Hymen, Honesty, and Fertility on a cloud and three nymphs of the Arno below.

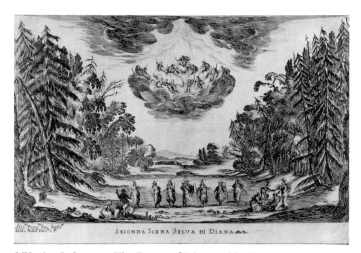

SECONDA SCENA SELVA DI DIANA

170 Act I, Scene 2: The Forest of Diana, with Diana and her nymphs on a cloud and below.

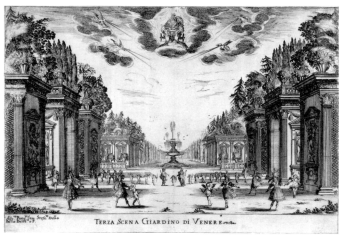

TERZA SCENA GIARDINO DI VENERE

170 Act II, Scene 3: The garden of Venus, with Juno on a chariot cloud surrounded by the four winds, and below Venus, Adonis, and their companions dancing a ballet with infant cupids.

masked by the extravagant celebrations held in honor of the wedding couple.

With frequent allusions to their marriage, Giovanni Carlo Coppola's libretto tells of Jupiter's decision to shower the earth with happiness by celebrating four celestial weddings on the same day, between Juno and Jupiter, Venus and Vulcan, Pallas Athena and Pluto, and Diana and Neptune. Quickly, however, complications arise, as proposals are declined and jealousies aroused. In the end, a four-way wedding does occur, but between Neptune and Amphitrite, Pluto and Persephone, Jupiter and Juno, and Venus and Vulcan.

The settings for this opera were designed by Giulio Parigi's son, Alfonso (1606–56). The stage was set up on the garden side of the Pitti courtyard, and a curtain and proscenium arch were constructed between the two wings of the palace, extending from the entablature of the second story of each. The stage was made of faux marble panels with elaborate volutes. The audience sat or stood in a semicircle to either side of a raised platform that held the grand duke and his party.

Seven of the fifteen stage settings for *The Wedding of the Gods* were recorded by Stefano della Bella, the most talented and creative of the followers of Jacques Callot. The prologue, set in the countryside of Florence, featured a cloud machine carrying Hymen, the God of Nuptials, and allegorical figures of Honesty and Fertility singing a *canzonet*, wishing happiness to Ferdinand and Vittoria. Nymphs were seen floating on a small, mobile island and, together with a chorus of more nymphs, they sang blessings on the young couple and their descendents.

The second scene of the first act took place in the pine forest of Diana. The goddess and fourteen of her maidens appeared, followed by Mercury, who on behalf of Jupiter invited them to attend the wedding ceremonies. Diana refused, and with her maidens sang a *canzonet* extolling the virtue of chastity. A cloud machine then rose from a trap in the floor and carried the group away.

The opera's fourth set represented the garden of Venus enclosed by gilded loggias and adorned with a gushing fountain and alleys of plane trees. Venus sang the praises of love to Adonis while cupids and shepherds danced. Then Juno appeared in a cloud machine intending to interrupt the love-making. The winds blew, thunder and lightning struck, and it began to rain and hail. The lovers fled and the stage filled with clouds.

The next scene in della Bella's suite of prints shows the island of Cyprus, the birthplace of Venus. The forest and garden of the earlier scenes has been

transformed into a rocky grotto with Neptune and his wife, Amphitrite, enthroned on a sea-shell chariot. As the chariot floated among wave machines, Neptune lamented Amphitrite's coldness. Moved to pity, Venus commanded Cupid to charm the nymph. Then, amoretti sang a hymn to beauty, dancers performed, and Venus ascended into the heavens on her cloud machine.

The forge of Vulcan on the Isle of Lesbos was the setting for Act IV, Scene 6. Vulcan and two smithies hammered on their forge in a cavern, Jupiter and his retinue appeared on a cloud machine high above, while a second cloud held the choruses of Venus and Juno. A mock battle then took place between the forces of Mars and Vulcan. When the battle became most fierce, Mercury miraculously appeared from above and called the fighting to a halt.

Hades, the realm of Pluto, was the scene of Act V, Scene 1. Pluto and Persephone, and a company of devils, the Fates, and the Furies, were assembled in a fantastic architectural set representing Hades. As smoke and flames filled the court, hellish monsters leapt and pranced about. At the climax of this scene, Mercury appeared and brought the news of a compromise which would allow Persephone to spend half the year in the underworld and the other six months with her mother on earth. Hymen then entered bringing cheer to this frightening scene, as a grotesque, celebratory ballet of eight centaurs and eight devils was enacted for all to see and enjoy.

Della Bella closed his suite of prints with the finale of the opera, which took place in the heavens with Jupiter and the assembly of the gods. The stage filled with cloud machines and the side wings of painted clouds moved in as a chorus of Muses and Apollo, Diana, and Hymen, appeared on stage. Jupiter, Juno, Vulcan, and Venus took their places on their thrones, and Jupiter gave the command for singing and dancing. A bolt of lightning streaked across the stage as an equestrian ballet with four horsemen and twenty-four cavaliers began. On the stage floor, center stage, and in the wings, still other dancers moved about and formed the letters "FO" for Ferdinand and "VA" for Vittoria.

The numerous scene changes and the marvelous illusions of forest, sea, hell, and heavens were all ingeniously worked out within the natural restrictions of the outdoor theater. The horses, for example, which seem to prance on clouds in della Bella's etching of the finale, were actually dancing on the flat roof over the grotto, which also held the celestial choruses. In all, it was a masterful opera, rich with scenographic effects and sung by more than 150 voices, all of whom, the Florentines were proud to note, lived in the Grand

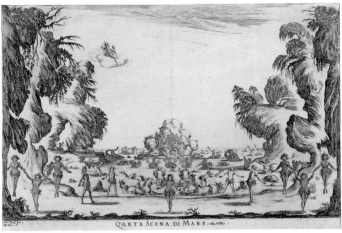

170 Act III, Scene 2: Seashore on Cyprus, with Neptune and Amphitrite enthroned, Venus on a cloud, and tritons dancing a ballet.

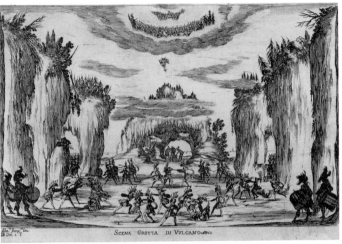

170 Act IV, Scene 5: The forge of Vulcan on the Isle of Lemnos, with Jupiter and retinue in the clouds, choruses of Venus and Juno in the clouds, Mercury in flight, and the battle between Mars and Vulcan.

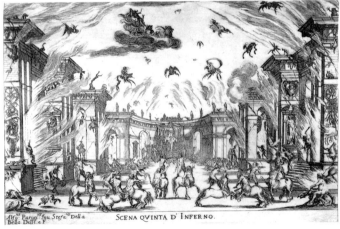

170 Act V, Scene 1: Hades, the realm of Pluto, with Pluto and Persephone enthroned, Ceres and Mercury on a chariot in the clouds, and the dance of the centaurs and devils.

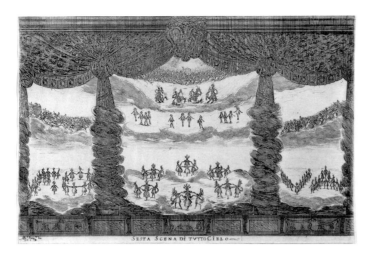

170 Act V, Scene 2, Finale: The heavens, with Jupiter and the gods, Castor, Pollux, and four horsemen in an equestrian ballet; infant cupids dancing on clouds; celestial chorus and orchestra on clouds; cavaliers of Diana and Apollo dancing in the center; and dancers forming the letters "FO" and "VA."

Ducal territory and thus were not imported for the event. Parigi's theatrics apparently stunned the audience, for after the conclusion of the four-hour opera, in the early hours of the morning, they called out for more. This grand work was Parigi's last theatrical design and has proven to be his most original contribution to baroque sceneography and theatrical technique (Blumenthal, p. 177).

BIBLIOGRAPHY

Blumenthal, Arthur R. *Theater Art of the Medici*. Hanover, N.H.: Dartmouth College Museum and Galleries, 1980. Esp. pp. 160–79.

Nagler, A. M. *Theatre Festivals of the Medici, 1539–1637*. New Haven: Yale University Press, 1964. Esp. pp. 162–74.

STEFANO DELLA BELLA
Italian, 1610–64
(after ALFONSO PARIGI, Italian 1606–56)

171 *"Proteo e Fama": The Ship of Columbus and a Formation of Knights Entering the Amphitheater in the Boboli Gardens with a Whale Issuing from a Grotto*

After 1652
Etching
27.5 x 43.5 cm. (10¾ x 17⅛ in.)
Harvard Theatre Collection, Harvard University, Cambridge, Massachusetts

On the night of April 28, 1652, the amphitheater of the Boboli Gardens behind the Pitti Palace was the site of a spectacular festival to mark the visit to Florence of Anna de' Medici (1616–60), youngest daughter of Cosimo II, who was married to Ferdinand Karl of Austria, the son of Claudia de' Medici and Archduke Leopold V of Tyrol (Blumenthal, pp. 183–85). The festival included an equestrian ballet and joust; the scenography, costumes, and decorations for the event were designed by Alfonso Parigi.

This print by Stefano della Bella shows the amphitheater as seen from the palace. At the entrance from the gardens, in the far background, is a mountain with the double-headed eagle of the Habsburgs at its summit. An enormous whale is being pulled toward the entrance of the amphitheater. The conceit of the ballet was that Neptune had changed Christopher Columbus's ship into a whale for having challenged the authority of the sea god. Proteus, Neptune's son, later changed the whale back into a ship, and Fame challenged the attendant knights of Germany and Spain (the two houses of the Habsburgs) to fight for the honor of Austria against the Turks.

Della Bella depicts both stages in the event, as the whale is evident in the background and the ship in the foreground. Evidently, Ferdinando Tacca, Alfonso Parigi's assistant in charge of the ballet's theatrical machinery, designed a small "ship" that could be telescoped into a whale-like vehicle. This delighted the spectators, who saw Winged Fame and Proteus seated on a cloud at the top of the poop of the ship. The torch-lit parade ended with a fully orchestrated and choreographed equestrian ballet.

BIBLIOGRAPHY

Blumenthal, Arthur R. *Theater Art of the Medici*. Hanover,

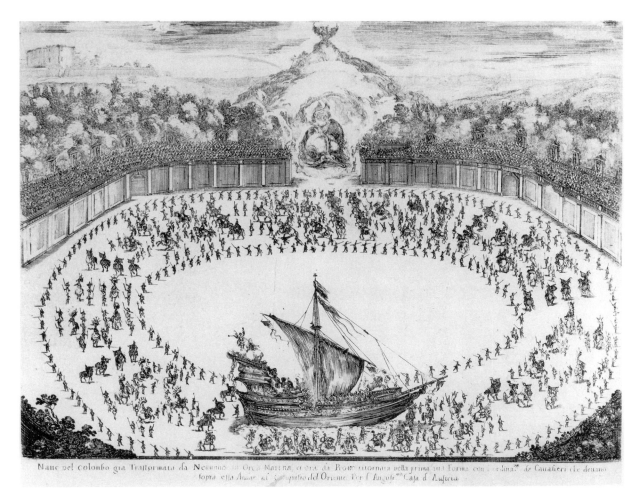

Naue pel colonbo gia Trasformata da Nettunno in Orca Marrina, et ora di Proto ritornata nella prima sua forma con i ordinat.me de Cauallieri che deuano
sopra essa Amar al Conquisto del Oriente Per l'Auguli.ma Casa d'Austria

171

N.H.: Dartmouth College Museum and Galleries, 1980.
Esp. pp. 185–86.

Massar, Phyllis Dearborn. *Presenting Stefano della Bella: Seventeenth Century Printmaker.* New York: The Metropolitan Museum of Art, 1971. Esp. pp. 26–27.

STEFANO DELLA BELLA
Italian, 1610–64
(after FERDINANDO TACCA, Italian, 1619–86)

172 *"Il mondo festeggiante": Equestrian Ballet in the Amphitheater of the Boboli Gardens — Entry of Prince Cosimo as Hercules, Chariots of Sun and Moon, and Knights of Four Continents Parading around Giant*

Figure of Atlas Supporting the Heavens on His Shoulders

1661
Etching
28.7 x 43.5 cm. (11⅜ x 17⅛ in.)
Harvard Theatre Collection, Harvard University, Cambridge, Massachusetts
Edwin Binney, 3rd, Collection
Acc. no. Binney SD 227

In April 1661 Cosimo III de' Medici, son of Ferdinand II, was married by proxy to an unwilling Marguerite Louise of Orléans in the chapel of the Louvre. Louis XIV, first cousin and guardian of Marguerite, wished to marry her to the son of the Tuscan grand duke for political reasons. She, however, was in love with Prince Charles of Lorraine, and pleaded not to be sent to Florence. With Cardinal Mazarin scheming to

401

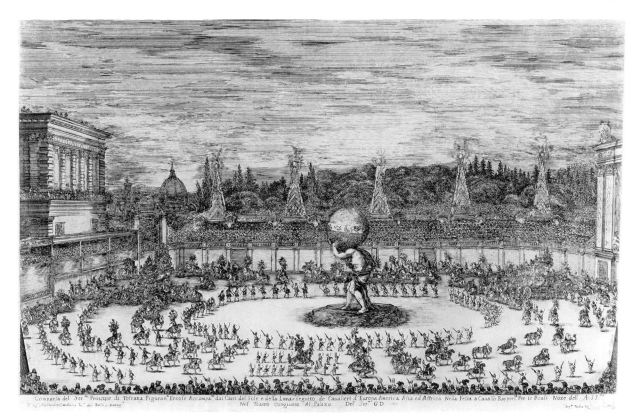

Comparía del Ser.ᵐᵒ Principe di Tofcana Figuran Ercole Accompaᵗ dai Carri del Sole e della Luna e feguito de Caualieri d'Europa America Afia ed Affrica Nella Fefta a Cauallo Rappreᵗ Per le Reali Noze dell A S S.ᵐᵉ
Nel Teatro Congiunto Al Palazzo Del Ser.ᵐᵒ G D.

aid Louis XIV in his political ambitions, Marguerite was sent to Florence to join her new husband. She entered the city on June 23 and thus began twenty days of festivities meant, as much as anything, to impress the French diplomatic representatives in young Marguerite's company (Blumenthal, pp. 194–99).

Among the events, the equestrian ballet of July 1 was the most impressive. Designed by Ferdinando Tacca, previously assistant to Alfonso Parigi but now architect to Ferdinand II and stage designer for the entire festivities, it took place in the amphitheater of the Boboli Gardens before twenty thousand spectators. Stefano della Bella made three etchings after Tacca's designs for inclusion in a description of the ballet. This was handed out to thousands of spectators before the ballet and was meant to aid them in understanding the complicated symbolism of the story.

As della Bella's print shows, the amphitheater was illuminated by numerous wax torches set atop enormous pyramids. Barely visible on the far right is a grand triumphal arch, a temporary structure decorated with the arms of the Medici and the Orléans families. A colossal figure of Atlas bearing the heavens on his shoulders has just been drawn through the triumphal arch and stands in the center of the am-

phitheater. The ballet's main theme was that Atlas has come to tell the spectators that Hercules, Apollo, and Diana had descended from heaven to attend the wedding of Cosimo and Marguerite. Knights from every part of the world have come to meet Hercules, played by Cosimo himself, who is on horseback in the center and wears an enormous headdress. Twenty torchlight bearers are on either side of him, while the chariots of Diana and Apollo are drawn around the amphitheater and led by the knights of the four continents, Europe, America, Asia, and Africa.

In the second part of this extraordinary ballet, the figure of Atlas splits in two and is transformed into Mount Atlas. The chariots of Diana and Apollo are then drawn to either side of the mountain and a formation of torchbearers gathers before them and on either side of Cosimo-Hercules. The ballet is now directed to the grand ducal box, and everyone sings the praises of the hosts and the newlyweds.

The celebration, as grand as any of the century, was the last Medici wedding festival. The lavishness of its production masked a rapid decline in Medici fortunes, as the Florentine family was actually suffering from crippling economic problems and a weakened political position. This print by della Bella therefore

402

marks the last in a great line of prints commissioned from the most important Florentine etchers of the century to record the theatrical designs of Medici festivals.

BIBLIOGRAPHY

Blumenthal, Arthur R. *Theater Art of the Medici*. Hanover, N.H.: Dartmouth College Museum and Galleries, 1980. Esp. pp. 194–96.

ISRAEL SILVESTRE
French, 1621–91
(after GIACOMO TORELLI, Italian, 1636–1707)

173 *"Aprestées aux noces de Pelée et Thetis": Set Designs for the Third Scene and Seventh Scene*

Paris, 1654
Etchings

Copy A: Third Scene
22.8 x 30.5 cm. (9 x 12⅛ in.)
The Metropolitan Museum of Art, New York
The Elisha Whittelsey Collection, The Elisha Whittelsey Fund, 1951
Acc. no. 51.501.4157
Venues: DC, NC

Copy B: Seventh Scene
22.6 x 30.2 cm. (9 x 12⅛ in.)
The Metropolitan Museum of Art, New York
The Elisha Whittelsey Collection, The Elisha Whittelsey Fund, 1951
Acc. no. 51.501.4161
Venues: HO, HI

Giacomo Torelli was one of the most important stage designers of the seventeenth century and a key figure

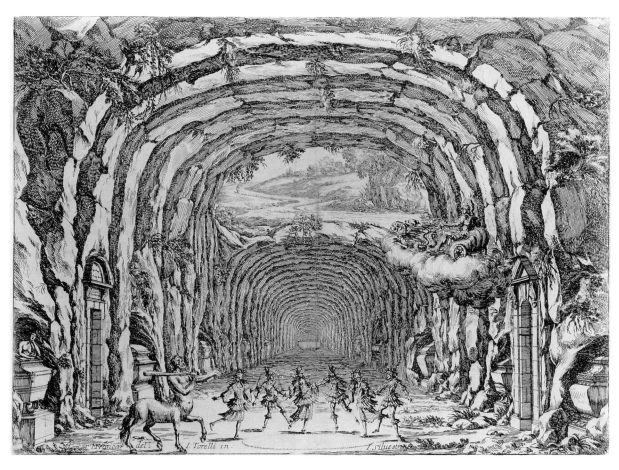

173A

403

in the transmission of the ideals of Italian theater to northern Europe. A native of Fano in northern Italy, he first made a name for himself in Venice, where between 1641 and 1645 he produced seven operas at the recently constructed Teatro Novissimo. From 1645 to 1661 Torelli worked in Paris, producing ballets, operas, and tragedies for the court of the dowager queen, Anne of Austria, and later Louis XIV. Following this long sojourn, he returned to Fano, where in addition to his activities as a stage designer he served as a member of the town council.

Called the great sorcerer (*il gran stregone*) by his contemporaries, Torelli developed and perfected stage machinery that greatly heightened the seemingly magical effects of theatrical productions. The most important of these devices was the chariot and pole system, which allowed the two-dimensional flat wings of a set to be changed simultaneously. Previously, the separate wings of a stage set had to be changed manually by a team of men who, however well trained, could not be perfectly coordinated in their movements. With the system designed by Torelli, the flats were all brought under the control of a central winch beneath the stage floor. The flats were attached to wheeled carriages (or chariots) through slits in the floor, and these carriages in turn were connected by cables to the main winch. When a counterweight was released, the winch revolved, thus causing the wings to suddenly move backward or forward. This system enabled designers to increase the number of set changes and to introduce many more flats to create the illusion of a vast space extending behind the proscenium.

Before Torelli's time, changes in scenery were coordinated with the structural breaks of the play or opera, and the audience usually was diverted by other entertainments. With the chariot and pole system, however, Torelli could make daring set changes *within* acts and thus arouse the audience's sense of wonder by a succession of transformations that occurred without interruption and in an apparently mysterious way.

One of Torelli's most famous productions, *Les Noces de Pelée et de Thetis* (The Marriage of Peleus and Thetis), was staged in Paris in 1654. Israël Silvestre's prints of this performance reveal the complexity and the grandeur of the sets, with their numerous wings and deep perspective views. While an enormous grotto was created in one act, the impression of a heavenly paradise was made for another. Torelli's elaborate production incorporated all the stage designer's tricks: cloud machines, illusionistic floods, fires, and smoke, as well as simulated thunder and lightning.

The figures of gods and goddesses appeared, as if by magic, in the air, while terrifying monsters seemed to rise up from the ground. A production that required dozens of scene changes, it was a visual and aural marvel for those who saw it and a spectacle that offered abundant evidence of Torelli's ingenuity and his imaginative powers.

BIBLIOGRAPHY

Baur, Margarete. *The Baroque Theatre: A Cultural History of the 17th and 18th Centuries.* New York: McGraw-Hill, 1967.
Berthold, Margot. *A History of World Theater.* Trans. Edith Simmons. New York: Ungar, 1972.
Bjürstrom, Per. *Giacomo Torelli and Baroque Stage Design.* Stockholm: Nationalmuseum, 1962. Esp. pp. 160–75.

JOSEF FURTTENBACH
German, 1591–1667

174 *Mannhaffter Kunstspiegel*

Ausburg, Johann Schultes, 1663
Illustrated book
30.6 x 20.8 x 4.1 cm. (12 x 8⅛ x 1⅝ in.)
New York Public Library, New York
Astor, Lenox and Tilden Foundations
Science and Technology Research Center
Acc. no. OAD + 1663

Josef Furttenbach, a native of Leutkirch in southern Germany, is a major figure in the history of theater design. He spent approximately ten years in Italy, traveling to such city centers as Genoa, Milan, Verona, Florence, and Rome. After the Italian sojourn, which he described in *Newes Itinerarium Italiae* (1627), Furttenbach settled in the German city of Ulm. He became a successful and highly respected architect and engineer and published numerous illustrated treatises covering a wide range of topics: gunpowder and fireworks; civil, naval, and military architecture; private homes; and recreational architecture for parks and gardens. Following two major publications on architecture (*Architectura civilis* of 1628 and *Architectura recreationis* of 1640), he published *Mannhaffter Kunstspiegel* (Noble Mirror of Art) in 1663. A strange compendium, it consists of sixteen treatises, many of which provide new information on subjects he had treated before: arithmetic, geometry, planimetrics, geography, astronomy, navigation, perspective, scenery, mechanics, grottoes, water fountains, gunpowder, and architecture.

Mannhaffter Kunstspiegel, and parts of the earlier books also, have become well known for the information they give about the late-Renaissance theater and related forms of entertainment. Additionally, they reveal how Furttenbach was instrumental in carrying back to his native Germany the principles and methods of stage design he learned in Italy. The performances staged by Giulio Parigi for the Medici court in Florence made an especially deep impression on him. Furttenbach aspired to emulate these magnificent productions in the theater at Ulm, but, to his regret, the small provincial city had no great patrons (or, as he called them, "enemies to ugly stinginess") who could underwrite such extravagances. Even though many of the productions described by Furttenbach were not realized in the Ulm theater, the author repeatedly states that the task of the stage designer is to create effects of surprise and wonder.

The volume contains the only detailed accounts of stage lighting from this period, as well as instructions for creating rain and hail, a rushing wind, thunder and lightning, and for making cloud and wave machines. One of the clouds, which could be raised and lowered by ropes attached to a windlass, was, he says, especially suitable for plays of the Nativity. A box-like apparatus was outfitted with benches upon which young boys dressed as angels could sit. The interior of the box was "lined with pieces of beaten brass or gold tinsel," which, when illuminated by candles concealed behind the frame of illusionisticallly painted clouds, gave off a shimmering light. Elsewhere in the *Mannhaffter Kunstspiegel* Furttenbach describes machines for "still waves," "a sliding wave," "violent waves," and an "upstanding wave." The first two types were created by painting waves on flat boards that then were moved back and forth along grooves in the stage floor. The third type consisted of a roller (or long drum) to which boards painted with wild waves were attached. When the roller was turned, "like a roast-spit," the illusion of a stormy sea was created. The last type, used in combination with the "violent wave" machine, operated differently. Boards, fourteen feet long, were set vertically in the rear pit of the stage. Operated by levers and counterweights, the waves could be raised and lowered at the appropriate points in a play. According to Furttenbach they were particularly effective in a tragicomedy about Jonah and the whale. The "sight made the hair of the spectators stand on end and brought tears to their eyes," he notes with characteristic enthusiasm; "the whole action produced a great effect and almost broke the hearts of the audience."

174 An "upstanding" wave (detail). Woodcut.

BIBLIOGRAPHY

Hewitt, Barnard, ed. *The Renaissance Stage: Documents of Serlio, Sabbattini and Furttenbach*. Trans. Allardyce Nicoll, John H. McDowell, George R. Kernodle. Coral Gables, Fla.: University of Miami Press, 1958. Esp. pp. 178–251.

Kindermann, Heinz. *Theatergeschichte Europas*. Vols. 2, 3. Salzburg: Otto Müller Verlag, 1959.

Nagler, A. M. "The Furttenbach Theater in Ulm." *Theater Annual* 11 (1953): 45–69.

Zucker, Paul. "Furttenbach (Furttembach) Josef." *Allgemeines Lexikon der Bildenden Künstler*. Vol. 12. Ed. Ulrich Thieme and Felix Becker. Leipzig: E. A. Seemann, 1916. Esp pp. 605–6.

405

MELCHIOR KUSSEL
German, 1626–83
(after LUDOVICO BURNACINI,
Austrian, 1636–1707)

175 *Il pomo d'oro: Entrance to Hell*

1667
Engraving
Each approx. 26.7 x 43.7 cm. (10⅝ x 18⅞ in.)

Copy A: The Metropolitan Museum of Art,
New York
Harris Brisbane Dick Fund, 1953
Acc. no. 53.600.3545
Venues: DC, NC

Copy B: Harvard Theatre Collection, Harvard
University, Cambridge, Massachusetts
Edwin Binney, 3rd, Collection
Acc. no. SD
Venues: HO, HI

In the second half of the seventeenth century the most lavish theatrical productions were staged at the imperial court in Vienna. Here, between 1652 and 1707, Giovanni Burnacini, a stage designer who had worked previously in Venice and Mantua, and his son

Ludovico Ottavio gained international fame creating spectacles that could have been financed only by patrons with enormous wealth.

Together, the Burnacini designed more than 115 spectacles; of these, the most famous was Ludovico's production of Antonio Draghi's *Il pomo d'oro* (The Golden Apple). The five-act opera told the story of the judgment of Paris and was planned for the occasion of Leopold I's wedding to Margherita of Spain. The opera involved twenty-three set changes, thirty-five machines, and, in the final scene, three groups of dancers who performed simultaneously on the land, in the sea, and in the air.

Melchior Küssel's engraving of one of the sets—a representation of a Hell Mouth—vividly conveys the extraordinary scale and complexity of the Burnacini's production. A gigantic monstrous head fills the forward part of the stage: smoke and fire seem to pour out of its ears and nostrils, while through its gaping mouth a choppy sea and distant view of a burning city can be seen. The painted flats and machinery employed for this and other sets of the opera created a series of illusions—by turns terrifying, joyous, and resplendent—to surprise the unwary audience and excite the greatest possible wonder.

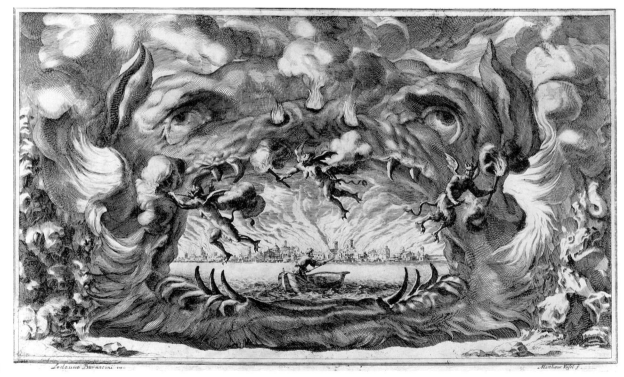

175

406

THE CATALOGUE

BIBLIOGRAPHY

Baur-Heinhold, Margarete. *The Baroque Theater: A Cultural History of the 17th and 18th Centuries*. New York: McGraw-Hill, 1967.

Berthold, Margot. *A History of World Theater*. New York: Ungar, 1972.

Biach-Schiffmann, Flora. *Giovanni and Ludovico Burnacini: Theater und Feste am Wiener Hof*. Vienna and Berlin: Krystall, 1931.

Kindermann, Heinz. *Theatergeschichte Europas*. Vols. 2, 3. Salzburg: Otto Müller Verlag, 1959.

Weil, Mark S. *Baroque Theatre and Stage Design*. St. Louis: Gallery of Art, Washington University, 1983. Esp. pp. 28–31.

MELCHIOR KUSSEL
German, 1626–83
(after LUDOVICO BURNACINI,
Austrian, 1636–1707)

176 *"Il pomo d'oro": The Theater at
Vienna, 1667*

Engraving
33.5 x 43.7 cm. (13⅛ x 17¼ in.)
The Metropolitan Museum of Art, New York

Harris Brisbane Dick Fund, 1953
Acc. no. 53.600.3561

This engraving depicts the court theater in Vienna as it was designed by Ludovico Burnacini for the performance of the opera *Il pomo d'oro* (The Golden Apple). Here, unlike earlier theaters, the dais is moved forward, close to the stage, thus permitting rows of seats to fill up most of the auditorium (Weil, p. 29). Additionally, the orchestra is located between the stage and the auditorium. These two innovations, now standard features of theater design, had the effect of making a distinct separation between the audience and the performance on the stage, or, to put it another way, between reality and illusion. Whereas previously the marvels of theatrical performances extended into the space of the spectator, they were now confined to the stage, taking place in a world set apart from the audience (see cat. no. 169).

BIBLIOGRAPHY

Weil, Mark S. *Baroque Theatre and Stage Design*. St. Louis: Gallery of Art, Washington University, 1983. Esp. pp. 28–31.

176

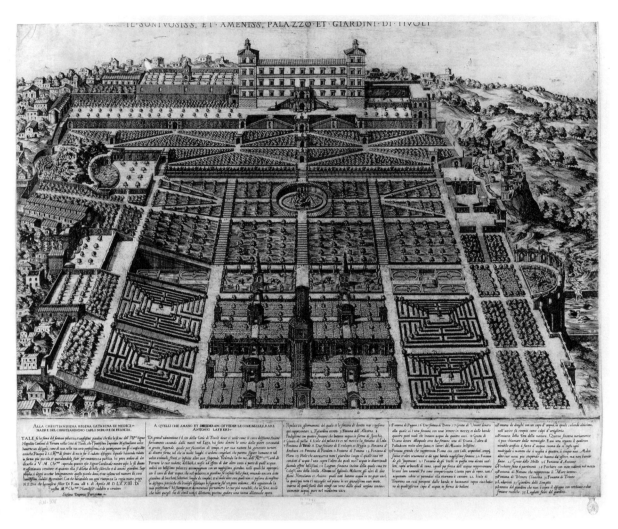

177

ETIENNE DUPERAC
French, 1525/35–1604

177 *Il Sontuosiss. et ameniss. palazzo e giardino di Tivoli*

1573
Engraving
48.6 x 58 cm. (19⅛ x 22⅞ in.)
Avery Architectural and Fine Arts Library,
 Columbia University, New York

This large plan of the gardens at the Villa d'Este, Tivoli, was executed by Etienne Dupérac, a Frenchman who lived and worked in Rome from about 1559 to 1578. During this period Dupérac gained his reputation as a printmaker, particularly for his accurately rendered views of architectural monuments and an-

cient ruins. Dupérac's prints were published by another French resident in Rome, Antonio Lafreri, and during the 1560s and 1570s the two men collaborated on several projects, including the design and publication of the bird's-eye *Plan of Ancient Rome*. The work for which Dupérac is best known, however, is the series of prints published in 1575 under the title *I vestigi dell' antichità di Roma* (The Ruins of Ancient Rome).

The plan of the gardens at Tivoli antedates *I vestigi* by two years and usually, as is the case with the impression exhibited here, was included in Lafreri's famous 1575 production, *Speculum romanae magnificentiae* (Mirror of Roman Magnificence). The engraving is based on a lost drawing of the gardens made by Dupérac sometime in 1571. As Coffin observes, the drawing probably was made after a projected design for the garden, since the engraving contains several

elements that were never constructed (1960, p. 15 n.3). Nonetheless, Dupérac's print stands as an important visual document of the gardens, offering the viewer reliable evidence about their original appearance.

The impressive garden complex was designed by Piero Ligorio for Cardinal Ippolito d'Este, who in 1550 was named governor of Tivoli, a hill town approximately twenty miles east of Rome. The refashioning of the governor's official residence, an old monastery, and the surrounding land began in 1551 and continued until the cardinal's death in 1572. This mammoth project—which involved moving great quantities of earth; constructing conduits and reservoirs; mass plantings of trees and shrubs; building terraces, staircases, fountains, ponds; and the transformation of the monastery into a summer palace—was a triumph of engineering and of architectural and landscape design. The grandest of late-sixteenth-century Italian gardens, it drew lavish praise from visitors, especially for its hydraulic-mechanical marvels, its great abundance of water, and its spectacular vistas.

The symbolic program of the garden revolved about the themes of virtue and vice, the relationship of nature to art, and the achievements of Cardinal Ippolito as patron of the arts (Coffin, 1979, pp. 327–329; Coffin, 1960, Chapter V). These interrelated themes, which drew heavily on the poetic imagery of Ovid, were presented to the visitor in many stages, beginning at the northwest entrance (the portal visible at the bottom of Dupérac's plan) and proceeding to the summer palace on the crest of the hill. Owing to the numerous cross axes and diagonal ramps of the garden's design, however, the visitor was constantly diverted from the central path. Encouraged to explore all parts of the garden, he thus would experience the multiplicity and variety of its forms, see and hear its many changing water displays, and be taken unawares by dripping handrails, weeping holes in garden benches, sudden spurts of water from trick paving stones, and other similar *giocchi d'acqua* (Coffin, 1979, pp. 326–27). A place of surprise, spectacle, and great beauty, the garden at the Villa d'Este became a favorite attraction for visitors traveling through Italy. Through Dupérac's engraving, which was republished and reprinted in other versions, its fame quickly spread to most parts of Europe.

BIBLIOGRAPHY

Ciprut, Edouard Jacques. "Nouveaux documents sur Etienne Dupérac." *Bulletin de la Société de l'histoire de l'art français* (1960): 161–73.

Coffin, David R. *The Villa d'Este at Tivoli.* Princeton: Princeton University Press, 1960.
Coffin, David R. *The Villa in the Life of Renaissance Rome.* Princeton: Princeton University Press, 1979.
Hulsen, Christian. "Das 'Speculum Romanae Magnificentiae' des Antonio Lafreri." In *Collectanea Varie Doctrinae Leoni S. Olshki.* Munich: J. Rosenthal. 1921. Esp. pp.121–70.
Robert-Dumesnil, A. P. F. *Le Peintre-graveur français.* Paris: Mme. Bouchard-Huzard, 1885–71. Reprint. Paris, 1967. Esp. vol. 8, pp. 87–117; vol. 11, pp. 85–86.

GIOVANNI BATTISTA FALDA
Italian, ca. 1640/3–1678

178 *Le fontane di Roma*

Part 4
Rome, ca. 1690
Illustrated book
Each approx. 28 x 40 cm. (11 x 15⅝ in.)

COPY A: Dumbarton Oaks, Trustees for Harvard University, Washington, D.C.
Venues: DC, NC

COPY B: Avery Architectural and Fine Arts Library, Columbia University, New York
Acc. no. AA 9400 R73 f.
Venues: HO, HI

Giovanni Battista Falda was one of Italy's most accomplished printmakers in the second half of the seventeenth century. Born in a small town in Lombardy, he spent most of his life in Rome, where he mastered the art of engraving and etching. Although his career was not long, he produced a great many prints, notably those illustrating the gardens, fountains, piazzas, and palaces of Rome and nearby Frascati. Toward the end of his career, Falda was joined in his efforts by Giovanni Francesco Venturini, a Roman who had studied engraving under Giovanni Battistta Galestruzzi. Venturini was responsible for the series of twenty-six engravings of the Villa d'Este, which here comprise the fourth part of Falda's *Le fontane di Roma* (1675). The plates of Tivoli give detailed views of the fountains as they appeared in the late seventeenth century and like Dupérac's plan provide important visual documentation of monuments that either were destroyed or significantly changed over the centuries.

The Fountain of the Water Organ (Fontana dell'organo), constructed on the northeast slope of the garden, looked over rectangular fishpools forming the garden's first dominant cross axis. (It appears about halfway up on the left side of Dupérac's plan.)

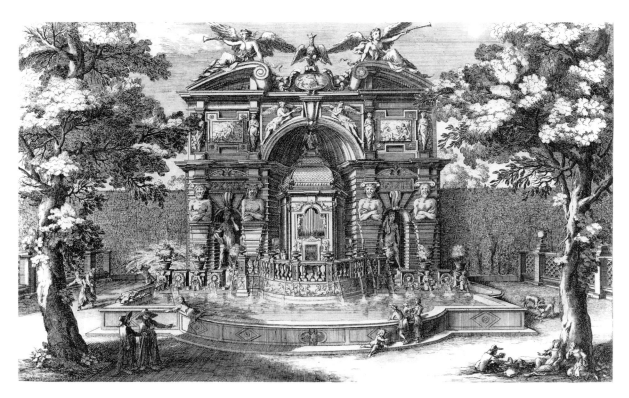

178 Fountain of the Water Organ. Engraving.

The fountain consisted of an impressive architectural front with three niches. The large central niche originally contained a statue symbolic of Mother Nature, the many breasted Diana of Ephesus. In the seventeenth century, as the print shows, the statue was replaced with a temple-like structure. The mechanical apparatus of the organ, set behind the figure of Diana, was activated by water rushing into an enclosed cavity. While this action forced air through the organ pipes, another mechanism, also water driven, opened and closed the pipes, thereby creating the music. The water organ recalled hydraulic mechanisms described by the ancient writers Vitruvius and Hero of Alexandria, but whereas the ancient devices included keys that had to be played by an organist, all that was necessary at Tivoli was to set the water going. An ingenious design, requiring minimum human intervention, it was considered one of the wonders of its time (Coffin, 1960, p. 17).

Another of the famous hydraulic marvels at Tivoli was the Owl Fountain (Teatro e fontana della civetta). This was constructed on the southwest side of the garden, at the end of the second major cross axis, the Alley of One Hundred Fountains. (It appears on the right side of Dupérac's plan, just below the rectangular space framed by staircases.) The fountain, set within an imposing architectural frame, consisted of

an artificial mount, a vase with three youths (made of stucco) holding a wineskin, and numerous bronze birds, including an owl perched on the rim of the vase. This was an elaborate version of a hydraulic marvel described by Hero of Alexandria. By means of a mechanism hidden inside the rocky mount, the fountain simulated the sounds of chirping birds. Based on simple pneumatic principles, water flowed into a sealed chamber, forcing the air within to escape through pipes inside the birds. Their singing came to an end once most of the air had been displaced by water. Meanwhile, as the water rose to the top of the concealed chamber, it emptied through another pipe, causing the owl to screech. Simultaneously, the emptying water activated a winch that made the owl turn in the direction of the other birds. Thus it seemed that the birds had been silenced by the frightening action and cry of the owl. This mechanism was enhanced by water flowing from the wineskin held by the youths. The water spilled into the vase and thence into a pool surrounding the whole ensemble. In addition, the paving stones in this part of the garden were outfitted with trick spouts which sent sudden jets of water into the faces of unsuspecting visitors. A fountian complex filled with unexpected delights, it was one of the favorite attractions at the Villa d'Este.

The focal point of the gardens at the Villa d'Este

was the Fountain of the Dragons (Fontana dei Draghi), which was situated along the central axis about halfway up the steep hill rising to the summer palace. Its various elements were intended to symbolize the mythical garden of the Hesperides and Hercules's decision to take the difficult path of virtue as opposed to the easy road of vice. As originally planned, the large oval basin was to include the many-headed dragon, the guardian of the golden apples, who was vanquished by Hercules. However, four winged dragons were constructed instead, as a reference to the personal device of Pope Gregory XIII, who visited the Villa in 1573 (Coffin, 1960, pp. 78–81). The theme of virtue and vice, which alluded to the moral choice of Cardinal d'Este, was expressed by the divergent paths visitors encountered in this part of the garden. They could follow the garden walk to the left or right of the fountain or could ascend one of the two semicircular staircases that framed the oval basin. The fountain complex was also supposed to have three statues of Hercules, including a colossal figure of the hero victorious after his struggle with the dragon (Coffin, 1960, p. 80).

According to contemporary accounts, the fountain was an extraordinary visual and aural spectacle. While the four dragons spit water into the oval basin, a huge jet of water simultaneously rose above them. The gushing jets of water varied in intensity, so that the fountain produced a variety of remarkable sounds. According to Antonio del Re, a historian who wrote of the Villa d'Este in 1611, "it made explosions like a small mortar, or many arquebuses discharged together; and at times it grew larger like a pavilion representing a downpour of rain" (del Re, p. 65; cited in Coffin, 1960, p. 22). Supplementing this hydraulic wonder were the trick handrails of the surrounding staircases. As unsuspecting visitors discovered, they were not secure, dry handholds, but conduits for rippling streams of water.

BIBLIOGRAPHY

Coffin, David R. *The Villa d'Este at Tivoli.* Princeton: Princeton University Press, 1960.

Coffin, David R. *The Villa in the Life of Renaissance Rome.* Princeton: Princeton University Press, 1979. Esp. pp. 311–40.

Del Re, Antonio *Dell'Antichità tiburtine Capitolo V.* Rome: Giacomo Mascardi, 1611. Esp. p. 65.

Kristeller, Paul. "Falda, Giovanni Battista." *Allgemeines Lexikon der Bilden Künstler.* Vol. 11. Ed. Ulrich Thieme and Felix Becker. Leipzig: E.A. Seemann, 1915. Esp. p. 226.

Servolini, L. "Venturini, Giovanni Francesco." *Allgemeines Lexikon der Bildenden Künstler.* Vol. 34. Ed. Ulrich Thieme and Felix Becker. Leipzig: E.A. Seemann, 1940. Esp. p. 218.

STEFANO DELLA BELLA
Italian, 1610–64

179 *Views of the Villa at Pratolino: Colossal Statue of the Apennines*

ca. 1652
Etching
Each approx. 37 x 24 cm. (14½ x 9½ in.)

Copy A: Private Collection
Venues: DC, NC

Copy B: The Cleveland Museum of Art, Cleveland, Ohio
Gift of The John D. Proctor Foundation
Acc. no. 88.113
Venues: HO, HI

This is one of several etchings by Stefano della Bella (see cat. no. 170) illustrating the marvels of the Medici villa at Pratolino. The most prominent feature of the gardens surrounding the villa, which were laid out between 1568 and 1588, was a colossal figure personifying the Apennine mountains. Executed by Giovanni da Bologna, the huge statue, which still exists, recalls several passages in Ovid's *Metamorphoses* (Hunt, p. 55) and brings to mind also Pliny the Elder's story of the architect Dinocrates, who proposed shaping Mount Athos into the statue of a man (*Natural History*, Book VII, ch. 37). Da Bologna's ability to transform nature by art—to give living stone the semblance of a man—is emphasized in della Bella's print. The huge, shaggy figure, still part of his rocky environment, towers above the semicircular fish pond and by the strength of his powerful hand, so it seems, forces a cascade of water out of the head of a monster. The remarkable figure held additional delights for sixteenth- and seventeenth-century visitors to Pratolino, for its interior chambers (one of which was inside the head) were decorated with frescoes showing muscled men mining precious ores in the earth's interior.

BIBLIOGRAPHY

Hunt, John Dixon. *Garden and Grove: The Italian Renaissance Garden in the English Imagination, 1600–1750.* Princeton: Princeton University Press, 1986.

Massar, Phyllis Dearborn. *Presenting Stefano della Bella: Seventeenth-Century Printmaker.* New York: Metropolitan Museum of Art, 1971.

Zangheri, Luigi. *Pratolino: il giardino delle meraviglie.* 2 vols. Florence: Gonnelli, 1979.

411

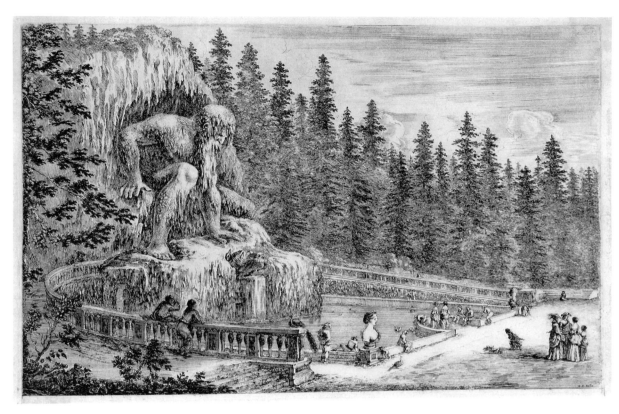

179B

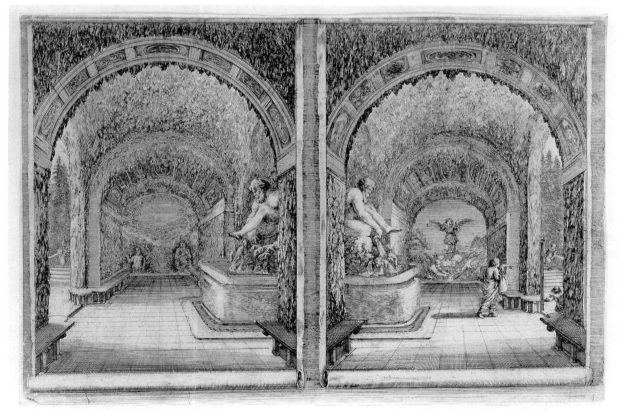

180B

412

STEFANO DELLA BELLA
Italian, 1610–64

180 *Views of the Villa at Pratolino: Grotto of Fame*

ca. 1652
Etching
Each approx. 25 x 36.8 cm. (9⅞ x 14½ in.)
Copy A: Private Collection
Venues: DC, NC

Copy B: The Cleveland Museum of Art,
Cleveland, Ohio
Gift of The John D. Proctor Foundation
Acc. no. 88.112
Venues: HO, HI

In this etching Stefano della Bella shows part of the famous grottoes that were located under terraces at the Medici villa at Pratolino. Designed by the Florentine artist and engineer Bernardo Buontalenti, the grottoes presented a fantastic world in which statues seemed to move of their own accord, walls dripped water, and musical and natural sounds were simulated. Recalling garden caves known to have been made by the ancients, the grottoes at Pratolino were encrusted with shells, pumice stone, and simulated stalactites. The rough-hewn and bizarre formations gave the impression of mysterious caverns inside the earth, which, in the late Renaissance, appealed to the culture's fascination with natural phenomena and the occult meanings believed to be behind them.

The complex of grottoes consisted of numerous tableaux set in niches and with these, to judge from traveler's accounts, Buontalenti succeeded in creating astonishing illusions. Visitors came upon a myriad of automata and surprising mechanical metamorphoses: trees appeared to rain; a cupid turned a little globe while images of ducks swam about in a pool; a shepherdess walked to a well, filled a pail, and then returned to her niche. The most famous hydraulic wonders, those found in the grotto of Fame (or, the grotto of the Mugnone), are pictured in della Bella's etching. The central feature was a large-scale statue representing the river Mugnone. To the left of the statue was a tableau where visitors could see the figure of Pan playing musical pipes to his mistress, who moved back and forth in front of him. More spectacular was the tableau located to the right of the Mugnone. Here an image of Fame sounded a trumpet, while a clown filled a dish with water. The clown offered the water to a figure of a tiger, who in turn drank the water up, raised is head, and then looked round about him.

Besides the spectacular automata, visitors to the

grottoes encountered the inevitable water tricks, a curious table that had a fountain in its midst, and simulated thunderstorms and floods. Demonstrations of Buontalenti's skills as a hydraulic engineer and as an illusionist, these artful manipulations and recreations of natural forms became the chief models for later garden designs, not only in Italy but also in northern Europe and England.

BIBLIOGRAPHY

Hunt, John Dixon. *Garden and Grove: The Italian Renaissance Garden in the English Imagination, 1600–1750.* Princeton: Princeton University Press, 1986. Esp. pp. 54–56.
Strong, Roy C. *The Renaissance Garden in England.* London: Thames and Hudson, 1979. Esp. pp. 78–82.
Wiles, Bertha Harris. *The Fountains of Florentine Sculptors and Their Followers from Donatello to Bernini.* New York: Hacker Art Books, 1975. Esp. pp. 76–77.
Zangheri, Luigi. *Pratolino; il giardino delle meraviglie.* 2 vols. Florence: Gonnelli, 1979. Esp. pp. 19ff.

GIOVANNI BATTISTA FALDA
Italian, ca. 1640/3–1678

181 *The Room of the Winds in the Theater of the Belvedere di Frascati*

ca. 1670
Etching and engraving
32.5 x 23.5 cm. (12¾ x 9¼ in.)
The New York Public Library, New York
Astor, Lenox and Tilden Foundations
Miriam & Ira D. Wallach Division of Arts, Prints and Photographs
Acc. no. MEZDP
Venues: DC, NC, HO

This handsome print by Falda (see cat. no. 178) records one of the chief attractions in the gardens of the Villa Aldobrandini at Frascati, a hill town outside Rome. The Room of the Winds (also known as the Hall of Apollo) was part of the villa's elaborate water theater. The room was decorated with clever *trompe-l'oeil* fresco paintings illustrating scenes from Ovid's *Metamorphoses.* At one end of the room was a fountain representing Apollo, the muses, and the winged horse Pegasus on Mount Parnassus. A water organ hidden inside the fountain created the impression that the god and his attendants were playing musical instruments. The room contained other marvels and surprises for visitors, such as trick wetting stones and an ingenious copper ball that continually bounced on a jet of air. Not just a toy, the ball was symbolic of the

413

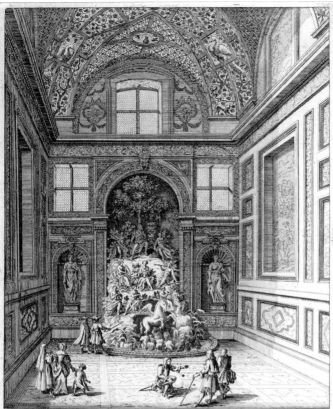

STANZA DE VENTI NEL TEATRO DI BELVEDERE DI FRASCATI CON LA FAMOSA FONTANA DEL MONTE PARNASO CON APOLLINE ET LE MVSE CHE SVONANO CON INSTRVMENTI HIDRAVLICI A FORZA D' ACQVA ARCHITETTVRA DI GIACOMO DELLA PORTA.

Gio-Batta Falda del-et sculp *Gio-Iac-Rossi le stampa in Roma alla Pace con Priu-del-S-P 7*

181

earth. According to one writer of this time, "The earth is a rare piece of [God's] staticks, being hanged upon nothing, as Job saith . . . it hangs in the very center and middle of the world, like a ball in the ayr" (Powell, p. 24).*

* Mark Segal provided this reference to Powell.

BIBLIOGRAPHY

Hunt, John Dixon. *Garden and Grove: The Italian Renaissance Garden in the English Imagination, 1600–1750.* Princeton: Princeton University Press, 1986. Esp. pp. 45–47, 78–79, 93.

Powell, Thomas. *Humane Industry or, A History of Most Manual Arts.* London: Henry Herringman, 1661.

Reed, Sue Welsh, and Richard Wallace. *Italian Etchers of the Renaissance and Baroque.* Boston: Museum of Fine Arts, 1989. Esp. pp. 202–4.

HERO OF ALEXANDRIA
Greek, fl. 1st century A.D.

182 *Gli Artifitiosi e curiosi moti spiritali di Herrone*

Giovanni Battista Aleotti, translator
Ferrara, Vittorio Baldini, 1589
Illustrated book
21.8 x 16 x 1 cm. (8⅝ x 6¼ x ⅜ in.)
The New York Public Library, New York
Astor, Lenox and Tilden Foundations
Science and Technology Research Center
Acc. no. Parsons–*KB 1589

Among the most important sources of inspiration for the hydraulic and mechanical marvels of sixteenth- and seventeenth-century gardens and festivals were the engineering texts of ancient authors, above all those written by Hero of Alexandria. Hero's studies of pneumatics and theatrical automata had been known to the fifteenth century in Latin and Arabic manuscripts, but they gained a much wider audience in 1501 when they were published for the first time in a volume assembled by Lorenzo Valla. The Valla publication was followed by other editions, the most influential of which was perhaps that produced by G.B. Aleotti in 1589. An Italian translation of the *Pneumatics* complete with numerous woodblock illustrations, it provided considerable material for later authors such as John Bate (*The Mysteries of Nature and Art*, 1634) and Salomon de Caus (see cat. no. 183).

Hero's text presents a series of theorems having to do with mechanical and hydraulic problems: the movement of liquids; the contraction and expansion of air; suction; water pressure; the behavior of gas and steam; and the uses of pulleys, winches, and weights. To clarify his scientific principles and to make them easily comprehensible to the reader, he offered demonstrations of moving machines in animal and human forms. These demonstrations are illustrated in Aleotti's book and served as prototypes for many mechanical marvels. Two of the most interesting constructions show "Hercules combatting the dragon in the garden of the Hesperides" and "Smithies at work in a forge." In the first instance, the figures are activated by water falling into a concealed chamber and then into smaller vessels below. Hercules, as a result, raises and lowers his club, and the head of the dragon bobbles up and down. In the illustration shown here of the forge of Vulcan, the tableau comes alive by means of a water wheel and a system of chains, winches, pulleys, and weights. The water wheel causes three of the smithies to strike an

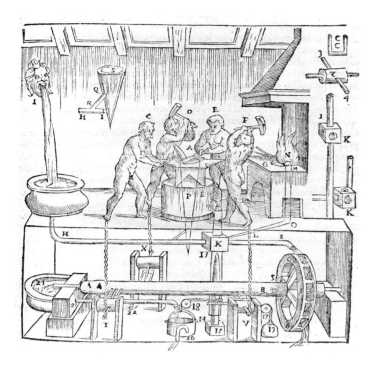

182 Forge of Vulcan. Woodcut.

anvil with their hammers; afterward, a simple turning mechanism redirects the water in the upper conduit. At this point air, entering from the pipe L-O, causes the water to expand and rise through figure E. The "boiling" water gushes on to the anvil and then returns to the main conduit (H-I).

BIBLIOGRAPHY

Brett, G. "The Automata in the Byzantine Throne of Solomon." *Speculum* 29 (1954): 477–87.
Drachmann, Aage Gerhardt. *The Mechanical Technology of Greek and Roman Antiquity.* Copenhagen: Munksgaard, 1963.
Lloyd, Geoffrey Ernest Richard. *Greek Science after Aristotle.* New York: Norton, 1973.
Strong, Roy C. *The Renaissance Garden in England.* London: Thames and Hudson, 1979.

SALOMON DE CAUS
French, ca. 1576?–1626

183 *Les Raisons des forces mouvantes*

Frankfurt, Ian Norton, 1615
Illustrated book
38.5 x 26.3 cm. (15⅛ x 10⅜ in.)
Arthur and Charlotte Vershbow,
 Boston, Massachusetts

Salomon de Caus, a French Huguenot born near Dieppe, was a true polymath whose wide-ranging interests included perspective, painting, geometry and mathematics, music, science, mechanics, and hydraulics. His several publications show that he had studied the works of numerous ancient authors, the most important of which were Pliny, Vitruvius, Euclid, and Hero of Alexandria. Between the years 1595 and 1598 de Caus traveled through Italy, where he was able to observe firsthand the spectacular gardens at Frascati, the Villa d'Este at Tivoli, and the Medici villa at Pratolino. His knowledge of these gardens, as well as of those in France (particularly Fontainebleau and Saint-Germain-en-Laye), played a critical part in the development of garden design and decoration in England, where he moved around 1608. Prior to his sojourn in England, de Caus had served as engineer to Archduke Albert of Brussels and in that capacity was involved in the restoration of the royal gardens, for which he designed fountains and grottoes in the "new" or Italian manner.

De Caus's most important work, however, was undertaken at the English court, initially for the new Queen, Anne of Denmark, and later for her son Henry, the Prince of Wales. While in the service of the queen, de Caus laid out the gardens at Somerset House and Greenwich. Both projects, strongly Italianate in character, gave him the opportunity to work on a large scale and to demonstrate his technical ingenuity in the design of startling hydraulic effects, automata, and other seemingly magical mechanical effects. Even more impressive were his plans for Prince Henry's garden at Richmond. This was to have been a monumental undertaking, including a colossus three times the size of the one at Pratolino, but Henry's premature death cancelled the project.

After leaving England in 1613 de Caus made his way to Heidelberg, where for Prince Henry's sister, Elizabeth, and her husband Frederick V, the Elector Palatine, he created his most famous garden. The Hortus Palatinus was, in a sense, a realization of the project that had to be abandoned at Richmond. It consisted of spectacular terraces and elaborate parterres, and counted among its wonders a river-god fountain, a grotto, and a speaking statue of Hercules-Memnon, obviously based on the one described by Hero of Alexandria.

The marvels for the garden at Somerset, Greenwich, Heidelberg, and elsewhere have long since disappeared, but one can gain a fairly good impression of de Caus's constructions, and the ingenious mechanisms that drove them, in his *Les Raisons des forces mouvantes*, written while he was in Heidelberg.

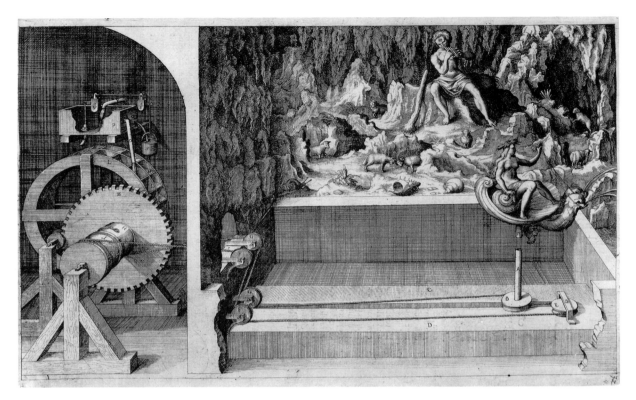

183 Grotto fountain with the figures of Galatea and Polyphemus, and a diagram of the machinery
for its operation. Engraving.

It is divided into three books. The first is devoted to
the theory and practice of hydraulics. Similar to Hero
of Alexandria's *Pneumatics*, it presents a series of
theorems on the effects of water and air and of various
mechanical principles. In book two these principles
are demonstrated by way of specific problems: foun-
tains, water clocks, automata, and other hydraulic
machines. The third book is concerned with the con-
struction of water organs.

Among the problems illustrated in book two is a
design for a grotto similar to one at Pratolino. A
tableau that features the mythical figures of Poly-
phemus and Galatea, it is powered by a double water
wheel and a system of pulleys, winches, and chains.
When water fills chamber P it flows through a pipe
(O) onto the near side of the water wheel. The wheel
moves clockwise, thus causing Galatea to move left
to right along a channel not visible to the be-
holder. Meanwhile water also flows from chamber P
into bucket S. When the bucket is full, the weight of
the water releases a valve (marked R), which thus
empties the water in the chamber onto the far side of
the water wheel. The water wheel then moves in a
counterclockwise direction, causing Galatea to sail
right to left. When all the water is emptied from

chamber P the valve closes, the bucket tips over, and
the cycle begins once more. This mechanism (which
operates on a principle similar to the modern flush
toilet), is complemented by another hidden device, a
hydraulic organ, which creates the sound of Poly-
phemus playing his pipes. Thus, the story of the cyc-
lops and his love for Galatea is made alive for the
beholder both musically and mechanically. As all the
machinery would have been hidden from view, the
visitor to the grotto would have been treated to a
tableau that seemed to move by itself.

BIBLIOGRAPHY

Chapuis, Alfred. *Le Monde des automates*. Paris: Gélis, 1928.
 Esp. pp. 31ff.
Chapuis, Alfred, and Edmond Droz. *Les Automates*. Neu-
 châtel: Griffon, 1949. Esp. pp. 33ff, 77ff.
Maks, C. S. *Salomon de Caus*. Paris, 1935.
Strong, Roy C. *The Renaissance Garden in England*. Lon-
 don: Thames and Hudson, 1979. Esp. chap. 4.

ROBERT PLOT
English, 1640–96

184 *The Natural History of Oxford-Shire*

Oxford, Leon Lichfield, 1705
Illustrated book
Each approx. 32.2 x 21.5 x 3.8 cm.
 (12⅝ x 8½ x 1½ in.)

Copy A: Dibner Library, Smithsonian Institution
 Libraries, Washington, D.C.
 Acc. no. qQH138.09072 CRLS RB

Copy B: Dartmouth College Library, Hanover,
 New Hampshire
 Acc. no. QH/138/09/P7/1705

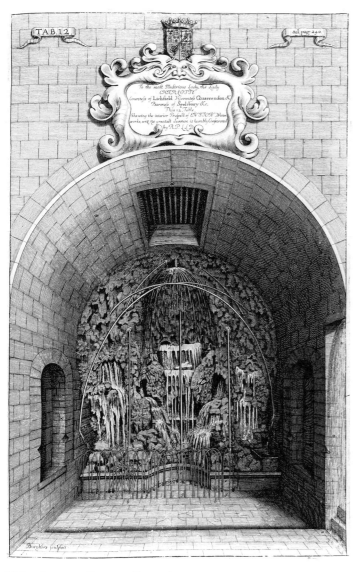

184B Grotto at Enstone. Engraving.

In his *Natural History of Oxford-shire* (originally published in 1677), Robert Plot, the first curator of the Ashmolean Museum and the first professor of chemistry at Oxford University, ponders a wide range of topics: strange and rare stones, antiquities, brutes, people who lived to an extraordinary age, and the origins of springs. He also describes one of the curiosities of early seventeenth-century England: Thomas Bushell's hermitage and grotto, or the Enstone Marvels, as they were called. Bushell, Francis Bacon's servant, was a bizarre man who was keenly interested in the secrets of nature. The grotto, located in the basement of his house, consisted of numerous hydraulic wonders, most of which were based on effects described by Salomon de Caus. There was a curtain of water over the entrance, a nine-foot jet of water that tossed a silver ball in the air, "many strange forms of Beasts, Fishes, and Fowles" that appeared as if by magic, the simulated chirping of nightingales, and strange sounds that "doth highly worke upon any Mans Fancy" (see Strong, p. 132). A spectacular creation that drew the admiration of King Charles and his wife, Henrietta, it demonstrated the close connection between scientific developments and the fantastic world of garden design.

BIBLIOGRAPHY

MacGregor, Arthur, ed. *Trandescant's Rarities: Essays on the Foundation of the Ashmolean Museum.* Oxford: Clarendon Press, 1983. Esp. pp. 44–46, 48–50, 52–54, 56–61.
Strong, Roy C. *The Renaissance Garden in England.* London: Thames and Hudson, 1979. Esp. pp. 130–33.
Thorndike, Lynn. *A History of Magic and Experimental Science.* 8 vols. New York: Columbia University Press, 1923–58. Esp. vol. 8, pp. 49–50, 394–95.

ISRAEL SILVESTRE
French, 1621–91

185 *Les Plaisirs de l'isle enchantée ou les festes, et divertissements du roy a Versailles, divisez en trois journées, et commencez le 7me jour de May, de l'année 1664*

Paris, 1673
Festival book
43.5 x 56.8 cm. (17⅛ x 22⅜ in.)
Tobin Collection, McNay Art Museum,
 San Antonio, Texas
Acc. no. TL1984.1.29 a&b
Venues: HO, HI

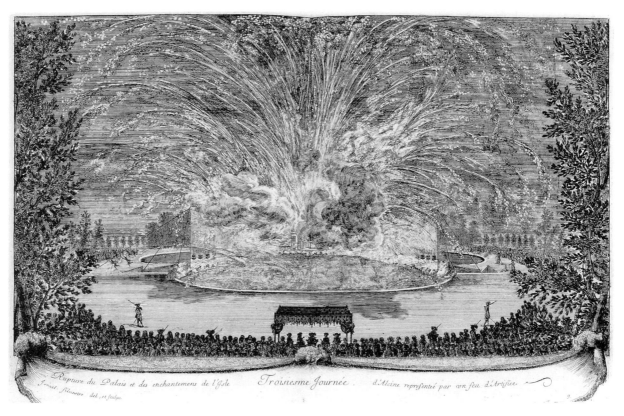

185 Amphitheater and perspective with the Ile d'Alcine. Engraving.

In 1664 Louis XIV mounted what was to be one of the most renowned spectacles of the century. He sponsored an extravaganza in honor of his mistress, Louise de la Vallière, that included equestrian events, banquets, plays by Molière, and music by Lully (Walton, p. 59). The three-day festival revolved around the antics of the witch Armida, a character from *Orlando furioso* by the great Italian poet Ludovico Ariosto. The grand finale to the entertainments was an enactment of the destruction of Armida's enchanted island, which included a spectacular display of fireworks.

As *graveuer ordinaire du roi*, Israël Silvestre recorded the 1664 festival in a series of nine prints; the explosive *rupture du palais* is illustrated here. Silvestre's print reflects the grand vision of Louis XIV and his minister Colbert for the complex of Versailles. In contrast to the earlier Medici festivals, where the dancers and marvelous displays were close at hand, the spectacle at Versailles was staged on a grand scale and at a great distance from the audience. In addition to recording the lavish court events, Silvestre also executed splendid views of the gardens of Versailles and the royal châteaux. His work publicized the transformation of Louis XIII's small hunting lodge into a magnificent stage for the court of Louis XIV. In this way he was instrumental in Colbert's extensive campaign to glorify the king.

BIBLIOGRAPHY

Babelon, Jean-Pierre. *Israël Silvestre: Vues de Paris*. Paris: Berger-Levrault, 1977.

Faucheux, L. E. *Catalogue raisonné de toutes les estampes qui forment l'ouvre d'Israël Silvestre*. Paris: F. de Nobele, 1969. Esp. p. 310.

Walton, Guy. *Louis XIV's Versailles*. Chicago: The University of Chicago Press, 1986.

Woodbridge, Kenneth. *Princely Gardens: The Origins and Development of the French Formal Style*. New York: Rizzoli International Publications, 1986.

418

THE CATALOGUE

JOHN BABINGTON
English, active ca. 1635

186 *Pyrotechnia*

London, Thomas Harper for Ralph Mab, 1635
Illustrated book
29 x 20 x 3.5 cm. (11½ x 8 x 1½ in.)
Chapin Library of Rare Books, Williams College,
 Williamstown, Massachusetts

John Babington was a mathematician and a gunner in the service of King Charles I. His *Pyrotechnia, or a Discourse of Artificiall Fire-works* was the first work in English to deal solely with the subject of fireworks for nonmilitary purposes. Fireworks are for delight, he states, but he also adds that his instructions for making them may excite an ingenious mind to create inventions for use in war.

Pyrotechnic mixtures were probably invented for military use and are thought to have originated in Asia around 1000 A.D. As early as 1232 the Chinese made explosive projectiles, and similar rockets were also known to have been used in India (Brock, p. 20).

Knowledge of such mixtures spread to Europe slowly, and it was a German monk, Bertold Schwarg, who adapted an explosive mixture for use in a gun. The display of fireworks for the purpose of entertainment first occurred in Asia at the end of the thirteenth century and spread to Europe by the sixteenth century. Italy seems to have embraced the practice first; Vannocio Biringuccio in his *De la pirotechnia* (1540) cites the earliest recorded use of fireworks at public celebrations (Brock, p. 29). The Italian practice of erecting elaborate structures and imaginative apparatus influenced the displays of fireworks throughout Europe, and the complex stages and mechanisms illustrated in Babington's treatise are indebted to the Italian manner of displaying fireworks. A large part of his treatise deals with "pyrotechnic automata," devices powered by wheels driven by rocket motors (Philip, p. 15).

On one page, a musical instrument (outfitted like a player piano) is powered by a fire wheel which rotates the music roll and causes little figures to spin around in a circle. The page illustrated here shows two views of a dragon propelled along a wire by lighting rockets in its belly.

BIBLIOGRAPHY

Brock, Alan St. H. *A History of Fireworks*. London: George G. Harrap, 1949.
Philip, Chris. *A Bibliography of Firework Books: Works on Recreative Fireworks from the Sixteenth to the Twentieth Century*. Winchester, Hampshire: St. Paul's Bibliographies, 1985.

JEAN LE PAUTRE
French, 1618–82

187 *The Conquest of the Golden Fleece by the Argonauts: A Theatrical Representation with Fireworks*

ca. 1660
Etching and engraving
21.5 x 26.2 cm. (8⅝ x 10½ in.)
The Metropolitan Museum of Art, New York
Harris Brisbane Dick Fund, 1953
Acc. no. 53.600.3217
Venues: HO, HI

Jean Le Pautre began his industrious career as an etcher who designed architectural plans and ornamental details for a carpenter. He soon devoted himself to printmaking, and during the course of his career made about fifteen hundred etchings and en-

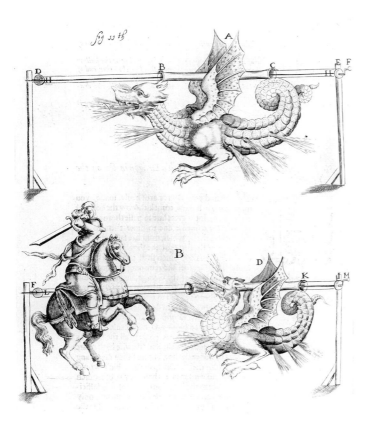

186 Two dragons and a knight on horseback. Engraving.

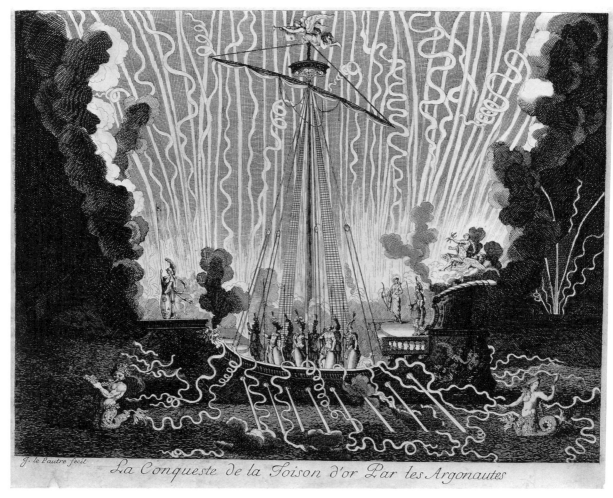

187

La Conqueste de la Toison d'or Par les Argonautes

gravings of architectural decorations, ceilings, vases, and ornaments of all types. With few exceptions, his prints recorded his own designs and are an important repository of the style called Louis XIV (Benezit, p. 591). He became a member of the Academy in 1667 and died in Paris in 1682.

The Conquest of the Golden Fleece gives a visual account of a theatrical tableau performed in France around 1660. The tableau which consisted of a dazzling display of fireworks is most effectively represented by Le Pautre. He captures the shimmering, almost wild, effect of the fireworks as they shoot up behind the *Argo* and emphasizes their reflections on the surface below.

BIBLIOGRAPHY

Benezit, E. "LePautre, Jean." In *Dictionnaire critique et documentaire des peintres, sculpteurs, dessinateurs et graveurs*. Rev. ed. 8 vols. Paris: Librairie Gründ, 1948–55.

Michaud, J. Fr. *Biographie universelle ancienne et moderne*. 45 vols. Paris, Mme. C. Desplaces, 1854–65.

MELCHIOR KUSSEL
German, 1626–83

188 *The Ingenious and Costly Fireworks Displayed in the Royal Enclosure at Vienna, December 8, 1666*

Engraving, after 1666
32 x 36.2 cm. (12⅞ x 14½ in.)
The Metropolitan Museum of Art, New York
Harris Brisbane Dick Fund, 1953
Acc. no. 53.600.3621
Venues: DC, NC

This print by Melchior Küssel records the "ingenious and costly" fireworks that were part of a series of theatrical events staged over a period of two months at the royal enclosure in Vienna. The festivities celebrated the marriage of Leopold I to the Spanish Infanta Margareta Theresa. The princess entered Vienna on December 5, 1666, and the display of fireworks de-

420

picted took place in the Hofburg courtyard three nights after her arrival. The event included various mythological figures and employed pyrotechnic effects to create a *tableau vivant*. According to one description of the activities (Schöne, p. 359), Mercury descended into the courtyard to announce the wedding and to ignite the fires of the festival. Hercules and the centaurs fought with blazing clubs, while Cupid forged the golden wedding ring in the fiery core of Mount Aetna before ascending into the sky. Flaming hearts inscribed with the letters L and M crowned the festive arches, while the letters VA (Vivat Austria) and VH (Vivat Hispania) shined over the castle towers. Most spectacular of all were the fireworks, which enlivened the evening sky with a parade of light. This astonishing display of pyrotechnology was the fourth and culminating spectacle in a series of events in which the four elements, earth, air, water, and fire, honored the royal couple.

Küssel's large etching itself is a rich display of technical and artistic virtuosity. He delights in rendering the sprays of light and in tracing the paths of the rocket fireworks and those resembling shooting stars and clusters of light. Through the complex juxtapositions of light and dark, Küssel captures the wondrous effects achieved at the imperial court in Vienna in 1666.

BIBLIOGRAPHY

Fuhler, E. *Feuerwerke des Barock*. Stuttgart: J. B. Metzler, 1974.

Griffin, Robert Arthur. *High Baroque Culture and Theatre in Vienna*. New York: Humanities Press, 1972. Esp. pp. 42–44.

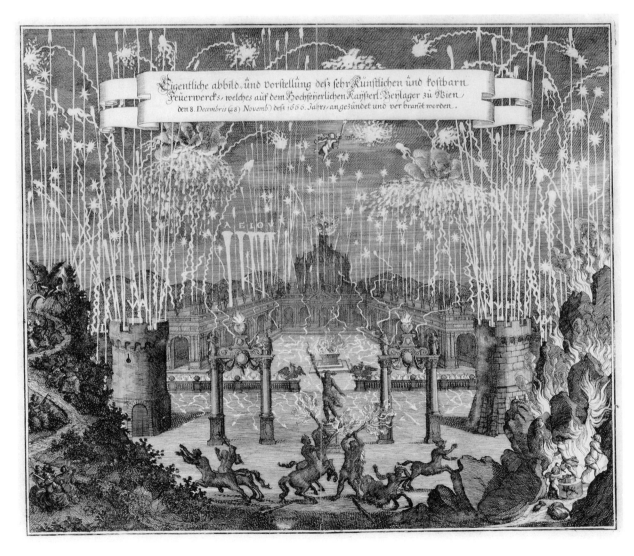

188

421

Schöne, Günter. "Barockes Feurwerkstheater." *Maske und Kothurn* 6:4 (1960): 351–62.

LUDGER TOM RING THE YOUNGER
German, 1522–84

189 *Open Missal*

ca. 1570
Oil on oak panel
63.1 x 61.1 cm. (24¾ x 24 in.)
Vassar College Art Gallery, Poughkeepsie,
 New York
Acc. no. 56.5

189

This superb painting, as William Kloss has shown, is the work of Ludger tom Ring the Younger, a member of a family of painters active in Münster, Westphalia, during the sixteenth century. A bold *trompe-l'oeil* image, it represents a precious book in which the word of God is recorded. Shown in stark isolation, the missal seems to be miraculously present in the spectator's space. The painting may have originally

decorated a lectern, and the impression it makes is that the pages of the book are being turned for a religious reading or lesson. Other *trompe-l'oeil* images of liturgical books are similarly treated, but they do not have either the visual or iconographic richness of the Vassar painting (see, for example, Langemeyer et al., figs. 256, 257). By means of his exceptional technical skills, Ludger tom Ring the Younger has recorded all the special details of the book: its leather strap, its elegant script, and part of an exquisite miniature painting showing the crucifixion. In addition, the artist has taken great care to imitate the *trompe-l'oeil* effects of the miniature painting itself, that is, the naturalistic flowers and insects framing the crucifixion scene.

According to Kloss (Connell and Kloss, p. 21), the purpose of this *trompe-l'oeil* is "to make concrete the concept of the 'Logos' or the Word of God." The plainsong on one of the open pages contains the words "Ave Maria," in reference to the angel's annunciation to Mary, "Hail, thou that are highly favored, the Lord is with thee . . . behold, thou shalt conceive in thy womb, and bring forth a son, and shalt call his name Jesus" (Luke 1:28–31). The Incarnation, when the Word of God was made flesh, lead to Christ's sacrifice, which is pictured on the last visible page of the *Open Missal*. Thus, Ring's painted deception reveals the central truth of Christianity, and in remarkably concentrated form makes it tangibly present to the beholder.

BIBLIOGRAPHY

Connell, E. Jane, and William Kloss. *More Than Meets the Eye: The Art of Trompe-l'oeil*. Columbus, Ohio: Columbus Museum of Art, 1985. Esp. pp. 21–22.

Kloss, William. "'And the Word was God': Vassar's *Open Missal*, A Miraculous Image." Lecture delivered at Vassar College, April 6, 1990.

Lammers, Joseph. "Innovation und Virtuosität." In *Stilleben in Europa*. Ed. Gerhard Langemeyer and Hans-Albert Peters. Munster: Landschaftsverband Westfalen-Lippe, 1979. Esp. pp. 480–512.

Pieper, Paul. "Ludger ton Ring d. J. und die Anfänge des Stillebens." In *Münchener Jahrbuch der Bildenden Kunst* (1964). Esp. pp. 113–22.

Pieper, Paul, and Theodor Riewerts. *Die Maler tom Ring: Ludger der Altere, Hermann, Ludger der Jüngere*. Munich: Deutscher Kunstverlag, 1955.

Vassar College. *Vassar College Art Gallery: Paintings, 1300–1900*. Poughkeepsie: Vassar College Art Gallery, 1983. Esp. p. 14.

SIMON LUTTICHUYS
English (active in Amsterdam), 1610–61

190 *Allegory of the Arts*

Signed and dated 1646
Oil on panel
46 x 67 cm. (18 x 26⅛ in.)
Private Collection
Venues: DC, NC

Although Simon Luttichuys was born in London, he spent most of his life in Amsterdam, where he earned a reputation as a master of still-life painting. *Allegory of the Arts* is one of about a half-dozen pictures executed by Luttichuys that focus on the theme of *vanitas*. As Ingvar Bergström has shown, virtually every object in the picture makes reference to the transience of life and to the ephemeral nature of man's achievements on earth. Among the assembled items, for instance, are a human thighbone symbolizing mortality, a glass globe alluding to the idea of *Homo bulla* ("man is but a bubble"), and a bust of Seneca, the ancient philosopher whose treatise *De brevitate vitae* was well known in the seventeenth century. While a fly, traditionally a symbol of transience, rests on the

painting of ships caught in a tempest, the illustrated herbal may well allude to the words of the prophet Job (14:1–2) that man "cometh forth like a flower, and is cut down" (Bergström, pp. 114–15). Furthermore, the perishability of man-made things is suggested by the dog-eared pages of the little book and the frayed edges of the drawing representing an old man.

While there can be no doubt about its message, Luttichuys's painting is not concerned exclusively with the ephemeral nature of life and art. *Allegory of the Arts* might just as easily be titled *Allegory of Sight*, for the act of seeing (and not seeing) seems to be one of its fundamental concerns. The old man in the drawing *peers* at the map next to him; the artist Peter Paul Rubens *gazes* at us from the engraving; the little bust of a man in the center of the composition *looks* up to the bust of Seneca. Seneca, by contrast, has the "blind eyes" of sculpture and does not see, like the antique bust hidden in the shadows. Luttichuys's picture challenges the viewer with the question "what do you see?" Is this a painting of collected objects, or the collection itself, complete with a pesky fly? Contained within this illusion are other *trompe-l'oeil* effects, other visual surprises: the convincingly rendered seascape, the drawing of a boy who appears to have fallen

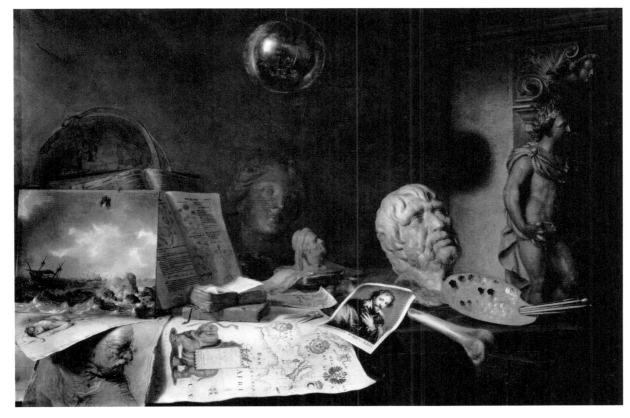

190

out of the seascape onto a beach, and the lifelike study of the old man, who seems curiously aware of the elephant represented in the adjacent map of Africa. Suspended above these objects, finally, is the glass ball—an exquisitely rendered form that reflects the artist at work in his studio. The viewer of the painting, in effect, is standing in the same spot as the artist who made it and is invited to admire his display of visual arts (painting, sculpture, drawing, engraving, book illustration, map making, and glass blowing). But the object that is the cause for greater marveling in the end is the picture itself, Luttichuys's expertly crafted illusion.

BIBLIOGRAPHY

Bergström, Ingvar. "Simon Luttichuys." In *Still Lifes of the Golden Age: Northern European Paintings from the Heinz Family Collection*. Ed. Arthur K. Wheelock, Jr. Washington, D.C.: National Gallery of Art, 1989. Esp. pp. 114–16.

Bredius, A. *Künstler-Inventare. Urkunden zur Geschichte der holländischen Kunst des XVIten, XVIIten, and XVIIIten Jahrhunderts*. 8 vols. The Hague: M. Nijhoff, 1915–22. Esp. vol. 4, p. 1289.

Garlick, K. J. "Catalogue of the Pictures at Althorp." *Walpole Society* 45 (1976): 56, no. 433.

JOHANNES HANNOT
Dutch, 1633–85

191 *Still Life with Lobster*

ca. 1650
Signed *J Hannot fc.*
Oil on canvas
84 x 72 cm. (33 x 28⅜ in.)
Private Collection

Johannes Hannot was born in Leiden in 1633 and painted there until his death in 1685. An artist who specialized in opulent still lifes, his works sometimes were falsely signed with Jan Davidsz. de Heem's signature (Segal, p. 161).

Hannot's *Still Life with Lobster* is an appealing illusionistic picture. Painted in rich colors and with careful attention to the reproduction of surface textures, it faithfully records rare and costly objects both natural and man-made—a boiled lobster, a Chinese porcelain bowl filled with strawberries, a bunch of grapes, peaches, and a bright Seville orange "enthroned" on a silver saltcellar.

Hannot plays upon the traditional function of the niche, which is to enframe and contain one or more objects. The lemon peel, lobster claw, and white nap-

kin spill over the edge of the niche into the foreground and seem to project into the viewer's space. An emerald green curtain is drawn across part of the niche, simulating the protective curtains that the Dutch often placed over their pictures. The illusionistic curtain also brings to mind the famous story told by Pliny about the painting contest between Zeuxis and Parrhasius. The artist Zeuxis painted grapes so lifelike that birds tried to eat them. His rival Parrhasius then painted a picture with an illusionistic curtain. Thinking it real, Zeuxis tried to pull the curtain away. As Pliny recounts, while Zeuxis fooled the birds of heaven, Parrhasius was the greater artist because he fooled Zeuxis. The story of Parrhasius's triumph is evoked in numerous sixteenth- and seventeenth-century paintings, among which Hannot's *Still Life with Lobster* is an especially fine example.

BIBLIOGRAPHY

Segal, Sam. *A Prosperous Past: The Sumptuous Still Life in the Netherlands 1600–1700*. The Hague: SDU Publishers, 1988. Esp. p. 161.

Welu, James A. *Seventeenth-Century Dutch Painting: Raising the Curtain on New England Private Collections*. Worcester, Mass.: Worcester Art Museum, 1979. Esp. pp. 9–11, 35–36.

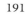

191

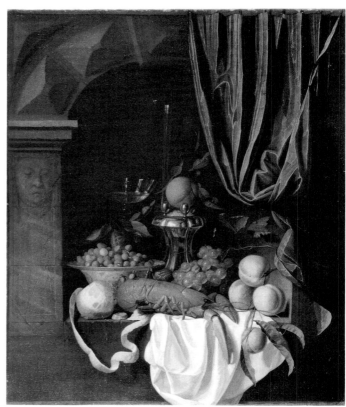

WILLEM VAN AELST
Dutch, ca. 1625/6–after 1683

192 *Vase of Flowers with a Pocket Watch
and Mouse*

ca. 1656
Oil on canvas
55.9 x 46.4 cm. (22 x 18¼ in.)
North Carolina Museum of Art, Raleigh
Purchased with funds from the State of
 North Carolina
Acc. no. 52.9.57

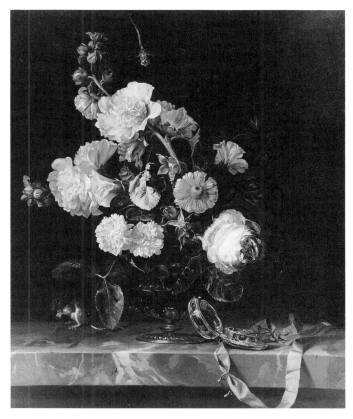

192

A master of rendering different textures, Willem van Aelst created ornate still lifes with fruit or fish or with hunting paraphernalia and dead game; he also rendered elaborate floral arrangements. He was, in fact, an important pioneer in the type of floral painting that became prevalent in the second half of the seventeenth century. His talents as a painter were recognized at an early age, and at seventeen he entered the guild of Saint Luke in Delft. He traveled through France (1649) and then in Italy (1656), where he worked as a court painter in Florence to Ferdinand II, grand duke of Tuscany. The artist returned to Delft in 1657 and then moved to Amsterdam, where he remained until his death.

This elegant and sensuously appealing still life gives ample proof of van Aelst's special abilities as a painter. The artist imitates the delicate colors and shapes of the flowers, and the different textures of the floral specimens, marble ledge, ribbon, and watch. He even recreates tiny beads of water on the leaves in a thoroughly convincing manner. The painting is an extraordinary technical achievement, for not a brushstroke is visible and every object is described with the utmost care and refinement.

The pocket watch and partly decayed leaf in the center of the composition allude to the transitory nature of life, as does the nibbling mouse, a standard symbol of the passage of time. But the picture also represents a victory over time and testifies to the power of the artist to be nature's rival. The objects he paints, particularly the lush poppies, hollyhocks, cabbage rose, marigolds, and chrysanthemums, seem to be preserved at the very peak of their beauty. As the seventeenth-century poet Jan Vos wrote about one of van Aelst's flower paintings: "Nature who stupifies with her brush all who paint, goes into a decline out of vexation now that she sees this. Aurora, set aside your covering of roses from your head. Here roses grow that surpass your coiffure. So van Aelst through art becomes renowned the world over. One ought to

extol him who has overcome others. His hand, full of wit, painted the leaf of these flowers with a splendor that will never wither. The leaf that endures heat and cold will last forever" (quoted by Goedde, p. 44, n. 37).

BIBLIOGRAPHY

Bowron, Edgar Peters, ed. *The North Carolina Museum of Art: Introduction to the Collections*. Chapel Hill: University of North Carolina Press, 1983. Esp. p. 14.
Goedde, Lawrence O. "A Little World Made Cunningly: Dutch Still Life and *Ekphrasis*." In *Still Lifes of the Golden Age: Northern European Paintings from the Heinz Family Collection*. Ed. Arthur K. Wheelock, Jr., Washington, D.C.: National Gallery of Art, 1989.

WILLEM KALF
Dutch, 1619–93

193 *Still Life with a Gold Cup*

ca. 1659
Oil on canvas
57.8 x 48.9 cm. (22¾ x 19¼ in.)
The Detroit Institute of Arts, Detroit, Michigan
Founders Society Purchase
Acc. no. 26.43
Venues: HO, HI

Willem Kalf, a native of Rotterdam, worked in Paris in the 1640s before settling in Amsterdam around 1653. A student of François Ryckhals, Kalf is best known for his "pronk" or "sumptuous" still lifes, which reveal the influence Jan Davidsz. de Heem. *Still Life with a Gold Cup* dates from Kalf's Amsterdam years. Its simplified composition distinguishes it from the artists' more elaborate Parisian works and from the often extravagant works of Rychkhals and de Heem.

As Susan Donahue Kuretsky has observed, Kalf's careful selection of objects "creates an effect of concentrated luxury." Exotic and expensive items are assembled on a table that is invitingly close to the viewer. A Turkish rug covers the table, on top of which is displayed a tall, gilt columbine goblet, a crystal *roemer* half-filled with wine, and, barely visible behind it, a long-stemmed wine glass. In front of these on a chased silver salver are a Ming bowl containing peaches and a lemon, whose rind spirals gradually down onto the table. A Seville orange and the translucent agate handle of a knife rest at the edge of the salver. Despite their small number, the objects provide an encyclopedic range of textures, surfaces, and colors. By casting the background and a large part of the foreground in shadow, Kalf highlights the objects and lends a sense of mystery to the setting.

Kalf's silver and gold objects seem deliberately chosen for their metallic surfaces, which lend themselves to light effects ranging from sharp reflection to soft shimmer (Bergström, p. 282). It is in the representation of such objects that Kalf's imitative powers are particularly apparent. Indeed, in the eighteenth century one of his still lifes prompted the great German writer Wolfgang Goethe to say: "One must see this painting in order to understand in what respect art is superior to nature and what the spirit of man lends to these objects when he observes them with a creative eye. For me there is no question: If I would have to choose between the golden vases and the painting, I would choose the painting" (quoted in Segal, p. 185).

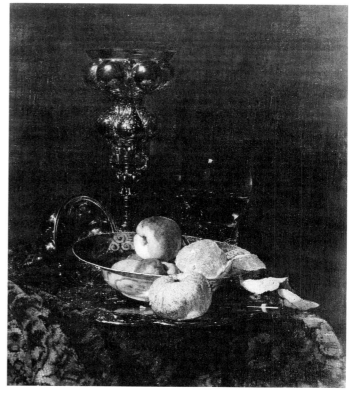

193

BIBLIOGRAPHY

Bergström, Ingvar. *Dutch Still-Life Painting in the Seventeenth Century*. Trans. Christina Hedström and Gerald Taylor. New York: Thomas Yoseloff, Inc., 1956. Esp. pp. 260–85.

Grisebach, Lucius. *Willem Kalf 1619–1693*. Berlin: Gebr. Mann, 1974. Esp. p. 256, cat. no. 100, ill. 108.

Kuretsky, Susan Donahue. Entry in catalogue of Dutch painting in the collection of the Detroit Institute of Arts. Detroit: Detroit Institute of Arts, forthcoming.

Segal, Sam. *A Prosperous Past: The Sumptuous Still Life in the Netherlands, 1600–1700*. The Hague: SDU Publishers, 1988. Esp. pp. 180–96.

EDWAERT COLYER
Dutch, d. 1702

194 *The Cartographer's Table*

ca. 1695–99
Oil on canvas
49.5 x 61.0 cm. (19½ x 24 in.)
The First National Bank of Chicago,
 Chicago, Illinois

Edwaert Colyer was born about 1640 in Breda. He is known to have worked in the city of Haarlem, but most of his active career was spent in Leiden, where he was a resident from about 1667 to 1691. Colyer passed the last decade or so of his life in London, and during this period he anglicized his name to Edward Collier. *The Cartographer's Table* most likely dates from these later years, since both the text of the open book (seen in the foreground) and the names of the months on the globe are written in English. As Katharine Kuh has observed (p. 48), various elements of the composition—the hourglass, the terrestial globe with its inscriptions of the months of the year, and the book open to pages on "dialling" (a method for measuring time)—allude to the transience of life and the ephemeral nature of human occupations.

The Cartographer's Table, however, in contrast to other pictures of the *vanitas* type by Colyer, does not press its moralizing message. There are no skulls here, nor are there any worn and dogeared books, guttering candles, or scraps of paper with warnings to remember death. Additionally, the objects in this painting have been given a physical integrity that is suggestive more of permanence than transience. Boldly modeled and set close to the picture's surface, the various items on the table exist in a space that appears to be coextensive with the viewer's own.

The title of the work is not quite accurate. The collection of objects suggests an owner interested in navigation and the art of dialling. Colyer's contemporary, the sea captain Samuel Sturmy, describes both occupations in writings published in the year 1700. According to the captain, by the art of navigation one could see the wonders of God's world; by the art of dialling one could trace "Sol's" path across the sky (Sturmy, pp. 87ff). He also states that the best-trained seamen were those who had a knowledge of all the mathematical arts, including dialling. Just as the two activities are related to each other in contemporary mariner's books, so references are made to them both in Colyer's painting.

There may be an alternative reading to this picture,

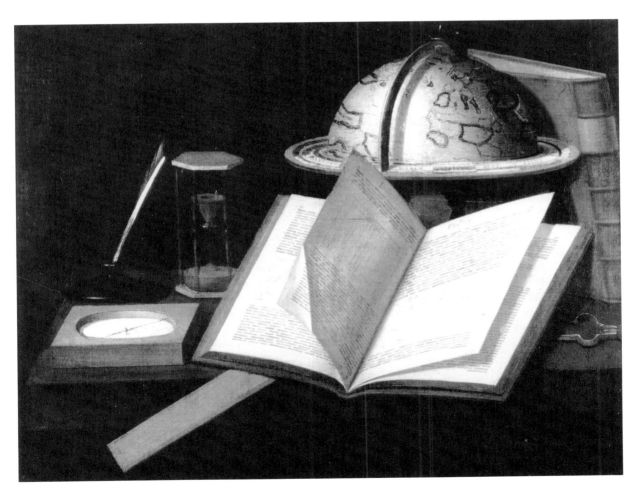

194

427

however. Dialling or horology was a popular science in the sixteenth and seventeenth centuries. It was concerned with the making of timepieces as well as with the measuring of time. Numerous books were published on the subject, many of which contained diagrams as aids to constructing dials, hourglasses, clocks, and other similar devices.* The book prominently displayed in Colyer's painting is one of these publications. Its presence, as well as that of the pen, straightedge, and the dividers, suggests that the picture is concerned not only with the philosphical implications of timepieces, but also with the art of making them.

* William Ashworth kindly provided information about the science of horology.

BIBLIOGRAPHY

Gammelbo, Poul. *Dutch Still-Life Painting from the 16th to the 18th Centuries in Danish Collections.* Copenhagen: Munksgaard, 1960.

Kuh, Katharine. *The Art Collection of The First National Bank of Chicago.* Chicago: R. R. Donnelley & Sons Company, 1974.

Sturmy, Samuel. *The Mariner's Magazine.* London: Printed for R. Mount, 1700. Esp. pp. 87ff.

EDWAERT COLYER
Dutch, d. 1702

195 *Composition with Engraving of Erasmus of Rotterdam*

Signed and dated *E Colier fecit Anno 1693*
Oil on canvas
46.7 x 38.1 cm. (18⅜ x 15 in.)
Fresno Metropolitan Museum, Fresno, California
Oscar and Maria Salzer Collection
Acc. no. FMM82.20

The simplest and most accessible form of *trompe-l'oeil* painting shows an object or objects attached to a wall or some other flat surface. In this picture Edwaert Colyer created the illusion of an engraved print tacked to a wooden board. His convincing simulation of the wood grain and of shadows cast by the wax seals and folded edges of the print creates the impression that the board and the object affixed to it are three-dimensional items within the spectator's grasp.

The print Colyer has depicted is based on a portrait by the German artist Hans Holbein and shows one of the most famous humanist scholars of the Renaissance, Erasmus of Rotterdam. Like other artists of

195

the time, Colyer makes a self-conscience reference to his own profession, and through his effective imitation of the black-and-white engraving he asserts the superiority of painting, his special area of expertise, over the graphic arts. Additionally, Colyer's picture carries a subtle *vanitas* meaning. The simulated print is accompanied by a Latin text reading: "Desiderius Erasmus of Rotterdam. Light of Our Country, Glory of Our Century." The famous humanist is honored here to be sure, but his portrait, ironically, appears in a dog-eared print attached unceremoniously to a plain board. As Colyer thus suggests, not only printed materials but fame of men also eventually succumb to time.

BIBLIOGRAPHY

Brewer, Donald J. *Portraits of Objects: Oscar and Maria Salzer Collection of Still Life and Trompe-l'oeil Paintings.* Fresno: Fresno Metropolitan Museum of Art, History and Science, 1984. Esp. cat. no. 9.

Brewer, Donald J., and Alfred Frankenstein. *Reality and Deception.* Los Angeles: University of Southern California, 1974. Esp. cat. no. 16.

EDWAERT COLYER
Dutch, d. 1702

196 *Wall Arrangement*

Oil on canvas
63.8 x 76.2 cm. (25⅛ x 30 in.)
Fresno Metropolitan Museum, Fresno, California
Oscar and Maria Salzer Collection
Acc. no. FMM82.19

By virtue of their shallowly described spaces, rack pictures (or letter racks) often are among the most successful *trompe-l'oeil* images. In paintings of this type, objects seem to be held in place against a flat surface by ribbons or tapes. The Venetian artist Carpaccio (1460/65–1526) painted one of the earliest letter racks, but it was not until the seventeenth century that this form of painted illusion gained popularity. The Dutch artists Samuel van Hoogstraten and Cornelius Gys-

brechts and the French born Wallerant Vaillant were particularly successful and prolific painters of letter racks, as was Edwaert Colyer, who helped to popularize them in both Holland and England.

In this rack picture, Colyer employs his familiar repertoire of objects: inscribed or printed materials, scissors, comb, magnifying glass, stick of sealing wax, quill pen, knife, and medal hanging on a ribbon. The printed materials and everyday objects suggest a *vanitas* theme and provide a personal record of the artist. The scissors and knife may allude to life's flimsy thread, while a memory booklet refers to the passage of time. The personal mementos include such things as the letter addressed by hand "ffor Mr. E. Collier Painter att London."

Some of these items may carry a sociopolitical meaning (the folded newspaper draws attention to a story in Madrid, and a pamphlet records the king's recent speech to Parliament), but, as Alfred Frank-

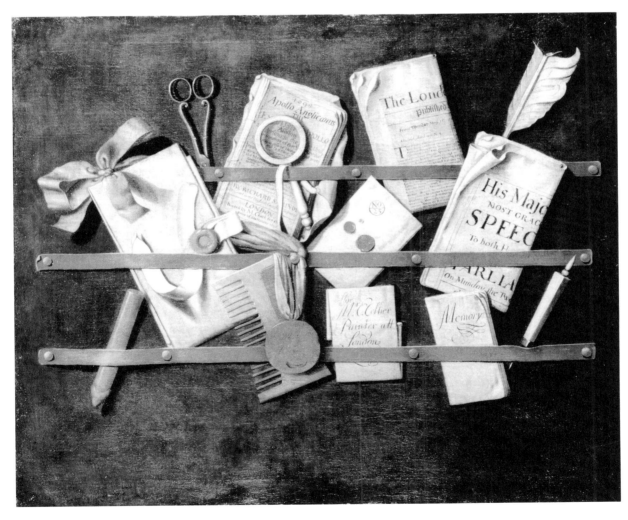

196

enstein has observed, Coyler often changed the words on these objects in related paintings. "His" Majesty's speech becomes "Her" Majesty's speech; the "Madrid" story is turned into one datelined "Tunis." The literature in Coyler's pictures, Frankenstein concludes, "may provide subjects for painting, but such literature seldom, if ever, has any deeper significance." The *Wall Arrangement* is most of all a demonstration of Colyer's mimetic skills. Because the items are so carefully described, viewers are fooled into thinking that they can remove them from the rack.

BIBLIOGRAPHY

Brewer, Donald J. *Portraits of Objects: Oscar and Maria Salzer Collection of Still Life and Trompe-l'oeil Paintings.* Fresno: Fresno Metropolitan Museum of Art, History and Science, 1984. Esp. cat. no. 8.

Brewer, Donald J., and Alfred Frankenstein. *Reality and Deception.* Los Angeles: University of Southern California, 1974. Esp. introduction (unpaginated).

Connell, E. Jane, and William Kloss. *More than Meets the Eye: The Art of Trompe-l'oeil.* Columbus, Ohio: Columbus Museum of Art, 1985. Esp. pp. 22–23.

Milman, Miriam. *Trompe-l'oeil Painting: The Illusions of Reality.* New York: Rizzoli International Publications, Inc., 1982. Esp. pp. 72–78.

CORNELIUS GYSBRECHTS
Flemish, active 1659–75

197 *The Cupboard*

Signed and dated *C.N. Gysbrechts 1665*
Oil on canvas
85.4 x 75.2 cm. (33⅝ x 29⅝ in.)
Fresno Metropolitan Museum, Fresno, California
Oscar and Maria Salzer Collection
Acc. no. FMM82.31

Cornelius Norbertus Gysbrechts was a native of Antwerp who served as court painter in Copenhagen, first to King Frederick III and later to Christian V. A follower of Samuel van Hoogstraeten, a Dutch artist whose complex illusionistic pictures were well known in Antwerp, Gysbrechts became one of the most famous practitioners of *trompe-l'oeil* painting in the late seventeenth century.

The work exhibited here belongs to a series of paintings in which Gysbrechts explored the illusionistic possibilities of a specific *trompe-l'oeil* motif—the cupboard. Recalling the format of letter-rack pictures, the painting represents a mass of documents—

an almanac, artist's sketchbook, opened and folded letters—supported by a horizontal bracing bar. A metal seal, attached to a ribbon, hangs from the key in the door's lock; beneath this and to the right, a quill pen is braced by a dual-purpose instrument (a combination spike and knife) stuck into the door's wooden frame. By showing the door partly open, the artist is able to reveal the interior space of the cupboard while creating the impression that the door projects outward into the space of the viewer. The picture's complex illusionism is further heightened by the glass panes of the cupboard door and what is seen through them: a pile of coins, a box with a pair of spectacles, a metal pot, and two sticks of sealing wax.

Many elements of the composition, especially the broken panes of glass, the dog-eared and worn documents, and the pile of coins, suggest a *vanitas* theme. At the same time, however, *The Cupboard* deliberately challenges the beholder to consider the subject of vision and to ponder what is seen or not seen. Spectacles, for instance, appear twice in the painting, as objects of vision, seen through a glass pane, and as instruments to aid vision, revealing texts affixed to the cupboard door. By contrast, the paper documents obscure each other as well as most of the space behind the door. The artist's convincing simulation of various textures—paper, metal, wax, glass, wood, feathers, and cloth—and his deft handling of multiple spatial levels deceive the viewer into thinking that the cupboard is not paint on canvas but reality itself. All of these aspects of the picture ultimately call attention to the artist himself—to his technical skills and to his cunning in making the deception. Indeed, Gysbrechts's achievement as a painter of *trompe-l'oeil* is made explicit by the central object in *The Cupboard*, the sketchbook with its drawing of a man. Presumed to be the artist's self-portrait and signed by him, it is the composition's focal point, the place where the painted illusion and its maker merge.

BIBLIOGRAPHY

Battersby, Martin. *Trompe-l'oeil: The Eye Deceived.* New York: St. Martin's Press, 1974. Esp. pp. 104–9.

Brewer, Donald J. *Portraits of Objects: Oscar and Maria Salzer Collection of Still Life and Trompe-l'oeil Paintings.* California: Fresno Metropolitan Museum of Art, History and Science, 1984. Esp. cat. no. 21.

Brewer, Donald J., and Alfred Frankenstein, *Reality and Deception.* Los Angeles: University of Southern California Art Galleries, 1974. Esp. cat. no. 30.

Gammelbo, Poul. "Cornelius Norbertus Gijsbrechts og Francisrus Gijsbrechts." *Kunstmuseets Årsskrift.* København: Statens Museum for Kunst, 1952–55. Esp. pp. 160–70.

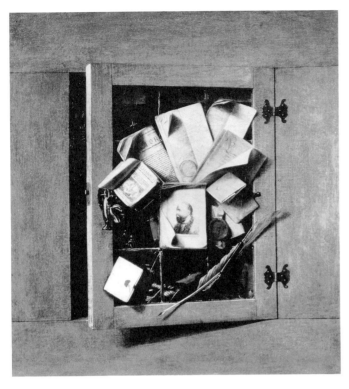

197

hancing the illusion of space within the niche. Even though the still life elements, all precisely described, have a believable three-dimensional presence, the picture's underlying meaning is not about permanence or concreteness but about the transience of earthly life.

The *vanitas* theme, however, applies not only to the transience of the worldly things in the picture, but also to painting itself. The illusion of the canvas peeling away from the frame is a virtuoso touch that draws attention to the artifice of painting, and at the same time conveys the idea that artistic achievements, like all other worldly things, are subject to the effects of time.

BIBLIOGRAPHY

Colie, Rosalie. *Paradoxia Epidemica*. Princeton: Princeton University Press, 1966. Esp. chap. 9.

Gammelbo, Poul. "Cornelius Norbertus Gijsbrechts og Franciskus Gijsbrechts." *Kunstmuseets Årsskrift*. Copenhagen: Statens Museum for Kunst, 1952–55. Esp. pp. 160–70.

Marlier, Georges. "C. N. Gijsbrechts illusioniste." *Connaissance des Arts* (March 1964): 96–105.

Milman, Miriam. *Trompe-l'oeil Painting: The Illusions of Reality*. New York: Rizzoli International Publications, Inc., 1982. Esp. p. 36.

Connell, E. Jane, and William Kloss. *More than Meets the Eye: The Art of Trompe-l'oeil*. Columbus, Ohio: Columbus Museum of Art, 1985. Esp. p. 50.

Marlier, Georges. "C. N. Gijsbrechts illusioniste." *Connaissance des Arts* (March 1964): 96–105.

CORNELIUS GYSBRECHTS
Flemish, active 1659–75

198 *Vanitas: Trompe-l'oeil of a Trompe-l'oeil*

1660–75
Oil on canvas
84.5 x 78.5 cm. (33¼ x 30⅞ in.)
Museum of Fine Arts, Boston, Massachusetts
Abbott Lawrence Fund
Acc. no. 58.357

Gysbrechts is well known for the *vanitas* paintings in which he combined the same small group of objects: skull, hourglass, candle, soap bubble, and musical instrument. In *Trompe-l'oeil of a Trompe-l'oeil* the marbleized mahlstick and ribbon seem to project beyond the picture plane while at the same time en-

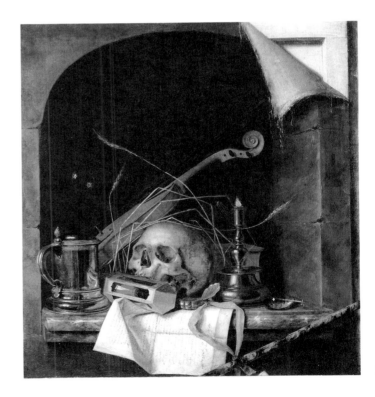

198

199

Italian

199 *A Vision of the Holy Family near Verona*

Dated 1581
Oil on canvas
88.8 x 109.8 cm. (35 x 43¼ in.)
Allen Memorial Art Museum, Oberlin College,
 Oberlin, Ohio
Kress Study Collection, 1961
Acc. no. 61.83
Venues: DC, NC, HO

The *Vision of the Holy Family near Verona* is an il-
lusionistic tour de force that represents a landscape
and figures, both normally excluded from *trompe-l'oeil*
pictures. An inscription on an imitation *cartellino* at
the bottom of the painting identifies the landscape
setting as a view of Verona and indicates that the
picture itself was made in 1581 at the monastery of
Santo Angolo. Wolfgang Stechow has suggested that

the name of the monastery in Monte, Sant'Angelo,
was deliberately misspelled by the artist to refer to his
own family name, Angolo del Moro (p. 85). The
painting has sometimes been incorrectly attributed
to Battista Angolo del Moro, who could not have
painted it since he died before 1573 (Venturi, p. 54).

Battista's son Marco may be the author of the paint-
ing, however. A painter and engraver like his father,
he also was a student of mathematics and perspective.
The Vision of the Holy Family near Verona bears some
striking similarities to Marco's landscape etching *Au-
gustus and the Tiburtine Sibyl* (see Reed and Wallace,
pp. 35–37) and like it shows the influence of such
painters as Titian and Veronese.

The painting itself reveals the period's fascination
with works of art that could represent multiple levels
of reality. It appears to be a landscape reminiscent of
scenes of the Annunciation of Christ's birth to the
shepherds. At the top, the artist has created the illu-
sion that the canvas on which this image has been
painted is peeling away to reveal the Holy Family and

the infant Saint John the Baptist. The shadowy forms of these figures appear in the landscape, as if the painting is transparent and the two paintings are superimposed—a play, perhaps, on the difference between the imperfection of our world and the higher spiritual reality that lies beyond it.

BIBLIOGRAPHY

Connell, E. Jane, and William Kloss. *More than Meets the Eye: The Art of Trompe l'Oeil.* Columbus, Ohio: Columbus Museum of Art, 1985. Esp. pp. 21–22.

Milman, Miriam. *Trompe-l'Oeil Painting: The Illusions of Reality.* New York: Rizzoli International Publications, Inc., 1982. Esp. p. 60.

Reed, Sue Welsh, and Richard Wallace. *Italian Etchers of the Renaissance and Baroque.* Boston: Museum of Fine Arts, 1989. Esp. pp. 35–37.

Stechow, Wolfgang. *Catalogue of European and American Paintings and Sculpture in the Allen Memorial Art Museum.* Oberlin, Ohio: Oberlin College, 1967. Esp. p. 85.

Venturi, A. *Storia dell'arte Italiana: La pittura del cinquecento.* Vol. 9, part 7. Milan: Ulrico Hoepli, 1934. Esp. pp. 54–57.

JAN VREDEMAN DE VRIES
Dutch, 1527–ca. 1604

200 *Perspective*

Leiden, Henric. Hondius., 1604
Illustrated book
28.5 x 36.5 x 3.5 cm. (11¼ x 14⅜ x 1⅜ in.)
Beinecke Rare Book and Manuscript Library,
 Yale University, New Haven, Connecticut
Acc. no. Beinecke/Folio 114/1–2 (1604–5)
Venue: DC

Jan Vredeman de Vries, the most important Dutch sixteenth-century practitioner of perspective drawing, had a varied career as a painter, graphic artist, and architectural designer. He produced many books of engravings on such subjects as architecture, ornamental designs, gardens, and perspective. This fascinating and imaginative book on the science and art of perspective, published at the close of his career, is considered his finest achievement. It contains numerous engravings of a variety of architectural spaces, which give unexpected views into domed ceilings, atria, courtyards, plazas, and archways. The depicted

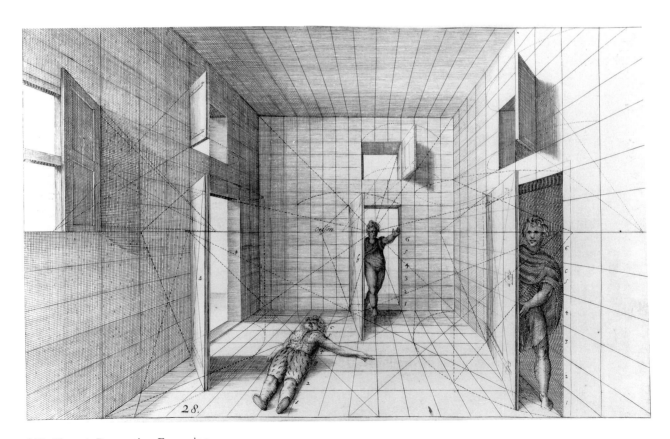

200 Plate 28. Perspective. Engraving.

spaces were in many cases imaginary or highly exaggerated, providing an almost surreal perspective into a rapidly receding topography. De Vries's *Perspective* was extremely influential and helped to foster a flourishing subcategory of illusionistic architectural painting in Netherlandish art.

The image shown here depicts a boxlike space intersected by an intricate system of perspectival lines generated by more than one viewpoint. It demonstrates the type of mathematical system that an illusionistic painter might use to create a spatially complex composition.

BIBLIOGRAPHY

Alpers, Svetlana. *The Art of Describing: Dutch Art in the Seventeenth Century.* Chicago: University of Chicago Press, 1983.
De Vries, Jan Vredeman. *Perspective.* New York: Dover Publications, 1968.
Kemp, Martin. *The Science of Art: Optical Themes in Western Art from Brunelleschi to Seurat.* New Haven: Yale University Press, 1990.

ERHARD SCHON
German, ca. 1491–1542

201 *Vexierbild:* Was siehst du?

1538
Anamorphic perspective, woodcut
21 x 85.5 cm. (8¼ x 33⅝ in.)
Graphische Sammlung, Albertina, Vienna, Austria
Venues: HO, HI

Anamorphoses, as developed by Erhard Schön, a Nuremberg engraver and a pupil of Albrecht Dürer, were symbolic compositions with hidden political, religious, or erotic meaning. These *vexierbilden* (or puzzle pictures) presented a confusion of elongated forms which, when viewed from an oblique angle, contract into a normal, or recognizable, image. This woodcut, one of Schön's most interesting constructions, represents Jonah and the whale above a tangle of lines. When the woodcut is viewed close up and from its left side, however, perspective causes the apparent image to disappear and the hidden image to appear. The viewer, challenged by the question "what do you see?," soon discovers that the artist has made a surprising analogy between this rectified image—a man relieving himself—and the representation of Jonah being vomited up from the belly of the whale.

BIBLIOGRAPHY

Baltrušaitis, Jurgis. *Anamorphic Art.* Trans. W. J. Strachan. New York: Harry N. Abrams, 1977. Esp. pp. 11–15.
Schuyt, Michael, and Joost Elffers. *Anamorfosen: spel met perspectief.* Amsterdam: Rijksmuseum, 1975–76.

ERHARD SCHON
German, ca. 1491–1542

202 *Vexierbild:* Aus du Alter Tor

ca. 1535
Anamorphic perspective, woodcut
15.5 x 75.5 cm. (6⅛ x 21¾ in.)
Graphische Sammlung, Albertina, Vienna, Austria
Venues: DC, NC

In this *vexierbild* by Schön, the scrambled image is framed by two normally rendered scenes, one showing a stag about to be trapped in a net and the other lovers on a boating excursion being serenaded by musicians. These scenes of entrapment and love are accompanied by a third vignette, showing an old man fondling a girl, who in turn dupes him by stealing his money and handing it over to her accomplice-lover. When the woodcut is viewed from the extreme left, the final episode of this little narrative is revealed: the chaotic lines turn into a lewd scene of the girl and her young lover, with the graybeard standing next to the bed. The accompanying inscription reads, "Out, you old fool."

BIBLIOGRAPHY

Baltrušaitis, Jurgis. *Anamorphic Art.* Trans. W. J. Strachan. New York: Harry N. Abrams, 1977. Esp. pp. 11–15.
Schuyt, Michael, and Joost Elffers. *Anamorfosen: spel met perspectief.* Amsterdam: Rijksmuseum, 1975–76.

MARIO BETTINI
Italian, 1582–1657

203 *Apiaria universae philosophiae mathematicae*

Bologna, Io. Baptistae Ferronij, 1645–55
Illustrated book
36.3 x 24.7 x 4.8 cm. (14¼ x 9¾ x 1⅞ in.)
The New York Public Library, New York
Astor, Lenox and Tilden Foundations
Science and Technology Research Center
Acc. no. OEF+

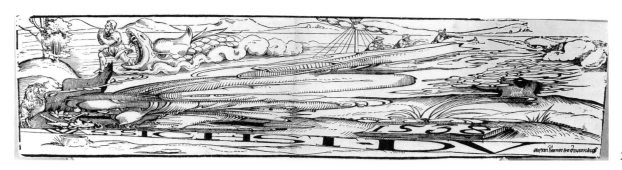

201

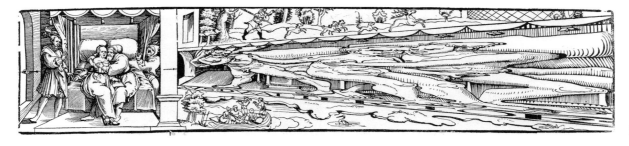

202

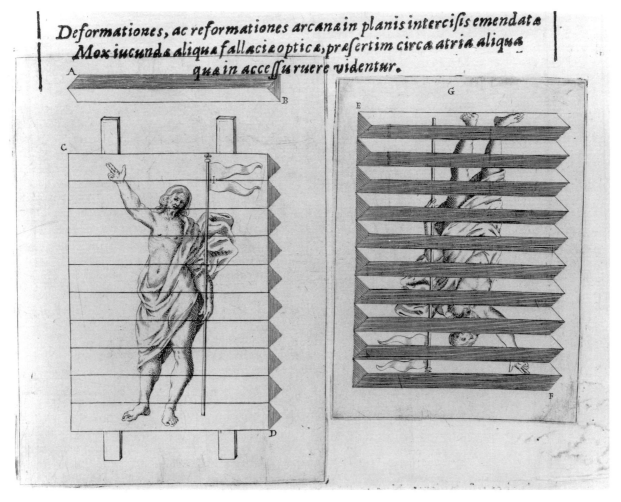

*Deformationes, ac reformationes arcana in planis intercisis emendata
Mox iucunda aliqua fallacia optica, præsertim circa atria aliqua
qua in accessu ruere videntur.*

203 Optical trick showing the Risen Christ. Engraving.

435

The Jesuit Mario Bettini was a professor of mathematics and science in Parma, Italy, and also the author of several plays. This book, reflecting his many interests, is a collection of scientific mysteries embracing everything from geometrical demonstrations to illusionistic stage sets, music, perpetual motion machines, and anamorphoses. According to Bettini, the natural world abounds in mathematical delights such as spider webs and the honeycombs of bees. From these creations of nature can be drawn geometrical principles useful for mechanical, optical, and artistic designs.

Apiaria describes numerous strange and surprising optical devices. One of these, illustrated here, is made of wooden prisms that can be moved back and forth to reveal a hidden image of the Risen Christ. Bettini offers instructions for making another very similar device to hang on a wall. The painting on the sides of the prisms facing upward and away from the viewer is reflected in a mirror. The optical trick is cleverly tied to the image's meaning. Like the two Marys that came to Christ's empty tomb, the viewer is informed (according to an accompanying inscription), "He is not here, but has risen." Indeed, the image of Christ is not on the unpainted sides of the prisms, but rather rises up "mysteriously" into the mirror. Elsewhere in his book, Bettini imagines an extraordinary anamorphic arrangement called "A Garden of the Instruments of Christ's Passion." Strange objects—a polyhedron, poles, a column, among other things—are scattered on rectangular plots of grass before a little house. When seen from a specific point of view, however, all the objects are transformed into a scene of the cross and the various instruments associated with Christ's passion.

BIBLIOGRAPHY

Baltrušaitis, Jurgis. *Anamorphic Art*. Trans. W. J. Strachan. New York: Harry N. Abrams, Inc., 1969. Esp. pp. 81, 82, 116, 153–54.
Kemp, Martin. *The Science of Art: Optical Themes in Western Art from Brunelleschi to Seurat*. New Haven: Yale University Press, 1990. Esp. pp. 180–82, 212.

JEAN-FRANCOIS NICERON
French, 1613–46

204 *La Perspective curieuse*

Paris, Jean du Pris, 1663
Illustrated book
37.5 x 24.5 x 4.4 cm. (14¾ x 9⅝ x 1¾ in.)
Linda Hall Library, Kansas City, Missouri
Acc. no. R.B.R QC353.N6 1663 folio

Jean-François Nicéron was a Parisian scholar and mathematician who belonged to the religious order of the Minims. Passionately interested in perspective, he published his observations in the 1638 *La Perspective curieuse*. This publication was emended by Nicéron and brought out in later, posthumous editions, including the 1663 version exhibited here. As Nicéron states, his treatise not only gives a summary and description of ordinary perspective, but is also dedicated to "curious perspective" and the "marvelous effects produced by artificial magic." He dwells at length on the curious perspectives of anamorphoses and, as an aid to the reader, supplies numerous illustrations showing how to construct them.

In one of these illustrations, Nicéron demonstrates how he made a huge (104 feet long) anamorphosis in fresco for the convent of Santa Trinità de' Monti, his place of residence during a trip to Rome in 1642. (Note: in the engraving the lower diagram should be read as a continuation of the one above.) The anamorphosis, which no longer exists, was constructed with the aid of strings and a normal (undistorted) picture marked with a grid. The various points on the undistorted picture (set at an angle to the wall) were plotted at a notional "window" by a bead or a moveable vertical string. The normal image was swung away toward the wall and a string extended from the eye point (A) past the bead to the wall, where its position was recorded. The procedure was repeated until all the points on the original design were transferred to the wall. The resulting image was a reversed and elongated form of the undistorted picture. When a viewer stood at point A, the scrambled painting on the wall was rectified, showing Saint John the Evangelist on Patmos, the subject of the original picture.

In another instance, Nicéron shows how to construct a smaller, catoptric (mirror) anamorphosis depicting Saint Francis of Paola. An image of the saint is squared, with each square corresponding to segments of a circle on a flat surface. The artist then transfers the main elements found in each square to its corresponding area in the circle. After the construction is completed, a cylindrical mirror is placed

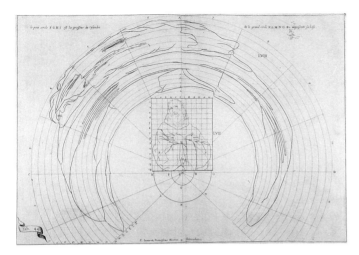

204 Perspective anamorphosis: Saint John the Evangalist at Patmos. Engraving.

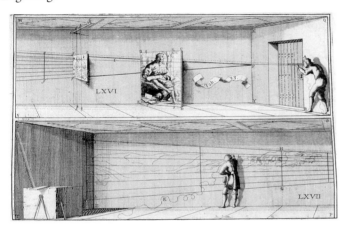

204 Perspective anamorphosis: Saint Francis of Paola. Engraving.

on its center, at a place indicated by a small circle. The distorted fan-like image is then reconstituted or made normal on the convex surface of the mirror. This type of anamorphosis created more surprising effects than earlier versions since at one and the same time the viewer could see both the distorted image and its rectification in the cylindrical mirror. During the seventeenth century anamorphic images, especially the mirror types, became widely popular as entertainments. For Nicéron, however, they were a form of artificial magic that revealed hidden spiritual truths: the saints that emerged out of the tangled lines of his constructions vividly demonstrated the divine order, which, he believed, lay behind appearances.

BIBLIOGRAPHY

Baltrušaitis, Jurgis. *Anamorphic Art*. Trans. W. J. Strachan. New York: Harry N. Abrams, 1977. Esp. pp. 11–15.

Kemp, Martin. *The Science of Art: Optical Themes in Western Art from Brunelleschi to Seurat*. New Haven: Yale University Press, 1990. Esp. pp. 210–11.

Naitza, Salvatore. "Anamorfosi e legittimità prospettiva tra rinascimento e barocco." *Annali delle facolta di lettere filosofia e magistero dell'università di Cagliari* 33, pt. 2 (1970): 175–239.

Schuyt, Michael, and Joost Elffers. *Anamorfosen: spel met perspectief*. Amsterdam: Rijksmuseum, 1975–76.

JEAN DU BREUIL
French, 1602–70

205 *De la Perspective pratique*

Part 3
Paris, Francois Langlois, 1647–51
Illustrated book
28 x 18 x 4 cm. (10¼ x 7½ x 1¾ in.)
Chapin Libary of Rare Books, Williams College,
Williamstown, Massachusetts

Jean du Breuil was a French Jesuit who, like Nicéron, developed a fascination for perspective constructions and distortions. His own treatise on the subject, *De la Perspective pratique*, was first published in 1642 and later brought out in several revised and amplified editions. Besides describing normal perspective systems, du Breuil offers instructions for making a great variety of anamorphoses. Two of these are variants of the cylinder anamorphosis. As in the cylinder type, a normally rendered image is projected geometrically on to a flat surface, where it becomes distorted. In order to find the reconstituted image, the spectator must look down at the apex of the conical or pyramidal mirror set in the center of the composition. The cone anamorphosis produces the most startling effect. The incomprehensible forms of the flat painting are dramatically transformed into a recognizable image on the reflective surface of the mirror. Simultaneously, the beholder sees chaos and the order that magically has been created out of it.

With the pyramid anamorphosis a rather different effect is achieved. Separate portraits are depicted on the flat painting. Widened or elongated, as the case may be, they appear in illogical relation to one another: two are upside down, while the others are right side up. A pyramidal mirror is placed in the center of the composition so that each of its reflecting surfaces will encompass a triangular section of the four portraits. When viewed from above, these triangular sections become inverted on the pyramid, thus forming a new and surprising composite portrait.

437

205 Diagram of a pyramidal anamorphosis. Engraving.

BIBLIOGRAPHY

Baltrušaitis, Jurgis. *Anamorphic Art*. Trans. W. J. Strachan. New York: Harry N. Abrams, 1977. Esp. pp. 46–49, 105–7, 151–53.

Schuyt, Michael, and Joost Elffer. *Anamorfosen: spel met perspectief*. Amsterdam: Rijksmuseum, 1975–76.

ATHANASIUS KIRCHER
German, 1602–80

206 *Ars magna lucis et umbrae*

Illustrated book

Copy A: Rome, Hermanni Scheus, 1646
31.5 x 21.5 x 6 cm. (12⅜ x 8½ x 2⅓ in.)
Harvey Cushing/John Hay Whitney
Medical Library, Yale University,
New Haven, Connecticut
Acc. no. 17th century +, Kircher
Venues: DC, NC

Copy B: Amsterdam, Joannem Janssonium, 1671
38.7 x 26.7 x 9.8 cm. (15¼ x 10½ x 3⅞ in.)
Dartmouth College Library, Hanover,
New Hampshire
Acc. no. Rare Book Q/155/K56/1671
Venues: HO, HI

Ars magna lucis et umbrae (Great Art of Light and Shadow), says its author Athanasius Kircher (see cat. no. 20), offers "new and varied experiments . . . for the diverse uses of mankind." In fact, the bulky volume contained little that was new, but the Jesuit scholar assembled every scrap of information that might have some relation to the main subject of his study. His quasi-scientific disquisitions cover such topics as the light of heavenly bodies, terrestrial flies, animal light, phosphorescence, the changing colors of chameleons, the structure of the eye, sundials, rules for painting and drawing pictures, dioptrics, observations through the microscope, "burning mirrors," and the magic of light and shadow.

In both the 1646 and 1671 editions of his book, Kircher describes the various types of camera obscura. An instrument known since the Middle Ages and the ancestor of our modern photographic cameras, it was based on the principle that rays of light from an object cross and form a divergent pattern when they pass through an aperture. When a screen or some other flat surface intercepts these crossed rays, an inverted image of the object appears. By the mid-sixteenth century a stronger, more clearly focused image was achieved by placing a convex lens in the aperture. Later, angled mirrors were added to reinvert the image.

One of Kircher's illustrations shows a camera obscura that artists could use outdoors. Each wall of the outer chamber is fitted with a lens. The images appear on the inner chamber, which is made of translucent paper. The artist, who views the image from behind, traces its pattern on the paper wall. According to Kircher's illustration, the artist entered the camera obscura through a trap door (E). The entire apparatus was mounted on two horizontal poles that were used to carry the camera from place to place. In fact, the camera obscura probably was not as large and unwieldy as pictured. Hammond (p. 26) suggests that it was no bigger than a sedan chair and that Kircher's illustration exaggerates its proportions to show more clearly how it was used.

The camera obscura, especially the small portable model, was very popular as an amusement. Kircher, who saw it in the context of natural magic, valued it especially for its wonder-producing effects. As the

438

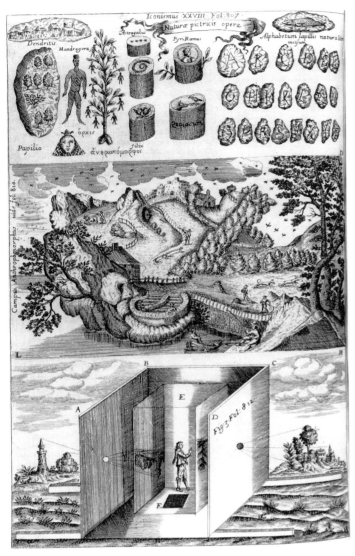

206 Images formed by nature; an anthropomorphic landscape; a camera obscura. Engraving.

with them. These forerunners of modern slide projectors were relatively simple constructions: light inside a closed chamber passed through a telescopic tube which magnified and projected painted images onto the wall of a darkened room. The watercolor paintings were made on glass, and mounted in a sliding oblong frame, thus allowing the operator to project a sequence of different images. While Kircher understood perfectly how to construct these machines, his engraver obviously did not. Incorrectly, he placed the telescopic tube inside the lantern and in front of the painting on glass. The telescopic lens actually belongs on the other side of the painting, outside the box.

BIBLIOGRAPHY

Hammond, John H. *The Camera Obscura. A Chronicle*. Bristol, Gloucestershire, England: A. Hilger Ltd., 1981. Esp. p. 26.

Kemp, Martin. *The Science of Art: Optical Themes in Western Art from Brunelleschi to Seurat*. New Haven: Yale University Press, 1990. Esp. pp. 188–92.

Reilly, P. Conor. S. J. *Athanasius Kircher: Master of a Hundred Arts*. Rome: Edizioni del Mondo, 1974. Esp. pp. 72–86.

JOHANN ZAHN
German, 1641–1707

207 *Oculus artificialis teledioptricus*

Nuremberg, Johannis Ernesti Adelbulneri, 1702
Illustrated book
34.6 x 21.6 x 5.4 cm. (13⅝ x 8½ x 2⅛ in.)
The New York Public Library, New York
Astor, Lenox and Tilden Foundations
Science and Technology Research Center
Acc. no. ONL +

illustration shows, he associated the marvels of the camera obscura with remarkable phenomena like a landscape shaped into an image of a human face and pictures made by nature— "alphabet stones," mandrake roots, and so forth.

In the 1671 edition of *Ars magna*, Kircher dwells at length on a favorite subject: the strange and wonderful effects produced by magic lanterns. Invented by the Dutch physicist Christian Huygens (1629–93), this projection apparatus quickly became a popular form of entertainment. Kircher had made several of these devices himself and, by his own account, had succeeded in surprising and astonishing audiences

This book on optics was written by Johann Zahn, a Premonstratensian monk from Wurzburg. First published in 1685, it offers a wealth of information about various optical instruments, including telescopes, microscopes, the camera obscura, and magic lanterns. In this illustration, Zahn represents three types of magic lantern. The lantern shown at the top of the illustration is the simplest. Here paintings on glass had to be inserted one at a time. With the other two lanterns multiple glass paintings were mounted on a wheel that could be rotated by the operator. Thus, he could change images more quickly and produce a livelier, more interesting show. Zahn discusses the educational value of such devices, especially for anatomical lectures; however, magic lanterns, like the

439

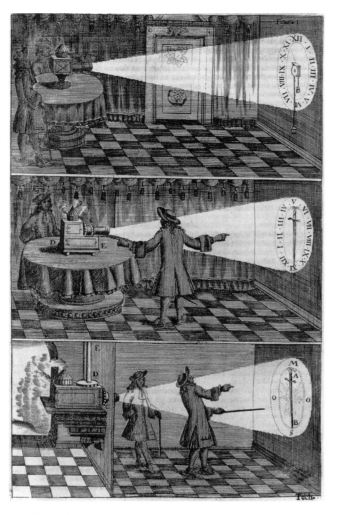

207 Magic lanterns. Engraving.

that appeared on this focusing glass, and the inside of the box and the tube were painted black to minimize reflections. Remarkably, as Gernsheim observes, it was not until the mid-nineteenth century that Zahn's reflex cameras were developed further, for "in 1685 the camera was absolutely ready and waiting for photography" (Gernsheim, p. 16).

BIBLIOGRAPHY

Eder, Josef Maria. *History of Photography*. Trans. Edward Epstean. New York: Columbia University Press, 1945. Esp. pp. 43–44, 48, 53.

Gernsheim, Helmut. *The Origins of Photography*. New York: Thames and Hudson, Inc., 1982. Esp. pp. 12–16.

Hammond, John H. *The Camera Obscura: A Chronicle*. Bristol, Gloucestershire, England: A. Hilger Ltd., 1981. Esp. pp. 27, 35–39.

Kemp, Martin. *The Science of Art: Optical Themes in Western Art from Brunelleschi to Seurat*. New Haven: Yale University Press, 1990. Esp. pp. 189–90.

Potonniée, Georges. *The History of the Discovery of Photography*. New York: Arno Press, 1973. Esp. pp. 26, 28–31.

camera obscura, were most commonly used for entertainment and were appropriated by charlatans who used them to conjure up ghosts and other phantasms before innocent and superstitious audiences.

Oculus artificialis is best known for the attention it gives to the camera obscura. Zahn describes a telescopic camera obscura that could be used for solar observations as well as a miniature version that was ingeniously contrived as a wine goblet. Most important, he provides the first illustrations of small, portable, boxlike instruments. Several of these show a wooden box with an adjustable tube outfitted with a lens (or lenses). The image was reflected by a mirror placed at a forty-five-degree angle to the axis of the lens and focused on oiled paper or a glass screen that had been prepared on one side with a film of white lead. A camera lid with side flaps shaded the image

440

THE CHRISTIAN MARVELOUS

THE SUPERNATURAL phenomena of Christian belief—God's miracles, his wondrous appearances on earth, and other related mysteries—were seen as the most exalted marvels, as sublime verities clearly distinguishable from the marvels of fiction and fable. Men have "drunk in these beliefs with their milk," so the poet Torquato Tasso declared, and "from the cradle" they have been taught that they are true. But in this period of great religious upheaval—the two most significant events were the Protestant Reformation and the counter-reform movement of the Catholic church—miracles and other wondrous events were disputed as never before, which resulted in the production of an unprecedented quantity of images attesting to their truth. While the etchings by Rembrandt (*The Angel Appearing to the Shepherds*, *The Raising of Lazarus*), and paintings by Noël Coypel (*The Resurrection of Christ*) and Aniello Falcone (*The Supper at Emmaus*) visualize miracles that were accepted both by Protestants and Catholics, the majority of works included here demonstrate the Catholic community's efforts to legitimize the miraculous occurrences denied by Protestants, that is, the religious marvels of the postbiblical period. In Carlo Dolci's *The Vision of Saint Louis of Toulouse* and Sassoferrato's *Saint Catherine of Siena Receiving the Crown of Thorns*, for instance, the visionary experiences of two medieval saints are presented with great factual conviction, making them appear as physical realities, immediately present to the beholder. Contemporary miracles and visions, like those of earlier times, were represented, and validated, through a variety of media—not only in paintings, such as those by Abraham Jansz. van Diepenbeeck and Francesco Solimena, but also in prints (Antoine Wierix's depiction of Saint Teresa's mystical transverberation) and books (Justus Lipsius's 1605 publication describing the miracles of the Madonna at Halle.). A work that is of particular interest for its documentary quality is Murrillo's painting *Fray Julián's Vision of the Ascension of the Soul of King Philip II of Spain*. Created in 1645–48, it asserts not only by artistic means but also through an accompanying inscription that the prophetic vision of a Spanish monk in 1603 had been fulfilled.

Like the visionary experiences of the saints, or their miraculous interventions on earth, holy relics were celebrateerd in art and given a similarly veristic treatment. One relic frequently represented in this era was the *sudarium* or veil of Saint Veronica. Dominico Fetti's painting of 1615 and Claude Mellan's engraving of 1649 offer two different but equally surprising renditions of this subject. The devices of illusionism have been employed with extraordinary success in both works, and as a result the holy relic, with

441

its supernaturally imprinted image of Christ's face, seems to be a palpable object, miraculously present before the viewer.

A final selection of works concerns the central mystery of the faith—the transubstantiation of bread and wine into the body and blood of Christ. In the years following the Council of Trent, increasing emphasis was given to the importance of this sacrament. The host was exposed to the faithful in elaborate monstrances and celebrated in ceremonies like the popular Devotion of the Forty Hours. For these occasions promoting the adoration of the Eucharist, spectacular decorations, such as those designed by the Jesuit Andrea Pozzo, were constructed at the altar end of churches. Consisting of illusionistic sets and concealed lamps, they created the impression that holy light streamed from the Eucharistic presence.

REMBRANDT HARMENSZ. VAN RIJN
Dutch, 1609–69

208 *The Angel Appearing to the Shepherds*

1634
Etching, engraving, and dry point
Each approx. 25.9 x 21.9 cm. (10¼ x 8⅝ in.)

Copy A: Museum of Fine Arts, Boston,
Massachusetts
Anonymous Gift 1975.279
Acc. no. 1975.279
Venues: DC, NC

Copy B: Fogg Art Museum, Harvard University,
Cambridge, Massachusetts
Bequest of Edwin de T. Bechtel
Acc. no. M 13, 393

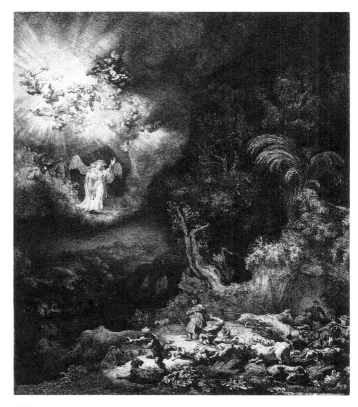

208A

This beautiful etching represents the popular Christian story narrated in the Gospel of Luke (2:8–14).

And there were in the same country shepherds abiding in the field, keeping watch over their flock by night.

And, lo, the angel of the Lord came upon them, and the glory of the Lord shone round about them: and they were sore afraid.

And the angel said unto them, Fear not: for, behold, I bring you good tidings of great joy, which shall be to all people.

For unto you is born this day in the city of David a Saviour, which is Christ the Lord.

And this *shall be* a sign unto you; Ye shall find the babe wrapped in swaddling clothes, lying in a manger.

And suddenly there was with the angel a multitude of the heavenly host praising God, and saying.

Glory to God in the highest, and on earth peace, good will toward men.

Rembrandt's rendering of this story is, as Clifford Ackley has observed, "a wonderful amalgam of soaring, operatic grandeur and earthly Dutch realism" (p. 129). The heavenly vision is a burst of white light in the dark sky, and almost everything in the landscape below is affected by it: men and boys react with fear, wonder, or bewilderment; animals stampede in panic or crouch in stark terror; even the trees and grassy

hillocks seem responsive to the unearthly presence. Here the miraculous apparition is not a distant but an immediate phenomenon. The angel hovers close to the shepherds and their flocks; heavenly and earthly beings are drawn together by a shimmering and bright light.

BIBLIOGRAPHY

Ackley, Clifford S. *Printmaking in the Age of Rembrandt*. Boston: Boston Museum of Fine Arts, 1980–81.

White, Christopher. *Rembrandt as an Etcher: A Study of the Artist at Work*. 2 vols. University Park: Pennsylvania State University Press, 1969.

REMBRANDT HARMENSZ. VAN RIJN
Dutch, 1609–69

209 *The Raising of Lazarus*

ca. 1631–32
Etching
36.5 x 26.4 cm. (14⅜ x 10⅜ in.)
Bayly Art Museum of the University of Virginia, Charlottesville, Virginia
Gift of John Barton Payne
Acc. no. 1920.2.64
Venues: HO, HI

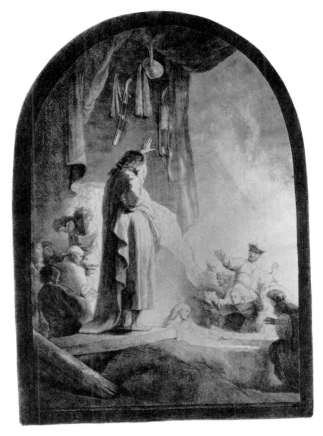

209

This etching represents the greatest of Christ's miracles, the raising of Lazarus from the dead. As told by John (11:1–44), Lazarus had been dead four days when Jesus arrived at his grave. "Lazarus, come forth!" he commanded, and immediately the shrouded figure rose up from his tomb. Every element of Rembrandt's print emphasizes the drama of the narrative: the powerful vertical and diagonal accents, the abrupt contrasts of light and shadow, and the unexpected point of view. Christ is shown not frontally but from behind—as if from a stage wing. The spectator thus has a privileged position with respect to the action described: he sees Christ draw Lazarus forth by his authoritative gesture, and at the same time views the astonishment and fear that the miracle has aroused in the surrounding figures.

Rembrandt's *The Raising of Lazarus* is based on his painting of the same subject from 1631–32. He reworked the plate many times. This impression is from the seventh state, which includes changes made by another hand.

BIBLIOGRAPHY

Bruyn, J., et al. *A Corpus of Rembrandt Paintings*. Boston: M. Nijhoff Publishers, 1982.

Münz, Ludwig. *Rembrandt's Etchings*. London: Phaidon, 1952. Esp. p. 170.

Sell, Stacey Lynn. "Fine Etchings by Rembrandt." *Annual Report 1988–1989, Bayly Art Museum of the University of Virginia*. Charlottesville: University of Virginia, 1989. Esp. pp. 1–2.

White, Christopher. *Rembrandt as an Etcher: A Study of the Artist at Work*. 2 vols. University Park: Pennsylvania State University Press, 1969.

NOEL COYPEL
French, 1628–1707

210 *The Resurrection of Christ*

Second half of the 17th century
Oil on canvas
93.9 x 74.9 cm. (37 x 29½ in.)
The Snite Museum of Art, University of Notre Dame, South Bend, Indiana
Gift of Mrs. J. C. Bowes
Acc. no. 57.62

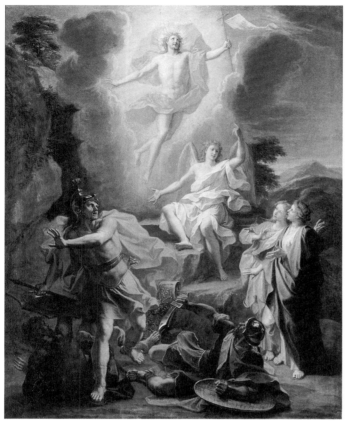

210

shown simultaneously: the resurrection itself, which no one saw; the appearance of the angel, who frightened the guards at Christ's tomb; and the angel's announcement to the two Marys that Christ had risen. By combining these parts of the story, Coypel dramatizes the miracle and stresses its reality. The guards and the women seem to react not only to the angel, but also to the figure of Christ. Furthermore, because the artist depicts Christ as a solid and tangible form, he affirms the belief that Christ rose bodily from his grave.

BIBLIOGRAPHY

Cornu, Paul. "Noël Coypel." *Allegemeines Lexikon der Bildenden Künstler*. Vol. 8. Ed. Ulrich Thieme and Felix Becker. Leipzig: E. A. Seemann, 1913.

Marcel, Pierre. *La Peinture française au début du dix-huitième siècle, 1690–1721*. Paris: Libraries-imprimeries réunies, 1906.

Noël Coypel, patriarch of a well-known family of artists in France, first came to prominence as decorator of the royal apartments at the Tuileries and the Louvre. He was particularly successful as a painter of large-scale works, which, like his smaller easel pictures, display the influence of Nicolas Poussin, Eustache Le Seur, and Charles Le Brun. Louis XIV appreciated Coypel's talents as a painter and in 1672 appointed him director of the French Academy in Rome. In the years following his sojourn in Italy, Coypel was involved in a host of major painting projects, including those for the Church of the Invalides in Paris and the Grand Trianon and Hall of Kings at Versailles.

The painting illustrated here, one of Coypel's small devotional works, represents the most important miracle of Christianity. Three days after his crucifixion, as all the Gospels relate, Christ rose from the dead. According to the faithful, this was the event by which Christ transformed the world—it marked the end of Death, which came into the world with Adam's sin, and was the beginning of new and eternal life.

Coypel's picture is based on the gospel account of Matthew (28:1–18). Several parts of the narrative are

Attributed to ANIELLO FALCONE
Italian, 1607–56

211 *The Supper at Emmaus*

First half of 17th century
Oil on canvas
139.6 x 194.3 cm. (55 x 76½ in.)
Collection of the J. Paul Getty Museum,
Malibu, California
Acc. no. 72.PA.11

Aniello Falcone, to whom this work is attributed with some reservations, was a versatile and internationally known artist from Naples. His naturalistic style shows the distinct influence of works by Caravaggio, Ribera, and Velázquez and sometimes has been associated with that of the Bamboccianti, a group of Dutch artists in Rome who specialized in scenes of everyday life. The classicizing elements in his pictures, on the other hand, relate him to Domenichino and possibly to artists in France, where he may have spent some time.

The Supper at Emmaus, based on Caravaggio's famous painting of the same subject from around 1601, represents Christ's first appearance to his disciples after his resurrection. According to the gospel account (Luke 24:13–32), two of the disciples, Cleophas and Simon Peter, met a stranger on the road to Emmaus and invited him to take supper with them. When the stranger blessed the bread and broke it, they suddenly recognized him as the Risen Christ:

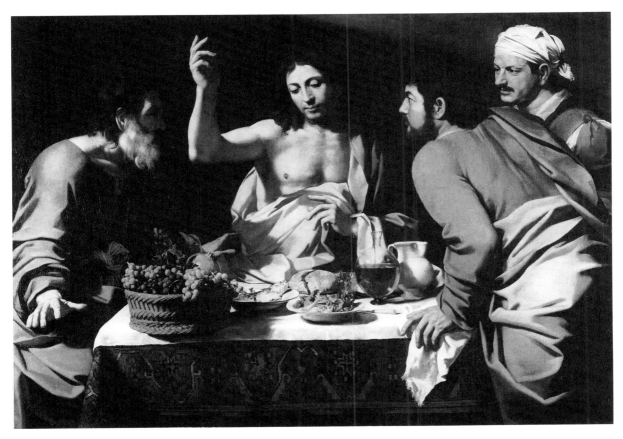

211

"Their eyes were opened, and they knew him; and he vanished out of their sight." Like Caravaggio's work, this painting shows Christ, the disciples, and an innkeeper gathered around a table covered with an oriental rug and a white tablecloth and set with food. Cleophas and the innkeeper are on the left, reversing Caravaggio's composition. Although the moment of revelation is represented here much as it is in Caravaggio's painting, Falcone envisions it less dramatically. He eschews the extreme foreshortenings in Caravaggio's picture and significantly modifies its sharply delineated forms and precisely controlled action.

But like Caravaggio and the other painters to whom he was indebted, Falcone gives a lifelike immediacy to his subject. In this picture, meant to affirm the truth of Christ's bodily resurrection, the figures move and act spontaneously and are painted as large solid forms that seem to project out into the spectator's space. The beautiful still life engages the viewer most of all: the foods spread on the table are rendered with the utmost concern for surface textures and optical truth. And, as in Caravaggio's earlier picture, a basket of fruit has been placed tantalizingly close to the spectator's grasp.

BIBLIOGRAPHY

Dominici, Bernardo de. *Vite de' pittori, scultori ed architetti napoletani non mai date alla luce da antore alcune*. Vol. 3. Naples: Nella stamperia del Ricciardi, 1742–45. Esp. pp. 70ff.

Moir, Alfred E. *The Italian Followers of Caravaggio*. Cambridge: Harvard University Press, 1967. Esp. pp. 171–72.

Spear, Richard E. *Caravaggio and His Followers*. Cleveland: The Cleveland Museum of Art, 1971. Esp. pp. 90–91.

DOMENICO FETTI
Italian, ca. 1589–1624

212 *The Veil of Veronica*

ca. 1615
Oil on wood
81.5 x 67.5 cm. (32⅛ x 26½ in.)
National Gallery of Art, Washington, D.C.
Samuel H. Kress Collection
Acc. no. 1952.5.7
Venues: DC, NC

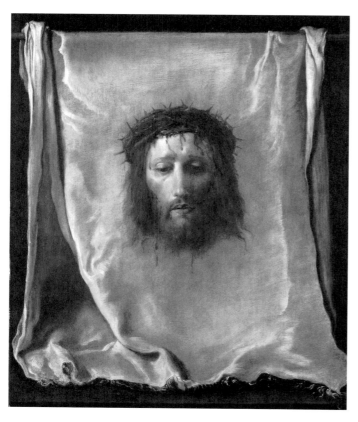

212

The details of Domenico Fetti's early artistic activity are obscure, but we do know that he entered the studio of Lodovico Cigoli at an early age. Through this Florentine painter, who was then working in Rome, Fetti encountered Ferdinand II (Gonzaga), who became his most important patron. As a cardinal in Rome, he became interested in Fetti's work, and when he became the duke of Mantua (ca. 1613) he summoned Fetti to become his court painter. Fetti was also the curator of the duke's collections and traveled to Tuscany (1618) and to Venice (1621) to purchase works. In 1622 Fetti returned to Venice, where he remained until his death in 1624.

Fetti painted *The Veil of Veronica* while he was at the court of Mantua. The subject was popular during the Renaissance and baroque periods. When, according to legend, Christ was carrying the cross to Golgotha, a woman—later named Veronica, for *vera icon* or "true image"—wiped the sweat from his brow with her veil. Miraculously, an impression of his face appeared on the linen cloth. In this painting Fetti has created a strikingly realistic image of Saint Veronica's veil: the fabric seems to hang in the spectator's space, and through the use of pinkish tones Fetti creates the impression that Christ's face is a palpable and living presence. The effect is almost shocking. By means of illusionistic devices the artist makes the relic and the miracle of Christ's supernaturally imprinted portrait appear as concrete facts.

BIBLIOGRAPHY

Endres-Soltmann, M. "Fetti, Domenico." *Allgemeines Lexikon der Bildenden Künstler*. Vol. 11. Ed. Ulrich Thieme and Felix Becker. Leipzig: E. A. Seemann, 1915. Esp. pp. 508–9.
Hetzer, Theodor. *Venezianische Malerei: von ihren Anfängen bis zum tode Tintorettos*. Stuttgart: Urachhaus, 1985.

CLAUDE MELLAN
French, 1598–1688

213 *The Sudarium*

1649
Engraving
Each approx. 42.6 x 31.5 cm. (16¾ x 12⅜ in.)

Copy A: Yale University Art Gallery, New Haven, Connecticut
Bequest of Ralph Kirkpatrick, Hon. M.A. 1965
Acc. no. 1984.54.121
Venues: DC, NC

Copy B: Grunwald Center for the Graphic Arts, University of California, Los Angeles
Acc. no. 1962.33
Venues: HO, HI

Born in Abbeville in 1598, Claude Mellan became one of the preeminent printmakers of France. He traveled to Rome in 1624 and there met Simon Vouet, who profoundly influenced his art. Mellan has been called "the most brilliant representative of the art of line engraving" (Metcalfe, p. 259), and, indeed, his great strengths in this medium eventually led to his appointment as official engraver to Louis XIV, a position he shared with Robert Nanteuil.

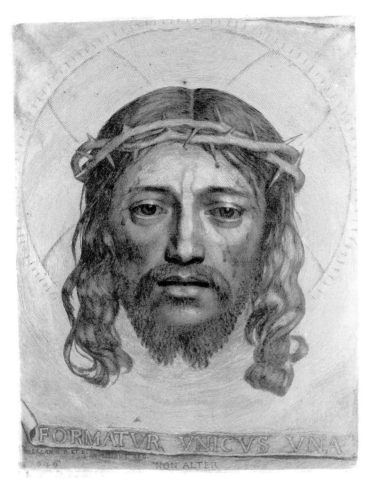

de Montaiglon, Anatole. *Catalogue raisonné de l'ouvre de Claude Mellan d'Abbéville*. Abbeville: P. Briez, 1856.

Préaud, Maxime. "Claude Mellan." *Inventaire du fonds français*. Vol. 17. Paris: Bibliothèque nationale, 1988. Esp. pp. 46, 47, no. 21.

Wengström, Gunner. "Claude Mellan: His Drawings and Engravings." *Print-Collector's Quarterly* 11 (1924): 10–43.

HIERONYMOUS WIERIX
Flemish, 1553?–1619

214 *Saint Cecilia*

Early 17th century
Engraving
14.9 x 10.6 cm. (6¼ x 4⅜ in.)
The Metropolitan Museum of Art, New York
The Elisha Whittelsey Collection, The Elisha
 Whittelsey Fund, 1951
Acc. no. 51.501.6239

Hieronymous Wierix and his brothers Antonie and Jan were well-known engravers from Antwerp who together produced over two thousand prints. Hieronymous and Jan modeled themselves after Albrecht Dürer and the Behams, who were the most prominent German "Kleinmeister" (Kristeller, p. 316). In addition to small oval portraits and life-size portrait heads, Hieronymous's works consist mainly of depictions of saints, the church fathers, and allegories.

This engraving by Hieronymous shows Saint Cecilia, a third-century Roman martyr who was sentenced to death for her Christian faith and for refusing to pray to the pagan idols. In 1599, while the church of Santa Cecilia in Trastevere was undergoing restoration, Cecilia's sarcophagus was discovered. When Cardinal Sfondrato, who was supervising restorations, opened the small wood casket, the body of the martyr was found to be miraculously intact. It was believed that it was in the same position in which it had been placed eight centuries before. She was "not lying upon the back, like a body in the tomb, but upon the right side, like a virgin in her bed, with her knees modestly drawn together, and offering the appearance of sleep" (Bosio, p. 15).

To commemorate the extraordinary event, Cardinal Sfondrato ordered the sculptor Stefano Maderno to carve a life-size marble statue of Cecilia as she was found. Around 1603 the painter Francesco Vanni, inspired by the description of the saint at the time of her discovery and by Maderno's statue, painted the main altarpiece for the church's crypt, *The Death of*

213 *The Sudarium* is Mellan's most celebrated work and a remarkable *tour de force*, the sort of act of ingenious virtuosity so sought after by contemporary collectors. The entire composition is composed of a single, uninterrupted engraved line that begins at the tip of Christ's nose and includes the inscription at the base. By means of this single line—a demonstration of absolute mastery over the engraver's tool, the burin— the artist describes all the subtleties of Christ's features, the crown of thorns, the surrounding halo, and the hem of the veil or *sudarium*. Mellan's use of one line, as indicated in the inscription, "FORMATUR UNICUS UNA, NON ALTER," is ingeniously related to the subject—a unique object representing the one true God of Christianity.

BIBLIOGRAPHY

Clark, Alvin, Jr. *From Mannerism to Classicism: Print-making in France, 1600–1660*. New Haven: Yale University Art Gallery, 1987. Esp. p. 46, no. 31 (illus.).

Metcalfe, Louis R. "Claude Mellan (1598–1688)." *Print-Collector's Quarterly* 5 (1915): 258–93.

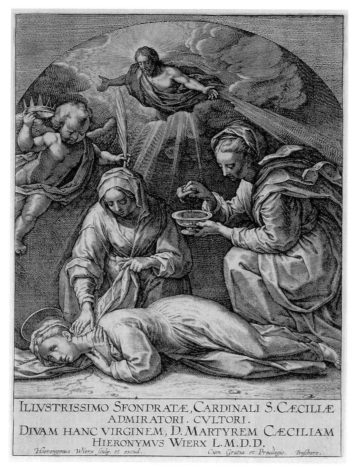

ILLVSTRISSIMO SFONDRATÆ, CARDINALI S.CÆCILIÆ
ADMIRATORI. CVLTORI.
DIVAM HANC VIRGINEM, D.MARTYREM CÆCILIAM
HIERONYMVS WIERX L.M.D.D.

Hierongmus Wierx Sculp. et excud. *Cum Gratia et Prudegio. Buschere.*

214

Saint Cecilia. In this work, and in Wierix's print made after it, the miraculous discovery is turned into a scene of the martyr being cared for by two women while she lays dying. But her hands, crossed on her breast in a gesture of devotion, transform the deathly finality of her posture into an attitude of sleep or prayer. In contrast to Vanni's composition, Wierix introduces a martyr's palm and an image of God the Father in order to affirm the saint's spiritual salvation.

BIBLIOGRAPHY

Bosio, Antonio. *Historia passionis beatae Caeciliae Virginis.* Rome, 1600. Esp. pp. 1–26.

Caraffa, Filippo, and Antonio Massone. *Santa Cecilia martire Romana passione e culto.* Titulus Caeciliae: Centro di Spiritualità Liturgica, and Rome: Fratelli Palombi, 1983.

Farmer, David Hugh. *Oxford Dictionary of Saints.* New York: Oxford University Press, 1987. Esp. pp. 79–80.

Kristeller, Paul. *Kupferstich und Holzschnitt in vier Jahrhunderten.* Berlin: Bruno Cassirer, 1905.

Lippmann, Friedrich. *Der Kupferstich.* Ed. Siebente Auflage

and Fedja Anzelwesky. Berlin: Walter de Gruyter & Company, 1963. Esp. p. 116.

Riedl, Peter Anselm. "Zu Francesco Vannis Tätigkeit für Römische Auftraggeber." *Mitteilungen für Kunstgeschichte* (1978): pp. 313–54.

"Wierix (Wierx, Wiricx, Wiericz), Hieronymous." In *Allgemeines Lexikon der Bildenden Künstler.* Vol. 35. Ed. Ulrich Thieme and Felix Becker. Leipzig: E. A. Seemann, 1942. Esp. pp. 537–38.

FRA LINO MORONI DI FIRENZE
Italian, active early 17th century

215 *Descrizione del Sacro Monte della Vernia*

Florence, 1612
Illustrated book
43.1 x 30 cm. (17 x 11^{13}/16 in.)
Arthur and Charlotte Vershbow, Boston, Massachusetts
Venue: DC

At the invitation of the archbishop of Monreale, Fra Lino Moroni wrote a book honoring the mountain in the Tuscan Apennines where Saint Francis had received the stigmata in 1224 and had founded a monastic community. Though it traces the miraculous events in the saint's life, the work is essentially a seventeenth-century travel guide illustrated with twenty-two views of the Monte della Vernia, including several of the monastic buildings.

Moroni hired the famous scientific illustrator and painter Jacopo Ligozzi (cat. nos. 166, 167) to illustrate the fantastic mountain landscape and the miracles that took place there. Seven of Ligozzi's large landscape drawings were etched by Raffaelo Schiaminossi. One of these illustrates the time when a demon tried to convince Francis that he could fly. It is a dramatic image in which the saint's small figure is contrasted with the great mass of the mountain, which takes up three-fourths of the picture's space. This and other major events, as well as points of interest, are described in the text. Throughout the text, moreover, the reader is informed of all the natural marvels at Monte della Vernia: a miraculous crack in the mountain, a famous outcrop of rock, and "marvelous" trees that took root on the mountain's precipitous edge.

BIBLIOGRAPHY

d'Afflitto, Chiara, Maria Pia Mannini, and Claudio Pizzorusso. *Il paessaggio nella pittura fra cinque e seicento a firenze.* Poggibonsi: T.A.P. Grafiche, 1980. Esp. p. 78.

215 Saint Francis being tempted by the devil. Etching.

Reed, Sue Welch, and Richard Wallace. *Italian Etchers of the Renaissance & Baroque*. Boston: Museum of Fine Arts, 1989. Esp. pp. 214–16.

SASSOFERRATO
(GIOVANNI BATTISTA SALVI)
Italian, 1609–85

216 *Saint Catherine of Siena Receiving the Crown of Thorns and a Rosary from the Christ Child*

ca. 1643
Oil on canvas
74 x 84 cm. (29½ x 33 in.)

The Cleveland Museum of Art, Cleveland, Ohio
Mr. and Mrs. William H. Marlatt Fund, 1966
Acc. no. 66.332
Venues: HO, HI

Giovanni Battista Salvi, also called Sassoferrato, worked most of his life in Rome and Umbria and was known especially for his devotional pictures. In this small votive painting, the figure of Saint Catherine of Siena (1347–80) has been adapted from the artist's larger altarpiece in Santa Sabina, *Madonna of the Rosary and Two Saints*. In contrast to the altarpiece, this painting shows an intimate view of Saint Catherine at prayer.

Saint Catherine began to see visions as a child, and her early and intense devotional fervor caused her to become a well-known religious figure in Siena. She joined the Third Dominican Order at the age of sixteen, and in her twenties, because of her prominence, she was drawn into the politics of the church. She traveled to Avignon in 1376, where she was instrumental in persuading Pope Gregory XI to return the papal seat to Rome. She also dictated several treatises—it was only late in her short life that she learned to write—the most famous of which was *The Dialogue*.

Although active in the community and in church matters throughout the region and in Rome, Saint Catherine is known primarily for her visions, her piety, and the intensity of her religious feeling. In 1375 when she was in Pisa on a mission to turn the city's political and (religious) leaders away from an alliance

216

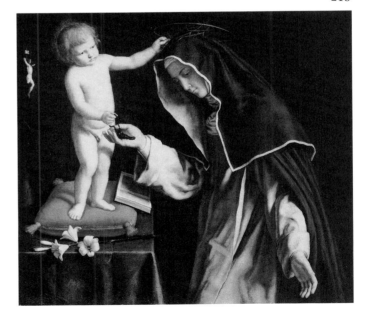

449

with an antipapal league, she experienced an intense vision of Christ on the cross. In this vision, the blood of his wounds in the form of brilliant red rays were transformed into pure light as they pierced her heart, hands, and feet. At her own request the wounds were visible only to herself.

In Sassoferrato's painting, Saint Catherine kneels before the Christ Child, who seems to have materialized upon the prayer cushion at her own small altar. He places upon her head a crown of thorns, which is emblematic of Christ's passion, and places in her hand a rosary. According to one legend, Saint Catherine chose the crown of thorns over a crown of gold. It was put upon her head and pressed down until the thorns appeared to penetrate her skull. Sassoferrato has painted her in a Dominican habit, and next to the Infant Christ on the altar he has placed three lilies, which are symbols of the saint. The painting's dark and somber background pushes the figures toward the foreground and adds to the sense that the viewer is witnessing the saint's private vision.

BIBLIOGRAPHY

Bowron, Edgar Peters, ed. *The North Carolina Museum of Art: Introduction to the Collections*. Chapel Hill: University of North Carolina Press, 1983. Esp. p. 14.

The Bulletin of The Cleveland Museum of Art (December 1967): 313, 343.

European Paintings of the 16th, 17th, and 18th centuries. Cleveland: Cleveland Museum of Art, 1982. Esp. pp. 403–5.

Fredericksen, Burton B., and Federico Zeri. *Census of Pre-Nineteenth-Century Italian Paintings in North American Public Collections*. Cambridge: Harvard University Press, 1972. Esp. p. 184.

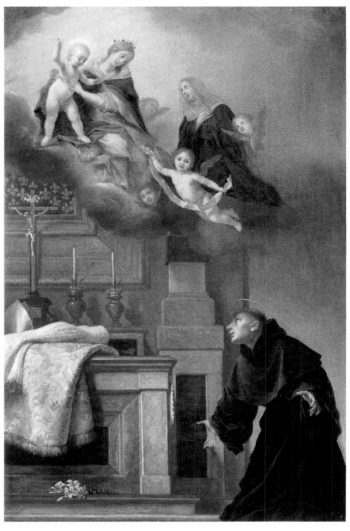

217

CARLO DOLCI
Italian, 1616–86

217 *The Vision of Saint Louis of Toulouse*

ca. 1675–81
Tempera on wood panel
55.3 x 36.8 cm. (21¾ x 14½ in.)
New Orleans Museum of Art, Louisiana
The Samuel H. Kress Collection
Acc. no. 61.84

Carlo Dolci was a prodigy who, according to Baldinucci, at the age of nine already showed signs of his genius in painting. The biographer speaks often of the young Florentine's great skills: he was a painter of *cose rarissime* and *miracoli* came from his hand (Baldinucci, pp. 339–40). Although Dolci was known to have painted numerous portraits, the overwhelming majority of his works depict religious subjects. Indeed, the artist made a vow to paint nothing but sacred images or holy stories (Baldinucci, p. 341) and he frequently inscribed the reverse side of his paintings and drawings with "pious phrases and dedications" (McCorquodale, p. 478n.).

This small painting is the model for an altarpiece illustrating one of the visions of Saint Louis d'Anjou, bishop of Toulouse from 1274 to 1297. As the saint kneels before an altar, the Virgin and Christ Child, together with the Blessed Salomea and angels, appear in a glory of light. Dolci has represented the miraculous vision as a convincingly immediate and deeply personal human experience. All the elements of the composition are rendered in a highly naturalistic way, and by means of a diagonal scheme the artist effec-

tively connects the heavenly figures with Saint Louis. As the saint gazes up at them with silent reverence, they in turn regard him with great tenderness. The picture has been rendered with exquisite care and demonstrates clearly the fine technique for which Dolci was so often praised.

BIBLIOGRAPHY

Heinz, Günther. "Carlo Dolci, Studien zur Religiösen Malerei im 17 Jahrhundert." *Jahrbuch der Kunsthistorischen Sammlungen in Wien* 56 (1960).
McCorquodale, Charles P. "A Fresh Look at Carlo Dolci." *Apollo* 97 (May 1973): 477–88.
McDermott, Betty N. (ed.), and Joan G. Caldwell (researcher). *Handbook of the Collection*. New Orleans: New Orleans Museum of Art, 1980.

ANTONIE WIERIX
Dutch, ca. 1552–1624?

218 *Transverberation of Saint Teresa*

1622
Engraving
12.0 x 7.8 cm. (4⅞ x 3⅛ in.)
The Metropolitan Museum of Art, New York
The Elisha Whittelsey Collection, The Elisha
 Whittelsey Fund, 1951
Acc. no. 51.501.6213

Antonie Wierix was the youngest of the three Wierix brothers (see cat. no. 214), who were active printmakers in Flanders in the early seventeenth century. His delicate engravings reveal the influence of such artists as Frans Floris and tend to be more freely executed than those by his brothers (Lippmann, p. 116).

This engraving depicts Teresa of Avilá, a Spanish Carmelite nun who had frequent visions of Christ and the Virgin Mary, and many of the angels. After her death in 1582 her written accounts of these visionary experiences were used as evidence in the process of canonization, and in 1622 she was finally named a saint. Teresa's visions, especially the mystic transverberation in which an angel pierced her breast with an arrow of God's love, were popular subjects of art in the seventeenth century. In Wierix's engraving, the saint is shown falling backward into the supporting arms of angels. The artist, however, has introduced several elements alluding to Teresa's death. According to accounts, Jesus, Mary, and Saint Joseph appeared to the saint in her dying hours. The young Jesus replaces the angel of the mystic transverberation, while a martyr's palm and floral wreath refer respectively to

her martyrdom through spiritual love and her spiritual marriage to God at death (Lavin, p. 114).

The integration of these two episodes from Teresa's life served as an important conceptual source for Bernini's *The Ecstasy of Saint Teresa* of 1647–51 (Lavin, p. 109). Indeed, as Lavin has shown (p. 113), ecstasy traditionally was associated with death — "the pain of spiritual love was conceived as a wound" — and death constituted the ultimate spiritual union of the lover and the beloved.

Wierix's print reveals the contemporary emphasis on the depiction of visions as deeply felt personal experiences. Teresa's whole body responds to the gentle pain of her ecstatic union with God, and virtually every element in the composition directs attention to her form and her state of spiritual bliss.

BIBLIOGRAPHY

Kristeller, Paul. *Kupferstich und Holzschnitt in vier Jahrhunderten*. Berlin: Bruno Cassirer, 1905. Esp. pp. 318ff.
Lavin, Irving. *Bernini and the Unity of the Visual Arts*. 2 vols.

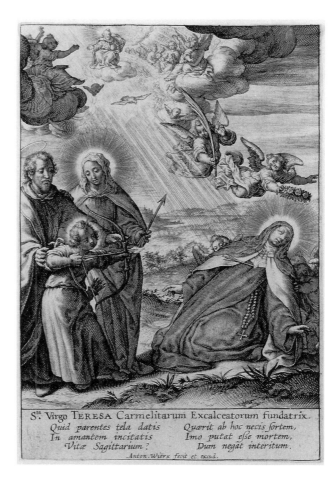

S.ta Virgo TERESA Carmelitarum Excalceatorum fundatrix.
Quid parentes tela datis Quærit ab hoc necis fortem,
In amantem incitatis Imo putat effe mortem,
Vitæ Sagittarium ? Dum negat interitum.
Anton. Wierx fecit et excud.

218

New York: Oxford University Press, 1980. Esp. vol. 1, pp. 109–15.

Lippmann, Friedrich. *Der Kupferstich*. Ed. Fedja Anzel-wesky. Berlin: Walter de Gruyter & Company, 1963. Esp. p. 116.

ABRAHAM JANSZ. VAN DIEPENBEECK
Flemish, 1596–1675

219 *Saint Ignatius of Loyola's Vision of Christ and God the Father*

17th century
Oil on canvas
127 x 91.5 cm. (50 x 36 in.)
The Berkshire Museum, Pittsfield, Massachusetts
Gift of Zenas Crane 1915.36
Acc. no. 1915.36

Abraham Jansz. van Diepenbeeck was born in Her-togenbosch in 1596 and moved to Antwerp around

219

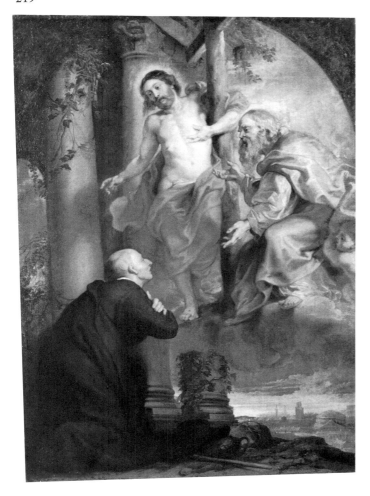

1623, where soon after his arrival he received substan-tial commissions as a glass painter, a trade he had learned from his father. He was also an accomplished draughtsman who made drawings for etchings and for book illustrations. By 1627 his name was associated with the renowned Plantin Press. In addition, Die-penbeeck was an accomplished painter and worked within the artistic circle of Peter Paul Rubens.

In their initial representations of newly canonized saints, artists drew from pictorial traditions as well as from scripture to establish an iconography. Such a meaningful adaptation is apparent in this exception-ally beautiful work which shows the unmistakable influence of Rubens. The subject of the painting, Saint Ignatius of Loyola (1491–1556), was the founder of the Jesuit order and one of the principal figures of the Counter-Reformation. This image of his vision of Christ and God the Father supports the claim made by the Catholic church for the continuing validity of miracles in the contemporary world. To lend author-ity and legitimacy to Saint Ignatius's role as founder of the Jesuit order, the artist, drawing from a biog-raphy of the saint written in 1566 by Pedro de Ribadeneira, renders the vision of Saint Ignatius as if it were the vision of Saint Peter. With such an as-sociation, one infers that Saint Ignatius founded his ministry with direct authority from not only the founder of the Catholic church and but also from God.

BIBLIOGRAPHY

von Manteuffel, K. Zoege. "Diepenbeeck, Abraham (Jansz.)." *Allgemeines Lexikon der Bildenden Künstler*. Vol. 9. Ed. Ulrich Thieme and Felix Becker. Leipzig: E. A. Seemann, 1913. Esp. pp. 243–45.

von Wurzbach, Alfred. *Niederländisches Künstler-Lexikon*. Vienna and Leipzig: Halm and Goldmann, 1906–11.

BARTOLOME ESTEBAN MURILLO
Spanish, 1617–82

220 *Fray Julián's Vision of the Ascension of the Soul of King Philip II of Spain*

1645–48
Oil on canvas
170 x 187 cm. (67 x 73⅝ in.)
Sterling and Francine Clark Art Institute, Williamstown, Massachusetts
Acc. no. 1968.19

Bartolomé Esteban Murillo, who dominated painting in Seville during the second half of the seventeenth century, began his artistic training at the age of fifteen or sixteen, not long after his plans to emigrate to the New World fell through. Influenced by Zurbarán, Velázquez, Juan de las Roelas, and Francisco Herrera the Elder, all of whom worked in Seville, Murillo developed a naturalistic style with strong chiaroscuro effects. His style did not change significantly until his visit to Madrid in 1658. According to the biographer Antonio Palomino, the artist enjoyed extraordinary popularity in his lifetime and was esteemed for his superior technical skills and the lifelike quality he imparted to his images (pp. 1031–36). Murillo was renowned for his devotional pictures, and during most of his career he received the patronage of the religious societies and confraternities of Seville.

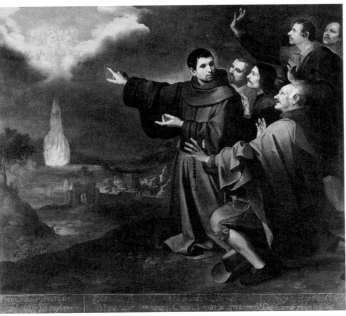

220

Murillo's illustrious career as a religious painter was launched with a cycle of paintings executed between 1645 and 1648. The series commemorates miraculous episodes from the lives of Franciscan friars and saints, and was designed to stretch across the four walls of the Claustro Chico in the convent of San Francisco. The painting included here comes from this series. As Diego Angulo Iñiguez has convincingly shown (1972, pp. 55–57), the picture presents an event from the life of Fray Julián de San Agustín, or de Alcalá, to whom no less than six hundred miracles had been attributed. Specifically, the picture illus-

trates one of the friar's prophetic visions. One day in September 1603, five years after the death of Philip II, Fray Julián stated before five witnesses that shortly after nine o'clock in the evening two radiant clouds would appear in the sky from different directions. The union of the clouds, according to the friar, would indicate that the soul of the king had left the flames of purgatory and entered the glory of heaven. According to the accounts of the witnesses, neither the flames of purgatory nor the soul of Philip II were visible. However, Murillo gives them a vivid presence in his pictorial account. Indeed, the artist presents the miraculous vision as a historical actuality by means of his naturalizing style. Each witness has a solid, almost sculptural, form and is given individualized features. The inscription at the base of the picture describes Fray Julián's prophecy and thus serves to strengthen the documentary nature of the image.

BIBLIOGRAPHY

Angulo Iñiguez, Diego. *Murillo.* 3 vols. Madrid: Espasa-Calpe, 1981.

Angulo Iñiguez, Diego. "Murillo: La Profecia de Fray Julián de San Agustín, de Williamstown." *Archivo Español de Arte* 177 (1972): 55–57.

Kubler, George. "El 'San Felipe de Heraclea' de Murillo y los cuadros del claustro chico." *Archivo Español de Arte* 169 (January 1970): 11–31.

Palomino, Antonio. *El Museo pictórico y escala óptica.* Ed. M. Aguilar. Madrid: M. Aguilar, 1947. Esp. pt. 1, pp. 1031–36.

Sullivan, Edward J., and Nina A. Mallory. *Painting in Spain 1650–1700 from North American Collections.* Princeton: Princeton Art Museum, Princeton University, in association with Princeton University Press, 1982. Esp. pp. 84–86.

The Bowes Museum. *Four Centuries of Spanish Painting.* Barnard Castle (Co. Durham), Great Britain: The Bowes Museum, 1967. Esp. p. 54, no. 69.

JUSTUS LIPSIUS
Flemish, 1547–1606

221 *Diva Virgo Hallensis beneficia eius & miracula fide atque ordine descripta*

Antwerp, Ioannem Moretum, 1605
Illustrated book
26.7 x 18.4 x 2.2 cm. (10½ x 7¼ x ⅞ in.)
Collection Julius S. Held

Justus Lipsius, whose Flemish name was Joest Lips, was a humanist scholar considered by many of his con-

SACELLVM D. VIRGINIS, ET PRAECIPVI ORNATVS.

1. *Statua sacra*. 2. *Duodecim Apostoli argentei, donum Philippi Boni*. 3. *Statua Diuæ argentea, eiusdem munus*. 4. *Maximilianus Imp. Albertus Dux Saxoniæ, & quidam procerum*. 5. *Arbor aurea Maximiliani, inscripta* ANNO VIIII. 6. *Lampas argentea Iulij II. P.M. inscripta*, ANNO VIIII. IVLIVS PONT. MAX. 7. *Paludamentum Caroli V. Imp*. 8. *Statua argentea viri geniculantis, donum Fuggerorum*.

221

numerous objects given in thanks for the miracles performed at the shrine. The key to the most important items, located at the bottom of the print, identifies silver statues of the Virgin and the twelve apostles given by a Philip Boni; a silver lamp that belonged to Pope Julius II; statues of Emperor Maximilian and Albert, Duke of Saxony; and another statue in silver from a famous German family of merchants and bankers, the Fuggers.

BIBLIOGRAPHY

Farmer, John David. *Rubens and Humanism*. Birmingham, Ala.: Birmingham Museum of Art, 1978.

Morford, Mark. *Stoics and Neostoics: Rubens and the Circle of Lipsius*. Princeton: Princeton University Press, 1991.

Rooses, Max. *Rubens*. Vol. 1. London: Duckworth and Company, 1904. Esp. p. 116.

Trevor-Roper, Hugh. *Princes and Artists: Patronage and Ideology at Four Habsburg Courts, 1517–1633*. New York: Harper & Row, 1976.

FRANCESCO SOLIMENA
Italian, 1657–1747

222 *The Miracle of Saint John of God*

1690
Oil on canvas
93.5 x 75.5 cm. (36⅞ x 29¾ in.)
Private Collection

temporaries as "the greatest philosopher of his time" (Trevor-Roper, p. 131). The leader of neo-stoicism, a philosophical movement that had wide appeal in the Netherlands, he greatly influenced Peter Paul Rubens and Rubens's brother Philip, who was his student. Lipsius's most famous published work was *Of Constancy*, a title that seems ironic given that he changed his religion three times. Born and raised a Catholic, he turned to Lutheranism and then Calvinism before returning finally to the Catholic faith.

Lipsius's *Diva Virgo Hallensis*, written after his reconversion to Catholicism, is one of many books published in the late sixteenth and early seventeenth centuries devoted to miracle-working images. The philosopher describes the Madonna at Halle, a sacred statue in a shrine near Brussels that was associated with numerous miracles. Lipsius was among those healed at the shrine and, as he relates, he left his silver pen as a votive offering. One of Cornelis Galle's engravings for the book shows the statue of the Madonna placed above the altar and surrounded by

As Carmen Cappel has observed, "Francesco Solimena brought Neapolitan art to its greatest glory" (p. 163). Although he never traveled outside Italy, he was extraordinarily well known abroad. Influenced by the art of Luca Giordano, Giovanni Lanfranco, and Mattia Preti, his grand and decorative style was particularly favored by the courts of Europe. The *Miracle of Saint John of God* dates from the middle of Solimena's career. Its sharply contrasting areas of light and dark, accents of vivid color, and sweeping linear rhythms give it a dramatic, restless energy that is appropriate to the subject matter.

Saint John of God, who lived in Portugal and Spain during the sixteenth century, was canonized in 1690. According to legend, he brought an end to the horrible plague that afflicted Naples in the middle of the seventeenth century, a miracle that he performed after his death. This painting is the model for an altarpiece that commemorates the miracle as well as the saint's canonization. Saint John is shown in the act of saving Naples, represented here in symbolic

222

form by the woman in the bed. In gratitude, she presents the saint with an image of himself.

BIBLIOGRAPHY

Cappel, Carmen. *A Taste for Angels: Neapolitan Painting in North America, 1650–1750.* New Haven: Yale University Art Gallery, 1987. Esp. pp. 163–213.

Bologna, Ferdinando. *Francesco Solimena.* Naples: L'arte Tipografica, 1958. Esp. fig. 91; pp. 96, 270.

Spinosa, Nicola. *La pittura napoletano del'600.* Milan: Longanesi and Company, 1984. Esp. p. 764 (illus.).

Spinosa, Nicola. *Pittura napoletano del settecento.* Naples: Electa, 1986. Esp. p. 104, no. 10; p. 182, illus. 12.

FRANCESCO PIRANESI
Italian, 1758/9?–1810

223 *Devotion of the Forty Hours in the Pauline Chapel, the Vatican*

1787
Etching
68.8 x 46.7 cm. (27⅛ x 18⅜ in.)
The Metropolitan Museum of Art, New York

The Elisha Whittelsey Collection, The Elisha Whittelsey Fund, 1967
Acc. no. 67.761.1
Venue: DC

In the seventeenth century Catholic churches produced grandly staged ceremonies focusing on the Eucharist. The most popular of these celebrations were known as the *Quarantore* or "Devotions of the Forty Hours." Originally, these devotions were held from Good Friday evening until Easter morning—a period of forty hours when the pious kept watch over a replica of Christ's tomb. In the 1600s the *Quarantore* were also celebrated during the last days of carnival (just before Lent), and on these occasions the focus of attention was the Eucharist (the holy wafer in the monstrance) (Weil, pp. 218–20).

This beautiful hand-colored etching is by Francesco Piranesi, a distinguished etcher from Rome and son of Giovanni Battista Piranesi, one of the most famous printmakers of the eighteenth century. The

223

etching illustrates a Devotion of the Forty Hours similar to those held in the seventeenth century. According to an inscription at the bottom of the second state of this etching, not included in this first state, the machinery used for this spectacle in the Pauline Chapel was that designed by Gian Lorenzo Bernini, the most celebrated artist of seventeenth century Italy.* Bernini, who staged a famous Devotion in the Pauline in 1628, turned the *Quarantore* into exceptionally elaborate and magnificent productions. The decorations consisted of illusionistic columns, a huge sacrament tabernacle, and more than a thousand shining lamps and candles. The entire spectacle emphasized the miraculous quality of the Eucharist, from which the intense light appeared to emanate. As one observer said about a very similar devotion staged by Bernini, it showed "the Glory of Paradise shining with tremendous brightness" (Weil, p. 227). As this print indicates, stagings of these devotions remained popular well into the eighteenth century.

* The inscription is quoted in full by Weil, p. 243.

BIBLIOGRAPHY

Fagiolo dell'Arco, Maurizio, and Silvia Carandini. *L'effimero barocco. Strutture della feste nella Roma del'600*. Rome: Bulzoni Editore, 1977. Esp. vol. 1, pp. 252–54; and vol. 2, pp. 29–34.

Lavin, Irving. *Bernini and the Unity of the Visual Arts*. 2 vols. New York: Oxford University Press, 1980. Esp. pp. 96–97.

Weil, Mark. "The Devotion of the Forty Hours and Roman Baroque Illusions." *Journal of the Warburg and Courtauld Institutes* 37 (1974): 218–48.

Wollin, N. G. *Gravures originales de Desprez ou exécutées d'aprés ses dessins*. Malmo, 1933. Esp. pp. 110ff.

Italian

224 *Design for an Altar Crèche*

Rome, 1650–1700
Pen and brown ink, gray wash
36.3 x 23.8 cm. (14½ x 9½ in.)
Cooper-Hewitt, National Museum of Design,
 Smithsonian Institution, New York
Gift of Sarah and Eleanor Hewitt
Acc. no. 1901–39–2554
Venue: DC

This delicate pen and wash drawing is a project for an altar decoration meant for the Christmas season. The work of an unidentified Roman artist and datable from the second half of the seventeenth century, it

transforms the whole altar area into a crèche or nativity scene: the humble place of Christ's birth is suggested by the illusionistic walls of a cave and makeshift wooden roof, while in the middle of the composition is a painting of the Virgin adoring her infant son. The separate elements of the decoration, probably constructed of painted plaster, wood, and canvas, thus create a stagelike setting in which the miraculous event appears as a tangible reality to the viewer.

Beginning in the late sixteenth century, elaborate decorations such as these were constructed to help people better grasp the mysteries of their faith. Here, as in many other decorations, the focus of attention is a monstrance containing the bread or wafer that invisibly changes (or transubstantiates) into the body of Christ. The radiating metal rays of the monstrance and shining light of the surrounding candles convey the sense of a living spiritual presence. Indeed, the Holy Spirit is often represented in art as a shining light or flames.

224

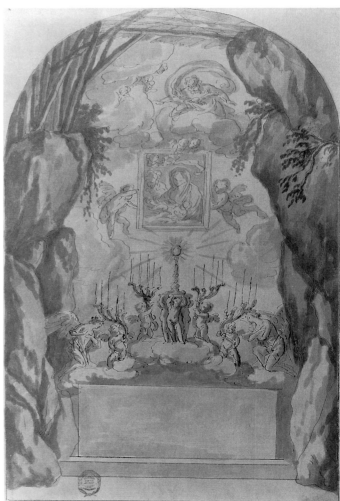

The design therefore is not for a crèche scene in the normal sense. Rather, the story of Christ's nativity is bound to the idea of the trinity; that is, that God exists in three persons. All three appear in the drawing's central axis: God the Father in the clouds above, God the Son in the painting, and God the Holy Spirit in the monstrance. Such a scheme draws attention to God's will to bring his only begotten son into the world (he seems to preside over the angels carrying the picture above the altar), to the birth of God in human form (as represented in the picture), and to the sacrifice of God the Son (as signified by the wafer and the tomb-altar below). At the same time, the glory of light around the monstrance and the triumphal archlike contours of the drawing allude to Christ's victory over death. By means of this decorative scheme, therefore, the artist emphasizes the importance of the Eucharist and the presence of the Holy Spirit.

BIBLIOGRAPHY

Berliner, R. *Die Weihnachtskrippe*. Munich: Prestel Verlag, 1955. Esp. p. 75 and no. 29 (illus).

ANDREA POZZO
Italian, 1642–1709

225 *Perspectiva pictorum et architectorum*

Rome, S. Angelum Cuftodem, 1693
Illustrated book
Each approx. 42.7 x 28.3 x 3.5 cm.
(16¾ x 11⅛ x 1⅜ in.)

Copy A: The New York Public Library, New York Astor, Lenox and Tilden Foundations Miriam and Ira D. Wallach Division of Art, Prints and Photographs Acc. no. 3-MBF +

Copy B: The Beinecke Rare Book and Manuscript Library, Yale University, New Haven, Connecticut Acc. no. Fol. 462 1693 Venue: DC

Copy C: *Perspectivae pictorum atcq architectorum* Ausburg, Jeremias Wolff, 1706 Tobin Collection, McNay Art Museum, San Antonio, Texas Acc. no. TL1984.1.276 Venues: HO, HI

Andrea Pozzo was an Italian painter and architect renowned for his work with perspective illusions. A lay brother of the Jesuit order, which he entered at the age of twenty-two, he was esteemed by some of the most important patrons of the time, including Emperor Leopold, and enjoyed tremendous success for his decorations of churches and palace interiors. Pozzo's best-known works were carried out for the Jesuit churches in Rome, and in his influential *Perspectiva pictorum et architectorum* he offers detailed instructions for their construction. In his address to "The Lovers of Perspective," Pozzo states that "the art of perspective does, with wonderful pleasure, deceive the eye, the most subtle of all our outward senses." He outlines the basic rules of this deceptive art and then discusses some of the decorations for the Devotions of the Forty Hours that he himself designed. Pozzo's designs for these occasions were among the most famous and popular of the time, and they were regarded by the Jesuits as effective rivals to secular festival decorations (Bjurström, p. 99).

Shown here is Pozzo's design for the 1685 *Quarantore* held in the Church of Il Gesù. A grandiose biblical pageant, it celebrated Christ's first public miracle, the turning of water into wine at the Marriage of Cana. As Pozzo says, "it struck the eye when seen by daylight but was more especially surprising by candlelight." Thousands of lights were hidden behind the sets, and because the artist cleverly integrated the sets with the real architecture of the church, he created a stunning illusion of vast space. The culminating feature, placed in the middle of the great arch, was an image of "clouds filled with angels adoring the blessed Sacrament." Pozzo has omitted this from the illustration, however, so that his illusionistic set can be more clearly seen. The entire apparatus appeared as a magnificent tableau, a kind of living theater, that brought the congregation into immediate contact with the religious mysteries. As such, it was entirely consistent with the ideas of Saint Ignatius, who, in his *Spiritual Exercises*, recommended that the faithful employ all their senses in "seeing the place"—of the nativity, the resurrection, or other great miracles described in the scriptures.

Besides the temporary and movable sets he made for the *Quarantore*, Pozzo was responsible for two remarkable ceiling decorations in the Church of Sant' Ignazio. Because a real dome or cupola was never constructed over the crossing of the church, Pozzo was asked to simulate one instead. The illusion, painted on a perfectly flat surface, was extraordinarily effective, and in *Perspectiva pictorum et architectorum* the artist shows how it was done. In the accompanying text, Pozzo relates how some architects disliked the way he set the columns on corbels since this was not practiced in solid architecture. But, as he goes on to

say, "a certain painter, a friend of mine, removed all their scruples by answering for me, that if at any time the corbels should be so much surcharged with the weight of the columns, as to endanger their fall, he was ready to repair the damage at his own cost."

The second and grandest achievement for Sant'Ignazio was Pozzo's illusionistic fresco painting in the nave vault. The fictive architecture (rendered according to a single-point perspective system) is integrated with the real architecture below and seems to extend beyond the limits of the church into a heavenly atmosphere. The painting celebrates the works of the Jesuit missionaries throughout the world. At the center of the vault—deep in the illusionistic space— Jesus sends a "ray of light to the heart of Saint Ignatius, which is then transmitted by him to the most distant hearts of the four parts of the world" (Tietze, p. 440). Pozzo's decoration is meant to demonstrate the impact of the Jesuit mission on earth, but unlike earlier illusionistic paintings it does not bring the spectator into the closest possible contact with the holy figures or with the Christian mysteries. Rather, his sensational and breathtaking illusion gives the viewer a glimpse of a distant realm of which he is not a part. Immediacy has been replaced by a distant, yet still glorious vision.

BIBLIOGRAPHY

Bjurström, Per. "Baroque Theater and the Jesuits." In *Baroque Art: The Jesuit Contribution*. Ed. Rudolf Wittkower and Irma B. Jaffe. New York: Fordham University Press, 1972.

Haskell, Francis. *Patrons and Painters: A Study in the Relations between Italian Art and Society in the Age of the Baroque*. New Haven: Yale University Press, 1980.

Kerber, Bernhard. *Andrea Pozzo*. New York: de Gruyster, 1971.

Tietze, Hans. "Andrea Pozzo und die Fürsten Liectenstein." *Jahrbuch für Landeskunde von Niederösterrich* (1914–15). Esp. pp. 432–46.

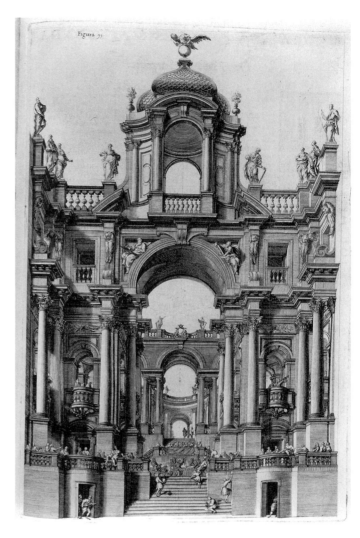

225B The apparatus for the *Quarantore*, Il Gesú. Engraving.

BIBLIOGRAPHY

THIS BIBLIOGRAPHY is organized in two parts: documents and publications before 1755 (including reprints and facsimiles) and general bibliography. Translations and modern editions or collections of works written before 1755 are contained in the general bibliography.

The bibliography does not include books that also appear in the exhibition. Information regarding these works can be found in the catalogue.

DOCUMENTS AND PUBLICATIONS BEFORE 1755

Aldrovandi, Ulisse. *Ornithologiae, hoc est de avibus historiae*. Vol. 1. Bologna: Franciscum de Franciscis Senensem, 1599.

Aldrovandi, Ulisse. *De quadrupedibi digitatis viviparis libri tres: et de quadrupedibi digitatis oviparis libro duo*. Bologna: N. Tebaldinum, 1637.

Angel, Philips. *Lof der Schilder-konst*. Leiden: Willem Christiaens, 1642.

Anghiera, Peter Martyr. *The Decades of the Newe Worlde or West India*. Translated by Rycharde Eden. London: Guilhelmi Powell, 1555.

Bacon, Francis. *The Two Bookes of Francis Bacon of the Proficience and Advancement of Learning, Divine and Humane*. London: Henrie Tomes, 1605.

Barbaro, Daniele. *La pratica della perspettiva*. Venice: Camillo & Rutilio Borgominieri Fratelli, 1569.

Bellori, Giovan Pietro. *Le vite de' pittori, scultori et architetti moderni*. Rome: Mascardi, 1672.

Belon, Pierre. *L'Histoire naturelle des estranges poissons marins*. . . . Paris: R. Chaudiere, 1551.

Belon, Pierre. *Les Observations de plusieurs singularitez et choses memorables*. . . . Paris: G. Corrozet, 1553.

Belon, Pierre. *L'Histoire de la nature des oyseaux, avec leurs descriptions, et naifs protraicts retirex du naturel*. Paris: G. Cavellat, B. Prevoust, 1555.

Beni, Paolo. *Risposta alle considerationi o dubbi dell'Ecc.mo Sig. Dottor Malacreta* Padova, 1600.

Besler, Basilius. *Hortus Eystettensis: sive, diligens et accurata omnium plantarum*. Nuremberg, 1613.

à Beughem, Cornelis. *Bibliographia mathematica et artificiosa novissima*. Amsterdam: Van Waesbergen, 1688.

Biblioteca Apostolica Vaticana. Ms. Barb. Lat. 4236. *"Indice di medaglie, di miniature rappresentanti fatti storici o cose naturali, che si contenavano in CXII Casette."*

Biblioteca Apostolica Vaticana. Ms. Barb. Lat. 4265. [Inventory of Plants in the Barberini Garden, 1630].

de Bie, Cornelis. *Het Gulden Cabinet van de Edel vry Schilderconst*. . . . Antwerp: Jan Meyssens, 1661.

de Bie, Cornelis. *Het Gulden Cabinet van de Edel vry Schilderconst*. . . . [Antwerp, 1622] Edited by G. Lemmens. Soest: Davaco, 1971.

Blaeu, Joan. *Catalogue des atlas, théâtre des citez globes, spheres & cartes géographique & marinez*. Amsterdam, n.d. Published in Facsimile: *A Catalogue by Joan Blaeu. A facsimile with an accompanying text by Cornelis Koeman*. Amsterdam: Nico Israel, 1967.

Boaistuau, Pierre, et al. *Histoires prodigieuses*. Paris, 1560. Reprint. Paris: Club Français du Livre, 1961.

Borel, Pierre. Catalogue des choses rare qui sont dans le Cabinet de Maìstre *Pierre Borel, médecin de Castres au haut Languedoc*. Published in A. Colomiez, *Les Antiquitez, raretez, plantes, minéraux & autres considérables de la ville et du conté de Castres*. . . . Castres, 1649.

Bosio, Antonio. *Historia passionis beatae Caeciliae Virginis*. Rome, 1600.

Brandt, Sebastian. *Das Narrenschiff*. Basel, 1494.

Braun, Georg, and Franz Hogenberg. *Civitates orbis terrarum*. 6 vols. Cologne, 1572–1618.

de Bry, Theodor. *Brevis narratio eorum quae in Florida Americae provicia Gallis acciderunt.* . . . Frankfurt-am-Main: Joannis Wechelli, 1591.

de Bry, Theodor. *Dritte Buch Americae*. . . . Frankfurt, 1593.

Burton, Robert. *The Anatomy of Melanchology*. Oxford: John Lichfield and James Short, 1621.

Camerario, Joachimo. *Symbolorum et emblematum ex re herbaria.* . . . Frankfurt: Johannis Ammony, 1654.

de Caus, Isaac. *New and Rare Inventions of Water-Works.* . . . Translated by John Leak. London: Joseph Moxon, 1659.

Clusius, Carolus. *Rariorum aliquot stirpium per Hispanias observatarum historia*. Antwerp: Christophori Plantini, 1576.

Cotgrave, Richard. *A Dictionarie of the French and English Tongues*. London, 1611.

Del Re, Antonio. *Dell'antichità tiburtine capitolo V*. Rome: Giacomo Mascardi, 1611.

Dioscorides. *De materia medica*. Colle: Johannes de Medemblick, 1478.

Dodoens, Rembert. *Florum et coronarium odoratarumque nonnullarum herbarum historia*. Antwerp: Christophori Plantini, 1568.

Dodoens, Rembert. *Stirpium historiae pemptades sex sive libri XXX*. Antwerp: Christophori Plantini, 1583.

de Dominici, Bernardo. *Vite de' pittori, scultori ed architetti napoletani non mai date alla luce da autore alcune*. Naples: Nella stamperia del Ricciardi, 1742–43.

Doughtie, Edward. *The Wonder of Wonders*. London, 1698.

Euclid. *Elements of Geometrie of the Most Ancient Philosopher Euclide of Megara*. Translated by H. Billingsley. London: I. Daye, 1570.

Furttenbach, Joseph. *Architectura Recreationis*. Edited by Bernard Hewitt. Augsburg: Johann Schultes, 1640.

Galen [Galenus]. *Opera Omnia*. Venice: Philipum Pintum de Caneto, 1490.

Gerarde, John. *The Herball; or, Generall Historie of Plantes*. London: A. Islip, John Norton, and R. Whitakers, 1597.

Gerard, John. *The Herball or General Historie of Plantes*. The complete 1633 edition as revised and enlarged by Thomas Johnson. Reprint. New York: Dover Publications, Inc., 1975.

Gesner, Konrad. *Historiae animalium*. 4 vols. in 3. Zurich: C. Froschower, 1551–58.

Gesner, Konrad. *Thierbuch, das ist ein kurtze Beschreybung.* . . . Zurich: C. Froschower, 1563.

Gesner, Konrad. *Fischbuch, das ist ein kurtze doch vollkomne Beschreybung aller Fischen.* . . . Zurich: C. Froschower, 1575.

Gesner, Konrad. *Vogelbuch darinn die Art, Natur, und Eigenschafft aller vöglen.* . . . Zurich: C. Froschower, 1581.

Hariot, Thomas. *A Brief and True Report of the New Found Land of Virginia.* . . . Frankfurt-am-Main: Joannis Wecheli, 1590.

van Hoogstraten, Samuel. *Inleyding tot de Hooge Schoole der Schilderkonst: anders de Zichtbaere Werelt*. Rotterdam: François van Hoogstraeten, 1678.

Johnson, Samuel. *A Dictionary of the English Language*. Vol. 2. London, 1755.

Joncquet, Dionys. *Hortus regius.* . . . Paris, 1665.

Jonstonus, Joannes. *Dendographias sive historia naturalis de arboribus et fructibus.* . . . Frankfurt-am-Main: Hieronymi Polichii, 1662.

Jonstonus, Johannes. *Historia naturalis*. 6 vols. Frankfurt, 1650–53.

Lassels, Richard. *The Voyage to Italy, or A Compleat Journey through Italy*. Paris: Vincent du Moutier, 1670.

L'Ecluse, Charles. *Rariorum aliquot stirpium per Hispanias observatorum historia*. Antwerp, 1576.

L'Ecluse, Charles. *Exoticorum libri decem*. Leiden: Christophori Plantini, 1605.

Lee, Rensselaer W. *Ut Pictura Poesis: The Humanistic Theory of Painting*. New York: W. W. Norton & Company, 1967.

Liceti, Fortunio. *De monstrorum caussis, natura & differentiis libri duo.* . . . Padua: Casparem Crivellarium, 1616.

Liceti, Fortunio. *De monstrorum caussis, natura & differentiis libri duo.* . . . 2nd ed. Padua: Paulum Frambottum, 1634.

Lomazzo, Giovanni Paolo. *Trattato dell'arte della pittura*. Milan: Paolo Gottardo Pontio, 1584.

Lomazzo, Giovanni Paolo. *Idea del tempio della pittura*. Milan: Paolo Gottardo Pontio, 1590.

Lomazzo, Giovanni Paolo. *A Tracte Containing the Artes of Curious Paintings, Carvings, Buildings*. Translated by Richard Haydocke. Oxford: I. Barnes, 1598.

Lycosthénes, Konrad [Wolffhart]. *Prodigiorum ac ostentorum chronicon*. Basil: Henricum Petri, 1557.

Malpighi, Marcello. *Disseratio epistolica de bombyce.* . . . London: J. Martyn & J. Allestry, 1669.

van Mander, Carel. *Het Schilder-Boeck*. Haarlem, 1604. [Utrecht: Davaco Publishers, 1969.]

Mattioli, Pietro Andrea. *De plantis eptiome . . . Com-*

pendium de plantis omnibus. Bound with *Accessit . . . opusculum de itinere quo e Verona in Baldum montem plantarum refertissimum itur.* Venice, 1586.

Minturno, Antonio. *L'arte poetica.* Venice: Gio. Andrea Valvassori, 1564.

Mission, François. *New Voyage to Italy.* 2 vols. London, 1739.

de Molinet, Claude. *Le Cabinet de la bibliothèque de Sainte-Geneviève.* Paris: Antoine Dezallier, 1692.

Neirembergii, Joannis Eusebio. *Historia naturae, naturae maxime peregrinae, libris XVI. . . .* Antwerp: Plantiniana B. Moreti, 1635.

Oehme, Ruthardt. *Introduction to the 1550 edition of* Cosmographia *by Sebastian Münster.* Facsimile ed. Amsterdam, 1968.

Ophovius, Michel. *D. Catharinae serensis virginis SSmae Ord. praedicatorum vita ac miracula selectoria formis aeneis expressa.* Antwerp: Joannem Gallaeñ, 162?.

Orlers, J. J. *Beschrijvinge der Stadt Leyden.* Leiden/Delft: Cloeting, 1641.

Palomino, Antonio. *El museo pictórico y escala optica.* [1715–24] 3 vols. Madrid: L. A. de Bedmar, 1947.

Paré, Ambroise. *Les Oeuvres . . .* 4th ed. Paris: Gabriel Buon, 1585.

de Passe, II, Crispin. *A Garden of Flowers.* Translated by John Frampton. Utrecht: Salomon de Roy, 1615.

Pigna, Giovan Battista. *I romanzi.* Venice: Vincenzo Valgrisi, 1554.

de Piles, Roger. *Abregé de la vie des peintres. . . .* 2nd ed., rev., and corr. Paris: Jacques Estienne, 1715.

della Porta, Giambattista. *Magiae naturalis, sive, de miraculis rerum natvralium libri IIII.* Naples, 1558.

della Porta, John Baptista. *Natural Magick.* London, 1658. Facsimile ed. Edited by Derek J. Price. New York: Basic Books, 1957.

Powell, Thomas. *Humane Industry or, A History of Most Manual Arts.* London: Henry Herringman, 1661.

Raymond, John. *Il Mercurio Italico. An Itinerary Contayning a Voyage Made Through Italy in the Yeare 1646 and 1647.* London: Humphrey Moseley, 1648.

Raynaud, Théophile, S. J. *De incorruptione cadavarum.* Arausioni: Typis Eduardi Rabani, 1651.

Reisch, Gregor. *Margarita philosophica cum additionibus novis. . . .* Basel: Furter, 1517.

Ridolfi, Carlo. *Le maraviglie dell'arte. . . .* Venice: G. B. Sagua, 1648. Reprint. Ed. by Detlev von Hadeln. Rome: Societá multigrafica editrice SOMU, 1965.

Salviani, Ippolito. *Aquatilium animalium historiae.* Rome, 1554–58.

Serlio, Sebastiano. *Tutte l'opere d'architettura et prospettiva.* Venice: G. de' Franceschi, 1619.

de Serres, Olivier. *Le Théâtre d'agriculture et mesnage des champs.* Paris, 1605.

Skelton, Raleigh Ashlin. *Introduction to the 1513 Strasbourg edition of* Geographia *by Claudius Ptolemy.* Facsimile ed. Amsterdam: Theatrum Orbis Terrarum, 1966.

Skelton, Raleigh Ashlin. *Introduction to the 1570 edition of* Theatrum Orbis Terrarum *by Abraham Ortelius.* Facsimile ed. Amsterdam: Theatrum Orbis Terrarum, 1966.

Skelton, Raleigh Ashlin. *Introduction to the 1636 English text edition of Mercator-Hondius-Jansson Atlas.* Facsimile ed. Amsterdam, 1968.

Staden, Hans. *Warhäftige Historia und Beschreibung eyner Landschafft de Wilden.* Marburg, 1557.

Sturmy, Samuel. *The Mariner's Magazine.* London: Printed for R. Mount, 1700.

Swammerdam, Jan. *Biblia naturae; sive, historia insectorum.* 2 vols. Leiden: I. Severinum, B. Vander Aa, P. Vander Aa, 1737–38.

Sweert, Emmanuel. *Florilegium.* Frankfurt-am-Main: Anthonium Kempner, 1612.

Taegio, Bartolommeo. *La villa.* Milan: Francesco Moscheni, 1559.

Tesauro, Emmanuele. *Il cannocchiale aristotelico.* Turin, 1670. August Buck facsimile edition. Berlin: Verlag Gehlen, 1968.

Terzago, Paolo Maria. *Museo ò galerie adunata dal sapere: e dallo studio del Sig. Canonico Manfredo Settala.* Tortona: Eliseo Viola, 1666.

Theophrastes. *De historia et de causis plantarum.* Treviso: Bartholomaeus Confalonerius, 1483.

da Vignola, Giacomo Barozzi. *Le due regole della prospettiva pratica.* Rome: Francesco Zannetti, 1583.

GENERAL BIBLIOGRAPHY

Accordi, Bruno. "Ferrante Imperato (Napoli 1550–1625) e il suo contributo alla storia della geologia." *Geologica Romana* 20 (1981):43–56.

Ackley, Clifford S. *Printmaking in the Age of Rembrandt*. Boston: Museum of Fine Arts, 1981.

d'Afflitto, Chiara, Maria Pia Mannini, and Claudio Pizzorusso. *Il paessaggio nella pittura fra cinque e seicento a firenze*. Poggibonsi: T. A. P. Grafische, 1980.

The Age of Caravaggio. New York: The Metropolitan Museum of Art, and Milan: Electra Editrice, 1985.

Alberti, Leon Battista. *On Painting*. Translated by John Spencer. London: Routledge & Kegan Paul, 1956.

Almagià, Roberto. "Un grande planisfero di Giuseppe Rosaccio." *Revista Geografica Italiana* 31 (1924).

Alpers, Svetlana. *The Art of Describing: Dutch Art in the Seventeenth Century*. Chicago: University of Chicago Press, 1983.

D'Ancona, Alessandro. *L'origini del teatro italiano. . . .* 2 vols. 2nd. ed., rev. and enl. Turin: Ermano Loescher, 1891.

Anderson, Frank. *An Illustrated History of the Herbals*. New York: Columbia University Press, 1977.

Andreas, Charlotte Henriëtte. *In en om een botanische tuin: Hortus Groninganus 1626–1966*. Groningen: Erven B. van der Kamp, 1976.

Angiolillo, Marialuisa. *Leonardo feste e teatri*. Naples: Società Editrice Napoletana, 1979.

Angulo Iñiguez, Diego. "Murillo: La profécia de Fray Julián de San Agustín, de Williamstown." *Archivo Español de Arte* 177 (1972):55–57.

Angulo Iñiguez, Diego. *Murillo*. 3 vols. Madrid: Espasa-Calpe, 1981.

Anker, Jean. *Bird Books and Bird Art: An Outline of the Literary History and Iconography of Descriptive Ornithology*. Copenhagen: Levin and Munksgaard and Ejnar Munksgaard, 1938.

Arber, Agnes. "The Draughtsman of the 'Herbarum vivae eicones'." *The Journal of Botany, British and Foreign* 59 (May 1921):131–32.

Arber, Agnes. *Herbals, Their Origin and Evolution: A Chapter in the History of Botany, 1470–1670*. 2nd ed. Cambridge: Cambridge University Press, 1938.

Arber, Agnes. "Nehemiah Grew (1641–1712) and Marcello Malpighi (1628–1694): An Essay in Comparison." *Isis* 34 (1942–43):7–16.

Arias, Ricardo. *The Spanish Sacramental Plays*. Boston: Twayne Publishers, 1980.

Ariosto, Ludovico. *Orlando Furioso*. Edited by Lanfranco Caretti. Milan-Naples: Riccardo Ricciardi, 1963.

Aristotle. *Metaphysics*. Translated by Richard Hope. Ann Arbor: The University of Michigan Press, 1960.

Aristotle. *Poetics I*. Translated by Richard Janko. Indianapolis: Hackett Publishing Company, 1987.

Aristotle. *The Rhetoric and the Poetics of Aristotle*. Translated by Friedrich Solmsen. New York: Random House, 1954.

Aristotle. *The Rhetoric of Aristotle*. Translated by Lane Cooper. New York: Appleton-Century Crofts, 1960.

Armenini, Giovanni Battista. *On the True Precepts of the Art of Painting*. Edited and translated by Edward J. Olszewski. New York: Burt Franklin and Co., 1977.

Armstrong, Joe C. W. *Champlain*. Toronto, Ont.: Macmillan of Canada, 1987.

Art of the Renaissance Craftsman. Cambridge, Mass.: Fogg Art Museum, 1937.

Ashworth, Jr., William B. "Marcus Gheeraerts and the Aesopic Connection in Seventeenth Century Scientific Illustration." *Art Journal* 44 (1984):132–38.

Aymonin, Gérard G. *The Besler Florilegium: Plants of the Four Seasons*. Translated by Eileen Finletter and Jean Ayer. New York: Harry N. Abrams, 1989.

Babelon, Jean-Pierre. *Israël Silvestre: Vues de Paris*. Paris: Berger-Levrault, 1977.

Bagrow, Leo. *History of Cartography*. 2nd ed. Chicago: Precedent Publishing, Inc., 1985.

Baldinucci, Filippo. *Notizie dei professori del disegno* 1682. Edited by F. Ranalli. Florence: V. Batelli e Compagni, 1845–46. Reprint. 7 vols. Florence: Studio per edizione scelte, 1974–75.

Baldinucci, Filippo. *The Life of Bernini*. Translated by Catherine Enggass. University Park: Pennsylvania State University, 1966.

Balsiger, Barbara Jeanne. "The *Kunst- und Wunderkammern*: A Catalogue Raisonné of Collecting in Germany, France, and England, 1565–1750." Ph.D. dissertation, University of Pittsburgh, 1970.

Baltrušaitis, Jurgis. *Anamorphic Art*. Translated by W. J. Strachan. New York: Harry N. Abrams, Inc., 1977.

Bandello, Matteo. *Tutte le opere di Matteo Bandello*. 2 vols. Edited by Francesco Flora. 3rd ed. Milan: Arnaldo Mondadori, 1952.

Barbin, Hérve, and Jean-Pierre Duteil. "Miracle et pélerinage au XVIIe siècle." *Revue l'histoire de l'église de France* 61(1975):250–53.

Barbour, Philip L. *The Three Worlds of Captain John Smith*. Boston: Houghton Mifflin, 1964.

Barocchi, Paolo, ed. *Trattati d'arte del cinquecento, fra manierismo e controriforma*. 3 vols. Bari: Laterza, 1960–62.

Barocchi, Paolo, ed. *Scritti d'arte del cinquecento*. 3 vols. Milan-Naples: Riccardo Ricciardi Editore, 1977.

Barocchi, Paola, and Giovanna Ragionieri, eds. *Gli Uffizi, quattro secoli di una galleria: atti del convegno internazionale di studi, Firenze 20–24 settembre 1982*. 2 volumes. Florence: Leo S. Olschki, 1983.

Barthelmess, Klaus. "The Sperm Whales *Physeter Macrocephalus* at Berckhey in 1598 and on the Springersplaat in 1606—A Discovery in Early Iconography." *Lutra: Bulletin de la Société pour l'etude et la protection des mammiféres* 32(1989):185–89.

Battersby, Martin. *Trompe-l'oeil: The Eye Deceived*. New York: St. Martin's Press, 1974.

Battisti, Eugenio. *Rinascimento e barocco*. Turin: Einaudi, 1960.

Bauer, Rotraud, and Herbert Haupt. "Das Kunstkammerinventar Kaiser Rudolfs II, 1607–11." In *Jahrbuch der Kunsthistorischen Sammlungen in Wien*. 72 (1976).

Baur-Heinhold, Margarete. *The Baroque Theatre: A Cultural History of the 17th and 18th Centuries*. New York: McGraw-Hill, 1967.

Bazin, Germain. *The Museum Age*. Translated by Jane van Nuis Cahill. New York: Universe Books, 1967.

Bean, J., and F. Stampfle. *Drawings from New York Collections I: The Italian Renaissance*. New York: The Metropolitan Museum of Art, 1965.

Becher, Charlotte, et al. *Das Stuttgarter Harnisch-Musterbuch, 1548–1563*. Vienna, 1980.

Bedini, Silvio A. "The Evolution of Science Museums." In *Technology and Culture* 6 (1965):1–29.

Bedini, Silvio A. "The Papal Pachyderms." *Proceedings of the American Philosophical Society* 125 (1981):75–90.

Benezit, E. *Dictionnaire critique et documentaire des peintres, sculpteurs, dessinateurs et graveurs. . . .* Rev. ed. 8 vols. Paris: Librairie Gründ, 1948–55.

Benisovich, Michel N. "The Drawings of Stradanus (Jan van der Straeten) in the Cooper Union Museum for the Arts of Decoration, New York." *Art Bulletin* 38 (December 1956):249–51.

Bergström, Ingvar. *Dutch Still-Life Painting in the Seventeenth Century*. Translated by Christina Hedström and Gerald Tayler. New York: Thomas Yoseloff, Inc., 1956.

Berliner, Rudolf. *Die Weihnachtskrippe*. Munich: Prestel Verlag, 1955.

Berthold, Margot. *A History of World Theater*. Translated by Edith Simmons. New York: Ungar, 1972.

Best, George. *The Three Voyages of Martin Frobisher*. Edited by Vilhjalmur Stefansson. London: Argonaut Press, 1938.

Biach-Schiffman, Flora. *Giovanni und Ludovico Burnacini: Theater und Feste am Wiener Hofe*. Vienna and Berlin: Krystall Verlag, 1931.

Biester, James P. "Strange and Admirable: Style and Wonder in the Seventeenth Century." Ph.D. dissertation, Columbia University, 1989.

Bjürstrom, Per. *Giacomo Torelli and Baroque Stage Design*. Stockholm: Almquist & Wiksell, 1962.

Bjürstrom, Per. *Giacomo Torelli and Baroque Stage Design*. Stockholm: Nationalmuseum, 1962.

Blaher, Damian Joseph. *The Ordinary Processes in Causes of Beatification and Canonization: A Historical Synopsis and a Commentary*. Washington, D.C.: Catholic University of America Press, 1949.

Blankert, Albert. *Gods, Saints and Heroes: Dutch Painting in the Age of Rembrandt*. Washington, D.C.: National Gallery of Art, 1980.

Blumenthal, Arthur R. *Theater Art of the Medici*. Hanover, N.H.: Dartmouth College Museum and Galleries, 1980.

Blunt, Wilfrid. *Tulipomania*. London, 1935.

Blunt, Wilfrid. *The Art of Botanical Illustration*. London: Collins, 1950.

Blunt, Wilfrid, and Sandra Raphael. *The Illustrated Herbal*. New York: Metropolitan Museum of Art, 1979.

Boas, Marie. *The Scientific Renaissance: 1450–1630*. New York: Harper and Row, 1962.

Boase, T. S. R. *Giorgio Vasari: The Man and the Book*. Princeton: Princeton University Press, 1979.

von Bode, Wilhelm. *Die Italienischen Bronzestatuetten der Renaissance-Kleine neu bearbeitete Ausgabe*. Berlin: Cassirer, 1922.

Bohlin, Diane DeGrazia. *Prints and Related Drawings of the Carracci Family: A Catalogue Raisonné*. Washington, D.C.: National Gallery of Art, 1979.

Bologna, Ferdinando. *Francesco Solimena*. Naples: L'arte Tipografica, 1958.

Bonelli, M. L. Righini. *Catalogo degli strumenti del museo di storia della scienza*. Florence: Leo S. Olschki, 1954.

Bonelli, M. L. Righini, and William R. Shea, eds. *Reason, Experiment, and Mysticism in the Scientific*

Revolution. New York: Science History Publications, 1975.

van den Boogaart, E. *Johan Maurits van Nassau-Siegen, 1604–1679: A Humanist Prince in Europe and Brazil.* The Hague: The Johan Maurits van Nassau Stichting, 1979.

The Bowes Museum. *Four Centuries of Spanish Painting.* Barnard Castle (Co. Durham), Great Britain: The Bowes Museum, 1967.

Bowron, Edgar Peters, ed. *The North Carolina Museum of Art: Introduction to the Collections.* Chapel Hill: University of North Carolina Press, 1983.

Boxer, C. R. *The Portuguese Seaborne Empire 1415–1825.* London: Hutchinson, 1969.

Braun, Joseph. *Der Christliche Altar in seiner Geschichtlichen Entwicklung.* 2 vols. Münich: Alte Meister Guenther Koch, 1924.

Bredekamp, Horst. *Vicino Orsini und der heilige Wald von Bomarzo: ein Fürst als Künstler und Anarchist.* 2 vols. Worms: Werner, 1985.

Bredius, A. *Künstler-Inventare. Urkunden zur Geschichte der holländischen Kunst des XVIten, XVIIten, and XVIIIten Jahrhunderts.* 8 vols. The Hague: M. Nijhoff, 1915–22.

Brett, G. "The Automata in the Byzantine Throne of Solomon." *Speculum* 29 (1954):477–87.

Brewer, Donald J. *Portraits of Objects: Oscar and Maria Salzer Collection of Still Life and Trompe-l'oeil Paintings.* Fresno: Fresno Metropolitan Museum of Art, History and Science, 1984.

Brewer, Donald J., and Alfred Frankenstein. *Reality and Deception.* Los Angeles: University of Southern California, University Art Galleries, 1974.

Brewer, E. Cobham. *A Dictionary of Miracles: Imitative, Realistic, and Dogmatic. . . .* Philadelphia, Lippincott, 1884.

British Museum. *Catalogue of Books Printed in the Fifteenth Century Now in the British Museum.* Vol. 2. Ed. Alfred W. Pollard. London: British Museum, 1908–72.

Brock, Alan St. H. *A History of Fireworks.* London: George G. Harrap, 1949.

Brooks, Jerome E. *Tobacco: Its History Illustrated by the Books, Manuscripts and Engravings in the Library of George Arents, Jr.* 2 vols. New York: The Rosenbach Company, 1937–38.

Brooks, Jerome E. "The Library Relating to Tobacco Collected by George Arents." *Bulletin of the New York Public Library* 48 (January 1944):3–15.

Brooks, Neil C. *The Sepulchre of Christ in Art and Liturgy with Special Reference to the Liturgy Drama.* Vol. 7, no. 2. Urbana: University of Illinois, 1921.

Brown, Basil. *Astronomical Atlases, Maps and Charts:*

An Historical & General Guide. London: Dawsons of Pall Mall, 1968.

Brown, Beverly Louise, and Arthur K. Wheelock, Jr. *Masterworks from Munich: Sixteenth- to Eighteenth-Century Paintings from the Alte Pinakothek.* Washington, D.C.: National Gallery of Art, 1988.

Brown, Lloyd A., ed. *The World Encompassed.* Baltimore: The Walters Art Gallery, 1952.

Brueghel: Een Dynastie van Schilders. Brussels: Paleis Voor Schone Kunsten, 1980.

Brunner, Herbert, and Hans Thoma. *Schatzkammer de Residenz Munchen, Katalog.* 3rd ed. Munich: Bayerische Verwaltung der Staatlichen Schlösser, Gärten und Seen, 1970.

Bruyn, J., et al. *A Corpus of Rembrandt Paintings.* Boston: M. Nijhoff Publishers, 1982.

Bryer, Anthony, and Judith Herrin, eds. *Iconoclasm: Papers Given at the Ninth Spring Symposium of Byzantine Studies, University of Birmingham, March 1975.* Birmingham: Centre for Byzantine Studies, University of Birmingham, 1977.

Bucher, Bernadette. *Icon and Conquest: A Structural Analysis of the Illustrations in de Bry's Great Voyages.* Translated by Basia Miller Gulati. Chicago: University of Chicago Press, 1981.

The Bulletin of The Cleveland Museum of Art. December (1967):313, 343.

Büttner, Manfred, and Karl H. Burmeister. "Sebastian Münster 1488–1552." *Geographers (Bibliographical Studies).* Vol. 3. Edited by T. W. Freeman and Philippe Pinchemel. London: Mansell, 1979.

Calvin, Jean. *Traité des reliques.* Introduction by A. Autin. Paris: Editions Bossard, 1921.

Cantaro, Maria Teresa. *Lavinia Fontana, bolognese: "pittora singolare" 1552–1614.* Milan: Jandi Sapi Editori, ca. 1989.

Caprotti, Erminio, ed. *Mostri, draghi e serpenti nelle silografie dell'opera di Ulisse Aldrovandi e dei suoi contemporanei.* Milan: Gabriele Mazzotta Editore, 1980.

Caraffa, Filippo, and Antonio Massone. *Santa Cecilia martire Romana passione e culto.* Rome: Fratelli Palombi, 1983.

Carlos, Edward Stafford, trans. *The Sideral Messenger of Galileo Galilei and a Part of the Preface to Kepler's Dioptrics.* London: Dawsons of Pall Mall, 1964.

Carroll, Michael P. *Catholic Cults and Devotions: A Psychological Inquiry.* Kingston, Ont.: McGill-Queen's University Press, 1989.

Casciato, M., M. G. Ianniello, and M. Vitale, eds. *Enciclopedismo in Roma Barocca.* Venice: Marsilio Editori, 1986.

Catalogue of Botanical Books in the Collection of Rachel

McMasters Miller Hunt. Compiled by Jane Quinby. Pittsburgh: The Hunt Botanical Library, 1958.

Catalogue of the Collection 1972. Fort Worth: Kimbell Art Museum, 1972.

Céard, Jean. *La Nature et les prodiges: l'insolite au XVIe siècle, en France*. Geneva: Librairie Droz, 1977.

Cellini, Benvenuto. *The Autobiography of Benvenuto Cellini*. Translated by George Bull. Baltimore: Penguin Books, 1956.

Chapius, Alfred. *Le Monde des automates: étude historique et technique*. Paris: E. Gélis, 1928.

Chapuis, Alfred, and Edmond Droz. *Les Automates*. Neuchâtel: Griffon, 1949.

"Charles de l'Ecluse (Carolus Clusius), 1526–1609." *Janus* 31 (1927):39–151.

Chiappelli, Fredi, ed. *First Images of America*. 2 vols. Berkeley: University of California Press, 1976.

Christian, William A., Jr. *Local Religion in Sixteenth-Century Spain*. Princeton, N.J.: Princeton University Press, 1981.

Christian, William A., Jr. *Apparitions in Late Medieval and Renaissance Spain*. Princeton, N.J.: Princeton University Press, 1989.

Church, A. H. "Brunfels and Fuchs." *The Journal of Botany, British and Foreign* 57 (1919):233–44.

Cicero. *De oratore*. 2 vols. Translated by E. W. Sutton and H. Rackham. Cambridge, Mass.: Harvard University Press, 1959–60.

Ciprut, Edouard Jacques. "Nouveaux documents sur Etienne Dupérac." *Bulletin de la Société de l'histoire de l'art français* (1960):161–73.

Clark, Alvin L., Jr. *From Mannerism to Classicism: Printmaking in France, 1600–1660*. New Haven: Yale University Art Gallery, 1987.

Classical Literary Criticism. Translated by T. S. Dorsh. Harmondsworth: Penguin Books, 1977.

Cleveland Museum of Art. *European Paintings of the 16th, 17th, and 18th Centuries*. Cleveland: Cleveland Museum of Art, 1982.

Coe, Ralph T. "Small European Sculptures." *Apollo* 96, no. 130 (December 1972):521–23.

Coffin, David R. *The Villa d'Este at Tivoli*. Princeton, N.J.: Princeton University Press, 1960.

Coffin, David R. *The Villa in the Life of Renaissance Rome*. Princeton, N.J.: Princeton University Press, 1979.

Coffin, David R., ed. *The Italian Garden*. First Dumbarton Oaks Colloquium on the History of Landscape Architecture. Washington, D.C.: Dumbarton Oaks, 1972.

Colie, Rosalie. *Paradoxia Epidemica*. Princeton: Princeton University Press, 1966.

Comelli, Giambattista. "Ferndinando Cospi e le origine del Museo Cospiano de Bologna." *Atti e memorie della Regia deputazione di storia patria per le provincie di Romagna*. 3rd ser. 7 (1888–89):96–129.

Connell, E. Jane, and William Kloss. *More Than Meets the Eye: The Art of Trompe-l'oeil*. Columbus, Ohio: Columbus Museum of Art, 1985.

Cumming, W. P., Raleigh Ashlin Skelton, and D. B. Quinn, *The Discovery of North America*. New York: American Heritage Press, 1972.

Cunningham, J. V. "Woe or Wonder: The Emotional Effect of Shakespearean Tragedy." In *The Collected Essays*. Chicago: Swallow Press, 1976.

Dam-Mikkelsen, Bente, and Torben Lundbaek, eds. *Etnografiske genstande I Det kongelige danske Kunstkammer: 1650–1800. Ethnographic Objects in the Royal Danish Kunstkammer: 1650–1800*. Copenhagen: Nationalmuseet, 1980.

Dance, S. Peter. *Shell Collecting: An Illustrated History*. Berkeley: University of California Press, 1966.

Darnall, Margaretta J., and Mark S. Weil. "Il Sacro Bosco di Bomarzo: Its 16th-Century Literary and Antiquarian Context." *Journal of Garden History* 4 (1984):1–94.

Dartmouth College Galleries. *The Other Side of Dreams: The Baroque: An Age of Voluptas, An Age of Dementia*. Hanover, N.H.: Dartmouth College, 1970.

Daumas, Maurice. *Scientific Instruments of the Seventeenth and Eighteenth Centuries*. Edited and translated by Mary Holbrook. New York: Praeger Publishers, 1972.

Davis, Richard B. "Early Editions of George Sandys's Ovid: the Circumstances of Production." *Papers of the Bibliographical Society of America* 35 (4th Quarter 1941):255–76.

Davis, Richard B. "America in George Sandys' Ovid." *The William and Mary Quarterly* 4:1 (July 1947):297–304.

Davis, Richard B. *George Sandys: Poet-Adventurer: A Study in Anglo-American Culture in the Seventeenth Century*. London: The Bodley Head, 1955.

Dean, Bashford. *Catalogue of a Loan Exhibition of Arms and Armor*. New York: Metropolitan Museum of Art, 1911.

Delaunay, Paul. *Pierre Belon, naturaliste*. Le Mans: Monnoyer, 1926.

Delen, Adrien Jean Joseph. *Histoire de la gravure dans les anciens Pays-Bas*. Reprint of 1924–35 edition. 2 vols. Paris: F. De Nobele, 1969.

Delooz, Pierre. *Sociologie et canonizations*. Liège: Faculté de droit, 1976.

Delumeau, Jean. *La Mort des pays de cocagne: comportements collectifs de la renaissance à l'âge classique*.

Paris: Université de Paris, Centre de recherches d'histoire moderne, 1976.

Denise, Louis. *Bibliographie historique & iconographique du jardin des plantes: Jardin royal des plantes médicinales et musée d'histoire naturelle*. Edited by H. Darragon. Paris, 1903.

Descartes, René. *The Philosophical Writings of Descartes*. Translated by John Cottingham, Robert Stoothoff, and Dugald Murdoch. Cambridge: Cambridge University Press, 1985.

De Valencia, Don Juan. *Catálogo histórico descriptivo de la Real Armeria de Madrid*. Madrid, 1898.

De Vries, Jan Vredeman. *Perspective*. New York: Dover Publications, 1968.

Dewhirst, David W. *Notes for a Biographical List of Some British and Continental Scientific Instrument Makers from Medieval Times to the Close of the 19th Century*. Cambridge: Christ College, Cambridge University, n.d.

Dictionary of Scientific Biography. Edited by Charles Coulston Gillispie. 14 vols. New York: Scribner, 1970–76.

Dictionnaire de spiritualité, ascétique et mystique, doctrine et histoire. 6 vols. Paris: G. Beauchesne et ses fils, 1937–67.

Dizionario biografico degli Italia. Vol. 8. Rome: Istituto della Enciclopedia Italiana, 1966.

Dobell, Clifford, ed. *Antony Van Leeuwenhoek and His "Little Animals."* London: John Bale & Sons and Danielsson, 1932.

Dobell, Clifford, ed. *Antony Van Leeuwenhoek and His "Little Animals."* New York: Dover Publications, 1960.

Doe, Janet. *A Bibliography of the Works of Ambroise Paré*. Chicago: University of Chicago Press, 1937.

Donato, Eugenio. "Tesauro's Poetics: Through the Looking Glass." *Modern Language Notes* 78 (1963):15–30.

Donne, John. *The Complete Poetry and Selected Prose*. Edited by Charles M. Coffin. New York: The Modern Library, 1952.

D'Onofrio, Cesare. *La villa Aldobrandini di Frascati*. Rome: Staderini Editore, 1963.

Drachmann, Aage Gerhardt. *The Mechanical Technology of Greek and Roman Antiquity*. Copenhagen: Munksgaard, 1963.

Drake, Stillman. "Galileo's First Telescopic Observations." *Journal of the History of Astronomy* 7 (1976):153–168.

Drake, Stillman. *Galileo Pioneer Scientist*. Toronto: University of Toronto Press, 1990.

Duerbeck, Hilmar W. "Der Christiche Sternhimmel des Julius Schiller." *Sterne und Weltraum* 18 (1979):408–13.

Dupuy, Ernest. *Bernard Palissy. L'homme, l'artiste, le savant, l'ecrivain*. Geneva: Slatkine Reprints, 1970.

Duval, Cynthia P., and Walter J. Karcheski, Jr. *Medieval and Renaissance Splendor*. Sarasota, Fla.: John and Mable Ringling Museum of Art, 1983.

Eco, Umberto. *Art and Beauty in the Middle Ages*. Translated by Hugh Bredin. New Haven: Yale University Press, 1986.

Eder, Josef Maria. *History of Photography*. Translated by Edward Epstean. New York: Columbia University Press, 1945.

Elledge, Scott. *The Continental Model; Selected French Critical Essays of the Seventeenth Century, in English Translation*. Edited by Scott Elledge and Donald Schier. Ithaca: Cornell University Press, 1970.

Enggass, Robert, and Jonathan Brown. *Italy and Spain, 1600–1750: Sources and Documents*. Sources and Documents in the History of Art Series. Englewood Cliffs, N.J.: Prentice-Hall, 1970.

Evelyn, John. *The Diary of John Evelyn. . . .* 6 vols. Ed. by E. S. de Beer. Oxford: Clarendon Press, 1955.

Evelyn, John. *Memoirs of John Evelyn: Comprising his Diary from 1641 to 1705–6 and a Selection of his Familiar Letters*. Chandos Library. Ed. by William Bray. London: Frederick Warne and Co., n.d.

Ey, John A., ed. *The Billings Microscope Collection*. 2nd ed. Washington, D.C.: Armed Forces Institute of Pathology, 1987.

Fabbri, Mario, Elvira Garbero Zorzi, and Anna Maria Petrioli-Tofani. *Il luogo teatrale a Firenze . . . Spettacolo e musica nella Firenze medicea: Documenti e restituzioni, 1*. Milan: Electa, 1975.

Fagiolo dell'Arco, Maurizio, and Marcello Fagiolo. *Bernini, una introduzione al gran teatro del barocco*. Rome: Mario Bulzone Editore, 1967.

Fagiolo dell'Arco, Maurizio, and Silvia Carandini. *L'effimero barocco: strutture della feste nella Roma del'600*. Rome: Bulzoni Editore, 1977.

Fáhler, Eberhard. *Feuerwerke des Barock*. Stuttgart: J. B. Metzler, 1974.

Farmer, David Hugh. *Oxford Dictionary of Saints*. Oxford, New York: Oxford University Press, 1987.

Farmer, John David. *The Virtuoso Craftsman: Northern European Design in the Sixteenth Century*. Worcester, Mass.: Worcester Art Museum, 1969.

Farmer, John David. *Rubens and Humanism*. Birmingham, Ala.: Birmingham Museum of Art, 1978.

Faucheux, L. E. *Catalogue raisonné de toutes les estampes qui forment l'ouvre d'Israël Silvestre*. Paris: F. de Nobele, 1969.

466

Ferrero, Giuseppe Guido, ed. *Marino e i marinisti*. Milan and Naples: Riccardo Ricciardi editore, n.d.

Festschrift anlässlich der 400 jährigen Wiederkehr der wissenschaftlichen Tätigkeit von Carolus Clusius (Charles de l'Escluse) im pannonischen Raum. Eisenstadt: Landesregierung, Landesarchiv, 1973.

Festschrift Ulrich Middeldorf. Edited by Antje Kosegarten und Peter Tigler. Berlin: W. de Gruyter, 1968.

Filipczak, Zirka Zaremba. "Van Dyck's 'Life of St. Rosalie'." *Burlington Magazine* 131 (1989):695–96.

Finan, John J. "Maize in the Great Herbals." *Annals of the Missouri Botanical Garden* 35 (1948):149–91.

Finan, John J. *Maize in the Great Herbals*. Waltham, Mass.: Chronica Botanica Co., 1950.

Findlen, Paula. "The Museum: Its Classical Etymology and Renaissance Genealogy." *The Journal of the History of Collections* 1:1 (1989):59–78.

Firenze e la Toscana dei Medici nell'Europa del Cinquecento: Astrologia, magia e alchimia. Milan: Electa; Florence: Centro Di, 1980.

Firenze e la Toscana dei Medici nell'Europa del Cinquecento: La rinascita della scienza. Milan: Electa; Florence: Centro Di, 1980.

Fogelman, Peggy, and Peter Fusco. "A Newly Acquired Bronze by Girolamo Campagna." *The J. Paul Getty Museum Journal* 16(1988):105–10.

Fogolari, Gino. "Il Museo Settala, contributo per la storia della colture di Milano nel sec. XVII." *Archivio Storico Lombardo* 14:17 (1900):58–126.

Franchini, Dario A., et al. *La scienza a corte: Collezionismo eclettico, natura e immagine a Mantova fra rinaascimento e manierismo*. Rome: Bulzoni, 1979.

Frank, Stuart M. "The Legacy of Stranded Whales." Part 1. *Whalewatcher: Journal of the American Cetacean Society* 20:3 (Fall 1986):3–4.

Fredericksen, Burton B., and Federico Zeri. *Census of Pre-Nineteenth-Century Italian Paintings in North American Public Collections*. Cambridge, Mass.: Harvard University Press, 1972.

Freedberg, David. "The Hidden God: Image and Interdiction in the Netherlands in the Sixteenth Century." *Art History* 5 (1982):133–53.

Freedberg, David. *The Power of Images: Studies in the History and Theory of Response*. Chicago: Chicago University Press, 1989.

Friedlaender, Walter. *Caravaggio Studies*. New York: Schocken Books, 1969.

Friedman, John Block. *The Monstrous Races in Medieval Art and Thought*. Cambridge, Mass.: Harvard University Press, 1981.

Fritz, Rolf. *Die Gefässe aus Kokosnuss in Mitteleuropa: 1250–1800*. Mainz: P. von Zabern, 1983.

Gagnon, François Marc. *Ces hommes dits sauvages: l'histoire fascinante d'un préjugé qui remonte aux premiers découvreurs du Canada*. Montréal: Libre Expression, 1984.

Galilei, Galileo. *Sidereus Nuncius or the Sideral Messenger*. Translated with text by Albert van Helden. Chicago: University of Chicago Press, 1989.

Gallo, R. "Some Maps in the Correr Museum in Venice." *Imago Mundi* 15 (1960):46–51.

Gammelbo, Poul. "Cornelius Norbertus Gijsbrechts og Franciscus Gijsbrechts." *Kunstmuseets Årsskrift*. Copenhagen: Statens Museum for Kunst, 1952–55.

Gammelbo, Poul. *Dutch Still-Life Painting from the 16th to the 18th Centuries in Danish Collections*. Copenhagen: Munksgaard, 1960.

García Villoslada, Riccardo. *Storia del Collegio Romano dal suo inizio (1551) alla soppressione della Compagnia di Gesù (1773)*. Rome: Universitatis Gregorianae, 1954.

Garlick, K. J. "Catalogue of the Pictures at Althorp." *Walpole Society* 45 (1976):56.

Garrison, Fielding Hudson, and Leslie T. Morton. *A Medical Bibliography: An Annotated Check-list of Texts Illustrating the History of Medicine*. Aldershot, Hampshire: Gower, 1983.

de Gennep, Arnold. *Les Vierges miraculeuses de la Belgique. . . .* Brussels: Parent, 1856.

George, Wilma. *Animals and Maps*. Berkeley: University of California Press, 1969.

George, Wilma. *Animals and Maps*. London: Secker and Warburg, 1969.

George, Wilma. "Sources and Background to Discoveries of New Animals in the Sixteenth and Seventeenth Centuries." *History of Science* 18 (1980):79–104.

Gernsheim, Helmut. *The Origins of Photography*. New York: Thames and Hudson, Inc., 1982.

Gernsheim, Helmut, and Alison Gernsheim. *The History of Photography from the Camera Oscura to the Beginning of the Modern Era*. New York: McGraw-Hill, 1969.

Giamatti, A. Bartlett. *The Earthly Paradise and the Renaissance Epic*. Princeton, N.J.: Princeton University Press, 1966.

Gilliard, E. T. *Birds of Paradise and Bower Birds*. London: Weidenfeld & Nicolson, 1969.

Gingerich, Owen. "Early Astronomical Books with Moving Parts." *Cite AB* (October 23, 1989):1505–1508.

Glassman, Elizabeth, and Richard S. Field. *Reading*

Prints: A Selection of 16th- to Early 19th-Century Prints from the Menil Collection. Houston: Menil Foundation, 1985.

Goddard, Stephen H. *Sets and Series: Prints from the Low Countries.* New Haven: Yale University Art Gallery, 1984.

Godine, David R., and Owen Gingerich. *Renaissance Books of Science from the Collection of Albert E. Lownes.* Hanover, N.H.: Trustees of Dartmouth College, 1970.

Godwin, Joscelyn. *Athanasius Kircher. A Renaissance Man and the Quest for Lost Knowledge.* London: Thames and Hudson, 1979.

Goff, Frederick Richmond, ed. *Incunabula in American Libraries: A Third Census of Fifteenth-Century Books Recorded in North American Collections.* New York: Bibliographical Society of America, 1964.

Gombrich, E. H. "Icones Symbolicae: The Visual Image in Neo-Platonic Thought." *Journal of the Warburg and Courtauld Institutes* 11 (1948):163–92.

de Góngara y Argote, Luis. *Obras completas.* Edited by Juan Millé y Giménez and Isabel Millé y Giménez. Madrid: Aguilar, 1956.

Gracián, Baltasar. *Agudeza y arte de ingenio.* 2nd. ed. Buenos Aires: Espasa Argentina, S. A., 1944.

Grancsay, Stephen V. *Catalogue of Armor: The John Woodman Higgins Armory Museum.* Worcester, Mass.: Higgins Armory Museum, 1961.

Grancsay, Stephen V. *Loan Exhibition of European Arms and Armor.* New York: Metropolitan Museum of Art, 1931.

Greene, Edward Lee. *Landmarks of Botanical History.* Edited by Frank Egerton. Stanford: Stanford University Press, 1983.

Gregor, Joseph. *Weltgeschichte des Theaters. . . .* Zurich: Phaidon-Verlag, 1933.

Griffin, Robert Arthur. *High Baroque Culture and Theatre in Vienna.* New York: Humanities Press, 1972.

Grisebach, Lucius. *Willem Kalf 1619–1693.* Berlin: Gebr. Mann Verlag, 1974.

Guide to the Loan Exhibition of the J. Pierpont Morgan Collection. New York: Metropolitan Museum of Art, 1914.

Gusler, Wallace B., and James D. Lavin. *Decorated Firearms 1540–1870 from the Collection of Clay P. Bedford.* Williamsburg, Va.: The Colonial Williamsburg Foundation, 1977.

Hagstrum, Jean H. *The Sister Arts: The Tradition of Literary Pictorialism and English Poetry from Dryden to Gray.* Chicago: University of Chicago Press, 1958.

Hairs, Marie-Louise. *The Flemish Flower Painters in the XVIIth Century.* Translated by Eva Grzelak. Brussels: Lefebure and Gillet, 1985.

Hammond, John H. *The Camera Obscura: A Chronicle.* Bristol, Gloucestershire, England: Adam Hilger Ltd., 1981.

Hamy, Dr. Ernest Theodore. "Les Anciennes ménageries royales et la ménagerie nationale fondée le 14 brumaire an II (4 Novembre 1793)." Reprinted in *Nouvelles archives du museum d'histoire naturelle* 4, 5 (1893):1–22.

Hand, John Oliver, J. Richard Judson, William W. Robinson, and Martha Wolff. *The Age of Bruegel: Netherlandish Drawings in the 16th Century.* Washington, D.C.: National Gallery of Art, and New York: Cambridge University Press, 1986.

Handbook of the Collection. Fort Worth: Kimbell Art Museum, 1981.

Harley, J. B. *Maps and the Columbian Encounter: An Interpretive Guide to the Travelling Exhibition.* Milwaukee: University of Wisconsin Press, 1990.

Harms, Hans. *Themen Alter Karten.* Oldenburg: Ernst Völker, 1979.

Harper, John Murdock. *Dominus domi; or, The Château Saint-Louis.* Québec: Chien d'or Stationery Depot, 1898.

Harris, Ann Sutherland, and Linda Nochlin. *Women Artists: 1550–1950.* Los Angeles: Los Angeles County Museum of Art, 1976.

Haskell, Francis. *Patrons and Painters: A Study in the Relations between Italian Art and Society in the Age of the Baroque.* New York: Harper and Row, 1971.

Haskell, Francis. *Patrons and Painters: A Study in the Relations between Italian Art and Society in the Age of the Baroque.* New Haven: Yale University Press, 1980.

Haskell, Francis, and Nicholas Penny. *Taste and the Antique: The Lure of Classical Sculpture 1500–1900.* New Haven: Yale University Press, 1981.

Hassig, Debra. "Transplanted Medicine: Colonial Mexican Herbals of the Sixteenth Century." *Res* 17/18 (1989):30–53.

Hathaway, Baxter. *The Age of Criticism: The Late Renaissance in Italy.* Ithaca, N.Y.: Cornell University Press, 1962.

Hathaway, Baxter. *Marvels and Commonplaces: Renaissance Literary Criticism.* New York: Random House, 1968.

Haverkamp-Begemann, Egbert, with Carolyn Logan. *Creative Copies.* New York: The Drawing Center, 1988.

Hayward, John Forrest. *Virtuoso Goldsmiths and the Triumph of Mannerism, 1540–1620.* New York: Rizzoli International, 1976.

468

Hazard, Paul. *The European Mind, 1680–1715*. New York: Meridian Books, 1963.

Heidenreich, Conrad E. *Explorations and Mapping of Samuel de Champlain*. Toronto: B. V. Gutsell, 1976.

Heikamp, Detlef. "La Tribuna degli Uffizi come era nel cinquecento." *Antichità Viva* 3 (May 1964):11–30.

Heinz, Günther. "Carlo Dolci, Studien zur religiösen Malerei im 17 Jahrhundert." *Jahrbuch der Kunsthistorischen Sammlungen in Wien* 56 (1960).

Held, Julius S. *The Oil Sketches of Peter Paul Rubens: A Critical Catalogue*. 2 vols. Princeton, N.J.: Princeton University Press for National Gallery of Art, 1980.

M. Henry Collection. Sale catalogue. Paris: Hôtel Drouot, 1886.

Herbert, George. *The English Poems of George Herbert*. Edited by C. A. Patrides. London: Dent, 1974.

Heron-Allen, Edward. *Barnacles in Nature and in Myth*. London: Oxford University Press, 1928.

Hetzer, Theodor. *Venezianische Malerei: von ihren Anfängen bis zum Tode Tintorettos*. Stuttgart: Urachhaus, 1985.

Hewitt, Bernard. ed. *The Renaissance Stage: Documents of Serlio, Sabbatini and Furttenbach*. Translated by Allardyce Nicoll, John H. McDowell, George R. Kernodle. Coral Gables, Fla.: University of Miami, 1958.

Hill, J. P., and E. Caracciolo-Trejo, comps. *Baroque Poetry*. London: Dent, 1975.

Holt, Elizabeth Gilmore, ed. *A Documentary History of Art*. 3 vols. Princeton, N.J.: Princeton University Press, 1981–86.

Homann, Holger. *Studien zur Emblematik des 16. Jahrhunderts*. Utrecht: Haentjens Dekker & Gumbert, 1971.

Honour, Hugh. *The European Vision of America*. Cleveland: Cleveland Museum of Art, 1975.

Honour, Hugh. *The New Golden Land: European Images of America from the Discoveries to the Present Time*. New York: Pantheon, 1975.

Hood Museum of Art. *From Titian to Sargent: Dartmouth Alumni and Friends Collect*. Hanover, N.H.: Hood Museum of Art, 1987.

Hulley, Karl K., and Stanley T. Vandersall, eds. *Ovid's Metamorphosis Englished, Mythologized, and Represented in Figures, by George Sandys*. Lincoln: University of Nebraska Press, 1970.

Hulsen, Christian. "Das 'Speculum Romanae Magnificentiae' des Antonio Lafreri." In *Collectanea Varie Doctrinae Leoni S. Olshki*. Munich: J. Rosenthal, 1921.

Hulten, Karl Gunnar Pontus, et al. *The Arcimboldo Effect: Transformations of the Face from the Sixteenth to the Twentieth Century*. Venice: Palazzo Grassi, and New York: Abbeville Press, 1987.

Hulton, Paul, ed. *The Work of Jacques Le Moyne de Morgues: A Huguenot Artist in France, Florida and England*. 2 vols. London: British Museum Publications, 1977.

Hulton, Paul. *America, 1585: The Complete Drawings of John White*. London: British Museum Publications, 1984.

Hunger, Friedrich Wilhelm Tobias. "Dodoens e comme botaniste." *Janus* 22 (1917):153–62.

Hunger, Friedrich Wilhelm Tobias. *Charles de l'Escluse (Carolus Clusius) Nederlandsch kruidkundige, 1526–1609*. 2 vols. 's-Gravenhage: Martinus Nijhoff, 1927–43.

Hunt, John Dixon. *Garden and Grove: The Italian Renaissance Garden in the English Imagination, 1600–1750*. Princeton: Princeton University Press, 1986.

Hunt, Rachel McMasters Miller. *Books, Drawings, Prints From the Botanical Collection of Mrs. Roy Arthur Hunt*. Charlottesville: University of Virginia Press, 1952.

Hunter, Michael, and Simon Schaffer, eds. *Robert Hooke: New Studies*. Woodbridge: Boydell Press, 1989.

Husband, Tim. *The Wild Man: Medieval Myth and Symbolism*. New York: The Metropolitan Museum of Art, 1980.

Hutchison, Jane Campbell. *Albrecht Dürer: A Biography*. Princeton: Princeton University Press, 1990.

Hyland, Douglas, and Marilyn Stokstad, eds. *Catalogue of the Sculpture Collection, Spencer Museum of Art*. Lawrence: University of Kansas, 1981.

Ignatius Loyola, Saint. *The Autobiography of St. Ignatius Loyola*. Edited by John C. Olin. New York: Harper & Row, 1974.

Impey, Oliver and Arthur MacGregor, eds. *The Origins of Museums: The Cabinet of Curiosities in Sixteenth- and Seventeenth-Century Europe*. Oxford: Clarendon Press, 1985.

In Pursuit of Quality: The Kimbell Art Museum: An Illustrated History of the Art and Architecture. Fort Worth: The Kimbell Art Museum, 1977.

Janson, Anthony F. *Great Paintings from the John and Mable Ringling Museum of Art*. Sarasota and New York: The John and Mable Ringling Museum of Art and Harry N. Abrams, Inc., 1986.

Janssen, Johannes. *History of the German People at the Close of the Middle Ages*. Vol. 13. Translated by A. M. Christie. New York: AMS Press, Inc., 1966.

Jones, E. Alfred. *Catalogue of the Gutmann Collection*

of Plate now the property of J. Pierpont Morgan, Esquire. London: Bemrose and Sons, 1907.

Jones, Pamela M. "Federico Borromeo as a Patron of Landscapes and Still Lifes. Christian Optimism in Italy ca. 1600." *The Art Bulletin* 70 (1988):261–72.

Jungmann, Josef Andreas, S. J. *The Mass of the Roman Rite: Its Origins and Development (Missarum sollemnia)*. 2 vols. New York, Benziger, 1951.

Kaftal, George. *Saints in Italian Art*. Florence: Sansoni, 1952.

Karcheski, Jr., Walter J. "Steel Men . . . Man of Steel." *Man at Arms* 12 (January/February 1990):14.

Kaufmann, Thomas DaCosta. "Arcimboldo's Imperial Allegories: G. B. Fonteo and the Interpretation of Arcimboldo's Painting." *Zeitschrift für Kunstgeschichte* 39 (1976):275–96.

Kaufmann, Thomas DaCosta. "Remarks on the Collections of Rudolf II: The *Kunstkammer* as a Form of *Representatio*." *Art Journal* 38 (1978):22–28.

Kaufmann, Thomas DaCosta. *The School of Prague: Painting at the Court of Rudolf II*. Chicago: University of Chicago Press, 1988.

Keith, D. Graeme, et al. *The Triumph of Humanism: A Visual Survey of the Decorative Arts of the Renaissance*. San Francisco: The Fine Arts Museums of San Francisco, 1977.

Kemp, Martin. *The Science of Art: Optical Themes in Western Art from Brunelleschi to Seurat*. New Haven: Yale University Press, 1990.

Kenyon, Walter Andrew. *Tokens of Possession: The Northern Voyages of Martin Frobisher*. Toronto: Royal Ontario Museum, 1975.

Kerber, Bernhard. *Andrea Pozzo*. New York: de Gruyter, 1971.

Kernodle, George R. and Portia. "Dramatic Aspects of the Medieval Tournament." *Speech Monographs* 9 (1942):161–72.

Keuning, J. *Willem Jansz. Blaeu. A Biography and History of His Work as a Cartographer and Publisher*. Edited by Marijke Donkersloot-Vrij. Amsterdam: Theatrum Orbis Terrarum, Ltd., 1973.

Kindermann, Heinz. *Theatergeschichte Europas*. 10 vols. Salzburg: Otto Müller Verlag, 1955–74.

Kleks, Arnold. "Incunable editions of Pliny's *Historia naturalis*." *Isis* 24 (1935–36):120–21.

Kloss, William. " 'And the Word was God': Vassar's *Open Missal*. A Miraculous Image." Lecture delivered at Vassar College, April 6, 1990. Mimeographed.

Koeman, Cornelis. "Some New Contributions to the Knowledge of Blaeu's Atlases." *Tijdschrift van Het Aardrijkskundig Genootschap* 77 (1960):278–86.

Koeman, Cornelis. *The History of Abraham Ortelius and His Totius Orbis Terrarum*. Lausanne: Sequoia, 1964.

Koeman, Cornelis. *Joan Blaeu and His Grand Atlas*. London: George Philip and Son, Ltd. in cooperation with Amsterdam: Theatrum Orbis Terrarum, 1970.

Koeman, Cornelis. "Life and Works of Willem Janszoon Blaeu: New Contributions to the Study of Blaeu, Made During the Last Hundred Years." *Imago Mundi* 26 (1972):9–16.

König-Nordhoff, Ursula. *Ignatius von Loyola: Studien zur Entwicklung einer neuen Heiligen- Ikonographie im Rahmen einer Kanonisationskampagne um 1600*. Berlin: Mann, 1982.

Koreny, Fritz. *Albrecht Dürer and the Animal and Plant Studies of the Renaissance*. Translated by Pamela Marwood and Yehuda Shapiro. Boston: Little, Brown, 1988.

Koyrè, Alexandre. *From the Closed World to the Infinite Universe*. Baltimore: Johns Hopkins Press, 1957.

Krempel, Ulla. *Jan van Kessel D. Ä 1626–1679: Die vier Erdteile*. Munich: Alte Pinakothek, 1973.

Kristeller, Paul. *Kupferstich und Holzschnitt in vier Jahrhunderten*. Berlin: Bruno Cassirer, 1905.

Kristeller, Paul. *The Philosophy of Marsilio Ficino*. New York: Columbia University Press, 1943.

Kroon, J. E. *Nieuw netherlandsch biografisch Woordenboek*. 10 vols. Leiden: A. W. Sijthoff, 1924. Reprint. Amsterdam: N. Israel, 1974.

Kubler, George. "El 'San Felipe de Heraclea' de Murillo y los cuadros del claustro chico." *Archivo Español de Arte* 169 (January 1970):11–31.

Kuh, Katharine. *The Art Collection of The First National Bank of Chicago*. Chicago: R. R. Donnelley & Sons Company, 1974.

Kuhn, Charles L. *German and Netherlandish Sculpture 1280–1800: The Harvard Collections*. Cambridge, Mass.: Harvard University Press, 1965.

Kunsthistorisches Museum, Vienna. *Prag um 1600: Kunst und Kultur am Hofe Kaiser Rudolfs II*. 2 vols. Freren: Luca Verlag, 1988.

Ladis, Andrew. *Italian Renaissance Maiolica from Southern Collections*. Athens, Ga.: Georgia Museum of Art, 1989.

Larsen, Erik. *Frans Post, interprète du Brésil*. Amsterdam and Rio de Janiero: Colilbris Editora, 1962.

Laufer, Berthold. *Ostrich Egg-Shell Cups of Mesopotamia and the Ostrich in Ancient and Modern Times*. Chicago: Field Museum of Natural History, 1926.

Lavin, Irving. *Bernini and the Unity of the Visual Arts*. 2 vols. London: Oxford University Press, 1980.

Lavin, Irving, ed. *Gianlorenzo Bernini: New Aspects of*

His Art and Thought. University Park, Pa.: Pennsylvania State University Press, 1985.

Lawrence, George H. M. "Herbals, Their History and Significance." In *History of Botany*. Los Angeles: The Clark Memorial Library, and Pittsburgh: The Hunt Botanical Library, 1965.

Lazzaro, Claudia. *The Italian Renaissance Garden*, New Haven: Yale University Press, 1990.

Le Bras, Gabriel, Jacques Hourlier, and M. Cocheril. *Les Ordres religieux, la vie et l'art*. Paris: Flammarion, 1979.

Lecky, W. E. H. *History of the Rise and Influence of Rationalism in Europe*. 2 vols. New York, 1878.

Lee, Rensselaer W. "Ut Pictura Poesis: The Humanistic Theory of Painting." *Art Bulletin* 22 (1940): 197–269.

Lee, Rensselaer W. *Ut Pictura Poesis: The Humanistic Theory of Painting*. New York: W. W. Norton & Company, 1967.

van Leeuwenhoek, A. *The Collected Letters of Antoni van Leeuwenhoek*. 11 vols. Amsterdam: Swets and Zeitlinger, 1939–.

Lehmann-Haupt, Hellmut. "The Microscope and the Book." *Festschrift für Claus Nissen*. Wiesbaden: Pressler, 1973.

Leithe-Jasper, Manfred. *Renaissance Master Bronzes from the Collection of the Kunsthistorisches Museum, Vienna*. Washington, D.C.: Scala Books, 1986.

Libri, Guillaume. *Histoire des sciences mathématiques en Italie, depuis la renaissance des lettres*. 4 vols. Paris: J. Renouard et cie, 1838–41.

Lindberg, David C., and Robert S. Westman. *Reappraisals of the Scientific Revolution*. Cambridge: Cambridge University Press, 1990.

Lippmann, Friedrich. *Der Kupferstich*. Edited by Fedja Anzelwesky. Berlin: Walter de Gruyter & Company, 1963.

Lloyd, Geoffrey Ernest Richard. *Greek Science after Aristotle*. New York: Norton, 1973.

Lloyd, Joan Barclay. *African Animals in Renaissance Literature and Art*. Oxford: Clarendon Press, 1971.

Logan, Anne-Marie S. *The 'Cabinet' of the Brothers Gerard and Jan Reynst*. Amsterdam and New York: North Holland Publishing Company, 1979.

Lorant, Stefan, ed. *The New World; the First Pictures of America, made by John White and Jacques Le Moyne and engraved by Theodore De Bry, with contemporary narratives of the Huguenot settlement in Florida, 1562–1565, and the Virginia colony, 1585–1590*. New York: Duell, Sloan & Pearce, 1946.

Löwe, Regina. *Die Augsburger Goldschmiedwerkstatt des Matthäus Walbaum*. Munich and Berlin: Deutscher Kunstverlag, 1975.

Lucian. *Works*. 8 vols. Translated by K. Kilburn. Cambridge, Mass.: Harvard University Press, 1968–79.

Lucius, Henriette. *La Littérature visionnaire en France au début du XVIe au début du XIXe siècle* Bienne: Arts graphiques Schüler, 1970.

Lugli, Adalgisa. *Naturalia et mirabilia: Il collezionismo enciclopedico nell Wunderkammern d'Europa*. Milan: Gabriele Mazzotta editore, 1983.

Luther, Martin. *Sämmtliche Werke*. 67 vols. Erlangen: C. Heyder, 1826–57.

Lynam, Edward. *The First Engraved Atlas of the World: the Cosmographia of Claudius Ptolemaeus*. Jenkintown: The George H. Beans Library, 1941.

MacDougall, Elisabeth B., ed. *Medieval Gardens*. Washington, D.C.: Dumbarton Oaks, Research Library and Collection, 1986.

Macken, Thomas F. *The Canonisation of Saints*. Dublin: M. H. Gill & Son, 1910.

The Clarence H. Mackey Collection. Privately printed, 1931.

Mahon, Denis. *Studies in Seicento Art and Theory*. London: The Warburg Institute, 1947.

Major, Emil. "Dürer's Kupferstich 'die wunderbare Sau von Landser' im Elsass." *Monatshefte für Kunstwissenschaft* 6 (1913):327–30.

Maks, C. S. *Salomon de Caus*. Paris, 1935.

Malatesta, Enzio. *Armi ed armaioli*. Milan, 1939.

Mâle, Emile. *L'Art religieux après le Concile de Trente: Etude sur l'iconographie de la fin du XVIe siècle, du XVIIe, du XVIIIe siècle*. Paris: A. Colin, 1932.

van Mander, Carel. *Dutch and Flemish Painters*. Translated by Constant Van de Wall. New York: McFarlane, Warde, McFarlane, 1936.

Marcel, Pierre. *La Peinture française au début du dix-huitième siècle, 1690–1721*. Paris: Libraries-imprimeries réunies, 1906.

Marie, Alfred. *Jardins français créé à la Renaissance*. Paris: Editions Vincent Fréal and Co., 1955.

Marion Koogler McNay Art Museum. The Tobin Wing. *Courtly Splendor*. San Antonio: Marion Koogler McNay Art Museum, 1988.

Marlier, Georges. "C. N. Gijsbrechts illusioniste." *Connaissance des Arts* (March 1964):96–105.

Martin, Henri-Jean. *Livre, Pouvoirs et société a Paris au XVII siècle*. 2 vols. Geneva: Droz, 1969.

Martin, John Rupert. *The Decorations for the Pompa Introitus Ferdinandi*. Corpus Rubenianum Ludwig Burchard, pt. 16. London and New York: Phaidon, 1972.

Marvell, Andrew. *Andrew Marvell: The Complete Poems*. Edited by Elizabeth Story Donno. Harmondsworth: Penguin Books, 1972.

Maryon, Herbert. "The Colossus of Rhodes." *The*

Journal of Hellenic Studies 76 (1956):68–86.

Massar, Phyllis Dearborn. *Presenting Stefano della Bella: Seventeenth-Century Printmaker.* New York: Metropolitan Museum of Art, 1971.

Mazzeo, Joseph Anthony. *Renaissance and Seventeenth Century Studies.* New York: Columbia University Press, 1964.

McCary, Ben Clyde. *John Smith's Map of Virginia: with a Brief Account of its History.* Charlottesville: University Press of Virginia, 1981.

McCorquodale, Charles P. "A Fresh Look at Carlo Dolci." *Apollo* 97 (May 1973):477–88.

McCracken, G. E. "Athanasius Kircher's Universal Polygraphy." *Isis* 39 (1952):385ff.

McDermott, Betty N., ed., and Joan G. Caldwell, researcher. *Handbook of the Collection.* New Orleans: New Orleans Museum of Art, 1980.

McMahon, Norbert. *St. John of God.* New York, 1951.

Meijer, Fred. *Catalogue raisonné of the Work of David de Coninck.* Forthcoming publication.

Meredith, Peter, and John E. Tailby, eds. *The Staging of Religious Drama in Europe in the Later Middle Ages: Texts and Documents in English Translation.* Kalamazoo: Mich.: Medieval Institute Publications, Western Michigan University, 1983.

Metcalfe, Louis R. "Claude Mellan (1598–1688)." *Print Collector's Quarterly* 5 (1915):258–93.

The Metropolitan Museum of Art. *The Renaissance: Six Essays.* New York: Harper and Row, 1962.

Michaels, Peter. "Technical Observations on Early Painted Enamels of Limoges." *Journal of the Walters Art Gallery* 27–28 (1964–65):21–43.

Michaud, J. F., and L. G. Michaud. *Biographie universelle ancienne et moderne.* 2nd. ed. 45 vols. Paris: Mme. C. Desplaces, 1854–65.

de Michele, Vincenzo, L. Cagnolaro, Antonio Aimi, and Laura Laurencich-Minelli. *Il museo di Manfredo Settala nella Milano del XVII secolo,* Milan, 1983.

Milizia, Francesco. *Dizionario delle belle arti del disegno.* 2 vols. Bologna: Stamperia Cardinali e Frulli, 1827.

Milman, Miriam. *Trompe-l'oeil Painting: The Illusions of Reality.* New York: Rizzoli International Publications, Inc., 1982.

della Mirandola, Giovanni Pico. *Oration on the Dignity of Man.* Translated by A. Robert Caponigri. South Bend, Ind.: Regnery/Gateway, Inc., 1956.

Mirollo, James V. *The Poet of the Marvelous: Giambattista Marino.* New York: Columbia University Press, 1963.

Mitchell, Peter. *European Flower Painters.* London: Adam and Charles Black, 1973.

Moir, Alfred E. *The Italian Followers of Caravaggio.* Cambridge, Mass.: Harvard University Press, 1967.

Molière, Jean Baptiste Poquelin. *Theatre.* 5 vols. Paris: Editions Hachette, [1949].

Molinari, Cesare. *Le nozze degli dèi: un saggio sul grande spettacolo italiano nel seicento.* Rome: M. Bulzoni, 1968.

Monden, Louis, S. J. *Signs and Wonders. A Study of the Miraculous Element in Religion.* New York, Desclee Co., 1969.

Mongan, Agnes. "A Fête of Flowers: Women Artists' Contribution to Botanical Illustration." *Apollo* 119 (April 1984):34–37.

de Montaiglon, Anatole. *Catalogue raisonné de l'oeuvre de Claude Mellan, d'Abbéville.* Abbeville: P. Briez, 1856.

de Montaigne, Michel Eyguem. *Oeuvres complètes.* Edited by Albert Thibaudet and Maurice Rat. Paris: Editions Gallimard, 1962.

de Montaigne, Michel Eyguem. *Montaigne's Travel Journal.* Translated by Donald M. Frame. San Francisco: North Point Press, 1983.

Montreal Museum of Fine Arts. *The Painter and the New World.* Montreal: Montreal Museum of Fine Arts, 1967.

Morford, Mark. *Stoics and Neostoics: Rubens and the Circle of Lipsius.* Princeton: Princeton University Press, 1991.

Morison, Samuel Eliot. *Samuel de Champlain, Father of New France.* Boston: Little, Brown, 1972.

Morison, Samuel Eliot. *The European Discovery of America: The Southern Voyages A.D. 1492–1616.* New York: The Oxford University Press, 1974.

Müller, Hannelore. *The Thyssen-Bornemisza Collection, European Silver.* Translated by P. S. Falla and Anna Somers Cocks. New York: Vendome Press, 1986.

Münz, Ludwig. *Rembrandt's Etchings.* London: Phaidon, 1952.

Murata, Margaret. *Operas for the Papal Court.* Ann Arbor, Mich.: UMI Research Press, 1981.

Murray, David. *Museums: Their History and Their Use.* Glasgow: James MacLehose and Sons, 1904.

Nagler, A. M. "The Furttenbach Theater in Ulm." *Theater Annual* 11(1953):45–69.

Nagler, A. M. *Theatre Festivals of the Medici, 1539–1637.* Translated by George Hickenlooper. New Haven: Yale University Press, 1964.

Naitza, Salvatore. "Anamorfosi e legittimità prospettiva tra rinascimento e barocco." *Annali delle facolta di lettere filosofia e magistero dell'università di Cagliari* 33:2(1970):175–239.

Neviani, A. "Ferrante Imperato speziale e naturalista

napoletano con documenti inediti." In *Atti e Memorie Accademia di Storia dell'arte sanitaria.* 2nd ser. 2 (1936).

New York Public Library. *The Age of Atlantic Discoveries.* New York: Brazilian Cultural Foundation, ca. 1990.

Nichtlinger, Elizabeth Beasley. "The Iconography of Saint Margaret of Cortona." Ph.D. dissertation. George Washington University, 1982.

de Nicolas, Antonio. *Powers of Imagining: Ignatius de Loyola.* Albany: State University of New York Press, 1986.

Nissen, Claus. *Die Botanische Buchillustration.* Stuttgart: Hiersemann, 1951–66.

Nissen, Claus. *Die illustrierten Vogelbücher: ihre Geschichte und Bibliographie.* Stuttgart: Hiersemann, 1953.

Nissen, Claus. *Herbals of Five Centuries: A Contribution to Medical History and Bibliography.* Translated by Werner Bodenheimer and Albert Rosenthal. Zurich: L'Art Ancien S. A., 1958.

Nordenskiöld, Nils Adolf Erik. *Facsimile Atlas to the Early History of Cartography with Reproductions of the Most Important Maps Printed in the Fifteenth and Sixteenth Centuries.* Translated by Johan Adolf Ekelöf and Clements R. Markham. Stockholm: [Printed by P. A. Norstedt] 1889. Reprint. 1973.

Olmi, Giuseppe. *Ulisse Aldrovandi: Scienza e natura nel secondo cinquecento.* Trent: University of Trent, 1976.

Onians, John. *Art and Thought in the Hellenistic Age: The Greek World View 350–50 BC.* London: Thames and Hudson, 1979.

Osler, M. J., and P. L. Farber. *Religion, Science, and Worldview: Essays in Honor of Richard S. Westfall.* Cambridge, Mass.: Cambridge University Press, 1985.

Palissy, Bernard. *De l'art de la terre, de son utilité, des esmaux et du feu.* Introduction by Jean-Yves Pouilloux. Caen: L'Echoppe, 1989.

Panofsky, Erwin. *Idea: A Concept in Art Theory.* Translated by Joseph J. S. Peake. Columbia: University of South Carolina Press, 1968.

Panofsky, Erwin. *The Art and Life of Albrecht Dürer.* Princeton, N.J.: Princeton University Press, 1971.

Paré, Ambroise. *Des monstres et prodiges.* Edited with critical commentary by Jean Céard. Geneva: Librairie Droz, 1971.

Paré, Ambroise. *On Monsters and Marvels.* Translated with an introduction and notes by Janis Pallister. Chicago: University of Chicago Press, 1982.

Park, Katharine, and Lorraine J. Daston. "Unnatural Conceptions: The Study of Monsters in Sixteenth- and Seventeenth-Century France and England." *Past & Present: A Journal of Historical Studies* 92 (August 1981):20–54.

Parke-Bernet Galleries, New York. *Valuable Objects of Art . . . from the Collection Formed by the Late Edward J. Berwind.* Sale no. 139. November 10, 1939.

Parks, George B. "The Contents and Sources of Ramusio's *Navigationi*." *Bulletin of the New York Public Library* 52 (June 1955): 279–313.

Parry, J. H. *The Discovery of South America.* New York: Taplinger Publishing Co., 1979.

von Pastor, Ludwig Freiherr. *The History of the Popes.* 40 vols. London: J. Hodges, 1891–1953.

Pastoureau, Mireille. "Le premier atlas mondial français . . . de Nicolas Sanson d'Abbeville (1658)." *Revue français d'histoire du livre* 18 (1978).

Pastoureau, Mireille. "Les Atlas imprimés en France avant 1700." *Imago Mundi* 32 (1980).

Pattaro, Sandra Tugnoli. *Metodo e sistema della scienza nel pensiero di Ulisse Aldrovandi.* Bologna: CLUEB, 1981.

Pedretti, Carlo. *Leonardo Architect.* Translated by Sue Beill. New York: Rizzoli, 1981.

Peers, E. Allison, trans. and ed. *The Complete Works of Saint Teresa of Jesus.* London and New York: Sheed and Ward, 1946.

Pennington, Richard. *A Descriptive Catalogue of the Etched Work of Wenceslaus Hollar, 1607–1677.* New York: Cambridge University Press, 1982.

Pérez Sánchez, Alfonso E. *Pintura Española de Bodegones y Floreros de 1600 a Goya.* Madrid: The Prado Museum, 1983.

Philip, Chris. *A Bibliography of Firework Books: Works on Recreative Fireworks from the Sixteenth to the Twentieth Century.* Winchester, Hampshire: St. Paul's Bibliographies, 1985.

Philostratus the Elder. *Philostratus,* Imagines; *Callistratus,* Descriptions. Translated by Arthur Fairbanks. Cambridge, Mass.: Harvard University Press, 1979.

Pieper, Paul. "Ludger tom Ring d. J. und die Anfänge des Stillebens." *Münchener Jahrbuch der Bildenden Kunst* (1964):113–22.

Pieper, Paul, and Theodor Riewerts. *Die Maler tom Ring: Ludger der Altere, Hermann, Ludger der Jüngere.* Munich: Deutscher Kunstverlag, 1955.

Planiscig, Leo. *Venezianische Bildhauer der Renaissance.* 2 vols. Vienna: Anton Schroll, 1921.

Planiscig, Leo. *Andrea Riccio.* Vienna: A. Schroll & Company, 1927.

Platelle, Henri. *Les Chrétiens face au miracle. Lille au XVIIe siècle.* Paris: Editions du Cerf, 1986.

Plietzch, E. *Die frankenthaler Maler: Van der Borcht.* Leipzig: E. A. Seemann, 1910.

Pliny the Elder. *The Natural History of Pliny.* Translated by John Bostock and H. T. Riley. London: H. G. Bohn, 1855–57.

Pliny the Elder. *Natural History.* 10 vols. Translated by H. Rackham. Cambridge, Mass.: Harvard University Press, 1966–79.

Pliny the Younger. *Letters and Panegyricus.* 2 vols. Translated by Betty Radice. Cambridge, Mass.: Harvard University Press, 1972–75.

Plummer, John. *The Last Flowering: French Painting in Manuscripts, 1420–1530, from American Collections.* New York: The Pierpont Morgan Library, 1982.

Pollig, Hermann, et al. *Exotische Welten, europäische Phantasien.* Stuttgart: Edition Cantz, 1987.

Pollitt, J. J. *The Ancient View of Greek Art: Criticism, History, and Terminology.* New Haven: Yale University Press, 1974.

Pomian, Krzysztof. *Collectionneurs, amateurs et curieux. Paris, Venise: XVIe–XVIIIe siècle.* Mayennes: Editions Gallimard, 1987.

Pontonniée, Georges. *The History of the Discovery of Photography.* New York: Arno Press, 1973.

Pope, Maurice. *The Story of Archaeological Decipherment from Egyptian Hieroglyphics to Linear B.* New York: Charles Scribner's Sons, 1975.

Pope-Hennessy, John. *An Introduction to Italian Sculpture.* Vol. 3. London: Phaidon, 1963.

Pope-Hennessy, John. *Italian High Renaissance and Baroque Sculpture.* London: Phaidon Press, 1963.

Poulet, Georges. *The Metamorphoses of the Circle.* Trans. by Carley Dawson and Elliot Coleman. Baltimore: Johns Hopkins University Press, 1966.

Préaud, Maxime. *Inventaire du fonds français: graveurs du xvii siècle: tome 17 — Claude Mellan.* Paris: Bibliothèque Nationale, 1988.

Preminger, Alexander S., comp. *Classical and Medieval Literary Criticism: Translations and Interpretations.* Edited by Alex Preminger, O. B. Hardison, Jr. and Kevin Kerrane. New York: F. Ungar Publishing Co., 1974.

Prest, J. *The Garden of Eden. The Botanical Garden and the Re-Creation of Paradise.* New Haven: Yale University Press, 1981.

Puricelli-Guerra, Arturo. *Armi in occidente.* Milan, 1966.

Putnam, Samuel, ed. and trans. *The Portable Rabelais.* New York: The Viking Press, 1967.

Quintilian. *The Institutio Oratoria.* 4 vols. Translated by H. E. Butler. Cambridge, Mass.: Harvard University Press, 1979–80.

Raimondi, Ezio. *Trattatisti e narratori del seicento.* Milan-Naples: Riccardo Ricciardi, 1960.

Rathke-Köhl, Sylvia. *Geschichte des Augsburger Goldschmiedegewerbes vom Ende des 17. bis zum Ende des 18 Jahrhunderts.* Augsburg: Vorwort, 1964.

Reed, Sue Welsh, and Richard Wallace. *Italian Etchers of the Renaissance and Baroque.* Boston: Museum of Fine Arts, 1989.

Renouard, Antonie. *A Bibliographical Sketch of the Aldine Press at Venice.* Translated and revised by Edmund Goldsmid. Edinburgh: E. & G. Goldsmid, 1887.

de Reume, Auguste Joseph. *Les Vierges miraculeuses de la Belgique.* Brussels: Parent, 1856.

Reynolds, Sir Joshua. *Discourses on Art.* Edited by Robert R. Wark. New Haven: Yale University Press, 1975.

Reznicek, Emil Kavel Josef. *Die Zeichnungen von Hendrick Goltzius.* Utrecht: Haentjens Dekker and Gumbert, 1961.

Richter, H. "W. J. Blaeu with Tycho Brahe on Hven and His Map of the Island." *Imago Mundi* 3 (1939):53–60.

Riedl, Peter Anselm. "Zu Francesco Vannis Tätigkeit für Römische Auftraggeber." *Mitteilungen für Kunstgeschichte* (1978):313–54.

Rivosecchi, Valerio. *Esotismo in Roma Barocca, Studi sul Padre Kircher.* Rome: Bulzoni Editore, 1982.

Robert-Dumesnil, A. P. F. *Le Peintre-graveur français.* Paris: Mme. Bouchard-Huzard, 1855–71. Reprint. Paris, 1967.

Robinson, Franklin W., and William H. Wilson, eds. *Catalogue of the Flemish and Dutch Paintings 1400–1900.* With contributions by Larry Silvers. Sarasota: John and Mable Ringling Museum of Art, 1980.

Rochon, Andre. *La Jeunesse de Laurent de Médicis (1449–1478).* Paris: Société d'édition "Les Belles Lettres," 1963.

Rodriquez, F. *Il museo Aldrovandiano nella biblioteca Universitaris di Bologna.* Bologna: Cooperativa tip Azzoguidi, 1956.

Rohde, Eleanor Sinclair. *The Old English Herbals.* 2 vols. London: Longmans, Green, 1922.

Rooses, Max. *Rubens.* 2 vols. London: Duckworth and Company, 1904.

Roth, Linda Horvitz, ed. *J. Pierpont Morgan, Collector: European Decorative Arts from the Wadsworth Atheneum.* Hartford: Wadsworth Atheneum, 1987.

Rousset, Jean. *La Littérature de l'âge baroque en France: Circé et le Paon.* Paris: Libraire José Corti, 1954.

Rubin, Deborah. *Ovid's Metamorphoses Englished:*

George Sandys's Translator and Mythographer. New York: Garland, 1985.

The Rudolf L. Baumfeld Collection of Drawings and Prints. Los Angeles: Grunwald Center for the Graphic Arts, 1989.

Rudwick, Martin J. S. *The Meaning of Fossils: Episodes in the History of Palaeontology*. 2nd ed. New York: Science History Publications, 1976.

Ruland, H. L. "A Survey of the Double-page Maps in Thirty-five Editions of the *Cosmographia Universalis* 1544–1628 of Sebastian Münster and in His Edition of Ptolemy's *Geographia* 1540–1552." *Imago Mundi* 16 (1962):84–97.

Russell, Diane H., Jeffrey Blanchard, and John Krill. *Jacques Callot: Prints and Related Drawings*. Washington, D.C.: National Gallery of Art, 1975.

Russell, Jeffrey B. *A History of Witchcraft: Sorcerers, Heretics, and Pagans*. London: Thames and Hudson, 1980.

Sabin, Joseph, Wilberforce Eames, and R. W. G. Vail. *Bibliotheca Americana. A Dictionary of Books Relating to America*. 29 vols. New York: Bibliographical Society of America, 1868–1936.

The Saint Louis Art Museum: Handbook of the Collections. St. Louis: St. Louis Art Museum, 1975.

Saintyves, Pierre. *Les reliques et les images légendaires*. Paris: R. Laffont, 1987.

Sánchez Cantón, F. J. *Fuentes literarias para la historia del arte español*. 5 vols. Madrid: Imprenta Clásica española, 1923–41.

Sarton, George. *The Appreciation of Ancient and Medieval Science during the Renaissance (1450–1600)*. Philadelphia: University of Pennsylvania Press, 1955.

Schama, Simon. *The Embarassment of Riches: An Interpretation of Dutch Culture in the Golden Age*. New York: Alfred A. Knopf, 1987.

Schenda, Rudolf. *Die französische Prodigienliteratur in der zweiten Hälfte des 16. Jahrhunderts*. Munich: M. Hueber, 1961.

Schepelern, H. D. *Museum Wormianum, dets Forudsaetninger og Tilblivelse*. Odense, Denmark: Wormianum, 1971.

Schepelern, H. D. "The *Museum Wormianum* Reconstructed: A note on the Illustration of 1655." *Journal of the History of Collections*. 2:1 (1990):81–85.

Scherer, Christian, comp. *Die Braunschweiger Elfenbeinsammlung: Katalog de Elfenbeinbildwerke des Herzog Anton Ulrichs-museums in Braunnschweig*. Leipzig, K. W. Hiersemann, 1931.

Schilder, Günter, and James Welu. *The World Map of 1611 by Pieter van den Keere*. Amsterdam: Nico Israel, 1980.

Schiller, Gertrud. *Iconography of Christian Art*. Translated by Janet Seligman. Greenwich, Conn.: New York Graphic Society, 1971.

von Schlosser, Julius. *Die Kunst- und Wunderkammern der Spätrenaissance: Ein Beitrag zur Geschichte des Sammelwessens*. Leipzig: Klinkhardt & Biermann, 1908.

Schöne, Günter. "Barockes Feuerwerkstheater." *Maske und Kothurn* 6:4 (1960)351–62.

Schrader, J. L. *The Waning Middle Ages: An Exhibition of French and Netherlandish Art from 1350 to 1500*. Lawrence: University of Kansas Museum of Art, 1969.

Schuchard, Margaret. *A Descriptive Bibliography of the Works of John Ogilby and William Morgan*. Bern: Herbert Lang and Frankfurt: M. Peter Lang, 1975.

Schuchard, Margaret. *John Ogilby, 1600–1676. Lebensbild eines Gentleman mit vielen Karrieren*. Hamburg: P. Hartung, 1973.

Schuhl, Pierre-Maxime. *L'Imagination et le merveilleux: La Pensée et l'action*. Paris: Flammarion, 1969.

Schulz, Eva. "Notes on the History of Collecting and Museums." In *Journal of the History of Collections* 2:2 (1990):202–18.

Schuyt, Michael, and Joost Elffers. *Anamorfosen: Spel met Perspectief*. Amsterdam: Rijksmuseum, 1975–76.

Schwartz, Seymour I., and Ralph E. Ehrenberg. *The Mapping of America*. New York: Harry N. Abrams, Inc., 1980.

Segal, Sam. *A Flowery Past: A Survey of Dutch and Flemish Flower Painting from 1600 to the Present*. Amsterdam: Gallery P. de Boer, 1982.

Segal, Sam. *A Prosperous Past: The Sumptuous Still Life in the Netherlands 1600–1700*. Edited by William B. Jordan. The Hague: SDU Publishers, 1988.

Sell, Stacey Lynn. "Five Etchings by Rembrandt." *Annual Report 1988–1989, Bayly Art Museum of the University of Virginia*. Charlottesville, Va.: University of Virginia, 1989.

Shaffer, Ellen. *The Nuremberg Chronicle: A Pictorial World History from Creation to 1493*. Los Angeles: Dawson's Book Shop, 1950.

Shearman, John. *Mannerism*. Harmondsworth, Middlesex, England; New York: Penguin Books, Ltd., 1967.

Shirley, Rodney W. *The Mapping of the World: Early Printed World Maps 1472–1700*. London: The Holland Press, Ltd., 1983.

Leidse Fijnschilders: van Gerrit Dou tot Frans van Mieris de Jonge, 1630–1760. Edited by Eric J. Sluijter, Marlies Enklaar, and Paul Nieuwenhuizen. Zwolle:

Waanders; Leiden: Stedelijk Museum De Laken-hal, 1988.

Smith, Robert C. "The Brazilian Landscapes of Frans Post." *The Art Quarterly* 1 (1938):257.

Smith, W. A. *Horace Walpole: Writer Politician, and Connoisseur.* New Haven: Yale University Press, 1967.

Sotheby's, *A Magnificent Collection of Botanical Books: being the finest color-plate books from the celebrated library formed by Robert de Belden.* Uxbridge, Middlesex, Great Britain: Hillingdon Press, 1987.

Sotheby's, London. *Old Master Paintings.* Sales auction catalogue. July 6, 1988.

de Sousa-Leào, Joaquim. *Frans Post 1612–1680.* Amsterdam: A. L. van Gendt and Company, 1973.

Spear, Richard E. *Caravaggio and His Followers.* Cleveland: The Cleveland Museum of Art, 1971.

Spinosa, Nicola. *La pittura napoletano del'600.* Milan: Longanesi and Company, 1984.

Spinosa, Nicola. *La pittura napoletano del settecento.* Naples: Electa, 1986.

Sponsel, J. L. *Das Grüne Gewölbe zu Dresden: eine Auswahl von Meisterwerken der Goldschmiedekunst.* 4 vols. Leipzig: K. W. Hiersemann, 1925–32.

Sprague, Thomas Archibald. "The Herbal of Otto Brunfels." *The Journal of the Linnean Society of London* 48 (December 1928):79–124.

Sprague, Thomas Archibald, and Ernest Nelmes. "The Herbal of Leonhardt Fuchs." *The Journal of the Linnean Society of London* 48 (October 1931): 545–642.

Stechow, Wolfgang. *Sources and Documents: Northern Renaissance Art, 1400–1600.* Englewood Cliffs, N.J.: Prentice-Hall, 1966.

Stechow, Wolfgang. *Catalogue of European and American Paintings and Sculpture in the Allen Memorial Art Museum.* Oberlin: Oberlin College, 1967.

Stephens, Leslie, and Sidney Lee, eds. *Dictionary of National Biography.* Vol. 20. Reprint. Oxford: Oxford University Press, 1921–22.

Stevenson, Edward L. *Willem Janszoon Blaeu, 1571–1638: A Sketch of His Life and Work with an Especial Reference to His Large World Map of 1605.* New York: De Vinne Press, 1914.

Stilleben in Europe. Munster: Westfalisches Landes-museum, 1979.

Still Lifes of the Golden Age: Northern European Paintings from the Heinz Family Collection. Edited by Arthur K. Wheelock, Jr. Washington, D.C.: National Gallery of Art, 1989.

Stillwell, Margaret Bingham. *The Awakening Interest in Science during the First Century of Printing 1450–*

1550. New York: Bibliographical Society of America, 1970.

Stix, Hugh and Marguerite, and Robert Tucker Abbott. *The Shell: Five Hundred Million Years of Inspired Design.* New York: Harry N. Abrams, Inc., 1968.

Stock, Robert D., ed. *Samuel Johnson's Literary Criticism.* Regents Critics Series. Lincoln: University of Nebraska Press, [1974].

Stone, Darwell. *A History of the Doctrine of the Holy Eucharist.* London: Longmans, Green, 1909.

Strong, Roy C. *Festival Designs by Inigo Jones.* Washington, D.C.: International Exhibitions Foundation, 1967–68.

Strong, Roy C. *The Renaissance Garden in England.* London: Thames and Hudson, 1979.

Strong, Roy C. *Art and Power: Renaissance Festivals, 1450–1650.* Berkeley: University of California Press, 1984.

Suida, William E. *A Catalogue of Paintings in the John and Mable Ringling Museum of Art.* Sarasota: John and Mable Ringling Museum of Art, 1949.

Sullivan, Edward J., and Nina A. Mallory. *Painting in Spain, 1650–1700: from North American Collections.* Princeton, N.J.: Princeton Art Museum, Princeton University, in association with Princeton University Press, 1982.

Sutton, Denys. "Works of Art from the Paul Wallraf Collection." *The Connoisseur* (June 1961):2–14.

Taggert, Ross E. *The Gods of High Olympus.* Kansas City: Nelson-Atkins Museum of Art, 1983.

Taggert, Ross E., and George L. McKenna, eds. *Handbook of the Collections in the William Rockhill Nelson Gallery of Art and Mary Atkins Museum of Fine Arts.* Vol. 1 (Art of the Occident). Kansas City: Nelson-Atkins Museum of Art, 1973.

Talbot, Charles W., ed. *Dürer in America: His Graphic Work.* Notes by Galliard F. Ravenel and Jay A. Levenson. Washington, D.C.: National Gallery of Art, 1971.

Tasso, Torquato. *Discourses on the Heroic Poem.* Translated by Mariella Cavalchini and Irene Samuel. Oxford: Clarendon Press, 1973.

Tasso, Torquato. *Prose.* Edited by Ettore Mazzali. Milan: Riccardo Ricciardi, 1959.

A Taste for Angels: Neapolitan painting in North America, 1650–1750. New Haven: Yale University Art Gallery, 1987.

Tavernari, Carla. "Manfredo Settala, collezionista e scienziato milanese del'600." *Annali dell'Istituto e Museo di Storia della Scienza di Firenze* 1 (1976):43–61.

476

Tavernari, Carla. "Il Museo Settala 1660–1680." *Critica d'Arte*. 163–65 (1980):202–20.

Taylor, Francis Henry. *The Taste of Angels: A History of Art Collecting from Ramses to Napoleon*. Boston: Little, Brown, 1948.

Theuerkauff, Christian. "Fragen zur Ulmer Kleinplastik im 17./18. Jahrhunderts—1. David Heschler (1611–1667) und sein Kreis." *Alte und Moderne Kunst* 190/191 (1983):33–34.

Theuerkauff, Christian. *Die Bildwerke in Elfenbein des 16.–19 Jahrhunderts*. Berlin: Staatliche Museen Preussischer Kulturbesitz, 1986.

Theunisz, Johan. *Carolus Clusius: het merkwaardige Leven van een Pionier der Wetenschap*. Amsterdam: Kampen, 1939.

Thieme, Ulrich, and Felix Becker. *Allgemeines Lexicon der Bildenden Künstler*. Leipzig: Wilhelm Engelman; E. A. Seeman, 1907–50.

Thomas, Keith. *Religion and the Decline of Magic: Studies in Popular Beliefs in Sixteenth- and Seventeenth-Century England*. Harmondsworth, England: Penguin Books, 1973.

Thomas, Joseph. *Universal Pronouncing Dictionary of Biography and Mythology*. Philadelphia: J. B. Lippincott, 1915.

Thorndike, Lynn. *A History of Magic and Experimental Science*. 8 vols. New York: Columbia University Press, 1923–58.

Thornton, John L., and R. I. J. Tully. *Scientific Books, Libraries and Collectors: A Study of Bibliography and the Book Trade in Relation to Science*. 3rd rev. ed. London: The Library Association, 1971.

Tick, D. B., F. Greenberg, and J. M. Graham. *The Pattern and Form of Human Somatic Structural Ectopy*. Los Angeles: UCLA School of Medicine, and Houston: Baylor College of Medicine, n.d.

Tietze, Hans. "Andrea Pozzo und die Fürsten Liechtenstein." *Jahrbuch für Landeskunde von Niederösterrich* (1914–15):432–46.

Timofiewitsch, Wladimir. *Girolamo Campagna: Studien zur venezianischen Plastik um das Jahr 1600*. Munich: Fink, 1972.

Tomasi, Lucia Tongiorgio. "Francesco Mingucci 'Giardiniere' e pittore naturalista: Un aspetto della committenza Barberiniana nella Roma seicentesca." In *Federico Cesi*. Rome, 1986.

Tomasi, Lucia Tongiorgio. "Projects for Botanical and Other Gardens: A Sixteenth Century Manual." *Journal of Garden History* 3 (1983):1–34.

Tooley, Ronald V. *Collector's Guide to Maps of the African Continent and Southern Africa*. London: Carta Press, 1969.

Topsell, Edward. *The History of Four-Footed Beasts and Serpents and Insects*. New York: Da Capo Press, 1967.

The Treasure Houses of Britian. Washington, D.C.: National Gallery of Art, 1985.

Trevor-Roper, Hugh. *Princes and Artists: Patronage and Ideology at Four Hapsburg Courts, 1517–1633*. New York: Harper and Row, 1976.

Tufts, Eleanor. "Ms. Lavinia Fontana from Bologna: A Successful 16th Century Portraitist." *Art News* 73 (1974):60–64.

Tyrrell, William G. *Champlain and the French in New York*. Albany: University of the State of New York, 1959.

University of Notre Dame Art Gallery. *The Age of Vasari*. South Bend: University of Notre Dame, 1970.

Van Eerde, Katherine S. *John Ogilby and the Taste of His Times*. Folkestone, England: Dawson, 1976.

Vasari, Giorgio. *The Lives of the Artists: A Selection*. Translated by George Bull. London: Penguin Books, 1965.

Vasari, Giorgio. *Le Vite de' più eccelenti pittori, scultori, e architetti*. Edited by Lucia and Carlo L. Ragghianti. Milan: Rizzoli, 1971–78.

Vasari, Giorgio. *Le vite de' più eccelenti pittori, scultori, e architettori*. 1568. Ed. by Gaetano Milanesi. Florence: G. C. Sansoni, 1981.

Vassar College. *Vassar College Art Gallery: Paintings, 1300–1900*. Poughkeepsie: Vassar College Art Gallery, 1983.

Venturi, A. *Storia dell'arte italiana: La pittura del cinquecento*. Vol. 9. Part 7. Milan: Ulrico Hoepli, 1934.

Verdier, Philippe. *Catalogue of the Painted Enamels of the Renaissance*. Baltimore: The Walters Art Gallery, 1967.

Vermeule, Cornelius. "An Imperial Medallion of Leone Leoni and Giovanni Bologna's statue of the Flying Mercury." *Spinks' Numismatic Circular* (November 1952):506–10.

Vickers, Michael, et al. *Ivory: An International History and Illustrated Survey*. New York, Harry N. Abrams, Inc., 1987.

de Viguerie, Jean. "Le Miracle dans La France du XVIIe siècle." *XVIIe Siècle* 140 (1983):313–31.

de Villiers, E. S. "Flemish Art Theory in the Second Half of the 17th Century—an Investigation on an Unexplored Source." *South African Journal of Art History* 2 (1987):1–11.

Vlieghe, Hans. *Saints*. London and New York: Phaidon, 1973.

Volkoff, Ivan, Ernest Franzgrote, and A. Dean Lar-

sen. *Johannes Hevelius and His Catalog of Stars.*
Provo, Utah: Brigham Young University Press,
1971.

Wadsworth Atheneum Handbook. Hartford: Wadsworth Atheneum, 1958.

Wagner, Henry R. *The Cartography of the Northwest Coast of America to the year 1800.* Berkeley: University of California Press, 1937. Reprint. 1968.

Walker, John. *National Gallery of Art, Washington, D.C..* New York: Harry N. Abrams, Inc., 1975.

Walton, Guy. *Louis XIV's Versailles.* Chicago: The University of Chicago Press, 1986.

Ward, Benedicta. *Miracles and the Medieval Mind.* Philadelphia: University of Pennsylvania Press, 1982.

Warner, Marina. *Alone of All Her Sex: The Myth and the Cult of the Virgin Mary.* New York: Vintage Books, 1983.

Watson, Wendy M. *Italian Renaissance Maiolica from the William A. Clark Collection.* London: Scala Books, 1986.

Weber, Ingrid. *Deutsche, Niederländische und Französische Renaissance Plaketten 1500–1600.* 2 vols. Munich: Bruckmann, 1975.

Weil, Mark S. "The Devotion of the Forty Hours and Roman Baroque Illusions." *The Journal of the Warburg and Courtauld Institutes* 37 (1974):218–48.

Weil, Mark S. *Baroque Theatre and Stage Designs.* St. Louis: Gallery of Art, Washington University, 1983.

Weinberg, Bernard. *A History of Literary Criticism in the Italian Renaissance.* 2 vols. Chicago: University Press of Chicago, 1961.

Weinberg, Bernard, ed. *Trattati di poetica e retorica del Cinquecento.* 4 vols. Bari: G. Laterza, 1970–74.

Weinstein, Donald, and Rudolph M. Bell. *Saints and Society. The Two Worlds of Western Christendom, 1000–1700.* Chicago and London: University of Chicago Press, 1982.

Welu, James A. *Seventeenth Century Dutch Painting: Raising the Curtain on New England Private Collections.* Worcester, Mass.: Worcester Art Museum, 1979.

Welu, James A. *The Collector's Cabinet: Flemish Paintings from New England Private Collections.* Worcester, Mass.: Worcester Art Museum, 1983.

Wengström, Gunner. "Claude Mellan: His Drawings and Engravings." *Print Collector's Quarterly* 11 (1924):10–43.

Wesselovsky, A. "Italienische Mysterien in einem Russischen Reisebericht des XV. Jahrhunderts." *Russische Revue* 10 (1877):425–41.

Wheelock, Arthur K., Jr. "Constantijn Huygens and Early Attitudes Towards the *Camera Obscura.*" *History of Photography* 1 (1977):93–103.

Wheelock, Arthur K., Jr. *Perspective, Optics, and Delft Artists Around 1650.* New York: Garland Publishers, 1977.

Whitaker, Ewen A. "Galileo's Lunar Observations and the Dating of the Composition of 'Sidereus Nuncius.' " *Journal of the History of Astronomy* 9 (1978):155–169.

White, Christopher. *Rembrandt as an Etcher: A Study of the Artist at Work.* 2 vols. University Park, Pa.: Pennsylvania State University Press, 1969.

White, Christopher, and Karel G. Boon, comp. *Hollstein's Dutch and Flemish Etchings, Engravings, and Woodcuts.* Vols. 19, 28. Amsterdam: Van Gendt, 1969.

Whitehead, P. J. P. "The Original Drawings for the *Historia naturalis Brasiliae* of Piso and Marcgrave (1648). *Journal for the Society for the Bibliography of Natural History* 7(1976):409–22.

Whitehead, P. J. P., G. van Vliet, and W. T. Stearn. "The Clusius and Other Natural History Pictures in the Jagiellon Library, Krakow." *The Archives of Natural History* 16 (1989):15–32.

Whitehead, P. J. P., and M. Boeseman. *A Portrait of Dutch Seventeenth-Century Brazil: Animals, Plants and People by the Artists of Johan Maurits of Nassau.* Amsterdam and New York: North-Holland Publishing Co., 1989.

Wiles, Bertha Harris. *The Fountains of Florentine Sculptors and Their Followers from Donatello to Bernini.* New York: Hacker Art Books, 1975.

William H. Schab Gallery. *Three Centuries of Illustrated Books: 1460–1760.* Catalogue 35. New York: William H. Schab Gallery, n.d.

Wilson, Adrian. *The Making of the Nuremberg Chronicle.* Assisted by Joyce Lancaster Wilson, with introduction by Peter Zahn. Amsterdam: A. Asher, 1976.

Wilson, Stephen, ed. *Saints and their Cults.* Cambridge, Mass.: Cambridge University, 1983.

Wilson, Timothy, et al. *Ceramic Art of the Italian Renaissance.* Austin: University of Texas Press, 1987.

Wisch, Barbara, and Susan Scott Munshower. *All the World's a Stage: Art and Pageantry in the Renaissance and Baroque.* Vol. 6. University Park, Pa.: Pennsylvania State University, 1990.

Wittkower, Rudolf, and Irma B. Jaffe, eds. *Baroque Art: The Jesuit Contribution.* New York: Fordham University Press, 1972.

Wolf, Edwin, ed. *Legacies of Genius: A Celebration of Philadelphia Libraries.* Philadelphia, Pa.: Phila-

delphia Area Consortium of Special Collections Libraries, 1988.

Wolf, Dr. Rudolf. *Handbuch der Astronomie: ihrer Geschichte und Litteratur*. Amsterdam: Meridian Publishing Company, 1973.

Wollin, N. G. *Gravures originales de Desprez ou exécutées d'apres ses dessins*. Malmo, 1933.

Woodbridge, Kenneth. *Princely Gardens: The Origins and Development of the French Formal Style*. New York: Rizzoli International Publications, 1986.

Worp, J. A. "Fragment eener Autobiographie van Constantijn Huygens." In *Bijdragen en Mededeelingen van het historisch Genootschap*. (Utrecht) 18 (1897):1–122.

Wright, Christopher. *A Golden Age of Painting: Dutch, Flemish, German Paintings, Sixteenth–Seventeenth Centuries, from the Collection of The Sarah Campbell Blaffer Foundation*. San Antonio: Trinity University Press, 1981.

von Wurzbach, Alfred. *Niederländisches Künstler-Lexikon*. Vienna and Leipzig: Halm and Goldmann, 1906.

Yates, Francis A. *Theater of the World*. Chicago: The University of Chicago Press, 1969.

Zangheri, Luigi. *Pratolino; il giardino delle meraviglie*. 2 vols. Florence: Gonnelli, 1979.

Zorzi, Gian Giorgio. *I disegni delle antichità di Andrea Palladio*. Venice: N. Pozzo, 1959.

Zorzi, Ludovico. *Il teatro e la città, saggi sulla scena italiana*. Turin: G. Einaudi, 1977.

Zorzi, Ludovico, et al. *Il luogo teatrale a Firenze*. Milan: Electa, 1975.

INDEX

482

PHOTOGRAPHY CREDITS

All works in the exhibition from the Dartmouth College Library, Hood Museum of Art, and the collection of Arthur and Charlotte Vershbow were photographed by Jeffrey Nintzel. Robert D. Rubic and Richard C. Baker photographed the images from the books lent by The New York Public Library and Linda Hall Library respectively. Christopher Gallagher of The Art Institute of Chicago photographed the maps on loan from the collection of Barry L. MacLean.

Other photography credits are:

Terry Schank, cat. no. 11; Hickey and Robertson, Houston, cat. nos. 24, 28, 155; K. Weremeychik, cat. no. 41; Donald Waller, cat. nos. 34, 37, 41; Don Eaton, cat. nos. 63, 64, 65; Patrick J. Young, cat. no. 72; Eric Pollitzer, cat. no. 122; Robert Browning, cat. no. 209.